African American Identity

African American Identity

Racial and Cultural Dimensions of the Black Experience

Edited by Jas M. Sullivan and Ashraf M. Esmail

LEXINGTON BOOKS
Lanham • Boulder • New York • Toronto • Plymouth, UK

Published by Lexington Books
A wholly owned subsidiary of The Rowman & Littlefield Publishing Group, Inc.
4501 Forbes Boulevard, Suite 200, Lanham, Maryland 20706
www.rowman.com

10 Thornbury Road, Plymouth PL6 7PP, United Kingdom

British Library Cataloguing in Publication Information Available

Library of Congress Cataloging-in-Publication Data
African American identity : racial and cultural dimensions of the Black experience /
edited by Jas M. Sullivan and Ashraf M. Esmail.
 p. cm.
 Includes bibliographical references.
 ISBN 978-0-7391-7174-5 (cloth : alk. paper) — ISBN 978-0-7391-7175-2 (electronic)
 1. African Americans—Race identity. 2. African Americans—Ethnic identity. 3.
United States—Race relations. 4. United States—Ethnic relations. 5. African
Americans—Social conditions—1975– I. Sullivan, Jas M. II. Esmail, Ashraf.
 E185.625.A375 2012
 305.896'073—dc23 2011052632

Printed in the United States of America

For

Samaah and Malik
—J.M.S.

Asmah, Mohammad and Nathim
—A.M.E.

Contents

Figures

Tables

Foreword

In the midst of March Madness and the 2011 NCAA Basketball Tournament, ESPN ran a documentary film on the University of Michigan's Fab-5, a team that consisted of five freshmen—all from the inner city—"who rode their talent, hip-hop style and trash talk to the 1992 championship game" played against Duke University (Washington, 2011). Duke fielded an integrated team, including Grant Hill, who went on to a stellar career in the NBA (Washington, 2011). Hill, who is also black, is the son of two middle-class and highly successful parents. In the film, Jalen Rose, a member of the Fab-5 and the progeny of a poor single-parent household from Detroit's inner city, recalls during an interview clip that he literally hated the 1992 Duke team and considered blacks who played for Duke, i.e., the likes of Grant Hill, "Uncle Toms." This insult eventually drew a critical response from Grant Hill, and in short order the American public was witness to a "blacker-than-thou" variant of the *dozens*. Lord knows this volume on black identity research could not be timelier.

"African American Racial Identity" is a misnomer, and the articles and research covered in this volume are better captured by the hyphenated term: racial-cultural identity, or better yet, the exploration of the racial and cultural components of the social identity of African Americans. In a comprehensive sense, the social identity of African Americans is more akin to a *matrix of factors* such as gender, social class, region of birth and socialization, urban-rural, bi-racial or multiracial status, and LGBT status, among others; however, racial and cultural issues have traditionally dominated the psychological discourse. Placing equal emphasis on race as well as culture may seem strange coming from a scholar who has played no small role in the creation and application of two racial-identity measures: RIAS and CRIS. The RIAS was a scale developed by Thomas Parham for use in his dissertation at Southern Illinois University under the guidance of the then- aspiring and now renown black psychologist named Janet Helms. Thomas called me when I was teaching at the Africana Studies and Research Center at Cornell University to request permission to use the items from a Q-Sort that William S. Hall and I created based on the Stages from my 1971 article on the Negro-to-Black Con-

version Experience. I was humbled and excited that Parham was interested in even creating a paper-pencil measure and readily granted permission.

After completing his dissertation, Parham moved in a different direction, and refining the scale was undertaken by Dr. Helms, so that today the RIAS is better known, and rightfully so, as the Helms-Racial-Identity-Attitude-Scale or RIAS for short. As an important aside, Dr. Helms and her former student, Robert Carter, who has become a distinguished scholar in his own right, both reference the RIAS as a measure of racial identity generally devoid of ethnic-cultural dynamics.

If my input into the creation of the RIAS was at arm's length, the story of the creation of the CRIS is another story altogether. In 1991, twenty years after the publication of the Negro-to-Black essay, I revised what is now referenced as the stages of *Nigrescence Theory*. Under the guidance of Dr. Beverly Vandiver, a team based at Penn State University and consisting of Frank Worrell (now at UC-Berkeley, Peony Fhagen-Smith (now at Wheaton College), and myself (I am now at UNLV), along with important input from Kevin Cokley (now at University of Texas at Austin), worked to construct a new measure of racial-identity based on the revised 1991 version of *Nigrescence Theory*. As documented elsewhere (Vandiver et al., 2002), it took nearly five years of development before the CRIS was released for general use, and the painstaking steps behind the creation of the CRIS has resulted in a "racial-identity" with solid psychometric properties.

Today, my writings on "race"—and the legacy of the CRIS more particularly —hang like an *albatross* around my neck. I confess to adding to the intellectual confusion, if not outright conceptual mess, captured in the *racial-identity versus cultural-identity debate* (also referenced as ethnic-identity versus racial-identity debate). That said, I now declare, in the voice of the Church-Lady from Saturday Night Live, "Hey, folks, that is not what I meant, and my work has never been solely about "race-oppression." Truth be told, my work has always been about racial identity as oppression *as well as* racial identity as culture. I need to take the reader back to a commentary I wrote for Joe Ponterotto (Cross, 2001) in an essay he requested on the history of the origin of Nigrescence Theory. I apologize for the length of the quote, but the relevance of the material will soon become apparent.

In the 1960s, while going through my own identity conversion, I attended meetings on Chicago's South Side sponsored by a cultural-nationalist organization, and these experiences greatly informed my early writings on black identity (Cross, 2001). Cultural-nationalism was a precursor to Afrocentrism, and culture was foundational to each orientation, a point repeatedly underscored at the South Side meetings:

> Black artists and cultural nationalists organized the Organization of Black American Culture (OBAC) as an artistic forum, but on Sundays, open meetings were held in which people, ordinary people, stepped forward to confess to their previous cultural backwardness, miseducation, and self-hatred and proclaim the healing power and rejuvenation of their new-found Blackness. . . . An invited

speaker addressed our souls, our music, our art, and our communities. In a manner of speaking, we were being urged to be openly "cultural" as well as "racial.

To this day, I do not consider my model to be one of "race consciousness," but rather, one of race and culture consciousness because people like Jeff [Donaldson], author Lerone Bennett, editor of *Negro Digest* Hoyt Fuller and poet Don L. Lee pounded into our heads that "race" was only part of the issue. More important was a black person's consciousness of black culture. . . . The model I eventually produced would not be a race identity analysis, it would be a race and ethnicity or race and cultural identity conception, which simultaneously combined elements of "how one can learn to live and negotiate imposed notions of race" and "how one can learn to embrace blackness as ethnicity and culture." Because I believe so strongly that blackness is far more ethnic-cultural and existential than "racial," it may come as a surprise to the reader that I experience a certain degree of discomfort when one refers to my work as solely as "racial" (Cross, 2001, p. 34-35).

In 1971 I penned an essay on black identity change and the psychological dynamics of the Black Consciousness Movement (Cross, 1971). In the original essay five stages were described: Pre-Encounter, Encounter, Immersion-Emersion, internalization, and Internalization-Commitment. Although "race" permeates each stage, more obvious is that race *and* culture are addressed simultaneously. *Pre-encounter* captures a person's possible denial of race-oppression, but this stage also depicts the naïveté of a person who is a stranger to black history and black culture. *Encounter* not only marks an awakening to racial oppression but also to the immense possibilities of becoming more culturally centered. *Immersion-Emersion* depicts an *"über"* awareness of racial-oppression, but it also depicts a person's immersion into black culture. The later stages [Internalization and Internalization-Commitment] continue this diunital analysis, wherein "advanced" consciousness is grounded in an understanding of oppression and a commitment to black culture.

Twenty years later in my 1991 revision of Nigrescence Theory (Cross, 1991), the balance of race and culture is even more explicit in the various archetypes created to amplify characteristics said to be emblematic of each stage. For Pre-encounter the cultural boundaries of the archetype "Assimilated" is riddled with mainstream (American) culture elements, and the archetype "Miseducated" is a direct reference to a person who has been culturally deracinated to the point that the person views black people through the prism of "false" (culture-historical) consciousness. The archetypes for advanced consciousness (i.e., Stages Four and Five) carry the titles "Afrocentric," "Multicultural" and "Bi-cultural" for which the importance of culture is quite transparent. As in the original 1971 model, elements of race, culture, and history are interwoven throughout all the stages of the model.

Many of the young men and women who experienced identity change in the 1960s and 1970s as graduate students went on to became pioneers in the "black" studies movement. The curriculum of black studies reflected the identity and consciousness of these pioneers. Racial oppression was interrogated in courses on

black history and the sociology of racial oppression, but majors in black studies were systematically exposed to black literature, black dance, jazz and black music, black art, and black theology. In the 1980s, the term "black studies" was replaced by "African American Studies," and while this name change accorded more explicit importance to culture, it was generally understood among "black" studies advocates that the previous term "black studies" was not about "race" studies.

Turning to an exemplar closer to home for many of the authors in this volume, it is important to recall that the founders of ABPsi were themselves the product of identity change. In his short but influential text (Thomas, 1971) titled, *Boys No More*, and his important interview on black identity change published in *Psychology Today* (Thomas, 1970), one of the ABPsi founding members, Charles W. Thomas, discussed black identity change in both racial and *cultural* terms. The famous elder of ABPsi, Robert Williams, often named test and survey instruments he invented with race and *culture* loaded terms (BITCH Test, Ebonics, etc.). And more to the point, the name the Association of Black Psychologists and the association's *Journal of Black Psychology* can hardly be described as solely concerned with issues of race oppression. In short, many, including myself, have participated in labeling as "racial identity," what all along should have been categorized as racial-cultural identity.

Ironically and as an important aside, the original racial scientists (i.e., pseudo-scientists) were subject to the same error in thinking. European explorers, upon the "discovery" of other peoples in far away lands, made note of the differences in physical features between themselves and various indigenous folk, and this eventually lead to the "science" of racial classification. Overlooked by many is the fact that race-scientists used as "evidence" of racial difference not just physical features, but *culture differences*. Thus to racialists, race could mean the "bodies" of a "different" group as well as the fact that these "inferior" groups did not speak English or German or French and their religions were different and their art was different (etc.). At the time, race-theorists could not produce biologic evidence (other than skin color and physiological differences) to support their claims of racial inferiority; consequently, they used instead, *culture variations*, thus creating the oxymoronic phrase: cultural-racism. The *race as culture difference* thesis was recently reactivated by Charles Murray (author of *The Bell Curve*) in his text titled *Human Accomplishment: The Pursuit in the Arts and Sciences, 800 B. C. to 1950*. My point being that even for those who invented the term race, they used it as much to reference culture as to classify body types.

Another literature with which we are all familiar that also uses the term "race" and then turns around and links *race and culture* are writings on racial socialization. There is not one study on racial socialization that has found that the parents of children of color equate preparation for encounters with racial oppression or prejudice as the *sole purpose* of their socialization. Rather, such studies report a "dual" purpose of (1) preparation for encounters with prejudice and (2) the inculcation of cultural pride. Just as studies of racial identity are in reality about racial-cultural identity, so it is that racial socialization studies turn out to be about

racial-cultural socialization, even though this literature continues to be categorized as racial socialization.

The current volume brings together scholars some in the racial-identity camp and others who are more focused on issues of culture and ethnicity. There are identity measures that attempt to voice each position, such as the CRIS and RIAS for measurement of racial-identity and the MEIM for measurement of ethnicity-culture. The problem is, we now have a handful of well-conducted studies that show these measurements are *highly correlated* (Casey-Cannon et al., 2011; Hall and Carter, 2006; also see study by Cross, Grant and Ventuneac, in this volume). The associations are not so strong that the MEIM can be used as a proxy for the RIAS or CRIS or vice versa. Nevertheless, there simply is little to no empirical evidence supporting the claim that racial identity is about "oppression" and is thus distinct (separate from) identity as culture. And the reverse appears to be true in that the MEIM has been shown to be as sensitive to measures of oppression and racial stress as the RIAS (Hall and Carter, 2006; see also the study is this volume by Cross, Grant and Ventuneac).

There are two lines of research that may provide insight if not an outright answer to the riddle. Recall my earlier discussion of the racial-socialization research has tended to equate a two-factor structure to such socialization: preparation for encounters with prejudice and inculcation of pride. Less understood is that the two factors can *interact* such that children socialized across the two domains, *but especially with regard to cultural socialization*, are better prepared for encounters with race-prejudice than children primarily socialized solely to anticipate prejudice (Quintana and Vera, 1999). This suggests that, even if racial and cultural identity were totally distinct constructs (which, of course, they are not), adequate psychological functioning requires development of both domains and that in their combination (connectivity), one is afforded the best defense against internalized oppression and good coping in the face of race and related stress. This, of course, is what the founders of OBAC were so concerned about: that to focus solely on "race" was a form of "incomplete" awareness and that, to borrow a term used by Linda Myers, *optimal* awareness in blacks (and by inference other folks of color) *combines* racial-awareness with culture-awareness.

A second line of theorizing and research that holds much promise in helping us understand that black identity is as much about culture as about race, focuses on the lived experiences of black folk. That is, how do black people enact or perform identity in everyday life, and do their enactments reflect a separate identity for transacting "race" and another for transacting "culture," or as an alternative perspective, is one (coherent and integrated) identity linked to a repertoire of identity actions. *That is, one identity capable of multiple forms of expression or enactment.*

At the forefront of such research is Daphna Oyserman (Oyserman and Destin, 2010) at the University of Michigan and Howard Stevenson of the University of Pennsylvania. My work with Linda Strauss of Penn State University has also contributed to this new approach (Strauss and Cross, 2005). This approach suggests

that by the time a black person reaches adolescence and early adulthood, years of (racial-cultural) socialization produces a person who can "read" the racial-cultural cues of a situation, and then enact identity in accordance to the demand characteristics of that situation. In situations of race-or-culture related threat-stress, black identity is enacted in order to accomplish identity protection (buffering). However, black youth are also taught and encouraged on a daily basis how to "exit" the black community and "enter" and be *successful within* mainstream institutions such as schools, the workplace, hospitals, banks, etc. Such "in-and-out" identity transactions involve the ability to "identity-switch" (code switch).

Buffering and code switching are forms of intergroup identity enactments, but there is also the question of identity performance within one's community [i.e., intragroup identity enactments]. It is beyond the scope of this commentary to lay out all the transactional modalities enacted in intragroup circumstances, other than to note that some activities reinforce a sense of belonging and connection to the group (Attachment-Bonding), while enactments help black youth deal during negative interactions with fellow black people who evidence internalized oppression.

Scholars pursuing this line of research do not end up with a "fragmented" self, with one type of identity meant to perform, for example, buffering, and another code switching, and still others dedicated to Attachment-Bonding or protection against internalized oppression (i.e., Within-Group Buffering). Rather the person is said to have a multidimensional but coherent and integrated identity that is web-like in structure, wherein the identity enactment competencies are reticulated (connected). Thus cognitions, memories, and feelings relevant to one competency can be "shared." For example, in a race-related situation that is stressful (classic racial identity circumstance), the person may recollect historical or cultural information (classic cultural identity dynamic) that allows him/her to feel grounded, self-confident and not easily made insecure by the race-related stress. In this model, identity is linked to a *repertoire of expression* in which racial identity and cultural identity are inextricably interwoven.

The works in this important collection will extend far beyond the race versus culture debate. The voice of political scientists, sociologists and historians are of particular note. The identity subscales constructed by Robert Sellers for the MIBI, as well as the subscales integrated into the CRIS, pay homage to black politics, sociology, psychology and history. For example, the names accorded the CRIS Subscales are directly linked to ideas derived from black history, black sociology and black politics, in that "Assimilated" captures the sociological images found in Nathan Hare's (1965) and E. Franklin Frazier's (1957) scathing critiques of the Black Bourgeois; "Miseducation" is a tribute to Carter G. Woodson's notion of the *Miseducation of the Negro*; the "Racial-Self-Hatred" subscale resonates to Toni Morrison's *Bluest Eye* and Kenneth Clark's Negro-Self-Hatred; while the CRIS subscales "Afrocentric" and "Multicultural" are linked to the ideas of psychologist Joseph Baldwin (for the former) and multicultural experts James and Cherry Banks

(for the later). Such "hidden" interdisciplinary associations are replaced by openly the interdisciplinary works included in this volume.

In closing, we confront the age-old problem of "what's in a name?" If we believe that black identity is as much about culture as race, then we need to abandon the term racial identity, because it is misleading and leaves out the element of culture. This means the RIAS is in need of a letter "c" as in Racial-Cultural Identity Attitude Scale (RCIAS), and the CRIS becomes the CCRIS as in Cross Cultural-Racial Identity Scale. If I had the power to change the title of this text, I would substitute "social" for "racial" to make it read *African American Social Identity: Readings in Psychological Exploration of the Racial and Cultural Dimensions of the Black Experience.*

<div align="right">

Harambee,
William E. Cross, Jr.
Department of Counselor Education, UNLV

</div>

References

Casey-Cannon, S. L., Coleman, L. K., Knudtson, L. F., and Velazquez, C. C. (2011). Three ethnic and racial identity measures: Concurrent and divergent validity for diverse adolescents. *Identity: An International Journal of Theory and Research, 11*(1), 64-91.

Cross, W. E., Jr. (1971). The negro-to-black conversion experience: Toward a psychology of black liberation. *Black world*, Vol. 20, No. 9, July, pp. 13-27.

Cross, W. E., Jr. (1991). *Shades of black.* Philadelphia: Temple University Press.

Cross, W. E., Jr. (2001). Encountering nigrescence. In J. S. Ponterotto, J. M. Casas, L. A. Suzuki, and C. M. Alexander (Eds.), *Handbook of multicultural counseling* (Second edition). Thousand Oaks, CA: Sage Publications, 30-44.

Hall, S. P., and Carter, R. T. (2006). The relationship between racial identity, ethnic identity, and perceptions of discrimination in an Afro-Caribbean descent sample. *Journal of Black Psychology, 32*(2), 155-175.

Oyserman, D., and Destin, M. (2010). Identity based motivation: Implications for intervention. *The Counseling Psychologist, 38*(7), 1001-1043.

Quintana, S. M., and Vera, E. M. (1999). Mexican American children's ethnic identity, understanding of ethnic prejudice, and parental ethnic socialization. *Hispanic Journal of Behavioral Sciences, 21*(4), 387-404.

Strauss, L. C., and Cross, W. E., Jr. (2005). Transacting black identity: A two-week daily-diary study. In G. Downey, J. S. Eccles, and C, M. Chatman (Eds.), *Navigating the Future: Social Identity, Coping, and Life Tasks,* pp. 67-95. New York: Russell Sage Foundation.

Thomas, C. W. (1970). Different strokes for different folks. *Psychology Today, 4*(4): 48-53.

Thomas, C. W. (1971). *Boys no more.* Beverly Hills, CA: Glencoe Press.

Vandiver, B. J., Cross, Jr., W. E., Worrell, F. C., and Fhagen-Smith, P. E. (2002). Validating the Cross Racial Identity Scale. *Journal of Counseling Psychology, 49*(1), 71-85.

Washington, Jesse (2011). 'Uncle Toms' assertion exposes deeper issues: Ex-Fab Fiver's remark about Duke players ignites uproar. Associated Press article published in *Las Vegas Review Journal,* Sports Section, 2C.

Preface

What is African American racial identity? How do we measure it? What are the factors shaping identity development? What are the effects of racial identity on psychological, political, educational, and health behavior? In this edited volume, these questions are explored. Accordingly, all of the chapters included in this volume engage in some aspect connected to questions of African American racial identity. Unlike most edited volumes on African American racial identity, this book is multidisciplinary; it contains contributions from scholars from a broad spectrum of social science disciplines. In addition, methods of analysis utilized to explore questions of African American racial identity include both quantitative, qualitative and in some cases, mixed-methods. From both of these vantage points (a multi-disciplinary approach and multi-method approach to studying African American racial identity), this book provides for a unique opportunity to further our understanding, to extend our knowledge, and continue the debate.

The first part of this volume deals with the theoretical and methodological issues surrounding African American racial identity. In chapter 1, Worrell reviews the evolution of Cross's nigrescence theory. He discusses the scales that were developed to measure the original and expanded models; major contributions of the theory to our understanding of African American racial identity attitudes; the empirical work examining the relationship between racial identity profiles and psychological functioning; and the recent work extending Cross's nigrescence model to other racial and ethnic groups. Chapter 2 reviews the various models and measures of racial identity and identification. To that end, Harvey, Blue, and Tennial categorize these models within four categories: Social Development, Africentric, Affiliation-Commitment, and Multidimensional, and they consider the following: how the various dimensions within these models fit within a typology, and how each relates to both African American and European-American identity. They also provide a critique on the conceptualizations and measurements across these models. Most notably, they introduce a mixed-method measurement tool called "Piping" that is able to overcome some of the limitations within the extant conceptualizations and measures of racial identity and identification. Sullivan and

Ghara, in chapter 3, propose a number of theoretical and methodological limitations found in studies of African American racial identity in political science. They argue that one source of confusion in the literature concerns the lack of a clear conceptual definition of the key concept and the different theoretical underpinnings associated with its measures (e.g., racial identity vs. racial consciousness). Moreover, they argue that political scientists have not taken into full account the complexity of African American racial identity, typically relying on simple measures of the concept that provide a limited perspective of its multifaceted nature. The ultimate the goal of the chapter is to call attention to the need for conceptual clarification and the use of a multidimensional measure of African American racial identity in political science.

The second part of the volume explores questions dealing with African American racial identity and psychological well-being. In chapter 4, Elmore, Mandara, and Gray conduct a meta-analysis of studies that assessed the effects of racial identity on African American youth and young adult mental health and academic adjustment. They cite the following findings: There exist thirty-eight studies with over 9,000 different participants; the measures of racial pride were positively and strongly related to well-being; and the other dimensions of racial identity were not as strongly related to well-being, especially for girls. Their hope is that the conceptual framework developed in this study helps to clarify much of the inconsistencies in the racial identity literature, and that future intervention efforts should be directed at instilling a sense of pride and agency and comfort within one's skin. African American identity and well-being are explored, in chapter 5, using independent measures of ethnicity and racial/cultural identity to determine the overlap between ethnicity and racial identity. Cross, Grant, and Ventuneac find that high scores on ethnic identity were associated with positive self-esteem and advanced ego-identity development; however, ethnic identity scores did not differentiate African Americans from Black Immigrants. In addition, they find that the racial identity measure distinguished between Assimilation, Afro-centric, and Multicultural forms of African American identity, and the results of regression analysis show these three identity orientations were equally efficacious as pathways to well-being. Their overall findings suggest that in studies of social identity, racial-cultural and ethnic-racial are blended rather than distinct constructs. Reitzes and Jaret, in chapter 6, examine the impact of racial/ethnic identity meanings and the importance of the identity on the self-esteem and self-efficacy of African American students. They find that students construct identity meanings to distinguish their racial/ethnic group from others and to highlight ties to group members. In addition, their findings suggest that there is also some support for an interaction effects expectation that, for students who attribute greater importance to being African American, their racial/ethnic identity meanings have a greater impact on self-esteem and self-efficacy than for those who attribute less importance to their African American identity. The goal of chapter 7 is to extend previous research by examining the influence of stressful events on African American adolescents' self-reports of depressive and anxiety symptoms. Mulser, Hucke,

Trask-Tate and Cunningham find that while stressful events were positively related to adolescents' depressive symptoms scores, the adverse effects of this relationship were lessened for those adolescents reporting a strong racial identity. However, racial identity did not act as a protective in the relation between stressful events and adolescents' reports of anxiety symptoms. They argue that these results may indicate that racial identity acts as more of a long-term global coping strategy for more chronic stressors, rather than as a reactive coping strategy for acute stressors.

The third part of the volume examines questions dealing with African American racial identity and physical health. In chapter 8, Thompson, Clark, and Purnell provide a brief overview of racial identity, racial identification and its varied aspects, and well as the factors influencing it. They then provide a description of the Theory of Planned Behavior/Reasoned Action and the Precaution Adoption Process Model as theoretical frameworks that suggest the importance of racial/ethnic identification for health and health behavior and promotion. Specifically, they review what is known about the relationship between racial identification and health behaviors, including physical activity, diet and nutrition, screening behaviors, risk behaviors, treatment utilization, and health communications preferences. Finally, they conclude with a discussion of methodological concerns and recommendations for future research. Persaud, Singh, Whitbourne, and Sneed, in chapter 9, provide an overview of the *Heart and Soul Study* at Harlem Hospital Center in New York City and detail the ways in which this academic-community partnership has attempted to spread awareness about vascular depression and increase African American participation in mental health research. They also discuss that diagnosis and treatment of vascular depression may be complicated by stigma and shame, religiosity, distrust, economic bias, and provider bias, and that these complicated ideas and beliefs about mental illness are not just whimsical beliefs, but are manifested in the African American racial identity and are central to how they perceive themselves.

The fourth part of the volume explores African American identity development and its effects on parents and children. Chapter 10 focuses on the role that African American nonresident fathers can play in the lives of their sons. Thomas, Caldwell, and De Loney examine race socialization because of its possible contribution to building resilience in African American children and because of African American fathers' special advantage in communicating these types of messages. Specifically, they explore the characteristics of these fathers while also investigating the congruency between the race socialization messages that fathers communicate, and those that the sons remember receiving from their fathers. Their findings suggest that fathers who did not identify strongly with their race reported more job-related stress and were also more likely to transfer barriers messages to their sons, in that, the messages that the sons reported hearing from their fathers were congruent with those fathers reported conveying. In chapter 11, Rowley, Varner, Ross, Williams, and Banerjee reviews existing research on racial identity and parenting and offer examples of ways in which parenting and child outcomes may be impacted by parental racial identity, parent experiences, and the social context in which parent-

ing processes occur. They then discuss the limitations of existing work and directions for future research, and conclude the chapter with a call for additional research examining the role of parental racial identity in parent beliefs, parenting behaviors, and socialization processes. Quintana and Smith, in chapter 12, review African American children's development of racial perspective-taking ability that informs the development of their racial identifications and racial identities. They propose racial identity as the construction and integration of racial narratives, with advancement to higher levels of perspective-taking ability providing the possibility of constructing more advanced and complex racial narratives involving inter-racial, intra-racial, and intra-individual dynamics.

The fifth and final part of the volume deals with African American racial identity and its influence on educational behavior. In an effort to further explore the buffering effects of racial identity, Roberts and Taylor, in chapter 13, examine the linkages between discrimination, racial identity, and academic performance. Their results suggest that ethnic identity did buffer the negative effects of discrimination on academic performance among males. Specifically, ethnic identity development had more of an effect on academic performance at high levels of discrimination than at lower levels of discrimination. Chapter 14 examines the congruence between students' racial identity beliefs and their experienced racial climates related to their motivation and engagement. Byrd and Chavous find that academic racial climate moderated associations between students' racial identity beliefs and engagement with their proximal school contexts (intrinsic school motivation and academic satisfaction)—specifically, students with strong and positive racial identity beliefs that were consistent with their experienced racial climates showed more positive engagement, while students whose strong and positive racial identity beliefs were less congruent with their perceived racial climates showed lower academic engagement. In chapter 15, Arbuthnot investigates how racial identity influences the standardized test-taking experiences of African American college students. Specifically, the study examines how one's racial regard, or one's evaluative attitude toward one's race, impacts standardized test-taking. The findings show that African American students' public regard, or their interpretation of how others view African Americans, had a significant impact on the extent to which a student worried, had issues with time constraints or felt confused while taking the standardized test. Specifically, there was a negative relationship between public regard and the worry and cognitive disorganization constructs. Consequently, the higher an African American student's public regard, the lower their worry and cognitive disorganization while taking standardized tests. Barker, in chapter 16, explores the complexity and dynamics of African American identity as it operates in doctoral education. Specifically, the study examines the ways in which African American doctoral students in cross-race advising relationships perceived and situated their racial and doctoral student identities within the context of their doctoral student experiences in general and their advising relationship with their White faculty advisors in particular, and the correlation between the African American doctoral students' quantitative and qualitative perceptions toward race

and racial identity. The findings suggest that African American doctoral students reported moderate to high levels of Emersion and Internalization; however, these students still face instances where they are forced to grapple with and negotiate their Black identity. Using Astin's theoretical framework for student involvement, Johnson and Cuyjet, in chapter 17, examine the connections among African American college men's family cultural values and beliefs, their engagement in male-oriented groups, and their social, psychological, intellectual, and identity development. The chapter reveals advantages of participation in these groups for African American male students, such as mutual support for success in their academic endeavors, the opportunity to acquire leadership experience and to hone skills related to leadership roles, and the chance to explore the heterogeneity of the African American male population.

In the end, the chapters in this volume are neither a starting point nor the end of our discussion of African American racial identity. However, each contribution is embedded within a well-established and long-enduring debate within African American racial identity. Consequently, the central contribution of this volume is to continue to explore the complexities and find answers to the puzzle of African American racial identity and its influence on human behavior.

<div style="text-align: right;">J. M.S. and A.M.E</div>

Acknowledgments

We are grateful to the many people who have guided, supported, and encouraged us on this project. We begin our sincere thanks to all of our contributors. We have brought together many of the most well-respected and emerging scholars on African American racial identity, and this volume could not have been accomplished without their enthusiasm and invaluable involvement and contribution. Additionally, we are grateful to William E. Cross, Jr., for writing the foreword. Lastly, we would like to thank the staff at Lexington Books for their extraordinary support and assistance throughout the publishing process.

J.M.S. and A.M.E.

Part One

Theoretical and Methodological Issues in African American Racial Identity

Chapter One
Forty Years of Cross's Nigrescence Theory: From Stages to Profiles, From African Americans to All Americans

Frank C. Worrell

Introduction

In 1971, William E. Cross, Jr., a graduate student at Princeton, published a short piece on a nigrescence model of Black racial identity (Worrell, 2008a). The publication outlet, *Black World*, was not a refereed journal, and Cross's nigrescence model was one of several models published in 1971 and one of eleven models published before 1985 (Helms, 1990c). Several decades later, racial identity is one of the most frequently studied psychological constructs in African Americans (Cokley, 2002; Cokley, Caldwell, Miller, and Muhammad, 2001; Cokley and Chapman, 2009), in large part due to the influence of Cross's nigrescence model. The purpose of this chapter is to describe how Cross's original nigrescence model became one of the most influential racial identity theories in the psychological literature, and also to show how revisions of this model (i.e., Cross, 1991; Cross and Vandiver, 2001) continue to have a substantial impact on research on cultural identities.

I begin by detailing the evolution of nigrescence theory from the original (Cross, 1971, 1978) to the revised (Cross, 1991, 1995; Cross, Parham, and Helms, 1991, 1998) and expanded (Cross and Vandiver, 2001; Vandiver, Cross, Worrell, and Fhagen-Smith, 2002; Vandiver and Worrell, 2001) models, drawing on empirical research using the instruments that operationalize the original and

expanded models, that is, the Racial Identity Attitude Scale (RIAS; Helms and Parham, 1990, 1996; Parham and Helms, 1981) and the Cross Racial Identity Scale (CRIS; Vandiver et al., 2000; Worrell, Vandiver, and Cross, 2004), respectively. Next, I review the model's contributions to current conceptualizations of cultural identities. Finally, I provide a preview of ongoing work extending the expanded model's framework to Americans who are *not* of African descent.

The Evolution of Cross's Nigrescence Model

The Historical Context of the Original Nigrescence Model (NT-O)

NT-O (Cross, 1971) was a product of its time in at least two major ways (Worrell, 2008a). First, it was in keeping with psychology's fascination with stage theories of development (e.g., Erikson, 1950, 1968; Freud, 1949; Kohlberg, 1973; Piaget, 1948, 1962; Tapp and Kohlberg, 1971). Second, and of critical importance, it reflected the sociopolitical zeitgeist of the previous two decades, including the Black Power movement and the civil rights movement (Altman, 1997; Smith, 2003). In 1954, in *Brown versus Board of Education of Topeka, Kansas*, the U. S. Supreme Court ruled that separate schooling for African Americans was inherently unequal schooling and set the stage for integration of the K-12 educational system and an ever-increasing number of African Americans attending predominantly White colleges and universities. The Montgomery bus boycott, led by Martin Luther King, Jr., took place in 1955 and 1956, and Dr. King founded the Southern Christian Leadership Center in 1957. Dr. King delivered his "I Have a Dream" speech in 1963 and was awarded the Nobel Peace Prize in 1964. The Civil Rights Act prohibiting discrimination on the basis of race, color, religion, gender, ethnicity or national origin was also enacted in 1964.

In 1965, Malcolm X was assassinated, and the Voting Rights Act eliminated literacy tests and allowed for federal challenges to the use of poll taxes to determine eligibility for voting, two tactics that had been used to deny voting rights to African Americans. The Black Panthers were founded in Oakland, California in 1966. In 1968, Shirley Chisholm became the first African American woman to be elected to the U. S. House of Representatives, Martin Luther King Jr. was assassinated, the Civil Rights Act banning discrimination in housing was passed, and the Black Power movement was gaining greater prominence. In 1971, NT-O (Cross, 1971) was published.

Tenets of NT-O

In NT-O, Cross (1971) argued that Black racial identity developed in a series of five stages—Pre-Encounter, Encounter, Immersion/Emersion, Internalization, and Internalization Commitment—which reflected the movement from Black self-

hatred to Black self-acceptance. He contended that African Americans in Stage 1, Pre-Encounter, had low self-esteem and negative feelings about their reference group, Blacks. They were pro-White and anti-Black in orientation (cf. Clark and Clark, 1950). In Stage 2, Encounter, African Americans experience either personally or vicariously the negative impact of race (e.g., discrimination) upon their lives in the United States. Although described as a stage in its own right, Encounter was really a pivot point between the Pre-Encounter and Immersion/Emersion stages.

Cross (1991, pp. 201-202) described Stage 3, Immersion/Emersion, as "the most sensational aspect of Black racial identity development. . . . [in essence] the vortex of psychological nigrescence." In this volatile stage, he contended that African Americans came to terms with the realization that they experience difficulties in American society due solely to their race, and Black identity in this stage is pro-Black and anti-White—in essence, the inverse of Black identity in the Pre-Encounter stage. At the beginning of this stage, African Americans *immerse* themselves in being Black; however, the immersion "is fueled by anti-White sentiment rather than pro-Black affirmation (Worrell, Vandiver, et al., 2004, p. 1; cf. Cross, 1971). However, as time passes and the rage subsides, African Americans become Black-affirming (Emersion) and move into Stage 4. In Stage 4, Internalization, African Americans become increasingly secure in their Black identities and with living in a country in which discrimination against Blacks is common. When their sense of commitment leads them to start working proactively in support of Black causes, they have entered Stage 5, Internalization Commitment.

Operationalizing NT-O

In 1972, Hall, Freedle, and Cross published the first empirical investigation of NT-O. Using twenty-eight containing descriptions representing Pre-Encounter (seven), Encounter (four), Immersion-Emersion (fourteen), and Internalization (three), Hall et al. asked 180 participants (50 percent female, 50 percent African Americans, 50 percent European Americans) to cluster the cards into thematic groups and order those groups into a temporal sequence. They reported general support for the themes and the stages, concluding that "Cross's hypothesis concerning the existence of several stages of Black awareness in American has received general positive support" (Hall et al., 1972, p. 18). The authors also found that African American and European American students were similar in their responses, but they did note that some items were not assigned to the stage for which they had been developed.

The RIAS

The cards used by Hall et al. (1972) became the basis for the development of the RIAS (Parham and Helms, 1981), and the publication of the RIAS catapulted NT-O

into prominence, leading to a huge increase in the empirical examination of Black racial identity based on this model. In spite of its popularity, reliability and structural validity concerns were raised about RIAS scores (e.g., Burlew and Smith, 1991; Cokley, 2007; Fischer, Tokar, and Serna, 1998; Lemon and Waehler, 1996; Pollard, 2010; Ponterotto and Wise, 1987; Tokar and Fischer, 1998; Yanico, Swanson, and Tokar, 1994), leading to criticisms of NT-O, itself. Despite these concerns and subsequent revisions of the nigrescence model, the RIAS continues to be used in dissertation (e.g., Cooke, 2009; Hill, 2009) and refereed articles (Lott, 2008).

Contributions of NT-O

It is clear that NT-O (Cross, 1971) resonated with cultural identity researchers. As Vandiver (2001) noted, the theory was parsimonious, straight-forward, and easily understandable, giving it substantial face validity. Indeed, several theorists acknowledged the influence of NT-O as they developed identity theories for other cultural groups based on ethnicity (e.g., Arce, 1981; Phinney, 1989), gender (e.g., Downing and Roush, 1985), minority status (e.g., Atkinson, Morten, and Sue, 1989), race (Helms, 1990b; Kim 1981; Ponterotto, 1988), and sexual orientation (Cass, 1979). Although four decades have passed since it entered the literature, NT-O is almost always cited in discussions of Black racial identity, sometimes as if it were the most recent version of the model (e.g., Belgrave and Allison, 2010). In some cases, when the expanded model is cited, the description uses the original stage formulation (e.g., Ford and Whiting, 2009). Also, much like NT-O, the RIAS was a powerful stimulus for empirical research on Black racial identity and provided the impetus for the development of new theoretical models and measurement instruments.

The Revised Nigrescence Model (NT-R)

Research conducted with the RIAS led to the NT-R (Cross, 1991, 1995; Cross et al., 1991, 1998), the first revision of the nigrescence model. The revision included three major changes. First, Cross (1991) collapsed Stages 4 and 5 into one stage with the name of the original Stage 4, Internalization. Second, he argued that there was more than one attitude present in each stage. For example, in the Pre-Encounter stage, he separated the pro-White/anti-Black identity into two independent attitudes, presaging the elimination of stages that came in the next revision of the model. Third, he decoupled personal identity (e.g., self-esteem) from social identity or reference group orientation (e.g., racial identity). In other words, African Americans could have low or high self-esteem in any of the four stages, and only self-hating attitudes (one of the Pre-encounter attitudes) were postulated as related to self-esteem.

Although NT-R (Cross, 1991; Cross and Fhagen-Smith, 2001) maintained the stage formulation, it began moving toward an attitudinal model by incorporating two ideas. First, Parham's (1989a, 1989b) notion of recycling was incorporated. Parham argued that individuals can recycle through a previous stage (e.g., through an encounter that happened after becoming internalized), and contended that this recycling of racial identity attitudes happened across the life span. Second, NT-R included Helm's (1986) conception of stage as world view to counter the notion of Black identity being continually in flux until internalization occurred: "Each stage related profile may reflect a complete identity" (Cross et al., 1991, p. 334). The use of terms such as attitudes, profiles, and world views to describe the stages suggests a growing disenchantment with the limitations of a stage model of identity and reflect an increased interest in Black racial identity in personal contexts (Cross and Strauss, 1998; Cross, Smith, and Payne, 2002) and across the life-span (Cross and Fhagen-Smith, 2001). No measure was ever developed to operationalize NT-R.

The Expanded Nigrescence Model (NT-E)

NT-E (Cross and Vandiver, 2001; Worrell et al., 2001) came about in the process of developing the CRIS (Vandiver et al., 2000; Worrell, Vandiver et al., 2004) to operationalize NT-R. This development of the CRIS included both a review of the extant literature and the actual scale development process, which took place over a five year period, 1995 to 2000. It is worth noting that as this work was going on, the Multidimensional Inventory of Black Identity (MIBI; Sellers, Rowley, Chavous, Shelton, and Smith, 1997; Sellers, Shelton, et al., 1998; Sellers, Smith, Shelton, Rowley, and Chavous, 1998), another attitudinal measure of Black racial identity, entered the literature. In NT-E, the movement away from stages and toward attitudes is mostly explicit. Cross and Vandiver (2001, p. 373) noted that "the theory presupposed the existence of a spectrum of Black identities" existing in a "vast universe of Black identities," and the former *stages* became identity *types* or *exemplars*. According to NT-E, Black racial identity is a constellation of attitudes held by individuals of African descent with regard to how these individuals (a) view themselves as Blacks, (b) view other individuals of African descent, and (c) view individuals from other ethnic and racial groups. This view of nigrescence is the one that has been the foundation of work on Cross's nigrescence model over the last decade.

Operationalizing NT-E: The CRIS

In developing the CRIS, the authors were cognizant not only of NT-E, but also of the ongoing criticisms about the psychometric properties of cultural identity instruments in general and RIAS scores in particular. The publication of the MIBI did not allay these concerns, as the scale development studies (i.e., Sellers et al., 1997; Sellers, Smith et al., 1998) revealed structural validity concerns for MIBI

scores, concerns that have surfaced in the literature in several studies (Cokley and Helm, 2001; Helm, 2002; Simmons, Worrell, and Berry, 2008; Vandiver, Worrell, and Romero-Delgado, 2009). Thus, substantial care and sufficient time were taken in developing the CRIS (Worrell et al., 2001).

Although NT-E identifies nine Black identity types (Worrell et al., 2001), only the six identities related to three themes are currently assessed by the CRIS. These are Pre-Encounter Assimilation (considering oneself American rather than African American), Pre-Encounter Miseducation (believing negative stereotypes about African Americans), Pre-Encounter Self-Hatred (disliking the fact that one is African American), Immersion/Emersion Anti-White (disliking European Americans), Internalization Afrocentricity (believing that African Americans should live by Afrocentric principles), and Internalization Multiculturalist Exclusive (having a strong Black identity as well as a respect for and willingness to engage with individuals from other cultural groups in society). A conscious decision was made *not* to measure Internalization Bicultural identities, given the potential number of these (e.g., gender and racial, religion and racial identity, sexual orientation and racial identity) and the researchers' specific interest in racial identity. There are ongoing efforts to develop subscales measuring Immersion/Emersion Intense Black Involvement and Internalization Multiculturalist Racial identities in ways that capture these constructs without overlapping with existing constructs measured by the CRIS.

Psychometric Properties of the CRIS

The decisions made in developing the CRIS have resulted in an instrument whose scores have held up to rigorous psychometric scrutiny over the past decade. Internal consistency estimates based on both alpha and omega have typically been in the .78 to .90 range (Worrell, Mendoza-Denton, Telesford, Simmons, and Martin, in press; Worrell and Watson, 2008). CRIS scores are stable over a three-week period (Vandiver, 2007) and modestly stable over periods up to twenty months (Vandiver, 2007; Worrell et al., in press). The structural validity has been supported using exploratory and confirmatory factor analyses in samples of adolescents (Gardner-Kitt and Worrell, 2007), emerging adults (Helm, 2002; Simmons et al., 2008; Vandiver et al., 2002; Worrell et al., in press; Worrell and Watson, 2008), and middle-aged adults (Worrell, Vandiver, Cross, and Fhagen-Smith, 2004), as well as item-response theory analyses in emerging adults (Worrell, Beaujean, Sussman, and Watson, 2011).

Convergent validity has been demonstrated with scores on the African Self-Consciousness Scale (Baldwin, 1996; cf. Simmons et al., 2008), the MIBI (Sellers et al., 1997; cf. Helm, 2002; Simmons et al., 2008; Vandiver et al., 2002), and the Multigroup Ethnic Identity Measure (MEIM; Phinney, 1992; cf. Worrell and Gardner-Kitt, 2006). Discriminant validity has been established with self-esteem, social desirability and the Big Five personality traits (Vandiver et al., 2002). Samples have included participants from the Northeast, Midwest, South and West

in the United States, and students attending predominantly White (PWIs) and historically Black institutions (HBIs). In sum, the CRIS has been endorsed as an exemplar with regard to cultural scale development (Burkard and Ponterotto, 2008; Ponterotto and Park-Taylor, 2007) and as the instrument to use in studying NT-E (e.g., Cokley, 2007; Ponterotto and Mallinckrodt, 2007).

Contributions of the Expanded Nigrescence Model

Benson (1998, p. 10) observed that "validation is the most critical step in test development and use because it is the process by which test scores take on meaning." In other words, if the inferences derived from a construct are not validated, any conclusions drawn from those scores are suspect and cannot be trusted. This concern applies to all aspects of validity from internal consistency estimates (cf. Thompson, 2003) to construct validity broadly defined to include all types of reliability and validity evidence. Thus, it is on the basis of the strength of CRIS scores and their relationship to the theoretical model that NT-E (Cross and Vandiver, 2001; Worrell et al., 2001) continues to have a substantial impact on the theorizing about racial identity. In the next section, I highlight four substantial contributions of NT-E: (a) racial identity is *not* developmental, (b) profiles are important in understanding an individual's racial identity, (c) multicultural identities are viable in the African American population, and (d) racial identity relationships to other constructs are predictable but limited.

Racial Identity Is Not Developmental?

As mentioned previously, NT-O (1971) was developed in response to what was seen to be a change in African Americans' racial identity awareness—nigrescence or the process of becoming Black—on the basis of their involvement in the racial equality struggles of the 1950s and 1960s. However, although *development is about change, not all change is development.* Valsiner and Connelly (2003, p. ix) described development as the "process of change with direction." Developmental change implies that the change is typical and predictable for members of a group (e.g., from babbling to one-word to two-word utterances in children; the release of hormones as individuals reach adolescence), and developmental change is often associated with a change in age.

Racial identity does not fit neatly into this definition of development. For example, studies with the RIAS have failed to find consistent changes related to age (Neil, 2003; Parham and Williams, 1993; Plummer, 1996). Worrell (2008b) also demonstrated that cross-sectional data collected with the CRIS do not support a developmental interpretation: (a) the pattern of mean scores on all CRIS subscales is remarkably similar and almost identical on the Anti-White, Afrocentricity, Multiculturalist Inclusive subscales in adolescents, emerging adults, and adults; (b) the subscale means on Anti-White scores are the lowest means in these three

developmental periods, although they should be highest in emerging adults developmentally; (c) the Afrocentricity and Multiculturalist Inclusive means are highest in all three groups, although they should be lowest for adolescents and highest for adults; and (d) the small differences in mean scores for the Pre-Encounter identities place adults rather than emerging adults in the middle of the three groups. Although no absolute statements can be made in the absence of longitudinal studies, the evidence in the extant literature does not support a developmental interpretation of Black racial identity.

Racial Identity Profiles Should Be Used for Interpretation

Much of the research on racial identity has examined the relationship between racial identity subscale scores and outcomes. However, if one accepts the premise that racial identity is multidimensional, researchers should be examining relationships with racial identity profiles rather than individual scores (Vandiver and Worrell, 2009; Worrell et al., 2001). Worrell, Vandiver, Schaefer, Cross, and Fhagen-Smith (2006) contended that studies of racial identity attitudes are based on at least two assumptions:

The first is that general profiles of racial identity attitudes exist across African Americans and that these attitudes are stable, at least some of the time. The second assumption is that different racial identity profiles are related to different patterns of functioning. (Worrell et al., 2006, p. 520). Using cluster analysis, Worrell and colleagues (2006) identified six racial identity profiles interpretable using NT-E—Assimilated, Low Race Salient, Miseducated, Afrocentric, Immersed (Anti-White), and Multiculturalist Inclusive—in a sample of African American students attending a PWI and demonstrated that five of these profiles generalized to another PWI student sample and four to an HBI sample.

Worrell et al. (2006) highlighted how looking at a single subscale score can lead to incorrect conclusions, as individuals with different racial identity profiles could have similar scores on one subscale but widely differing scores on other subscales. Since the initial study, clusters have been replicated in several other studies (e.g., Korell, 2008; Telesford, Mendoza-Denton, and Worrell, 2011; Whittaker and Neville, 2010). Worrell et al. (2006) argued that the fact that a Multiculturalist cluster was found in the two samples attending PWIs but not in the HBI sample provided support for an attitudinal interpretation of Black racial identity.

Racial Identity Profiles as Predictors

Although Worrell et al. (2006) found profiles that generalized to African American samples, they did not address the assumption indicating that different profiles would predict different patterns of functioning. However, this assumption has now been addressed in several studies. In a study of college students, Korell (2008)

identified clusters that were similar to the ones reported by Worrell et al. (2006), and showed that cluster status or racial identity profile was related to both acculturation and social distance. She found that individuals with an Assimilated profile reported significantly and meaningfully higher acculturation scores than individuals with Afrocentric profiles ($d = .77$) and Immersion/Anti-White ($d = .72$) profiles; individuals with Self-Hating profiles also reported higher acculturation scores than individuals with Afrocentric ($d = .68$) profiles.

Korell (2008) found similar results in relationship to a canonical variate reflecting dominant culture group preference. Individuals with Assimilated (.57) and Self-Hating (.58) profiles reported moderate pro-dominant group preference; individuals with Intense Black Involvement (-.20) and Afrocentric (-.29) profiles reported mild anti-dominant group preference; individuals with an Anti-White profile (-.82) reported a strong anti-dominant group preference; and individuals with a Multiculturalist profile (.01) did not have either a strong pro- or anti-dominant group preference. Taken together, these findings provide strong support for looking at racial identity profiles rather than individual subscale scores in research and clinical settings.

The Multiculturalist Identity Is Neither Atypical Not Abnormal

Several of the racial identity perspectives in the literature are substantially separatist in philosophy (e.g., the African self-consciousness perspective; Baldwin, 1981, 1996; Baldwin and Bell, 1985; Kambon, 1996), and some researchers embracing this perspective have dismissed NT-E's multiculturalist inclusive construct:

> This Black self-acceptance and multiculturalist inclusive orientation, by being ideologically laden with amalgamations, integrations, "I accept you, so please accept me" sentiment, is a depiction of a lame, injured personality state mistakenly promulgated by psychologists as "normal" . . . it violates common sense to (mis)construe "Blackness" or Africanity" as so boundlessly distensible, an example being the multiculturalist inclusive orientation "If Blackness is everything, then it is nothing" (a maxim of Bobby Wright). (Azibo and Robinson, 2004, p. 251)

This viewpoint reflects a fundamental misunderstanding of the Multiculturalist Inclusive (IMCI) identity. It construes IMCI as being based on an apology for being Black and the embracing of other cultural groups as a plea for other groups to accept the individual.

However, the IMCI identity is not best thought of as a *Black plus* identity. This identity is grounded in Black self-acceptance, which is complemented by an openness to other cultural groups, as reflected in three of the five IMCI items on the CRIS that invoke both a Black identity and a multiculturalist perspective. Moreover, there is empirical support for a multiculturalist perspective. In an examination of the relationship between ethnic identity and racial identity, Worrell and Gardner-

Kitt identified two interpretable variates, which they labeled Black Racial/Ethnic Identification and Grounded Multiculturalism. The Black Racial/Ethnic Identification variate was based on negative Assimilation, Self-Hatred, and Other Group Orientation (MEIM) scores and positive Anti-White, Afrocentric, and Ethnic Identity (MEIM) scores. The Grounded Multiculturalism variate consisted of negative Self-Hatred and Anti-White scores and positive Afrocentric, Multiculturalist Inclusive, Ethnic Identity and Other Group Orientation scores.

Based on NT-E (Cross and Vandiver, 2001) and empirical work on the CRIS (Vandiver et al., 2002; Wester, Vogel, Wei, and McLain, 2006), one would expect both of these variates to be unrelated to self-esteem and psychological distress (low self-hatred scores). Moreover, the Grounded Multiculturalist variate demonstrates that high IMCI scores can occur alongside high scores on ethnic identity scores and low anti-White scores. The presence of Multiculturalist Inclusive profiles that differ from other low or negative salience profiles (e.g., Assimilation, Low Race Salience, Miseducation, Self-Hatred) in several studies (Korell, 2008; Whittaker and Neville, 2010; Worrell et al., 2006) also contradicts Azibo and Robinson's (2004) conceptualization of what multiculturalism means in NT-E, and it suggests that their view of the range of Black racial identities is limited. I would contend that individuals who cannot respect other cultural groups' perspectives without losing their one's own heritage are not yet fully self-accepting. Indeed, this perspective seems akin to Cross's (1971) notion of an identity based on opposition to others rather than an acceptance of self.

Correlates of Racial Identity Attitudes

Given the literature on Black racial identity over the last four decades, it is not a stretch to conclude that researchers were convinced that this construct was related to almost every aspect of African American functioning. A search of PsycINFO indicates that in the last four decades, scholars have examined the relationship between Black racial identity and autonomy, body image, counseling, demographic variables, ego development, gender-role attitudes, intercultural values, participation in campus organizations, perception of counselor behaviors, perception of discrimination, personal problem-solving strategies, preference for counselor race, preferences for social change strategies, psychological functioning, racial socialization, self-actualization, self-esteem, and social class, among others. In many cases, the findings are mixed or there is no relationship with racial identity. NT-E (Cross and Vandiver, 2001) suggests that one should consider the identity theme or profile and context in making predictions about relationships with other constructs, and that personal identity (e.g., self-esteem, psychological functioning) should not be related to one's racial identity profile, except via self-hatred. I now take a look at several key constructs that have been examined previously and have been re-examined using the CRIS.

Demographic Variables

Age, gender, community type, and social class are the demographic variables that have been examined most frequently in relationship to racial identity. As described in relationship to development, age has not been found to be related to racial identity. NT-E does not provide a theoretical rationale relating racial identity attitudes to gender, community type, or social class, and not surprisingly, the findings in this area are inconsistent with small effect sizes. In the only study using the CRIS, Fhagen-Smith, Vandiver, Worrell, and Cross (2010) reported that males had significantly higher Afrocentricity ($d = .28$) scores than females and lower Multiculturalist Inclusive ($d = -.43$) scores, but only the latter had an effect size approaching medium strength. In the same study, individuals raised in the suburbs reported higher Assimilation ($d = .31$) and Miseducation ($d = .26$) scores than individuals raised in urban areas, and no significant differences were found among social class groups (poor, lower, middle class, upper).

Self-Esteem

The relationship between self-esteem and racial identity has supported NT-E's thesis—that only self-hatred will be related to racial identity. Vandiver et al. (2002) reported a correlation with a moderate effect size between self-hating attitudes and self-esteem, and no meaningful relationships with other CRIS subscales. This finding has been replicated by Jones, Cross, and Defour (2007) and Miller and Vandiver (2011). However, Miller and Vandiver examined *cluster* or *profile* differences on self-esteem scores, as well. Miller and Vandiver found that individuals with a Self-Hatred profile have the lower self-esteem scores than individuals with Assimilated ($d = -.89$), Multiculturalists ($d = -.67$), Anti-White ($d = -.58$), and Afrocentric ($d = -.68$) profiles, all with substantial effect sizes. However, the self-hating group did not differ from the intense Black involvement group ($d = -.18$), again providing support for the notion of this identity being more in opposition to White culture than Black affirming. The similarity in self-esteem means between the Multiculturalists ($M = 2.48$, $SD = .42$) and Afrocentrics ($M = 2.47$, $SD = .39$, $d = .03$) and the difference of the two former from the Self-Haters contradicts Azibo and Robinson's (2004) conception of Multiculturalists as abnormal.

Miller and Vandiver (2011) also examined the relationship between the racial identity clusters and the race-based version of collective self-esteem. They conducted a one-way MANOVA of the four CSES subscales (Membership, Private, Public, and Importance to Identity) with clusters' membership as the grouping variable. The significant MANOVA was followed by a descriptive discriminant function analysis, the recommended but often ignored post-hoc procedure for MANOVA (Weinfurt, 1995). They found two interpretable functions, which they labeled Social Influence on Group Evaluation and Salience of Racial Identity.

These two functions create a two by two grid with four quadrants in which they plot centroids for the clusters on each function.

The two internalized profiles—Afrocentrics and Multiculturalists—have positive scores on both functions (salient race and positive group evaluation) placing them in the top right quadrant. The Assimilated profile with a positive score on their evaluation of their group and a negative score on race salience falls in the bottom right quadrant. The Intense Black Involvement and Immersion (i.e., anti-White) clusters fall in the top left quadrant, indicating positive salience of race and less positive evaluations of their group membership. Finally, the Self-Hating cluster falls in the bottom left quadrant with negative scores for both race salience and group evaluation. These findings provide elegant support for NT-E, CRIS scores, and the use of racial identity profiles.

Psychological Adjustment

Several studies have examined the relationship between racial identity and psychological adjustment using the CRIS. Wester et al. (2006) found that self-hatred attitudes partially mediated the relationship between gender role conflict and psychological distress. Jones et al. (2007) found that self-hating attitudes predicted depression and that multiculturalist inclusive attitudes moderated the relationship between racial stress and depression. In a third study, Worrell et al. (in press) examined the bivariate relationships between CRIS subscale scores and scores on the Brief Symptom Inventory (Derogatis, 1993). In keeping with NT-E, he found that scores on the nine BSI subscales as well as the total score (i.e., the Global Severity Index) were significantly correlated with self-hatred scores ($.21 \leq r \leq .39$), with the correlations for six of the nine subscales and the global index attaining medium effect sizes. Interestingly, Worrell et al. (in press) also found that six of the nine BSI subscale scores, and the global index were also significantly related to anti-White attitudes ($.25 \leq r \leq .33$), although only Hostility and Paranoid Ideation attaining correlations greater than .30. Worrell et al. (in press) pondered if negative racial identity attitudes, whether turned inward (like self-hatred) or outward (like anti-White) were more likely to be related to psychological adjustment.

In another recent study, Whittaker and Neville (2010) examined the differences among five racial identity profiles created using CRIS scores on three measures of psychological adjustment—psychological distress (higher scores indicate less distress), hardiness, and psychological well-being. The profiles included Low Race Salience, Self-Hatred, Immersion-Anti-White, Afrocentric, and Multiculturalist Inclusive. A summary of the results is presented in Figure 1.1. There are several general comments that can be made about these results. First, contrary to NT-E, the Self-Hatred profile does not have the worst outcomes—they are fourth out of five. Second, the Immersion/Anti-White profile, which is the smallest group by far, reports substantially poorer adjustment on all three constructs than all the other groups, including the self-haters by a substantial margin ($.79 \leq r \leq .87$). Third, the Multiculturalists report the best psychological adjustment on the three constructs;

they have substantially better outcomes than the Immersion/Anti-Whites (.78 $\leq d \leq$ 1.74). Fourth, only the Anti-Whites report poorer adjustment than other groups on psychological well-being; the other four groups have comparable scores. Fifth, although the Self-Hatred group did have substantially worse scores than the Multiculturalists on Hardiness ($d = .49$) and psychological distress ($d = .69$), Self-Haters did not differ significantly or meaningfully from Multiculturalists on psychological well being ($d = -.02$).

Figure 1. 1: Psychological Adjustment Scores on CRIS Profiles from Whittaker and Neville (2010)

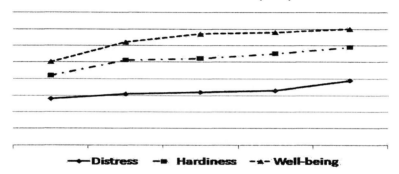

The findings by Whittaker and Neville (2010) and Worrell et al. (in press) suggest that the anti-White attitudes may also have implications for psychological adjustment. Whittaker and Neville's work also suggests that it will be important to examine psychological distress and psychological well being differently, as the Self-Hatred group reports comparable scores to the Multiculturalists on well being, but substantially lower scores on hardiness and psychological distress. The findings also highlight a need for studies that look at more than mean group differences among cluster groups. Researchers also need to examine the actual level of functioning, as it is possible that despite the differences in means, members of all of the groups may have scores that do not place them in the clinically at-risk range.

Expanding Cross's Nigrescence Framework to Other Racial/Ethnic Groups

In this final section, I turn briefly to a new direction for NT-E. As mentioned previously, NT-E postulates that racial identity is a set of attitudes that African Americans hold about themselves as a member of a racial group, as well as others from their group and other groups. In the context of this definition, the CRIS assesses six different racial identity attitudes. However, the literature on variables such as acculturation, assimilation, and cultural mistrust is not limited to African Americans; these variables are also important psychological constructs in Ameri-

cans from other cultural groups and with individuals in other nations. Currently, researchers interested in cross-cultural work on ethnic identity within and beyond the United States have typically used the MEIM (Phinney, 1992; Phinney and Ong, 2007). However, the original MEIM (Phinney, 1992) was limited because it only had two subscales, an Ethnic Identity subscale (sense of belonging to one's own group) and an Other Group Orientation subscale (willingness to engage with other groups). The most recent version of the MEIM (Phinney and Ong, 2007) only assesses ethnic identity attitudes.

Since developing the CRIS (Vandiver et al., 2002; Vandiver and Worrell, 2001), the CRIS Team has received several requests from researchers who want to adapt the instrument for use with other ethnic groups in the United States or with individuals in a different country, as has been done with the MIBI in several studies. Given that the model was based on a nigrescence theory about individuals of African descent, these offers were declined. However, the CRIS Team decided that it might be useful to develop a scale that serves this purpose for several reasons. First, there is a need in the literature for an instrument that allows us to conduct comparative and cross-cultural studies of cultural identity in a more nuanced fashion than can be done with the MEIM. Second, the CRIS Team would control the scale development process to develop an instrument with reliable and valid scores. In 1997, Helms and Talleyrand (p. 1246) wrote a pointed response to Phinney (1996), arguing that "race is not ethnicity" (cf. Helms, 1996). An instrument such as this would allow researchers to assess the similarities and differences of these groups and evaluate claims that have been made (e.g., Helms, 1996; Helms and Talleyrand, 1997; Phinney, 1996). What role does cultural identity play in the psychological functioning of different groups? Do assimilation attitudes mean the same things for African Americans, Asian Americans, and Latinos, and do they have similar correlates in these groups? How is Afrocentrism in African Americans related to ethnocentric views in American Indians and European Americans? Do self-hating attitudes result in lowered self-esteem in all cultural groups?

Table 1.1 contains a list of CRIS subscales and their adaptation for a new measure called the Cross Scale of Social Attitudes (CSSA; Worrell, Vandiver, Cross, and Fhagen-Smith, 2010). Each of the six subscales retains much of its original meaning with items being reworded to allow them to be completed by individuals from any ethnic/racial group. Assimilation, self-hating, and multi-culturalist attitudes essentially keep the same meaning. Afrocentric attitudes are re-conceptualized as ethnocentric attitudes, and anti-White attitudes have been reframed as anti-dominant group attitudes. Miseducation attitudes in the CSSA focus on all stereotypes about a group rather than just on negative stereotypes as in the CRIS. Although it is relatively easy to see how members of other ethnic minority groups (e.g., Latinos, American Indians, Asian Americans) can relate to the items, it is not yet clear how European Americans will respond to the anti-dominant culture and ethnocentric items, and more importantly, what these constructs will mean in the context of this group. One hypothesis is that there will be positive correlations between Assimilation and Ethnocentricity for this group.

There may also be positive correlations between Self-Hatred and Anti-Dominant Group. Preliminary data on the CSSA from two pilot samples are presented next.

**Table 1. 1: Cross Racial Identity Scale (CRIS) and
Cross Scale of Social Attitudes (CSSA) Subscales**

CRIS Subscales	CSSA Subscales	CSSA Descriptions
Assimilation	Assimilation	Referring to oneself as American rather than an American from an ethnic/racial group
Miseducation	Miseducation	Believing societal stereotypes about one's ethnic/racial group
Self-Hatred	Self-Hatred	Not liking oneself due to group membership
Anti-White	Anti-Dominant Group	Not liking the dominant group in one's society
Afrocentricity	Ethnocentricity	Believing that the ethnic/racial values of one's group should guide one's behavior
Multiculturalist	Multiculturalist	Being strongly connected to one's ethnic/racial group but also willingness to engage meaningfully with members of other groups

Latino Results

Sample 1 consisted of thirty-three Latinos (69.7 percent female [$n = 23$]) attending a selective public institution in a diverse urban area in a Western state. All of the students were in their first year at the institution and were participating in an orientation program in the dormitory. They ranged from seventeen to twenty-three ($M = 18.2$, $SD = 1.08$) years old. Participants completed a forty-item measure consisting of thirty CSSA items (five per subscale) and ten fillers using a seven-point Likert scale (1 = *strongly disagree,* 4 = *neither agree nor disagree,* 7 = *strongly agree*). Reliability estimates indicated that one item on each of the subscales was decreasing the internal consistency of the scores, and these items were removed. Means, standard deviations, intercorrelations, and alpha estimates based on the best four items per subscale are provided in Table 1.2.

Table 1.2: Preliminary Descriptive Data on CSSA Scores

	AS	ME	SH	AD	ET	MI	M	SD	α
Latinos (N=33)									
AS (4)	1.00						2. 87	1.29	. 80
ME (4)	-.04	1.00					3. 82	1.26	. 80
SH (4)	. 23	. 42	1.00				2. 17	1.08	. 72
AD (4)	-.29	. 16	. 11	1.00			1.66	1.06	. 89
ET (4)	-.38	. 15	. 18	. 42	1.00		4. 11	1.21	. 77
MI (4)	-.17	-.17	. 34	. 07	. 17	1.00	5. 70	1.04	. 75
European Americans (47)									
AS (5)	1.00						4. 95	1.42	. 89
ME (5)	. 15	1.00					3. 01	1.14	. 81
SH (5)	-.12	. 23	1.00				2. 13	1.37	. 91
AD (5)	-.17	. 47	. 64	1.00			2. 10	0.86	. 67
ET (5)	-.07	. 02	. 23	. 12	1.00		3. 00	1.01	. 79
MI (5)	-.09	-.15	. 23	-.05	. 52	1.00	5. 63	0. 84	. 71

Note. CSSA = Cross Scale of Social Attitudes; AS = Assimilation; ME = Miseducation; SH = Self-Hatred; AD = Anti-Dominant; ET = Ethnocentricity; MI = Multiculturalist Inclusive.

As can be seen, intercorrelations were generally low, with only three greater than |. 30|. As with CRIS scores, the largest correlation was between anti-dominant (anti-White) and ethnocentric (Afrocentric) attitudes. The pattern of means was also similar to the patterns found with the CRIS: Self-hatred and anti-dominant attitudes had the lowest means, and Afrocentricity and multiculturalist attitudes had the highest means (see Figure 1.2 for a comparison with an African American sample). Reliability estimates based on the four items were moderate to high.

European American CSSA Results

Items that had resulted in lower reliability estimates in the Latino sample were tweaked, and a revised version of the CSSA was administered to a sample of forty-seven European American college students attending a public university in a small city in a Mountain state. A substantial proportion of the population in the area (> 70 percent) is European American. As shown in Table 1.1, reliability estimates for scores on the five-item subscales were moderate to high, and the pattern of means was generally similar to the Latinos with some exceptions (see Figure 1.2). Three intercorrelations were greater than 40 in the European American sample: (a) mis-education and anti-dominant attitudes, (b) self-hatred and anti-dominant group attitudes, and (c) ethnocentric and multiculturalist attitudes.

Figure 1.2: Mean Scores for Latinos and European Americans on the Cross Scale of Social Attitudes and for African Americans on the Cross Racial Identity Scale (from Vandiver et al., 2002).

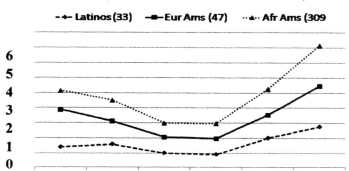

The elevated Miseducation/Anti-Dominant and Self-Hatred/Anti-Dominant correlations are in keeping with the application of this model to majority group members, who are in essence rating themselves their group on all three constructs, and this suggests that the anti-Dominant sentiment may be coming both from believing negative stereotypes of the group and having self-hating attitudes. In both Korell's (2008) and Whittaker and Neville's (2010) study of African American, the Immersion/Anti-White clusters had elevated self-hatred scores alongside the high anti-White scores.

The high intercorrelation between ethnocentric and multiculturalist attitudes is not as easily understood, but one possible explanation is that European Americans view multicultural attitudes as a reflection of their reference group's perspective (i.e., ethnocentrically). Nonetheless, the findings in these pilot studies suggest that it is possible to develop a scale that is viable across multiple groups. This work continues.

Comparisons with CRIS Scores from African Americans

Figure 1.2 contains the Latino and European American CSSA means as well as the means for African Americans on the CRIS from one of the scale development studies (Vandiver et al., 2002). As can be seen, the groups report similar scores on three of the constructs: multicultural attitudes are similarly high and self-hating and anti-dominant/anti-White attitudes are similarly low. Not unexpectedly, European Americans report substantially higher assimilation attitudes than African Americans, $t(354) = 6.81, p < .001, d = 1.80$, and Latinos, $t(78) = 6.81, p < .001, d = 1.52$. An interesting question to consider is how these data would look for European Americans who are strongly ethnically identified (e.g., Hassidic Jews or

American Gypsies [aka Travelers]). For example, in one of the few studies on the latter group, middle school Travelers reported significantly and substantially higher ethnic identity attitudes ($d = .99$) than non-Traveler middle schoolers, but substantially lower other group orientation attitudes ($d = -.41$; Morton, 2008).

Latinos reported substantially higher miseducation attitudes than European Americans, $t(78) = 2.94$, $p< .005$, $d = .68$, and African Americans, $t(354) = 4.73$, $p< .001$, $d = .95$, suggesting that Latinos may internalize negative stereotypes about their group more than African Americans. Ethnocentricity is the third attitude on which the groups differed, with Latinos reporting higher scores on this construct than European Americans, $t(78) = 4.32$, $p< .001$, $d = 1.01$. Although Latinos' level of ethnocentricity did not differ from African Americans' level of Afrocentricity, $t(354) = 1.01$, $p> .05$, $d = .20$, it is not clear if Afrocentricity, which has a positive connotation, is equivalent to Ethnocentricity, which has a negative connotation. Future work in this area will require comparing among groups on the same constructs using the CSSA, as well as comparing African Americans' responses on the CRIS and the CSSA.

Discussion

Cross's nigrescence theory has come a long way in forty years. Since its publication in *Black World* in 1971, Cross's nigrescence model has had a profound impact on theorizing about and assessing of Black racial identity and cultural identities in general (Helms, 1990a). The model has inspired theorists working with constructs as distinct as gender, ethnicity, and sexual orientation. On the journey from NT-O (Cross, 1971) to NT-E (Cross and Vandiver, 2001), nigrescence theory has sparked the development of two of the most frequently used measures of Black racial identity, the RIAS (Parham and Helms, 1981) and the CRIS (Vandiver et al., 2000), in addition to the current development of the CSSA (Vandiver et al., 2010), an instrument that will be able to assess the ethnic identities of all racial/ethnic groups in the United States when completed.

Cross's nigrescence models have led to important reconceptualizations of African American racial identity. In addition to the disentangling of personal and social identities, nigrescence theory has resulted in a growing consensus that racial identity is not developmental (Quintana, 2007; Worrell, 2008b; Worrell et al., 2006). Recent work on the model has indicated that (a) gender and socioeconomic status are not meaningfully related to Black racial identity attitudes (Fhagen-Smith et al., 2010), (b) there are generalizable profiles of racial identity in the African American population (Korell, 2008; Telesford et al., 2011; Whitaker and Neville, 2010; Worrell et al., 2006), (c) multiple racial identity attitudes are present in African Americans from at least adolescence (Worrell, 2008b), and (d) similar racial identity attitudes exist across American-born and foreign born Blacks in the United States (Worrell, 2008b).

Research on nigrescence has demonstrated that it is possible to develop instruments to measure cultural identity constructs that yield reliable and valid scores (Vandiver et al., 2002; Vandiver and Worrell, 2001), in part because nigrescence theory and its evolution exemplifies "the reciprocal interaction between a theoretical model and empirical investigation" (Vandiver, 2001, p. 165). Validation must be viewed as a matter of degree, not an all-or-nothing property. Numerous studies may be required, utilizing different approaches, different samples, and different populations to build a body of evidence that supports or fails to support the validity of scores derived from a test. As such validation is a continual process. (Benson, 1998, p. 10)

The process "is tremendously time consuming" (Worrell et al., 2001, p. 203), but working with a theorist like William E. Cross, Jr., is certainly worth the investment. I look forward to several more decades of novel contributions from Cross's (1971, 1991; Cross and Vandiver, 2001) nigrescence model.

References

Altman, S. (1997). *The encyclopedia of African American heritage*. New York, NY: Facts on File.

Arce, C. A. (1981). A reconsideration of Chicano culture and identity. *Daedalus, 110,* 177-192.

Atkinson, D. R., Morten, G., and Sue, D. W. (Eds.). (1989). *Counseling American minorities: A cross-cultural perspective* (Third edition). Dubuque, IA: William C. Brown.

Azibo, D. A., and Robinson, J. (2004). An empirically supported reconceptualization of African-U.S. racial identity development as an abnormal process. *Review of General Psychology, 8,* 249-264. doi:10. 1037/1089-2680. 8. 4. 249.

Baldwin, J. A. (1981). Notes on an Africentric theory of Black personality. *Western Journal of Black Studies, 5,* 172-179.

Baldwin, J. A. (1996), pp. 207-215. An introduction to the African Self-Consciousness Scale. In R. L. Jones (Ed.), *Handbook of tests and measurements for Black populations*. Hampton, VA: Cobb and Henry.

Baldwin, J. A., and Bell, Y. R. (1985). The African Self-Consciousness Scale: An Africentric personality questionnaire. *The Western Journal of Black Studies, 9,* 61-68.

Belgrave, F. A., and Allison, K. W. (2010). *African American psychology: From Africa to America* (Second edition). Thousand Oaks, CA: Sage Publications.

Benson, J. (1998). Developing a strong program of construct validation: A test anxiety example. *Educational Measurement: Issues and Practice, 17,* 10-17. doi:10. 1111/j. 1745-3992. 1998. tb00616. x.

Brown v. Board of Education, 347 U. S. 483 (1954).

Burkard, A. W., and Ponterotto, J. G. (2008). Cultural identity, racial identity, and the multicultural personality. In L. A. Suzuki, and J. G. Ponterotto (Eds.),

Handbook of multicultural assessment: Clinical, psychological, and educational applications (pp. 52-72). San Francisco, CA: Jossey-Bass.

Burlew, A. and Smith, L. (1991). Measures of racial identity: An overview and a proposed framework. *Journal of Black Psychology, 17,* 53-71.

Cass, V. C. (1979). Homosexual identity formation: A theoretical model. *Journal of Homosexuality, 4,* 219-235. doi:10. 1300/J082v04n03_01

Clark, K. B., and Clark, M. P. (1950). Emotional factors in racial identification and preference in Negro children. *Journal of Negro Education, 19,* 341-350. doi:10. 2307/2966491.

Cokley, K. O. (2002). Testing Cross' revised racial identity model: An examination of the relationship between racial identity and internalized racism. *Journal of Counseling Psychology, 49,* 476-483. doi:10. 1037/0022-0167. 49. 4. 476.

Cokley, K. O. (2007). Critical issues in the measurement of ethnic and racial identity: A referendum on the state of the field. *Journal of Counseling Psychology, 54,* 224-234. doi:10. 1037/0022-0167. 54. 3. 224.

Cokley K. O, Caldwell, L. D., Miller, K., and Muhammad, G. (2001). Content analysis of the Journal of Black Psychology (1985-1999). *Journal of Black Psychology, 27,* 424-438. doi:10. 1177/0095798401027004003.

Cokley, K. O., and Chapman, C. (2009). Racial identity theory: Adults. In H. A. Neville, B. M. Tynes, and S. O. Utsey (Eds.), *Handbook of African American psychology* (pp. 283-297). Thousand Oaks, CA: Sage Publications.

Cokley, K. O., and Helm, K. (2001). Testing the construct validity of scores on the Multidimensional Inventory of Black Identity. *Measurement and Evaluation in Counseling and Development, 34,* 80-95.

Cooke, M. A. (2009). The relationship between Black identity and multiculturalism, and Black students' experiences in COAMFTE programs. *Dissertation Abstracts International Section B: The Sciences and Engineering, 69* (10-B), 6405.

Cross, W. E., Jr. (1971). The Negro-to-Black conversion experience. *Black World, 20*(9), 13-27.

Cross, W. E., Jr. (1978). The Thomas and Cross models of psychological nigrescence: A review. *Journal of Black Psychology, 5,* 13-31. doi:10. 1177/009579847800500102.

Cross, W. E., Jr. (1991). *Shades of Black: Diversity in African American identity.* Philadelphia: Temple University Press.

Cross, W. E., Jr. (1995). The psychology of nigrescence: Revising the Cross model. In J. G. Ponterotto, J. M. Casas, L. A. Suzuki, and C. M. Alexander (Eds.), *Handbook of multicultural counseling* (pp. 93-122). Thousand Oaks, CA: Sage.

Cross, W. E., Jr., Fhagen-Smith, P. E. (2001). Patterns of African American identity development: A life-span perspective. In C. L. Wijeyesinghe and B. W. Jackson (Eds.), *New perspectives on racial identity development: A theoretical and practical anthology.* (pp. 243-270). New York, NY: New York University Press.

Cross, W. E., Jr., Parham, T. A., and Helms, J. E. (1991). The stages of Black identity development: Nigrescence models, pp. 319-338. In R. L. Jones (Ed.), *Black Psychology* (Third edition). Berkeley, CA: Cobb and Henry.

Cross, W. E., Jr., Parham, T. A., and Helms, J. E. (1998). Nigrescence revisited: Theory and research, pp. 3-72. In R. L. Jones (Ed.), *African American identity development*. Hampton, VA: Cobb and Henry.

Cross, W. E., Jr., Smith, L. and Payne, Y. (2002). Black identity: A repertoire of daily enactments. In P. B. Pedersen, J. G. Graguns, J. E. Lonner, and J. E. Trimble (Eds.), *Counseling across cultures* (Fifth edition, pp. 93-108). Thousand Oaks, CA: Sage.

Cross, W. E., Jr., and Strauss, L. (1998). The everyday functions of African American identity. In J. K. Swim and C. Stangor (Eds.), *Prejudice: The target's perspective* (pp. 267-279). New York, NY: Academic Press.

Cross, W. E., Jr., and Vandiver, B. J. (2001). Nigrescence theory and measurement: Introducing the Cross Racial Identity Scale (CRIS). In J. G. Ponterotto, J. M. Casas, L. A. Suzuki, and C. M. Alexander (Eds.), *Handbook of multicultural counseling* (Second edition, pp. 371-393). Thousand Oaks, CA: Sage.

Derogatis, L. R. (1993). *The Brief Symptom Inventory (BSI): Administration, scoring, and procedures manual*. Minneapolis, MN: NCS Pearson.

Downing, N. E., and Roush, K. L. (1985). From passive acceptance to active commitment: A model of feminist identity development for women. *The Counseling Psychologist, 13,* 695-709. doi:10. 1177/0011000085134013.

Erikson, E. H. (1950). *Childhood and society*. New York, NY: W. W. Norton and Co.

Erikson, E. H. (1968). *Identity, youth and crisis*. New York, NY: W. W. Norton and Co.

Fhagen-Smith, P. E., Vandiver, B. J., Worrell, F. C., and Cross, W. E., Jr. (2010). (Re) Examining racial identity differences across socioeconomic status, community of origin, and gender among African American college students. *Identity: An International Journal of Theory and Practice, 10,* 164-180.

Fischer, A. R., Tokar, D. M., and Serna, G. S. (1998). Validity and construct contamination of the Racial Identity Attitude Scale—Long Form. *Journal of Counseling Psychology, 45,* 212-224. doi:10. 1037/0022-0167. 45. 2. 212.

Ford, D. Y., and Whiting, G. W. (2009). Racial identity and peer pressures among gifted African American students: Issues and recommendations. In H. A. Neville, B. M. Tynes, and S. O. Utsey (Eds.), *Handbook of African American psychology* (pp. 223-236). Thousand Oaks, CA: Sage Publications.

Freud, S. (1949). *An outline of psychoanalysis*. New York, NY: W. W. Norton and Co.

Gardner-Kitt, D. L., and Worrell, F. C. (2007). Measuring nigrescence attitudes in school-aged adolescents. *Journal of Adolescence, 30,* 187-202. doi:10. 1016/j. adolescence. 2006. 01. 001.

Hall, W. S., Freedle, R., and Cross, W. E. Jr. (1972). *Stages in the development of a Black identity*. Iowa City, IA: American College Testing Program.

Helm, K. M. (2002). A theoretical and psychometric analysis of the revised Black racial identity development model and the multidimensional model of racial identity. *Dissertation Abstracts International: Section B: The Sciences and Engineering, 62* (10-B), 4833.

Helms, J. E. (1990a). *Black and White racial identity: Theory, research and practice.* New York, NY: Greenwood.

Helms, J. E. (1990b). The measurement of Black racial identity attitudes, pp. 34-47. In J. E. Helms (Ed.), *Black and White racial identity: Theory, research and practice.* New York, NY: Greenwood.

Helms, J. E. (1990c). An overview of Black racial identity theory, pp. 9-32. In J. E. Helms (Ed.), *Black and White racial identity: Theory, research and practice.* New York, NY: Greenwood.

Helms, J. E. (1986). Toward a methodology for measuring and addressing racial identity as distinguished from ethnic identity. In G. Sodowsky and J. Impara (Eds.), *Multicultural assessment in counseling and clinical psychology* (pp. 285-311). Lincoln, NE: Buros Institute of Mental Measurement.

Helms, J. E., and Parham, T. A. (1990). Black Racial Identity Attitude Scale (Form RIAS-B), pp. 245-247. In J. E. Helms (Ed.), *Black and White racial identity: Theory, research, and practice.* New York: Greenwood Press.

Helms, J. E., and Parham, T. A. (1996). The development of the Racial Identity Attitude Scale, pp. 167-174. In R. L. Jones (Ed.), *Handbook of tests and measurements for Black populations* (Vol. 2). Hampton, VA: Cobb and Henry.

Helms, J. E., and Talleyrand, R. M. (1997). Race is not ethnicity. *American Psychologist, 52,* 1246-1247. doi:10. 1037/0003-066X. 52. 11. 1246.

Hill, R. (2009). Hanging out on Crenshaw: Examining the role of racial identity on the academic achievement of Black students at a southern California community college. *Dissertation Abstracts International Section A: Humanities and Social Sciences, 68* (5-A), 1530.

Jones, H. L., Cross, W. E., Jr., and DeFour, D. C. (2007). Race-related stress, racial identity attitudes, and mental health among Black women. *Journal of Black Psychology, 33,* 208-231. doi:10. 1177/0095798407299517.

Kambon, K. (1996). The Africentric paradigm and African American psychological liberation, pp. 57-69. In D. Azibo (Ed.), *African psychology in historical perspective and related commentary.* Trenton, NJ: Africa World Press.

Kim, J. (1981). *Processes of Asian-American identity development: A study of Japanese American women's perceptions of their struggle to achieve positive identities as Americans of Asian ancestry. Dissertation Abstracts International, 42* (4-A), 1551.

Kohlberg, L. (1973). Stages and aging in moral development: Some speculations. *The Gerontologist, 13,* 497-502.

Korell, S. (2008). A cluster analysis of Cross Racial Identity Scale scores and their usefulness in predicting levels of acculturation and social distance in the lives of Black college students. *Dissertation Abstracts International Section A: Humanities and Social Sciences, 68* (10-A), 4213.

Lemon, R. L. and Waehler, C.A. (1996). A test of stability and construct validity of the Black Racial Identity Scale, Form B (RIAS_B) and the White Racial Identity Scale (WRIAS). *Measurement and Evaluation in Counseling and Development*, 29, 77-85.

Lott, J. L., II. (2008). Racial identity and Black students' perception of community outreach: Implications for bonding social capital. *Journal of Negro Education, 77*, 3-14.

Miller, A., and Vandiver, B. J. (2011). *Re-examining the relationship between Black racial identity and self-esteem using the Cross Racial Identity Scale.* Manuscript submitted for publication.

Morton, K. A. H. (2008). *The early exit of the American "Gypsy" population from mainstream school.* Unpublished masters paper, Cognition and Development, University of California, Berkeley.

Neil, D. M. (2003). Racial integration history and ego-identity status: Predicting student racial attitudes. *Dissertation Abstracts International: Section A: Humanities and Social Sciences*, 63 (A), 316.

Parham, T. A. (1989a). Cycles of psychological nigrescence. *The Counseling Psychologist, 17*, 187-226. doi:10. 1177/0011000089172001.

Parham, T. A. (1989b). Nigrescence: The transformation of Black consciousness across the life cycle, pp. 151-166. In R. L. Jones (Ed.), *Black adult development and aging.* Berkeley, CA: Cobb and Henry Publishers.

Parham, T. A., and Helms, J. E. (1981). The influence of Black students' racial identity attitudes on preference for counselor's race. *Journal of Counseling Psychology, 28*, 250-258. doi:10. 1037/0022-0167. 28. 3. 250.

Parham, T. A., and Williams, P. T. (1993). The relationship of demographic background variables to racial identity attitudes. *Journal of Black Psychology, 19*, 7-24. doi:10. 1177/00957984930191002.

Phinney, J. S. (1989). Stages of ethnic identity in minority group adolescence. *Journal of Early Adolescence, 9*, 34-49. doi:10. 1177/0272431689091004.

Phinney, J. S. (1992). The Multigroup Ethnic Identity Measure: A new scale for use with diverse groups. *Journal of Adolescent Research, 7*, 56-176. doi: 10. 1177/074355489272003.

Phinney, J. S. (1996). When we talk about American ethnic groups, what do we mean? *American Psychologist, 51*, 918-927. doi:10. 1037//0003-066X. 51. 9. 918.

Phinney, J. S., and Ong, A. D. (2007). Conceptualization and measurement of ethnic identity: Current status and future directions. *Journal of Counseling Psychology, 54*, 271-281. doi:10. 1037/0022-0167. 54. 3. 271.

Piaget, J. (1948). *The moral judgment of the child.* New York, NY: Free Press.

Piaget, J. (1962). The stages of intellectual development of the child. *Bulletin of the Menninger Clinic, 26*, 120-128.

Plummer, D. L. (1996). Black racial identity attitudes and stages of the life span: An exploratory investigation. *Journal of Black Psychology, 22*, 169-181. doi:10. 1177/00957984960222003.

Pollard, K. (2010). Assessing construct validity of African American acculturation and racial identity scales for use in clinical populations. *Dissertation Abstracts International Section B: The Sciences and Engineering, 70* (8-B), 5227.

Ponterotto, J. G. (1988). Racial consciousness development among White counselor trainees: A stage model. *Journal of Multicultural Counseling and Development, 16,* 146-156.

Ponterotto, J. G., and Mallinckrodt, B. (2007). Introduction to the special section on racial and ethnic identity in counseling psychology: Conceptual and methodological challenges and proposed solutions. *Journal of Counseling Psychology, 54,* 219-223. doi:10. 1037/0022-0167. 54. 3. 219.

Ponterotto, J. G., and Park-Taylor, J. (2007). Racial and ethnic identity theory, measurement, and research in counseling psychology: Present status and future directions. *Journal of Counseling Psychology, 54,* 282-294. doi:10. 1037/0022-0167. 54. 3. 282.

Ponterotto, J. G., and Wise, S. L. (1987). Construct validity study of the Racial Identity Attitude Scale. *Journal of Counseling Psychology, 34,* 218-223. doi:10. 1037/0022-0167. 34. 2. 218.

Quintana, S. M. (2007). Racial and ethnic identity: Developmental perspectives and research. *Journal of Counseling Psychology, 54,* 259-270. doi:10. 1037/0022-0167. 54. 3. 259.

Sellers, R. M., Rowley, S. A. J., Chavous, T. M., Shelton, J. N., and Smith, M. A. (1997). Multidimensional inventory of black identity: A preliminary investigation of reliability and construct validity. *Journal of Personality and Social Psychology, 73,* 805-815. doi:10. 1037/0022-3514. 73. 4. 805.

Sellers, R. M., Shelton, J. N., Cooke, D. Y., Chavous, T. M., Rowley, S. A., and Smith, M. A. (1998). A multidimensional model of racial identity: Assumptions findings, and future directions, pp. 275-302. In R. L. Jones (Ed.), *African American identity development.* Hampton, VA: Cobb and Henry Publishers.

Sellers, R. M., Smith, M. A., Shelton, J. N, Rowley, S. A., and Chavous, T. M. (1998). Multidimensional model of racial identity: A reconceptualization of African American racial identity. *Personality and Social Psychology Review, 2,* 18-39. doi:10. 1207/s15327957pspr0201_2.

Simmons, C., Worrell, F. C., and Berry, J. M. (2008). Psychometric properties of scores on three Black racial identity scales. *Assessment, 15,* 259-276. doi: 10. 1177/10731911083 14788.

Smith, R. C. (2003). *Encyclopedia of African American politics.* New York, NY: Facts in File.

Tapp, J. L., and Kohlberg, L. (1971). Developing senses of law and legal justice. *Journal of Social Issues, 27,* 65-91. doi:10. 1111/j. 1540-4560. 1971.tb00654. x.

Telesford, J., Mendoza-Denton, R., and Worrell, F. C. (2011). *Profiles of Cross Racial Identity Scores and psychological adjustment.* Unpublished manuscript, Department of Psychology, University of California, Berkeley.

Thompson, B. (2003). Understanding reliability and coefficient alpha, really, pp. 3-23. In B. Thompson (Ed.), *Score reliability: Contemporary thinking on reliability issues.* Thousand Oaks, CA: Sage.

Tokar, D. M., and Fischer, A. R. (1998). Psychometric analysis of the Racial Identity Attitude Scale—Long Form. *Measurement and Evaluation in Counseling and Development, 31,* 138-149.

Valsiner, J., and Connolly, K. J. (2003). The nature of development: The continuing dialogue of processes and outcomes. In J. Valsiner and K. J. Connolly (Eds.), *Handbook of developmental psychology* (pp. ix-xviii). Thousand Oaks, CA: Sage.

Vandiver, B.J. (2001). Psychological nigrescence revisited: Introduction and overview. *Journal of Multicultural Counseling and Development,* 29, 165-173.

Vandiver, B. J. (2007, August). *Examining the reliability of the CRIS scores.* Poster presented at the annual conference of the American Psychological Association, San Francisco, CA.

Vandiver, B. J., Cross, W. E., Jr., Fhagen-Smith, P. E., Worrell, F. C., Swim, J. K., and. Caldwell, L. D. (2000). *The Cross Racial Identity Scale.* State College, PA: Author.

Vandiver, B. J., Cross, W. E., Jr., Worrell, F. C., and Fhagen-Smith, P. E. (2002). Validating the Cross Racial Identity Scale. *Journal of Counseling Psychology, 49,* 71-85. doi:10. 1037/0022-0167. 49. 1. 71.

Vandiver, B. J., and Worrell, F. C. (Eds.). (2001). Psychological nigrescence revisited. [Special issue]. *Journal of Multicultural Counseling and Development, 29*(3).

Vandiver, B. J., and Worrell, F. C. (2009). *Assessing Black racial identity using the Cross Racial Identity Scale.* Continuing education workshop presented at the annual meeting of the American Psychological Association, Toronto, Canada.

Vandiver, B. J., Worrell, F. C., and Romero-Delgado, E. (2009). A psychometric examination of Multidimensional Inventory of Black Identity (MIBI) scores. *Assessment, 16,* 337-351. doi:10. 1177/1073191109341958.

Weinfurt, K. P. (1995). Multivariate analysis of variance. In L. G. Grimm and P. R. Yarnold (Eds.), *Reading and understanding multivariate statistics* (pp. 245-276). Washington, DC: American Psychological Association.

Wester, S. R., Vogel, D. L., Wei, M., and McLain, R. (2006). African American men, gender role conflict, and psychological distress. *Journal of Counseling and Development, 84,* 419-429.

Whittaker, V. A., and Neville, H. A. (2010). Examining the relation between racial identity attitude clusters and psychological health outcomes in African American college students. *Journal of Black Psychology, 36,* 383-409. doi:10. 1177/0095798409353757.

Worrell, F. C., and Cross, W. E., Jr. (2008a). Cross-cultural counseling, pp. 1078-1080. In F. T. L. Leong (Series Ed.), and M. G. Constantine and R. L. Worthington (Vol. Eds.), *Encyclopedia of counseling. Volume 3: Cross-cultural counseling.* Thousand Oaks, CA: Sage Publications.

Worrell, F. C. (2008b). Nigrescence attitudes in adolescence, emerging adulthood, and adulthood. *Journal of Black Psychology, 34,* 156-178. doi:10. 1177/ 0095798408315118.

Worrell, F. C., Beaujean, A. A., Sussman, J., and Watson, S. (2011). *An IRT analysis of Cross Racial Identity Scale (CRIS) scores.* Manuscript submitted for publication.

Worrell, F. C., Cross, W. E., Jr., and Vandiver, B. J. (2001). Nigrescence theory: Current status and challenges for the future. *Journal of Multicultural Counseling and Development, 29,* 201-210.

Worrell, F. C., and Gardner-Kitt, D. L. (2006). The relationship between racial and ethnic identity in Black adolescents: The Cross Racial Identity Scale (CRIS) and the Multigroup Ethnic Identity Measure (MEIM). *Identity: An International Journal of Theory and Research, 6,* 293-315.

Worrell, F. C., Mendoza-Denton, R., Telesford, J., Simmons, C., and Martin, J. F. (in press). Cross Racial identity scale (CRIS) scores: Stability and relationships with psychological adjustment. *Journal of Personality Assessment.*

Worrell, F. C., Vandiver, B. J., and Cross, W. E. Jr. (2004). *The Cross Racial Identity Scale: Technical manual* (Second edition). Berkeley, CA: Authors.

Worrell, F. C., Vandiver, B. J., Cross, W. E. Jr., and Fhagen-Smith, P. E. (2004). The reliability and validity of Cross Racial Identity Scale (CRIS) scores in a sample of African American adults. *The Journal of Black Psychology, 30,* 489-505. doi:10. 1177/0095798404268281.

Worrell, F. C., Vandiver, B. J., Cross, W. E., Jr., and Fhagen-Smith, P. E. (2010). *The Cross Scale of Social Attitudes.* Unpublished Scale, Cognition and Development, University of California, Berkeley.

Worrell, F. C., Vandiver, B. J., Schaefer, B. A., Cross, W. E., Jr., and Fhagen-Smith, P. E. (2006). Generalizing nigrescence profiles: A cluster analysis of Cross Racial Identity Scale (CRIS) scores in three independent samples. *The Counseling Psychologist, 34,* 519-547. doi:10. 1177/0011000005278281.

Worrell, F. C., and Watson, S. (2008). A confirmatory factor analysis of Cross Racial Identity Scale (CRIS) scores: Testing the expanded nigrescence model. *Educational and Psychological Measurement, 68,* 1041-1058. doi:10. 1177/001 3164408318771.

Yanico, B. J., Swanson, J. L., and Tokar, D. M. (1994). A psychometric investigation of the Black Racial Identity Attitude Scale—Form B. *Journal of Vocational Behavior, 44,* 218-234. doi:10. 1006/jvbe. 1994. 1015.

Chapter Two
The Conceptualization and Measurement of Racial Identity and Racial Identification within Psychology

Richard D. Harvey, Cathryn D. Blue, and Rachel E. Tennial

Introduction

Few constructs have been as important to the study of African Americans as those of racial identity and racial identification. Indeed, these constructs have been used as key antecedents, mediators, moderators, and consequences at virtually every level of variable construction. For example, they have been implicated as key variables at the intrapersonal (e.g., self-concept and self-esteem: Parham and Helms, 1985; Wilson, 1999), interpersonal (e.g., interpersonal relationships and socialization: Taub and McEwen, 1992; Demo and Hughes, 1990), intragroup (e.g., collective action and collective self-esteem: Morris and Mueller, 1992), and intergroup levels (e.g., conflict and cultural mistrust: Brown, 2010; Phelps, Taylor, and Gerard, 2001). Thus, racial identity and identification may be considered paramount constructs given their pervasive application to virtually all areas of African American life.

Since its inception, the conceptualization and measurement of racial identity has evolved and branched off into a few different paradigms. Perhaps the earliest study to assess racial identity among African Americans was a study on racial stereotypes conducted by James Bayton (1941). He asked a sample of African American college students to choose from a list of eighty-five adjectives that they believed described both their African American collegiate peers and African

Americans in general. He found that the students described African Americans in general as "intelligent, progressive, faithful, and imitative." This list of traits clearly diverged from the traits that Whites had assigned African Americans in an earlier study using the same adjective checklist (cf. Katz and Braly, 1933: ignorant, stupid, naïve, slovenly, and physically dirty). However, their list also included traits that Whites in the earlier study did choose, such as "superstitious, lazy, happy-go-lucky, very religious, ostentatious, loud, and musical." This study revealed that while the conception that African American college students had of their larger racial group was not completely tainted by the oppressive stereotypes that existed in society, it was nonetheless heavily influenced by it. Understandably, the next focused line of research on African American racial identity by Charles Thomas (1971) and William Cross (1971) focused more on identifying optimum levels of racial ideology necessary for healthy psychological adjustment. This has been the most pervasive paradigm within racial identity research ever since.

In this chapter, we will first review the extant models and measures of racial identity/identification. Our goal is not to provide a comprehensive discussion of all models that are in existence, but rather to provide the reader with a sense of the psychological study of racial identity/identification within certain themes. However, across those themes, we then provide the reader with a typology that we hope will prove helpful to gauge the similarities and differences among models. Furthermore, we provide a critique on the conceptualizations and measurements across these models. Finally, we introduce a mixed-method measurement tool that is designed to overcome some of the limitations within the extant conceptualizations and measures of racial identity and identification.

Racial Identity Models

We suggest that the extant racial identity models may be conceptualized as either (1) Social Development, (2) Africentric, (3) Affiliation-Commitment, or (4) Multidimensional models. While all models are likely to have some components of all of these, we sorted them based upon their primary thrust.

Social Development Models

The social development models of racial identity reflect a desire to locate African Americans along a continuum that tends to begin with an apathy and repression of their racial identity and end with a concomitant embracing of one's identity along with the values of other groups. These models have historically been both descriptive and prescriptive in nature. By descriptive, we mean that they have tried to describe the status of a respondent's perspective on racial topics and group phenomena. However, they have also trended toward the prescriptive in that they have suggested optimum statuses of psychological health (i.e., a mentally healthy perspective of racial issues). While the first of these models was proposed by

Thomas (1971), the two most popular versions of this perspective were proposed by Cross (1971) and Helms (1990).

Nigrescence

Cross (1971) proposed a *Nigrescence* model to explain the *Negro to Black* conversion: the process African Americans undergo as they acknowledge and learn to accept Black racial group membership within the hierarchical American social structure. The Nigrescence model was later revised as a result of empirical studies performed by Cross and other researchers that suggested a more complex and dynamic rendering of the various stages of Nigrescence. The scale used in the development of the revised Nigrescence theory is known as the Cross Racial Identity Scale (CRIS) (Vandiver, Cross, Fhagen-Smith, Worrell, Swim, and Caldwell, 2000).

Pre-encounter, the first stage of the Nigrescence model, describes a period when the individual identifies with White culture and/or rejects or denies membership in Black culture (Cross, 1971, 1991; Vandiver, et al., 2000). Cross, Swim, and Fhagen-Smith (1995) demonstrated that anti-Black attitudes do not necessitate pro-White attitudes. As a result of this analysis, the Pre-Encounter dimension of the Nigrescence model was dichotomized into *Pre-encounter Assimilation* (having pro-White attitudes)and *Pre-encounter Anti-Black* (Vandiver, et al., 2000). Vandiver, Cross, Worrell, and Fhagen-Smith (2002) later added a third dimension of Pre-encounter: *Pre-Encounter Self-Hatred* (having attitudes that represent internalized hatred of Black people and subsequently, hatred of one's self as a Black individual).

The second stage was originally referred to by Cross (1971, 1991) as *Encounter*: Blacks became submerged in Black/African culture and hostile toward Whites as a result of a negative interracial experience during which one's Blackness was made salient. In the updated version of the model (Vandiver et al., 2000), the Encounter stage was eliminated and replaced with two dimensions of the *Immersion-Emersion* stage much in the way that Pre-Encounter had been dichotomized. These dimensions were defined as *Immersion-Emersion Intense Black Involvement* (the individual embraces Black culture, learns about Black history, and becomes somewhat an activist in the Black community) and *Immersion-Emersion Anti-White* (the individual vilifies members of White culture and often fantasizes about harm coming to Whites) (Vandiver et al., 2000).

During *Internalization/Commitment,* the final stage of Nigrescence (Cross, 1971), Blacks recognized their membership in the Black racial group and worked to fight general oppression of all people. Furthermore, Internalization/Commitment was originally prescribed by the authors as the most optimal Black identity. Cross and colleagues (1995) later concluded that an internalized Black identity was not necessarily optimal in terms of psychological functioning, but instead was an indicator of reference group orientation. In other words, one abandons anti-Black and/or pro-White attitudes to focus on issues outside of the self (Vandiver et al., 2001). The Internalization/Commitment stage was dichotomized into *Internali-*

zation Black Nationalist (the individual is focused on Black empowerment, independence, and history) and *Internalization Multiculturalist* (the individual focuses on at least two other identity categories to define him or herself and acceptance of others is important). As a result of further analyses, multiple dimensions of the Black Nationalist and Multiculturalist stages emerged.

Exploratory and confirmatory factor analyses support the six-factor structure of the CRIS, and demonstrate construct validity of the scale and its dimensions (e.g., Vandiver et al., 2002). Furthermore, the CRIS has been used in countless studies to establish correlations between racial identity and other variables. For example, criterion validity of the CRIS was demonstrated through the use of the scales dimensions to predict variables such as academic achievement (Hood, 1998), gender role conflict (Wade, 1996), social class (Carter and Helms, 1988) and self-esteem (Manning, 1998).

Racial Identity Attitudes

Helms (1990) proposed that racial identity development occurs in response to transactions among a variety of factors, including parental, family, school, and institutional influences. She noted that racial identity progresses through sequential, yet permeable ego-identity statuses. Each status represents a cluster of attitudes, beliefs, and values that affect how an individual perceives the world and influences the way he or she processes information about race. The sequential order of statuses reflects increasing complexity and flexibility in the processing of racially related information. Helms also posited that at any given time in an individual's life, one status will usually predominate, although some characteristics of other statuses may be present. In addition, she noted that an individual may revert from his or her current predominant status to a lower one, which is relatively different from other proposed stage models of racial identity (e.g. Cross, 1971). However, it is made very clear that the tasks and challenges of each lower status must be resolved in order for an individual to progress to the next status.

Helms (1995) offered an alternative to the perceptively rigid stages of racial identity introduced by the Nigrescence model. Focusing on the attitudes associated with Pre-Encounter, Encounter, Immersion/Emersion, and Internalization statuses, Parham and Helms (1981) developed the Racial Identity Attitudes Scale (RIAS) form A. The RIAS Form B was later created as a result of various studies and reorganization of the factor structure of the RIAS (Helms, 1990; Helms and Parham, 1996).

Helms (1995) noted the importance of using the RIAS in its entirety when measuring the relationship between racial identity and other constructs. The author posited that though some statuses represent dominant attitudes through which individuals process racial information, nondominant statuses are also simultaneously accessible (Helms, 1995). The racial identity statuses are not mutually

exclusive and analyzing them altogether provides a more cohesive understanding of an individual's racial identity development. Criterion validity of the RIAS has been established in predicting relationships between Black racial identity and self-esteem (Parham and Helms, 1985), client attitudes regarding counselors' race (e.g., Parham and Helms, 1981), and academic achievement (Witherspoon, Speight, and Thomas, 1997).

Africentric Models

The Africentric perspective on psychological inquiry focuses on the values, assumptions, and beliefs thought to be characteristic of people of African descent throughout the African Diaspora (e.g., Belgrave, Brome, and Hampton, 2000). Some theorists claim that adherence by African Americans to an Africentric worldview reflects optimal psychological health, suggesting diagnostic uses for these models (e.g., Baldwin and Bell, 1985). The Africentric approach also assumes that Blacks with Eurocentric personalities will suffer from cognitive and emotional dissonance associated with inconsistencies between one's life philosophy and one's natural tendencies and desires (e.g., Belgrave, et al., 2000). Though many scholars have introduced models to describe the various components of an Africentric racial identity, Randolph and Banks (1993) outlined a cohesive list of eight dimensions, synthesizing previous models:

(1) *Spirituality*. Spirituality represents a belief in a being greater than the self (also referred to as one's belief in God) that is more important than material things and provides a framework by which people of African descent evaluate themselves, problem solve, and connect to one another.

(2) *Communalism*. Communalism is the belief that the group or collective is more important than the individual. This interpersonal orientation stresses the importance of integrating the individual's goals with the goals of one's greater community.

(3) *Harmony and Balance*. Harmony describes the belief that all elements of life are connected and that one's life must be in balance. Harmony and balance include the idea that human beings are an integral part of nature.

(4) *Time as a social phenomenon*. Time is not its own entity, but exists as a consequence of social interaction. Furthermore, an Africentric time orientation emphasizes the present over the future and is conceptually akin to cyclical time (Gurvitch, 1964).

(5) *Affect sensitivity to emotional cues*. Emotions facilitate interactions between people, and being in tune with others' feelings is important. Awareness of one's feelings and the feelings of others is included in the cognitive aspects of the self and is necessary to adapt socially.

(6) *Expressive communication and orality*. This element of the Africentric perspective emphasizes the importance of oral over written expressions as well as subjective, abstract means of communication, such as music and art. The

oral tradition and call response pattern are particularly important in order to transmit knowledge.

(7) *Multidimensional perception and verve.* Multidimensional perception and verve describes the preference for multimodal learning, using all the senses. The use of rhythm and motion are of particular importance.

(8) *Negativity to positivity.* This dimension of the Africentric personality describes the ability to get good outcomes out of bad situations. This is often understood in the Black community as "making a way out of no way."

While a number of Africentric models abound, the two most popular models were developed by Baldwin (1981) and Williams (1981). Most other models reflect elaborations around one or more points initially stated within these models.

African Self-Consciousness

In light of the various dimensions of the Africentric personality, Baldwin (1981) proposed an Africentric Theory of Black Personality which asserts that a healthy Black personality shows evidence of (1) a biogenetic inclination toward asserting the African American reality, (2) a need to preserve African American culture and institutions, and (3) a desire to participate in activities that promote the integrity of African people (Baldwin, 1981; Burlew and Smith, 1991).

The Africentric Theory of Black Personality gave rise to the African Self-Consciousness Scale (ASC; Baldwin and Bell, 1985). Items in the ASC scale measure one's level of self-extension and communal orientation and cover a variety of topics, including religion, education, political orientations, and interpersonal relationships. The ASC scale is composed of elements that aim to capture the essence of the Black personality.

The ASC scale has been accepted as a valid and representative measure of Africentric identity. Convergent validity has also been demonstrated by correlations with other Black identity models like the Black Personality Questionnaire (BPQ) (Williams, 1981). Criterion validity of the ASC scale has been established in its ability to predict psychological well-being (Pierre and Mahalik, 2005) and health promoting behaviors (Thompson and Chambers, 2000) among African Americans.

Black Personality

In contrast to the stage theories of Black identity development, Williams (1981) proposed that a Black personality represents a variety of factors that exist in varying levels, depending on one's environment as well as individual characteristics. These characteristics include beliefs associated with either negation of one's own racial group or an orientation towards the majority (i.e., White) racial group. Williams's Black Personality Questionnaire (BPQ; Williams, 1981) assesses the way in which individual personality traits affect one's experiences of race throughout the racial

identity development process. Specifically, The BPQ measures differing behavioral styles in response to racial oppression.

The BPQ is comprised of six subscales that aim to evaluate the world view through which environment and/or personal perspective shape an individual Black personality. These subscales include *Pro-White, Anti-Black, Anti-White, Pro-Black, Pan-African, and Third-World.* The Anti-White, Pro-Black, Pan-African, and Third-World subscales identify the degree to which an individual endorses an Africentric response style when confronting oppression. The Pro-White and Anti-Black subscales measure the degree to which an individual endorses a Eurocentric response style.

Construct validity of the BPQ has been established using factor analysis in which six factors emerged that were consistent with the factors outlined in the scale (Azibo, 1996). Further construct validity was established based on correlations with the African Self-Consciousness Scale (Baldwin and Bell, 1985). Criterion validity of the BPQ was supported by the scale's ability to predict support of slavery reparations among a group of African American undergraduate students (Azibo, 2008).

Affiliation-Commitment Models

Racial identity has been conceptualized within the affiliation-commitment models as one's involvement with or connection to a given racial group (i.e. African Americans). The models within this typology are characterized by their focus on commitment to the group as the key element in understanding an individual's racial identity. For these models, the construct of interest is inherently expressed in individuals via their perceptions of how close to or a part of the group one feels. Feelings of connectedness and exploration/involvement in group activities and traditions are the major elements for affiliation-commitment focused models.

Multi-Construct African American Identity: Smith and Brookins (1997) proposed five constructs that are integral to fully understanding and assessing ethnic identity among African Americans: (1) positive orientation towards African American's physical and social characteristics, (2) positive attitudes toward African Americans as a group, (3) identification with Africans, (4) political ideology, and (5) group cooperation vs. group competitiveness. These five constructs all reflect aspects of how close to, involved or affiliated with the group individual members may be.

The Multi-Construct African American Identity Questionnaire (MCAIQ) (Smith and Brookins, 1997) was developed to measure these five aspects of the individual's perceived connection to their ethnic group. However, the five constructs proposed have been collapsed under two main foci (racial orientation and cooperative-competitive values), which are represented within three subscales (social orientation, appearance orientation and racial orientation [attitudes/stereotypes about African Americans]). The MCAIQ is a twenty-one item measure that

utilizes a five-point Likert format with response options ranging from *strongly agree* (1) to *strongly disagree* (5). The social orientation subscale targets respondent's attitudes around socializing with African Americans. The appearance orientation subscale is focused on the respondent's attitudes regarding the physical characteristics and attributes of the target group. Finally, the stereotyping subscale simply measures the degree to which respondents endorse stereotypes about the target group, African Americans. Within this measure the racial orientation focus is operationalized by the social and appearance orientation subscales, while the latter subscale reflects the cooperative-competitive focus of the model. (Smith and Brookins, 1997; Davis and Engel, 2011)

The psychometric properties of the MCAIQ were evaluated via establishing construct validity, specifically convergent validity, and internal consistency reliability. The MCAIQ had an internal consistency reliability of .87 with subscale alpha's ranging from .66 to .54 (Smith and Brookins, 1997; Davis and Engel, 2011). The MCAIQ was significantly correlated with the MEIM (a measure of multi-ethnic identity), thus establishing convergent validity and confirming that the measure of interest assesses the construct it posits to be measuring, racial/ethnic identity. The MCAIQ was related to self-esteem as measured via the Bronstein-Cruz Child/ Adolescent Self-Concept and Adjustment Scale. (Smith and Brookins, 1997; Davis and Engel, 2011) Furthermore, the MCAIQ has also been related to individual socialization with their ethnic group (Belgrave, Reed, Plybon, Butler, Allison, and Davis, 2004).

Multigroup Ethnic Identity. The second model within this category was developed to be a general, universal, conceptualization of ethnic identity intended for use across cultural groups. Phinney (1992) developed this model with the major purpose of being able to assess any individual's global ethnic identity. This model is the most commonly used and referenced model for ethnic identity and, interestingly, racial identity (Phinney, 1992; Rollins and Valdex, 2006; Johnson and Arbona, 2006; Yancey, Aneshensel, and Driscoll, 2001). Although this model was not developed to assess the latter construct, it has frequently been used as a proxy measure of racial identity and has become an integral piece of the racial identity research literature. Thus, its place in this chapter is warranted. However, criticisms exist of such proxy usage (e.g., Cokley, 2007). Therefore, researchers should make themselves aware of these criticisms and be clear about their assumptions and intentions when attempting to apply Phinney's model to the study of African American racial identity.

The Multigroup Ethnic Identity Measure (MEIM) was developed to operationally measure the construct of global ethnic identity proposed by Phinney (1992). The MEIM has two foci that are represented as subscales within the measure: commitment to the group and/or its members and exploration or involvement in ethnic group activities. These foci essentially assess how committed to a given group, in this case racial or ethnic group, the individual is. So via these subscales, the MEIM is believed to capture the essence of an individual's global ethnic

identity. The MEIM is a twelve-item scale that uses a four-point Likert scaling format with response options ranging from *strongly disagree* (1) to *strongly agree* (4) (Phinney, 1992; Davis and Engel, 2011). The commitment subscale contains seven items, while the exploration/involvement subscale is comprised of the remaining five items. Together, these two subscales are purported to be operationalizing the key components of global ethnic identity.

The MEIM has been validated across three ethnic groups (European Americans, African Americans, and Mexican Americans) with a sample of high school and undergraduate students. The measure was found to have good reliability with a Cronbach's alpha ranging from .81 to .90 across samples. A two- factor structure was established for the measure confirming the existence of two separate, but related, subscales. (Phinney, 1992; Davis and Engel, 2011; Worrell and Gardner-Kitt, 2006) As is standard when validating a measure, construct validity was established, and the MEIM was found to be correlated with measures of psychological well being such as self-esteem (Rollins and Valdex, 2006; Johnson and Arbona, 2006). In addition to being used as a proxy measure for racial identity, this measure has also been used to demonstrate construct validity for racial identity scales, specifically convergent validity (Sellers, Rowley, Chavous, Shelton, and Smith, 1997; Worrell and Gardner-Kitt, 2006; Yancey, Aneshensel, and Driscoll, 2001).

Multidimensional Models. Many of the models presented above are complementary to one another. This suggests that it might be advantageous to utilize multiple measures reflecting different dimensions rather than one unitary construct. Thus, there is a need for integrative models that highlight the multidimensionality of racial identity. To date, their have only been a few attempts to create multidimensional models. One of the earliest attempts was by Sanders Thompson (1995); however, the most widely known and used model of this sort was developed by Sellers and his associates (Sellers, Rowley, Chavous, Shelton, and Smith, 1997; Sellers, Smith, Shelton, Rowley, and Chavous, 1998). Multidimensional models represent an important shift in this literature from uni-dimensional, developmentally focused measures to models and scales that encompass and assess multiple aspects of racial identity.

Multidimensional Racial Identification. Sanders Thompson (1995, 2001) developed a multidimensional model of racial identity as a group-based approach to the study of racial identification. Moreover, this model sought to conceptualize racial identity as a multidimensional construct with four distinct parameters necessary for adequate understanding and study of this construct (Hilliard, 1985, as cited in Sanders Thompson, 1995). Thus, the purposes of the model were to un-package this construct further and develop a conceptualization that was inclusive of those four essential elements of racial identification.

The Multidimensional Racial Identity Scale-Revised (MRIS-R) was developed to measure racial identity and identification across four parameters (physical,

cultural, sociopolitical and psychological). The *physical identity* parameter refers to an individual's level of acceptance of the physical attributes of African Americans. *Cultural identity* focuses on the individual's knowledge about the African American contribution to society. The *sociopolitical identity* parameter examines the individual's beliefs about social, economic and political issues that affect African Americans. Finally, the *psychological identity* parameter targets the individual's concern for, commitment to, and pride in their racial group. Following Hilliard (1985, as cited in Sanders Thompson, 1995), who theorized that these four parameters were essential to gaining an adequate understanding of racial identity, the MRIS-R was developed to assess each parameter individually, but also to take the measure as a whole to gain understanding of an individual's racial identity.

The MRIS-R is a twenty-five item scale comprised of four subscales and measured using a five-point Likert format with response options ranging from *strongly agree* (5) to *strongly disagree* (1). The MRIS-R is the operationalized form of these four essential parameters that must be assessed to determine one's racial identity and level of identification. The items within the MRIS-R were found to fall into the four identity parameters proposed by the model via a four factor structure (Sanders Thompson, 2001; Sanders Thompson, 1995).

Multidimensional Model of Racial Identity. Like the MRIS-R, Sellers, Smith, Shelton, Rowley, and Chavous (1998) proposed a multidimensional model of racial identity (MMRI). The MMRI can be most broadly described as a hybrid model composed of the ideological elements of previous racial identity models (Nigrescence, RIAS-B and ASC) and the centrality focused facets of Social Identity Theory (Tajfel and Turner, 1979). This amalgam between ideology and centrality is exemplified by how racial identity is defined within this model, as " . . . the significance and qualitative meaning that individuals attribute to their membership within the Black racial group within their self-concepts" (Sellers et al., 1998, p. 23).

The MMRI is measured by the Multidimensional Inventory of Black Identity (MIBI) measure (Sellers, Rowley, Chavous, Shelton, and Smith, 1997). The MIBI is comprised of several dimensions, which are measured through the use of seven subscales: Centrality, Private and Public Regard, Nationalist ideology, Oppressed Minority ideology, Assimilationist ideology, and Humanist ideology. These subscales represent four dimensions of racial identity: *racial salience, racial centrality, racial regard,* and *racial ideology.* Salience refers to the relevance of one's race to their self-concept. Centrality reflects the extent to which an individual regularly defines themselves (i.e., within their self-concept) by their race. Regard attempts to assess an individual's evaluative judgment of their race (private) and their perceptions of how outsiders judge their race (public). Finally, ideology refers to the beliefs, opinions or attitudes that an individual holds regarding how they feel members of their group should either think or act with regard to social issues.

The MIBI has been found to predict the likelihood that an individual would take Black studies courses and/or interact with African Americans (Sellers et al., 1997) Furthermore, the MIBI has been found to be related to academic outcomes

in youth, such as increased positive academic beliefs and stronger attachment to school (Chavous, Hilkene Bernat, Schmeelk-Cone, Caldwell, Kohn-Wood, and Zimmerman, 2003; Chavous, Rivas-Drake, Smalls, Griffin, and Cogburn, 2008).

Typology

While all of the models discussed above may reflect different themes, they do aggregate around common clusters. More specifically, we suggest that all of the models essentially specify attitudes and opinions on two dimensions: in-group and out-group. That is, all of the racial identity models attempt to measure the degree to which a person either embraces or rejects their own racial group and out-groups. For African Americans, the dominant out-group is typically referenced as European Americans.

Thus, there are generally four possibilities: (1) embracing both African American identity and European-American Identity, (2) embracing African American while rejecting European-American identity, (3) rejecting African American identity while embracing European-American identity, and (4) rejecting both African American identity and European-American identity. Nevertheless, there are cases where a particular component of a model is simply silent on one of these dimensions. In that instance, the components can be said to be "neutral" with respect to that dimension. Table 2.1 provides the various stages, statuses, and dimensions across the models that have been presented based upon our interpretation of their orientations toward African American and European-American identities. The vast majority of components seem to cluster around the High African American identity and Low European-American identity category. The second most frequented category is its inverse: High European-American/Low African American. Very few of the subscales seem to assess the embracing of both African American and European-American groups or the rejection of both.

Critiques

The literature on African American racial identity has evolved quite a bit. However, like several other areas of social scientific inquiry, it suffers from a lack of conceptual agreement across models. We suggest that this lack of conceptual agreement is rooted in two fundamental limitations to the extant literature: (1) a missing essential conceptual core for what constitutes an "identity" and (2) a failure to distinguish between identity and identification. These limitations are evident in both the conceptualization and measurement of African American racial identity. Thus, future attempts to advance the study of African American racial identity must offer both theoretical and empirical solutions for them.

Table 2.1: Stages, Statuses, and Dimensions of Racial Identity Models

	High African American or African Identity	Neutral	Low African American or African Identity
High European-American Identity	Internalized Bicultural identity (CRIS)		Pre-Encounter (RIAS) Pre-Encounter-Assimilation (CRIS) Pre-Encounter-Self-Hatred (CRIS) Anti-Black (BPQ) Pro-White (BPQ) Assimilationist Ideology (MIBI)
Neutral	Positive attitudes toward African-American group (MCAIQ) Identification with Africans (MCAIQ) Racial Centrality (MIBI) Private Regard (MIBI)	Group Competitiveness (MCAIQ) Commitment (MEIM) Exploration/Involvement (MEIM) Oppressed Minority (MIBI) Third World (BBQ)	Humanist Ideology (MIBI)

Table 2.1: Stages, Statuses, and Dimensions of Racial Identity Models (Continued)

	High African American or African Identity	Neutral	Low African American or African Identity
Low European American Identity	Encounter (RIAS) Immersion/Emersion (RIAS) Immersion/Emersion Intense Black Involvement (CRIS) Immersion/Emersion Anti-White (CRIS) Internalization/Commitment Black Nationalist (CRIS) Anti-White (BPQ) Pro-Black (BPQ) Pan-African (BPQ) Positive orientation towards Physical and Social characteristics (MCAIQ) Political Ideology (MCAIQ) Group Cooperation (MCAIQ) Physical Identity (MRIS-R) Cultural Identity (MRIS-R) Sociopolitical Identity (MRIS-R) Psychological Identity (MRIS-R) Nationalist Ideology (MIBI)		Internalization (RIAS)

A myriad of conceptualizations exist across the various models of African American racial identity. For example, Helm's (1990) model appears to conceptualize racial identity as an ideological status. However, both William's (1981) and Baldwin's (1981) models treat racial identity as a personality variable. Furthermore, the model proposed by Smith and Brookins (1997) looks at racial identity as more of an index of the closeness and affiliation between the individual and the racial group. Thus, there is a lack of agreement between just what exactly is a "racial identity."

Such lack of agreement seems to be linked to the absence of an essentialist core to tie racial identity back to the genesis of what "identity" was supposed to define in the first place. Without such a core, there is no way to distinguish and separate "identity" from related but conceptually distinct constructs, like esteem and out-group bias. Hence, "identity" is typically confounded with constructs that should be construed as antecedents or consequences of it, rather than constituent parts or elements of it. Instead, just about any construct that seems to be "related" has been considered a "part of" racial identity at some point.

We suggest that the essentialistic core of the term *identity* is *self* and more specifically, the *self-concept*. This has been the primary conceptualization of identity within the more general literature on individual identity. That is, the term "identity" has long been considered as synonymous to or a component of the "self-concept." For example, in some instances, both have been used to refer to a mental self-image or a person's mental model of him or herself (Leary and Tangney, 2003). In other cases, identity has been proposed as one of the self-aspects that make up the self-concept (e.g., McConnell, 2011). Thus, any and all terms that utilize the word "identity" ought to refer to a self-reflective or self-definitional entity of some type.

The conceptual boundaries for the term "identity" ought to be limited to constructs that entail some attempt at self-definition at either the group or the individual level. Such boundaries would then relegate phenomena that are non-definitional in nature as either antecedents or consequences, or both. So for example, this should rule out constructs like "self-esteem" or even "collective self-esteem" in as much as these phenomena are not necessarily definitional as much as they are evaluative. It should also rule out attitudes toward out-groups for the same reason. Likewise, perceptions of outsiders' attitudes towards the racial group do not necessarily reflect how members themselves define the group, and thus should not be confused with racial identity. Of course, we might expect self-esteem, attitudes toward out-groups, and perceptions of others' attitudes to be empirically related to racial identity, however, as possible antecedents and consequences, rather than as constituent parts of it.

The second limitation in the African American racial identity literature is the failure of theorists to distinguish between *Racial Identity* and *Racial Identification*. These terms are consistently treated synonymously within the racial identity literature. This is not a fault of the African American racial identity literature alone. A similar problem exists across the various foci on collective identity (i.e., social,

ethnic, organizational, etc.). Nevertheless, this tendency to treat racial identity and identification as synonymous has induced a great deal of confusion within the literature.

Having established an essentialistic core, the distinction between "identity" and "identification" can be logically deduced. As noted above, 'identity' has been mainly consistent with the idea of a self-image or self-concept. Of course, this has been usually at the individual or personal identity level. However, the construct can be similarly noted at the collective level. Thus, racial identity might be best construed as a mental image or concept of one's racial group. It is best represented as an attempt by the group member to define or describe what their racial group is like. Hence racial *identity* is, in its essence, a *definition*. It is a definition of the racial group to which one belongs. This conceptualization of racial identity recalls the seminal work of Bayton (1941) described earlier, in that it reflects a form of self-stereotyping among group members.

In comparison, identification generically reflects levels of self-definitional affiliation and attachment. It is perhaps a better term to use when discussing the pioneering work of Erik Erickson (1968) when he attempted to describe the self-concept construction process. He was mainly concern with how various roles and group memberships ultimately get incorporated into the self-concept. This is the process of identification, by which external stimuli (i.e., people, values, objects, and such) become internalized within the self. Hence, identification reflects a process of attachment whereby the person's self-concept or personal identity becomes linked to the group. Thus, whereas *racial identity* could be used to refer to the description that an individual holds of his or her racial group, *racial identification* could be used to reflect the degree to which an individual holds that racial group description to be self-definitional. That is, it reflects the degree to which individuals define themselves in light of their racial group membership and the attributes that they associate with it.

While the distinction that we are making between racial identity and racial identification might seem new and perhaps foreign to the racial identity literature, it has become quite pervasive in other arenas of collective identity theorizing and research. For example, the literature on organizational identity/identification does contain deliberate distinctions between the terms identity and identification. For example, the primary conceptualization of an organizational identity is that of the mental image of the organization typically reflected in a list of beliefs and attributes deemed to be distinctive, central, and enduring about the organization (See Albert and Whetten, 1985; Dukerich, Golden, and Shortell, 2002; Ravasi and van Rekom, 2003; Rousseau, 1998). On the other hand, the primary conceptualization of organizational identification is that of a psychological bond between organizational members and their organizations, such that the members' self-conceptions become reflective of their organizational membership. According to Dutton, Dukerich, and Harquail (1994), organizational identification is indicated by the degree to which the same attributes that the member would use to describe their organization are also used to describe themselves. Hence, racial identity theorists and researchers

could benefit from paying attention to distinctions between group identity and identification in other areas.

Most of the extant measures in the African American racial identity literature actually reflect a mixture of racial identity and racial identification questions, although unintentionally. Furthermore, many measures typically labeled as "identity" are actually "identification" measures in that they usually attempt to assess the cognitive link that a person has with their race (i.e., salience, centrality, etc.), more so than the person's description of the race itself. Notable exceptions would include many of the models that we earlier identified as social development models. Because these models focus primarily on the racial ideology presumed to exist at various stages or statuses, these models do seem to primarily reflect racial identity. The racial ideology of these stages primarily addresses both descriptive and prescriptive attributes and beliefs about African Americans. On the other hand, most of the models that might be categorized under the affiliative-commitment category primarily reflect racial identification. While some of the detail within these models might lie considerably beyond the self-definitional threshold established above to be labeled either identity or identification, a decent amount of the detail does, in fact, reflect the psychological bond that the respondent feels towards African Americans as a group. This bond is, at least, implicitly assumed to serve as a source for self-definition.

Piping

We now propose both a conceptual and empirical strategy to advance the study of African American racial identity. Consistent with the arguments presented earlier, we define racial identity as the beliefs that people hold about their racial group. However, we define racial identification as the degree to which they define themselves (i.e., their personal identity or self-concepts) in light of the beliefs that they hold about their racial group, that is, the degree to which the individual uses beliefs about their racial group as a source for how they define themselves. These conceptualizations are consistent with Bayton's (1941) original paradigm, definitions of personal identity within the general self-literature, and definitional distinctions of identity and identification within other research areas (e.g., organizational identity).

Paper and pencil surveys do not allow for the simultaneous collection of beliefs that people hold about their racial groups (i.e., racial identity) and the degree to which they define themselves in light of these beliefs (i.e., racial identification). Thus, researchers would have to choose one or the other. Furthermore, when attempting to measure racial identification, scale developers usually have to pre-suppose the relevant beliefs that a respondent may have about the racial group, rather than assess them directly from the respondent. This creates a dilemma whereby respondents are being asked to identify with either descriptive or prescriptive beliefs that they may not personally associate with their racial group.

This can lead to the false classification of respondents as "low identifiers" when they fail to identity with attributes or beliefs that they do not personally believe to be definitive of their racial group.

Using computers to measure collective identity and identification offers a fix to the two problems noted above. Specifically, through a technique called "piping," computerized surveys allow for the simultaneous measurement of identity and identification. Piping enables a survey to carry input, text or numbers, from one question to another. That is, text inputted into one question can be subsequently inserted into the body of latter questions. Hence, piping allows the researcher to first assess the attributes that respondents associate with their group (i.e., group identity) and secondly, use those same attributes to assess the degree to which the respondents define themselves using the same attributes ascribed to their group (i.e., group identification).

This particular technique can also be used as a mixed-methods approach to studying racial identity and identification. Racial identity is captured as text in that respondents are asked to write in attributes used to define their racial group. Much like the initial work of Bayton (1941), researchers can study the content of what respondents ascribe to their racial groups through more qualitative methods like content analysis. On the other hand, racial identification is captured in the form of ratings when respondents are asked indicate the degree to which they believe that the attributes ascribed to their groups are also descriptive of themselves. The ratings for each attribute can be summed or averaged to create a composite score that can then be subjected to traditional quantitative analyses. Hence, the piping technique reflects a mixed-methods approach in that the assessment of racial identity yields qualitative data, and the assessment of racial identification yields quantitative data.

Racial Identity/Identification Piping Validation Study

We tested the piping technique as a measure of Racial Identity and Racial Identification among African Americans using an online survey. The participants for this study were recruited using a snowball convenience sampling method whereby an initial sample of respondents were recruited through college courses and personal contacts of the research team. Those initial respondents were then asked to recruit other African Americans within their social networks by forwarding a link connected to the online survey. This technique yielded a sample that consisted of 107 African Americans (69 percent female, 23 percent male) with a median age of 35 (Range 18-70). Furthermore, this sample reported a median income range between $20k to $30k, with approximately 54 percent of the respondents holding a bachelors degree or higher.

In addition to the piping measures of racial identity and racial identification, we asked respondents to complete some previously established measures of Black identity, such as the Regard and Centrality subscales of the Multidimensional Inventory of Black Identity (MIBI) scaled (discussed earlier in the paper). Further-more, we asked participants to complete the Rosenberg Self-Esteem Scale

(Rosenberg, 1965) as self-esteem has been considered a fairly robust consequence of heightened racial identification. Also, drawing from literature on organizational identification (Albert and Whetten, 1985), we asked participants to provide ratings of how Distinctive, Enduring, and Central to their racial group each of the attributes that they listed were. According to literature on organizational identification, the most prominent attributes for a group ought to be those thought to be relatively more distinctive, enduring, and central to the group.

With regard to the piping technique, we first measured respondents' racial identity by asking participants to write in five attributes to describe their race. We then measured their racial identification by *piping* these attributes into a set of questions that then ask participants to rate the degree to which these attributes were descriptive of themselves on a 1 (Not at All) to 5 (Very Much) likert scale. Thus, identification is reflected in the degree to which participants rated themselves highly on the same attributes that they used to describe their racial group. To decrease common method bias induced by priming effects, the identity and identification measures were separated within the online survey, with the identity measure presented earlier in the survey and the identification measure presented near the end.

Content analyses on the attributes Black Americans used to describe their race yielded a wide variety of attributes, but nevertheless, some clear themes. These themes are presented using a word cloud in Figure 2.1. By far, the most frequent attribute was "Strong" (76 times). This attribute was used more than three times as frequently as the next four: Proud (20), Intelligent (19), Beautiful (13), and Creative (13). Interestingly, the prominence of the term "intelligent" recalls Bayton's (1941) research, in which the term "intelligent" was also prominent. In both cases, the salience and prominence of this term is likely to be a reaction against the enduring negative stereotype that Black Americans are not intelligent. Perhaps the best analysis of the text data would be around "themes" rather than actual words. This would allow an incorporation of synonyms of words. For example, terms like "resilient" and "courageous" were also frequently reported and would further strengthen the prominence of "Strong" within content analyses.

The five self- descriptive ratings were averaged to create a racial identification score (RIS) (alpha= .72). Overall racial identification was high (M= 4. 29, SD=. 80). The more central (r=. 34, p= .001) and enduring (r= .20, p= .04) the attributes were perceived to be to the racial group, the higher the RID score.

The RIS measure converged with both the Private Regard (r= .26, p= .007) and the Public Regard (r= .21, p=. 03) MIBI subscales, but not with the Centrality subscale (r=-.11, p=. 27). An initial significant regression of self-esteem scores on Private Regard scores (b=. 22, t (101) =2.25, p=. 03) was reduced to non-significance (b=. 16, t (101) =1. 62, p=. 11) when RIS scores (b=. 22, t(101)=2.24, p=. 03) were added to the equation on a second block. This is typically considered partial evidence of a mediation effect. Thus, the piping racial identification score proved to be more indicative of overall self-esteem than private regard, a fairly

common correlate of self-esteem. It is important to note that none of the other MIBI subscales were correlated with self-esteem.

Figure 2.1: Attributes Listed to Describe African Americans

Note: Size of the word is correlated with the frequency of its listing.

This preliminary data supports the use of piping as an advanced method of collecting qualitative and quantitative data. But more importantly, it supports the idea of and the ability to distinguish racial identity from racial identification. There are a number of additional analyses that can be performed on datasets collected using this method. Furthermore, there are also a variety of ways in which this method can be used to study other areas of collective identity such as team, organizational, and even biracial or multiracial identity and identification. Much of current and future research of the authors is focusing on exploring these possibilities and further refining the method itself.

Discussion

Future directions for the study of African American racial identity should include expanding the interdisciplinary perspectives that inform it. Much of the early racial identity research had more of a clinical psychology and developmental psychology focus, as reflected in the social development models (e.g., Cross, 1971). As discussed earlier, these models focused primarily on specifying both dysfunctional and functional racial ideology for ensuring optimum mental health. Sellers et al. (1998) later infused social psychological perspectives (e.g., centrality, private, and public regard) into their racial identity model. In a sense, the piping methodology that we have introduced in this chapter reflects an infusion of insights from the Industrial/Organizational psychology perspective. Nevertheless, there are still

opportunities to further expand the area. For example, some of principles historic-ally used to study implicit memory within cognitive psychology have been used to study implicit group identification. This research has demonstrated that group identification can be detected through the use of reaction time data (see Smith, Coats, and Walling, 1999). Thus, the often neglected issue of racial identity *salience* could be examined by methods used to assess implicit cognition originated within cognitive psychology.

The implications of a more comprehensive understanding of African American racial identity are many. This is primarily due to the fact that racial identity seems to be connected to many social processes within the lives of African Americans, from the intrapersonal to the intergroup. One recent example of how racial identity might be leveraged has been on the literature on cultural tailoring of health care messages. Theorists and practitioners have realized that they must move beyond 'surface' level features (i.e., skin color) to 'deep' processes (i.e., cultural ideology) when attempting to persuade African Americans to engage in a range of health practices (Kreuter et al., 2003; Resnicow et al., 2005). Research suggests that both racial identity and racial identification are key cognitive construal variables in the way that African Americans perceive health behaviors (Davis et al., 2010; Harvey and Afful, in press). Thus, they hold important implications for the tailoring of health messages.

The study of African American racial identity has had a long and varied history within the psychological literature. While its conceptualization and measurement has varied, its importance as both a descriptive and prescriptive construct in the lives of African Americans has not. Primarily because the issue of race itself will continue to be a master status for most African Americans, we anticipate that racial identity will continue to be important well into the distant future. For this reason, it will be important to continue to refine the theories, models, conceptualizations, and measures used to represent African American racial identity and identification, as well.

References

Albert, S., and Whetten, D. A. (1985) Organizational identity. In L. L. Cummings and M. M. Staw (Eds.) *Research in organizational behavior, 7*, 263-295.

Azibo, D. (1996). Personality, clinical, and social psychological research on Blacks: Appropriate and inappropriate research frameworks, pp. 203-234. In D.A. Azibo (Ed.), *African psychology in historical perspective and related commentary*. Trenton, NJ: Africa World Press.

Azibo, D. (2008). Psychological Africanity (Racial Identity) and its influence on support for reparations. *Journal of Negro Education, 77,* 117-130.

Baldwin, J. (1981). Notes on an Africentric theory of Black personality. *Western Journal of Black Studies, 5,* 229-238.

Baldwin, J., and Bell, Y. (1985). The African self-consciousness scale: An Africentric personality questionnaire. *Western Journal of Black Studies, 9,* 61-68.

Bayton, J. A. (1941). The racial stereotypes of Negro college students. *Journal of Abnormal and Social Psychology, 36,* 97-102.

Belgrave, F., Brome, D., and Hampton, C. (2000). The contribution of Africentric values and racial identity to the prediction of drug knowledge, attitudes, and use among African American youth. *Journal of Black Psychology, 26,* 386-401.

Belgrave, F. Z., Reed, M. C., Plybon, L. E., Butler, D. S., Allison, K. W., and Davis, T. (2004). An evaluation of sisters of nia: A cultural program for African American girls. *Journal of Black Psychology, 30* (3), 329-343.

Brown, U. (2010). Black/White interracial young adults: Quest for a racial identity. *American Journal of Orthopsychiatry, 65,* 125-130.

Burlew, A. and Smith, L. (1991). Measures of racial identity: An overview and a proposed framework. *Journal of Black Psychology, 17,* 53-71.

Carter, R. T., and Helms, J. E. (1988). The relationship between racial identity attitudes and social class. *Journal of Negro Education, 57,* 22-30.

Chavous, T. M., Hilkene Bernat, D., Schmeelk-Cone, K., Caldwell, C. H., Kohn-Wood, L., and Zimmerman, M. A. (2003). Racial identity and academic attainment among African American adolescents. *Child Development, 74* (4), 1076-1090.

Chavous, T. M., Rivas-Drake, D., Smalls, C., Griffin, T., and Cogburn, C. (2008). Gender matters, too: The influences of school racial discrimination and racial identity on academic engagement outcomes among African American adolescents. *Developmental Psychology, 44* (3), 637-654.

Cokley, K. (2007). Critical issues in the measurement of ethnic and racial identity: A referendum on the state of the field. *Journal of Counseling Psychology, 54* (3), 224-234.

Cross, W. (1971). The Negro to black conversion experience: Toward a psychology of black liberation. *Black World, 20,* 13-27.

Cross, W. (1991). *Shades of black: Diversity in African American identity.* Philadelphia: Temple University Press.

Cross, W., Swim, J., and Fhagen-Smith, P. (1995). *Black identity: Nigrescence and the search for the smallest Mariska doll.* Unpublished manuscript, Pennsylvania State University, University Park.

Davis, R. E., Alexander, G., Calvi, J., Wiese, C. L., Greene, S., Nowak, M., Cross, W. E., and Resnicow (2010). A new audience segmentation tool for African Americans: The black identity classification scale. *Journal of Health Communication, 15,* 532-554.

Davis, L. E., and Engel, R. J. (2011). *Measuring Race and Ethnicity.* New York, New York: Springer.

Demo, D. and Hughes, M. (1990). Socialization and Racial Identity among Black Americans. *Social Psychology Quarterly, 53,* 364-374.

Dukerich, J. M., Golden, B. R., and Shortell, S. M. (2002). Beauty is in the eye of the beholder: The impact of organizational identity and image on the cooperative behaviors of physicians. *Administrative Science Quarterly, 47*, 507-533.

Dutton, J. E., Dukerich, J. M., and Harquail, C. V. (1994). Organizational images and member identification. *Administration Science Quarterly, 39*, 239- 263.

Erikson, E. H. (1968). *Identity: Youth and crisis*. New York: W. W. Norton.

Graham, R. (1981). The role of perception of time in consumer research. *Journal of Consumer Research, 7*, 335-342.

Gurvitch, G. (1964). *The spectrum of social time*. Dordrecht, Holland: D. Reidel.

Harvey, R. D., and Afful, S. (in press). Racial typicality, racial identity, and health behaviors: A case for culturally sensitive health interventions. *Journal of Black Psychology*.

Helms, J. E. (1990). *Black and White racial identity*. New York, NY: Greenwood Press.

Helms, J. E. (1995). An update of Helm's white and people of color racial identity models. In J. G. Ponterotto, J. M., L. A. Suzuki, and C. M. Alexander, *Handbook of Multicultural Counseling* (p. 181-198). Thousand Oaks: Sage Publication.

Hood, D. W. (1998). Racial identity attitudes and African American students' academic achievement, campus involvement, and academic satisfaction. Dissertation Abstracts International, *59(3-A)*, 749A.

Johnson, S. C., and Arbona, C. (2006). The relation of ethnic identity, racial identity, and race-related stress among African American college students. *Journal of College Student Development, 47* (5), 495-507.

Katz, D. And Braly, K. (1993). Racial stereotypes of one hundred college students:. *The Journal of Abnormal and Social Psychology*, 28, 208-290.

Kreuter, M. W., Sugg-Skinner, C., Holt, C. L., Clark, E. M., Haire-Joshu, D., Fu, Q., Booker, A. C., Steger- May, K., and Bucholtz, D. (2005). Cultural tailoring for mammography and fruit and vegetable intake among low-income African American women in urban health centers. *Preventative Medicine, 41*, 53-62.

Leary, M. & Tangney, J.P. (2003). The self as an organizing construct in the behavioral and social sciences. In M. Leary, and J. P. Tangney (Eds.) Handbook of self and identity (pp. 3-14). New York: Guilford Press.

Manning, M. C., Jr. (1998). The relationship between racial identity and self-esteem among African Americans. Dissertation Abstracts International, *58 (9-A)*, 3723A.

McConnell, A. R. (2011). The Multiple Self-aspects Framework: Self-concept representation and its implications. Personality and Social Psychology Review, 15, 3-27.

Morris, A., and Mueller, C. M. (1992). *Frontiers in social movement theory*. Yale University Press: New York.

Parham, T., and Helms, J. (1981). The influence of Black students' racial identity attitudes on preferences for counselor's race. *Journal of Counseling Psychology, 28,* 250-257.

Parham, T., and Helms, J. (1985). Attitudes of racial identity and self-esteem of black students: An exploratory investigation. *Journal of College Student Personnel,* 143-147.

Phelps, R., Taylor, J., and Gerard, P. (2001). Cultural mistrust, ethnic identity, racial identity, and self-esteem among ethnically diverse black university students. *Journal of Counseling and Development, 79,* 209-216.

Phinney, J. S. (1992). The multi-group ethnic identity measure: A new scale for use with adolescents and young adults. *Journal of Adolescent Research, 7,* 156-176.

Pierre, M., and Mahalik, J. (2005). Examining African self-consciousness and black racial identity as predictors of black men's psychological well-being. *Cultural Diversity and Ethnic Minority Psychology, 11,* 28-40.

Randolph, S., and Banks, H. (1993). Making a way out of no way: The promise of Africentric approaches to HIV prevention. *Journal of Black Psychology, 19,* 406-422.

Ravasi, D., and van Rekom, J. (2003). Key issues in organizational identity and identification theory. *Corporate Reputation Review, 6,* 118-132.

Resnicow, K., Jackson, A., Blissett, D., Wang, T., McCarty, F., Rahotep, S., and Periasamy, S. (2005). Results of the healthy body healthy spirit trial. *Health Psychology, 24,* 339-348.

Rollins, V. B., and Valdex, J. N. (2006). Perceived racism and career self-efficacy in African American adolescents. *Journal of Black Psychology, 32* (2), 176-198.

Rosenberg, M. (1965). *Society and the adolescent self-image.* Princeton, NJ: Princeton University Press.

Rousseau, D. M. (1998). Why workers still identify with organisations. *Journal of Organisational Behaviour, 19,* 217-233.

Sanders Thompson, V. L. (1995). The multidimensional structure of racial identification. *Journal of Research in Personality, 29,* 208-222.

Sanders Thompson, V. L. (2001). The complexity of African American racial identification. *Journal of Black Studies, 32* (2), 155-165.

Sellers, R. M., Rowley, S. A., Chavous, T. M., Shelton, J. N., and Smith, M. A. (1997). Multidimensional inventory of black identity: A preliminary investigation of reliability and construct validity. *Journal of Personality and Social Psychology, 73* (4), 805-815.

Sellers, R. M., Smith, M. A., Shelton, J. N., Rowley, S. A., and Chavous, T. M. (1998). Multidimensional model of racial identity: A reconceptualization of African American racial identity. *Personality and Social Psychology Review, 2* (1), 18-39.

Smith, E. P., and Brookins, C. C. (1997). Toward the development of an ethnic identity measure for African American youth. *Journal of Black Psychology, 23* (4), 358-377.

Smith, E. R., Coats S., and Walling, D. (1999). Overlapping mental representations of self, in-group, and partner: Further response time evidence and a connectionist model. *Personality and Social Psychology Bulletin, 25,* 873-882.

Tajfel, H. and Turner, J. (1979). An integrative theory of intergroup conflict. In W. Austin and S. Worchel (Eds.). *The social psychology of intergroup relations.* Monterey, CA: Brooks/Cole.

Taub, D., and McEwen, M. K. (1992). The relationship of racial identity attitudes to autonomy and mature interpersonal relationships in Black and White undergraduate women. *Journal of College Student Development, 33,* 439-446.

Thomas, C. (1971). *Boys no more.* Beverly Hills, CA: Glenco Press.

Thompson, S., and Chambers, J. (2000). African self-consciousness and health-promoting behaviors among African American college students. *Journal of Black Psychology, 26,* 330-345.

Vandiver, B., Cross, W., Fhagen-Smith, P., Worrell, F., Swim, J., and Caldwell, L. (2000). *The Cross racial identity scale.* Unpublished scale.

Vandiver, B., Cross, W., Worrell, F., and Fhagen-Smith, P. (2002). Validating the Cross Racial Identity Scale. *Journal of Counseling Psychology, 49,* 71-85.

Vandiver, B., Fhagen-Smith, P., Cokley, K., Cross, W., and Worrell, F. (2001). Cross's nigrescence model: From theory to scale to theory. *Journal of Multicultural Counseling and Development, 29,* 174-200.

Wade, J. C. (1996). African American men's gender role conflict: The significance of racial identity. *Sex Roles, 34,* 17-33.

Williams, R. L. (1981). *The collective Black mind: An Afrocentric theory of Black personality.* St. Louis: Williams & Associates.

Wilson, J. (1999). Racial identity attitudes, self-concept, and perceived family cohesion in black college students. *Journal of Black Studies, 29,*354-366.

Witherspoon, K. M., Speight, S. L., and Thomas, A. J. (1997). Racial identity attitudes, school achievement, and academic self-efficacy among African American high school students. *Journal of Black Psychology, 23,* 344-357.

Worrell, F. C., and Gardner-Kitt, D. L. (2006). The relationship between racial and ethnic identity in Black adolescents: The Cross racial identity scale and the multigroup ethnic identity measure. *Identity: An International Journal of Theory and Research, 6* (4), 293-315.

Yancey, A. K., Aneshensel, C. S., and Driscoll, A. K. (2001). The assessment of ethnic identity in a diverse urban youth population. *Journal of Black Psychology, 27* (2), 190-208.

Chapter Three
African American Racial Identity Research in Political Science: The Need for a Multidimensional Measure

Jas M. Sullivan and Alexandra Z. Ghara

Introduction

Racial identity is widely regarded as the central organizing mechanism through which African Americans come to understand politics (White, 2007). Indeed, many researchers believe that racial considerations matter more in African Americans' political decision-making than more broadly shared beliefs such as party identification and political ideology (Allen, Dawson, and Brown, 1989; Dawson, 1994; Kinder and Sanders, 1996; Tate, 1993). Studies in political science, psychology, and sociology have demonstrated the importance of racial identity as a factor influencing both individual and group political behavior (e.g., Broman et al., 1988; Dawson, 1994, 1996, 2001; Gurin, Miller, and Gurin, 1980; Miller, Gurin, Gurin, and Malanchuk, 1981; Jackson, 1987; Kinder and Sanders, 1996; Kinder and Winter, 2001; Shingles, 1981; Tate, 1991, 1993; Verba and Nie, 1972).

African Americans' sense of racial identification influences both the degree and nature of their political participation. Those with a greater sense of racial identification are more likely to engage in a wider range of political activities (Bledsoe, Welch, Sigelman, and Combs, 1995, p. 435). For example, Olsen (1970, p. 692) found that African Americans who identified with the group were more likely to vote, discuss politics, engage in campaign activities, and contact

government officials than were other African Americans. Verba and Nie (1972) found that African Americans who frequently mentioned race in their discussion of political issues were more likely to vote and engage in campaign activities than those who gave less race-oriented responses. And, Tate (2003, p. 142) found that "black identification was significantly related to black political interest and to voter participation in congressional elections."

Researchers have also examined the relationship between racial identity and several factors of psychological orientations (e.g., political interest, political awareness, political efficacy, and trust in government), and their influence on political participation (Tate, 1991, 1993; Shingles, 1981; Miller et al., 1981; Verba, Schlozman, and Brady, 1993). They have found that "racial identity potentially heightens political interest and awareness, boosts group pride and political efficacy, alters perception of group problems, and promotes support for collective action" (Chong and Rogers, 2005, p. 350). For example, Shingles (1981, p. 77) found that "Black consciousness has a dramatic effect on political participation because it contributes to the combination of a sense of political efficacy and political mistrust which in turn induces political involvement."

African American racial identity has also been shown to be related to social movements. Racial identity can motivate individuals to take part in social movements and collective action. For example, African Americans with a stronger sense of racial identity are more likely "to belong to an organization intended to improve the status of blacks, and to work in developing the black community rather than pursuing integration" (Bledsoe, Welch, Sigelman, and Combs, 1995, p. 435). Also, Shingles (1981) found that involvement in the Civil Rights movement and political participation are strong predictors of racial group identification and consciousness. Furthermore, social movements can change the meanings of specific racial and ethnic identities (Eggerling-Boeck, 2004). Condi and Christiansen (1977, p. 53) found that there has been a "significant shift in identity structure of blacks and that the Black Power movement was an important causal factor in effecting change." And Omi and Winant (1994, p. 99) concluded that the civil rights and Black Power movements "redefined the meaning of racial identity, and consequently of race itself in American society."

In addition to the effects of racial identity on political participation and social activism, racial identity also impacts African Americans' vote choice and feelings toward electoral candidates and political leaders (Chesley, 1993, Jackson, 1987, Huckfeldt and Kohfeld, 1989, Sigelman and Welch, 1984, Strickland and Whicker, 1992, Bullock and Campbell, 1984, Herring and Forbes, 1994, Lieske and Hilliard, 1984). With regards to the effects of African American racial identity on candidate evaluations and leadership preference, Sullivan and Arbuthnot (2009) found that racial identity affects African Americans' support for different candidates, and influences the way in which African American respondents perceive White, biracial, and Black candidates. Specifically, "differences in how Blacks feel about a Black candidate will depend on the candidate's racial background, their own attitudes and beliefs about being Black, and where they fall on various demographic

measures" (Sullivan and Arbuthnot, 2009, p. 217). In another study, Sullivan (2009) examined the effects of African American racial identity (measured as racial salience and linked fate) on feelings toward African American leaders, using the 1996 National Black Election Study. He found that African American racial identity was significant in predicting feelings toward Louis Farrakhan, Jesse Jackson, Carol Moseley-Braun, and Kweisi Mfume; however, it was not significant for Clarence Thomas or Colin Powell.

Besides influencing African Americans' feelings toward electoral candidates and leadership preferences, racial identity is also essential in accounting for African Americans' opinion on a range of policy issues. Researchers have found a relationship between racial identity and African Americans' support for affirmative action (Tate, 1993; Dawson, 1994; Kinder and Winter, 2001), social welfare programs (Tate, 1993), and reparations for slavery (Dawson and Popoff, 2004). Dawson (1994) concluded that racial identity is stronger than identities based on class, gender, religion, or any other social characteristics as appreciation of attitudes toward a range of policy issues. Additionally, White (2007) found that explicit racial cues (and to a lesser extent implicit cues) elicit racial thinking about policy issues by activating racial identification.

Lastly, racial identity has been shown to impact a number of other political choices. For example, Dawson (1994) examined the role of racial identity and perceptions of group-interests in the development of African Americans' connections to the major political parties. He suggests that African Americans from various social classes form party attachments based on how well different parties pursue common African American interests. This explains African Americans' enduring ties to the Democratic Party. Furthermore, Dawson's (2001) findings in *Black Visions* reveal the impact African American racial identity has on various ideological supports. For example, he found that believing one's fate is linked to that of the race is a strong predictor for economic nationalism (p. 130), supportive of Black feminist orientations and ideology (p. 157, p. 164), allowing more women to become members of the clergy (p. 349), and warmth for lesbians (p. 348).

Although African American racial identity has been used in political science to examine African Americans' political attitudes and behaviors, studies have not produced consistent results. For example, early studies on political participation reported that African Americans participate in politics at higher rates than Whites of similar socioeconomic status (e.g., Orum, 1966; Verba and Nie, 1972). Researchers hypothesized that racial identity motivates African Americans to engage in political activity (Olsen, 1970; Shingles, 1981; Verba and Nie, 1972). However, more recent studies have not found the same positive relationship between racial identity and African American political participation. A number of studies have found insignificant or no correlation between racial group identity and political participation (e.g., Leighley and Vedlitz, 1999; Verba et al., 1993, 1995; Tate, 1991, 1993).

There also appears to be disagreement over the effects of African American racial identity on African Americans' policy preferences. For example, White

(2007, p. 341), points out that while racial identity explains African Americans opinions about issues of race that are explicitly racial (i.e., affirmative action and reparations for slavery), there is no consensus that racial identity influences African Americans' opinions on ostensibly non-racial issues. Specifically, although Tate (1993) found a relationship between racial identification and African Americans' support for social welfare programs like food stamps and job security, which could have implicit racial meaning, Kinder and Winter (2001) found little correlation between racial group identity and preferences for social welfare policies. Furthermore, Tate did not find a correlation between racial group identification and other non-racial issues like funding for public education and foreign policy. It is clear that the racial identity research in political science is in need of clarification.

In this chapter, we propose a number of theoretical and methodological limitations that may account for the inconsistencies found across studies of African American racial identity in political science. One source of confusion in the literature concerns the lack of a clear conceptual definition of the key concept and the different theoretical underpinnings associated with its measures (e.g., racial identity vs. racial consciousness). Scholars have conceptualized African American racial identity in a number of ways, and consequently, several different psychometric scales have been used to tap the various dimensions of racial identity. Moreover, political scientists have not taken into full account the complexity of African American racial identity, typically relying on simple measures of the concept that provide only a limited perspective of its multifaceted nature. To the extent that researchers have oversimplified the measurement of African American racial identity, they may have underestimated its effects on individual political attitudes and behaviors. This problem is further compounded when studies use index measures of several different racial identity factors rather than examining the effects of individual components. Additionally, the use of limited, outdated survey data may also contribute to the lack of clarity in this research. Ultimately, the goal of this chapter is to call attention to the need for conceptual clarification and the use of a multidimensional measure of African American racial identity in political science.

Theoretical and Conceptual Issues of African American Racial Identity

Conceptualizing African American Racial Identity

Racial identity is an ambiguous and socially constructed concept. It implies a "consciousness of self within a particular group" (Spencer and Markstrom-Adams, 1990, p. 292). In a general sense, racial identity has been viewed as the "meanings a person attributes to the self as an object in a social situation or social role" (Burke, 1980, 18), and it relates to a "sense of people-hood, which provides a sense of belonging" (Smith, 1989, p. 156). Speaking specifically about African Americans, racial identity is "emerging, changing, and complex" (Hecht and Ribeau, 1991, p.

503). Banks (1981, pp. 129-139) suggests that "there is no one identity among Blacks that we can delineate, as social scientists have sometimes suggested, but many complex and changing identities among them." The "level of uncertainty about the nature of racial identity" (Herring et al., 1999, p. 364) and the "indicative confusion about the topic" (Phinney, 1990, p. 500) is illustrated by the lack of a standard definition.

Racial identity formation is produced by the everyday "interactions and challenges" (Davis and Gandy, 1999, p. 367) that an individual encounters. It is "dynamic and changing over time, as people explore and make decisions about the role of race in their lives" (Phinney, 1990, p. 502). This suggests that racial identity sentiments and attitudes are heterogeneous even among people of the same race, because individuals have different experiences and encounters.

Due to its multifaceted nature, scholars have conceptualized African American racial identity in a variety of different ways, including "racial categorization" (Jaret and Reitzes, 1999), "common fate or linked fate" (Dawson, 1994, 1996; Gurin, Hatchett, Jackson, 1989; Tate, 1991, 1993), "racial salience" (Herring, Jankowski, and Brown, 1999), "closeness" (Broman et al., 1988; Conover, 1984), "Black separatism" (Allen and Hatchett, 1986; Allen, Dawson, Brown, 1989), "racial self-esteem" (Porter and Washington, 1979), "Africentrism" (Grills and Longshore, 1996), "racial solidarity" (Chong and Rogers, 2005), and "racial awareness and consciousness" (Jackson, 1987; Gurin et al., 1980; Miller et al., 1981). Others suggest that African American racial identity has "multiple dimensions" (Sanders Thompson, 1995a, 2001; Sellers et al., 1998) and formation occurs over time through various "stages" (Cross, 1978; Parham and Helms, 1981).

Some researchers studying African American racial identity have focused on universal aspects of group identity, using African Americans as an example. Gains and Reed et al. (1994, 1995) refer to this work as part of the mainstream approach. Researchers of the mainstream perspective typically employ measures of group identity that are applicable to a variety of groups (e.g., Phinney, 1992). Much of the early mainstream perspective research defined African American racial identity based on the group's stigma and status in society. The earliest sociological research investigated the racial preferences and self-identification of children, which they determined by having children select between White and Black stimuli such as dolls (Horowitz and Horowitz, 1938; Clark and Clark, 1939, 1940). Based on this work, researchers concluded that African American children had a more negative orientation to their own race than White children. Consequently, African Americans' "self-hatred" became a staple in much of the early work from the mainstream perspective (Sellers et al., 1998).

In the late 1960s researchers began to redefine the concept based on the uniqueness of African American oppression and cultural experiences. Cross (1971) defined African American racial identity as stages of identity change across an individual's lifetime; he called this process "nigrescence." According to Cross (1971, 190), nigrescence is a *resocializing* experience; it seeks to transform a preexisting identity (a non-Afrocentric identity) into one that is Afrocentric." This

research constitutes an Afrocentric approach, or what Gains and Reed (1994, 1995) refer to as the underground perspective. The underground (or Afrocentric) approach emphasizes "the experiential properties associated with the unique historical and cultural influences associated with African American experience (Sellers et al., 1998, p. 21); for this reason, Afrocentric theorists argue against using models based on other racial or ethnic groups to explain the experiences of African Americans (Sellers et al., 1998).

Afrocentric researchers have defined African American racial identity based on physical characteristics, cultural and political alliances, ancestry, and history. Sanders Thompson (2001, p. 155) defines racial identity as "a psychological attachment to one of several social categories available to individuals when the category selected is based on race or skin color and/or a common history, particularly as it relates to oppression and discrimination due to skin color." For Sanders Thompson (1995a, 2001), racial identification is particularly significant for African Americans because it provides insight into the unique psychological orientation resulting from sustained disparities in the historical conditions of racial groups in American society.

A pivotal component of Afrocentrism is the measure of adherence to the seven principles (or Nguza Saba) of Afrocentric worldview. These Afrocentric principles are essentially "codes of conduct for daily life" that "represent guidelines for healthy living" (Grills and Longshore, 1996, p. 88). The main tenets include *umoja* (unity), *kujichagulia* (self-determination), *ujima* (collective work and responsibility), *ujamaa* (cooperative economics), *nia* (purpose), *kuumba* (creativity), and *imani* (faith). These tenets are symbolic and philosophical and not empirical and materialistic, as the Eurocentric model would be considered (Akbar 1984).

Research in the underground approach has also defined racial identity by describing what it means to be "Black." For example, Sellers et al. (1998, p. 19) refer to racial identity as "the significance and meaning that African Americans place on race in defining themselves." Put another way, this research provides "identity profiles" regarding individuals' feelings about their racial group membership (Sellers et al., 1998, p. 21). These profiles can vary "as a function of identity development," as described in Cross' nigrescence model, "or exposure to a fostering sociocultural environment," as seen in Baldwin's model (Sellers et al., 1998, p. 21).

Together, the diversity in these definitions illustrates the complexity of racial identity among African Americans. Recognizing the various dimensions of African American racial identity and the different measures that tap them, scholars have forged ahead with the understanding that no one conceptualization of racial identity is better than the other. In fact, Marks et al. (2004, p. 399) have suggested that future theorists should strive to integrate the various conceptualizations of African American racial identity into a single "mega theory" that incorporates all of the contributions of the existing definitions. We recommend that in their research, scholars should make clear the definition of racial identity that they are using, and specify how their measure of racial identity relates to their conceptualization.

Racial Identity versus Ethnic Identity

In defining what racial identity is, it may help to clarify what it is not. In doing so, we must distinguish between racial identity and ethnic identity, which are often confused in the literature. Some authors simply meld the two concepts together without attempting to establish a real dividing line. They also use the terms interchangeably in the literature (e.g., Phinney, 1990). Others insist that the two must be studied as related but distinct constructs (Helms, 2007; Cokley, 2005). Cokley (2005) defines racial and ethnic identity as two different constructs. Racial identity refers to the connectedness among members of group based on common physical traits and a shared experience of social oppression. Ethnic identity refers to a sense of belonging to a group united by shared culture. Broadly speaking, "ethnicity refers to differences in nationality, ancestry, religion, language, culture, and history to which personal and social meanings of group identity are usually attached" (Cokley, 2005, p. 518). Moreover, racial identity models describe individuals' reactions to societal oppression based on race, while ethnic identity models describe the achievement and preservation of cultural characteristics such as religion and language (Helms, 2007). Even though race and ethnicity are two distinct constructs, in a discussion of African American identity, there is a great deal of overlap: African Americans' ethnic identity (customs and culture) is often closely intertwined with their racial identity (more closely linked to physical traits) (Spencer and Markstrom-Adams, 1990; Quintana, 1998).

Even though race and ethnicity are two distinct constructs, in a discussion of African American identity, there is a great deal of overlap. In fact scholars like Eggerling-Boeck (2004) consider African Americans to be both a racial group and an ethnic group. According to Eggerling-Boeck (2004), "the social context of slavery erased many previously existing ethnic identities and provided blacks with a common language and culture that formed the basis for a black racial identity" (p. 27). Furthermore, Cornell and Hartman (1998) suggest that while the racial identity "black" is predominantly an assigned identity, African Americans "also have become an ethnic group, a self-conscious population that defines itself in part in terms of common descent (Africa a homeland), a distinctive history (slavery in particular), and a broad set of cultural symbols (from language to expressive culture) that are held to capture much of the essence of their peoplehood" (p. 33).

Racial Group Membership, Identity, and Consciousness

In addition to distinguishing between racial identity and ethnic identity, we must also differentiate between the concepts of racial group membership, racial identity, and racial consciousness. Beginning with racial group membership, a basic distinction needs to be made between the two concepts of ascription (how others describe an individual) and identification (how an individual describes him/herself). Ascription can be understood as racial group membership, which "refers to the

assignment of an individual into a particular group based on characteristics that are specific to that group, in accordance with widely held intersubjective definitions" (McClain, Carew, Walton, and Watts, 2009, p. 473). However, this assignment does not mean that an individual necessarily identifies as a member of the ascribed group, nor does it mean that all individuals identify with the group in the same way.

It is important that race as a descriptive category not be used in the place of racial identity; broader social and cultural values cannot be assumed based solely on the descriptive categories. Sellers et al. (1998, p. 25) explain the drawback of ascribing individuals a certain racial identity while investigating the relationship between identity and some outcome: such ascription does not necessarily account for the individual differences in the meaning and relevance of race to the individuals assigned these classifications. Such arbitrary assignment of individuals into the "Black" racial group has resulted in "the psychological unification of many individuals who vary a great deal in their experiences and cultural expressions" (Sellers et al., 1998, p. 18-19). Consequently, these studies do not achieve accurate estimates of the relationship between racial identity and the outcome under examination.

Racial group identity has been confused in the literature, and used as two different constructs: (1) the basic psychological *identification* with a particular racial group; and (2) a more expansive *consciousness* that includes the influence of ideological beliefs and evaluations (Jackman and Jackman, 1973; Gurin et al., 1980; Miller et al., 1981; Conover, 1984; Chong and Rogers, 2005). Political scientists do not always distinguish between elements of identification and consciousness, and some researchers have used the terms "interchangeably" and "inconsistently" (see Chong and Rogers, 2005, p. 350). But there needs to be a distinction made between group identification and group consciousness. Group identification simply implies a "consciousness of self within a particular group" (Spencer and Markstrom-Adams, 1990, p. 292). However, group consciousness refers to "in-group identification politicized by a set of ideological beliefs about one's group's social standing, as well as a view that collective action is the best means by which the group can improve its status and realize its interest" (McClain et al., 2009, p. 476). In other words, group consciousness is a product of racial identity and not the identity itself. It is the activation of feelings of identity to join organizations or work toward promotion of the in-group (Jackman and Jackman, 1973; Gurin et al., 1980; Miller et al., 1981). In other words, when racial identity is defined in terms of racial consciousness, it serves as a goal to be (Cross, 1991). We agree with scholars like Miller et al. (1981) and Chong and Rogers (2005) that studies of African American racial identity need to rely on scales that measure the multidimensional components of both identification and consciousness.

Unitary Measures of African American Racial Identity

The greatest challenge facing political scientists in the study of African American racial identity is their reliance on unitary or simple measures of the concept, which do not capture its true complex nature. Political scientists typically rely on one of three items to measure racial identity: (1) self-identification with one's racial group; (2) a feeling of closeness to one's group; and (3) a belief that one's fate is linked to that of the group. A summary of these measures and the corresponding research findings can be found in Table 3.1.

Much of the early published work in this area determined racial identity based on a single item asking whether a respondent identifies as a member of a certain group. For example, Olsen (1970) asked respondents whether or not they identify as a member of an "ethnic minority." Verba and Nie (1972) used an index that summed the number of times African American respondents referred to race in answering various open-ended questions. And Jones-Correa and Leal (1996) asked respondents whether or not they identify as a member of a certain group. However, self-identification indicates little about an individual's racial identity. Identifying with a racial group only demonstrates that an individual is aware that he or she is Black; it says nothing about how they feel about being Black (e.g., Are they proud to be Black? Is race even important to that individual?). It is possible for two individuals to be equally identified with their group but have very distinct ideologies about the meaning of their membership in that group, in addition to having different feelings about their group and beliefs about how others view their group (Sellers et al. 1998). Thus, according to Miller et al. (1981, p. 495), there is no theoretical reason to assume a direct connection between basic group identification and individual political attitudes and behaviors." Hence, self-identification/classification is too basic and subjective to qualify as a valid measure of African American racial identity.

The second way that political scientists measure African American racial identity is based on group "closeness," i.e., the extent to which individuals feel that their ideas, feelings, and thoughts are similar to that of other African Americans (Conover, 1984; Gurin et al., 1980; Miller et al., 1981; Lau, 1989; Harris, 1995). However, "close to" ratings are prone to intersubject variability" (Herring, 1999, 369)—in that, it is possible that an individual could be "psychologically attached to a group; on the other hand, 'closeness' may merely indicate feelings of sympathy, proximity, or even empathy for the group" (Conover, 1984, p. 767)

The conceptualization of racial identity as "closeness" brings up another issue of measurement within the literature: even when political scientists agree on the conceptualization of racial identity, they sometimes use different measures to tap the same component. This is often because the specific item measures depend on which of the surveys researchers use (Herring, Jankowski, and Brown, 1999). For example, when African American racial identity is conceptualized as "closeness," the *American National Election Studies* ask respondents to rate their closeness to Blacks as a whole (Campbell et al., 1960; Conover, 1984; Lau, 1989; Miller et al.,

1981); the *National Survey of Black Americans* assesses closeness with sub-groups of Blacks such as poor, middle class, religious, elected officials or the elderly (Broman, Neighbors, and Jackson, 1988; Demo and Hughes, 1990; Harris, 1995); and the 1984 and 1988 *National Black Election Studies* asked respondents to rate their closeness to Blacks in Africa, the Caribbean, and America (Gurin et al., 1989; Herring et al. 1999; Jackson et al., 1991). These are three very different psychometric questions that measure the same element of African American racial identity. This inconsistency has sometimes produced divergent results in political research. For example, although Tate (1993), using the 1984 National Black Election Study, found a relationship between racial group closeness and African Americans' support of social welfare programs, Kinder and Winter (2001), using the 1992 National Election Study, found little correlation between group closeness and preferences for social welfare policies. A breakdown of the three different measures of closeness can be found in Table 3.1.

Lastly, African American racial identity has often been conceptualized in political science through the notion of "linked-fate," or the degree to which African Americans believe that their personal well being is connected to that of other African Americans. Dawson (1994) developed a framework for analyzing African American political choice using the concept of linked fate. He used research based in the psychology of social groups to establish a "black utility heuristic." In Dawson's construction, racial identity is a function of self-interest and individual perceptions of racial group interests. Among the three unitary measures, linked-fate is largely regarded as the most valid measure of racial consciousness (see e.g., Herring et al., 1999, p. 365; Chong and Rogers, 2005, p. 351; McClain et al., 2009, p. 477; Tate, 1991, p. 1166). African Americans derive group consciousness and feelings of linked fate from a specific shared history and common experiences (Dawson, 1994, 2001; Tate, 1993). The linked fate measure captures the intricate heuristic processes used by most voters (Allen et al., 1989; Dawson, 1994), and it incorporates the feelings of in-group identification and an awareness of a shared group status with other members. A description of the linked fate measure and research findings is located in Table 3.1.

Demonstrating Problems in the Literature: Racial Identity and Political Participation

In order to illustrate the theoretical and measurement issues that have been discussed so far, we now turn to an examination of the research on African American racial identity and political participation. A review of the literature reveals inconsistent findings regarding the effects of racial identity on African American political participation. Early works produced the socioeconomic status model of political participation, which posited that individuals with higher levels of socioeconomic resources (e.g., education, income, and occupational status) tend to engage more in political activities (e.g., vote, campaign, organize, and contact

officials) than those with lower status. Based on this theory, African Americans are expected to engage in politics at lower rates than Whites in the aggregate. However, many early studies reported that African Americans actually participate at a higher rate than was predicted based on their average level of education, income, and occupational status; they also participate at a higher rate than White Americans of similar status (e.g., Matthews and Prothro, 1966; Orum, 1966; Olsen, 1970; Verba and Nie, 1972; Greenberg, 1974; Antunes and Gaitz, 1975).

Some researchers attributed this difference to African Americans' heightened sense of racial identity or consciousness (Olsen, 1970; Verba and Nie, 1972; Miller et al., 1981; Shingles, 1981).

Table 3.1: Unitary Measures of African American Racial Identity

Measure	Operationalization	Findings
Racial Categorization as Identification	Olsen (1970) asked respondents whether or not they identify as a member of an "ethnic minority." Verba and Nie (1972) used an index that summed the number of times African American respondents referred to race in answering various open- ended questions. Jones-Correa and Leal 1996) asked respondents whether or not they identify as a member of a certain group.	Olsen (1970, 692) found that African Americans who identified with the group were more likely to vote, discuss politics, engage in campaign activities, and contact government officials than were other African Americans. Verba and Nie (1972) found that African Americans who frequently mentioned race in their discussion of political issues were more likely to vote and engage in campaign activities than those who gave less race-oriented responses.
Linked Fate	Linked fate is the degree to which African Americans believe that their own well-being is linked to that of other African Americans (e.g., "Do you think what happens generally to Black people in this country will have something to do with what happens in your life?" and "People differ in whether they think about being Black—what they have in common with Blacks. What about you—do you think about this a lot, fairly often, once in a while, or hardly ever?")	Tate (1993) found that linked fate was significantly related to African Americans' opinions on affirmative action, as well as to African American political interest and voter participation in congressional elections (Tate 2003). Dawson (1994) suggested African Americans' feelings of "linked-fate" with other African Americans leads them to form party attachments based on how well the major parties pursue common African American interests. This explains African Americans' lasting ties to the Democratic Party. Dawson (1994) concluded that racial identity is stronger than identities based on class, gender, religion or any other social characteristics as appreciation

Measure	Operationalization	Findings
Linked Fate (continued)		of attitudes toward policy issues. Furthermore, believing one's fate is linked to that of the race is a strong predictor of various ideological positions (e.g., economic nationalism showing support for African American feminist orientations and ideology, allowing more women to become members of the clergy, and warmth for lesbians) (Dawson 2001).
Closeness	The National Election Studies ask respondents to rate their **closeness to Blacks as a whole**. Respondents are given a list of groups and asked which ones they feel particularly close to—people who are most like them in their ideas, interests, and feelings about things. Once respondents have rated their closeness to all of the groups, they are asked to pick the one group to which they feel the closest.	Kinder and Winter (2001) found that group closeness is a strong predictor of African Americans' preferences for racial issues like affirmative action policies, but it has little effect on African Americans' opinions of implicitly racial issues like social welfare policies.
	The National Survey of Black Americans assesses **closeness to various subgroups of Blacks such as the poor, middle class, elected officials, religious, or the elderly.** Researchers sum up respondents' level of closeness to the different groups of African Americans and use this single score as a measure of African American racial identity.	Broman et al. (1988) found that older African Americans, less educated African Americans living in urban areas, and college-educated African Americans living outside the West scored higher on the index measuring closeness to other African Americans. They also found that childhood interracial contact decreases feelings of closeness to other African Americans.
	The National Black Election Studies ask questions of **closeness to Blacks in Africa, the West Indies, and America.**	Herring et al. (1999) found that there is less variance in closeness to Blacks in the U.S. than in closeness to non-American Blacks. Jackson et al (1991) used close to ratings to measure ingroup attachments and found that positive ingroup orientations were weakly correlated to anti-white orientations.

For example, Olsen (1970, p. 692), focusing on African Americans who identified themselves as members of an "ethnic minority" as opposed to those who did not, found that African Americans who identified with the group were more likely to engage in political activities than were other African Americans. Verba and Nie (1972), using an index that summed the number of times African American respondents referred to race in answering various open-ended questions, found that African Americans who frequently mentioned race were more likely to vote and engage in campaign activities than were African Americans who gave less race-oriented responses.

Miller et al. (1981) refined the group consciousness model, testing it with a more complex measure of the consciousness. Contrary to the previous conceptualizations, Miller et al. (1981, p. 495) proposed that group consciousness requires a perception of relative deprivation, which basic identification does not by itself entail. According to Miller and his colleagues, group identification is "a perceived self-location within a particular social stratum, along with a psychological feeling of belonging to that particular stratum," while group consciousness "involves identification with a group and a political awareness or ideology regarding the group's relative position in society along with a commitment to collective action aimed at realizing the group's interests (Miller et al., 1981, p. 495). In other words, group consciousness is a product of racial identity and not the identity itself.

Miller et al. (1981) posit a model of group consciousness in which group identification is only one distinct element. The model includes four components: (1) "group identification"; (2) "polar affect," a preference for one's in-group and resentment toward the out-group; (3) "polar power," expressed satisfaction or dissatisfaction with one's group status, power, or material resources relative to that of the out-group; and (4) "individual vs. system blame," the belief that the group's low social status is due to individual failures or to structural inequalities. In their model, there is no direct relationship between basic identification and political participation; race consciousness serves as the link between the two. Miller et al. (1981, p. 503) found that "politicized group consciousness acts to promote electoral [and nonelectoral] participation among highly identified members of subordinate groups at rates higher than expected on the basis of socioeconomic characteristics alone."

Shingles (1981) further expanded the group consciousness model, providing empirical supports for several psychological connections between racial consciousness and political participation. Shingles (1981) applied the same measure of group consciousness as Verba and Nie (1972). He demonstrated how African American mistrust, low political efficacy, and race consciousness are associated with different forms of political participation. Specifically, he found that "Black consciousness has a dramatic effect on political participation because it contributes to the combination of a sense of political efficacy and political mistrust which in turn induces political involvement" (Shingles, 1981, p. 77).

These early studies illustrate the confusion between group identification and group consciousness. They emphasize the importance of individuals' psychological

orientations (e.g., group consciousness, political interest, political efficacy, and trust in government). Consciousness potentially heightens political interest and awareness, boosts group pride and political efficacy, alters perception of group problems, and promotes support for collective action" (Chong and Rogers, 2005, p. 350). Ultimately, these early studies concluded that racial identity/consciousness is a key determinant of African American political participation along with socio-economic status and psychological orientations.

While early studies examined the psychological aspects of social connected-ness, later studies on political participation have used "structural or behavioral factors such as organizational involvement, church attendance, home ownership, and marital status as indicators of social connectedness" (Leighley and Vedlitz, 1999, p. 1095). These studies, however, have not found the same positive relationship as previous studies. A number of studies have found insignificant or no correlation between racial group identity and political participation (e.g., Leighley and Vedlitz, 1999; Verba et al., 1995; Tate, 1991, 1993). For example, in Tate's (1991) study on political participation, she created a measure of racial con-sciousness using two items from the National Black Election Study, asking respondents the degree to which they are affected by what happens to Blacks in this country and the degree to which they think about being Black. Tate also included measures for other group-based resources (e.g., organizational involvement and church membership) and political context (i.e., candidate evaluations). She found that racial consciousness had an inconsistent effect on participation. While it was not significant in the 1984 election, race consciousness did positively affect African American participation in the 1988 election. Also, "in several instances, member-ship both in black organizations and in politically active churches promoted black participation" (Tate, 1991, p. 1172). Tate (1991, p. 1166) admits that although her measure of African American racial identity is not as complex as the one used by Miller et al. (1981), it is better than the other measures employed by political scientists such as group closeness, because her measure captures perceptions of shared interests. Theoretically, it should be more accurate than simple awareness of group membership (i.e., identification). She also reported that African Americans who belonged to an African American organization or a *politicized* church were more likely to vote than African Americans who did not.

In another study on political participation, Leighley and Vedlitz (1999) measured racial identity based on group closeness and intergroup distance (e.g., affect toward other racial groups). The authors found that in-group closeness was insignificant but intergroup distance was significantly related to African Americans' political participation. Specifically, "African Americans who feel more distant from other groups are *less* likely to participate than are those who feel closer to other groups" (Leighley and Vedlitz, 1999, p. 1104). These findings contradict Miller's (1981) earlier finding that African Americans are mobilized by negative feelings toward the out-group (i.e., polar affect).

The differences in findings across studies of political participation are puzzling. To the extent that researchers have oversimplified the measurement of African

American racial identity, they may have underestimated its effects on individual political attitudes and behaviors. The effect of African American racial identity may vary depending on which conceptual element was measured and the specific items used to operationalize it. When researchers have relied on only one or two indicators of racial identity, it is possible that they have overlooked an existing relationship that would have been found had a more comprehensive measure been used. In contrast, it is also possible that by oversimplifying the measure of African American racial identity, researchers may have mistakenly found a relationship that would not have been found significant had a more comprehensive measure was used.

Some political researchers have recognized the methodological limitations of unitary measurements, and, in order to create a more comprehensive measure, they have combined items that already appear in the literature. For example, after Tate (1991) found that racial consciousness, narrowly defined and measured by two items of linked fate, only weakly influenced African American political participation, Chong and Rogers (2005) returned to the same dataset (1984 NBES) to investigate whether a more comprehensive measure of African American racial identity demonstrates a greater impact on participation. They separate group identity and group consciousness into distinct measures. Group identity is measured using three items of linked fate and four items that test "Black autonomy" (i.e., tendency to regard oneself as being "Black" rather than American and the preference for separation between "Blacks" and other groups in social and economic relations). In addition to the two previously described linked fate items, Chong and Rogers (2005) included the additional item of linked fate from the 1984 NBES: "Do you think that the movement for black rights has affected you personally?" The Black autonomy items include the following: "Which is more important, being: Black, both Black and American, or American"; Black children should learn an African language"; "Black people should shop in Black-owned stores; and "Blacks should not have anything to do with Whites" (Agree strongly, Agree somewhat, Disagree somewhat, Disagree strongly). On the other hand, group consciousness is measured based on four components: (1) discontent with group status (e.g., "Do blacks as a group have too much influence, just about the right amount of influence, or too little influence in American life and politics?"); (2) perception of discrimination (e.g., "If black people don't do well in life, it is because: they are kept back because of their race; or they don't work hard enough to get ahead"); (3) support for collective strategies to correct group inequalities (e.g., "To have power and improve their position in the United States: Black people should be more active in black organizations; or Each black person should work hard to improve his or her own personal situation"); and (4) belief in group political efficacy (e.g., "If enough blacks vote, they can make a difference in who gets elected President").

Using a more complex model that distinguishes between racial identification and racial consciousness, Chong and Rogers (2005) found that racial identification and consciousness had a more powerful influence on political participation in the

1984 presidential election than was previously found by Tate (1991). Furthermore, the two forms of racial identity (i.e., linked fate and Black autonomy) bolster participation in two different ways: those who believe in a linked fate are more likely to express their demand through conventional political channels, while those who endorse the more radical notion of racial autonomy favor protest and other forms of direct action. The independent influence of these two forms of racial identification confirms that groups can have multiple identities and ideologies, each of which may function as a source of political engagement for different sectors of the group (Chong and Rogers, 2005, p. 368). Based on their findings, Chong and Rogers (2005) conclude that researches using simple measures of racial identity are likely to have systematically underestimated its influence on the political participation of African Americans.

Complex Models of African American Racial Identity

Outside of political science, scholars have argued that it is a methodological disadvantage to use unitary measures of racial identity (e.g., Allen, Dawson, and Brown, 1989; Baldwin, 1985; Demo and Hughes, 1990; Hilliard, 1985; Sanders Thompson, 1995a; Sellers et al., 1998). Within the area of counseling psychology, scholars have investigated African American racial identity as a developmental process. William Cross (1971) proposed the nigrescence theory which, in its original form, described an individual's progression from a pre-existing state that was not connected with a positive reference group orientation to a self-actualized and healthy state racial identity. However, after research revealed that African Americans' self-esteem does not change as they move through the stages of nigrescence, Cross (1995) revised his nigrescence theory and later extended it in empirical work (Vandiver, Cross, Worrell and Fhagen-Smith, 2002). Early theorizing of the nigrescence model (Cross, 1971, 1978) is referred to as the original model.

In the original nigrescence model, Cross (1971) proposed five stages of identity development. *Pre-Encounter* (Stage 1) describes Black individuals who minimize the importance of race in their lives. During *Encounter* (Stage 2), the individual is confronted by an event which challenges their Pre-Encounter attitudes about themselves and their understanding of the condition of African Americans. This reexamination can propel them into Stage 3, *Immersion-Emersion*, in which the individual immerses him or herself in Blackness and feels liberated from Whiteness. *Internalization* (Stage 4) describes the individual's acceptance of being Black. Finally, in Stage 5, *Internalization-Commitment*, the individual incorporates their new identity attitudes into a commitment to social activism. The nigrescence model is largely regarded as the foundation for many subsequent theories and measures of African American racial identity (e.g. Thomas, 1971; Jackson, 1975; Milliones, 1980; Banks, 1981; Parham and Helms, 1981; Vandiver et al., 2001).

Parham and Helms (1981) designed the Racial Identity Attitude Scale (RIAS) to measure the original nigrescence model. The RIAS measures various attitudes that individuals are likely to have as they move through the four stages of nigrescence. Figure 3.1 provides examples of item measures for the RIAS. Parham (1989) introduced a lifespan theory of racial identity development which challenged the nigrescence theory assumptions of a linear, unidirectional movement through stages. He suggests three alternative pathways to racial identity development: *stagnation* (i.e., an individual maintains a single racial identity throughout their lifetime), *linear progression* (i.e., an individual moves through the stages as expected) and *recycling* (i.e., an individual has moved through the identity stages but encounters an experience that causes them to reevaluate their racial identity and revert back to an earlier stage). Examples of question items and research findings for the RIAS can be found in Table 3.2.

Cross's theorizing in the 1990s, which led to the development of the Cross Racial Identity Scale, is known as the revised model. The revised nigrescence theory now suggests that its individuals' racial identity attitudes that change over time and these changes (i.e., stages) "reflect a restructuring in the cognitive and affective approaches to self and society rather than an invariant developmental trajectory" (Worrell, Vandiver, Cross, 2004). The latest version of the nigrescence theory is operationalized using the Cross Racial Identity Scale (CRIS; Vandiver, Fhagen-Smith, Cokley, Cross, and Worrell, 2001). Six identities are measured in the current version of the CRIS (Vandiver, Cross, Worrell, and Fhagen-Smith, 2002): three Pre-Encounter identities (Assimilation, Miseducation, and Self Hatred); one Immersion-Emersion identity (Anti-White), and two Internalization identities (Afrocentricity and Multiculturalist Inclusive).

Figure 3.1: Subscales of the RIAS

For details of item development and refinement, see Cross and Vandiver (2001) and Vandiver et al. (2002). *Pre-Encounter Assimilation* describes individuals with a pro-American or mainstream identity for whom race is not important. In contrast, the Pre-Encounter identity characterizes individuals who despise African Americans and being African American. Anti-African American racial identity is based on two factors: *Miseducation*, in which individuals hold negative

stereotypical beliefs about African Americans depicted by mainstream society, and *Self-hatred*, in which individuals fuse negative stereotypes about African Americans into their personal identity. *Internalized Afrocentric* identity is actualized through social and political activism in empowering the African American community. *Multiculturalist Inclusive* identity includes a matrix of three or more cultural frames of reference (e.g., African American racial identity plus gender, sexual orientation, sense of "Americanness," or racial reference group orientation other than Black). Figure 3.2 provides examples of item measures for the CRIS.

Another set of models describe the multidimensional structure and nature of racial identity. These instruments cluster questions to capture the different dimensions that may influence the individual's overall racial identity. This allows them to explore which factors are most influential and how the various elements of racial identity interact. Insofar as racial identity is multidimensional, its various elements may have different effects on political choice. These models are interested in the individual differences in racial identity. Demo and Hughes (1990) separate African American racial identity into three areas: *closeness* (i.e., how similar an individual feels in their ideas, feelings, and thoughts to other African Americans); *Black separatism* (i.e., commitment to African culture and the preference for separation between Blacks and other groups in social and economic relations), and *racial group evaluation* (i.e., the belief that most African Americans possess positive characteristics, but do not possess negative characteristics). Allen, Dawson, and Brown (1989) conceptualized racial identity as an African American belief system based on five dimensions: (1) *closeness to Black elites* (i.e., civic and political leaders); (2) *closeness to Black masses* (e.g., African Americans who are poor, religious, young, middle-class, working class, and older); (3) *positive stereotypes* (e.g., "Blacks are hard-working"); (4) *negative stereotypes* (e.g., "Most Blacks are lazy"); and (5) *Black autonomy* (i.e., an ideological position that advocates building political and social institutions based on the cultural values and interests of African Americans).

The multidimensional models proposed by both Demo and Hughes (1990) and Allen et al. (1989) reflect a similar conceptualization of African American racial identity and share common subscales. Both models recognize the importance of closeness in one's racial identity, although in Allen et al.'s (1989) model, closeness is divided into two components. One component, closeness to Black elites, measures whether an individual believes that their personal political interests and the political interests of the African American community are best met by supporting African American leaders. The other component, closeness to the Black masses, indicates an individual's perception that African Americans share a "common fate" as a group. Both models also emphasize the importance of how an individual feels about African Americans as a group. Allen et al. (1989) measure these feelings using the positive and negative stereotype dimensions in their model, while Demo and Hughes (1990) use the racial group evaluation component in their model. Lastly, both models contain subscales that measure an ideological position

that emphasizes Afrocentric values: Allen's model includes a Black autonomy scale and Demo and Hughes use a similar Black separatism scale.

Figure 3.2: Stages and Subscales of the CRIS

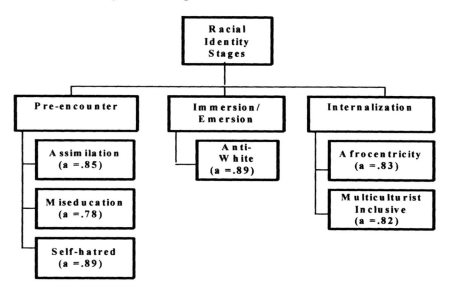

Sanders Thompson (1991) proposed another multidimensional model, the Multidimensional Racial Identification Scale (MRIS; Sanders Thompson 1995a), which divides African American racial identity into four distinct parameters: *Physical* (i.e., acceptance and comfort with the physical attributes of African Americans); *Cultural* (i.e., awareness, knowledge of, and commitment to the cultural traditions of African Americans); *Sociopolitical* (i.e., commitment to resolving the economic, social, and political issues facing the Black community); and *Psychological* (i.e., concern for and pride in the racial group). Figure 3.3 provides examples of item measures for the MRIS. Parham Sanders Thompson developed this model based on the notion that individuals can have varying levels of identification among different components of racial identity. Responses within the parameters describe which components of racial identity are most important to the individual and which areas are lacking in the overall identification. Examples of items from the MRIS and research findings are located in Table 3.2.

Another multidimensional model was proposed by Sellers, Rowley, Chavous, Shelton, and Smith (1997) called the Multidimensional Model of Racial Identity (MMRI). This model defines four dimensions of racial identity that capture "the significance and qualitative meaning that individuals attribute to their membership in the Black racial group within their self-concepts" (Sellers et al., 1998, p. 23). The four dimensions defined in the MMRI include racial salience and centrality, which

measure the significance of race, and racial regard and ideology, which assess the meaning of race. Examining both the meaning and significance of racial identity affords the opportunity to investigate the complexity inherent in the role that race plays in the lives of African Americans. The MMRI theorizes that individuals have multiple identities that are hierarchically ordered. In examining the hierarchy of identities, the MMRI focuses on the relative importance of race compared to other identities.

Figure 3.3: Subscales of the MRIS

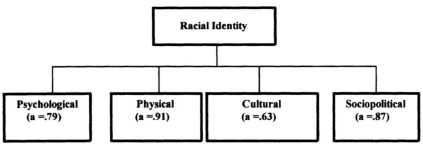

The MMRI is operationalized using the Multidimensional Inventory of Black Identity (MIBI; Sellers et al., 1998), which encompasses a total of seven subscales (see Figure 3.4). The first dimension, *Centrality*, measures the extent to which an individual normatively defines themselves with regards to race. The second dimension, Regard, is divided into two subscales—*Private Regard* (i.e., an individual's evaluative judgment about his or her race) and *Public Regard* (i.e., how an individual perceives that others view their group). The other four subscales are based on ideologies that capture African Americans' views on what it means to be a member of their racial group: *Nationalist* (i.e., the extent to which one's philosophy stresses the importance and uniqueness of being of African descent), *Oppressed Minority* (i.e., the extent to which one's philosophy emphasizes the commonalities between African Americans and other oppressed groups), *Assimilationist* (i.e., the extent to which one's philosophy emphasizes the commonalities between African Americans and the rest of American society), and *Humanist* (i.e., the extent to which one's philosophy emphasizes the commonalities among all human beings). See Table 3.2 for sample items and research findings of the MIBI.

Although each of the models emphasize different elements of racial identity and have unique features that distinguish it from the others, they actually complement one another (Marks et al., 2004, p. 399). For example, while the developmental models characterize individuals' racial identity according to where they reside along the developmental sequence, the multidimensional measures provide a rubric for describing the significance and meaning of race at a various point on these developmental trajectories. Using one of the multidimensional models along with a developmental model could help validate the assumptions of

both approaches and provide a more comprehensive understanding of the nature and development of African American racial identity.

Figure 3.4: Subscales of the MIBI

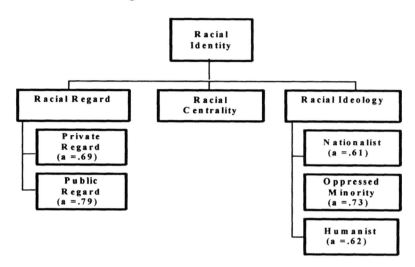

Table 3.2: Complex Measures of African American Racial Identity

Measure	Items	Findings
Racial Identity Attitudes Scale (RIAS) Parham and Helms (1981)	Fifty-item questionnaire that assesses four stages of the *original* nigrescence model: **Pre-Encounter** (e.g., "I feel Black people do not have as much to be proud of as White people do.") **Encounter** (e.g., "I am determined to find my African American racial identity.") **Immersion/Emersion** (e.g., "I believe everything that is Black is good, and consequently, I limit myself to Black activities.") **Internalization** (e.g., "I feel good about being Black but not limiting myself to Black activities.")	Parham and Helms (1981) used the RIAS to assess the influence of racial identity attitudes on counselor race preference and found that Black clients with "pre-encounter" racial identity attitudes preferred White counselors. However, Want et al. (2004) found that counselors with high race consciousness were preferred over White counselors. Black counselors with light race consciousness was preferred. Other researchers who have used the RIAS report evidence linking the Pre-encounter identity to poor ego identity development (Looney 1988), low levels of self-acceptance (Parham and Helms 1985), and lower psychological well-being (Pillay 2005).

Measure	Items	Findings
Cross Racial Identity Scale (CRIS) Vandiver et al. (2001, 2002)	Forty-item inventory that measures six of the racial identities described in the *expanded* nigrescence model: **Pre-Encounter Assimilation** (e.g., "I am not so much a member of a racial group as I am an American"), **Pre-Encounter Self-Hatred** (e.g., "I sometimes have negative feelings about being Black"), and **Pre-Encounter Miseducation** (e.g., "Blacks place more emphasis on having a good time than on hard work"); **Immersion-Emersion Anti-White** (e.g., "I have a strong feeling of hatred and disdain for all White people"); **Internalization Multiculturalist Inclusive** (e.g., "I believe it is important to have both a African American racial identity and a multicultural perspective, which is inclusive of everyone"); **Internalization Afrocentricity** (e.g., "As Black Nationalists, we must work on empowering ourselves and not on hating others")	Anglin and Wade (2007)found an internalized-multicultural identity positively contributed to college adjustment, while pre-encounter miseducated racial identity and an internalized Afrocentric identity negatively contributed. Additionally, Awad (2007) found racial identity does not predict either GPA or GRE test performance among college students. Ferguson et al. (2008) used the CRIS to revisit Parham and Helm's (1981) study of counselor preferences, and found that racial identity predicts preferences for a black counselor.
Multi-dimensional Racial Identification Scale (MRIS) Sanders Thompson (1995a)	Thirty-item instrument that measures African American racial identity based on four parameters: **Physical** (e.g., "African American actress, actors, models, etc. are as attractive as those of other groups in films and on TV"); **Cultural** (e.g., "African Americans have a culture worth protecting and documenting"), **Sociopolitical** (e.g., African American representation is important in all occupations, activities, etc."), and **Psychological** (e.g., "There is more to like than dislike about African Americans")	Sanders Thompson assessed predictors of the four parameters in a series of studies (1991, 1994, 1995b). She found that all four parameters were positively correlated with having had more family racial socialization. Also, psychological, sociopolitical, and cultural racial identities were positively related to political and community involvement. Lastly, physical racial identity was associated with having experienced racism at an older age and psychological racial identity was related to having experienced more discrimination.

Measure	Items	Findings
Multi-dimensional Inventory of Black Identity (MIBI) Sellers et al. (1998)	Fifty-six item measure consisting of seven subscales, including **Centrality** (e.g., "Being Black is important to my self-image"); **Private Regard** (e.g., "I feel good about Black people"); **Public Regard** (e.g., "Others respect Black people"); **Nationalist Ideology**(e.g., "Blacks would be better off if they accepted Afrocentric values"); **Oppressed Minority Ideology** (e.g., "The same sources which have led to the oppression of Blacks have also led to the oppression of other groups") **Assimilationist Ideology** (e.g., "Blacks should strive to be full members of the American political system"); and **Humanist Ideology** (e.g., "People regardless of their race have strengths and limitations")	Rowley, Sellers, Chavous, and Smith (1998) found that private regard attitudes were strongly related to higher self-esteem in African American adolescents. In another study, Sellers, Chavous, and Cooke (1998b) that assimilation and nationalist ideology subscales were negatively associated with GPA and an oppressed minority ideology was positively associated with GPA for students who scored high on racial centrality. The relationships found in both of these studies were moderated by racial centrality (i.e., no significant relationship was found for those with low racial centrality scores). Sellers, Copeland-Linder, Martin, & Lewis (2006) suggest an interrelationship among racial identity, racial discrimination, and psychological functioning. Specifically, "Although individuals who believe that other groups hold more negative attitudes toward African Americans (low public regard) were at greater risk for experiencing racial discrimination, low public regard beliefs also buffered the impact of racial discrimination on psychological functioning" (187).

A closer look at the various subscales reveals some important conceptual similarities. Consider the Cross Racial Identity Scale (Vandiver et al., 2001) and the Multidimensional Inventory of Black Identity (Sellers et al., 1998). Both models have similar subscales. Vandiver et al. (2002, p. 80) tested the convergent validity between subscales on the MIBI and CRIS. Both nigrescence theory (Cross, 1991, Cross and Vandiver, 2001) and the MIBI (Sellers et al., 1997) examine the salience of race and a hierarchy of identities in an individual's self-concept (Vandiver et al., 2002). Vandiver et al. (2002, p. 75-77) points out that in the CRIS, the Anti-White and Afrocentric subscales stress the importance of race, while the Assimilation scale does not; in the MIBI, the Centrality and Nationalist subscales stress the importance of race, whereas the Assimilation and Humanist subscales do not.

Research has also found a positive correlation between the MIBI Humanist subscale and the CRIS Multiculturalist subscale. The Humanist racial identity highlights the commonalties across races. Individuals with this type of racial identity hold values that are important to the average individual regardless of race (e.g., hard work and achievement). Similarly, the Multiculturalism identity in the CRIS demonstrates that some African Americans embrace values related to other social identities in addition to those associated with their racial identity. Moreover, the models demonstrate that the various stages or dimensions encompassing African American racial identity may produce distinct effects on individuals' attitudes and behavior, and thus, it is necessary to describe racial identity in terms of each stage or dimension separately.

Discussion

Implications for Political Research

The political implications of these findings are significant. First, this research shows it is important not to assume that all African Americans place the same importance on race in their overall self-concept. The significance of race likely affects African Americans' candidate evaluations, policy preference, political participation, and other psychological orientations (e.g., political efficacy and trust in the government). For instance, individuals for whom race is very significant may be less likely to support a White candidate in a biracial election. Conversely, individuals for whom race is less important may be less likely to support affirmative action policies or other racial policy issues.

Individuals have multiple identities within their self-concept which are hierarchically ordered in a way that has significant consequences for their identification. Racial identity is likely to interact with these competing identities and alter its meaning for the individual (Sellers et al., 1998). For example, "African American women's racial ideology may vary according to the ideologies associated with their gender identity" (Sellers et al., 1998, p. 33). This variation can affect political decision -making, depending on which ideology is more salient in a given situation or context. Using a complex identity measure, political scientists can investigate how different group identities within an individual's self-concept interact and affect his or her political attitudes and behavior. The Multidimensional Inventory of Black Identity (MIBI; Sellers et al., 1998), for example, examines the hierarchy of identities by focusing on the relative importance of race compared to other identities.

The use of simple measures of racial identity in political science also has implications for our ability to make predictions regarding African Americans' political behavior. Consider the conceptualization of racial identity as "closeness," which is often used in political research. Such a simple conceptualization does not explain why one African American may express their political demands through

protests and direct forms of action, another prefers using conventional political channels like contacting government officials, a third is only comfortable voting, while a fourth feels equally comfortable doing everything, and yet another prefers doing nothing. All of these individuals can feel equally close to members of their racial group. Explaining the different preferences in these individuals' political participation might be better explained by various racial ideologies, such as those described in the Multidimensional Measure of Racial Identity (MMRI; Sellers et al., 1997). Without a dimension like ideology, we cannot capture some of the individual differences in African Americans' racial identity.

A multidimensional measure of racial identity can potentially contribute to the extensive literature on candidate preferences. The variation in African American racial identity can make a difference in how African Americans perceive and respond to political candidates. In politics, perception of candidates can depend not only on the messages one receives from political campaigns but also on the sentiments of those making the decisions. In other words, there is only so much a candidate can do in elections; the rest depends on the voter's sentiments toward his or her race. The differences in how African Americans feel about a candidate may depend not only on the candidate's race, but also the individual's personal attitudes and beliefs about being African American (Sullivan and Arbuthnot, 2009).

Researchers have learned a great deal about the nature of African American racial identity and its effects on individual social behavior. Considering the theoretical and methodological contributions made by scholars outside of political science, *why do political scientists continue to use simple measures of African American racial identity in current research?* One possible reason is the lack of national survey data containing the necessary question items to create more complex scales. There has not been a national survey that includes a multidimensional measure of African American racial identity. The few surveys that have used multidimensional measures of racial identity have been administered at the local level or across college campuses. However, these studies do not provide a representative sample of the African American population, which is crucial in research on group-based attitudes and behavior.

As for why multidimensional scales have not been included in national surveys, it is possibly because much of the work in the field used data from the National Survey of Black Americans and the National Black Election Studies, which were gathered in the 1980s. However, most of the popular multidimensional measures were not developed until later (e.g., the MRIS was created in 1995; the MIBI was designed in 1998; the CRIS was developed in 2001). There is clearly a need for more recent data. For example, the MIBI contains fifty-six items; the CRIS contains forty items; and the MRIS is a thirty-item measure. This is a large number of items to include in national election surveys, which already include items that assess a multitude of policy preferences, political participation, candidate and leadership evaluations, and various other political attitudes. Furthermore, national surveys such as the American National Election Survey polls participants of all races and ethnicities, so including a large number of items for only African

American respondents may not be suitable. However, a large scale measure of racial identity could be included in a survey that only polls African Americans like the National Black Election Studies.

All things considered, there is no reason for political scientists to still rely on such simple, outdated measures of African American racial identity in present research. American politics is credited with having some of the richest data in academia, yet political scholars have not implemented a more detailed measure of racial identity. With the abundance of research demonstrating the benefits of complex racial identity models, why do political scientists remain apathetic to the need for more valid and reliable measures of the construct?

Conclusion

A review of the racial identity literature in political science reveals inconsistent findings regarding the effects of racial identity on African Americans' political participation and policy preferences. In this chapter, we have presented a number of theoretical, conceptual, and methodological issues that can account for the discrepancies in the findings. One source of confusion in the literature concerns the lack of a clear conceptual definition of African American racial identity. The wide range in conceptualizations is bound to have caused disparate findings and disagreement regarding the effects of African American racial identity. Still, even though researchers may not agree on the best conceptualization of African American racial identity, there does appear to be a consensus (at least outside of political science) that African American racial identity is a multidimensional concept which requires complex measures.

Another source of confusion in the literature deals with the different theoretical underpinnings associated with the concept (racial identity versus ethnic identity and group identification versus group consciousness). It is sometimes assumed that ethnic identity is theoretically the same as racial identity, and the two constructs have been measured using the same identity model. However, the definitions of these two concepts are noticeably different. On one hand, racial identity refers to the connectedness among members of group based on common physical traits and a shared experience of social oppression. On the other hand, ethnic identity refers to the sense of belonging with a group that is united by shared culture. Although race and ethnicity are two distinct constructs, in a discussion of African American identity, there is a great deal of overlap because the ethnic identity of many African Americans is often closely intertwined with their racial identity. Nevertheless, African American racial identity requires a model and measure separate from that of ethnic identity. Similarly, racial identity is often confused with racial consciousness in the literature. Yet many scholars argue that the two concepts are significantly different. Group identity refers to a psychological sense of attachment to a group. Group consciousness involves in-group identification along with ideological beliefs about the group's social status, and commitment to collective

action. Political science research does not always distinguish between the elements of identification and consciousness, and consequently, identity can be interpreted as basic group identification or a complex belief system. Although racial group identity and racial group consciousness are related, they are two different concepts that should not be used interchangeably or in place of one another.

The most critical issue facing political scientists in the study of African American racial identity, is the use of a more valid and reliable measure of the construct. Given the complexity of African American racial identity, an accurate test of its influence on individuals' attitudes and behavior requires a comprehensive measure that can tap into its various dimensions. Without a more valid measure of the key concept, there is little that can be done in the way of political research on African American racial identity. We strongly urge political scholars to fill the current methodological void in the existing literature by employing a more comprehensive measure of African American racial identity that can be applied across areas of academic study. This will not only promote better-integrated research and greater inter-subject reliability, but also aid in the overall development of African American racial identity theory in future research.

References

Akbar, N. (1984). Africentric social sciences for human liberation. *Journal of Black Studies* 14: 395-414.

Allen, R., and Hatchett, S. (1986). The media and social reality effects: Self and system orientations of blacks. *Communication Research* 13:97-123.

Allen, R., Dawson, M., and Brown, R. (1989). Aschema-based approach to modeling an African American racial belief system. *American Political Science Review* 83:421-41.

Anglin, D. M. and Wade, J. C. (2007). Racial socialization, racial identity, and black students' adjustment to college. *Cultural Diversity and Ethnic Minority Psychology* 13(3):207-215.

Antunes, G. and Gaitz, C. M. (1975). Ethnicity and participation: A study of Mexican-Americans, blacks and whites. *American Journal of Sociology* 80:1192-1211.

Awad, G. H. (2007). The role of racial identity, academic self-concept, and self-esteem in the prediction of academic outcomes for African American students. *Journal of Black Psychology* 33:188-207.

Baldwin, J. (1985). *African (Black) personality: From an Afrocentric framework.* Chicago: Third World Press.

Banks, J. (1981). Stages of ethnicity: Implications for curriculum reform. pp. 129-139. In J. A. Banks (Ed.) *Multiethnic Education: Theory and Practice.* Boston: Allyn and Bacon.

Bledsoe, T., Welch, S., Sigelman, L., and Combs, M. (1995). Residential context and racial solidarity among African Americans. *American Journal of Political Science* 39: 434-458.

Bobo, L., and Kluegel, J. (1993). Opposition to race-targeting: Self-interest, stratification ideology, or racial attitudes. *American Sociological Review* 58:443-464.

Broman, C., Neighbors, H., and Jackson, J. (1988). Racial group identification among black adults. *Social Forces* 67(1):146-58.

Bullock, C. and Campbell, B. (1984). Racist or racial voting in the 1981 Atlanta municipal elections. *Urban Affairs Quarterly* 20:149-64.

Burke, P. J. (1980). The self: Measurement requirements from an interactionist perspective. *Social Science Quarterly* 43:18-29.

Campbell, A., Converse, P., Miller, W., and Stokes, D. (1960). *The American voter.* Chicago: University of Chicago Press.

Chesley, R. (1993). Group is small but dedicated, and risky to court. *Detroit Free Press* 8 August.

Chong, D., and Rogers, R. (2005). Racial solidarity and political participation. *Political Behavior* 27(4):347-374.

Clark, K. B., and Clark, M. K. (1939). The development of consciousness of self and the emergence of racial identification in negro preschool children. *Journal of Social Psychology* 10: 591-599.

Clark, K. B., and Clark, M. K. (1940). Skin color as a factor in racial identification of negro preschool children. *Journal of Social Psychology* 11: 350-359.

Cokley, K. O. (2002). Testing Cross's revised racial identity model: An examination of the relationship between racial identity and internalized racialism. *Journal of Counseling Psychology* 49:476-483.

Cokley, K. O. (2005). Racial(ized) identity, ethnic identity, and afrocentric values: Conceptual and methodological challenges in understanding African American identity. *Journal of Counseling Psychology* 52: 517-526.

Cokley, K. O. (2007). Critical issues in the measurement of ethnic and racial identity: A referendum on the state of the field. *Journal of Counseling Psychology 54*: 224-234.

Condi, J., and Christiansen, J. (1977). An indirect technique for the measurement of changes in black identity. *Phylon* 38:46-54.

Conover, P. (1984). The influence of group identification on political perception and evaluation. *Journal of Politics* 46:760-85.

Cornell, S., and Hartmann, D. (1998). *Ethnicity and Race: Making Identities in a Changing World.* Thousand Oaks, CA: Pine Forge Press.

Cross, W. E. (1971). Discovering the black referent: the psychology of black liberation, pp. 95-110. In V. J. Dixon and Foster, B. G. (Eds.) *Beyond black and white: An alternative America.* Boston: Little, Brown and Company.

Cross, W. E. (1978). The Thomas and Cross models of psychological nigrescense: A review. *Journal of Black Psychology* 5:13-31.

Cross, W. E. (1991). *Shades of black: Diversity in African American identity.* Philadelphia: Temple University Press.

Cross, W. E. (1995). The psychology of nigrescence: Revising the Cross model, pp. 93-122. In J. G. Ponterotto, J. M. Casas, L. A. Suzuki, and C. M. Alexander (Eds.), *Handbook of multicultural counseling*. Thousand Oaks, CA: Sage.

Cross, W. E., and Vandiver, B. (2001). Nigrescence theory and measurement: Introducing the cross racial identity scale (CRIS), pp. 371-393. In J. G. Ponterotto, J. M. Casas, L. A. Suzuki, and C. M. Alexander (Eds.), *Handbook of multicultural counseling* (Second edition). Thousand Oaks, CA: Sage.

Davis, J., and Gandy, O. (1999). Racial identity and media orientations: Exploring the nature of constraint. *Journal of Black Studies* 29: 367-397.

Dawson, M. (1994). *Behind the mule: Race and class in African American politics*. Princeton, NJ: Princeton University Press.

Dawson, M. (1996). Black power and demonization of African Americans. *PS: Political Science and Politics* 24:456-61.

Dawson, M. (2001). *Black vision: The roots of contemporary African American political ideologies*. Chicago: University of Chicago Press.

Dawson, M., and Popoff, R. (2004). Reparations: Justice and greed in black and white. *Du Bois Review* 1:47-91

Demo, D., and Hughes, M. (1990). Socialization and racial identity among black Americans. *Social Psychology Quarterly* 53:364-374.

Eggerling-Boeck, J. L. (2004). *The Intricacies of African American identity. Dissertation*. University of Wisconsin-Madison.

Ferguson, T. M., Leach, M. M., Levy, J. J., Nicholson, B. C., and Johnson, J. D. (2008). Influences on counselor race preferences: Distinguishing Black racial attitudes from Black racial identity. *Journal of Multicultural Counseling and Development* 36:66-76.

Gaines, S. O. and Reed, E. S. (1994). Two social psychologies of prejudice: Gordon W. Allport, W. E. B DuBois, and the legacy of Booker T. Washington. *Journal of Black Psychology* 20:8-28.

Gaines, S. O., and Reed, E. S. (1995). Prejudice: from Allport to DuBois. *American Psychologist* 50:96-103.

Greenberg, S. B. (1974). *Politics and poverty*. New York: John Wiley.

Grills, C., and Longshore, D. (1996). Africentrism: Psychometric analysis of a self-report measure. *Journal of Black Psychology* (22):86-106.

Gurin, P., Hatchett, s., and Jackson, J. (1989). *Hope and independence: Blacks' response to electoral party politics*. New York: Russell Sage Foundation.

Gurin, P., Miller, A. H., and Gurin, G. (1980). Stratum identification and consciousness. *Social Psychology Quarterly* 43(1):30-47.

Harris, D. (1995). Exploring the determents of adult black identity. *Social Forces* 74:227-241.

Helms, J. (2007). Some better practices for measuring racial and ethnic identity constructs. *Journal of Counseling Psychology* 54:235-246.

Hecht, M. L. and Ribeau, S. (1991). Sociocultural roots of ethnic identity: A look at black America. *Journal of Black Studies* 21:501-513.

Herring, M., and Forbes, J. (1994). The overrepresentation of a white minority: Detroit's at-large city council. 1961-1989. *Social Science Quarterly* 75:431-45.
Herring, M., Jankowski, T., and Brown, R. (1999). Pro-black doesn't mean anti-white: The structure of African American group identity. *Journal of Politics* 61:363-386.
Horowitz, E. L. and Horowitz, R. E. 1938. Development of social attitudes in children. *Sociometry*. 3/4:301-338.
Huckfeldt, R., and Fohfeld. C. (1989). *Race and the decline in American politics*. Urbana: University of Illinois Press.
Hughes, M. and Demo, D. (1989). Self-perceptions of black Americans: Self-esteem and personal efficacy. *American Journal of Sociology* 95:132-159.
Jackson, B. (1987). The effects of racial group consciousness on political mobilization in American cities. *Western Political Quarterly* 40:631-646.
Jackson, J. S., McCullough, W. R., Gurin, G., and Broman, C. L. (1991). *Race identity: In life in Black America*, ed. James S. Jackson. Newbury Park, CA: Sage.
Jackman, M. R. and Jackman, R. W. (1973). An interpretation of the relation between objective and subjective social status. *American Sociological Review* 38:569-82.
Jaret, C., and Reitzes, D. (1999). The importance of racial-ethnic identity and social setting for blacks, whites, and multiracials. *Sociological Perspectives* 42:711-737.
Jones-Correa, M. and Leal, D. L. (1996). Becoming Hispanic: Secondary panethic identification among Latin American-origin populations in the United States. *Hispanic Journal of Behavioral Sciences* 18:214-253.
Kinder, D. R. andSanders, L. M. (1996). *Divided by color: Racial politics and democratic ideals*. Chicago: University Chicago Press.
Kinder, D. R. and Winter, N. (2001). Exploring the racial divide: Blacks, whites, and opinion on national policy. *American Journal of Political Science* 45:439-456.
Lau, R. (1989). Individual and contextual influences on group identification. *Social Psychology Quarterly* 52:220-31.
Leighley, J. E., Vedlitz, A. (1999). Race, ethnicity, and political participation: Competing models and contrasting explanations. *Journal of Politics* 61:1092-1114.
Lieske, J., and Hilliard, J. W. (1984). The racial factor in urban elections. *Western Political Quarterly* 37:545-63.
Looney, J. (1988). Ego development and Black identity. *Journal of Black Psychology* 15(1):41-56.
Marks, B., Settles, I. H., Cooke, D. Y., Morgan, L., and Sellers, R. M. (2004). African American racial identity: A review of contemporary models and measures, pp. 383-404. In R. L. Jones (Ed.), *Black psychology* (Fourth edition). Hampton, VA: Cobb and Henry.

Matthews, D. and Prothro, J. (1966). *Negroes and the new southern politics*. New York: Harcourt, Brace.

McClain, P. D., Johnson Carew, J. D., Walton, Jr., e., and Watts, C. S. (2009). Group membership, group identity, and group consciousness: Measures of racial identity in American politics? *Annual Review of Political Science* 12:471-485.

Miller, A., Gurin, P., Gurin, G., and Malanchuk, O. (1981). Group consciousness and political participation. *American Journal of Political Science* 25:494-511.

Milliones, J. 1976. The Pittsburg project-part II: Construction of a Black consciousness measure. Paper presented at the Empirical Research in Black Psychology, Cornell University.

Milliones, J. (1980). Construction of a black consciousness measure: Psychotherapeutic implications. *Psychotherapy: Theory, Research and Practice* 17(2):175-182.

Olsen, M. (1970). Social and political participation of blacks. *American Sociological Review* 35:682-96.

Omi, M., and Winant, H. (1994). *Racial formation in the United States: From the 1960s to the 1990s*. London: Routledge.

Orum, A. (1966). A reappraisal of the social and political participation of negroes. *American Journal of Sociology* 72:32-46.

Parham, T. A., and Helms, J. (1981). The influence of Black students' racial identity attitudes on preference for counselor's race. *Journal of Counseling Psychology 28:*250-258.

Parham, T. A. and Helms, J. (1985). Attitudes of racial identity and self-esteem of Black students: An exploratory investigation. *Journal of College Student Personnel* 26 (2):143-147.

Phinney, J. S. (1990). Ethnic identity in adolescents and adults: Review of research. *Psychological Bulletin* 108:499-514.

Phinney, J. S. (1992). The Multigroup Ethnic Identity Measure: A new scale for use with adolescents and young adults from diverse groups. *Journal of Adolescent Research* 7:156-176.

Pillay, Y. (2005). Racial identity as a predictor of the psychological health of African American students at a predominantly white university. *Journal of Black Psychology* 31:46-66.

Porter, J., and Washington, R. (1979). Black identity and self-esteem. *Annual Review of Sociology* 5:53-74.

Quintana, S. M. (1998). Children's developmental understanding of ethnicity and race. *Applied and Preventative Psychology* 7:27-45.

Rowley, S. J., Sellers, R. M., Chavous, T. M., and Smith, M. A. (1998). The relationship between racial identity and self-esteem in African American college and highschool students. *Journal of Personality and Social Psychology* 74(3):715-724.

Sanders Thompson, V. L. (1990). Factors Affecting the Level of African American identification. *Journal of Black Psychology* 17 (1):19-35.

Sanders Thompson, V. L. (1991). Perceptions of race and race relations which affect African American identification. *Journal of Applied Social Psychology* 21(18):1502-1516.

Sanders Thompson, V. L. (1994). Socialization to race and its relationship to racial identification among African Americans. *Journal of Black Psychology* 20(2):175-188.

Sanders Thompson, V. L. (1995a). The multidimensional structure of racial identification. *Journal of Research in Personality* 29(2):208-222.

Sanders Thompson, V. L. (1995b). Sociocultural influences of African American racial identification. *Journal of Applied Social Psychology* 25(16):1411-1429.

Sanders Thompson, V. L. (2001). The complexity of African American racial identification. *Journal of Black Studies* 32:155-165.

Sellers, R. M., Rowley, S. J., Chavous, T. M., Shelton, J. N., and Smith, M. A. (1997). The multidimensional inventory of black identity: Construct validity and reliability. *Journal of Social and Personality Psychology* 73(4):805-815.

Sellers, R. M., Chavous, T. M., and Cooke, D. Y. (1998). Racial ideology and racial centrality as predictors of African American college students academic performance. *Journal of Black Psychology* 24 (1):8-27.

Sellers, R. M., Shelton, J. N., Cooke, N. D., Chavous, T. M., Rowley, S. J., and Smith, M. A. (1998). A multidimensional model of racial identity: Assumptions, findings and future directions. *African American Identity Development* 275-302.

Sellers, R. M., Smith, M. A., Shelton, J. N., Rowley, S. J., and Chavous, T. M. (1998). Multidimensional model of racial identity: A reconceptualization of African American racial identity. *Personality and Social Psychology* 2:18-39.

Sellers, R. M., Copeland-Linder, N., Martin, P. P., and L'Heureux Lewis, R. . (2006). Racial identity matters: The relationship between racial discrimination and psychological functioning in African American adolescents. *Journal of Research on Adolescence* 16(2):187-216.

Shingles, R. D. (1981). Black consciousness and political participation: The missing link. *American Political Science Review* 75:76-91.

Sigelman, L., and Welch, S. (1984). Race, gender, and opinion toward black and female presidential candidates. *Public Opinion Quarterly* 48:467-75.

Smith, E. M. (1989). Black racial identity development: Issues and concerns. *The Counseling Psychologist* 17:277-288.

Spencer, M. B. and Markstrom-Adams, C. (1990). Identity process among racial and ethnic minority children in America. *Child Development* 61:290-310.

Strickland, R. A., and Whicker, M. L. (1992). Comparing the Wilder and Grant campaigns: A model for black candidate success in statewide elections. *PS: Political Science and Politics* 25:204-12.

Sullivan, J. M. (2009). Black identity: What does it mean for black leaders? *National Political Science Review* 12:163-177.

Sullivan, J. M. and Arbuthnot, K. N. (2009). The effects of black identity on candidate evaluations: An exploratory study. *Journal of Black Studies* 40(2):215-237.

Tate, K. (1991). Black political participation in the 1984 and 1988 presidential elections. *American Political Science Review* 85(4):1195-1176.

Tate, K. (1993). *From protest to politics: The new black voters in American elections.* Cambridge: Harvard University Press.

Tate, K. (2003). *Black faces in the mirror: African Americans and their representatives in the U. S. Congress.* New Jersey: Princeton University Press.

Thomas, C. 1971. *Boys No more: A Black Psychologist's View of Community.* Beverly Hills, CA: Glencoe Press.

Vandiver, B. J., Cross, W. E., Worrell, F. C., and Fhagen-Smith, P. E. (2002). Validating the Cross racial identity scale. *Journal of Counseling Psychology* 49:71-85.

Vandiver, B. J., Fhagen-Smith, P. E., Cokley, K., Cross, W. E., and Worrell, F. C. (2001). Cross nigrescence model: From theory to scale to theory. *Journal of Multicultural Counseling and Development* 29:174-200.

Verba, S. and Nie, N. (1972). *Participation in America: Political democracy and social equality.* New York: Harper and Row.

Verba, S., Schlozman, K., and Brady, H. (1993). Race, ethnicity, and political resources: Participation in the United States. *British Journal of Political Science* 23:453-497.

Verba, S., Schlozman, K., and Brady, H. (1995). *Voice and equality: Civic voluntarism in American politics.* Cambridge: Harvard University Press.

Want, V., Parham, T. A., Baker, R. C., and Sherman, M. 2004. African American students' ratings of Caucasian and African American counselors varying in racial consciousness. *Cultural Diversity and Ethnic Minority Psychology* 10(2):123-136.

White, I. (2007). When race matters and when it doesn't: Racial group differences in response to racial cues. *American Political Science Review* 101:339-354.

Worrell, F. C., Vandiver, B. J., and Cross, W. E. (2004). *The Cross racial identity technical manual* (Second edition). Berkeley, CA: Authors.

Part Two
African American Racial Identity and Psychological Well-Being

Chapter Four
The Effects of Racial Identity on African American Youth Well-Being: A Clarification of the Research and Meta-analysis

Corinn A. Elmore, Jelani Mandara, and Lauren Gray

Introduction

Several researchers suggest that racial identity is important to African American youths' mental health and overall well-being for a number of reasons (Jones, Cross, Defour, 2007; Mandara, Gaylord-Harden, Richards, and Ragsdale, 2009). The main reasons seem to be related to the fact that it helps youth cope with the stresses of discrimination (Caldwell, Zimmerman, Bernat, Sellers, and Notaro, 2002; Rowley, Sellers, Chavous, and Smith, 1998; Sellers, Copeland-Linder, Martin, and Lewis, 2006). For instance, Spencer (1995) argued that normative development for African American youth is inextricably linked with exposure to environments which often devalue their racial group. Such environments can lead to debilitating perceptions of oneself as a person of African descent, one's self-esteem and general mental health. She further argued that a positive view of one's racial group buffers African American youth from the negative psychosocial consequences of such environments (Spencer, Dupree, and Hartmann, 1997). A related notion is that a positive racial identity may allow individuals to not internalize negative stereotypes of African Americans because those with positive views of their "Africanness" are less concerned about the perceptions of others (McLoyd, Cauce, Takeuchi and Wilson, 2000).

However, the actual relationship between racial identity and African American youth well-being is unclear. For example, some research has shown that high levels of racial identity among African American adolescents and young adults is associated with positive outcomes such as academic attainment, fewer risky behaviors, less aggression, active coping, and mental health (McMahon and Watts, 2002; Yasui, Dorham and Dishion, 2004; Rowley et al., 1998; Townsend and Belgrave, 2000; Wong, Eccles, Sameroff, 2003). Counter to these findings, several studies have also found no relationship between racial identity and well-being (Awad, 2007; Caldwell et al., 2002; Carter, DeSole, Sicalides, Glass, and Tyler, 1997), while others found that some aspects of racial identity are related to lower mental health and academic achievement (Anglin and Wade, 2007; Munford, 1994; Pierre and Mahalik, 2005).

We propose several reasons for these discrepancies. First, given that there are over fifteen major racial identity theories, there may be differences in the theoretical conceptualizations of racial identity (e.g., stage versus multidimensional). Second, there are several racial identity sub-factors, which may be differentially related to various well-being outcomes. This problem is further compounded when studies use composite measures of several different racial identity factors. Another problem may be that most studies failed to assess the effects of potentially important moderators such as gender. This abundance of racial identity models and factors and other limitations makes it difficult to compare studies and interpret the overall findings.

Therefore, the purpose of this chapter was twofold. The first was to organize the disparate racial identity theories, models and sub-factors into a coherent conceptual framework. The second purpose was to conduct a meta-analysis of the racial identity effects on African American youth well-being using the framework. The ultimate goal was to come to a better understanding of how racial identity is related to African American youth's well-being.

Primary Racial Identity Theories and Measures

The earliest formal theories of racial identity were stage models similar to Erikson's (1968) stages of identity development (e.g., Cross, 1991; Parham and Helms, 1981, Phinney, 1989). Perhaps the most famous of the various racial identity theories is Cross's Nigrescence stage model of racial identity (Cross, 1991). This theory conceptualizes racial identity as stages that African Americans matriculate through based on life events. Cross's model originally had three major stages: pre-encounter, immersion-emersion, and internalization. The pre-encounter type refers to the stage before a person has had racial discrimination experience. It includes the assimilation, miseducation, and self-hatred subtypes, which include various identities that may exist before one has given serious consideration to their racial identity (Marks, Settles, Cooke, Morgan, and Sellers, 2004). The immersion-emersion type refers to when a person experiences a discrimination event and

therefore becomes immersed in Black culture and includes the anti-White and Black involvement subtypes. The last identity stage according to Cross's model is the internalization stage, which constitutes a mature racial identity. The three subtypes in this stage are the internalization nationalist, the internalization bi-culturalist, and the internalization multi-culturalist. The Cross Racial Identity Scale (Vandiver et al., 2000) is a forty-item scale based on the revised concepts of this theory, which measures the presence of these racial identity types.

Parham (1989) expanded Cross's theory by looking at racial identity development as a life-long developmental process rather than simply end stages of development. Parham also added ideas of three pathways related to how one matriculates through these racial identity stages. The first pathway is called stagnation. This refers to when a person maintains one racial identity stage in his or her life. Linear progression is when a person moves through the different stages over time. Finally, recycling is when someone moves through the racial identity stages but experiences a situation which causes him or her to return to a stage of racial identity that has already been experienced (Marks, Settles, Cook, Morgan, Sellers, 2004). Parham and Helms (1981) created the Racial Identity Attitudes Scale (RIAS) based on the original Nigescence model and its four stages: Pre-encounter, Encounter, Immersion/Emersion, and Internalization. Examples of subscales and items in this measure can be seen in Table 4.1.

Another important model based on Eriksonian (1968) theory used in assessing African American youth racial identity is Phinney's (1992) model of ethnic identity development. Ethnic identity is distinguished from racial identity in that it is more often used to compare identities across groups and can be used across ethnicities. This theory conceptualizes ethnic identity as a fundamental part of self, which includes a sense of membership and feelings associated with that membership (Phinney, 1989). Phinney's studies state that ethnic minority individuals must explore their identities more often because society has not highlighted their identity as much as with the racial majority. When an ethnic minority child, such as an African American child, begins to explore their identity and comes to terms with the fact that he or she has a distinctly different identity and culture than the majority, the child will resolve issues that come with this exploration. With resolution of identity issues, Phinney's studies have shown that children have higher self-esteem (Phinney, Cantu, and Kurtz, 1997). African American children have a more difficult time than White children with having positive feelings about their ethnic identity because the majority's standards are prevalent in today's society. Standards of beauty, economic status, and media may all add to negative images in African Americans and can make the child have negative associations with his or her ethnic identity as in Cross's "pre-encounter miseducation" type. According to this model, the components of ethnic identity are self-identification and ethnicity, ethnic behaviors and practices, affirmation and belonging, ethnic identity achievement, and attitudes toward other groups. From this model of ethnic identity the Multigroup Ethnic Identity Measure (MEIM) was developed. The MEIM has four subscales based on the previously mentioned components of ethnic

identity. The overall ethnic identity score is determined by the averaging the sums of these subscales. Self-identification is an open-ended question, used for background information, and is not included in the score (Phinney and Chavira, 1992). See Table 4.1 for the subscales and sample items.

Another set of theories on racial identity lie in multidimensional theories. Multidimensional theories include both the meaning of one's race to them as well as how they believed others regard their race. Multidimensional models view racial identity as having several aspects rather than moving uniformly in people through a sequence. In contrast to the stage models, changes according to multidimensional models are not based on development and may fluctuate individually.

One of the earliest conceptualizations of a multidimensional model of racial identity was in the form of a three component model from Demo and Hughes (1990) which discussed closeness, Black separatism and Black group evaluation as three of the factors. A five component model of racial identity comes from Allen and colleagues (1989) where the dimensions are further divided into the following components: closeness to elite Blacks (more wealthy, elite groups), closeness to mass groups (less SES, oppressed in age and religion), positive stereotypes (embracing only positive beliefs about Blacks), negative stereotypes (embracing only negative beliefs about Blacks), and Black autonomy which refers to building up the Black community through political and social institutions and Black cultural values (Marks et al., 2004).

Table 4.1: Racial Identity Subscales and Sample Items

Subscale	Item
Racial Identity Attitudes Scale (RIAS)	
Pre-Encounter	I believe that large numbers of Blacks are untrustworthy.
Encounter	I am determined to find my Black identity.
Immersion-Emersion	White people can't be trusted.
Internalization	I feel good about being Black but I don't limit myself to Black activities.
Cross Racial Identity Scale (CRIS)	
Pre-Encounter: Assimilation	I am not so much a member of a racial group as I am an American.
Pre-Encounter: Miseducation	Blacks place more emphasis on having a good time than on hard work.
Pre-Encounter: Self-Hatred	I sometimes have negative feelings about being Black.
Immersion-Emersion: Anti-White	I have a strong feeling of hatred and disdain for all White people.

Table 4.1: Racial Identity Subscales and Sample Items (Continued)

Subscale	Item
Internalization: Black Nationalist	As Black Nationalists, we must work on empowering ourselves and not on hating others.
Internalization: Multiculturalist Inclusive	I believe it is important to have both a Black identity and a multicultural perspective, which is inclusive of everyone.

Multigroup Ethnic Identity Measure (MEIM)

Affirmation and Belonging	I am happy that I am a member of the group I belong to.
Ethnic Identity Achievement	I have a clear sense of my ethnic background and what it means for me.
Ethnic Behaviors	I participate in cultural practices of my own group, such as special food, music, or customs.
Other Group Orientation	I like meeting and getting to know people from ethnic groups other than my own.

Multidimensional Inventory of Black Identity (MIBI)

Centrality	In general, being Black is an important part of my self-image.
Private Regard	I am proud to be Black.
Public Regard	Overall, Blacks are considered good by others.
Nationalist	Black people must organize themselves into a separate Black political force.
Assimilation	Blacks should view themselves as being Americans first and foremost.
Oppressed Minority	Black people should treat other oppressed people as allies.
Humanist	Blacks should judge Whites as individuals and not as members of the White race.

Table 4.1: Racial Identity Subscales and Sample Items (Continued)	
Subscale	**Item**
	Ethnic Identity Scale (EIS)
Exploration	I have attended events that have helped me learn more about my ethnicity.
Affirmation	I wish I were of a different ethnicity.
Resolution	I have a clear sense of what my ethnicity means to me.

From these theories, Sellers, Smith, Shelton, Rowley, and Chavous (1998) created the Multidimensional Model of Racial Identity (MMRI) which combines ideas of the meaning African Americans attribute to their race, as well as how this meaning may change situationally. This model argues that racial identity should be understood in the context of other important identities, such as gender and occupation. The MMRI, specifically, discusses four race dimensions. Salience refers to how significant one's race is to their own self-concept at a specific moment in time or event. It is flexible and dynamic and changes over time. Centrality refers to how important one's race is to their self-concept in general. The ideology dimension pertains to how one believes people of one's race should behave in society. The final dimension is regard, which is what one believes about their own race. This dimension is divided into how one believes society feels about his or her race (public) and the way that individual feels about his or her own group (private). From the MMRI model both the Multidimensional Inventory of Black Identity (MIBI) and a teen version (MIBI-T) were created to assess these dimensions in African American participants. Table 4.1 lists sample items from the MIBI.

Effects of Racial Identity on African American Youth Well-Being

Although several researchers have theorized about the benefits of racial identity, its effects on youth well-being are not clear. For instance, a study of African American adolescents found that racial identity was negatively related to depressive symptoms and aggressive behaviors (McMahon and Watts, 2002). They also found that racial identity was positively related to self-esteem and coping. A similar study found racial identity was negatively related to depressive symptoms and general psychological distress among African American adolescents (Yasui, Dorham and Dishion, 2004). In the Sellers et al. (2006) study, which did not find significant effects of public regard, they found that the private regard subscale of the MIBI was related to fewer depressive symptoms and general well-being. Other studies have also found that the similar measures of racial identity were strongly related to African American adolescents' self-esteem (Rowley et al., 1998; Townsend and Belgrave; 2000) and psychological resiliency (Wong et al., 2003). Racial identity

has also been associated with higher levels of academic achievement (Chavous et al., 2003; Witherspoon, Speight, Thomas, 1997; Wong et al., 2003).

Another set of studies have not found such strong effects of racial identity on African American youth mental health and achievement. Roberts et al. (1999) found that a revised version of Phinney's (1992) Multigroup Ethnic Identity Measure (MEIM) was positively correlated with over 1200 African American early adolescents' coping, but not with their self-esteem and depressive symptoms. One study found that those who have less racial identity and instead adopt racelessness beliefs have better academic outcomes but have lower collective self-esteem (Arroyo and Zigler, 1995). They also found that racial identity had no relationship with their depressive or anxiety symptoms. Simons and colleagues (2002) also found that ten- to twelve-year-old African Americans' racial identity did not correlate with their depressive symptoms. Other studies found similar null effects of racial identity on African American youth mental health (Caldwell et al., 2002; Sellers et al., 2006). These rather stark inconsistencies prevent researchers from making more definitive statements about the effects of racial identity.

Possible Reasons for the Inconsistencies

There are several possible reasons for these inconsistencies. First, although demographic factors such as age and gender may influence the association between racial identity and outcomes, few studies accounted for these differences. For example, a few studies found that racial identity is correlated with outcomes more for boys than girls (Mandara et al., 2009; Chavous, Rivas-Drake, Smalls, Griffin, Cogburn, 2008). Second, some research uses a global measure of racial identity that combines several dimensions (McMahon and Watts, 2002; Swenson and Prelow, 2005). As described previously, there are several dimensions or stages which encompass racial identity, ranging from racial pride to racial self-hate, and the different dimensions may produce distinctive outcomes. For example, the pre-encounter stage, or before one has had a significant race encounter, has been found to be related to lowered self-esteem and overall psychological health (Pillay, 2005; Poindexter-Cameron and Robinson, 1997), while having a strong internal representation of one's race has been associated with greater self-esteem and greater college adjustment (Anglin and Wade, 2007; Munford, 1994). Meanwhile, immersing oneself in African American culture has been related to higher rates of depression (Munford, 1994). Because of these differences it may be inaccurate to describe racial identity in terms of total benefits and instead discuss each sub-factor separately.

Further, there may be differences in how racial identity manifests in youth and adult well-being. In adults, racial identity has been measured in relation to mood problems, vocational ability, and self-esteem (McCowan and Alston, 1998; Phinney, 1991; Thomas and Speight, 1999). In youth, however, other more developmental outcomes may be more salient such as psychosocial, academic, and cognitive development (Awad, 2007; Munford, 1994; Pope, 2000). Also, the way

in which youth and adults present these different outcomes may differ from each other. So that depression may appear as sadness in adults but as irritability in youth (American Psychiatric Association, 2000). These differences should be noted and accounted for in the literature.

An additional reason for these inconsistencies is that studies utilize a variety of different instruments which may have the same name for different constructs. For example, the Pre-encounter Assimilation scale of the CRIS refers to one's sense of identity related to being American rather than African American, while the Assimilation scale of the MIBI has more to do with denying one's Blackness in order to blend in with White society (Scottham, Sellers, Nguyen, 2008; Vandiver, Cross, Worrell, and Fhagen-Smith, 2002). Another inconsistency is in the different theoretical underpinnings associated with the measures (e.g., ethnic identity vs. racial identity). Additionally, differences in methodology in these studies also affect the standardization. Studies may be generalized as positively affecting mental health, despite differences in significance requirements, effects sizes, and analyses used (Cokely, 2007). Also important is the way in which racial identity is conceptualized. As mentioned previously, some studies utilize a stage model, while others use a multidimensional conceptualization. Studies from these two different paradigms may be compared to each other and may not provide an accurate view of the processes which are occurring.

Comprehensive Conceptual Framework

To help bring a sense of coherence to the field and further our understanding of exactly how racial identity influences African American youth's well-being, we organized the prevailing models and measures of racial identity into a comprehensive conceptual framework. To develop this framework, we reviewed most of the seminal articles on racial identity theory and the sub-factors and items of the most prominent racial identity measures. Several commonalities were found across the different measures. As shown in Table 4.2, we were then able to classify most of the sub-factors from the different racial identity measures into one of the five conceptual categories based on the similarities and differences of the items themselves. The five racial identity conceptual categories or dimensions are: (1) racial pride, (2) racial exploration, (3) cultural mistrust, (4) race salience, and (5) humanistic identity. Each dimension is discussed in more detail below.

Racial Pride

The most common racial identity dimension measured by the prominent instruments is related to a sense of racial pride or esteem. The pride dimension refers to one's positive or negative feelings about their African and African American heritage, culture and phenotypic features (Mandara et al., 2009). It is fundamentally an affective dimension that is concerned with one's feelings about their Blackness

and refers to developing positive feelings related one's racial group (Mandara et al., 2009). These ideas may develop through the messages received from one's parents around race, experiences where one feels connected to their culture, or through education around various aspects of one's culture. Examples of racial pride behaviors include engaging in cultural practices related to one's race, holding one's race in high regard, telling others about one's race, and being knowledgeable about the accomplishments one's race has made (Hughes, Rodriguez, Smith, Johnson, Stevenson, and Spicer, 2006). Studies have consistently highlighted the fact that racial pride is an important aspect of racial identity (Mandara, et al., 2009; Phinney, 1992; Rowley et al., 1998).

The measurements tools reflect this idea as well. The internalization in the RIAS-B, private regard in the MIBI, affirmation and belonging subscales from the MEIM, and Ethnic Group Esteem scale display this concept. Overall, many studies describe the concept that ideas about race must be shared, then internalized, which then leads to feelings of satisfaction, pride, or regard for one's race. For example, the internalization stage from Cross's model describes how one incorporates one's sense of Blackness with balancing their other identities (e.g., gender, religion, etc.) (Vandiver et al, 2002). For this aspect of racial pride, the person embraces traditional cultural values and customs. Sellers, Smith, Shelton, Rowley, and Chavous's (1998) concept of private regard also reflects these ideas. With private regard, youth hold their race in high regard, or have pride in their race. Examples of questions in this measure are "I feel good about Black people," "I am happy that I am Black," and "I am proud to be Black." Another indicator of racial pride can be seen in MEIM (Phinney, 1992) and in the EIS (Umana-Taylor, Yazedjian, and Bamaca-Gomez, 2004). This concept highlights belonging to one's race and the process of affirming one's pride in the culture. It emphasizes the communalism aspect of Black identity and taking pride in experiencing this identity with others.

Another component commonly assessed in racial identity instruments refers to the exact opposite of racial pride. We called this construct racial self-hate. The measures based on the RIAS-B and CRIS measures capture this idea in several of their subscales. The pre-encounter subscale of the RIAS-B refers to individuals for whom race is not as salient to their identity as much as other aspects are, and they may even have negative views of African Americans despite being African American themselves. The CRIS also refers to both of these components in its miseducation and self-hate subscales in items such as "I sometimes have negative feelings about being Black" and "Blacks place more emphasis on having a good time than on hard work." The miseducation subscale refers to the idea of having stereotyped views of African Americans, usually from societal representation in entities like the media. Instead of creating a separate conceptual category, we considered racial self-hate as the reverse of racial pride. Examples of more items in these scales can be found in Table 4.1.

Table 4.2: Modified Racial Identity Factors

	Racial Pride	Mistrust	Humanism/ Multicultural	Salience	Exploration
RIAS Pre-Encounter Encounter Immersion-Emersion Internalization	Pre-Encounter (-) Internalization	Immersion /Emersion			Encounter
CRIS Assimilation Miseducation Self-Hatred Anti-White Nationalist Multiculturalist	Self-Hatred (-) Miseducation (-)	Anti-White Nationalist	Multiculturalist		
MEIM Affirmation/Belonging Ethnic Identity Achieve. Ethnic Behaviors	Affirmation/ Belonging			Ethnic Identity Achieve	Ethnic Behaviors

Table 4.2: Modified Racial Identity Factors (Continued)

	Racial Pride	Mistrust	Humanism/ Multicultural	Salience	Exploration
MIBI Centrality Private Regard Public Regard Nationalist Oppressed Minority Humanist	Private Regard	Nationalist	Humanist	Centrality	
Ethnic Identity Scale Exploration Affirmation Resolution	Affirmation			Resolution	Exploration
MADIC Ethnic Group Esteem Total Score	Ethnic Group Esteem				
CBIS Total Score	CBIS				
Children's Afrocentric Values Scale	Total Score				

Exploration

Another commonly assessed racial identity area refers to one seeking a deeper understanding of their heritage and racial group. This often manifests itself in the enactment of culturally based behaviors, associating with members of one's racial group, and reading about one's history and culture. The Encounter subscale from the RIAS-B describes how one has an encounter which compels him or her to reevaluate how they feel about their race. This may be an experience in which he or she is discriminated against or an experience where one witnesses a positive aspect of African Americans that challenges what they already believed about the Black race. Questions in this subscale include items such as "I am determined to find my Black identity." The MEIM also references this stage in its ethnic behaviors subscale where adolescents began to search for meaning regarding their racial group through engaging in more cultural practices (e.g., "I participate in cultural practices of my own group, such as special food, music or customs." (Phinney, 1992). Finally, items from the exploration subscale of the EIS were included in our conceptualization of this area of racial identity (Umana-Taylor et al., 2004). This subscale includes items such as "I have attended events that have helped me learn more about my ethnicity."

Cultural Mistrust

The cultural mistrust dimension of racial identity is also referenced in several measures. Mistrust refers to having wary or negative feelings related to other races, especially towards Whites. When one experiences mistrust they caution themselves against other races for fear of possible discrimination (Sellers, Rowley, Chavous, Shelton, and Smith, 1997). In Cross's model this stage (Immersion-Emersion) also may include an abhorrence of anything that is "not Black" (Cross, 1971). Items from the RIAS include "White people can't be trusted." This idea is also in the Anti-White subscale of the CRIS where African Americans abhor anything "White" due to their mistrust of the majority culture.

Salience

Another component in the literature that is referred to in many of the racial identity measures is salience. In the MIBI, this is measured by the centrality subscale with questions such as "Being Black is an important reflection of who I am," and "Overall, being Black has very little to do with how I feel about myself." The MIBI assumes that racial identity is stable, but it is influenced situationally (Sellers et al., 1997). The centrality of one's race, according to this theory, varies across individuals. Phinney's MEIM measure also captures this idea with items such as "I have a clear sense of what my ethnic background and what it means for me" (Phinney, 1992). Also included in our conceptualization was the EIS resolution subscale with

items such as "I have a clear sense of what my ethnicity means to me" (Umana-Taylor et al., 2004).

The salience of one's race seems to affect how racial identity will be related to other outcomes (Phinney, 1991). For example, if one's race is not salient to him or her, then changes in their identity may not have a significant effect on their self-esteem. The component of salience is especially important to consider when evaluating the complex influence of racial identity across individuals and may determine how the interplay of environment and individual attributes predict outcomes. While the CRIS does not have a specific salience subscale, the salience of race is implied in the revised Cross model (Vandiver et al., 2000). This model describes the concept of Reference Group Orientation, which refers to salience of one's social group membership (e.g., racial group) to them and then also the valence or direction in which that salience is shown (Vandiver et al., 2002). For example, a person may have high racial salience, which means that being a member of a racial group is of high importance, but he or she may have a negative valence meaning that the views about his or her racial group are negative.

Humanistic

The humanistic dimension of racial identity has to do with a mature form of racial identity where one is able to embrace their Blackness as well as embrace other social identities. In this dimension, individuals are also able to accept members of other groups while simultaneously embracing their own. Many of the current racial identity measures include this concept. The MIBI has these components in its Humanistic subscale, with items such as, "Blacks should judge Whites as individuals and not as members of the White race," or "Black values should not be inconsistent with human values." The humanistic racial identity does not separate Blacks from other races but rather highlights the commonalties across races. People with this type of racial identity may stress values that are important to all people such as hard work, determination, achievement, and virtue. Similar to the MIBI, Cross's model of racial identity describes Multiculturalism as how some Blacks chooses to embrace ideals related to being Black as well as other social identity values (Vandiver et al., 2002). The CRIS includes items such as "I believe it is important to have both a Black identity and a multicultural perspective, which is inclusive of everyone." In fact, research has shown a positive correlation between the Humanist subscale from the MIBI and the Multiculturalist subscale from the CRIS (Vandiver et al., 2002).

The Current Study

In sum, there is a great deal of literature on racial identity and well-being among African American youth, although the findings are often inconsistent. We argue that these inconsistencies are due to differences in measurement and conceptualization. To help bring consistency to the field, we critically evaluated the prevailing theories

and measures and were able to develop a comprehensive conceptual framework, which included the five most common dimensions of racial identity. Next, we conducted a meta-analysis of the available studies which assessed the effects of racial identity on African American youths' well-being using the new conceptual framework.

Methodology

To be included in the meta-analysis, the studies had to (1) be written in English; (2) include a sample that was primarily college aged or younger; (3) include at least one of the five dimensions of racial identity and at least one well-being measure (e.g., anxiety, depression, self-esteem, academic adjustment); (4) have been published since the early 1990s when many of the measures used in the conceptual framework were first developed; and (5) provide effect size estimates for the relationships between racial identity and well-being among African Americans. When studies also involved European American participants, we analyzed only the disaggregated data for African American youth and young adults. Often, studies reported data on other variables, but only data specific to racial identity and psychological well-being were included with the exception of some academic adjustment studies.

Two strategies helped to identity suitable published studies. First, the authors searched abstracts retrieved from the following electronic databases: PsycInfo, PsychARTICLES, Social Sciences Abstract, JSTOR, and ERIC. In these searches, the phrases *racial identity* and *ethnic identity* were crossed with a list of dozens of descriptors of variables of interest, including *African American, youth, adolescent, young adult, mental health, self-esteem, depression,* and *anxiety.* Second, the reference sections of identified studies were reviewed in order to locate additional articles that fit the inclusion criteria but were not initially found through the database searches.

Studies

This method resulted in thirty-eight studies which examined the relationship between racial identity and specific well-being variables in samples of African American youth and young adults (see Table 4.3). From those studies, 143 statistically non-redundant effect sizes were extracted. The number of participants represented across all studies was 9,539; (Mean age = 17.6). Twenty of the samples included adolescents, from middle to high school age, and seventeen measured college-aged individuals. Most were students, although three studies included young adults who were not in college. Most of the participants were from urban, working class environments (i.e., annual household income between $20K and $40K), and the adolescents largely attended schools where over 90 percent of the students qualified for free lunch.

Table 4.3: Individual Study Information
(See notes at end of table for abbreviation description)

Study No.	Authors, (Year)	Sample Size, N	Age Group	Racial Identity Measure	Racial Identity Subscales	Mental Health Variable	Mental Health Measure
1	Anglin and Wade, (2007)	141	YA	CRIS	As, Mi, SH, AW, N, Mu	Academic Adjus.	SACQ
2	Awad, (2007)	313	YA	CRIS	As, Mi, SH, AW, N, Mu	Self-Esteem	RSES
3	Banks and Kohn-Wood, (2007)	194	YA	MIBI	PrR, PuR, C, As, H, N, OM	Depression	CES-D
4	Bracey, Bámaca, and Umana-Taylor, (2004)	331	A	MEIM	AB	Self-Esteem	RSES
5	Buckley and Carter, (2005)	200	A	RIAS	PE, E, I-E, I	Self-Esteem	PHC-SCS
6	Caldwell, Zimmerman, Bernat, Sellers, and Notaro, (2002)	521	A	MIBI	PrR, C	Depression	BSI
6	Caldwell, Zimmerman, Bernat, Sellers, and Notaro, (2002)	521	A	MIBI	PrR, C	Anxiety	BSI
7	Caldwell, Kohn-Wood, Schmeelk-Cone, Chavous, and Zimmerman, (2004)	471	YA	MIBI	PrR, PuR, C	Academic Adjus.	GPA

Study No.	Authors, (Year)	Sample Size, N	Age Group	Racial Identity Measure	Racial Identity Subscales	Mental Health Variable	Mental Health Measure
7	Caldwell, Kohn-Wood, Schmeelk-Cone, Chavous, and Zimmerman, (2004)	471	YA	MIBI	PrR, PuR, C	Externalizing	VBQ
8	Chavous, Bernat, Schmeelk-Cone, Caldwell, Kohn-Wood, and Zimmerman, (2003)	606	A	MIBI	PrR, PuR, C	Academic Adjus.	GPA
8	Chavous, Bernat, Schmeelk-Cone, Caldwell, Kohn-Wood, and Zimmerman, (2003)	606	A	MIBI	PrR, PuR, C	Self-Esteem	SEM
9	Gaylord-Harden, Ragsdale, Mandara, Richards, and Petersen, (2007)	227A	MEIM AB	AnxietyST AI-C	AB	Anxiety	STAI-C

Study No.	Authors, (Year)	Sample Size, N	Age Group	Racial Identity Measure	Racial Identity Subscales	Mental Health Variable	Mental Health Measure
9	Gaylord-Harden, Ragsdale, Mandara, Richards, and Petersen, (2007)	227	A	MEIM	AB	Depression	CDI
9	Gaylord-Harden, Ragsdale, Mandara, Richards, and Petersen, (2007)	227	A	MEIM	AB	Self-Esteem	ESM
10	Goodstein and Ponterotto, (1997)	126	YA	RIAS	PE, E, I-E, I	Self-Esteem	RSES
11	Holmes and Lochman, (2009)	103	A	MEIM	TS	Self-Esteem	PCS-C
12	Jackson and Neville, (1998)	118	YA	RIAS	PE, E, I-E, I	Psych. Well-Being	HS
12	Jackson and Neville, (1998)	118	YA	RIAS	PE, E, I-E, I	Academic Adjus.	MVS
13	Jones, Cross, and DeFour, (2007)	262	YA	CRIS	As, Mi, SH, AW, N, Mu	Self-Esteem	RSES
14	Lockett and Harrell, (2003)	128	YA	RIAS	PE, E, I-E, I	Self-Esteem	RSES

Study No.	Authors, (Year)	Sample Size, N	Age Group	Racial Identity Measure	Racial Identity Subscales	Mental Health Variable	Mental Health Measure
15	Mandara, Gaylord-Harden, Richards, and Ragsdale, (2009)	259	A	Modified MEIM	AB	Anxiety	STAI-C
15	Mandara, Gaylord-Harden, Richards, and Ragsdale, (2009)	259	A	MEIM	AB	Self-Esteem	ESM
16	McMahon and Watts, (2002)	209	A	MEIM	TS	Coping	CCSC
17	Mandara and Smith (under review)	152	A	Modified MEIM		Depression	CDI
17	Mandara and Smith (under review)	152	A	Modified MEIM		Self-esteem	ESM
18	McMahon and Watts, (2002)	209	A	MEIM	TS	Anxiety	RCMAS
18	McMahon and Watts, (2002)	209	A	MEIM	TS	Externalizing	NBAS
18	McMahon and Watts, (2002)	209	A	MEIM	TS	Self-Esteem	SPPC
19	Munford, (1994)	229	YA	RIAS	PE, E, I-E, I	Depression	BDI

Study No.	Authors, (Year)	Sample Size, N	Age Group	Racial Identity Measure	Racial Identity Subscales	Mental Health Variable	Mental Health Measure
19	Munford, (1994)	229	YA	RIAS	PE, E, I-E, I	Self-Esteem	RSES
20	Phinney, Cantu, and Kurtz, (1997)	232	A	MEIM	AB	Self-Esteem	RSES
20	Pierre and Mahalik, (2005)	130	YA	RIAS	PE, I-E, I	Self-Esteem	SEI
21	Pillay, (2005)	136	YA	RIAS	PE, E, I-E, I	Psych. Well-Being	MHI
22	Poindexter-Cameron and Robinson (1997)	84	YA	RIAS	PE, E, I-E, I	Self-Esteem	RSES
23	Rowley, Sellers, Chavous, and Smith (1998)	176	YA	MIBI	PrR, PuR, C	Self-Esteem	RSES
24	Scott, (2003)	71	A	MIBI	C	Discrim. Distress	RLES
24	Scott, (2003)	71	A	MIBI	C	Coping	SRCS
25	Seaton, Scottham, and Sellers, (2006)	224	A	MEIM	Ex, Co	Depression	CES-D
25	Seaton, Scottham, and Sellers, (2006)	224	A	MEIM	Ex, Co	Psych. Well-Being	PWBS
26	Sellers, Copeland-Linder, Martin, and Lewis, (2006)	314	A	MIBI	PrR, PuR, C	Depression	CES-D

Study No.	Authors, (Year)	Sample Size, N	Age Group	Racial Identity Measure	Racial Identity Subscales	Mental Health Variable	Mental Health Measure
26	Sellers, Copeland-Linder, Martin, and Lewis, (2006)	314	A	MIBI	PrR, PuR, C	Psych. Well-Being	PWBS
26	Sellers, Copeland-Linder, Martin, and Lewis, (2006)	314	A	MIBI	PrR, PuR, C	Stress	DLES
27	Simons, Murry, McLoyd, Lin, Cutrona, and Conger, (2002)	867	A	MEIM	TS	Depression	DISC-IV
28	Smith, Walker, Fields, Brookins, and Seay (1999)	100	A	MEIM	EI, EB, AB	Self-Esteem	BC
29	Speight, Vera, and Derrickson, (1996)	232	YA	RIAS	PE, E, I-E, I	Self-Esteem	USRS
30	Swenson and Prelow, (2005)	133	A	MEIM	AB	Depression	CES-D
30	Swenson and Prelow, (2005)	133	A	MEIM	AB	Self-Esteem	RSES
30	Swenson and Prelow, (2005)	133	A	MEIM	AB	Externalizing	PBFS
31	Thomas, Townsend, and Belgrave, (2003)	104	A	CBIS	TS	Self-Esteem	PHC-SCS

Study No.	Authors, (Year)	Sample Size, N	Age Group	Racial Identity Measure	Racial Identity Subscales	Mental Health Variable	Mental Health Measure
31	Thomas, Townsend, and Belgrave, (2003)	104	A	CBIS	TS	Externalizing	CRS
31	Thomas, Townsend, and Belgrave, (2003)	104	A	CBIS	TS	Academic Adjus.	TRS
32	Umana-Taylor and Shin, (2007)	261	YA	EIS	Ex, A, R	Self-Esteem	RSES
33	Vandiver, Cross, Worrell, and Fhagen-Smith, (2002)	296	YA	CRIS	As, N, Mi, SH, AW, Mu	Self-Esteem	RSES
34	Walker, Wingate, Obasi, and Joiner, (2008)	296	YA	MEIM	TS	Depression	BDI
34	Walker, Wingate, Obasi, and Joiner, (2008)	296	YA	MEIM	TS	Stress	SAFE
36	Wong, Eccles, Sameroff, (2003)	629	A	MADIC	TS	Psych. Well-Being	SCL
36	Wong, Eccles, Sameroff, (2003)	629	A	MADIC	TS	Depression	SCL
36	Wong, Eccles, Sameroff, (2003)	629	A	MADIC	TS	Externalizing	PBQ
36	Wong, Eccles, Sameroff, (2003)	629	A	MADIC	TS	Self-Esteem	CDI

Study No.	Authors, (Year)	Sample Size, N	Age Group	Racial Identity Measure	Racial Identity Subscales	Mental Health Variable	Mental Health Measure
37	Yasui, Dorham, and Dishion, (2004)	82	A	MEIM	EI, AB	Depression	CDI
37	Yasui, Dorham, and Dishion, (2004)	82	A	MEIM	EI, AB	Externalizing	CBCL
38	Yip, Seaton, and Sellers, (2006)	940	A	MIBI	PrR, PuR, C, As, H, N, OM	Depression	CES-D

Note A = Adolescent. YA = Young Adult. MIBI = Multidimensional Inventory of Black Identity. CBIS = Children's Black Identity Scale. CRIS = Cross Racial Identity Scale. EIS = Ethnic Identity Scale. MADIC = Maryland Adolescents Development in Context Ethnic Identity Questionnaire. MEIM = Multigroup Ethnic Identity Measure. MMRI = Multidimensional Racial Identity Model. RIAS = Racial Identity Attitudes Scale. PrR = Private Regard. PuR = Public Regard. C = Centrality. As = Assimilation. H = Humanist. N = Nationalist. OM = Oppressed Minority. Mi = Miseducation. SH = Self-Hatred. AW = Anti-White. Mu = Multiculturalist. PE = Pre-Encounter. E = Encounter. I-E = Immersion-Emersion. I = Internalization. AB = Affirmation and Belonging. EI = Ethnic Identity. EB = Ethnic Behaviors. A = Affirmation. Ex = Exploration. Co = Commitment. R = Resolution. TS = Total Score. CDI = Children's Depression Inventory. BDI = Beck Depression Inventory. CES-D = Center for Epidemiological Studies Depression Scale. BSI = Brief Symptom Index. SCL = Symptoms Checklist Revised. DISC-IV = Diagnostic Interview Schedule for Children. STAI-C = State-Trait Anxiety Inventory for Children. RSES = Rosenberg Self-Esteem Scale. PHC-SCS = Piers-Harris Children's Self-Concept Scale. USRS = Unconditional Self-Regard Scale. POI = Personal Orientation Inventory/Self-Regard Subscale. ESM = Experiential Sampling Method. BC = Bronstein-Cruz Child/Adolescent Self-Concept and Adjustment Scale. PCS-C = Perceived Competence Scale for Children. SPCC = Self-Perception Profile for Children. SEI = Coopersmith Self-Esteem Inventory. SEM = School Efficacy Measure. GPA = Grade Point Average. MVS = My Vocational Situation. TRS = Teacher Rating Scale. SACQ = Student Adaption to College Questionnaire. VBQ = Violent Behaviors Questionnaire. NBAS = Normative Beliefs about Aggression Scale. PBFS = Problem Behavior Frequency Scale. CBCL=Child Behavior Checklist. CRS = Child Rating Scale. PBQ = Problem Behaviors Questionnaire. SRCS = Self-report Coping Scale. CCSC = Children's Coping Strategies Checklist. RLES = Racism and Life Experiences Scales. DLES = Daily Life Experiences Scale. SAFE = Societal, Attitudinal, Familial, and Environmental Acculturative Stress Scale. HS = Hope Scale. PWBS = Ryff's Psychological Well-Being Scale. MHI = Mental Health Inventory.

Table 4.4: Outcome Variables from Studies

Academic Adjustment	Depression	Well-Being	Psychological Problems	Self-Esteem
College Adjustment	Depressive Symptoms	Hope	Anxiety	Self-worth
School Attachment	Depression	Coping	Externalizing	Self-efficacy
School Relevance	Internalizing Behaviors	Overall Mental Health	Violent Behavior	Perceived Efficacy
School Efficacy		Psychological Resiliency	Psychological Problems	Self-regard
School Importance			Aggressive Behavior	
Grade Point Avg			Discrimination Distress	
School Interest			Anger	
Academic Self-concept			Perceived Stress	
Vocational Identity				

Table 4.5: Average Correlations between Racial Identity Factors and Mental Health Variables (Part 1)

Variables	Gender	Race Pride			Humanist			Exploration		
		M	N	E	M	N	E	M	N	E
Academic	Both	0.11	3471	10	0.16	282	2			
	Female	0.29^C	77	1						
	Male	0.26^B	41	1						
Depression	Both	-0.13	3418	10	-0.59	1134	2	-0.05	1246	3
	Female	-0.16	722	4	-0.02	262	1			
	Male	-0.49^C	200	2						
Well-being	Both	0.20^C	1855	9				0.27^C	224	1
	Female	0.21^A	77	1						
	Male	0.61^C	41	1						
Psych Probes	Both	-0.03	2358	8				-0.19	82	1
	Female	-0.07	200	2						
	Male	-0.12	460	3						
Variables	**Gender**	**M**	**N**	**E**	**M**	**N**	**E**	**M**	**N**	**E**
Self-esteem	Both	0.25^B	3979	21	0.16^B	609	2	0.29^A	200	2
	Female	0.03	922	5	0.02	262	1	0.06	200	1
	Male	0.36^C	330	3						
Total			1851	81		2549	8		1952	8

Note. M = mean correlation (r) across studies, N = number of studies that included both the racial identity factor and the mental health variable, E = effect size. $^C p < .001$, $^B p < .01$, $^A p < .05$

Table 4.5: Average Correlations between Racial Identity Factors and Mental Health Variables (Part 2)

Variables	Gender	Salience			Cultural Mistrust		
		M	N	E	M	N	E
Academic	Both	0.03	2895	5	-0.17	368	3
	Female				0.04	77	1
	Male				-0.07	41	1
Depression	Both	0.04	1969	4	0.05	1363	3
	Female				0.07	262	1
	Male						
Well-being	Both	-0.06A	865	2	-0.12	272	2
	Female				0.11	77	1
	Male				-0.12	41	1
Psych Probes	Both	-0.01	3030	7			
	Female						
	Male						
Variables	**Gender**	M	N	E	M	N	E
Self-esteem	Both	0.17	1043	4	-0.16	1462	8
	Female				-0.02	462	2
	Male				-0.13	130	1
Total			9802	22		4555	24

Note. M = mean correlation (r) across studies, N = number of studies that included both the racial identity factor and the mental health variable, E = effect size. C $p < .001$, B $p < .01$, A $p < .05$

Results

Computation and Analysis of Effect Size Estimates

The studies mainly reported zero-order correlations (Pearson's r) between some dimension of racial identity and some measure of well-being. To assess overall effect sizes, we averaged all correlations across studies for each of the five racial identity dimensions by depressive symptoms, self-esteem, academic adjustment, psychological problems, and psychological well-being separately (see Table 4.4). We also averaged the effect sizes by gender when the information was provided. Each effect size estimate was weighted by the number of participants in each analysis. Using standard fixed effects meta-analytic procedures (Mullen, 1989; Smith and Silva, 2010), each correlation was first transformed using Fishers z transformation of r, and then the sample size weighted averages were computed. The individual probability values of obtaining the average fixed effect sizes were calculated by combining the individual probability values of each correlation coefficient as suggested by Rosenthal (1991). Thus, as shown in Table 4.5, this resulted in averaged weighted effect sizes for males and females or both (studies that did not give gender specific information) for each racial identity dimension by the five well-being measures (See Table 4.4).

Effects of Racial Identity on Each Outcome by Gender

The results indicated that racial pride tended to have the most consistent and strong relationship with mental health and academic outcomes compared to the other racial identity dimensions, but the results were somewhat different for males and females. For males, higher levels of racial pride were associated with higher levels of academic achievement, self-esteem and emotional well-being. It was also negatively related to depressive symptoms and other psychological problems for males. Although not as strong, the same general pattern held for females, except that racial pride was not related to their self-esteem.

The humanist dimension was not as commonly assessed, but the few studies available did find significant and positive effects. In studies which did not separate findings by gender, the higher one's humanistic identity, the higher their academic achievement and self-esteem and lower their depressive symptoms tended to be. No significant effects were found in the one study which examined the effects for females only, which suggests that the males were driving most of the effects in the other studies.

The effects of the other four racial identity dimensions on each outcome were more modest. The exploration factor was negatively and close- to- significantly related to academic achievement, emotional well-being and psychological problems in studies which did not separate the sample by gender. No other effects for exploration emerged. As shown in Table 4.5, those who were higher in race

salience tended to have slightly higher self-esteem, but no other effects of salience emerged. Similarly, cultural mistrust was negatively related to self-esteem and academic achievement in studies that did not separate the sample by gender, but it was not related to any of the other outcomes. The public regard dimension was negatively correlated with depressive symptoms in studies which combined males and females, but it not related significantly related to any other outcomes.

Discussion

Most modern theorists suggest that racial identity is important for African American youths' academic and psychosocial development. However, the overall results have been inconsistent. Much of the inconsistency is clearly related to the multitude of racial identity instruments and sub-factors, which have different effects on various outcomes. In the current study, we reviewed the major models and measures of racial identity and then organized them into a comprehensive conceptual framework. This framework classified the sub-factors of the major racial identity measures into the following five dimensions: (1) racial pride, (2) racial exploration, (3) cultural mistrust, (4) race salience, and (5) humanistic identity. We then used this framework to conduct a meta-analysis of all the studies which assessed the effects of racial identity on the mental health and academic achievement of young African Americans since the early 1990s. The results of the meta-analysis showed that there are in fact very consistent effects of particular racial identity dimensions across most of the included studies. The strength of the effects were somewhat moderated by gender, but the general pattern of results was the same for African American male and female youth.

Racial pride, which refers to one's positive feelings about their racial group and themselves as a member of that group, was the most well-studied racial identity dimension. It was also the dimension with the strongest and most consistent effects on the mental health and academic outcomes. Overall, feelings of racial pride were positively and strongly related to African American youth's mental health. Feelings of racial pride were associated with less depressive symptoms. Racial pride was also a strong predictor of positive emotional well-being and self-esteem. These finding were especially large for males. For females, racial pride was not related to their self-esteem, but was still associated with better mental health overall.

Similarly, most studies found that positive feelings about being an African American or person of African descent was related to better academic outcomes. The effects were appreciably stronger in the one study which separated the results for males and females. Thus, given how important gender has been for the mental health effects, the actual effects of racial identity on academic outcomes probably will not be known until more studies are done which analyze the results separately for males and females.

In spite of a few inconsistencies, based on the studies in this area, it is clear that higher levels of racial pride are linked to positive outcomes for African American

youth. Mandara et al. (2009) and Rowley et al. (1998) suggested that measures of racial pride may be strongly related to African American youths' mental health because the affective and evaluative aspects of racial pride tap into the affective components of the self-esteem, depressive symptoms and overall emotional well-being measures. Mandara et al. (2009) also argued that may be why racial pride does not have as strong an effect on other, less emotionally based aspects of mental health such as anxiety. Thus, feeling positive about one's racial group and one's association with that group relates to one's feelings about themselves as an individual and their life chances, but it may have less influence on problems such as anxiety or PTSD symptoms. Future longitudinal and especially experimental studies will need to help clarify the direction of the racial pride effect. However, it seems more likely the case that strong positive feelings of racial pride facilitate mental health and academic achievement, probably because it increases African American youths' positive feelings about themselves as an individual and their ability to overcome obstacles.

The humanist dimension of racial identity is interesting because of its conceptual meaning and because of the findings. In general, the dimension is based on the measures derived from the Nigrescence models. In those models, it refers to the degree to which an individual has attained a mature level of identity, which is indicative of security and pride with one's own racial heritage, as well as an appreciation for other groups (Cross, 1971, Parham, 1989). This dimension is very different from assimilation, which is probably based on an individual's need to feel a part of something other than his or her heritage because of a low sense of racial pride. The humanistic dimension is a measure of one's comfortableness with themselves, to such a degree, that they can appreciate and relate to others without being reactive. There is no underlying insecurity about his or her blackness. In fact, dozens of studies which assessed the pride components of the MEIM have found that those who are higher in affirmation/belonging or the pride component of the MEIM have found that the same individuals are more likely to have a better relationship with those of other racial groups as well.

Although only a few studies have assessed the effects of the humanist dimension on African American youth, the findings mirror those for racial pride in terms of self-esteem. There was also a positive trend association with academic outcomes in similar studies. Thus, the humanist/multiculturalist dimension may be better thought of as a form of racial pride, and not necessarily a separate dimension. As measures of racial identity continue to develop, the relationship between humanism and pride will become clearer.

The salience subfactor had few significant findings but was positively associated with psychological well-being in studies of both boys and girls. Salience refers to how relevant one's race is to his or her self-concept during a specific event (Sellers et al., 1998). It is a dynamic process which fluctuates more than the other components situationally. Perhaps strong racial salience is associated with psychological well-being under certain circumstances. Therefore, not including the

context in which race is salient to a person may fail to capture the true nature of this process.

The exploration subfactor also revealed some interesting findings. Exploration, again, refers to the process by which individuals seek out information related to their race and culture to gain better understanding of their culture. Arroyo and Zigler (1995) discuss Ogbu's racelessness theory of how academically achieving adolescents may adopt "racelessness" belief or "mainstream European-American" values about education so as to not to adopt their culture's negative view about achieving academic excellence, which is contrary to exploring one's race. They found that racelessness was associated with negative psychological outcomes such as depression and anxiety. In line with this idea, exploration was positively associated with psychological well-being and self-esteem in studies which did not separate boys and girls, highlighting the importance of exploration of cultural values and norms in adaptive African American youth development.

There was a lack of significant findings associated with the cultural mistrust dimension in our review of the literature. The idea of cultural mistrust proposes that youth may become more distrustful of other races as they are discriminated against. Although there were not any significant findings in our review, it may be difficult for researchers to capture mistrust in paper and pencil measures. Perhaps youth may be hesitant to share their feelings around these issues with researchers or the measures may not capture their actual feelings on the topic. Even so, mistrust is an important concept in the race literature as several African Americans likely have little trust in the pure intentions of mainstream institutions such as schools and hospitals for valid reasons (Corbie-Smith, Thomas, and St. George, 2002; Terrell and Terrell, 1993). Future studies should examine the factors which moderate the effects of cultural mistrust.

The meta-analysis also revealed interesting differences in outcomes based on gender. Across most of the racial identity subfactors, there were more significant differences for males. Perhaps race is more important for males than it is for females at this age. Black males may be more likely to be victims of racial discrimination, which may make racial identity more important for them. Further, the way in which males express psychological symptoms is different for boys and girls. Perhaps racial identity is one way to capture the negative psychological symptoms that would not be seen if measuring outcomes alone. Also, boys are more likely to receive more racial socialization messages preparing them for societal racial discrimination, which may make race more salient for them than for girls (Bowman and Howard, 1985; Thomas and Speight, 1999). Therefore, if race is more salient for boys than girls, associations between racial identity and outcomes would be stronger for boys.

Limitations of the Study and Field

Limitations of the current study should be noted. The first lies in the limitations associated with meta-analytic review (Smith and Silva, 2011). For our study, only studies with quantitative findings were included, which may limit our understanding of these topics. Second, only published peer-reviewed journal studies were included. Dissertation studies and unpublished works may have added important findings to this research. Third, meta-analytic results are influenced by the methods in which the included studies were conducted. Many of the measures of racial identity have low reliabilities as well as few people included in the studies which may detract from their generalizability. Further, inconsistencies such as those we have previously discussed (e.g., different operational definitions, theoretical orientations, etc.) in these studies may skew results. Finally, since meta-analytic studies utilize effect sizes based on correlation, causal relationships cannot be inferred from the results. Another potential limitation is that we may have missed some other important information on other psychosocial outcomes that may be influenced by racial identity such as social skill development, self-control, or substance use. Research shows the link between racial identity and some of these outcomes; perhaps other components of racial identity besides racial pride would be salient for these outcomes (Borrell, 2005; Townsend and Belgrave, 2000).

Summary and Implications

Despite these limitations, several important findings were derived from the conceptual framework we developed and the subsequent meta-analysis. Overall, the findings from this study support the notion that developing positive feelings about one's racial group is related to mental health and academic success. Many of these findings were for both boys and girls. As mentioned previously, racial pride may prevent African American youth from internalizing negative stereotypes which may result in less negative mental health outcomes (McLoyd et al., 2000; Spencer, 1995). Additionally, racial pride may protect against the deleterious effects of racial discrimination (Caldwell et al., 2002; Cross, Parham, and Helms, 1998). The primary implication is that, for the most part, racial pride is the dimension of racial identity that matters most for the sort of questions social scientists interested in African American children usually have. We are usually concerned about how to best develop resiliency in African American children so that they can cope with racism and the multitude of trials and tribulations they will have to endure. We are also concerned with increasing their mental health and their performance in academic environments, and ultimately being positive forces in their families and communities.

 Towards those ends, the implications of this study are strikingly clear. African American children must develop a sense of comfortableness and pride in their "Blackness," or more accurately, their "Africaness." The studies of racial socializa-

tion confirm this. Those children who receive cultural empowerment and pride messages growing up tend to perform better in school and have much better mental health than those who do not receive such messages (Hughes et al., 2006). Therefore, prevention and intervention efforts should highlight racial pride in their efforts with this population (McMahon and Watts, 2002; Wills et al., 2007). For example, an intervention may incorporate the use of both implicit and explicit racial pride socialization messages in exposing youth to Black art, movies, and music which positively showcase their race to enhance racial pride. Highlighting salience of one's race and preparing for racial discrimination are not likely to be as useful in this area.

References

Allen, R. L., Dawson, M. C., and Brown, R. E. (1989). A schema-based approach to modeling an African American racial belief system. *American Political Science Review, 83*, 421-44.

American Psychiatric Association. (2000). *Diagnostic and statistical manual of mental disorders* (Revised 4th ed.). Washington, DC: Author.

Anglin, D. M., and Wade, J. C. (2007). Racial socialization, racial identity, and Black students' adjustment to college. *Cultural Diversity and Ethnic Minority Psychology. 13*(3), 207-215.

Arroyo, C. G., and Zigler, E. (1995). Racial identity, academic achievement, and the psychological well-being of economically disadvantaged adolescents. *Journal of Personality and Social Psychology,69*, 903-914.

Awad, G. H. (2007). The role of racial identity, academic self-concept, and self-esteem in the prediction of academic outcomes for African American students. *Journal of Black Psychology, 33*, 188-207.

Banks, K. H., and Kohn-Wood, L. P. (2007). The influence of racial identity profiles on the relationship between racial discrimination and depressive symptoms. *Journal of Black Psychology, 33*, 331-354.

Borrell, L. N. (2005). Racial identity among Hispanics: Implications for health and well-being. *American Journal of Public Health, (95)* 3, 379-381.

Bowman, P. J., and Howard, C. (1985). Race-related socialization, motivation, and academic achievement: A study of Black youths in three-generation families. *Journal of the American Academy of Child Psychiatry, 24*(2), 131-141.

Bracey, J. R., Bamaca, M. Y., and Umana-Taylor, A. (2004). Examining ethnic identity and self-esteem among biracial and monoracial adolescents. *Journal of Youth and Adolescence, 33*, 123-132.

Buckley, T. R. and Carter, R. T. (2005). Black adolescent girls: Do gender role and racial identity impact their self-esteem? *Sex Roles, (9/10) 53*, 647-661.

Caldwell, C. H., Kohn-Wood, L. P., Schmeelk-Cone, K. H., Chavous, T. M., and Zimmerman, M. A. (2004). Racial discrimination and racial identity as risk or

protective factors for violent behaviors in African American young adults. *American Journal of Community Psychology, 33,* 91-105.

Caldwell, C. H., Zimmerman, M. A., Bernat, D. H., Sellers, R. M., and Notaro, P. (2002). Racial identity, maternal support, and psychological distress among African American adolescents. *Child Development, 73,* 1322-1336.

Carter, R. T., DeSole, L., Sicalides, E. I., Glass, K., and Tyler, F. B. (1997). Black racial identity and psychosocial competence: A preliminary study. *Journal of Black Psychology, 23,* 58-73.

Chavous, T. M., Hilkene Bernat, D., Schmeelk-Cone, K., Caldwell, C. H., Kohn-Wood, L., and Zimmerman, M. A. (2003). Racial identity and academic attainment among African American adolescents. *Child Development, 74,* 1076-1090.

Chavous, T. M., Rivas-Drake, D., Smalls, C., Griffin, T., Cogburn, C. (2008). Gender matters, too: The influences of school racial discrimination and racial identity on academic engagement outcomes among African American adolescents. *Developmental Psychology, 44*(3), 637-654.

Cokley, K. (2007). Critical issues in the measurement of ethnic and racial identity: A referendum on the state of the field. *Journal of Counseling Psychology, 54,* 224-234.

Corbie-Smith, G., Thomas, S. B., St. George, D. M., (2002). Distrust, race and research. *Archive of Internal Medicine, 162,* 2458-2463.

Cross, W. E., Jr. (1971). The Negro-to-Black conversion experience. *Black World,* 20 (9), 13-27.

Cross, W. E., Jr. (1991). *Shades of black: Diversity in African American identity.* Philadelphia: Temple University Press.

Cross, W. E., Parham, T. A., and Helms, J. E. (1998). Nigresence revisited: Theory and research, pp. 3-71. In R. L. Jones (Ed.), *African American identity development.* Hampton, VA: Cobb and Henry.

Demo, D. H., and Hughes, M. (1990). Socialization and racial identity among Black Americans. *Social Psychology Quarterly, 53,* 364-374.

Erikson, E. H. (1968). *Identity: Youth and Crisis.* New York: Norton.

Gaylord-Harden, N. K., Ragsdale, B. L., Mandara, J., Richards, M. H., and Petersen, A. C. (2007). Perceived support and internalizing symptoms in African American adolescents: Self-esteem and ethnic identity as mediators. *Journal of Youth and Adolescence, 36,* 77-88.

Goodstein, R., and Ponterotto, J. G. (1997). Racial and ethnic identity: Their relationship and their contribution to self-esteem. *Journal of Black Psychology, 23,* 275-29.

Holmes, K. J., and Lochman, J. E. (2009). Ethnic identity in African American and European American preadolescents relation to self-worth, social goals, and aggression. *Journal of Early Adolescence, 29*(4), 476-496.

Hughes, D., Rodriguez, J., Smith, E. P., Johnson, D. J., Stevenson, H. C., and Spicer, P. (2006). Parents' ethnic-racial socialization practices: A review of

research and directions for future study. *Developmental Psychology, 42*(5), 747-770.

Jackson, C. C. and Neville, H. A. (1998). Influence of Racial Identity Attitudes on African American College Students' Vocational Identity and Hope. *Journal of Vocational Behavior, 53*, 97-113.

Jones, H. L., Cross, W. E. Jr., and DeFour, D. C. (2007). Race-related stress, racial identity attitudes, and mental health among Black women. *Journal of Black Psychology, 33*, 208-231.

Lockett, C. T., and Harrell, J. P. (2003). Racial identity, self-esteem, and academic achievement: Too much interpretation, too little supporting data. *Journal of Black Psychology, 29,* 325-336.

Mandara, J., Gaylord-Harden, N. K., Richards, M. H., and Ragsdale, B. L. (2009). The effects of changes in racial identity and self-esteem on changes in African American adolescents' mental health. *Child Development, (80),* 1660-1675.

Mandara, J. and Smith, C. D. (under review). *Pride over paranoia: The effects of racial socialization and identity on African American adolescents' mental health.*

Marks, B., Settles, I. H., Cooke, D. Y., Morgan, L., and Sellers, R. M. (2004). African American racial identity: A review of contemporary models and measures, pp. 383-404. In R. L. Jones (Ed.), *Black psychology* (Fourth edition). Hampton, VA: Cobb and Henry.

McCowan, C. J., and Alston, R. J. (1998). Racial identity, African self-consciousness, and career decision making in African American college women. *Journal of Multicultural Counseling and Development, 26* (1), 28-38.

McLoyd, V. C., Cauce, A. M., Takeuchi, D., Wilson, L. (2000). Marital processes and parental socialization in families of color: A decade review of research. *Journal of Marriage and the Family, 62,* 1070-1093.

McMahon, S. D., and Watts, R. J. (2002). Ethnic identity in urban African American youth: Exploring links with self-worth, aggression, and other psychosocial variables. *Journal of Community Psychology, 30,* 411-431.

Mullen, B. (1989). *Advanced BASIC Meta-analysis.* Hillsdale, NJ: Erlbaum.

Munford, M. B. (1994). Relationship of gender, self-esteem, social class, and racial identity to depression in Blacks. *Journal of Black Psychology, 20,* 143-156.

Parham, T. A. (1989). Cycles of Psychological Nigrescence. *The Counseling Psychologist, 17(2),* 187-226.

Parham, T. A., and Helms, J. E. (1981). The influence of Black students' racial identity attitudes on preference for counselor's race. *Journal of Counseling Psychology, 28,* 250-258.

Pierre, M. R., and Mahalik, J. R. (2005). Examining African self-consciousness and Black racial identity as predictors of Black men's psychological well-being. *Cultural Diversity and Ethnic Minority Psychology, 11,* 28-40.

Phinney, J. (1989). Stages of ethnic identity development in minority group adolescents. *Journal of Early Adolescence, 9,* 34-49.

Phinney, J. S. (1991). Ethnic identity and self-esteem: A review and integration. *Hispanic Journal of Behavioral Sciences, 13*,193-208.

Phinney, J. S. (1992). The Multigroup Ethnic Identity Measure: A new scale for use with adolescents and young adults from diverse groups. *Journal of Adolescent Research, 7,* 156-176.

Phinney, J., Cantu, C., and Kurtz, D. (1997). Ethnic and American identity as predictors of self-esteem among African American, Latino, and White adolescents. *Journal of Youth and Adolescence, 26*, 165-185.

Phinney, J. S., and Chavira, V. (1992). Ethnic identity and self-esteem: An explanatory longitudinal study. *Journal of Adolescence, 15,* 271-281.

Pierre, M. R., and Mahalik, J. R. (2005). Examining African self-consciousness and Black racial identity as predictors of Black men's psychological well-being. *Cultural Diversity and Ethnic Minority Psychology, 11,* 28-40.

Pillay, Y. (2005). Racial identity as a predictor of the psychological health of African American students at a predominantly White university. *Journal of Black Psychology, 31,* 46-66.

Poindexter-Cameron, J. M., and Robinson, T. L. (1997). Relationships among racial identity attitudes, womanist identity attitudes, and self-esteem in African American college women. *Journal of College Student Development, 38,* 288-296.

Pope, R. L. (2000). The relationship between psychosocial development and racial identity of college students of color. *Journal of College Student Development, 41,* 302-312.

Roberts, R. E., Phinney, J. S., Masse, L. C., Chen, Y. R., Roberts, C. R., and Romero, A. (1999). The structure of ethnic identity of young adolescents from diverse ethnocultural groups. *Journal of Early Adolescence, 19*, 301-322.

Rosenthal, R. (1991). Meta-analytic procedures for social research (Rev. ed.). Newbury Park, CA : Sage.

Rowley, S. A. J., Sellers, R. M., Chavous, T. M., and Smith, M. (1998). The relationship between racial identity and self-esteem in African American college students. *Journal of Personality and Social Psychology, 74,* 715-724.

Scott, L. D. (2003). The relation of racial identity and racial socialization to coping with discrimination among African American adolescents. *Journal of Black Studies, 33*(4), 520-538.

Scottham, K. M., Sellers, R. M., and Nguyen, H. X., (2008). A Measure of Racial identity in African American adolescents: The development of the Multidimensional Inventory of Black Identity-Teen. *Cultural Diversity and Ethnic Minority Psychology, 14*(4), 297-306.

Seaton, E. K., Scottham, K. M., and Sellers, R. M. (2006). The Status model of racial identity development in African American adolescents: Evidence of structure, trajectories and well-being. *Child Development, 77,* 1416-1426.

Sellers, R. M., Rowley, S., Chavous, T. M. , Shelton , J. N., and Smith, M. A. (1997). The multidimensional inventory of Black identity: Construct validity and reliability. *Journal of Social and Personality Psychology, 73*(4), 805-815.

Sellers, R. M., Shelton, N., Cooke, D., Chavous, T., Rowley, S. J., and Smith, M. (1998). A multidimensional model of racial identity: Assumptions, findings and future directions. *African American Identity Development*, 275-302.

Sellers, R. M., Smith, M. A., Shelton, J. N., Rowley, S. A. J., and Chavous, T. M. (1998). Multidimensional Model of Racial Identity: A reconceptualization of African American racial identity. *Personality and Social Psychology Review, 2*, 18-39.

Sellers, R. M., Copeland-Linder, N., Martin P. P., and Lewis, R. L. (2006). Racial identity matters: The relationship between racial discrimination and psychological functioning in African American adolescents. *Journal of Research on Adolescence, 16*(2), 187-216.

Simons, R. L., Murry, B., McLoyd, V., Lin, K., Cutrona, C., and Conger, R. D. (2002). Discrimination, crime, ethnic identity, and parenting as correlates of depressive symptoms among African American children: A multilevel analysis. *Development and Psychopathology, 14*, 371-393.

Smith, T., and Silva, L. (2011). Ethnic identity and personal well-being of people of color: A meta-analysis. *Journal of Counseling Psychology, 58*(1), 42-60.

Smith, E. P., Walker, K., Fields, L., Brookins, C. C., and Seay, R. C. (1999). Ethnic identity and its relationship to self-esteem, perceived efficacy and prosocial attitudes in early adolescence. *Journal of Adolescence, 22*, 867-880.

Speight, S. L., Vera, E. M., and Derrickson, K. B. (1996). Racial self-designation, racial identity, and self-esteem revisited. *Journal of Black Psychology, 22*, 37-52.

Spencer, M. B. (1995). Old issues and new theorizing about African American youth: A phenomenological variant of ecological systems theory, pp. 37-69. In R. L. Taylor (Ed.), *Black youth: Perspectives on their status in the United States*. Westport, CT: Praeger.

Spencer, M. B., Dupree, D., and Hartmann, T. (1997). A phenomenological variant of ecological systems theory (PVEST): A self-organization perspective in context. *Development and Psychopathology, 9*, 817-833.

Swenson, R. R. and Prelow, H. M. (2005). Ethnic identity, self-esteem, and perceived efficacy as mediators of the relation of supportive parenting to psychosocial outcomes among urban adolescents. *Journal of Adolescence, 28*, 465-477.

Terrell, F., and Terrell, S. L. (1993). Level of cultural mistrust as a function of educational and occupational expectation among Black students. *Adolescence, 28*(111), 573-579.

Thomas, D. E., Townsend, T. G., Belgrave, F. Z. (2003). The influence of cultural and racial identification on the psychosocial adjustment of inner-city African American children in school. *American Journal of Community Psychology. 32*(3-4), 217-228.

Thomas, A. J., and Speight, S. L. (1999). Racial identity and racial socialization attitudes of African American parents. *Journal of Black Psychology, 25*, 152-170.

Townsend, T. G. and Belgrave, F. Z. (2000). The impact of personal identity and racial identity on drug outcomes among African American children. *Journal of Black Psychology, 46*(4), 421-436.

Umana-Taylor, A. J., and Shin, N. (2007). An examination of ethnic identity and self-esteem with diverse populations: Exploring variation by ethnicity and geography. *Cultural Diversity and Ethnic Minority Psychology, 13,* 178-186.

Umana-Taylor, A. J., Yazedjian, A., Bamaca-Gomez, M. (2004). Developing the ethnic identity scale using Eriksonian and social identity perspectives. *Identity: An International Journal of Theory and Research, 4*(1), 9-38.

Vandiver, B. J., Cross, W. E. Jr., Fhagen-Smith, P. E., Worrell, F. C., Swim, J., and Caldwell, L. (2000). *The Cross Racial Identity Scale.* Unpublished scale.

Vandiver, B. J., Cross, W. E., Jr., Worrell, F. C., and Fhagen-Smith, P. E. (2002). Validating the Cross racial Identity Scale. *Journal of Counseling Psychology, 49,* 71-85.

Walker, R. L., Wingate, L. R., Obasi, E. M., Joiner, T. E. (2008). An empirical investigation of acculturative stress and ethnic identity as moderators for depression and suicidal ideation in college students. *Cultural Diversity and Ethnic Minority Psychology, 14* (1), 75-82.

Wills, T. A., Murry, V. M., Brody, G. H., Gibbons, F. X., Gerrard, M., Walker, C., Ainette, M. G. (2007). Ethnic pride and self-control related to protective and risk factors: Test of the theoretical model for the strong African American families program. *Health Psychology, 26*(1), 50-59.

Witherspoon, K., Speight, S., and Thomas, A. (1997). Racial identity attitudes, school achievement, and academic self-efficacy among African American high school students. *Journal of Black Psychology, 23*(4), 344-357.

Wong, C. A., Eccles, J. S., and Sameroff, A. (2003). The influence of ethnic discrimination and ethnic identification on African American adolescents' school and socioemotional adjustment. *Journal of Personality, 71,* 1197-1232.

Yasui, M., Dorham, C. L., and Dishion, T. J. (2004). Ethnic identity and psychological adjustment: A validity analysis for European American and African American adolescents. *Journal of Adolescent Research, 19,* 807- 825.

Yip, T., Seaton, E. K, Sellers, R. M. (2006). African American racial identity across the lifespan: Identity status, identity content, and depressive symptoms. *Child Development, 77,* 1504-1517.

Chapter Five
Black Identity and Well-Being:
Untangling Race and Ethnicity

William E. Cross, Jr., Bruce Ormond Grant, and Ana Ventuneac

Introduction

Black identity and well-being were explored, using independent measures of ethnicity and racial/cultural identity to determine the overlap between ethnicity and racial identity. One hundred thirty-eight male and female college students completed a survey packet containing separate measures of racial identity (CRIS) and ethnic identity (MEIM), along with two measures of well-being (general ego-identity development and global self-esteem). Fifty-eight (38 percent) of the participants identified as African American and eighty-six (62 percent) as Black Immigrant. High scores on ethnic identity were associated with positive self-esteem and advanced ego-identity development; however, ethnic identity scores did not differentiate African Americans from Black Immigrants. The racial identity measure distinguished between Assimilation, Afrocentric, and Multicultural forms of Black identity, and the results of regression analysis showed these three identity orientations were equally efficacious as pathways to well-being. Racial Self-Hatred, and, to a lesser degree, [racial] Miseducation were linked to negative self-esteem and less fully developed ego-identity. Post hoc analysis showed African Americans and Black Immigrants configure their racial identity differently. The overall findings suggest that in studies of social identity, racial-cultural and ethnic-racial are blended rather than distinct constructs.

Literature Review

Central to the discourse on black identity is an understanding that the self-concept has no less than two domains (Cross, 1991; Porter and Washington, 1979; Spencer, 1982): (1) a personality component reticulating general personality traits, general ego mechanisms, and general personality dynamics that, taken together, make possible a person's self-description using only personality descriptors ("I am defensive; sharing and caring; full of energy; forgetful; good under pressure, etc."); and (2) a social identity component variously labeled group identity, collectivist identity, and reference group orientation, which a person references in a depiction of the self that relies solely on group identity descriptors (I am a gay, black male, and I belong to the gay-friendly MCC Church of New York City, which allows me to be openly gay, Christian and connected to Jesus.").

Discussions of black identity build on knowledge gleaned from clinical, counseling, and social-personality psychology that individuals exhibiting positive general personality dynamics tend to be connected to and show a sense of belonging toward one or more social groups (Carter, 1995: Cross, 1991; Erikson, 1968; Tajfel, 1981). In this light, well-being, positive mental health, and positive ego identity development are said to go hand and hand with group affirmation, a sense of group belonging, and a meaning- making system or world view anchored by the belief systems, values, and ideas readily traceable to the social constructions of one or various reference groups (Stryker, 1987; Urry, 1973). Depression, alienation, sociopathic tendencies, lower self-esteem, ego-identity diffusion and dissociation have been linked to persons who are without a sense of group and social connectedness (Kernberg, 2006).

The hypothesized connection between the personality and group identity components of the self-concept is foundational to *generic* psychological theories. For example, core to Tajfel's Social identity Theory (1981) is the presupposition that self-esteem and group identity are critically linked. Erikson's Ego Identity Theory (Erikson, 1968) traces the unfolding of both personality and group identity and highlights the adolescent and early adulthood developmental periods, when individuals struggle to achieve self-concept integration. Finally, the linkage between the two domains or self-concept synthesis are core to both identity theories dedicated to explicating self-concept dynamics specific to black people (Aboud, 1988; Azibo, 2003; Helms, 1995; Nobles, 1973; Sellers et al., 1998) and a wide range of racial-cultural groups (Phinney, 1989).

In moving from the general proposition that human beings need positive group affirmations and a sense of group belonging in order to achieve a well-rounded and positively articulated self-concept, toward racial-cultural theories that define the connection between *ascriptive* identity and well-being, a critical point has generally been lost in translation. The general theorem does not prescribe which group or groups a person must select in order to achieve self-concept integration. Reference group theory (Hyman and Singer, 1968) evolved, in part, to explain how a person may achieve a sense of self and well-being by embracing a social perspective

derived from ideas and notions associated with a group to which the person is generally not associated. This means the original notion of a connection between personality and group identity incorporated a great deal of *plasticity*. In contrast, the various black identity theories (Azibo, 2003; Helms, 1995; Nobles, 1973; Sellers et al., 1998), as well as Phinney's (1989) Pan-Ethnic Identity Model, offer a more bounded interpretation, by holding that a minority group member can only achieve personal well-being through a group identity premised on one's social ascription. That is, if one's ascriptive or nominal category is "black," then the achievement of a black identity is thought to be *prescriptive* for positive well-being, and, by implication, the inculcation of an "other-group" orientation to negative well-being.

Nigrescence Theory and the CRIS

One theoretical orientation has attempted to modify the discourse on black identity by re-inserting the social category plasticity found in the original theorem. Nigrescence Theory (Cross, 1991; 1995; Cross and Fhagen-Smith, 2001) pre-supposes there is not a single form or type of black identity and that a large sample of black adults reveals a broad range of identity orientations, resulting in a classification challenge. Using the importance or salience of racial and black cultural content as an organizing principle, the theory suggests most identity orientations fall into one of three categories: (1) moderate-to-high race salience [HIGH-RS]; (2) low race salience [LOW-RS]; and (3) moderate-to-high *negative* race salience [NEGATIVE-RS] (Cross and Fhagen-Smith, 2001; Cross and Cross, 2008). Within the HIGH-RS cluster can be placed any variant of black racial/ cultural identity that accords moderate to high importance to black racial and cultural content and themes, as in Afrocentric (primary significance attached to a black perspective), Bi-cultural (a sense of being black balanced with a sense of being American), or Multicultural (a perspective that intersects race with two or more ethnic or cultural identity anchor points). LOW-RS exemplars reflect any type of positive identity that accords little or no significance to race and black culture and is sometimes assigned the inappropriate label "other-group-orientation," as if conservative-oriented black American citizens, as case in point, were precluded from claiming an American identity over a racial identity. In Nigrescence Theory, LOW-RS exemplars are thought to have the same psychological integrity, complexity and dimensionality as the HIGH-RS forms, only race and black culture play an insignificant role in the content, thematic, and ideological focus of the identity. Instead of race and black culture, black individuals holding LOW-RS stances may organize group identity around spiritualism and religiosity, gender or gender orientation, immigrant status, professional status or occupational status, or a pro-American, individualistic, Assimilationist orientation. The category "nega-tive" salience [NEGATIVE-RS] addresses the various forms of internalized oppression found in the black community, such as Miseducation (the acceptance as factual, beliefs about black people that are actually stereotypes); colorism (judgmental perceptions based on skin color variations within the black com-

munity), and racial/cultural self hatred (racial self loathing). Nigrescence Theory associates positive mental health with either the HIGH-RS or LOW-RS types of identity exemplars, while NEGATIVE-RS identity orientations are linked to poor mental health and negative well-being. In this scheme, ethnicity is not prescriptive of well-being, but holding negative feelings about one's group puts one at risk, psychologically speaking.

Since it would be unwieldy to try to capture every possible expression of black identity, the Theory's explication of black identity dynamics turns on *Assimilation* as an expression of low race salience; *Miseducation* and *Racial Self-Hatred* as expressions of internalized racism or negative race salience; *Anti-white* and *Racial Zeal* as expressions of identity instability; *Afrocentric* and *Multicultural* as moderate to high race salience orientations. Having established this range of identity exemplars as points of reference, the theory then compares and contrasts the orientations to determine (1) whether from infancy through early adulthood the socialization of each orientation is governed by similar or divergent psychological processes, inclusive of the Eriksonian Stages of adolescent identity development (Cross and Fhagen-Smith 2001; Cross and Cross, 2008); (2) which identity orientations may become the object of an adult identity conversion experience, as in a shift from a LOW-RS to HIGH-RS perspective (Cross, 1971, 1991); (3) how a process called identity recycling may explain the way an orientation well established at an earlier point in a person's life may show signs of refinement and elaboration at different points across the life span (Cross and Fhagen-Smith, 2001; Parham, 1989); (4) if the lived experience or *profile* of everyday enactments, transactions, and negotiations is similar or different for each orientation (Cross, Smith, and Payne, 2002; Strauss and Cross, 2005); and (5) whether the relationship between well-being and group identity is predicated on which racial/cultural orientation dominates the person's world view (Cross, 1991).

Concepts derived from Nigrescence Theory have been incorporated into a survey instrument, and the Cross Racial Identity Scale or CRIS (Vandiver et al., 2002) has six sub-scales that measure various LOW-RS, HIGH-RS and NEGATIVE-RS orientations. The CRIS can determine whether a dedicated measure of low race salience (e.g., the ASSIMILATION sub-scale of the CRIS) has different or similar psychological properties as compared to dedicated measures of moderate-to-high race salience (e.g., *Afrocentricity* or *Multicultural*) or internalized oppression (e.g., *Miseducation* or *Racial-Self-Hatred*). Findings from several studies show that persons holding an *Assimilationist* or LOW-RS orientation are no less positive in their mental health characteristics than those embracing *Afrocentric* or *Multicultural* orientations, while blacks scoring high on *Racial-Self-Hatred* show signs of poor mental health (Foster, 2004; Jones, 2005; Vandiver et al., 2002).

Ethnic Identity Development Theory and the MEIM

In contrast to Nigrescence Theory, Ethnic Identity Theory (EID Theory), as developed by Jeanne Phinney, tends to be prescriptive in suggesting that the

primary way an ethnic group member can achieve positive mental health is to avoid both NEGATIVE-RS and LOW-RS orientations, while inculcating an ethnic or HIGH-RS orientation (Phinney, 1989, 1990, 1996). Turning the spotlight on the developmental periods of pre-adolescence, adolescence, and early-adulthood, Phinney's Ethnic Identity Development Theory captures how a person comes to (1) positively "affirm" membership in a group to which she or he was accorded nominal membership at birth; (2) feel a positive sense of belonging or attachment to that group; (3) explore the ascribed group's history, culture and struggles to the point that the identification has substance, making possible an "achieved" status; and (4) translate attitudes and feeling into behaviors that are expressions of one's ethnicity, culture, and racial frame of reference. EID Theory is Pan-ethnic and is thought to be applicable to a wide range, if not all, ethnic groups, including blacks. EID Theory tends to compare and contrast ethnic archetypes such that there is "one" form of ethnic identity for group A, that can be compared to the archetype for group B, C, or D. In every instance, the theory is picturing the dynamics of what we are calling an ethnic identity that accords moderate to high salience to race and ethnicity (e.g., HIGH-RS).

EID Theory has been operationalized through The Multiple Ethnic Identity Measure or MEIM (Phinney, 1992), a paper-pencil survey scale designed to tap the affirmative, belonging, exploratory, achievement and behavioral dimension of ethnic identity. Factor analytic studies have generally failed to verify the independence of the distinct dimensions, as the inter-correlations between factors is quite high (Worrell, 2000; Worrell, Conyers, Mpofu, and Vandiver, 2006). Consequently, the MEIM is best understood as a valid and reliable measure of global HIGH-RS, but is of unproven if not questionable value for the measurement of either LOW-RS or NEGATIVE-RS.

The MEIM is referenced as a "global" measure of ethnicity, but that term does not do justice to what the MEIM is capable of providing. Recall that with regard to blacks, the exemplars Afrocentric, Bicultural, and Multicultural are expressions of the umbrella category HIGH-RS. Vandiver et al. (2001) have shown that there may be *variants* of each of these three HIGH-RS expressions. In addition, the concept of intersectionality, or the fusion of elements of race and ethnicity with other identity contingencies, such as social class status, gender identity, or lesbian or gay identity, means there are combinations and permutations of positive black identities that stretch the imagination. For the sake of discussion, let us speculate that there are three variants of Afrocentricity, three variants of Bicultural, and three variants of Multicultural. Intersectionality contingencies may add an additional twenty variants. Thus, in total, there may be as many as thirty-nine or more variations in the way black people express HIGH-RS forms of black identity. The MEIM cannot be used to isolate who amongst a sample has a specific type of HIGH-RS orientation. On the other hand the MEIM is very sensitive to any positive ethnic identity trend, regardless to which specific identity expression that trend is associated. In a manner of speaking, the MEIM hones in on the presence of ethnic identity dynamics and thus acts like a "net" that pulls in and aggregates these positive trends for the ethnic group members under study. Thus, while the CRIS

tries to isolate specific HIGH-RS orientations found in blacks, any one of which may account for a fraction of the variance associated with black identity dynamics, the MEIM sums across all expressions of ethnicity, or what we are calling HIGH-RS, and may account for far more variance.

A central focus of EID Theory is the relationship between ethnic identity self-esteem, ego identity status, and general well-being. Using the MEIM to operationalize ethnic identity, research to date suggests there is a strong positive relationship between ethnicity well-being variables, and this has been interpreted as proof that for certain ethnic groups, the development of an ethnic identity is prescriptive for positive well-being (Phinney, Cantu, and Kurtz, 1997).

Our discussion has focused solely on the capacity of the MEIM to provide global HIGH-RS information, and little has been said about the MEIM and measurement of LOW-RS or NEGATIVE-RS. Even though the MEIM is essentially a global measure of HIGH-RS and MEIM subscales do not incorporate robust, valid, and reliable subscales for LOW-RS and NEGATIVE-RS, low scores on the MEIM are often interpreted as evidence of NEGATIVE-RS and LOW-RS (Phinney, 1989). Whether or not low MEIM scores can be interpreted as a proxy for dedicated measures of LOW-RS or NEGATIVE-RS is an empirical question that will be addressed by the current study that involved the administration of both the CRIS and the MEIM to the same sample.

Predictions

In the current study, measures of ethnicity (MEIM) and racial/cultural identity (CRIS) were administered to the same sample of mostly black college students, and the outcome variables consisted of self-esteem (Rosenberg Self-Esteem Inventory: Rosenberg, 1965) and ego identity (modified version EOM-EIS: Bennion and Adams, 1986). It is predicted that ethnicity (HIGH-RS), as measured by the MEIM-TOTAL score, will be significantly and positively related to both ego identity and self-esteem. This anticipated finding would replicate previous research that has found a positive relationship between ethnicity and well-being. However, the MEIM does not incorporate an independent measure of LOW-RS, and it is not clear that low scores on ethnicity and LOW-RS are one and the same. On the other hand, the CRIS provides two exemplars of HIGH-RS (Afrocentricity and Multi-culturalism), one exemplar of LOW-RS (Assimilation), and two exemplars of Internalized Oppression or NEGATIVE-RS (Miseducation and Racial Self-Hatred). In line with Nigrescence Theory that sees either HIGH-RS or LOW-RS as equally efficacious though ideologically divergent pathways to personal mental health, and moderate to high NEGATIVE-RS as detrimental to one's well-being, it is predicted that Assimilation, Afrocentric and Multicultural will be undifferentiated in relationship to both self-esteem and ego identity, while Miseducation and especially Racial-Self-Hatred will be negatively linked. Because Miseducation is subject to self-concept compartmentalization, it is further predicted that the relationship between Miseducation and both self-esteem and ego identity will be negative

though not necessarily at a level of statistical significance. However, it is predicted that the relationship between Racial-Self-Hatred and the two well-being measures will be both negative and significant. Finding a negative link between the two NEGATIVE-RS exemplars and well-being as compared to a positive to neutral association between LOW-RS and well-being would underscore a key element of Nigrescence Theory that LOW-RS and NEGATIVE-RS are not one in the same and should be measured independently.

The MEIM does not incorporate independent and psychometrically robust LOW-RS or NEGATIVE-RS scales, but the CRIS does, and administration of the two measures to the same sample will allow us to study how MEIM scores relate to independent measures of LOW-RS and NEGATIVE-RS. Since people who embrace a LOW-RS orientation are likely to reject the importance of ethnicity in their everyday lives, it is predicted that Assimilation and MEIM scores will be negatively and significantly related. It is possible for a black person to have a positive, healthy, Assimilationist or LOW-RS identity that is not accounted for by scores from an ethnicity measure. Assimilation represents merely one expression of LOW-RS, and a new experimental CRIS subscale called LOW-RS-Global, meant to tap LOW-RS trends on a general or global level, will also be explored (Item example: "Things that bring me joy and make me happy are not connected to the fact that I am black."). It is predicted that LOW-RS-Global will have a neutral to positive association with the mental health, (e.g., self-esteem and ego identity), but a significant negative association with ethnicity (MEIM). This will provide additional evidence that low scores on the ethnicity should not be mistaken as evidence of a lack of a social identity and/or the presence of a negative identity.

We predict that ethnicity or MEIM scores will show no significant relationship to NEGATIVE-RS as measured by the Miseducation and Racial-Self-hatred subscales on the CRIS. Previous research with the CRIS has shown that these markers of internalized oppression can be found in black people who reject the importance of a black identity, as well as those who affirm it (Kelly and Floyd, 2006; Foster, 2004). This suggests that some people who score high on ethnicity could also score high on NEGATIVE-RS, indicating they are ethnically focused but suffer from some degree of internalized oppression. However, it is possible that other people will show a reverse pattern, indicating that they reject ethnicity and also experience self-loathing. These two patterns will cancel each other, increasing the probably that NEGATIVE-RS or Miseducation and Racial-Self-Hatred scores will show no relationship with ethnicity or MEIM scores. For this reason, we predict no relationship between ethnicity (MEIM) and NEGATIVE-RS (Mis-education and Racial-Self-Hatred).

We want to flesh out the relationship between the CRIS Afrocentric and Multicultural subscales and MEIM, with reference to the assessment of HIGH-RS. Given, as previously discussed, that there are variants of black identity, and Afrocentricity and Multicultural are exemplars of what are likely many such orientations, it is predicted that either of these two dedicated measures of HIGH-RS will be positively but weakly linked to MEIM scores. However, when Afro-centricity and Multicultural scores are aggregated, this moves us closer to a global

HIGH-RS score such as the MEIM. Consequently, combining scores from Afrocentric and Multicultural will produce a HIGH-RS-Global score that is predicted to be significantly and positively related to ethnicity, as measured by the MEIM. ... Nigrescence Theory and the CRIS are said to tap "racial" dynamics, while EID Theory and the MEIM tap ethnicity. In the current study, we try to test whether such a distinction can be made by including in the design a sample of black college students divided by levels of black ethnicity (African American and Black Immigrant). If the MEIM is more sensitive to the presence of ethnicity than racial identity, Black Immigrant participants should record higher MEIM scores than persons in the sample affirming an African American identity. This differentiation should be attenuated on the sub-set of items on the MEIM called behavioral, because immigrants tend to be more sensitive to cultural differences in terms of how they live and conduct their daily lives. Thus, the ability of the MEIM to differentiate African Americans from Immigrants should be even greater for scores that tap ethnic behaviors than is predicted for MEIM-total scores.

The CRIS was designed such that each subscale is independent of the other. Consequently, we will turn to the CRIS and the CRIS-subscales to explore the possible isolation of identity differences that may be related to immigrant status. Since this is the first study to engage the CRIS with a black sample that is ethnically diverse, we do not have any predictions. We do expect that at some point in the exploration, group classification (African American versus Black immigrant) will prove significant.

Methodology

Participants

One hundred fifty college students from several New York City four-year public colleges consented to participate, inclusive of ten who self-referenced as African, forty-five as African American/Black-American, seventy-six as West Indian/ Caribbean, seven as Latino/Latina, seven as Mixed-Racial, and five as Other. The African and West Indian/Caribbean participants were combined to form the category Black Immigrant [n = 86], and the Mixed-Racial and African American/ Black American participants were combined to form the category African American [n = 52]. Participants falling into the Other and Latino/Latina categories were dropped from the study; consequently, the size of the reduced sample was 138. All participants were solicited by fliers posted at a mid-sized northeastern public college, and each was paid $10 to complete a questionnaire battery. The sample of 138 students included 86. 2 percent undergraduates; of these, 21 percent were freshman, 22 percent sophomores, 26 percent juniors, and 31 percent seniors. Eight percent of the participants indicated that they were graduate students, and approximately 6 percent of the participants indicated that they were not students but were told about the study by their college friends and relatives, or, while in the vicinity of the college, spotted the flyers announcing the study and decided to

participate. The participants ranged in age from seventeen to fifty years (M = 23.65, SD = 6.3).

Measures

Ego Identity Status. The Extended Objective Measure of Ego Identity Status (EOM-EIS; Bennion and Adams, 1986) provides an overall measure of ego identity status. For the current study, the original sixty-four item multidimensional scale was modified and reduced to a 24-item global measure of ego identity development. Items were rated using a seven-point Likert scale ranging from (1) "strongly disagree" to (7) "strongly agree." Scores were computed by reversing the scales of the negatively worded items and obtaining a mean score, with a score of seven indicating ego identity development. In this study, the Cronbach a = .69.

Racial Identity: The Cross Racial Identity Scale (CRIS: Vandiver, Cross and Fhagen-Smith, 2001) is a forty-item measurement scale that uses a seven-point Likert format with values ranging from (1) "strongly disagree" to (7) "strongly agree." The CRIS measures a variety of identity attitudes found among black people that differ in degree of racial-cultural salience. The Assimilation subscale is an exemplar of low race salience and an identity that emphasizes one's sense of being an American ("I am not so much a member of a racial group, as I am an American."). The Miseducation and Self-Hatred subscales tap high negative race salience or forms of internalized oppression (Miseducation: "Blacks place more emphasis on having a good time than on hard work." Racial-Self-Hatred: "I sometimes struggle with negative feelings about being black."). The Anti-White and Black Zeal subscales tap forms of identity instability and transitional identity states (Anti-White: "I hate the white community and all that it represents." Racial Zeal: "It is absolutely necessary that I present myself to other blacks in an Afrocentric manner."). The Racial Zeal subscale is a new and thus experimental subscale. Exemplars of moderate to high race salience are captured by the Afrocentric and Multicultural subscales (Afrocentric: "I see and think about things from an Afrocentric perspective." Multicultural: "I believe it is important to have both a black identity and a multicultural perspective, which is inclusive of everyone" [e.g., Asians, Latinos, gays and lesbians, Jews, Whites, etc.]). In addition, for this study two exploratory scales were included: A four item measure of Global Low Race Salience (tendency not to give much weight to race and culture in one's everyday life) and, as noted above, a five item measure of Racial Zeal (tendency to zealously and positively stress racial and cultural ideas). In order to keep the CRIS from being too long and to make room for the two experimental subscales, the item count for each CRIS subscale was reduced by one or two items. Also, the ten filler items were also eliminated. The modified CRIS inclusive of the two experimental scales had fifty items. For this study, the Cronbach a for each subscale were: .81 for Assimilation; .74 for Miseducation; .83 Self-Hatred; .70 Anti-White; .76 Afrocentric; .73 Multicultural; .77 Global Low Race Salience (. 65 for Low Race Salience); and .75 Racial Zeal.

Global Self-Esteem. The Rosenberg Self-Esteem Scale (Rosenberg, 1965) is a ten-item scale that measures global self-esteem using a four-point Likert type response format ranging from (1) "strongly disagree" to (4) "strongly agree." Scores were computed by reversing the scale of the negatively worded items and obtaining a mean, with a score of (4) indicating high personal self-esteem. The reported reliability of this scale has ranged from .77 (McCarthy and Hoge, 1982) to .80 (Shahani, Dipboye and Phillips, 1990), and in the current study, Cronbach a = .86.

Ethnic Identity Formation. Jean Phinney's Multigroup Ethnic Identity Measure (MEIM, 1992) is a twelve-item scale that assesses ethnic identity formation; items are rated on a four-point Likert scale ranging from (1) "strongly disagree" to (4) "strongly agree." Scores are computed by reversing the scales of the negatively worded items and obtaining a mean score, with a score of four indicating strong ethnic identity development. The MEIM has been used in many studies and has shown consistently good reliability, typically with alphas in the .80 range. In the current study, the Cronbach a = .84.

Procedures

The subjects were greeted upon arrival by a male or female experimenter and seated in a psychology laboratory. The subjects were instructed not to speak to other subjects who were in the room during administration of the materials. The subjects completed the questionnaire battery. The subjects also completed a demographic form that asked questions about gender (male/female); age; ethnic background (African; African American/Black American; West Indian/Caribbean American; Latino/Latina Black; Mixed and Other); student status (undergraduate/graduate) and year in school (freshmen, sophomore, junior, or senior) or number of years in graduate school; socio-economic status of participant when she or he was a child (poor, working class, middle class, upper-middle, and wealthy); number of ethnic organizations belonged to; political affiliation (Republican/Democrat/Other); number of close black friends; number of white friends; number of close friends who are neither black or white. Upon completion of the task, all questionnaires were reviewed for completion. After the final check of the questionnaires, the subjects were escorted out of the testing room and ushered into a debriefing room, were they were paid and debriefed by the lead experimenter. All subjects were given a debriefing sheet. The debriefing sheet briefly described my hypotheses and offered contact information for any participant to ask any questions related to the questionnaire battery and current research aim. The debriefing sheet also contained referral information, should the participant become upset in reaction to answering questions on the survey; however, during the course of the research, not a single incident requiring outside assistance was recorded. Each person was paid ten dollars for participating in the research.

Results

Table 5.1 contains the Pearson correlation coefficients for all variables, and a number of significant associations were recorded. Participants with a strong ethnic identity (high MEIM scores) evidenced positive ego identity development and high self-esteem. With regard to black identity variability, as measured by the CRIS, significant relations also emerged. Both Afrocentricity and Multiculturalism were related to self-esteem, but in opposite directions. Participants with an Afrocentric orientation reported low self-esteem, while those reporting a Multicultural orientation reflected positive self-esteem. Assimilation was not related to self-esteem, but was negatively related to ego identity. LOW-RS was not related to self-esteem, but a negative association did emerge between LOW-RS and ego identity. Racial self-hatred was negatively associated with self-esteem, but not related to ego identity. Miseducation was negatively related to ego identity, but not to self-esteem.

The data were examined for possible associations between gender, age, ethnic group, undergraduate status, and childhood social class background with ego-identity and self-esteem, and significant differences ($p < .05$) were found for age and undergraduate status with ego identity development, $r_{(137)} = .21$ and $r_{(136)} = .28$, respectively. The older participants reported greater ego identity development ($r_{(138)} = .21$); likewise, participants with a senior level student status reported greater ego identity development ($r_{(138)} = .28$).

After controlling for age and undergraduate status, the MEIM, as hypothesized, emerged as a significant predictor of ego identity ($\beta = .43$, $p < .001$), accounting for 19 percent of the variance. A simultaneous regression analysis that included all of the dimensions of the CRIS (Assimilation, Self-Hatred, Miseducation, Afrocentric, Multicultural, Anti-white, and Racial Zeal) was conducted with ego identity as the outcome variable. Contrary to the prediction that only Miseducation and Racial Self-Hatred would be linked to ego identity, none of the CRIS subscales showed a relationship to ego-identity in the regression analysis. Contrary to prediction, Miseducation and Racial Self-Hatred were not negatively associated to ego identity.

Shifting to self-esteem as the outcome variable, the MEIM was positively linked to self-esteem and accounted for 11 percent of the variance ($\beta = .33$, $p < .001$), a finding in line with one of our predictions. The CRIS accounted for 19 percent of the variance, and persons holding Assimilation or Afrocentric frames did not differ in level of self-esteem, sustaining one of our predictions. Surprisingly, Multicultural identity was related to positive self-esteem ($\beta = .18$, $p < .05$). In line with what we predicted, Self-Hatred ($\beta = -.21$) and Miseducation ($\beta = .18$) were significantly ($p < .05$) related to lower self-esteem.

Table 5.1: Pearson Correlation Coefficients

	1	2	3	4	5	6	7	8	9	10	11	12	13	14
1)Assimilation	—													
2)Miseducation	$.35^B$	—												
3)Self-hatred	$.19^A$	$.25^B$	—											
4)Afrocentric	$-.22^B$	$.02$	$.21^A$	—										
5)Multicultural	$-.26^B$	$-.04$	$-.07$	$-.07$	—									
6)Anti-White	$-.05$	$.10$	$.33^B$	$.29^B$	$-.25^B$	—								
7)Racial Zeal	$-.16$	$.16$	$.22^A$	$.59^B$	$.03$	$.29^B$	—							
8)Ego Identity	$-.20^A$	$-.20^A$	$-.16$	$-.01$	$.17^A$	$-.16$	$.09$	—						
9)Ethnic Ident.	$-.26^B$	$-.11$	$-.07$	$.16$	$.10$	$.03$	$.09$	$.45^B$	—					
10)Self-esteem*	$-.10$	$.06$	$-.28^B$	$-.18^A$	$.25^B$	$-.27^B$	$-.14$	$.31^B$	$.32^B$	—				
11)LOW-RS	$.35^B$	$.23^B$	$-.04$	$-.31^B$	$-.11$	$-.09$	$-.22^A$	$-.18^A$	$-.31^B$	$-.01$	—			
12)LRS-Global	$.88^B$	$.36^B$	$.11$	$.76^B$	$-.23^B$	$-.08$	$-.23^B$	$-.23^B$	$-.34^B$	$-.08$	$.76^B$	—		
13)HRS-Global	$-.37^B$	$-.02$	$.07$	$.14$	$.55^B$	$.02$	$.48$	$.08$	$.21^A$	$.02$	$-.31^B$	$-.41^B$	—	
14)NRS-Global	$.34^B$	$.81^B$	$.77^B$		$-.07$	$.27^B$	$.24^B$	$-.23^B$	$-.12$	$-.14$	$.13$	$.30^B$	$.03$	—
M	3.00	3.76	2.23	3.76	5.76	1.85	3.27	4.92	3.21	3.37	4.37	3.59	4.76	2.99
SD	1.45	1.42	1.30	1.12	1.01	1.03	1.24	0.59	0.44	0.54	1.45	1.19	0.70	1.07

Note. A $p < .05$; B $p < .01$. *Data were negatively skewed and the exponentiated value is used.

In accordance to several hypotheses at the bivariate level of analysis, the MEIM showed a complex relationship to specific dimensions of black identity. The MEIM was negatively correlated to both Assimilation ($r_{(138)}$ = -.26, p< .01) and Low Race Salience ($r_{(138)}$ = -.31, p< .01). As hypothesized, the MEIM was not correlated with either Racial Self-Hatred or Miseducation. In line with the prediction that the MEIM as a global measure of identity shows very little overlap with highly specific expressions of black identity, the MEIM was not related to Afrocentric and Multicultural. However, when the Afrocentric and Multicultural values were combined to form a "global" measure of High Race Salience (HIGH-RS-Global) in line with the global characteristics of the MEIM, the correlation between the MEIM and HIGH-RS-Global was, as predicted, significant ($r_{(168)}$ = .21, p< .05).

To test whether Black Immigrant as compared to African American participants would score significantly higher on the MEIM as well as the behavioral subscale of the MEIM, separate ANOVAs were conducted. No significant differences were found on the MEIM as a whole between Black Immigrant participants (M = 3.24, SD = .43) and African American participants (M = 3.16, SD = .47), or on the behavioral sub-set of the MEIM (M = 3.04, SD = .53 for the Black Immigrant participants; M = 2.99, SD = .61 for African American participants).

In an exploratory, post-hoc analysis, we examined the role of ethnic status (African Americans compared to Black Immigrants) in the complex findings for Assimilation and Afrocentric attitudes, as measured by the CRIS, in relation to self-esteem. Earlier we noted that at the bivariate level (Table 5.1) and in reference to the sample as a whole, a surprising connection was found between Assimilation and Racial-Self-Hatred, and this link appeared to put participants at risk for lower self-esteem, since Racial Self-Hatred was found to be significantly and negatively related to self-esteem ($r_{(138)}$ = -.28, p = .01). Table 5.2 presents the associations between the variables of interest with self-esteem for each ethnic group separately (African American versus Black Immigrant). Among the African American participants, holding an Assimilationist frame was not linked to low self-esteem, but there was only an association with Miseducation ($r_{(138)}$ = .40, p < .01). However, for Black Immigrant participants holding Assimilation views, there was a significant link to Miseducation ($r_{(138)}$ = .33, p < .01), Racial Self-Hatred ($r_{(138)}$ = .29, p < .01), and lower self-esteem ($r_{(138)}$ = -.24, p < .05).

Table 5.2: Pearson Correlation Coefficients by Ethnicity

	1	2	3	4	5	6	M	SD
1)Assimilation	—	.33B	.29B	-.21	.01	-.24A	2.79	1.45
2)Miseducation	.40B	—	.17	-.06	.10	.05	3.76	1.39
3)Self-hatred	-.04	.36B	—	.09	.26A	-.24A	2.06	1.25
4)Afrocentric	-.25	.15	.43B	—	.34B	-.21	3.76	1.16
5)Anti-White	-.18	.11	.42B	.20	—	-.27A	1.78	1.06
6)Self-esteem*	.20	.07	-.32A	-.14	-.25	—	3.41	0.55
M	3.37	3.76	2.51	3.75	1.95	3.30		
SD	1.39	1.49	1.35	1.07	0.97	0.52		

Note. A p < .05; B p < .01. Pearson correlation coefficients for the African American participants (n = 52) are presented below the diagonal, and those for the Caribbean participants (n = 86) are presented above the diagonal.
*Data were negatively skewed and the exponentiated value is used.

We tested for mediation using regression analysis to test whether the link between Assimilation and self-esteem would be explained by Negative Race Salience (NEGATIVE-RS) factors (Miseducation and Racial Self-Hatred) among the Black Immigrant sample. To test for mediation, two criteria must be met as outlined by Baron and Kenny (1986). The mediator variable must significantly predict the dependent variable, and the predictability of the independent variables should disappear or decrease when the mediator is entered into the regression equation (Baron and Kenny, 1986). We controlled for age and/or undergraduate status as appropriate. As noted earlier, among the African American participants, there was a non-significant relationship between Assimilation and self-esteem. However, the picture appeared dramatically disparate when the focus shifted to Assimilationist attitudes held by Black Immigrants, and our findings are depicted in Figure 5.1. Essentially, Black Immigrants evidenced two patterns, one positive and one negative, based on one direct and two indirect paths. After controlling for undergraduate status, the negative and direct relation between Assimilation and self-esteem was not mediated by NEGATIVE-RS factors, indicating that those holding an Assimilationist frame were likely to report lower self-esteem. For Immigrants whose Assimilationist frame was linked to Racial Self-Hatred, the relationship to self-esteem was negative, although only marginally significant. However, holding an Assimilationist frame was also linked to Miseducation, after controlling for age and undergraduate status, and this was in turn linked to positive self-esteem. In either case, the paths for the Black Immigrants holding Assimilation attitudes diverged from that of the African American pattern.

Figure 5.1: The Link between Assimilation and Self-esteem among Black Immigrants

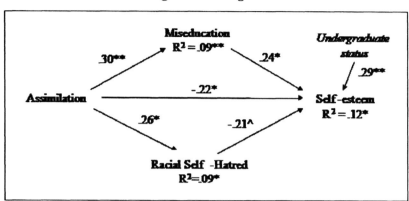

^p <. 10; * p<. 05; ** p <. 01.
Note: Standardized Beta coefficients are presented. R^2 represents the R^2 change when predictors were entered into the equation.

Figure 5.2: The Link between Afrocentricity and Self-esteem among Black Immigrants

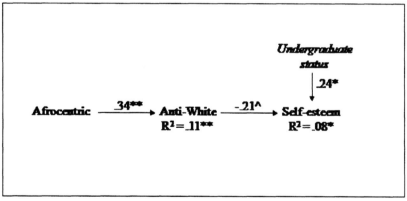

^p <. 10; * p<. 05; ** p <. 01.
Note: Standardized Beta coefficients are presented. R^2 represents the R^2 change when predictors were entered into the equation.

Now let us shift the focus to the link between Afrocentric and self-esteem. As shown in Table 5.1 that reflects data for the entire sample, a surprising connection was found between Afrocentric and low self-esteem. Holding an Afrocentric frame should not in and of itself be expected to show such a negative relation with self-

esteem, and as Table 5.2 indicates, the Pearson correlation coefficients for this relation was not significant among African Americans, but was marginally significant for the Black Immigrant participants ($p = .055$). Furthermore, the associations shown in Table 5.2 suggest the possibility that different models are applicable to each group. Looking at Table 5.2 there is the suggestion that for African Americans in this study, those who embraced Afrocentric ways of thinking are also likely to hold Racial Self-Hatred beliefs, while for Black Immigrants the link was between Afrocentricity and Anti-White and not Afrocentricity and Racial Self-Hatred. For African Americans holding Afrocentric beliefs there was no direct relationship to self-esteem, and only Racial Self-Hatred was related to lower self-esteem. For the Black Immigrants, Figure 5.2 displays the results of the regression analyses that showed a marginally significant indirect relationship ($p = .059$) between Afrocentricity and self-esteem through Anti-White sentiment. There was no direct connection between holding Afrocentric attitudes and self-esteem.

Discussion

We predicted and found a positive and significant relationship between ethnic identity and both ego identity and self-esteem, which replicates the findings from previous studies showing high salience for ethnicity or HIGH-RS is linked to positive mental health (Phinney, 1990, 1996). Can one conclude that ethnic group members who accord low salience to ethnicity (LOW-RS) are psychologically at risk? For example, working with a sample of first generation Chinese American high school students, Yip and Fuligni (2002) found that high but not moderate or low scores on ethnicity predicted positive well-being. The measure of ethnicity we employed, as did Yip and Fuligni, is one of the most popular and important in the field (MEIM: Phinney, 1992), and though it is, to a degree, a multidimensional instrument, it does not incorporate dedicated subscales for either LOW-RS nor expressions of negative ethnic salience (NEGATIVE-RS). Our study included a second measure that assessed various identity attitudes reflecting high (HIGH-RS), low (LOW-RS) and negative (NEGATIVE-RS) race salience. Results from this second measure showed participants holding either HIGH-RS (Afrocentric and Multicultural) or LOW-RS (Assimilation and Low Race Salience) perspectives evidenced adequate ego identity development, and, as predicted, only racial-self-hatred or NEGATIVE-RS attitudes were linked to diminished ego identity. This finding was essentially repeated when we shifted attention to self-esteem as the outcome variable, although the connection between HIGH-RS and self-esteem may be mediated by other identity attitudes.

We then explored in a more direct fashion the relationship between the measures of ethnicity and racial identity. The identity exemplars from the CRIS (Afrocentric and Multicultural), when combined to form a more global-like measure of (HIGH-RS-Global) that is characteristic of the MEIM, was positively and significantly correlated with the MEIM. The MEIM was negatively related to

identity exemplars of low race salience and Assimilation, and it showed nearly a zero correlation with explicit exemplars of negative salience (Racial-Self-Hatred and Miseducation). In effect, we demonstrated that the MEIM is a solid measure of HIGH-RS, but low scores on this measure must be interpreted with caution. Otherwise, researchers may inappropriately conclude that LOW-RS and NEGA-TIVE-RS are one and the same and can be extrapolated from low scores on the MEIM.

Our findings suggest that nominal members of an ethnic-racial group may achieve psychological well-being through both HIGH-RS and LOW-RS expressions of social identity. At the bi-variate level of analysis, persons holding either Assimilationist or Low Race Salience attitudes showed marginally negative levels of ego-identity development. However, when examined using multivariate procedures, neither Assimilation nor Low Race Salience attitudes were linked to lower self-esteem or negative ego-identity development. Assimilation was negatively linked to self-esteem but only among the Black Immigrants. Yip and Cross (2004) found no evidence that various measures of well-being, positive and negative emotions, and level of self-esteem differentiated Chinese high school students reflecting three types of identity configurations: Pro-American/Low Chinese Identity; High Chinese/Low American Identity; and Bicultural or high scores on both Chinese and American Identity scales. And in a partial compliment to our findings, Kelly and Floyd (2006), who did not measure LOW-RS, nevertheless recorded a zero correlation between HIGH-RS attitudes (Afrocentric Attitudes and General Internalized Pro-Black Attitudes) and general well-being. Our results suggest that what black people need to avoid is the development and inculcation of explicitly *negative* forms of identity expressions such as Racial-Self-Hatred and, to a lesser extent, negative stereotyping or what in this study was conceptualized as Miseducation. Otherwise, *at the level of the individual black person,* the world views that can lead to well-being and positive mental health varies considerably, from choices enveloped by racial-cultural content, ideology and functionality to personal philosophies proactively and positively grounded in something other than race and black culture.

There is considerable debate in the social science research literature on whether a meaningful distinction can be made between ethnic and racial identity (Cross, 2005; Phinney, 1996; Waters, 1999). Our black sample split along ethnic lines, with the majority identifying as Black immigrant and the remainder as African American. Given, as has been theorized (Phinney, 1996; Helms, 1995), that African Americans embrace a racially based social identity and Black immigrants a more ethnic stance, it was predicted that Black immigrant participants would score higher on ethnicity than African American participants. The results did not confirm this, nor did the frequency to self-report engaging in ethnic or cultural behaviors and activities separate the two groups. Thus, while the content of the cultural moorings of African American and Black immigrant participants may very well reflect considerable divergence, our findings suggest that African Americans as compared to immigrant blacks are no less likely to self-reflect about themselves and their

experiences in cultural terms, even though American blacks as opposed to immigrant blacks may self-reflect more often on the added dimension of "race" (Deaux et al., 2004).

Our independent identity scales (MEIM and CRIS) accounted for the same amount of variance across two measures of psychological well-being, although ethnicity was more sensitive to ego-identity dynamics, and, racial identity to self-esteem. In addition, the correlations between ethnicity, as measured by the MEIM, and LOW-RS and HIGH-RS exemplars captured by the CRIS, point to a significant overlap between the constructs ethnic identity and racial identity (Cross, 2005). Such an interpretation is more than hinted at by the findings from a large scale study conducted by Rumbaut (2001). In a longitudinal study of immigrant families and their children, Rumbaut (2001) showed that at Time 1, when the target children were between the ages of seven and eight, both parents and children overwhelmingly used cultural, ethnic and nationalistic categories to describe themselves, and racial self-categorization was an infrequent choice. However at Time 2, as the youth exited late adolescence and entered early adulthood, the sub-sample of black Caribbean youth seemed to experience a certain degree of racialization, as the category "black"—alongside the previously used ethnic labels— emerged as an important self-descriptor. The Black immigrant college students and adults in the current study are more akin to the participants at Time 2 of the Rumbaut study, and one might expect that, as happened in the Rumbaut study, their identity probably reflects a mixture of ethnic and racial dynamics. Perhaps there is a juncture during the acculturation process when the distinction between "race" and "ethnicity" begins to blur, as immigrants of color prove adept at negotiating both, even if at an earlier point in their adjustment they saw themselves positioned beyond the reach of race.

Ironically, the CRIS more so than the MEIM, facilitated the isolation of identity differences between the Black American and Black immigrant participants. The sensitivity of the CRIS to ethnic dynamics was revealed in exploratory path analyses. Black immigrants, as is true of immigrant groups in general, affirm pro-American attitudes more so than do Blacks in general, and in the course of exploring whether Racial-Self-Hatred mediated the relationship between Assimilation and self-esteem, Black immigrants, and not African Americans, evidenced a negative relationship between Assimilation attitudes and self-esteem. Two indirect relationships were also evident through Racial Self-Hatred and Mis-education, but they differed in direction: The first indirect relation was associated with lower self-esteem, while the second relation was associated with high self-esteem. In a second instance involving Afrocentric attitudes and level of self-esteem, Anti-White attitudes mediated the relationship such that too much involvement of either factor resulted in lower self-esteem. However, we were able to show that racial self-hatred was more likely to become intertwined with Afrocentric attitudes held by African Americans, while Anti-White attitudes, and not Racial Self-Hatred, were linked to the Afrocentric views held by Black immigrants.

Racial self-hatred has a long history in the discourse on African American identity development and reflects the internalization of race-based negativity over the course of one's socialization. Kelly and Floyd (2006) recently isolated a subset of adult African Americans whose mixture of pro-black (HIGH-RS) and anti-black (NEGATIVE-RS) attitudes was linked to diminished well-being. Black immigrants, on the other hand, do not enter the United States with a history of internalized oppression. Consequently, perhaps it is not coincidental that as some may gravitate toward Afrocentric thinking, they are more apt to *externalize* their anger about "race." In a related matter, stereotype threat when found among Black Americans is thought to be triggered by some as yet unknown internal psychological mechanism or mechanisms and can lead to lower performance in high- risk test taking situations. Yet in a recent study it was shown that first generation black immigrants are practically impervious to stereotype threat in testing-taking situations (Deaux et al., 2004). Thus, that which has been shown to drive part of the "internal" psychology of Black Americans is either shielded, compartmentalized or externalized by Black immigrants, and our finding that some Black immigrants may simultaneously hold Afrocentric and Anti-White attitudes, rather than Afrocentric and self-hatred feelings, may be another demonstration of a fundamental difference between the psychology of African Americans as compared to Black immigrants (Thomas, 2004).

Limitations

The primary limitation of the current study is the sample size; a larger sample would have made it possible to explore the extent to which the Behavioral Subscale of the MEIM is, in fact, sensitive the presence of ethnic behaviors that differentiate long- term Black residents of the United States as compared to first and perhaps even second generation Black immigrants. Our treatment of immigrant status as a categorical variable is another limitation, as we did not collect enough information to examine it as a continuous variable to consider generational status. Finally, the study needs to be repeated with a more robust measure of ego identity development.

References

Aboud, F. (1988). *Children and prejudice*. Cambridge: Basil Blackwell.

Azibo, D. (2003). *African-centered psychology*. Durham, NC: Carolina Press.

Bennion, L. D., and Adams, G. R. (1986). A revision of the expanded version of the objective measures of ego identity status. *Journal of Adolescence Research*, 1: 183-198.

Carter, R. T. (1995). *The influence of race and racial identity in psychotherapy*. New York: John Wiley and Sons, Inc.

Cross, W. E. Jr. (1971). The negro to black conversion experience: toward a psychology of black liberation. *Black World*, 20(9), 13-27.

Cross, W. E., Jr. (1991). *Shades of black*. Philadelphia: Temple University Press.

Cross, W. E., Jr. (2005). Ethnicity and development of ethnic identity in childhood: Response to papers by Deborah Johnson and Rubén Rumbaut. In Weisner, Thomas S. (Ed.), *Discovering successful pathways in children's development: New methods in the study of childhood and family life*. Chicago: University of Chicago Press.

Cross, W. E., Jr. (1995). The psychology of nigrescence: Revising the Cross model, pp. 93-122. In J. S. Ponterotto, Casa, J. M., Suzuki, L. A., and Alexander, C. M. (Eds.), *Handbook of multicultural counseling*. Sage Press: Newbury Park.

Cross, W. E., Jr., and Cross, T. B. (2008). Racial-ethnic-cultural identity development (REC-ID): Theory, research, and models, pp. 154-181. In C. McKown and S. Quintana (Eds.), *Handbook of race, racism, and the developing child*, Hoboken, NJ: Wiley Press.

Cross, W. E., Jr., and Fhagen-Smith, P. (2001). Patterns of African American identity development: A life span perspective. In Wijeyesinghe, C. L., and Jackson, B. W. III (Eds.), *New perspectives on racial identity development: a theoretical and practical anthology*. New York: New York University Press.

Cross, W., Smith, L. and Payne, Y (2002). Black identity: A repertoire of daily Enactments, pp.93-108. In P. Pedersen, J. Draguns, W. Lonner, and J. Trimble (Eds.), Counseling Across Cultures (Fifth Edition) Thousand Oaks, CA: Sage.

Deaux, K., Steele, C., Bikmen, N., Ventuneac, A., Joseph, Y., and Payne, Y. (2004). *Becoming American: Stereotype threat effects in black immigrant groups*. Manuscript under submission.

Erickson, E. H. (1959). *Identity and the life cycle*. Psychological Issues, Volume 1(1). New York: International Universities Press, Inc.

Erickson, E. H. (1968). *Identity: Youth and crisis*. New York: W. W. Norton and Company, Inc.

Foster, K. (2004). The relationship between well being, attitudinal and behavioral factors across three black identity orientations: Assimilated, afrocentric, and multicultural. Unpublished dissertation in social-personality psychology, Graduate Center for the City University of New York.

Helms, J. E. (1990). An update of Helm's white and people of color racial identity models. In Ponterotto, J. G., Casa, J. M., Suzuki, L. A., and Alexander, C. M. (Eds.), *Handbook of multicultural counseling* (First Edition). 181-198.

Helms, J. E. (1995). An update of Helms's White and People of Color racial identity models, pp. 1881-198. In J. G. Ponterotto, J. M. Casas, L. A. Suzuki, and C. M. Alexander (Eds.), *Handbook of multicultural counseling*. Thousand Oaks, CA: Sage.

Hyman, J. J., and Singer, E. (1968). *Readings in reference group theory and research*. New York: McGraw-Hill.

Jones, H. (2005). Experiencing, appraising, and coping with race-related stress: Black women living in New York City. Unpublished doctoral dissertation, Graduate Center-CUNY, New York.

Kelly, S., and Floyd, F. J. (2006). Impact of racial perspectives and contextual variables on marital trust and adjustment for African American couples. *Journal of Family Psychology*, 20, 79-87.

Kernberg, O. (2006). Identity: Recent findings and clinical implications. *Psychoanalytic Quarterly, 75:* 969-1003.

McCarthy, J. D. and Hoge, D. R. (1982). Analysis of age effects in longitudinal studies of adolescent self-esteem. Development Psychology, 18, 372-379.

Nobles, W. (1973). Psychological research and the black self-concept: A critical review. *Journal of Social Sciences*, 29(1), 11-31.

Parham, T. A. (1989). Cycles of nigrescence. *The Counseling Psychologist*, 17, 187-226.

Parham, T. A., and Helms, J. E. (1981). The influence of black students' racial identity attitudes on preference for counselor's race. *Journal of Counseling Psychology*, 28, 250-257.

Phinney, J. S. (1989). Stages of ethnic identity development in minority group adolescents. *Journal of Early Adolescence*, 9, 34-49.

Phinney, J. S. (1990). Ethnic identity in adolescents and adults: Review of research. *Psychological Bulletin*, 108, 499-514.

Phinney, J. S. (1992). The multigroup ethnic identity measure: A new scale for use with diverse groups. *Journal of Adolescent Research*, 7, 156-176.

Phinney, J. S. (1996). Understanding ethnic diversity: The role of ethnic identity. *American Behavioral Scientist*, 40(2), 143-152.

Phinney, J. S., Cantu, C. L., and Kurtz, D. A. (1997). Ethnic and American identity as predictors of self-esteem among African American, Latino and White adolescents. *Journal of Youth and Adolescence*, 26(2), 165-185.

Phinney, J. (1992). The Multigroup Ethnic Identity Measure: A new scale for use with adolescents and young adults from diverse groups. Journal of Adolescent Research, 7, 156-176.

Porter, J. D. R., and Washington, R. E. (1979). Black identity and self-esteem: A review of studies of black self-concept, 1968-1978. *Annual Review of Sociology* 5:53-74.

Rosenberg, M. (1965). *Society and adolescent self-image*. Princeton, NJ: Princeton University Press.

Rumbaut, R. G. (2001). Sites of belonging: Shifts in ethnic self-identities among adolescent children of immigrants. Presented at the conference on successful pathways in children's development: Mixed methods in the study of childhood and family life. January 25-27, 2001, Santa Monica, CA.

Sellers, R., Shelton, N., Cooke, D., Chavous, T., Rawley, S., and Smith, M. (1998). A multidimensional model of racial identity: Assumptions, findings and future directions, pp. 25-302. In Jones, R. (Ed.), *African American identity development*. Hampton, VA: Cobb and Henry Publishers.

Shahani. C., Dipboye, R. L., and Phillips, A. (1990). Global self-esteem as a correlate of work-related attitudes: A question of dimensionality. Journal of Personality Assessment, 54 (1 and 2), 276-288.

Spencer, M. B. (1982). Personal and group identity of black children: An alternate synthesis. *Genetic Psychology Monographs,* 106:59-84.

Strauss, L. C., and W. E. Cross, Jr. (2005). Transacting black identity: A two-week daily-diary study, pp. 67-95. In G. Downey, J. S. Eccles, and C. M. Chatman (Eds.), *Navigating the future: Social identity, coping, and life tasks.* New York: Russell Sage Foundation.

Stryker, S. (1987). Identity theory: Developments and extensions, pp. 89-103. In K. Yardley and T. Honess (Eds.), *Self and identity.* New York: Wiley.

Tajfel, (1981). *Human groups and social categories.* Cambridge, UK: Cambridge University Press.

Tatum, B. (1987). *Assimilation blues.* MA: Hazel-Maxwell.

Thomas, T. E. R. (2003). Black American and black immigrants: The influence of ethnic identification on perceptions of race, prejudice, and individual success in American society. Unpublished doctoral dissertation, Psychology Department, Stanford University.

Urry, J. (1973). *Reference groups and the theory of revolution.* London: Routledge and Kegan Paul.

Vandiver, B. J., Cross, W. E., Jr., Worrell, F. C., and Fhagen-Smith, P. E. (2002). Validating the Cross racial identity scale. *Journal of Counseling Psychology,* 49(1), 71-85.

Waters, M. C. (1999). *Black identities: West Indian immigrant dreams and American realities.* Cambridge: Russell Sage and Harvard University Press.

Worrell, F. C. (2000). A validity study of scores on the multigroup ethnic identity measure based on a sample of academically talented adolescents. *Educational and Psychological Measurement, 60,* 439-447.

Worrell, F. C., Conyers, L. M., Mpofu, E., and Vandiver, B. J. (2006). Multigroup ethnic identity measure (MEIM) scores in a sample of adolescents from Zimbabwe. *Identity: An International Journal of Theory and Research, 6,* 35-59.

Worrell, F. C., Conyers, E. M., and Vandiver, B. J. (2002). Multigroup ethnic identity measure (MEIM) scores in a sample of adolescents from Zimbabwe. *Identity: An International Journal of Theory and Research.*

Yip, T., and Fuligni, A. J. (2002). Daily variation in ethnic identity, ethnic behaviors, and psychological well-being among American adolescents of Chinese descent. *Child Development,* 73(5), 1557-1572.

Yip, T., and Cross, W. E., Jr. (2004). A daily diary study of mental health and community involvement outcomes for three Chinese American social identities. *Cultural Diversity and Ethnic Minority Psychology,* 10(4): 394-408.

Chapter Six
Black Racial/Ethnic Identity and Its Impact on Well-Being: Bridging Identity Theory and Racial/Ethnic Identity Research

Donald C. Reitzes and Charles Jaret

Introduction

W. E. B. Du Bois (1897, 1903) was the first sociologist to probe the nature of racial/ethnic identity when he raised questions about multiple identities ("American," "Negro," or "both") and the "double consciousness" they create. He inquired about the relative importance of racial/ethnic identities and asked whether one could "cease to be a Negro," or whether there is an "obligation to assert" one's racial/ethnic identity. The issues raised by Du Bois are fundamental to subsequent research on racial/ethnic identity. In addition, his statement that these identities are formed by "measuring one's soul by the tape of a world that looks on in amused contempt and pity" foreshadows the social dynamics that are key to the "identi- fication of" process. Further, when he noted that one's racial/ethnic identity might provoke being "cursed and spit upon" by others, or having "the doors of oppor- tunity closed roughly," he became one of the first to make a clear connection between racial/ethnic identity, well-being, and chances for achieving success in life. In this chapter, we return to the foundational issues raised by Du Bois, and we investigate interconnections among different dimensions of racial/ethnic identity

and their relationship with two important social psychological outcomes—self-esteem and self-efficacy.

"Identity" is understood generally as self meanings that link a person to others in a shared role or group (Reitzes and Jaret, 2007). It has generated "ubiquitous" attention across the social sciences, social movements and politics, as well as popular literature (Berezin, 2010). Indeed, references to identity have been so popular that Ashmore, Deaux, and McLaughlin-Volpe (2004) conclude that the identity literature is "vast and rocky," with inconsistent and contradictory definitions or "mismatches between theory and operationalization." A promising recent trend has been the efforts by both psychologists and sociologists to bridge disciplinary boundaries and to acknowledge common insights and understanding of identity processes and consequences (Burke and Stets, 2009; Deaux and Martin, 2003).

There has been a similar explosion in interest and research on race and ethnic identities, with some of the same concerns about ambiguous, inconsistent or a theoretical conceptualization and measurement of what it means to be a member of a racial or ethnic group (Roberts et al., 1999; Sullivan and Arbuthnot, 2009; Yip, Seaton, and Sellers 2006). Nevertheless, a shared recognition has emerged in the last several years that racial/ethnic identities are not just single and stable personality traits, but multidimensional, dynamic, and interactive self conceptions (Ashmore, Deaux, and McLaughlin-Volpe, 2004; Phinney and Ong, 2007).

In this chapter we use a symbolic interactionist approach to identity theory (Stryker and Burke, 2000) and data from a survey of college students attending a large, racially diverse public university in a major southeastern city to continue the interdisciplinary investigation of identity processes in general, and racial/ethnic identity in particular. Our exploration focuses on three issues, each of which is tied to interdisciplinary insights about identity or identity processes and particular research on racial/ethnic identity. First, our theoretical understanding of identity processes suggests that racial/ethnic identities are multidimensional (Jaret and Reitzes, 2009; Romero and Roberts, 2003). We therefore create three sets of racial/ethnic identity meaning dimensions and investigate how these meanings vary among Black, White, and Asian-American students. Second, our theory recognizes that individuals differ in the importance that they attribute to their identities (Stryker and Burke, 2000). We compare the importance that Black, White, and Asian-American students attribute to their racial/ethnic identity. Finally, a shared expectation across disciplines is that identities, in general, and racial/ethnic identities in particular, influence well-being (Reitzes and Jaret, 2007; Sellars et al., 2003). We explore the impact of racial/ethnic identity meanings and the importance of the identity on the self-esteem and self-efficacy of Black students. Our theory also suggests that in addition to direct effects, the importance of the racial/ethnic identity may mediate the impact of racial/ethnic identity meanings on well-being. The interaction of identity and importance has been proposed by identity researchers

(Wickrama et al., 1995) and racial identity researchers (Yip et al., 2006), and therefore, serves as another bridge connecting theoretical and empirical traditions.

Theoretical Background

Multiple Dimensions of Race/Ethnic Identity Meanings

Recent theoretical and empirical work both in race and in symbolic interaction theory recognizes that race/ethnic identities are multi-dimensional, but this common insight arose from different perspectives. Many researchers, based in psychology and education, understand and measure race/ethnic identities, and Black identity in particular, by invoking psychological concepts and processes. Two influential researchers in this tradition are Erikson and Tajfel (Roberts et al., 1999). Erikson (1968) was interested in the social factors that interact with personality in the creation of self and proposed eight stages in psychosocial development, each of which presents the individual with a challenge. Erikson's theoretical foundation has been applied to racial identity formation by Cross (1971), and by Phinney (1992) to ethnic identity.

A second major contribution has been Tajfel's (1981) work on social identity. Rather than a single, stable set of personality traits, Tajfel proposed that a social identity is a dynamic and interactive set of meanings that link a person to others in a (racial/ethnic) group, and that the meanings of social identities emerge through contrast and comparison with other social groups. There have been different conceptualizations of race/ethnic identity. Sellars et al.'s (1998) Multidimensional Model of Racial Identity (MMRI) proposed four dimensions including ideology, which taps an individual's beliefs, opinions, and attitudes regarding how group members should act; and regard, which refers to a person's affective and evaluative judgments of one's race. Phinney initially developed the Multigroup Ethnic Identity Measure (MEIM) with three dimensions, but later concentrated on two dimensions: exploration, which focuses on seeking information and experiences about one's ethnicity; and commitment, which related to one's sense of belonging and attachment to an ethnic identity (Phinney and Ong, 2007).

Symbolic interaction theory approaches racial/ethnic identities from a different perspective. Early theorists, such as Cooley (1902) and Mead (1934) were interested in the social and cognitive development of self. They shared the key assumption that the self develops through social interaction and that self processes provide individuals with intrinsic, independent, and self-derived motives for behavior and action (Stryker and Burke, 2000). Identity, from this perspective rests on James's (1890) insight that a person has as many selves as he or she gets recognition from others. In the early 1950s, Foote (1951) introduced "identity" to capture a "situated" or specific set of self meanings that an individual develops in social organizations and groups. Indeed, much of the work of identity theory from a symbolic interaction perspective concentrated on self meanings and attributes in

social roles, such as identities in the roles of parent, worker, spouse, and friend. More recently, identity theorists (Burke, 2004) have broadened identity to include both role and group identities, and often cite the work of social identity theorists such as Tajfel (1981). Finally, role identities and group identities develop as a consequence of two processes (Stone, 1962). Identification of entails the social learning of the meanings and expectations associated with a role or group. It highlights what a person shares with role or group members and what makes a role or group identifiable to one's self and others. Identification with, in contrast, involves the investing of self into a role and group ties and working out what the role or group means to the person.

Despite its rich theoretical foundation, work on racial/ethnic identity from a symbolic interaction perspective has not developed in a cumulative manner. Blumer (1958) stressed the importance of social comparison in formulating racial identity. He contended that members of racial groups form an image or "sense of group position" by judging or evaluating where they stand or rank in relationship to other racial groups. White and Burke (1987) constructed an ethnic identity measure by contrasting responses to meanings associated with being Black and White on twenty-three adjective-items organized in a semantic differential format. Hughes and Demo (1989) used data from a national sample of Blacks to measure Black identity by summing responses to a question that asked how close they felt in their ideas and feelings to Black people who are poor, religious, young, middle class, working class, older, elected officials, and professionals. Further, they measured racial self-esteem using an overall evaluation of Black people as a group and items attributing positive meanings to Blacks, such as being honest, hardworking, and loving their families. Somewhat differently, Hughes and Johnson (2001) created an ethnic identity scale based on three items: (1) closeness to others of the same ethnic or racial group; (2) preference to be with others of the same ethnic or racial background; and (3) more close friends belonging to the same ethnic or racial group.

Finally, Jaret and Reitzes (2009) proposed "perceived ethnic group advantage" as a dimension that reflects "identification of." This dimension is similar to Blumer's sense of group position, and taps a positive assessment of one's ethnic group. The process of "identification with" refers to self-investment in a role. Distance from one's racial/ethnic identity was captured by "ethnic estrangement," which measures alienation from one's ethnic group.

Importance of the Ethnic/Race Identity

Identity theory not only recognizes multiple dimensions of identity meaning, but also that people invest their identities with preference and importance. Returning to James's (1890) insight that individuals create multiple, situated self conceptions, identity theory postulates that individuals select and order their identities and differentially attribute importance to their identities. Centrality or importance refers

to the cognitive and evaluative ordering or ranking of identities (Stryker and Serpe, 1994). Identity theory suggests that individuals engage in the "identification of" process by ordering their multiple identities by the importance they attribute to them.

Race/ethnicity researchers have treated importance in two ways. First, they have conceptualized it as a dimension of racial/ethnic identity. Thus, Sellars et al. (1998) not only used "ideology" and "regard" as components of racial identity, but also "centrality," the extent to which a person normatively defines him/herself with respect to race, and Sullivan and Arbuthnot (2009) included "centrality" as part of a measure of racial identity in their investigation of the impact of African American identity on candidate evaluations. Second, importance can be treated as an independent construct of identity. Yip et al. (2006) found that Blacks with achieved racial identities were more likely to report race as central to their identity.

Research Expectations

We pursue four sets of research expectations. First, do racial/ethnic identities, importance, and well-being vary by race/ethnicity? Phinney (1992) and Phinney, Cantu, and Kurtz (1997) measured racial/ethnic identity meanings of Black, White, and several other groups of students. They found Blacks are highest or most positive and Whites lowest or least positive. Based on this, we hypothesize that Black college students will have the most positive racial/ethnic identities and Whites will have the least positive racial/ethnic identities.

On variation in the importance of racial/ethnic identities by race/ethnic groups, White and Burke (1987) found that Black college students assign greater importance to their ethnic identity than did White college students. Blacks attribute greater importance to their racial/ethnic identity than do Multiracials or Whites, and they see it as more important across a range of social settings (Jaret and Reitzes 1999). Massey et al. (2003) reported that in-group racial identity was important to most Black, Latino, and Asian first year college students and that racial identity seems especially important in the identity development of minority group members. For Whites, being White is "normal" and thus less likely to be invoked or to impact identity construction. So, we expect that Whites will have lower racial/ethnic importance scores than Blacks or Asian-Americans.

We also investigate variation by racial category on two indicators of well-being: self-esteem and self-efficacy. Studies show self-esteem for Blacks is equal to or higher than self-esteem for Whites. Massey et al. (2003) found that the college students in their study have high self-esteem, but Blacks show the highest, followed by Latinos, Whites, and Asian-Americans. The pattern for self-efficacy has been less extensively studied than that for self-esteem. Hughes and Demo (1989) suggest that Blacks have lower efficacy scores than Whites because Blacks attribute their fate to external sources, such as blocked opportunities and institutional barriers resulting from systematic racial discrimination, rather than personal agency or individual actions. Massey et al. (2003) found that their college students generally

had high self-efficacy, though Asian-Americans score relatively lower on efficacy, and that mean efficacy scores for Blacks are comparable to those of Whites. We expect that Blacks in our sample (many of whom are the first in their family to attend college) may feel that their educational status reflects personal control and achievement, so they may have a sense of efficacy even higher than white students. We hypothesize that, for both self-esteem and self-efficacy, Blacks will be highest, followed by Whites and Asian-Americans.

Our second set of research expectations focuses on the impact of racial/ethnic identities on well-being. Both social identity theory and identity theory suggest that positive racial/ethnic identity meanings have a positive impact on psychological well-being. Tajfel and Turner (1986) argue that individuals use positive and favorable social identities to bolster their self-esteem. Phinney (1992) proposed, especially for minority group members, that a positive racial/ethnic identity and identification with others who share their origins and traditions is critical in developing feelings of self-esteem and self-efficacy. Phinney, Cantu, and Kurtz (1997) found that ethnic identity had a positive effect on self-esteem for Black, Latino, and White adolescents. Numerous other researchers, studying a variety of students, find evidence supporting the link between feelings of positive racial/ethnic identity (e.g., pride, attachment) and higher levels of self-esteem (see Roberts et al., 1999; Romero and Roberts, 2003).

Identity theory also proposes that positive racial/ethnic identity meanings enhance self-esteem. Burke and Stets (2009) argued that identities based on self-meanings shared with others, such as an ethnic or racial identity, encourages recognition, approval, and acceptance from group members and therefore tend to lead to increased feelings of self-worth and self-esteem. Hughes and Demo (1989) studied the self-perceptions of Blacks and found that racial self-esteem (measured in terms of positive attributions to Blacks) had a positive effect on both self-esteem and personal efficacy, while Black identity (constructed from items that tapped closeness to different kinds of Black people) did not influence those two well-being variables. More recently, Reitzes and Jaret (2007) investigated identities among Black college students and report that "Black positional identity," but not "Black identity affiliation" had a positive effect on self-esteem and self-authenticity. So we expect that positive racial/ethnic identity meanings will encourage self-esteem and self-efficacy among students.

Our final research expectations concern the impact of racial/ethnic importance on well-being. White and Burke (1987) found that the importance of a racial identity was not correlated with self-esteem for either Black or White college students. Sellars et al. (2003) incorporated a measure of centrality into their measure of racial identity (MIBI) and studied Black ninth graders over several waves of data collection. They found that wave 4 centrality had a negative impact on wave 5 stress and distress. Smith et al. (1999) indicate that ethnic identity importance and self-esteem increased personal efficacy among students. We therefore expect that racial/ethnic importance will have positive impacts on self-esteem and self-efficacy.

The importance of a racial/ethnic identity may also increase the impact of positive identity meanings on well-being. Positive racial/ethnic identity meanings may provide a stronger support for well-being when the identities are more important than when they are not. Men's job satisfaction had a greater impact on men's health for men highly committed to job success than for men who indicated that they were less committed to job success (Wickrama et al., 1995). We expect that positive racial/ethnic identity meanings will have a greater influence on self-esteem and self-efficacy when individuals attribute greater importance to their racial/ethnic identity.

Methodology

Data

Data for this study come from a survey of college students conducted in January 2006 at a large public research university located near the center of a major southern metropolitan area. The university's student body is racially diverse: 49 percent White; 32 percent Black; 11 percent Asian; 3 percent Hispanic; and 5 percent mixed and other, but the average age of students is quite typical: nineteen years old for freshmen and twenty-four years old for seniors. Average SAT scores of entering students in this mid-tier university are 1100, which is similar to other public urban universities and somewhat lower than scores for students entering large, public flagship institutions. Finally, over 60 percent of the undergraduates come from families where the fathers (62 percent) or mothers (68 percent) have attended college (NSSE, 2007).

We constructed a questionnaire containing sixteen sets of questions, which took respondents approximately twenty-five minutes to complete, and then administered the instrument to undergraduates in lower division sociology courses. These courses were selected because they are included in the university's general education core and therefore draw the widest range of students from across different schools and majors and do not primarily consist of sociology majors.

Results were obtained from 655 students: 264 (40 percent) White; 263 (40 percent) Black; 47 (7 percent) Asian; 22 (3 percent) Hispanic; 56 (11 percent) mixed or other; and three declined to give a racial identity. This analysis focuses on the students who identified as Black. However, to provide context, our table presenting the descriptive statistics for Black students also shows how they compare to White and Asian students (the numbers in other racial categories are too small to be useful for comparison). A few students chose not to respond to some questions used to construct the variables in the statistical analysis, and we did not replace these missing data with an estimate; therefore, (as our tables indicate) the actual number of cases is less than the total numbers specified above. While not exactly representative of all Black college students, this sample allows us to investigate racial/ethnic identities, as well as well-being variables among a set of

Black students who seem to be similar to a large segment of those attending college today.

Variables and Statistical Analysis

Students self-identified their race by selecting either American Indian; Asian; Black; Latino and/or Hispanic; Pacific Islander; White; Mixed; or Other. We constructed indexes for three distinct dimensions of racial/ethnic identity meanings. Pretests showed that students at this university use "racial" and "ethnic" in inconsistent ways and often blur the common social science distinction between them; thus, in doing so they resemble many other Americans (Bailey, 2001; Oropesa, Landale and Greif, 2008). Therefore, in this research we merged these concepts, and in asking about "racial/ethnic" identities or groups, we told students to think of identities, groups, or behaviors associated with or based on shared inherited physical traits and/or cultural (e.g., linguistic, national) characteristics. Our first racial/ethnic identity meaning reflects an "identification of" process and is termed racial/ethnic *comparative advantage*. It contains five items that tap whether a respondent believes that "being a member of my ethnic group is an advantage in life"; "members of other ethnic groups often treat well and act fairly toward members of my ethnic group"; "being a member of my ethnic group is something for which other people look at me with respect"; "members of other ethnic groups often trust members of my ethnic group"; and "being a member of my ethnic group provides more opportunities for success in life than other people have" (alpha for Blacks = .60). Higher scores on this index signify a more positive outlook (i.e., one's group is viewed favorably, is well treated or advantaged).

Two other indexes of racial/ethnic identity capture "identification with" processes and self investment in one's race/ethnic identity. *Authenticity* is based on agreement or disagreement with five statements: being a member of my ethnic group is meaningful to me; doing things as a member of my ethnic group is rewarding for me; being a member of my ethnic group gives me a sense of meaning and direction; as a member of my ethnic group, I feel that I belong to an important group; and I enjoy and value the social ties and contact that I've made as a member of my ethnic group (alpha=.87). *Estrangement*, on the other hand, reflects ambivalence towards or alienation from the group and is based on agreement/disagreement with five statements: I feel good about myself as a member of my ethnic group (reverse coded); I feel that I'm a failure as a member of my ethnic group; I am uncertain about myself as a member of my ethnic group; Sometimes I question the value of being a member of my ethnic group; and I don't feel connected to others in my ethnic group (alpha=.70). As expected, comparative advantage, as an "identification of" meaning, is not correlated to either of the "identification with" meanings; the two "identification with" meanings are correlated but not identical (see Table 6.3 p. 160).

Identity theory proposed that in addition to creating self meanings or identities in social groups, individuals invest these identities with varying degrees of importance (Stryker and Serpe, 1994). We construct two measures of the importance of our students' racial/ethnic identity. The first, *racial/ethnic group importance* is based on a single item that asked students to indicate how important or unimportant being a "member of a racial or ethnic group" is to them (a four-point scale, with a high score signifying "very important" and a low score representing "not very important"). The second, *racial/ethnic activity-culture importance*, is from a question that asks respondents to rate the importance of eight activities (eating or preparing food of one's ethnic heritage; listening to ethnic music; dressing in ethnic style clothes; engaging in ethnic entertainment; learning about one's ethnic culture and history; following ethnic group traditions; participating in ethnic organizations; and spending time with friends from one's own ethnic group). The alpha coefficient for *racial/ethnic activity-culture importance* index is .88.

We examined two measures of well-being related to positive mental health. *Self-esteem* is measured by nine items from Rosenberg's (1979) self-esteem scale and captures a person's sense of self-worth. The scale's alpha value for Blacks is .88. *Self-efficacy* is a scale composed of eight items (Pearlin et al., 1981) to measure a sense of control and mastery (alpha value = .74), and, as expected, these two variables are positively correlated but not identical.

We included three social background variables in our analysis. Student's sex is a dummy variable coded to identify females (1) and males (0). Subjective *family social class* is measured by an item on "the social class of the family you grew up in" with five response categories: Working Class; Working/Middle Class; Middle Class; Middle/Upper Class; and Upper Class. In pre-tests these categories did a better job of spreading respondents across the continuum than the class categories used in the General Social Survey. Respondents also identified themselves as being either immigrant, 1. 5 generation, second generation, or third generation or more. Due to the small number of Black immigrants in this sample, we combine the immigrants, 1. 5 generation, and second generation students and compare them to third generation or higher students.

We include four other control variables. *College student confidence* is based on student agreement or disagreement with statements on the following: feeling good about being a college student; being satisfied with myself as a college student; feeling like a failure as a college student (reverse coded); feeling confident as a college student; and knowing what to do as a college student (alpha = .75). We also include three personality variables. After an introductory statement that asked students to "think about yourself as a person" we asked "how accurate is each of the following descriptions of you" with five response categories. The statements were: "I am *competitive*," "I am *passive*," and "I am *tense*" (high scores denote accurate descriptions).

We assess differences among and within racial/ethnic categories on our identity measures and well-being variables by using difference of means t-tests. The

multivariate analysis examining the effect of Black identity and other variables on self-esteem and self-efficacy is based on ordinary least squares multiple regression.

Results

We present our findings in four sections, beginning with a comparison of Black, White, and Asian students on racial/ethnic identity variables and other characteristics. The second section focuses solely on differences among our sample's Black students. In the third section, we examine correlations among indicators of Black racial/ethnic identity and self-esteem and self-efficacy. The final section consists of a test to see if an interaction effect exists, specifically, the hypothesis that the association between racial/ethnic "identification with" meanings (authenticity and estrangement) and self-esteem and self-efficacy is stronger for students who feel racial/ethnic identity is an important aspect of their identity than it is among students who feel it is not very important to them.

Comparisons of Black, White, and Asian Students

Evidence from our data strongly supports our hypothesis about inter-group differences on racial/ethnic identity, self-esteem, and self-efficacy. We begin by examining our variables measuring racial/ethnic identity meanings. The first is perceived *comparative advantage*, which reflects the extent to which students see their group as treated well, respected, and with opportunity for success. As row 1 of Table 6.1 shows, White students, as expected, are highest on perceived *comparative advantage* of their group (mean = 10.22) followed by Asians (9.57) and Blacks (7.45). Thus, Blacks students' sense of group position involves significantly higher percentages of them feeling disadvantaged than is the case among White and Asian students; conversely, more White students feel their racial/ethnic affiliation gives them an advantage.

For our next two identity meanings, high scores on *authenticity* imply very positive feelings regarding one's racial/ethnic group, and Black students' mean on authenticity (21.61) is significantly higher than Asians' (19.69) and Whites' (16.77). In contrast, high scores on our *estrangement* variable suggest an ambivalent, if not negative, orientation towards one's racial/ethnic group. Results are as expected: Black students express less racial/ethnic estrangement than do Asian and White students (difference in Table 6.1 significant, p < .01).

Turning to the *importance* of their racial/ethnic identities (rows four and five of Table 6.1), Blacks are much more likely to say it is very important than are either Asians or Whites. For example, *racial/ethnic group importance* has a mean of 4.16 among Black students, 3.84 among Asians, and only 2.91 among Whites (all inter-group differences significant at p < .01). In addition, the *racial/ethnic activity-culture importance* index shows very large inter-group differences: the mean for Blacks is 29.74 compared to 20.13 for Whites, with Asians in between at 27.57.

Specific items on which the largest inter-group differences exist are importance of "listening to my ethnic music" (percentages saying very important or important are 62 percent for Blacks, 43 percent Asians, and 17 percent for Whites) and importance of "learning about my ethnic culture and history" (percentages saying very important or important are 92 percent among Blacks, 65 percent among Asians, and 50 percent among Whites).

Table 6.1: Descriptive Statistics[1] on Racial/Ethnic Identity Variables, Self-Esteem and Self-Efficacy for College Students

Variables	Groups			
	Blacks	**Whites**	**Asians**	**Total**
Perceived **Comparative Advantage** of my racial/ethnic group	**7.45 a b** 240 1.691	**10.22 a c** 232 1.308	**9.57 b c** 44 1.576	8.87 517 2.024
Racial/ethnic **Authenticity**	**21.61 a b** 256 3.240	**16.77 a c** 259 4.787	**19.69 b c** 45 3.350	19.21 561 4.653
Estrangement from racial/ethnic group	**8.16 a b** 261 2.983	**10.32 a** 259 3.475	**10.26 b** 46 3.499	9.33 567 3.428
Importance of racial/ethnic **group membership**	**4.16 a b** 254 .912	**2.91 a c** 247 .935	**3.84 b c** 45 .952	3.57 544 1.105
Importance of racial/ethnic **activity-culture**	**29.74 a b** 255 6.017	**20.13 a c** 258 7.324	**27.57 b c** 46 6.555	25.12 560 8.142
Self-Esteem	**43.83 a b** 254 5.631	**39.91 a** 261 6.689	**38.84 b** 45 5.827	41.59 561 6.484
Self-Efficacy	**32.26 a b** 250 4.123	**30.37 a** 258 4.430	**29.07 b** 43 4.171	31.11 552 4.408

[1] In each cell, upper number is group mean, middle number is number of respondents, lower number is standard deviation.
Statistical significance level is .05 or lower. For the variable in each row, letter "a" indicates a significant difference between Blacks' and Whites' means. Letter "b" indicates a significant difference between Blacks' and Asians' means. Letter "c" indicates a significant difference between Whites' and Asians' means.

To put the importance placed on racial/ethnic identity in perspective, we also asked respondents to look at a list of ten different roles or statuses and select the three most important to them. Most students, regardless of race/ethnicity, chose familial roles (e.g., sons/daughters, spouses, siblings) or roles related to being a student, friend, or worker. Hardly anyone chose racial/ethnic status as one of their

three most important identities. In fact, more selected their religion as a "top 3" identity. However, slightly more Blacks (6 percent) chose their race/ethnicity as one of their three most important identities than did Whites (2 percent) or Asians (0 percent).

The final two rows in Table 6.1 show several significant inter-group differences in *self-esteem* and *self-efficacy*. Consistent with prior research and our expectations, Black students have higher self-esteem and a stronger sense of efficacy than do Asian and White students (the differences between Asians and Whites are not statistically significant).

Within-Group Comparisons for Black Students

We now focus on the Black students in this sample to see if any significant differences by gender, class, or generation exist on variables discussed above. Our findings are displayed in Table 6.2. The most pervasive intra-group differences among Black college students are found on *perceived comparative advantage*. Significant differences are found for gender, social class, and generation. Specifically, phrasing it positively, Black females indicate their racial/ethnic group is more of an advantage than do Black males. In terms of socioeconomic class, middle-class Black students perceive more advantage (or less disadvantage) to their race/ethnicity than do working-class Black students. As for generational differences, the first and second generation students, on average, have a more positive outlook, in that they perceive their racial/ethnic group as providing more advantage (or less disadvantage) than do Black students who are third or higher generation.

Examining the other racial/ethnic identity meanings variables, we find no significant differences on *authenticity* between Black males and females, between working- and middle-class students, or between Black students who are first and second generation compared to those who are third generation. However, the picture changes for racial/ethnic *estrangement*. The first and second generation is more estranged than Black students who are at least third generation (means of 9.65 vs. 7.85, respectively, p < .001). Due to the way the survey items were worded, we do not know whether the basis of the first and second generation's higher estrangement derives from feelings of disconnection or alienation from their nationality group (i.e., homeland from which they or their parents emigrated) or from disconnection or alienation from the larger native-born Black culture and peer groups that they come into contact with. The literature on Black immigrants and their children in the U. S. suggests that both sources of estrangement are present (Butterfield, 2004; Waters, 2001; Shaw-Taylor and Tuch, 2007), so this would be an important area of further research.

For variables measuring *importance* of racial/ethnic identity, we find only one significant difference. It is between Black males and females on *racial/ethnic activities-culture*: women's mean is higher than men's (30.29 vs. 28.22, p = .013). This significant difference is largely due to substantial differences between women

and men on two items: the importance of engaging in social or entertainment activities associated with one's racial/ethnic group and in participating in organizations that include members of one's own group.

Finally, with regard to *self-esteem* and *self-efficacy*, in neither case are differences between men and women or between socioeconomic classes statistically significant. However, as shown in Table 6.2, intergenerational differences in self-esteem and self-efficacy are statistically significant. In both self-esteem and in self-efficacy, Black third generation or higher students are higher than Black first and second generation students.

Relationships among Racial/Ethnic Identity and Well-Being Variables among Black Students

Table 6.3 shows how our variables of interest are correlated. Our primary concern is with the association between Black college students' racial/ethnic identity and self-esteem and self-efficacy. However, it is useful to comment on correlations among several racial/ethnic identity measures. As expected, the "identification of" identity meaning (*comparative advantage*) is independent from two "identification with" racial/ethnic identity meanings (i.e., not correlated with them). In other words, in this sample of Black students, the meanings related to *comparative advantage* are not connected to the "identification with" variables (authenticity and estrangement), but *authenticity* and *estrangement* are related (-.511). Finally, as expected, our two measures of racial/ethnic identity importance are positively correlated with each other (. 448). They are not related to *comparative advantage* but do have impressive correlations with *authenticity* (.510 and .574).

Next, we consider the relationships between racial/ethnic identity variables and well-being variables. While comparative advantage is not associated with well-being, both "identification with" meanings (authenticity and estrangement) and well-being are correlated: .378 for *authenticity* and *self-esteem*, .264 for *authenticity* and *self-efficacy*; -.433 for *estrangement* and *self-esteem*, and -.371 for *estrangement* and *self-efficacy*. Thus, as prior research suggests, positive racial/ethnic meanings are related to higher self-esteem and self-efficacy, and negative meanings associated with one's racial/ethnic identity are related to lower self-esteem and self-efficacy. In contrast, racial/ethnic identity importance is very weakly correlated with self-esteem and self-efficacy. The issue we examine next is our hypothesis about an interaction effect. Is the relationship between students' racial/ethnic meanings and self-esteem and self-efficacy stronger among those for whom racial/ethnic identity is important, or among those for whom it has much less importance?

Table 6.2: Racial/Ethnic Identity and Well-Being for Black College Students by Sex, Social Class, and Generation

Variable	Sex		Social Class		Generation	
	Males	Females	Working	Middle	First and Second	Third or more
Comparative Advantage of Racial/Ethnic Identity	6.89 a	7.66 a	7.23 b	7.77 b	8.15 c	7.29 c
Racial/Ethnic Authenticity	21.38	21.70	21.40	21.94	21.21	21.75
Estrangement from Racial/Ethnic Group	8.23	8.15	8.31	7.98	9.65 c	7.85 c
Importance: Racial/Ethnic Group	3.99	4.22	4.14	4.19	4.29	4.14
Importance: Racial-Ethnic Activity-Culture	28.22a	30.29a	29.86	29.54	31.09	29.52
Self-Esteem	43.18	44.11	43.37	44.58	42.17c	44.28c
Self- Efficacy	32.95	31.99	32.23	32.26	31.08c	32.53c

Note: In each row, bold numbers followed by letter "a" indicate statistically significant difference between males and females (p < .05). Bold numbers followed by letter "b" indicate statistically significant difference between middle- and working-class (p < .05). Bold numbers followed by letter "c" indicate statistically significant difference between generations (p < .05).

Table 6.3: Correlation Matrix of Variables for Black College Students

	Group Compara-tive Advantage	Racial/ Ethnic Authenticity	Estrangement from Racial/ Ethnic Group	Racial/Ethnic Group Importance	Ethnic Activity-Culture Importance	Self-Esteem	Self-Efficacy
Group Comparative Advantage	1.000						
Racial/Ethnic Authenticity	.105	1.000					
Estrangement From Racial/ Ethnic Group	.002	-.511**	1.000				
Race/Ethnic Group Importance	.109	.510**	-.155*	1.000			
Ethnic Activity-Culture Importance	.109	.574**	-.267**	.448**	1.000		
Self-Esteem	.018	.378**	-.433**.	.198**	.097	1.000	
Self-Efficacy	.023	.264**	-.371**.	.127*	.060	.559**	1.000

Note : ** significant at the 0.01 level; * significant at the 0.05 level

An Interaction Effect: Does Importance of Racial-Ethnic Identity Have a Mediating Effect?

We used multiple regression to understand the connection that racial/ethnic identity and other relevant variables have with college students' self-esteem and self-efficacy. Preliminary analyses led us to formulate multiple regression models for *self-esteem* and *self-efficacy* that contain, as independent variables, our racial/ethnic authenticity and estrangement indexes, an index measuring sense of confidence in the student role, three personality traits (competitiveness, passivity, and feeling tense), sex, and either family social class (in self-esteem model) or generation (in self-efficacy model). These models are relatively strong in terms of the amount of variation they explain in self-esteem and self-efficacy (see adjusted R^2 values in Tables 6.4 and 6.5). We present these results by first showing (as model 1) a "baseline" multiple regression analysis for all the Black students in the sample, which indicates how racial/ethnic authenticity and estrangement (and other variables) relate to self-esteem (Table 6.4) and self-efficacy (Table 6.5). Then, we test whether the relationships that authenticity and/or estrangement have with self-esteem and self-efficacy differ among students who feel that their racial/ethnic identity is very important and those who do not feel that way. This is done by dividing the Black students into two subgroups. The first is comprised of students at the high end on both racial/ethnic identity importance measures. Multiple regression results for them are shown in model 2 of Tables 6.4 and 6.5. The second set of Black students are those who were low or moderate on both measures of importance of racial/ethnic identity, and their multiple regression analysis is given in model 3 of Tables 6.4 and 6.5. If the hypothesized interaction effect exists, then there should be clear differences in the authenticity and estrangement coefficients in models 2 and 3; specifically, these coefficients in model 2 should be stronger than in model 3 (in fact, they might not even be statistically significant in model 3).

Self-Esteem

The baseline model for all Black students (Table 6.4, model 1) shows statistically significant relationships between both racial/ethnic identity variables and self-esteem. As expected, these relationships are of opposite significance: students with stronger sense of racial/ethnic authenticity have higher self-esteem, while higher racial/ethnic estrangement is associated with lower self-esteem. This supports the idea that feeling connected to a group that gives a person meaning, direction, and valued social ties has a beneficial impact on how an individual judges his or her own worth as a person. It is also consistent with work by researchers cited above. We also note the statistically significant relationships that other variables in model 1 have with self-esteem. Female students have higher self-esteem than males, and socioeconomic class is positively associated with self-esteem. Being confident in one's ability as a college student is related to higher self-esteem. Of the personality

traits included in the regression model, students who describe themselves as competitive had higher self-esteem than those who said they are not competitive, and being "passive" and being "tense" are associated with lower self-esteem. Based on size of standardized regression coefficients (betas), the strongest predictors of self-esteem in the model for all Black students are competitiveness, confidence in college student role, and feeling tense. Racial/ethnic estrangement, passivity, and sex are of moderate power as predictors, and racial/ethnic authenticity and socioeconomic class are weaker.

Table 6.4: Multiple Regression Results for Black College Students' Self-Esteem

Full Black Sample	High Importance		Moderate and Low Importance			
Variables	Model 1		Model 2		Model 3	
	b	β	b	β	b	β
R/E Authenticity	.198*	.118	.782***	.323	.008	.005
R/E Estrangement	-.400***	-.215	-.232	-.133	-.441**	-.225
Sex (m = 0; f = 1)	2.227**	.175	2.108*	.180	2.205*	.166
Confidence in College Student Role	.522***	.258	.478***	.279	.537**	.238
Competitive	1.526***	.287	1.021**	.211	1.883***	.333
Passive	-.933***	-.180	-.726*	-.175	-1.069*	-.172
Tense	-1.227***	-.240	-1.008**	-.231	-1.653***	-.296
Socioeconomic Class	.650*	.107	.384	.075	.717	.107
Constant	29.160		16.758		33.077	
Adjusted R^2	.465		.505		.433	
Number of Cases	234		99		125	

Notes: b = unstandardized regression coefficient; β = standardized regression coefficient (beta). *** $p < .001$; ** $p < .01$; * $p < .05$

Examining models 2 and 3 in Table 6.4 shows that the links between authenticity and estrangement and self-esteem really do differ depending upon how much importance students place on their racial/ethnic group membership. Among those for whom race/ethnicity is most important (model 2), we see a large jump in the strength of association between racial/ethnic authenticity and self-esteem: It now has the highest standardized regression coefficient. In contrast, model 2 shows that racial/ethnic estrangement loses significance as a predictor of self-esteem. Further analysis shows that students included in model 2 (i.e., those at the high end on racial/ethnic importance) are considerably lower on estrangement and higher on authenticity than students in model 3. This low level of estrangement among these students probably contributes to its lack of statistical significance here. In contrast,

model 3 (for students who place less importance on their race/ethnicity) is a "mirror opposite" of model 2, in that here racial/ethnic estrangement retains the significant association it had with self-esteem in model 1, while authenticity loses statistical significance. In other words, and this may seem paradoxical, for those Black college students who place less importance on their racial/ethnic identity, racial/ ethnic estrangement still does seem to matter : those who feel more estranged tend to have lower self-esteem than those who are less estranged from their group.

Self-Efficacy

We turn to Table 6.5 to analyze results regarding students' sense of efficacy. The multiple regression models for self-efficacy explain a little less variation in self-efficacy than was the case for self-esteem, but their adjusted R^2s are substantial (ranging from .350 to .470). Model 1 shows that for self-efficacy only one of the two racial/ethnic meaning variables, estrangement, is statistically significant. As was the case for self-esteem, racial/ethnic estrangement's association with self-efficacy is negative : More estranged students have lower self-efficacy than less estranged students. Racial/ethnic authenticity, on the other hand, has no significant association with self-efficacy. Judging from the standardized coefficients, the strongest effects on self-efficacy in this model come from variables measuring feeling tense (negative relationship) and level of confidence in the student role (positive relationship), while estrangement's standardized coefficient is of moderate magnitude relative to the others in model 1.

In models 2 and 3 of Table 6.5, we see an expected pattern, at least for racial/ ethnic estrangement. Among Black college students placing higher importance on race/ethnicity (model 2), the negative association between estrangement and self-efficacy remains statistically significant and, if anything, is slightly stronger than in model 1. On the other hand, for Black college students who place less importance on race/ethnicity (model 3), there is no significant relationship between racial/ethnic estrangement and self-efficacy. In neither model 2 nor 3 is racial/ethnic authenticity statistically significant, and that is consistent with model 1.

Discussion

One of our major goals in this study was to confirm the multidimensional character of racial/ethnic identity. We found support (Table 6.3), drawn from our theory, for distinguishing "identification of" and "identification with" meanings. *Comparative advantage* is not correlated with *authenticity* or *estrangement*, but *authenticity* and *estrangement* are related (-.511). Turning to the two *importance* measures, we see that they correlate well with each other (.448). Finally, while *authenticity* is correlated with both measures of importance, *estrangement* is only correlated with *activity-culture* importance (-.267), and *comparative advantage* is not related to racial/ethnic importance. In general, the findings support the validity of our theoretical expectation that racial/ethnic identity meanings are related, but not identical to measures of identity importance.

Table 6.5: Multiple Regression Results for
Black College Students' Self-Efficacy

Variables	Full Black Sample Model 1		High Importance Model 2		Moderate and Low Importance Model 3	
	b	β	b	β	b	β
R/E Authenticity	.069	.055	.174	.089	.072	.058
R/E Estrangement	-.224*	-.161	-.291*	-.204	-.111	-.079
Sex (m = 0; f = 1)	-.564	-.059	-1.052	-.110	-.482	-.050
Confidence in College Student Role	.421***	.280	.422***	.308	.470***	.287
Competitive	.383†	.096	.466	.119	.192	.047
Passive	-.423*	-.110	-.110	-.033	-.769*	-.170
Tense	-1.480***	-.379	-1.248***	-.355	-1.597***	-.377
Generation (3 = 0; 1 and 2 = 1)	-1.054†	-.101	.398	.040	-2.541**	-.234
Constant	28.387		24.539		28.651	
Adjusted R2	.409		.350		.470	
Number of Cases	228		99		120	

Notes: b = unstandardized regression coefficient; β = standardized regression coefficient (beta). *** p< .001**; p < .01*; p < .05†< .10

Turning to more substantive findings, we first investigated how racial/ethnic identity varies by race. The literature suggests that Blacks view it as a more important identity than Whites and report stronger identification with their racial/ethnic group, while Whites prefer to dismiss the significance of race and downplay their racial/ethnic identities. Our findings concur. With regard to *comparative advantage*, Du Bois's concern about being viewed with "contempt and pity" and "having the doors of opportunity closed roughly in his face" are still relevant. Blacks are much more likely than Asians or Whites to indicate that their racial/ethnic group brought disadvantages. Blacks perceive that being Black may carry less social status than other groups, but they identify more with their racial/ethnic group than do Whites and Asians. On the "identification with" meanings, Blacks are higher on *authenticity* than Whites or Asians, (Asians also are higher than Whites on authenticity) and Blacks feel less *estrangement* from others in their group than do Whites and Asians. This positive identification with being Black is also reflected in the importance that Blacks attribute to their racial/ethnic identity. Blacks are higher on both racial/ethnic *importance* variables than Asians or Whites.

Next, we consider variations in Black racial/ethnic identity by generation, social class, and sex. Straight-line assimilation theory suggests that racial/ethnic ties and identification weakens over generations (Alba and Nee, 2003). Our data reveal little support for "straight-line" assimilation among Blacks. Immigrant and second generation Blacks see less disadvantage in being Black than do those of third or higher generation, but they also are more *estranged* from their racial/ethnic group

than Blacks whose families have been in the United States longer, and there are no differences by generation in *authenticity* or *importance*. This is consistent with the idea that Black immigrants and their children are often more optimistic about their prospects but feel detached from or misunderstood by Blacks whose families have lived in the U.S. for many generations. We also note that Black females perceive greater *comparative advantage* to being Black than do Black males, which is consistent with observed educational and occupational trends. As expected, middle class Blacks may use their own success to attribute greater *comparative advantage* to being Black than do working class Blacks. More broadly, the relatively few significant racial/identity differences among Blacks by social class and sex suggests that racial/ethnic identity, similar to other identities and self concepts (LaRossa and Reitzes, 1993), may be more influenced by finer grain differences in face to face and interpersonal socialization and family experiences than these more general social categories.

Our main interest is to explore the relationship between racial/ethnic identity dimensions and well-being among Black college students. We expected that having positive racial/ethnic identity meanings and attributing importance to a valued identity would increase self-esteem and self-efficacy (Stryker and Burke, 2000; Tajfel and Turner, 1986). The correlation data presented in Table 6.3 offers initial support for our expectations. Our two "identification with" meanings, *authenticity* and *estrangement,* are significantly correlated with both self-esteem and self-efficacy, as is *activity-culture importance.* The next test is whether these identity variables continue to maintain their effect when other social background, personality, and college student role identity factors are included as controls in regression analyses. We find that both race/ethnic "identification with" meanings directly influenced self-esteem, and *estrangement* also influenced self-efficacy. The findings provide important confirmation that the way in which Black college students view themselves as Blacks influences their well-being. Attributing a sense of meaning, belonging, and value to one's racial/ethnic group contributes to both a sense of self-worth and control or mastery. Feeling less estranged, uncertain, and alienated from one's racial/ethnic group provide a foundation for self-efficacy.

We also were interested in exploring whether racial/ethnic identity meanings have a greater impact on well-being for Black students who attribute greater importance to their racial/ethnic identity. The possibility that identity meanings vary in impact on well-being by the importance of the identity is consistent with our theoretical understandings of identity processes, but this has not been widely studied. We find mixed support for the interaction expectation with regard to self-esteem. On one hand, among Black students who attribute greater importance to their racial/ethnic identity, authenticity, as expected, exerts a statistically significant effect on self-esteem, but this identity meaning does not influence self-esteem for those who attribute only moderate or low importance to racial/ethnic identity. On the other hand, for those Black students who attribute moderate and low importance to their racial/ethnic identity, identity meanings of *estrangement* exert a negative impact on self-esteem, but not for Black students who attribute high importance to being Black. An unexpected finding is that *estrangement* influences self-esteem for students who perceive only low or moderate *importance* to the Black identity, but

not those who assign high *importance* to being Black. *Estrangement* operates in a more expected manner with regard to self-efficacy. For Black students who attribute high importance to their racial/ethnic identity, *estrangement* negatively influences self-efficacy, but there is not a statistically significant impact of *estrangement* on self-efficacy for those who attribute moderate or low importance to the identity. Clearly, more theoretical work needs to be done on factors that may mediate the direct relationship between identity meanings and well-being.

We began this chapter by highlighting several issues about racial/ethnic identity that W. E. B. Du Bois raised over one hundred years ago, and we conclude by linking our findings to his ideas. First, our findings indicate that Du Bois was right when he said that in seeking to create "a better and truer self" Blacks would "not bleach [their] Negro soul in a flood of white Americanism." Researchers have described "whitening" processes among several American racial/ethnic groups (Brodkin, 1998; O'Brien, 2008; Roediger, 2005), but our findings, particularly on our *importance* and *authenticity* indexes, imply that Black students, more so than others we studied, find comfort, satisfaction, and meaning in their racial/ethnic identities. Moreover, while Black students recognize that some disadvantage and/or disrespect from others is associated with their racial/ethnic status, their identification with the group is not related to diminished self-concept or feelings of helplessness; on the contrary, the more they identify with their group, the higher their self-esteem and self-efficacy.

Du Bois also addressed internal variation within the Black community, more so along class lines than gender, and he was interested in identities and behaviors of the lower, middle, and upper ("talented tenth") classes. While the lower and upper ends of the socio-economic spectrum are under-represented in our college sample, we found surprisingly few differences in racial/ethnic identity meanings and importance between Black students from working-class and middle-class backgrounds. In contrast, we found interesting within-group differences for a segment of the Black community that did not exist or was invisible to Du Bois in the 1890s and early 1900s: Black immigrants and their children. The position and role in the community of the growing number of Black immigrants, comprising 8 percent of the U. S. Black population (U. S. Bureau of the Census, 2009), and their children, is an important area for future research. We found that compared to third or higher generations, Black immigrants and their children see less disadvantage associated with being Black, are higher on the estrangement index, but have lower self-esteem and self-efficacy. In our analysis the first and second generations were combined due to the small sample size, but it would be advisable for researchers in the future to design studies that permit separate analysis of immigrants, their children, and third or higher generations. This would enable ongoing research on Black racial/ethnic identities to connect more fruitfully with the exciting and growing sociological literature on the "new second generation" (Kasinitz, Mollenkopf, Waters, and Holdaway, 2008; Portes, Fernandez-Kelly, and Haller, 2009).

References

Alba, R., and Nee, V. (2003). *Remaking the American mainstream: Assimilation and contemporary immigration*. Cambridge, MA: Harvard University Press.

Ashmore, R. D., Deaux, K., and McLaughlin-Volpe. (2004). An organizing framework for collective identity: Articulation and significance of multi-dimensionality. *Psychological Bulletin*, 130, 80-114.

Bailey, B. (2001). Dominican-American ethnic/racial identities and United States social categories. *International Migration Review* 35, 677-708.

Berezin, M. (2010). Identity through a glass darkly : Review essay of Peter J. Burke and Jan E. Stets, *Identity Theory: Social Psychology Quarterly*, 73, 220-222.

Blumer, H. (1958). Race prejudice as a sense of group position. *Pacific Sociological Review*,1, 3-7.

Brodkin, K. (1998). *How Jews became white folks and what that says about race in America*. New Brunswick, NJ: Rutgers University Press.

Burke, P. J. (2004). Extending identity theory: Insights from classifier systems. Sociological Theory, 22:574-94.

Burke, P. J., and Stets, J. E. (2009). *Identity theory*. New York: Oxford University Press.

Butterfield, S. P. (2004). We're just black: The racial and ethnic identities of second generation West Indians in New York, pp. 288-312. In P. Kasinitz (Ed.), *Becoming New Yorkers*. NY: Russell Sage.

Cooley, C. H. (1902). *Human nature and social order*. New York: Charles Scribner and Sons.

Cross, W. E. (1971). The Negro-to-Black conversion experience. *Black World*, 9, 13-27.

Deaux, K., and Martin, D. (2003). Interpersonal networks and social categories: Specific levels of context in identity processes. *Social Psychology Quarterly*, 66, 101-117.

Du Bois, W. E. B. (1897). The conservation of the races, pp. 238-249. In D. S. Green and E. D. Driver (Eds.), *W. E. B. Du Bois on sociology and the Black community*. Chicago: University of Chicago Press.

Du Bois, W. E. B. (1903). *The Souls of Black Folks*. New York: Fawcett.

Erikson, E. (1968). *Identity: Youth and crisis*. New York: Norton.

Foote, N. (1951). Identification as the basis for a theory of motivation. *American Sociological Review*, 16, 14-21.

Hughes, D., and Johnson, D. (2001). Correlates in children's experiences of parents' racial socialization behaviors. *Journal of Marriage and the Family*, 63, 981-995.

Hughes, M., and Demo, D. H. (1989). Self-perceptions of Black Americans: Self-esteem and personal efficacy. *American Journal of Sociology*, 95, 132-59.

James, W. (1980). Principles of psychology. New York: Holt.

Jaret, C., and Reitzes, D. C. (1999). The importance of racial-ethnic identity and social setting for Blacks, Whites, and Multiracials. *Sociological Perspectives*, 42, 711-737.

Jaret, C., and Reitzes, D. C. (2009). Currents in the stream: College student identities and ethnic identities and their relationship with self-esteem, efficacy, and grade point average in an urban university. *Social Science Quarterly*, 90, 345-367.

Kasinitz, P., Mollenkopf, J. H., Waters, M. C., and Holdaway, J. (2008). *Inheriting the city: The children of immigrants come of age*. New York: Russell Sage.

LaRossa, R., and Reitzes, D. C. (1993). Symbolic interactionism and family studies, pp. 117-131. In P. G. Boss, W. J. Doherty, R. LaRossa, W. R. Schumm, and S. K. Steinmetz (Eds.), *Sourcebook of family theories and methods: A contextual approach*. New York: Plenum Press.

Massey, D. S., Camille, C. Z., Lundy, G. F., and Fischer, M. J. (2003). *The source of the river: The social origins of freshmen at America's selective colleges and universities*. Princeton, NJ: Princeton University Press.

Mead, G. H. (1934). *Mind, self, and society*. Chicago: University of Chicago Press.

National Survey of Student Engagement (NSSE). (2007). *NSSE 2007 background item frequency distributions: Georgia state university*. Available at (http://www2.gsu.edu/~wwwire/2007).

O'Brien, E. (2008). *The racial middle: Latinos and Asians living beyond the racial divide*. New York: New York University Press.

Oropesa, R. S., Landale, N. S. and Greif, M. (2008). From Puerto Rican to pan-ethnic in New York City. *Ethnic and Racial Studies* 31, 1315-1339.

Pearlin, L. I., Lieberman, M. A., Menaghan, E. G., and Mullan, J. T. (1981). The stress process. *Journal of Health and Social Behavior*, 22, 337-356.

Phinney, J. S. (1992). The multigroup ethnic identity measure: A new scale for use with diverse groups. *Journal of Adolescent Research*, 7, 156-176.

Phinney, J. S., Cantu, C. L., and Kurtz, D. A. (1997). Ethnic and American identity as predictors of self-esteem among African Americans, Latino, and White adolescents. *Journal of Youth and Adolescence*, 26, 165-185.

Phinney, J. S., and Ong, A. D. (2007). Conceptualization and measurement of ethnic identity: Current status and future directions. *Journal of Counseling Psychology*, 54, 271-281.

Portes, A., Fernandez-Kelly, P., and Haller, W. (2009). The adaptation of the immigrant second generation in America: A theoretical overview and recent evidence. *Journal of Ethnic and Migration Studies* 35, 1077-1104.

Reitzes, D. C., and Jaret, C. (2007). Identities and social-psychological well-being among African American college students. *Sociological Focus*, 40, 393-412.

Roberts, R. E., Phinney, J. S., Masse, L. C., Chen, Y. R., Roberts, C. R., and Romero, A. (1999). The structure of ethnic identity of young adolescents from diverse ethnocultural groups. *Journal of Early Adolescence, 19*, 301-322.

Roediger, D. (2005). *Working toward whiteness: How America's immigrants became white*. New York: Basic Books.

Romero, A. J., and Roberts, R. E. (2003). The impact of multiple dimensions of ethnic identity on discrimination and adolescents' self-esteem. *Journal of Applied Social Psychology*, 33, 2288-2305.

Rosenberg, M. (1979). *Conceiving the self*. New York: Basic Books.

Sellars, R. M., Caldwell, C. H., Schmeelk-Cone, K. H., and Zimmerman, M. A. (2003). Racial identity, racial discrimination, perceived stress, and psychological distress among African American young adults. *Journal of Health and Social Behavior*, 43, 302-317.

Sellars, R. M., Chavous, T. M., and Cooke, D. Y. (1998). Racial ideology and racial centrality as predictors of African American college students' academic performance. *Journal of Black Psychology*, 24, 8-27.

Shaw-Taylor, Y., and Tuch, S. A. (2009). *The other African Americans: Contemporary African and Caribbean immigrants in the United States*. Lanham, MD: Rowman and Littlefield.

Stone, G. P. (1962). Appearance and the self, pp. 86-118. In A. M. Rose (Ed.), *Human behavior and social processes*. Boston, MA: Houghton Mifflin.

Stryker, S., and Burke, P. J. (2000). The past, present, and future of identity theory. *Social Psychology Quarterly*, 63,284-297.

Stryker, S., and Serpe, R. T. (1994). Identity salience and psychological centrality: Equivalent, overlapping, or complementary concepts? *Social Psychology Quarterly*, 57, 16-35.

Smith, P. S., Walker. K., Fields, L., Brookins, C. C., and Seay, R. C. (1999). Ethnic identity and its relationship to self-esteem, perceived Efficacy and prosocial attitudes in early adolescence. Journal of Adolescence, 22, 867-880.

Sullivan, J. M., and Arbuthnot, K. N. (2009). The effects of Black identity on candidate evaluations: An exploratory study. *Journal of Black Studies*, 40, 215-237.

Tajfel, H. (1981). *Human groups and social categories: Studies in social psychology*. Cambridge, UK: Cambridge University Press.

Tajfel, H., and Turner, J. (1986). The social identity theory of intergroup behavior. In S. Worchel and W. Austin (Eds), *psychology of intergroup relations* (Second edition, pp. 7-24). Chicago: Nelson-Hall.

U. S. Bureau of the Census. (2009). *2007-2009 American community survey*, 3-year estimates. Table S0201, Selected Population Profile: "Blacks alone."

Waters, M. (2001). *Black Identities: West Indian immigrant dreams and American realities*. Cambridge, MA: Harvard University Press.

Wickrama, K., Conger, R. D., Lorenz, F. O., and Matthews, L. (1995). Role identity, role satisfaction, and perceived health. *Social Psychology Quarterly*, 58, 270-283.

White, C. L., and Burke, P. J. (1987). Ethnic role identity among Black and White college students: An interactionist approach. *Sociological Perspectives*, 30, 310-331.

Yip, T., Seaton, E. K., and Sellars, R. M. (2006). African American racial identity across the lifespan: Identity status, identity content, and depressive symptoms. *Child Development*, 77, 1504-1517.

Chapter Seven
When Racial Identity Matters: Stressful Events and Mental Health in Rural African American Adolescents

Rosa Maria Mulser, Kyle Hucke, Angelique Trask-Tate, and Michael Cunningham

Introduction

Previous research has demonstrated the negative effects of stressful events on African Americans' psychological well-being. Whereas most research examined urban populations, this study focuses on African American adolescents living in a rural environment. The study extends previous research by examining the influence of stressful events on seventy-two African American adolescents' self-reports of depressive and anxiety symptoms, respectively. We hypothesized that racial identity may moderate the relationship between stressful events and psychological distress. Regression analyses demonstrated that while stressful events were positively related to adolescents' depressive symptoms scores, the adverse effects of this relationship were lessened for those adolescents reporting a strong racial identity. However, racial identity did not act as a protective in the relation between stressful events and adolescents' reports of anxiety symptoms. These results may indicate that racial identity acts as more of a long-term global coping strategy for more chronic stressors, rather than as a reactive coping strategy for acute stressors. Thus, racial identity may serve more effectively as a buffer for developing depressive symptoms, which reflect long-term negative world view, but not as well

for coping with anxiety symptoms present during or shortly after an encounter with a stressful event.

Literature Review

Adolescence is a developmental period that is characterized by increasing life challenges and an elevated stress level. During adolescence individuals are more likely to engage in problem behaviors, hold poorer self-perceptions, and succumb to negative peer influences (Eccles et al., 1993). Furthermore, several researchers (Butler, Novy, Kagan, and Gates, 1994; Kurtz and Derevensky, 1993; Mullis, Youngs, Mullis, and Rathge, 1993) illustrated that academic pressure, work-related problems, interpersonal difficulties, death of loved ones, illnesses, and loss of relationships may demonstrate significant stressors for adolescents. Also during adolescence, individuals begin to spend more free time outside of their home in various public places, such as malls, restaurants, and schools (Sellers, Copeland-Linder, Martin, and Lewis, 2006). This new independence is associated with increased encounters with stressful events, such as community violence and racial discrimination. Experiences of stressful events have often been linked to an increase in adolescents' mental health problems, including depression and anxiety (Brown and Harris, 1978). In addition to the typical life stressors associated with adolescence (e. g., physical maturation, school transitions), the rural environment provides a vast range of challenges for the healthy development of adolescents. For instance, youths are often exposed to the economic distresses of poverty and lack of employment opportunities, among others, and limited access to resources and positive support networks (Kerpelman and Mosher, 2004).

To gain an understanding of how adolescents interpret specific contexts and react to stressors within these contexts, a contextually sensitive framework for individual development needs to be applied. Spencer's (2006) **Phenomenological Variant of Ecological Systems Theory (PVEST)** provides such a framework by analyzing the complex relationships between vulnerability, stress level, coping processes, and stage-specific coping outcomes throughout human development. Furthermore, PVEST serves as a model that examines the interactions of normative development with processes such as stressful events, racial identity, and depression and anxiety for youth of all ethnicities. This theory takes into account the diversity of individuals' experiences, perceptions, and their individual ways of resolving stress and dissonance. PVEST affords researchers the opportunity to view how normative development is challenged by specific risk factors (I. e., low income, low resource neighborhoods, lack of positive role models, low teacher expectations) and how resilience is fostered based on how individuals make meaning of their surroundings. Individuals' perceptions of their experiences are a core aspect of a PVEST perspective, and therefore, the theory is useful in examining adolescents' stressful events and their impact on their mental health.

Past research has illustrated that adolescents who are exposed to stressful events such as poverty, lack of employment opportunities and support networks, interpersonal difficulties, death of loved ones, illnesses, and community violence may be more likely to develop mental health problems, especially symptoms of depression and anxiety (Mazza and Overstreet, 2000). For example, a variety of research studies have illustrated that violence exposure is linked to numerous mental health problems, such as posttraumatic stress disorder, depression, suicidal behavior, anxiety, aggressive/antisocial behaviors, and academic difficulties (DuRant, Cadenhead, Pendergast, Slavens, and Linder, 1994; Singer, Anglin, Song, and Lunghofer, 1995). Wachs (2000) noted that no single experience of one stressful event is sufficient to explain developmental outcomes, and researchers should focus on combinations of factors to produce satisfactory explanations for outcomes. This notion of studying cumulative risks stems from Rutter (1979), who concluded that it is not any specific risk factor but the number of risk factors in a child's environment that determines the development of a psychiatric disorder. This means that the more risk factors are present in adolescents' lives, the likelihood of youth developing negative outcomes increases. For example, Shaw and Emery (1988) discovered that children exposed to a greater number of chronic family stressors experienced more internalizing symptoms, more behavior problems, and lower feelings of self-worth than children exposed to fewer stressors. Similarly, Gutman, Sameroff, and Cole (2003) investigated the effect of multiple risks on the academic performance of youth. They found that students experienced lower grades and a greater number of absences as their exposure to risks increased. Most previous empirical studies have focused on the impact of stressful events on the developmental outcomes of urban African American adolescent. Less research has been conducted, however, on how the stressful events affecting African American adolescents living in a rural environment impacts emotional functioning. More research focusing on rural adolescents is needed because they may be especially vulnerable to psychological disorders given the challenges associated with adolescence and residing in a rural environment. For example, Murry et al. (2009) noted that rural adolescents often stem from families that are nested within communities with similar socioeconomic status and racial background. However, such communities often find it difficult to overcome challenges such as stressful events due to a lack of structural resources, including a restricted range of employment opportunities, limited public transportation, and a lack of recreational activities and facilities for youth (Proctor and Dalaker, 2003). Therefore, rural adolescents may be just as vulnerable in terms of the development of mental health problems as urban adolescents.

Despite recent empirical findings directly linking stressful events and mental health, another possibility exists that some factors moderate this relationship. For instance, individuals' strong racial identification may function as a potent moderator. During the second decade of life, adolescents discover how race fits into their sense of self. For adolescents of color, issues associated with self identification

are typically associated with one's racial background. Racial identity is the part of an individuals' self-concept that is associated with their membership within a racial group (Rowley, Chavous, and Cooke, 2003). More specifically, the amount of significance and meaning that African Americans attribute to their race in defining themselves is referred to as racial identity (Rowley et al., 2003). In fact, racial identity has been found to be an important aspect for understanding the psychological well-being of African Americans (Banks and Kohn-Wood, 2007) as well as a major contributor to the development of protective competencies (Aroyo and Ziegler, 1995). One function of racial identity is to protect individuals from psychological insults that are caused by racism and discrimination (Cross et al., 1991). Another function of racial identity is that it may increase adolescents' ability to cope with a hostile environment. For example, Banks and Kohn-Wood (2007) investigated the function of racial identity within the relationship of racial discrimination and symptoms of depression in 194 African American college students. They found that students who identified strongly with their racial group indicated fewer depressive symptoms than students who tried to reach out and make connections with the mainstream population. Correspondingly, Sellers, Caldwell, Schmeelk-Cone, and Zimmerman (2003) found that both bivariate correlations and direct-effect models suggest that individuals characterized by strong racial identity were more likely to report lower levels of subsequent psychological distress. These results suggest that strongly identifying with one's race may be beneficial to young African American adults. One possible explanation for the protective properties of strong racial identity is that individuals who identify strongly with their race may possess a more effective coping repertoire for dealing with racist hassles as a result of greater practice dealing with racist experiences.

Even though racial identity has been identified as a protective factor in the relationship between racism and discrimination and poor mental health, there is a significant dearth of research on the function of racial identity in the relation between other types of stressful events and mental health, especially in rural adolescents. Furthermore, most previous studies investigated the function of racial identity in African American urban populations. More research is needed with rural populations because the characteristics of the environment can impede this process of identity exploration. For example, adolescents living in rural areas, compared to those living in urban areas, are at a greater disadvantage because of their restricted access to feedback about their identity development in terms of emotions, attitudes, and behavioral responses that derive from the objective characteristics of people's surroundings. In addition, the development of adolescents' identity within a rural environment can be hampered if their access to resources such as positive support networks is restricted (Kerpelman and Mosher, 2004).

This study extends existing research by focusing on the effects of stressful events of African American adolescents living in a rural environment. We hypothesize that stressful events will negatively affect the mental health (i.e., depressive and anxiety symptoms) of African American adolescents. Also, the

study hypothesizes that racial identity will moderate the effects of stressful events on the depressive and anxiety symptoms of the participants.

Methodology

Participants

The participants were seventy-two African American students from a high school in a rural area of south central Louisiana. The rural Parish that the school belonged to was composed of 50 percent European American and 49.4 percent of African American residents. Twenty three students were male, and forty-nine were female. Their age ranged from twelve to eighteen years (M = 15. 20, SD = 1. 52). The students were participating in a larger research project concerned with understanding the daily social and educational experiences of rural adolescents. The school has grades seventh through twelfth and has a population of approximately 550 students (49 percent Female, 51 percent Male, 16. 6 percent White, 82. 7 percent Black, 0. 6 percent Hispanic, 0. 2 percent American Indian/Alaska Native). Based on school records, 75. 8 percent of the students in the school qualified for free or reduced lunch programs and, according to the state's board of education, the high school dropout rate was 7.9 percent in 2005.

Procedure

As mentioned earlier, participants for the current study are part of a larger project that examines the daily experiences of adolescents from rural communities to determine what factors contribute to students' successes and challenges. In order to delineate the assets present in the schools, homes, communities, and lives of these youth, the researchers assessed students' perceptions of supports and barriers in the aforementioned contexts and the impact of these supports and challenges on various outcomes.

Data collection for the present analysis began during the spring 2007 semester. Before participating in the research project, parents and students signed informed consent and assent forms, respectively. The students were told their responses would be kept private. The study was conducted with small groups of students in a large meeting area at the school. At least one African American graduate student experimenter was present at all times. Each student participant completed a self-reported questionnaire. The participants did not discuss responses with one another. Participants were given $5 upon final completion of the study.

Measures

Stressful events were measured with the *Negative Life Events Scale* (Coddington, 1972). The measure is a revised version on Coddington's Life Events Questionnaire

(LEQ). The LEQ, which included sixty-one items, was designed to measure events in a child's life over the last year. The original LEQ was altered in sequence and language to best flow with the additions to the scale that were included in an effort to add events commonly associated with urban and/or ethnic minority neighborhoods (Spencer, 1999; McDermott and Spencer, 1995).

For the present study, fifty-four stressful events were used from the larger revised LEQ. Examples included, "One or two people you knew were killed; Parent started having an alcohol problem; Broke up with girlfriend or boyfriend, etc." "The events that were excluded were positive events such as "I won an award" and "I was accepted into a sports team. If the event occurred, it was coded "1" and if it did not occur it was coded as "0." In addition, the revised measure included a likert scale to measure the impact of the event (range 1-5). For instance, if an event occurred, the participant would mark "1" to indicate that it occurred and then mark 1-5 to indicate what level of impact the event had. Finally, the variable "stressful events" was calculated by multiplying the event occurred by the impact value. The internal consistency of stressful events measure was adequate ($\mu = .85$).

Depression was measured using the ten items from the Children's Depression Inventory (CDI) (Kovacs, 1999). The Children's Depression Inventory is a short version of the children's version of the Beck Depression Inventory. Higher scores indicate higher levels of depressive symptoms. For this sample the Children's Depression Inventory produced a Cronbach's alpha of .80 indicating moderate level of internal consistency. Responses are a forced choice yes or no coded as 0, 1 or 2. For instance, "How often are you sad? 0= I am sad once in a while, 1= I am sad many times, 2 = I am sad all the time. "

Anxiety was measured using part of the Revised Children's Manifest Anxiety Scale (RCMAS) (Reynolds and Richmond, 1978). Items are scored on a forced choice (1= yes, 0= no) and are summed to get a total Anxiety score. The RCMAS scale has four subscales: Physiological Anxiety, Worry/Oversensitivity, Concentration Anxiety, and a Social Desirability scale. For this study items from the first three subscales were used. The social desirability scale was not used because the alpha implied good internal consistency without it, and it does not address the issues of this study. Items include questions like "I get nervous when things do not go the right way for me. " Cronbach's alpha was .81 for this scale.

The *Multidimensional Inventory of Black Identity (MIBI)* (Sellers, Rowley, Chavous, Shelton, and Smith, 1997) measured the significance that individuals attach to race in defining themselves (racial salience and centrality) and individuals' perceptions of what it means to be Black (racial regard and ideology). The MIBI is comprised of three scales that measure racial centrality, ideology, and regard. Racial centrality refers to the degree to which individuals define themselves in regard to race. Racial ideology is "the individual's beliefs, opinions, and attitudes with regard to the way she or he feels that the members of the race should act" (Sellers et al., 1997). Regard refers to one's affective and evaluative judgment of one's own race (Sellers et al., 1997). Scale items can be summed or averaged to

obtain a scale score. High scores on the centrality subscale indicate that race is more central to one's self-definition. The protocol included an altered version of the three subscales form the MIBI. Race-specific items were changed to race-neutral. For example, the question "Being Black has very little to do with how I feel about myself" was changed to "My race has very little to do with how I feel about myself." Kiang and colleagues (2006) demonstrated the reliability of this alteration in a group of ethnically diverse adolescents. Examples of items included "Overall, my race has very little to do with how I feel about myself; In general my race is an important part of how I see myself; My destiny is tied to the destiny of others of my race, etc." Participants rated each item on a scale from 1 to 5 (1 = strongly disagree, 2 = disagree, 3 = not sure, 4 = agree, 5 = strongly agree), higher scores mean higher levels of racial centrality. The internal consistency of the centrality scale was adequate (α = . 79).

Results

The results of this analysis are presented in three sections. The first section includes descriptive statistics of the sample. The second section examines the bivariate correlations among the variables related to the hypothesis. The final section comprises the regression analyses used to further test the hypotheses.

Descriptive statistics were obtained for the variables in the hypotheses. As indicated in Table 7.1, the present sample included seventy-two African American adolescents from a rural county in a southern state. The sample ranged in age from twelve to eighteen years (M = 15.20, SD = 1.52) and was majority female (n = 49). The possible range of anxiety scores is 0-31, and the descriptive results show that the sample reported moderate levels of anxiety (M = 15.39, SD = 6.65). The possible range for depressive symptoms is 10-30. With a mean of 2.68, this sample reported moderately high levels of depressive symptoms (M = 26.57, SD = 3.90). We used the Negative Life Events Scale (Coddington, 1972) to examine stressful events. The sample reported a range of 2-26 stressful events (M = 10.83, SD = 5.06). The impact of those events was rated on a 1-5 scale (M = 4.03, SD = .70). The cumulative stress (the event multiplied by the impact) from negative life events ranged from 10-117 (M = 43.43, SD = 22.21). Racial identity scores have a possible range of 40-90, and this sample reported moderate levels of racial identity (M = 68.46, SD = 10.16).

Next, bivariate correlation analysis was conducted on all variables in the hypotheses (Table 7.2). This analysis shows that age was negatively correlated with sex (r = -.26, p < .05), which indicates that the males on average in this sample were older than the females. Racial identity was negatively correlated with sex (r = -.28, p < .05), which indicates that males had higher levels of racial identity than females. As previously cited in the literature, depressive symptoms and anxiety were statistically significantly correlated (r = .40, p < .01). In addition, there was a trend level correlation between anxiety with negative life events (r = .21, p < .10).

Likewise, the correlations between depressive symptoms and stressful events supported the hypothesis ($r = .33$, $p < .01$).

Table 7.1: Descriptive of the Study Variables ($N = 72$)

Variable	Possible Range	Mean	SD
1) Age	12-18	15.21	1.52
2) Sex	1=male/2=females	1.68	0.47
3) Cumulative Stress*	0-305	43.43	22.21
4) Event Impact*	1-5	4.03	0.70
5) Number of Events*	0-61	10.83	5.05
6) Depressive Symptoms	10-30	26.57	3.90
7) Anxiety	0-31	15.39	6.65
8) Racial Identity	20-100	68.46	10.16

*Cumulative stress was calculated by multiplying Event Impact by the Number of Events

Table 7.2: 2-Tailed Pearson Correlations of All the Study's Variables ($N = 72$)

	1	2	3	4	5	6	7
Age	—	-.26*	.08	.03	.02	.09	.01
Sex		—	-.28*	.13	.01	-.14	-.13
Racial Identity			—	-.01	.07	.25*	.12
Anxiety				—	.40**	.21+	.25*
Cumulative Stress					—	.33**	.47***
Stressful Events						—	.93***

*= p< .10, **= p < .05, ***= p < .001

Finally, we conducted step-wise regression analyses to further explore the hypothesized relationships. To aid in comparison across variables and to avoid multicollinearity among variables, Z-scores were used for correlation analyses and all variables used in the regression analyses were centered. The first step included the dependent variable (anxiety or depressive symptoms) and the stressful events. The second step added in racial identity as a potential buffer for that relationship. The third step examined the interaction of the stressor and racial identity as a potential moderator.

As illustrated in Table 7.3, the first regression tested the relationship between stressful events, racial identity, and depressive symptoms. According to the results, stressful events explained a significant amount of the variance in depressive symptom scores ($b = .32$, $p < .01$). In the second step, racial identity did not explain a statistically significant amount of the variance in depressive symptoms ($b= -.16$, $p > .05$). In the third step, the interaction between stressful events and racial identity was of statistically significant ($b= -.28$, $p < .05$). These results support racial

identity as a buffer for the development of depressive symptoms in response to stressful events.

Table 7.3 Stressful Events and Racial Centrality Associations to Depressive Symptoms

Variables	R^2	ΔR^2	ΔF	B	SE	β
Step 1	.10	.10	8.14			
Cumulative Stress				.32*	.12	.32*
Step 2	.13	.03	-2.98			
Cumulative Stress				.37**	.12	.37**
Racial Identity				-.16	.12	-.16
Step 3	.19	.06	.14			
Cumulative Stress				.42**	.11	.40**
Racial Identity				-.15	.11	-.15
Interaction				-.28*	.11	-.28*
Entire Model				$F(2, 70) = 9.75*$		

Note : * = p < .05, ** = p < .01

Figure 7.1 illustrates the interaction between racial centrality and stressful events. The results suggest that as stressful events and students' racial centrality increased, their depressive symptoms tended to slightly increase as well. Further, as stressful events increased for students with low racial centrality, depressive symptoms significantly increased. We conducted a simple slopes analysis to test the significance of the interaction found in regression analysis one. Results of the simple slope analysis show that, under conditions of low racial identity, stressful events led to significantly higher depressive symptoms ($B = .67$, $p < .001$). Under conditions of high racial identity, stressful events did not lead to significantly higher depressive symptoms scores ($B = .16$, $p > .10$). These results support our hypothesis that racial identity acts as a buffer for the development of depressive symptoms.

The second regression examined the relationship among stressful events, racial identity, and anxiety (Table 7.4). When stressful events was entered in step one, it explained a trend level amount of the variance in anxiety scores ($b = .22$, $p < .10$). Racial identity did not explain a significant amount of the variance in anxiety scores. Thus, unlike depressive symptoms, racial identity does not buffer the effects of stressful events on anxiety. These results suggest that racial identity may act as a long-term global coping strategy for chronic stressors, rather than as a reactive coping strategy for acute stressors. Thus, racial identity may serve more effectively as a buffer for developing depressive symptoms, which reflect long-term negative world view, but not as well for coping with anxiety symptoms present during or shortly after an encounter with a stressful event.

Figure 7.1: Racial Identity as a Buffer for Development of Depressive Symptoms in Response to Stressful Events

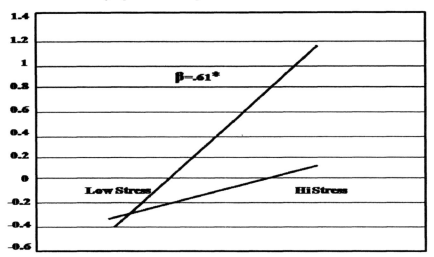

Table 7.4: Stressful Events and Racial Centrality Associations to Anxiety Symptoms

Variables	R^2	ΔR^2	ΔF	B	SE	β
Step 1	.05	.05	3.56			
Cumulative Stress				.22+	.13	.22+
Step 2	.05	.00	-2.69			
Cumulative Stress				.24+	.12	.23+
Racial Identity				-.07	.12	-.07
Step 3	.09	.04	.44			
Cumulative Stress				.25*	.11	.25*
Racial Identity				-.06	.11	-.06
Cumulative Stress X Racial Identity				-.14	.11	-.14
Entire Model				$F(2, 70) = 3.56^+$		

Note : $^* = p < .05^{**} = p < .01 ^{'} = p < .10$

Discussion

The purpose of the study was to examine the effect of stressful events on the mental health of rural African American adolescents. Further, the study investigated the role of racial identity in the relation between stressful events and symptoms of anxiety and depression. Specifically, the study hypothesized a negative association between stressful events and the mental health symptoms of African American adolescents. Racial identity was expected to buffer or lessen the adverse effects of

the stressors on adolescents' mental health symptoms. These hypotheses were based on findings that experiences of cumulative stressful events, such as exposure to community violence and life changes associated with adolescence and environmental challenges can increase African American adolescents' symptoms of anxiety and depression (Brown and Harris, 1978; Gorman-Smith and Tolan, 1998; Amaro, Russo, and Johnson, 1987). However, several researchers have postulated that racial identity may act as a buffer against stressful events and their impact on the mental health symptoms of African American adolescents (Cross et al., 1991; Miller, 1999; Banks and Kohn-Wood, 2007; Sellers et al., 2003). Additional research is needed, therefore, to confirm the protective role of racial identity in the relation between stressful events and symptoms of depression and anxiety among Black adolescents.

The authors' hypothesis that stressful events would be negatively associated with Black adolescents' mental health was supported. Specifically, bivariate correlation analyses suggested that stressful events were positively associated with anxiety and depressive symptoms. Furthermore, separate regression analyses demonstrated a significant and positive association among stressful events and depressive symptoms, as well as stressful events and anxiety symptoms. Overall, the findings add to previous studies identifying African American adolescents' reports of stressful events to be challenges to their mental health (Brown and Harris, 1978; Gorman-Smith and Tolan, 1998).

The second hypothesis investigated the role of racial identity in the relation between the stressful events and symptoms of depression and anxiety, respectively. The protective role of racial identity is believed to contribute to African American students' positive outcomes by providing them with coping mechanisms, such as acceptance and identification with their own group, in order to maintain a positive self-image and satisfy their need for belonging in the face of marginalization (Seaton et al., 2009). Additionally, racial identity is believed to buffer against the effects of differential racial treatment, specifically by providing a support system in which racial issues can be discussed comfortably and thereby, protect against feelings of threat (Ethier and Deaux, 1990, 1994). Although previous research has identified racial identity as a protective factor among African American adolescents, these studies have failed to examine the role of racial identity in buffering other adverse challenges, besides race-related stress, for Black adolescents. The current study, therefore, adds to extant literature by examining the interaction of racial identity with a variety of stressful events. Regression analyses demonstrated that while stressful events were positively related to adolescents' depressive scores, the adverse effects of this relationship were lessened for those adolescents' reporting espousal of a strong racial identity. However, racial identity did not act as a protective mechanism in the relation between stressful events and adolescents' reports of anxiety symptoms. Overall, the findings demonstrate that racial identity effectively buffers the development of depressive symptoms, which reflect long-term negative world view, while the role of racial identity differs for anxiety symptoms, which are typically thought of as being more acute as they are present during or shortly after an encounter with a stressful event.

Limitations and Future Directions

A few limitations of the current study are noteworthy. One possible limitation is the small sample size of seventy-two participants. It is quite possible that the size of our sample has limited the generalizability of our findings to other subgroups within the African American adolescent population. Additionally, the relatively low number of stressful events reported by the participants warrants further research to extend the current findings to other groups of African American adolescents, specifically those of low socioeconomic status residing in urban environments who may be exposed to more stressful events than those in rural areas.

Another limitation of the current sample is that it was composed primarily of female participants. According to extant literature, female adolescents are far more likely than males to report experiencing higher levels of depressive and anxiety symptoms (Grant et al., 2004; Hankin and Abramson, 2001). Prior to adolescence, gender differences in rates of depressive symptoms are non-existent; this trend ends, however, in the beginning of adolescence when females begin to report significantly higher rates of depression (Grant et al., 2004). Perhaps our results that stressful events were associated with higher levels of both depressive symptoms and anxiety symptoms may have been partially driven by the larger number of females who are already predisposed to higher rates of psychological distress. Previous research has uncovered that such gender differences in reports of psychological distress are due to differences in how males and females are socialized to cope with feelings of anxiety or depression. Extant literature has also unearthed gender differences in African American boys' and girls' experiences stressful events, as well as how they are socialized to cope with such encounters. Therefore, future research should examine gender differences in how stressful events impact the mental health of African American boys and girls separately. Specifically, given that males are more likely to display externalizing symptoms, while females are more likely to report higher levels of internalizing symptoms (i.e., depression and anxiety), future research should examine if the experience of stressful events results in different adverse psychological consequences for African American adolescent males and females.

Conclusion and Implications

In conclusion, the results contribute to previously established research on the deleterious effects of stressful events on the psychological functioning of rural African American adolescents. The results indicated that anxiety and depressive symptoms, two of the most prevalent adolescent mental health concerns, are associated with exposure to racism and discrimination, exposure to violence, as well as by challenges that typically occur during adolescence. The results support the promotion of racial identity as a protective mechanism that buffers the development of negative mental health outcomes. There are currently two varying

perspectives on the role of racial identity in young people's adjustment. One perspective suggests that identification with the cultural values, beliefs, and practice of one's group helps to center and focus the individual and therefore, serves as a protective factor that helps sustain healthy psychological functioning despite adversity (Smith et al., 2009). Others have argued that attributing a great deal of significance and meaning to one's race and integrating this meaning into one's self-concept may be detrimental (Smith et al., 2009). The current research supports the premise that racial identity is linked to successful outcomes, namely healthy psychological functioning in regards to depressive symptoms, in that it serves as a buffer that protects African American youth from the deleterious stressful events they are predisposed to based on their race, as well as the normative development challenges they face as adolescents. Therefore, the current findings suggest implications for future research that focus on the development of positive racial identity with an increased understanding of the influences that contribute to this development. Furthermore, given current interest in developing more culturally appropriate interventions for African American youth, racial identity is a construct deserving of further examination as a mechanism contributing to positive developmental outcomes.

References

Amaro, H., Russo, N., and Johnson, J. (1987). Family and work predictors of psychological well-being among Hispanic women professionals. *Psychology of Women Quarterly, 11*, 505-521.

Banks, K. H., and Kohn-Wood, L. P. (2007). The influence of racial identity profiles on the relationship of racial discrimination and depressive symptoms. *Journal of Black Psychology, 33,* 331-354. Brown, G. W., and Harris, T. (1978). Social origins of depressions: A reply. *Psychological Medicine: A journal of research in psychiatry and the allied sciences, 8*, 577-588.

Brown, G., W. and Harris, T. (1978). Social origins of depression: A reply. Psychological medicine: A journal of research in psychiatry and the allied sciences, 8, 577-588.

Butler, J. W., Novy, D., Kagan, N., and Gates, G. (1994). An investigation of differences in attitudes between suicidal and nonsuicidal student ideators. *Adolescence, 29*, 623-638.

Coddington, R. D. (1972). The significance of life events as etiologic factors in diseases of children: II. A study of a normal population. Journal of Psychosomatic Research, 16, 205-213.

Cross, W. E., Parham, T. A., and Helms, J. E. (1991). The stages of black identity development: Nigrescence models, pp. 319-338. In R. L. Jones (Ed.), *Black psychology* (Third edition). Berkeley, CA: Cobb and Henry.

DuRant, R. H., Cadenhead, C., Pendergrast, R. A., Slavens, G., and Linder, C. W. (1994). Factors associated with the use of violence among urban black adolescents. American *Journal of Public Health, 84*, 612-617.

Eccles, J. S., Midgley, C., Wigfield, A., Buchanan, C., M., Reuman, D., Flanagan, C., MacIver, D. (1993). Development during adolescence: The impact of stage environment fit on young adolescents' experiences in schools and in families. *American Psychologist, 48*, 90-101.

Ethier, K., and Deaux, K. (1990). Hispanics in Ivy: Assessing identity and perceived threat. *Sex Roles, 22*, 427-440.

Ethier, K. A., and Deaux, K. (1994). Negotiating social identity when contexts change: Maintaining identification and responding to threat. *Journal of Personality and Social Psychology, 67*, 243-251.

Gorman-Smith, D., and Tolan, P. (1998). The role of exposure to community violence and developmental problems among inner-city youth. *Development and Psychopathology, 10*, 101-116.

Grant, K. E., Lyons, A. L., Finkelstein, J. S., Conway, K. M., Reynolds, L. K., O'Koon, J. H., Waitkoff, G. R., and Hicks, K. J. (2004). Gender differences in rates of depressive symptoms among low-income, urban African American youth: A test of two mediational hypotheses. *Journal of Youth and Adolescence, 33*, 523-533.

Gutman, L. M., Sameroff, A. J., and Cole, R. (2003). Academic growth curve trajectories from 1st grade to 12th grade: Effects of multiple social risk factors and preschool child factors. *Developmental Psychology, 39*, 777-790.

Hankin, B. L., and Abramson, L. Y. (2001). Development of gender differences in depression: An elaborated cognitive vulnerability-transactional stress theory. *Psychological Bulletin, 127*, 773-796.

Kerpelman, J. L., and Mosher, L. S. (2004). Rural African American adolescents' future orientation: The importance of self-efficacy, control and responsibility, and identity development. *Identity: An International Journal of Theory and Research, 4*, 187-208.

Kiang, L., Yip, T., Gonzalles-Backen, M., Witkow, M., and Fuligni, A. J. (2006). Ethnic identity and the daily psychological well-being of adolescents from Mexican and Chinese backgrounds. *Child Development, 77*, 1338-1350.

Kovacs, M. (1992). Children Depression Inventory (CDI) manual. Toronto, Canada: Multi-Health Systems.

Kurtz, L., and Derevensky, J. L. (1993). Stress and coping in adolescents: The effects of family configuration and environment on suicidality. *Canadian Journal of School Psychology, 9*, 204-216.

Mazza, J. J., and Overstreet, S. (2000). Children and adolescents exposed to chronic community violence: A mental health perspective for school psychologists. *School Psychology Review, 29*, 86-101.

McDermott, P. A., and Spencer, M. B. (1995). *Measurement properties of Revised Life Questionnaire* in (Interim Research Report No. 9). Philadelphia, PA:

University of Pennsylvania, Center for Health, Achievement, Neighborhood, Growth, and Ethnic Studies.

Miller, D. B. (1999). Racial socialization and racial identity: Can they promote resiliency for African American adolescents? *Adolescence, 34*, 493-501.

Mullis, R. L., Youngs, G. A., Mullis, A. K., and Rathge, R. W. (1993) Adolescent stress: Issues of measurement. *Adolescence, 28*, 267-279.

Murry, V. M., Berkel, C., Brody, G. H., Miller, S., and Che, Y. (2009). Linking parental socialization to interpersonal protective processes, academic self-presentation, and expectations among rural African American youth. *Cultural Diversity and Ethnic Minority Psychology, 15*, 1-10.

Proctor, B. D., and Dalaker, J. (2003). *Poverty in the United States:* 2002 (U. S. Census Bureau Current Population Reports Series P60-222, Consumer Income). Washington, DC: U. S. Government Printing Office.

Reynolds, C. R., and Richmond, B. O. (1978). What I think and feel: A revised measure of children's manifest anxiety. *Journal of Abnormal Child Psychology, 6*, 271-280.

Rowley, S. J., Chavous, T. M., and Cooke, D. Y. (2003). A person-centered approach to African American gender differences in racial ideology. *Self and Identity, 2*, 287-306.

Rutter, M. (1979). Protective factors in children's responses to stress and disadvantage, pp. 49-74. In M. W. Kent and J. E. Rolf (Eds.), *Primary prevention of psychopathology: Social competence in children*. Hanover, NH: University Press of New England.

Seaton, E. K., Yip, T., and Sellers, R. M. (2009). A longitudinal examination of racial identity and racial discrimination among African American adolescents. *Child Development, 80*, 406-417.

Sellers, R. M., Rowley, S. J., Chavous, T. M., Shelton, J. N., and Smith, M. A. (1997). Multidimensional inventory of black identity: A preliminary investigation of reliability and construct validity. *Journal of Personality and Social Psychology, 73*, 805-815.

Sellers, R. M., Caldwell, C. H., Schmeelk-Cone, K. H., and Zimmerman, M. A. (2003). Racial identity, racial discrimination, perceived stress, and psychological distress among African American young adults. *Journal of Health and Social Behavior, 43*, 302-317.

Sellers, R. M., Copeland- Linder, N., Martin, P. P., and Lewis, R. L. (2006). Racial identity matters: The relationship between racial discrimination and psychological functioning in African American adolescents. *Journal of Research on Adolescence, 16*, 187-216.

Shaw, D., and Emery, R. (1988). Chronic family adversity and school-age children's adjustment. *Journal of the American Academy of Child and Adolescent Psychiatry, 27*, 200-206.

Singer, M. I., Anglin, T. M., Song, L. Y., and Lunghofer, L. (1995). Adolescents' exposure to violence and associated symptoms of psychological trauma. *Journal of the American Medical Association, 273*, 477-482.

Smith, O., Levine, D. W., Smith, E. P., Dumas, J., and Prinz, R. J. (2009). A developmental perspective of the relationship of racial-ethnic identity to self-construct, achievement, and behavior in African American children. *Cultural Diversity and Ethnic Minority Psychology, 15*, 145-157.

Spencer, M. B. (1989). *Patterns of developmental transitions for economically disadvantaged Black male adolescents.* Proposal submitted to and funded by the Spencer Foundation, Chicago, IL.

Spencer, M. B. (2006). Phenomenological and ecological systems theory: development of diverse groups, pp. 829-893. In W. Damon, and R. Lerner (Eds.) *Handbook of child psychology.* Vol. 1 (R. Lerner, Ed.): *Theoretical models of human development* (Sixth Edition). New York: Wiley.

Wachs, T. D. (2000). *Necessary but not sufficient.* Washington, DC: American Psychological Association.

Part Three

African American Racial Identity
and Physical Health

Chapter Eight
The Role of African American Racial Identification in Health Behavior

Vetta L. Sanders Thompson, Eddie M. Clark, and Jason Q. Purnell

Introduction

According to Greenwald (1988), identity development is a process by which an individual forms a relationship with a reference group, thus establishing the role of the reference group in influencing attitudes and behaviors through the adoption of group values and goals. Race provides one of several possible categories of social identity available to individuals, but not all individuals of the presumed same racial group place the same importance on the identity category (Cross, Strauss, and Fhaghen-Smith, 1999) or experience similar levels of identification (Thompson Sanders, 2001). Nevertheless, the historical realities of African American existence and individual efforts to cope with and adjust to racism make racial group identity a particularly salient identity for many. For the purposes of this paper, *African American* refers to individuals born in the United States who are descendants of African slaves or have African ancestry in the United States prior to emancipation.

Racial Identification

Turner (1982) described social identity development as a cognitive process that uses social categories to define the self. Categories of social identity can be based on a variety of characteristics, including, but not limited to, nationality, skin color, common history of oppression, and ancestry, among other characteristics. Individuals vary in the degree to which they identify with a group, resulting in

variation in their commitment to roles and behaviors associated with that identity. Identity salience refers to the influence of a particular identity on behavior as a result of its properties as a cognitive schema (Stryker and Serpe, 1994). The salience of the identity then affects when and how individuals access and use an identity, for example, in integrated settings, on the job, and in selecting health behaviors (Stryker and Stratham, 1985).

Racial group identification specifically refers to a psychological attachment to one of several social categories available to individuals, when the category selected is based on the social category defined as "race." Theoretical frameworks for organizing and understanding racial identification are typically focused on (1) developmental stages (Cross, 1971), (2) an Africentric orientation (Asante, 1980; Baldwin and Bell, 1985), (3) or group-based approaches (Sellers, Rowley, Chavous, Shelton and Smith, 1997; Sellers, Rowley, Chavous, Shelton and Smith, 1998; Cross, et al., 1999; Thompson Sanders, 1995a and b, 1999). Developmental models focused on movement from pro-White to a secure internalization of Blackness (Cross, 1971), with Africentric models emphasizing a progression from mere awareness and acceptance of skin color to a commitment to an African-centered lifestyle (Asante, 1980). The centrality, salience, and public and private regard of identity, as well as the ideologies associated with an identity, may be assessed (Sellers and Shelton, 2003). In addition, identification attitudes relevant to culture, physical attributes, social and political positions, and psychological attachment may be relevant and appropriate to assess (Thompson Sanders, 2001).

While the parameters of racial identification (Thompson Sanders, 1990, 1995b) reference the psychological attachment to and acceptance of African American culture, physical attributes, and efforts at social and political empowerment, racial identity ideologies (Sellers et al., 1997; Sellers et al., 1998) reference four components of belief. A nationalist philosophy is described as the ideal that emphasizes the importance and uniqueness of African heritage and descent; an oppressed minority ideology addresses the commonalities among oppressed groups; an assimilationist philosophy stresses the links between African Americans and the larger American society; and a humanist philosophy emphasizes the relationship and similarities among humankind. The ideologies are assumed to affect behavior across domains of functioning, including health.

Other processes are relevant to discussions of racial identification. For example, racial socialization is the process by which individuals are exposed to the messages and actions that provide information regarding a group identity based on race. Research indicates that racial socialization is strongly associated with racial identification attitudes (Thompson Sanders, 1995a, 1999). In addition, racial socialization has been found to correlate with racial identity salience and interaction with other African Americans. Racial socialization is influenced by family, nuclear and extended, as well as other African Americans in the community (Thompson Sanders, 2004); therefore, the composition and size of the African American community is relevant to racial identification.

Additionally, a sense of disadvantaged status, group comparison and competition, and the racial composition of the environment have also been associated with racial identity salience (Lau, 1989; Ramsey and Myers, 1990). Research demonstrates an association between racial identity salience and racial identification attitudes (Thompson Sanders, 1999). While experiences of discrimination affect racial identification, participation with other African Americans, political activism, and a composition of educational, work, and neighborhood environments, along with a number of within-group factors such as perceptions of social class and skin color conflicts, also influence the extent that individuals express a strong or weak acceptance of various aspects of racial identification (Thompson Sanders, 1990, 1991, 1995a). Finally, age, income, and education are associated with racial identity attitudes (Broman, Jackson, Neighbors, 1989; Broman, Neighbors, and Jackson, 1988), as are geographical location and religion (Demo and Hughes, 1990; Ellison, 1991). Theoretically, each of these variables likely influences racial identity due to its impact on the ability to observe and interact with in-group and out-group members (Prentice and Miller, 2002). Thus, racial socialization, racial identity salience, and racial identification set a context in which the health attitudes, beliefs, and behaviors found in the African American community may come to influence an individual's health beliefs and behaviors, in contrast to health beliefs and behaviors encountered in other communities.

This chapter begins with the description of a theoretical framework that suggests the importance of racial/ethnic identification for health and health behavior and promotion. We next review what is known about the relationship between racial identification and health behaviors, including physical activity, diet and nutrition, screening behaviors, risk behaviors, treatment utilization, and health communications preferences. We conclude with a discussion of methodological concerns and recommendations for future research.

In this chapter, we use the term *identification* when discussing the various aspects of attachment to race that individuals may experience, and we only reference *identity* when referring to the category of attachment. We have changed references to ethnic identity and identification to racial identity and identification when studies are clearly focused on race as the category of interest, while retaining references to ethnicity when specific models or measures are used. Thus, for the purposes of this chapter at least, race and ethnicity are synonymous.

Theoretical Framework

We now accept that because behavior occurs in a social context, it is culturally bound (Brach and Fraser, 2000; Helman, 1994; Kleinman, Eisenberg, and Good, 1978; Lewis-Fernandez and Diaz, 2002; Office of Behavior and Social Science Research [OBSSR], 2004; Smedley, Stith and Nelson, 2003). Kleinman et al. (1978) established the early link between culture, illness, and healthcare. Research has subsequently demonstrated links between culture and symptom recognition, ability to communicate symptoms to healthcare providers, expectations for care,

medication adherence, and preventive care adherence (Smedley et al., 2003). A wide range of factors can be included when a social and cultural perspective is considered, including ethnic identity.

The theory of reasoned action/planned behavior (TRA/TPB) emphasizes a central role for social cognition in the form of subjective norms, which may be used to assist in explaining how and why racial identification has implications for health behavior and promotion. Through the inclusion of subjective norms, TRA/TPB provides an important model that places the individual within the social context and suggests a role for values (Ajzen, 1992; Bandura, Adams, and Byer, 1977; Fishbein and Azjen, 1975; Fishbein and Ajzen, 2010). According to TRA, the most important determinants of behavior are attitudes about behavior, which may be positive or negative, and subjective normative perceptions (Fishbein and Azjen, 1975; Fishbein and Ajzen, 2010). Each of these components is then divided into beliefs and evaluations. Subjective normative perceptions are based on what someone believes people close to them feel about the behavior and how motivated the person is to please those people and/or the pressure felt to comply with normative expectations. These perceptions influence individual and group emotional reactions to as well as beliefs and cognitions related to health behavior and promotion. See Figure 8.1.

Figure 8.1: TRA/TPB Model of Health Behavior

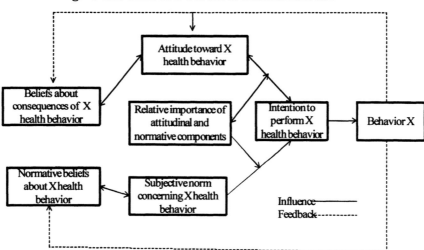

The theory emphasizes and research supports behavioral intentions as prerequisites to the pursuit of behavioral goals (Brubaker and Wickersham, 1990; Schifter and Ajzen, 1985). In the case of health promotion among African Americans, TRA/TPB suggests that if the individual believes that a health behavior will prolong life and improve health (attitude toward the behavior) and that

important people in his or her life believe that screening is good and/or engage in screening behaviors themselves, intention to screen should increase and, consequently, screening rates will be high. Racial/ethnic identification provides information about the reference group that is providing normative attitudes and beliefs. Cultural theorizing states that identification (ethnic identity) with other African Americans will dictate the importance of the subjective norms of this group and concern for community health (Spector, 1996). See Figure 8.2.

Figure 8. 2: TRA/TPB Model of Racial Identity and Health Behavior

Other theoretical models also provide a framework for understanding the importance and role of ethnic identity in health promotion. Weinstein's Precaution Adoption Process Model (Weinstein and Sandman, 1992) suggests that convincing someone that a risk affects people like him or her is important in moving the person towards precautionary action. If the data are perceived as more meaningful, a strategy such as the race/ethnicity of the physician or healthcare provider giving recommendations, demonstrations of health behaviors by same-race/ethnicity role models, or providing race-specific data and/or disparity data in a way designed to communicate risk by appealing to the population may be one way to accomplish this goal. This may be particularly true among those for whom culture and ethnic identity are very salient (Resnicow, Baranowski, Ahluwalia, and Braithwaite, 1999). See Figure 8.3.

**Figure 8.3: Precaution Adoption Process Model and
Racial Identity Influence on Health Behavior**

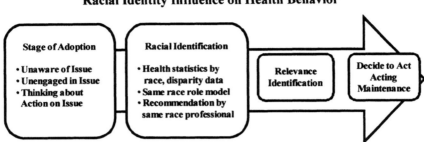

Racial Identification, Physical Activity,
Diet and Nutrition, and Behavior

Along with physical activity, diet and nutrition are central to health and are key factors in the prevention of chronic disease. Disparities in these key health indicators are of great concern and play a role in differential disease outcomes. In this section, we explore the contributions that an understanding of ethnic identity can make to improving physical activity and diet.

Physical Activity

According to the U. S. Department of Health and Human Services (USDHHS), adult participation in regular physical activity has been associated with decreased all-cause mortality; decreased risk for developing chronic conditions; maintenance of a healthy weight; increased health of bones, muscles, and joints; and good mental health (2009). In 2008, the national guidelines for physical activity included seventy-five minutes of vigorous physical activity or thirty minutes of moderate activity on at least five days per week as well as performing muscle-strengthening exercises on two or more days per week (USDHHS). Despite the interest in and promotion of physical activity as a component of a healthy lifestyle (Seefeldt, 2002), few studies have examined physical activity and cultural variables, including racial identification.

Reviews of physical activity and the promotion of physical activity among African Americans have focused on women (Banks-Wallace and Conn, 2002; Eyler et al., 2002) and have been linked to racial identity rather than racial identification. These reviews indicate that identification as African American is consistently associated with lower levels of physical activity. Researchers have also noted the difficulties of researching racial/ethnic identification related to physical activity and perhaps other health behaviors (Henderson and Ainsworth, 2001, 2003). It appears that in addition to the effects of race and biases of researchers, participants themselves may have difficulties articulating their thinking and responses to these

issues. Empirical and theoretical studies have also used different measurement strategies to approach this research. Siegel, Yancey, and McCarthy (2000) directly examined the role of ethnic identity (defined as connectedness with the African American community). Using a sample of 429 African American women, they found that leisure time activity was associated with high scores on a measure of ethnic identity. Based on this finding, they suggested a need to explore how ethnic identity enhancing strategies might assist in attracting individuals who could benefit from programs to increase physical activity.

In a theoretical paper addressing racial identification and physical activity among African American men, Harrison, Harrison, and Moore (2002) used the Cross Nigrescence model to understand preferences and participation patterns in athletics. These authors argued that a strong racial identification among African American males results in greater athletic participation. In using race to assist in developing a sense of self, certain activities, such as basketball, football, and track and field, are viewed as identity appropriate; while others such as golf, tennis, or lacrosse are viewed as identity inappropriate. The role of racial identification is theoretically related to the athletic activities selected for participation, with a focus on those with already high African American participation and success. Harrison et al. (2002) suggested that the influence of racial identity crosses socio-economic lines. If young African American males are successful in athletic endeavors, athletic identification increases while racial identification decreases.

Qualitative studies have indicated that some African American women believe that racial identity has nothing to do with their level of physical activity, while other women suggest that exercise norms among other African Americans affect their own levels of physical activity (Henderson and Ainsworth, 2000, 2001, 2003; Richter, Wilcox, Greaney, Henderson, and Ainsworth, 2002; Sanderson et al., 2002; Harley, Odoms-Young, Beard, Katz, and Heaney, 2009). To the extent that identification forms the basis of acceptance of social norms, the latter view would suggest a role for racial identification in physical identity. Other studies have suggested that cultural norms around body image and hair maintenance may present barriers to physical activity for African American women (Richter et al., 2002; Henderson and Ainsworth, 2003; Sanderson et al., 2002; Harley et al., 2009). In focus groups, some African American women suggested that women with smaller body sizes are not perceived as requiring physical activity; women with larger, more curvy body shapes and sizes are more culturally accepted and physical activity might be discouraged (Henderson and Ainsworth, 2003; Richter et al., 2002; Sanderson et al. 2002; Harley et al., 2009); and because exercise can lead to sweating, physical activity might be discouraged due to the expense of maintaining hairstyles (Henderson and Ainsworth, 2003; Richter et al., 2002; Harley et al., 2009). These sentiments were echoed in a study of physical activity among African American adolescent girls (Boyington, Carter-Edwards, Piehl, Hutson, Langdon, and McManus, 2008). These comments suggest some relevance for physical racial identification (Thompson Sanders, 1990, 1995a) in decisions about physical

activity, in addition to the role of psychological racial identification previously noted.

Diet and Nutrition

Obesity rates have led to concerns about diet and nutrition in the United States. The prevalence of obesity is greater for African American women compared to non-Hispanic white women (49.7 percent vs. 30.1 percent), as is the prevalence of overweight and obesity for women twenty years of age and older, with over 70 percent of African American women in this category. The issue is similar for African American men, but the disparities are smaller (Flegal, Carroll, Ogden, and Johnson, 2002; Hedley, Ogden, Johnson, Carroll, Curtin, and Flegal, 2004). Similar trends are observed among African American youth six to nineteen years of age, with 23. 2 percent of girls in or greater than 95th percentile for weight (Hedley et al., 2004). Due to the focus on obesity, the few studies that address racial identification and African American eating behavior directly are focused on either maladaptive eating attitudes and behaviors (fear of fatness, binge eating, bulimia, and so forth) or restrained eating (calorie restriction). Again, much of this literature is focused on African American women and uses inconsistent strategies to assess racial identification.

Siegel et al. (2000) found a positive association between restraint of eating and ethnic identity (defined as connectedness with the African American community). In a study of ninety-three African American women, Henrickson, Crowther, and Harrington (2010) found that expectations about eating and the management of affect and thinness moderated the relationship between maladaptive eating and ethnic (race as reference group) identity, as measured by the Multigroup Ethnic Identity Measure. Their data indicated that lower levels of ethnic (racial) identification affirmation, belonging, and commitment, as well as the cognitive component of identification were associated with maladaptive eating among African American women who reported using food to manage negative emotions and who believed that being thin or restricting caloric intake would improve their quality of life. Furthermore, among African American women who believed that being thin or restricting caloric intake would improve their quality of life, higher levels of other group identification, potentially White American, was associated with maladaptive eating. Thus, consistent with the findings of Siegel et al. (2010) strong racial identification is associated with eating habits that may support healthy weight control.

Studies of fruit and vegetable consumption have indicated that African Americans eat fewer fruits and vegetables than members of other ethnic and racial groups (Neumark-Sztainer, Wall, Perry, and Story, 2003; Robinson, 2008). Most studies that examine fruit and vegetable consumption are qualitative and note strong associations among cultural heritage and perceptions of healthy eating (James, 2004; Liburd, 2003; Boyington et al., 2008). James (2004) conducted six focus

groups that addressed food choices among African American men and women. This work emphasized that participants perceived calls for changes in the African American diet as requiring that they give up a part of their cultural heritage and conform to the dominant culture, which can be construed as a statement of cultural identification. This conclusion is also supported by participant statements that reinforced a sense that food serves as a cultural symbol. The work of Liburd (2003) is consistent with these findings, although the study focused on women (N=23). Boyington et al. (2008) reported similar findings in a sample of African American girls (twelve-eighteen years, n=12). However, some of the conversation in this discussion focused on food preparation more than food choice. Food preparation was viewed as promoting fat in the diet, in addition to the perceived lack of fresh fruits and vegetables.

Devine, Sobal, Bisogni, and Connors (1999) emphasized the complexity of food choice and ethnic (racial) identification. The multiple identities often available to individuals and families were noted to interact with levels of identification, situations, and roles to determine food selections among ethnic families, including African Americans. However, it is clear that one way that identification can be enacted is through food. As such, food choice is often a part of associating with and supporting other racial group members based on shopping and eating locations and selections (Devine et al., 1999). Consistent with the literature on factors affecting racial identification (Thompson Sanders 1995a, 1999), food choices consistent with racial identification are likely to be more salient among individuals with children or in environments where racial diversity is low and racial identity differences become more apparent and are easier when living in areas with high concentrations of members of the racial group.

Resnicow, Jackson, Braithwaite, Dilorio, Blisset, Rahotep, and Periasamy (2002) used some aspects of racial identification to develop a church-based physical activity and nutrition program. Although this article did not provide study results, it includes a detailed description of the intervention plan. The program development included the use of focus groups for ethnic mapping of fruit and vegetable intake and physical activities that divided foods/activities into three groups—Mostly Black (e. g., turnip greens, jump rope), Equally Black and White (e. g. apples, jogging), and Mostly White (e. g. artichokes, ice skating).

Cancer Screening Behavior

The relatively few studies that have explored the relationship between racial identification and cancer screening have done so primarily with women in the area of breast cancer. For example, Bowen, Christensen, Powers, Graves, and Anderson (1998) found that racial identification (as measured by an original instrument based on a Hispanic acculturation scale) was associated with changes in breast cancer worry and perceived cancer risk among African American women who participated in a counseling intervention. Lukwago, Kreuter, Bucholtz, Holt, and Clark (2001) developed a brief measure of racial pride that was subsequently used in a study

(Lukwago, Kreuter, Holt, Steger-May, Bucholtz, and Skinner, 2003) investigating breast cancer screening, disease, and treatment knowledge, as well as screening intention among urban African American women. Though the direction of the association was as hypothesized (I. e., higher levels of racial pride related to greater knowledge), racial pride was not significantly associated with any outcome.

Similar non-significant findings were reported in a more recent study where racial pride was one of several predictors of mammography adherence and stages of change for intended screening mammography (Steele-Moses, Russel, Kreuter, Monahan, Bourff, and Champion, 2009). This study examined the relationship between cultural constructs, including racial identification as measured by a racial pride scale, stage of change, and adherence to mammography, in a sample of lower income African American women. These data were collected as part of a large scale intervention study. The authors examined mammography adherence and positive stage movement, both from baseline to six month follow-up, and found that racial pride (a dimension of racial identification) did not uniquely predict either mammography or positive stage movement when other variables, such as religiosity, collectivism, future and present time orientation, education, and marital status were included in the logistic regression. The authors concluded that African American women may not associate their preventive health practices with their relationship to the African American community in general.

More research is necessary in order to establish whether racial identity is related to cancer screening. The relatively limited measurement of this construct in cancer screening studies is a potential area of concern. Racial pride, while a potentially important aspect of racial/ethnic identity, is but one aspect of a multidimensional construct. Likewise, the three-item measure of Society Identity used by Bowen et al. (1998) does not adequately capture the complexity of this construct. It is possible that more robust measures of racial identity will yield different results with respect to cancer screening attitudes and behaviors.

Risky Health Behaviors

The overwhelming majority of studies in the area of African American racial/ethnic identity and risky health behaviors (e. g., alcohol use, smoking, illicit drug use, risky sexual behaviors) have involved adolescents and young adults. Researchers in this area have suggested that there are opportunities to understand these behaviors in terms of developing racial/ethnic identity (Corneille and Belgrave, 2007; Phinney and Chavira, 1992; Scheier, Botvin, Diaz, and Ifill-Williams, 1997). This opportunity exists because adolescence is such a pivotal period in terms of identity development and because experimentation with risky health behaviors often begins at this developmental stage. This increased understanding suggests potential interventions and opportunities to prevent negative health outcomes. Several authors (Belgrave et al., 1994, 1997; Caldwell et al., 1994; Herd and Grube, 1996) also noted that the measurement of racial/ethnic identity advances knowledge

beyond simple racial and ethnic comparisons of problematic behaviors, allowing researchers and practitioners to examine the internalized meaning of race/ethnicity as well as in-group variability.

Although there is general agreement among researchers about the importance of measuring racial/ethnic identity (Belgrave et al., 1994, 1997; Resnicow et al., 1999; Sellers et al., 1997), there are several different measurement methods employed. One of the most popular instruments in studies examining racial/ethnic identity and risky health behaviors is the Multigroup Ethnic Identity Measure (MEIM; Phinney, 1992) or selected items from it. Other studies have used the Multidimensional Inventory of Black Identity (Sellers et al., 1997), the Adolescent Survey of Black Life (ASBL; Resnicow, Soler, Braithwaite, Selassie, and Smith, 1999), the Children's Africentric Values Scale (CAVS; Belgrave, Townsend, Cherry, and Cunningham, 1997), and the Children's Black Identity Scale (CBIS; Belgrave, Cherry, Cunningham, Walwyn, Letlaka-Rennert, and Phillips, 1994). Several authors have also developed their own measures of racial identity based upon their reviews of the literature and other formative research. This diversity makes it difficult to compare results across studies and may contribute to contradictory findings. The psychometric strength and quality of measures also varies across the studies that have employed them, which also raises questions about findings that are based upon them.

Substance Use

One of the earliest health behaviors to receive attention among researchers interested in African American racial/ethnic identity was substance use. Specifically, the use of alcohol, tobacco, and illicit drugs received a considerable amount of attention beginning in the mid-1990s. In a small convenience sample of African American fifth grade students, Belgrave et al. (1994) found that Africentric values emphasizing a sense of collective responsibility were associated with less tolerant views of drugs and alcohol, while racial identity and self-esteem were not. In 1997, Belgrave et al. followed this initial study by examining additional demographic information (I. e., age, gender, and household composition) and included spirituality as an additional cultural variable thought to be important to African American youth. They also expanded their original uni-dimensional, three-item Africentric values scale to a multidimensional scale (CAVS) that measured Collective Work/Responsibility, Cooperative Economics, and Self-Determination as aspects of Africentric values. Of these three factors, the first two were associated with less tolerant drug attitudes (as was spirituality), but none were related to behaviors among the fourth and fifth grade students in the study. In a 2000 study, Belgrave, Brome and Hampton measured Africentric values (CAVS) and racial identity (CBIS) and found that Africentric values were only positively associated with drug knowledge. Additionally, they determined that racial identity was associated with less tolerant attitudes towards drugs and lower levels of drug use. Townsend and

Belgrave (2000) reported that both personal and racial identity (CBIS) were related to drug attitudes but not drug use in a sample of fourth grade students.

Resnicow, Soler, Braithwaite, Selassie, and Smith (1999) also examined substance use attitudes and behaviors in the development of the Adolescent Survey of Black Life and found that the dimension of racial identity that they termed Pro-Black was associated with less tolerant attitudes toward drug use. Higher scores on the Anti-White and Awareness of Racism dimensions of the scale were positively associated with lifetime substance use (i.e., cigarettes, alcohol, and marijuana). Similarly, in a multi-ethnic sample of seventh grade students, African Americans with high levels of racial pride were less likely to have used drugs (including cigarettes, alcohol, hard drugs, and inhalants) in the previous four months, had fewer lifetime offers of drugs, and less lifetime use of drugs (Marsiglia, Kulis, and Hecht, 2001). However, the same study team found that while strong racial identification was generally protective in terms of endorsing anti-drug norms, it was associated with more lifetime cigarette use in African American adolescents (Marsiglia, Kulis, Hecht and Sills, 2004).

In a national study on black identity and drinking, Herd and Grube (1996) developed a multidimensional measure of black racial identification that included (a) consumption of black popular media, (b) black socio-political awareness, (c) inclusion in black social networks, and (d) endogamy (i.e., in-group dating and marriage). In contrast to Belgrave et al. (2000), this work proceeded from a conceptual model that suggested that socio-demographic characteristics like socio-economic status would influence racial identification and that the relationship between ethnic identification and drinking behavior would be mediated by religiosity and cultural norms around drinking for African Americans. Using structural equation modeling and measures original to the study, they found both a direct effect of racial identification on drinking behavior and significant indirect effects through religiosity and norms. Higher levels of most racial identification factors were associated with higher levels of religiosity and more conservative alcohol norms, which in turn were associated with lower levels of drinking. Only the consumption of black media was related to increased levels of drinking, which the authors attributed to the relatively high availability of alcohol-related content in black media (Wallace, 1999). In an attempt to replicate the earlier findings of Herd and Grube, researchers Smith, Phillips, and Brown (2008) used validated, multidimensional measures of ethnic identity (MEIM) and religiosity and reported that only a particular dimension of religiosity (daily spiritual experiences) mediated the relationship between ethnic belonging (from MEIM) and average consumption of alcohol.

Several studies considered the potential moderating effect of racial/ethnic identification. For example, Scheier et al. (1997) found that racial identification buffered the effect of several psychosocial risk factors for alcohol and marijuana use in African American and Hispanic youth in seventh and eighth grade. However, in two instances high racial identification and high risk behavior (i.e., cognitive-affective risk for alcohol use and competence risk for marijuana use) was positively

associated with drug use. Racial identification also had a direct influence on alcohol use in eighth grade in longitudinal analyses that adjusted for baseline use of alcohol in seventh grade and other risk factors. Brook, Balka, Brook, Win, and Gursen (1998) also examined racial identification (measured by selected items from the MEIM and author generated items) and its interaction with several risk and protective factors for drug use (in the categories of personality, family, peers, and ecology). While they found no direct effect of racial identification on drug use in their sample of late adolescents, they did find significant interactions with risk and protective factors: racial identification attenuated risks and enhanced protective factors among African Americans. Caldwell et al. (2004) found an interaction between aspects of racial identification (as measured by the MIBI) in which less alcohol use was associated with having both high private regard and high centrality among African American high school students. They also found that private regard alone was associated with alcohol use after controlling for age, gender, and parental support. Corneille and Belgrave (2007) found that racial identification (measured by ASBL) moderated the relationship between neighborhood risk factors and intention to use drugs, such that higher racial identification buffered the effect of high-risk neighborhoods on early adolescent, African American girls' intention to use drugs.

A diverse set of studies have demonstrated that racial identification does appear to be associated with substance abuse attitudes and behaviors. There is more evidence in favor of the former than the latter, though, with fairly consistent findings that higher levels of racial identification are associated with less tolerant views about drug use, even in the presence of risk factors that might predispose youth to use drugs. However, results regarding actual drug use behaviors are more mixed, with some studies reporting no association with racial identification, some suggesting a protective or buffering effect, and others showing higher levels of racial identification associated with more drug use. This variability may be explained by the inconsistent measurement of racial identification across these studies, as well as the wide range of ages and developmental stages considered by different authors. Although adolescence may be an opportune time to assess racial/ethnic identification and drug use, it is also a very volatile time during which identity is still under formation and behaviors are changing rapidly. It would be interesting to see what the results of similar studies would be in adult African Americans whose racial/ethnic identification would presumably be more stable. Some consensus about the measurement of racial/ethnic identification would be helpful as well. Studies guided by a theoretical framework would also be an improvement in this area.

Sexual Behavior

One of the earliest studies in the area of racial identification and risky sexual behaviors involved early adolescent African American girls and found that ethnic

identity (measured by Affiliation and Belongingness subscales of MEIM) was associated with less risky sexual attitudes after controlling for age, family structure, family cohesion, school interest, self-esteem, gender roles, and religiosity (Belgrave, Marin, and Chambers, 2000). Researchers attributed the result to the high importance placed on a sense of belonging in this developmental stage, and they suggested that belonging to one's racial group is protective against risky sexual behavior, whereas alienation is a risk factor. Townsend (2002) found that menarche had a moderating effect on the relationship between racial identification and sexual attitudes in preadolescent African American girls. Girls who had experienced menarche, had high levels of racial identification, and those who endorsed both masculine and feminine gender roles had the least tolerant attitudes towards risky sexual behavior. Sexual attitudes and behaviors were also assessed in a study by Corneille and Belgrave (2007), mentioned earlier in the discussion of substance use. Higher levels of racial identification were related to higher sexual refusal self-efficacy among early adolescent African American girls.

Espinosa-Hernandez and Lefkowitz (2009) examined racial identification and sexual attitudes and behaviors in a multi-ethnic sample of African American, European American, and Latino American college students. They found that a strong sense of ethnic identity was associated with less risky sexual attitudes regardless of ethnicity. However, African Americans in the sample did not report less risky sexual behaviors with high levels of ethnic identity; only European Americans did. For African American males in particular, strong ethnic identity was associated with the risky sexual behavior of using alcohol prior to or during intercourse. The authors speculated that these young men may be reacting to stereotypes about African American sexuality and suggested that ethnic identification may not be protective for this subset of African American youth. Related scholarship on the impact of hip hop culture on African American youth suggests that preadolescent boys and girls are regularly exposed to sexual "scripts" through music and videos that depict hypersexuality among African American males and a variety of sexualized images of African American females (Stephens and Few, 2007).

In a rare study with adults (Beadnell et al., 2003), ethnic identity (full-scale MEIM) was associated with fewer risky sexual behaviors (i.e., unprotected sex) in the prior four months among African American women participating in an HIV/STD prevention intervention. Higher levels of ethnic identification were also associated with positive abstinence and monogamy outcome beliefs as well as positive normative beliefs regarding monogamy.

Though less extensive than the literature on drug use, the studies (Beadnell et al., 2003; Belgrave, Marin, and Chambers, 2000; Corneille and Belgrave, 2007; Espinosa-Hernandez and Lefkowitz, 2009; Townsend, 2002) exploring racial identification with respect to risky sexual behavior seemed to point to a similar pattern, at least among African American women. Higher levels of racial identification appear to be related to less tolerant sexual attitudes and, in one study with adults, less risky sexual behaviors. African American males may be engaging

in more risky sexual behavior at higher levels of racial identification, but one study is not enough to establish this definitively. Problematic media depictions of African American sexuality may be having an adverse impact on African American males, who are already engaging in sexual activity earlier than males from other ethnic groups and who report a higher number of concurrent sexual partners.

Racial Identity and Health Communication

Racial identity theory and measurement have been used to help enhance the cultural appropriateness of health communications. Some of these approaches have included using racial identification, among other socio-cultural variables, to develop culturally targeted messages for African Americans as a group or for some subset of African Americans (for example, African American women who are forty years and older in the case of messages to promote mammography). Resnicow, Baranowksi, Ahluwalia, and Braithwaite (1999) noted that as of the late 1990s, many public health researchers agreed on the importance of making health communications culturally sensitive, but there was little research on how to define or operationalize cultural sensitivity in health promotion programs. Among the more important variables discussed, Resnicow et al. (1999) explained, consistent with previous research, that ethnic identification (EI) was multi-dimensional and may include ethnic pride, affinity for in-group culture (media, food, language), attitudes toward White American culture, experience with racism and discrimination, involvement with in-group and out-group members, and attitudes toward interracial marriage. They also noted the large amount of variability on this construct by members within a given ethnic group and the importance of developing a process (e.g. using exploratory focus groups, pre-testing) to help operationalize the EI construct and incorporating it into health promotion efforts.

Like Resnicow et al. (1999), Kreuter, Lukwago, Bucholtz, Clark, and Thompson Sanders (2003) also discussed how to achieve cultural appropriateness in health communications. *Cultural targeting* was defined as "a single intervention approach for a defined population subgroup that takes into account characteristics shared by that subgroup's members" (Kreuter et al., 2003, p. 136; Kreuter and Skinner, 2000). For example, a racial identification, culturally- targeted message may take advantage of the power of descriptive and injunctive subjective norms (Cialdini and Goldstein, 2004; Fishbein and Ajzen, 2010) by providing peripheral (for example, including the phrase "African Americans" in the title of the materials or photos of African American families), evidential (for example, providing relevant epidemiological data for African Americans), linguistic (for example, using language important to African Americans), or constituent-involving (for example, mentioning that an African American medical advisory board provided information for these materials) information relevant to African American culture (Kreuter et al., 2003), or by discussing how many African Americans are making health enhancing behavior changes (for example, more are getting screened for colorectal cancer) or decreasing health compromising behaviors (for example, fewer are

smoking; Nicholson et al., 2008; Thompson, Kalesan, Wells, Williams, and Caito, 2010). Nicholson et al. (2008) found that African American adults responded more favorably and were more likely to report their intent to be screened for colorectal cancer after reading progress messages (for example, more African Americans are being screened than before) than after receiving disparity messages (for example, more African Americans than Whites get colorectal cancer.) Mediational analyses showed that this was partially due to disparity messages evoking more negative affect, but not less positive affect, than the progress messages.

Racial identity has further been used in culturally tailoring health communications to African Americans. According to Kreuter et al. (2003), tailoring is "any combination of information or change strategies included to reach one specific person, based on characteristics that are unique to that person, related to the outcome of interest, and have been derived from an individual assessment" (p. 137) and seems to be an extension of what some scholars have called schema-correspondence (Brannon and Brock, 1994). *Cultural tailoring* has included sociocultural variables in tailoring efforts, including racial identification. Recipients complete a brief racial identification measure and then receive different health messages, depending on their racial identification score. For example, someone who scored high on racial identification would receive the type of information discussed above under targeting (for example the importance of the health issue to the African American community), whereas someone low in racial identification would receive a different message (Kreuter, Sugg-Skinner, et al., 2005).

Racial Identification Targeting

Several studies have used racial identification targeting. Thompson, Kalesan, Wells, Williams, and Caito (2010) compared the effects of a peripheral+evidential (PE) approach to a peripheral+evidential+sociocultural (PE+SC) approach to health communication and hypothesized that the latter would be especially effective among those for whom culture and racial identification were highly salient. They assessed the participants' racial identification, which might influence affective and cognitive processing of the different types of messages. The study of 771 African Americans, from forty-five to seventy-five years old, was a two-arm randomized control study of colorectal cancer communication effects on affective and cognitive processing and behavioral outcomes related to colorectal cancer screening over a twenty-two week intervention. Evidential (E) messages emphasized comparative statistics related to incidence, mortality, and screening rates in the African American community, as they are often seen in the media. Sociocultural messages focused on the ideals of collectivism by emphasizing the family and community benefits to screening and countered issues of mistrust and desire for privacy and how they undermined health and thus the community. Participants also completed, among other measures, an adaptation of the ideology dimension of the Multidimensional Model of Racial Identity (MMRI; Sellers, Rowley, Chavous, Shelton,

and Smith, 1998). A factor analysis of the MMRI showed four factors similar to those found in the original scale development: (1) nationalist ideology that emphasizes the importance and uniqueness of African heritage and descent, (2) an oppressed minority ideology that emphasizes similarities among oppressed groups, (3) an assimilationist ideology that addresses the similarities between African Americans and the larger American society, and (4) a humanist ideology that suggests relationships and similarities among all people. The authors found that participants with higher assimilationist and humanist identity scores reported increased positive affect in the PE+SC condition. The authors speculated that the family appeals of the PE+SC publications may have overcome the anticipated antipathy toward racial group appeals expected from those high in these two racial identity attitudes.

Some interventions are developed with the stated goal of raising racial identification that, in turn, would increase health-enhancing and decrease health-compromising behaviors. Belgrave (2002) reported on two cultural- enhancement interventions for African American girls. The first intervention, Project Naja, recruited 210 girls, ages ten to twelve, from a lower income area of Washington, D.C. to a two and one-half year, three-phase intervention to help participants develop strong resiliency, including communication and decision making skills, self-concept, Africentric values, and racial and gender identity. The goals of Project Naja were to prevent or delay drug use, increase drug refusal skills, and decrease early sexual activity and pregnancy. Using the Children's Racial Identity Scale, Belgrave found higher levels of racial identification, Africentric values, and physical appearance concept compared to a comparison group. Alcohol use was significantly higher for participants in the comparison group, but the author found no significant differences for any other drug measures. There were no differences in attitudes toward risky sexual behaviors between the two groups. The author attributed the minimal differences to a ceiling effect: Participants' attitudes toward drug use and sexual behaviors were very negative both pre- and post- assessment.

The second Belgrave (2002) intervention, the Cultural Enhancement Project, included sixth grade girls in Virginia and a fifteen-week cultural enhancement curriculum that included topics such as hair care, appearance, self-esteem, female role models, and Africa. Students using the cultural enhancement curriculum showed an increase in racial identification from pre- to post-test. The intervention group had lower average relational aggression than the comparison group. The comparison group showed a large increase from pre- to post-measurement, but for the intervention group, the level of relational violence declined. The authors noted that the assessment of program effectiveness for reducing risky sex and drug use was ongoing.

Extant research demonstrates that health educators can use racial identification in the development of their materials to improve the processing of health information and eliciting health behavior change. The effectiveness of materials that use racial identification may be due to the incorporation of style and information relevant to the person's racial identity.

Racial Identification Tailoring

Kreuter and colleagues examined the effects of cultural tailoring using several socio-cultural variables, including the racial pride dimension of racial identification. Kreuter, Steger-May, Bobra, Booker, Holt, Lukwago, and Skinner (2003) investigated whether African American women who scored lower or higher on the cultural constructs of racial pride (a dimension of racial identification), religiosity, collectivism (kinship), present time orientation, and future time orientation would differ in their cognitive and affective responses to breast cancer prevention and control materials that were behavioral, culturally, or both behaviorally and culturally tailored. The racial pride tailoring was completed as a result of examining participants' responses to a brief racial pride questionnaire developed by Kreuter, Lukwago, et al. (2002; Lukwago, Kreuter, Bucholtz, et al., 2001). The authors found that even though responses to culturally tailored materials were no different than responses to other materials, regardless of women's cultural characteristics, women scoring high on racial pride and religiosity liked the materials more, found them more personally relevant, and paid more attention to the materials than those low on racial pride and religiosity. Therefore, people's level of racial identification moderated their cognitive and affective responses to the materials.

Kreuter, Skinner, Steger-May, Holt, Bucholtz, Clark, and Haire-Joshu (2004) examined whether responses to behaviorally tailored breast cancer prevention and control materials can be enhanced by adding cultural tailoring on racial pride (a dimension of racial identification), religiosity, collectivism, present time orientation and future time orientation. The study examined outcomes of attention, liking, yielding, relevance, memory storage, and sharing materials. There were few between-group differences (behavioral tailoring, cultural tailoring, behavioral + cultural combined tailoring). The authors noted that all the tailoring groups showed very similar and positive responses to the magazines, and that there was little evidence that adding cultural tailoring to the more traditional behavioral tailoring improved participants' cognitive and affective responding. But the study does demonstrate that cultural tailoring alone can work as well (similar level of positive responses) as behavioral tailoring. As the authors observed, this is consistent with the Elaboration Likelihood Model (ELM; Petty and Cacioppo, 1986), in which making the materials personally relevant (high involvement) to the participants evokes increased cognitive processing and elaboration. Kreuter, Sugg-Skinner, et al., (2005) found that women receiving the combined behaviorally+culturally tailored magazines (cultural tailoring included tailoring on the racial pride dimension of racial identity) were more likely to report getting a mammogram and had greater increases in daily fruit and vegetable consumption than women in the comparison groups.

Davis, Alexander, Calvi, Wiese, Greene, Nowak, Cross, and Resnicow (2010) reported data on the Black Identification Classification Scale (BICS) that was specifically designed for use in tailoring health communications. They noted that

most of the current racial identity scales are not very suitable for health communication research and were developed and validated using college students, and may thus have items that are not appropriate for community samples. Further, many scales were not developed to be appropriate for telephone administration. Sixteen EI (ethnic identity) types were based on various combinations of five core types of racial identity: *assimilated* (low racial salience and places little importance on being Black), *Black American* (high racial salience, proud of racial heritage), *Afrocentric* (high racial salience, feels strong connection with Africa), *bicultural* (proud of ability to succeed in Black and White worlds yet sees the separation between the two), and *multicultural* (high racial salience, appreciates many different ethnic groups and cultures). Health message text was developed to match the EI type (Davis et al., 2010, p. 540). The authors did not report results of their intervention in this article, but they reported some EI group characteristics. For example, there seems to be variability in those reporting high blood pressure/hypertension, with assimilated lowest and Afrocentric being highest (Assimilated, 37.9 percent; Black American, 41.5 percent; Bicultural, 41.6 percent; Multicultural, 44.0 percent; and Afrocentric, 45.6 percent), and in those reporting that they exercise more than others their age, Black American being lowest and Afrocentric being highest (Black American, 26.2 percent; Multicultural, 28.6 percent; Bicultural, 30.5 percent; Assimilated, 31.0 percent; and Afrocentric, 34.1 percent). However, there was not much variability in mean self-efficacy for fruit and vegetable intake (Assimilated, 3.0; Black American, 3.0; Afrocentric, 3.1; Bicultural, 3.1; Multicultural, 3.1) or body mass index (Assimilated, 30.3; Afrocentric, 31.0; Black American, 31.2; Multicultural, 31.2; Bicultural, 32.2).

Resnicow, Davis, et al. (2009) have also tailored health communications using racial identity. They used the Black Identity Classification Scale (BICS), described above, to assign participants to one of sixteen ethnic identity (EI) types. The tailoring was accomplished via message text (for example, referring to Black Americans and/or other ethnic groups to match EI type) and graphics (photos of African Americans and/or people of other ethnic groups to match EI type). The Afrocentric subgroup seemed the most influenced by tailoring, as shown by a significant increase in fruit and vegetable consumption compared to the Afrocentric control group over three months (Resnicow, Davis et al., 2009). The authors concluded that some EI subgroups are more influenced by EI tailoring, and that the better the EI match, the more effective the tailoring efforts.

Racial Identification and the Health Care Services Utilization

Despite the large body of literature on racial identity theory, measurement, and applications, there remains relatively little published research on the relationship between African American racial identification and the utilization of physical health care services and patient-provider relationships. Most of the physical health care utilization research focuses on differences between ethnic groups in health care utilization or the role of ethnicity in patient-provider relationships. But there is little

recognition of the heterogeneity in racial/ethnic identification among African Americans that may influence health care utilization and patient-provider relationships. However, as discussed below, there is significant research in the utilization of mental health care services that may inform our understanding of physical health care utilization.

Austin, Carter, and Vaux (1990) investigated the relationship between racial identification and attitudes toward the university counseling center. The authors assessed racial identification using the Racial Identity Attitudes Scale-Form B (RIAS-B; Helms, 1990), including Pre-encounter, Encounter, Immersion/Emersion, and Internalization dimensions. Regression analyses suggested that higher levels of Pre-encounter (European American worldview while devaluing or denying ones Blackness) attitudes and lower levels of Internalization (feels secure and satisfied with Blackness, lower anti-White attitudes) attitudes predicted more favorable attitudes toward counseling being effective. Their analyses also suggested that those who are higher Pre-encounter or Immersion/Emersion (Black culture is idealized while White culture is rejected) believe that seeing a counselor reflects a weakness in personality (the authors did not discuss the possibility that the direction of the pre-encounter effect may be due to statistical suppression).

In a similar study, Delphin and Rollock (1995) investigated the relationship between racial identification and attitudes, knowledge, and likelihood of using a university counseling center. Like Austin et al. (1990), the authors assessed racial identity using the Racial Identity Attitudes Scale-Form B (RIAS-B). They found that students with higher Pre-encounter attitudes were more favorable toward the university counseling services (a significant low positive correlation), but that there was no relationship between Internalization attitudes and attitudes toward the university counseling services. The participants' attitudes about the university counseling service also positively correlated with Immersion/Emersion scores (unlike Austin et al.'s findings) and negatively correlated with Encounter scores. These findings suggest that students who focused on Black identity were more favorable toward the university counseling services, and those with inconsistent attitudes toward their Black identity and toward Whites, including beginning their identification with Blacks and more negative attitudes towards Whites, were more negative toward the university counseling services. Using regression analyses, the authors found some evidence that participants with higher pre-encounter attitudes and lower immersion/emersion attitudes were more likely to have more favorable attitudes toward seeking psychological help as assessed by the Attitudes toward Seeking Professional Psychological Help Scale (ATSPPHS; Fischer and Turner, 1970). Interestingly, they also found that racial identification, especially higher immersion/emersion attitudes, predicted participants' preference for an ethnically similar counselor.

Townes, Chavez-Korell, and Cunningham (2009), using the Cross Racial Identity Scale (Vandiver, Cross, Worrell, and Fhagen-Smith, 2002), found correlations suggesting that those with lower pre-encounter assimilation attitudes, higher immersion/emersion anti-White, and higher internalization Africentricity

attitudes had stronger preferences for a counselor of a similar race, and these findings were confirmed in a regression analysis. They also found that those with lower assimilation attitudes, higher Africentric attitudes, and higher mistrust were more likely to prefer a Black counselor. They noted that these combined mistrust and racial identity attitudes may lead to poorer client-provider interactions (e.g. less self-disclosure) which may be related to Black clients' higher attrition rates. Townes et al. further noted that the underlying assumption of much of the extant research is that Black and White counselors are equally available, which is often not the case. More research is needed to see if these findings are replicated under higher versus lower probability conditions of having a Black or White counselor. It is possible that it is the client's perception of not having a choice of therapist that underlies some of the preference for a Black therapist.

Several other unpublished studies also suggested that racial identification or acculturation predicted psychological professional help-seeking, perceptions of therapy, and/or a preference for a same-race therapist (Baur, 1997; Campbell-Flint, 2000; Floyd, 2007; Raymond, 2006; Schachner, 2009). While the results are not completely consistent, the bulk of the data seems to indicate that some dimensions of racial identification (for example, higher pre-encounter, assimilation) are related to positive attitudes toward help-seeking. Other dimensions (for example, higher immersion/emersion) predict negative attitudes toward help-seeking and, more clearly, a preference for a same-race therapist within counseling.

In general, there appear to be mixed results as to whether racial identification is positively, negatively, or not at all correlated with seeking out psychological care. While further research is needed on the role of racial identification in *physical* health services seeking and patient-provider relationships, we might expect that the physical and psychological help seeking findings would be similar. These mixed results in the psychological help seeking literature are probably due to several mediating and moderating variables, including medical or cultural mistrust, which racial identification measure was used, or which dimensions were assessed in any given study. In the psychological help seeking research, several studies have found that African Americans with a higher racial identification are more likely to prefer an African American therapist or counselor than those with a lower racial identity. It is probable that similar results would be found in the medical health care research, but as noted by Townes et al., the role of perceived availability of counselor/health care provider needs to be investigated.

Discussion

Methodological Concerns and Recommendations

There are three major issues of concern in research on racial identification and African American health behaviors and health promotion efforts in the African American community. First, there are several models of racial identification that

could contribute to the understanding of African American health attitudes and behaviors. Racial identity can be organized around (1) developmental stages, (2) Africentric orientation, (3) and group-based approaches. The conceptual model of racial identity used to inform research has varied across health behaviors and health promotion efforts. The majority of research in health promotion and prevention has focused on racial pride, stage of racial identification associated with health protective or risk behaviors, or response to interventions based on racial identification categorization. Notwithstanding the number of conceptual models available to explain the various aspects of racial identification and their relationship to health, at this time, there is little consensus regarding the appropriate aspect of racial identification to measure.

Racial identification measures may assess centrality, salience, and public and private regard of racial identity and attitudes relevant to physical attributes, culture, psychological attachment, and social and political ideology. However, few of these racial identification measurement options have been explored consistently in the health behavior and promotion literature. In addition, there is no consensus on the appropriate measures for conducting racial identification research in health promotion. In fact, authors have created their own measures rather than rely on existing measures with known psychometric reliability and validity. For these reasons, even if the appropriate aspects of racial identification have been measured, there is not consistent data on the psychometric properties of the scales used, calling into question the reliability and validity of findings. The diversity of racial identification dimensions measured and the diversity of measures used make it difficult to draw conclusions across studies, particularly when there are contradictory findings.

Another methodological consideration involves sample composition. Outside of studies on the relationship between racial identification and risk behaviors, study samples have focused on women. While an argument can be made for why this might be true in physical activity and diet (obesity concerns), it is unclear why this has been the case in areas such as cancer screening and health communication. This is a serious omission given what we know about health disparities among African American men. Similarly, while the focus on risk behaviors among African American youth is reasonable, the failure to consider the influence of racial identification in relationship to risk behaviors among African American adults may obscure evidence that would improve community intervention efforts. In addition, despite several qualitative and quantitative papers reporting findings on racial identification and health behaviors (Kreuter et al., 2004, Kreuter et al., 2003; Kreuter et al., 2005; Lukwago et al., 2003; Henderson and Ainsworth, 2000, 2001, 2003; Richter, Wilcox, Greaney, Henderson, and Ainsworth, 2002), many of these papers are based on analyses from the same dataset. This may lead to bias in our evidence base for the role of racial identity in health behavior promotion.

In order to determine how useful racial identification will be in efforts to address African American health disparities, future research must attempt to include more aspects of racial identification so that we begin to understand what com-

ponents of the construct are relevant. We need more quantitative research, using samples that include men and women, and when appropriate, a broad age range. There are now a range of reliable and valid measures of most aspects of racial identification, which should be considered prior to development of new measures of unknown psychometric properties. If inappropriate for health, these measures should be modified. Finally, we must broaden the range of health attitudes, decisions, and behaviors studied.

Conclusion

Despite methodological concerns, what can be said with confidence is that most studies indicate that some form of strong, positive racial identification is associated with positive health attitudes, but findings are contradictory where actual health behaviors are concerned. In addition, it is clear that information about racial identification is worth considering when developing health promotion activities or interventions. Racial identification information has been useful in understanding some aspects of mental health service utilization and may prove important in understanding the use of health services. Studies that have included African American male youth suggest that we must take greater care to understand gender differences in the construal and therefore, the impact of racial identification on health behaviors. It appears that, in contrast to the positive images and under-standings that women internalize as a function of racial identification, men may internalize images and understandings that make negative health behaviors more normative. However, the available evidence supports a role for racial identification in establishing important subjective norms of African Americans with respect to health attitudes and behaviors. Future research must address the pervasiveness and centrality of this role across health behaviors and subpopulations.

References

Ajzen, I. (1992). *Attitudes, personality, and behavior*. Chicago, IL: Dorsey Press.

Asante, M. (1980). *Afrocentricity: The theory of social change*. Buffalo, NY: Amulefi Publishing Company.

Austin, N. L., Carter, R. T., and Vaux, A. (1990). The role of racial identity in Black students' attitudes toward counseling and counseling centers. *Journal of College Student Development, 31*, 237-244.

Baldwin, J. A., and Bell, Y. (1985). The African Self-Consciousness Scale: An Africentric personality questionnaire. Western Journal of Black Studies, 9(2), 61-68.

Bandura, A. (1982). Self-efficacy mechanism in human agency. *American Psychologist 37*(2), 122-147.

Bandura, A., Adams, N., and Byer, J. (1977). Cognitive processes mediating behavioral change. *Journal of Personality and Social Psychology, 35*(3), 125-139.

Banks-Wallace, J., and Conn, V. (2002). Interventions to promote physical activity among African American women. *Public Health Nursing,* 19(5), 321-335.

Baur, K. M. (1997). African American females' rating of treatment acceptability for depression therapies. *Dissertation Abstracts International: Section B: Sciences and Engineering, 57* (7-B), 469.

Beadnell, B., Stielstra, S., Baker, S., Morrison, D. M., Knox, K., Guiterrez, L., and Doyle, A. (2003). Ethnic identity and sexual risk-taking among African American women enrolled in an HIV/STD prevention intervention. *Psychology, Health and Medicine, 8,*187-198.

Belgrave, F. Z. (2002). Relational theory and cultural enhancement interventions for African American adolescent girls. *Public Health Reports, 117* (Supplement 1), S76-S81

Belgrave, F. Z., Brome, D. R., and Hampton, C. (2000). The contribution of Africentric values and racial identity to the prediction of drug knowledge, attitudes and use among African American youth. *Journal of Black Psychology, 26,* 386-401.

Belgrave, F. Z., Cherry, V., Cunningham, D., Walwyn, S., Letlaka-Rennert, K., and Phillips, F. (1994). The influence of Africentric values, self-esteem, and Black identity on drug attitudes among African American fifth graders: A preliminary study. *Journal of Black Psychology, 20,* 143-156.

Belgrave, F. Z., Marin, B. V. O., and Chambers, B. (2000). Cultural, contextual, and intrapersonal predictors of risky sexual attitudes among urban African American girls in early adolescence. *Cultural Diversity and Ethnic Minority Psychology, 6,* 309-322.

Belgrave, F. Z., Townsend, T. G., Cherry, V. R., and Cunningham, D. M. (1997). The influence of an Africentric worldview and demographic variables on drug knowledge, attitudes, and use among African American youth. *Journal of Community Psychology, 25*(5), 421-433.

Bowen, D. J., Christensen, C. L., Powers, D., Graves, D. R., and Anderson, C. A. M. (1998). Effects of counseling and ethnic identity on perceived risk and cancer worry in African American women. *Journal of Clinical Psychology in Medical Settings, 5,* 365-379.

Boyington, J. E. A., Carter-Edwards, L., Piehl, M., Hutson, J., Langdon, D., and McManus, S. (2008). Cultural attitudes toward weight, diet, and physical activity among overweight African American girls. *Preventing Chronic Disease, 5*(2), http://www.cdc.gov/pcd/issues/2008/apr/07_0056.htm. Accessed December 2010.

Brach, C., and Fraser, I. (2000). Can cultural competency reduce racial and ethnic health disparities? A review and conceptual model. *Medical Care Research and Review, 57*(1), 181-217.

Brannon, L. A. and Brock, T. C. (1994). Test of schema correspondence theory of persuasion: Effects of matching an appeal to actual, ideal, and product selves, pp. 169-188. In E. M. Clark, T. C. Brock, and D. W. Stewart (Eds.), *Attention, attitude, and affect in response to advertising*. Hillsdale, NJ: Lawrence Erlbaum Associates, Inc.

Broman, C. L., Jackson, J. S., and Neighbors, H. W. (1989). Sociocultural context and racial group identification among Black adults. *Revue Internationale Sociale, 2*, 367-378.

Broman, C. L., Neighbors, H. W., and Jackson, J. S. (1988). Racial group identification among black adults. *Social Forces, 67*, 146-158.

Brook, J. S., Balka, E. B., Brook, D. W., Win, P. T., and Gursen, M. D. (1998). Drug use among African Americans: Ethnic identity as a protective factor. *Psychological Reports, 83*, 1427-1446.

Brubaker, R., and Wickersham, D. (1990). Encouraging the practice of testicular self-examination: A field application of the theory of reasoned action. *Health Psychology, 9*(2), 154-163.

Burlew, K., DeKimberlen, N., Johnson, C., Hucks, C., Purnell, B., Butler, J., Lovett, M., and Burlew, R. (2000). Drug attitudes, racial identity, and alcohol use among African American adolescents. *Journal of Black Psychology, 26*, 402-417.

Caldwell, C. H., Greene, A. D., and Billingsley, A.(1994). Family support programs in black churches: A new look at old functions, pp. 137-160. In L. S. Kagan and B. Weisbourd (Eds.), *Putting families first*. New York: Jossey-Bass.

Caldwell, C. H., Sellers, R. M., Bernat, D. H., and Zimmerman, M. A. (2004). Racial identity, parental support, and alcohol use in a sample of academically at-risk African American high school students. *American Journal of Community Psychology, 34*, 71-82.

Campbell-Flint, M. E. C. (2000). Relation of level of Black identity to destructive behavior, emotional disturbance, mental health attitudes and help seeking behavior: A study of Black male inmates. *Dissertation, Abstracts International: Section B: Sciences and Engineering, 60* (11-B), 5764.

Centers for Disease Control and Prevention (2008). *Behavioral risk factor surveillance system: Prevalence and trends data, 2007*. Retrieved December 15, 2010 from http://apps.nccd.cdc.gov/brfss/display.asp?cat=PAandyr.

Cialdini, R. B., and Goldstein, N. J. (2004). Social influence: Compliance and conformity. *Annual Review of Psychology, 55*(1), 591-621.

Cokley, K. and Helms, K. (2001). Testing the construct validity of scores on the multidimensional inventory of Black identity. *Measurement and Evaluation in Counseling and Development, 34* (2), 80-95.

Corneille, M. A. and Belgrave, F. Z. (2007). Ethnic identity, neighborhood risk, and adolescent drug and sex attitudes and refusal efficacy: The urban African American girls' experience. *Journal of Drug Education, 37*, 177-190.

Cross, N. E., Jr., Strauss, L., and Fhagen-Smith, P. (1999). African American identity development across the life span: Educational implications, pp. 29-47. In R. Hernandez Sleets and E. Hollins (Eds.), *Racial and ethnic identity in school practices: Aspects of human development.* Mahwah, NJ : Lawrence Erlbaum Associates, Publishers.

Cross, W. (1971). Negro-to-Black conversion experience: Toward a psychology of Black liberation. *Black World, 2019,* 13-27.

Davis, R.E., Alexander, G., Calvi, J., Wiese, C., Greene, S., Nowak, M., Cross, W. E. and Resnicow, K. (2010). A new audience segmentation tool for African Americans: The Black identity classification scale. *Journal of Health Communication,* 15(5), 532–554.

Delphin, M. E., and Rollock, D. (1995). University alienation and African American ethnic identity as predictors of attitudes toward, knowledge about, and likely use of psychological services. *Journal of College Student Development, 36,* 337-346.

Demo, D. H., and Hughes, M. (1990). Socialization and racial identity among Black Americans. *Social Psychology Quarterly, 53,* 364-374.

Devine, C. M., Sobal, J., Bisogni, C. A., and Connors, M. (1999). Food choices in three ethnic groups: Interactions of ideals, identities, and roles. *Journal of Nutrition Education, 31,* 86-93.

Ellison, C. G. (1991). Identification and separatism: Religious involvement and racial orientations among Black Americans. *Sociological Quarterly, 53,* 364-374.

Espinosa-Hernandez, G., and Lefkowitz, E. (2009). Sexual behaviors and attitudes and ethnic identity during college. *Journal of Sex Research, 46,* 471-482.

Eyler, A. E., Wilcox, S., Matson-Koffman, D., Evenson, K., Rohm-Young, D., Sanderson, B., and Wilbur, J. (2002). Correlates of physical activity among women from diverse racial/ethnic groups: A review. *Journal of Women's Health and Gender-Based Medicine,* 11(3), 239-264.

Fischer, E. H. and Turner, J. L. (1970). Orientation to seeking professional help : Development and research utility of an attitude scale. *Journal of Consulting and Clinical Psychology, 35,* 79-90.

Fishbein, M. and Azjen, I. (1975). *Beliefs, attitudes, intention, and behavior: An introduction to theory and research.* Reading, MA: Addison-Wesley.

Fishbein, M. and Ajzen, I. (2010). *Predicting and changing behavior: The reasoned action approach.* New York: Psychology Press (Taylor and Francis).

Flegal, K. M., Carroll, M. D., Ogden, C. L., and Johnson, C. L. (2002). Prevalence and trends in obesity among US adults, 1999-2000. *Journal American Medical Association, 288,* 1723-1727.

Floyd, S. C. (2007). The attitudes of African American undergraduate college students toward psychotherapy. *Dissertation Abstracts International: Section B: Sciences and Engineering, 67*(10-B), 6052.

Greenwald, A. G. (1988). A social-cognitive account of the self's development, pp. 30-42. In D. Lapsley and F. Power (Eds.), *Self, ego, identity: Integrative approaches*. New York : Springer-Verlag.

Harley, A. E., Odoms-Young, A., Beard, B., Katz, M. L., and Heaney C. A. (2009). African American social and cultural contexts and physical activity: Strategies for navigating challenges to participation. *Women and Health*, 49(1), 84-100.

Harrison, L., Harrison, K., and Moore, L. N. (2002). African American racial identity and sport. *Sport, Education and Society*, 7(2), 121-133.

Hedley, A. A., Ogden, C. L., Johnson, C. L., Carroll, M. D., Curtin, L. R., and Flegal, K. M. (2004). Prevalence of overweight and obesity among US children, adolescents, and adults, 1999-2002. *Journal American Medical Association, 291*, 2847-2850.

Helman, C. (1994). *Culture, health and illness: An introduction for health professionals* (Third Edition). Oxford, England: Butterworth-Heinemann Ltd.

Helms, J. E. (Ed.). (1990). Black and White racial identity: Theory, research, and practice, pp. 67-80. Westport, CT: Greenwood Press.

Henderson, K. A., and Ainsworth, B. E. (2000). Sociocultural perspectives on physical activity in the lives of older African American and American Indian women: A cross cultural activity participation study. *Women and Health, 31*(1), 1-20.

Henderson, K. A. and Ainsworth, B. E. (2001). Researching leisure and physical activity with women of color: Issues and emerging questions. *Leisure Sciences, 23*, 21-34.

Henderson, K. A., and Ainsworth, B. E. (2003). A synthesis of perceptions about physical activity among older African American and American Indian women. *American Journal of Public Health, 93*(2), 313-317.

Herd, D., and Grube, J. (1996). Black identity and drinking in the US: A national study. *Addiction, 91*, 845-857.

Henrickson, H. C., Crowther, J. H., and Harrington, E. F. (2010). Ethnic identity and maladaptive eating: Expectancies about eating and thinness in African American women. *Cultural Diversity and Ethnic Minority Psychology, 16*, 87-93.

James, D. C. S. (2004). Factors influencing food choices, dietary intake, and nutrition-related attitudes among African Americans: Application of a culturally sensitive model. *Ethnicity and Health, 9*(4), 349-367.

Kleinman, A., Eisenberg, L., and Good, B. (1978). Culture, illness, and care: Clinical lessons from anthropologic and cross-cultural research. *Annals of Internal Medicine,88*(2), 251-258.

Kreuter, M. W., Lukwago, S. N., Bucholtz, D. C., Clark, E. M., and Thompson Sanders, V. (2003). Achieving cultural appropriateness in health promotion programs: Targeted and tailored approaches. *Health Education and Behavior, 30*, 133-146.

Kreuter, M. W., and Skinner, C. S. (2000). Tailoring: What's in a name? *Health Education Research, 15*, 1-4.

Kreuter, M. W., Skinner, C. S., Steger-May, K., Holt, C. L., Bucholtz, D. C., Clark, E. M., and Haire-Joshu, D. (2004). Responses to behaviorally vs. culturally tailored cancer communication among African American women. *American Journal of Health Behaviour, 28*(3), 195-207.

Kreuter, M., Skinner, C. S., Steger-May, K., Holt, C. L., Bucholtz, D. C., Clark, E. M., and Haire-Joshu, D. (2003). Reactions to behaviorally vs. culturally tailored cancer communication among African American women. Presented at the American Public Health Association Annual Meeting. San Francisco, CA.

Kreuter, M. W., Steger-May, K., Bobra, S., Booker, A., Holt, C. L., Lukwago, S. N., and Skinner, C. S. (2003). Sociocultural characteristics and responses to cancer education materials among African American women. *Cancer Control. 10*, 69-80.

Kreuter, M. W., Sugg-Skinner, C., Holt, C. L., Clark, E. M., Haire-Joshu, D., Fu, Q., Booker, A. C., Steger-May, K., Bucholtz, D. (2005). Cultural tailoring for mammography and fruit and vegetable intake among low-income African American women in urban public health centers. *Preventive Medicine, 41*, 53-62.

Lau, R. R. (1989). Individual and contextual influences on group identification. *Social Psychology Quarterly, 52*, 220-231.

Lewis-Fernandez, R., and Diaz, N. (2002). The cultural formulation: A method for assessing cultural factors affecting the clinical encounter. *Psychiatric Quarterly, 73*(4), 271-295.

Liburd, L. (2003). Food, identity, and African American women with type II diabetes: An anthropological perspective. *Diabetes Spectrum, 16*, 160-165.

Lukwago, S. N., Kreuter, M. W., Bucholtz, D. C., Holt, C, L., and Clark, E. M. (2001). Development and validation of brief scales to measure collectivism, religiosity, racial pride, and time orientation in urban African American women. *Family and Community Health, 24*, 63-71.

Lukwago, S. N., Kreuter, M. W., Holt, C. L., Steger-May, K., Bucholtz, D. C., and Skinner, C. S. (2003). Sociocultural correlates of breast cancer knowledge and screening in urban African American women. *American Journal of Public Health, 93*, 1271-1274.

Marsiglia, F. F., Kulis, S., and Hecht, M. L. (2001). Ethnic labels and ethnic identity as predictors of drug use among middle school students in the Southwest. *Journal of Research on Adolescence, 11*, 21-48.

Marsiglia, F. F., Kulis, S., Hecht, M. L., and Sills, S. (2004). Ethnicity and ethnic identity as predictors of drug norms and drug use among preadolescents in the US Southwest. *Substance Use and Misuse, 39*, 1061-1094.

Neumark-Sztainer, D., Wall, M., Perry, C., and Story, M. (2003). Correlates of fruit and vegetable intake among adolescents: Findings from project EAT. *Preventive Medicine, 37*, 198-208.

Nicholson, R. A., Kreuter, M. W., Lapka, C., Wellborn, R., Clark, E. M., Thompson Sanders, V., Jacobsen, H., and Casey, C. (2008). Unintended effects

of emphasizing disparities in cancer communication to African Americans. *Cancer Epidemiology, Prevention and Biomarkers, 17*(11), 2946-2953.

Office of Behavior and Social Science Research (2004). Progress and promise in research on social and cultural dimensions of health: A research agenda. Washington D.C.: National Institute of Health.

Petty, R. E., and Cacioppo, J. T. (1986). The elaboration likelihood model of persuasion, pp. 124-206. In L. Berkowitz (Ed.), *Advances in experimental social psychology* (Vol. 19). Orlando, FL: Academic Press.

Phinney, J. S. (1992). The multigroup ethnic identity measure: A new scale for use with diverse groups. *Journal of Adolescent Research, 7*, 156-176.

Phinney, J. S., and Chavira, V. (1992). Ethnic identity and self-esteem: An exploratory longitudinal study. *Journal of Adolescence, 15*, 271-281.

Prentice, D. A., and Miller, D. T. (2002). The emergence of homegrown stereotypes. *American Psychologists, 57*, 352-359.

Ramsey, P. G., and Myers, L. C. (1990). Salience of race in young children's cognitive, affective, and behavioral responses to social environments. *Journal of Applied Development Psychology, 11*, 49-67.

Raymond, S. P. (2006). Sexual violence in the lives of women: An exploration of help-seeking, emotional social support, race, and culture. *Dissertation Abstracts International: Section B: Sciences and Engineering, Vol. 67 (2-B)*. p. 1163.

Resnicow, K., Baranowski, T., Ahluwalia, J., and Braithwaite R. (1999). Cultural sensitivity in public health: Defined and demystified. *Ethnicity and Disease*, 9, 10-21.

Resnicow, K., Davis, R., Zhang, N., Strecher, V., Tolsma, D., Calvi, J., Alexander, G., Anderson, J. P., Wiese, C., Cross, W. E., Jr. (2009). Tailoring a fruit and vegetable intervention on ethnic identity: Results of a randomized study. *Health Psychology, 28*, 394-403.

Resnicow, K., Jackson, A., Braithwaite, R., Dilorio, C., Blisset, D., Rahotep, S., Periasamy, S. (2002). Healthy Body/Healthy Spirit: A church-based nutrition and physical activity intervention. *Health Education Research: Theory and Practice, 17*, 562-573.

Resnicow, K., Soler, R. E., Braithwaite, R., Selassie, M. B., and Smith, M. (1999). Development of a racial and ethnic identity scale for African American adolescents: The survey of Black life. *Journal of Black Psychology, 25*(2), 171-188.

Richter, D. L., Wilcox, S., Greaney, M. L., Henderson, K. A., Ainsworth, B. E. (2002). Environmental, policy, and cultural factors related to physical activity in African American women. *Women and Health, 36*(2), 89-107.

Robinson, T. (2008). Applying the socio-ecological model to improving fruit and vegetable intake among low-income African Americans. *Journal of Community Health, 33*, 395-406.

Sanderson, B., Littleton, M., and Pulley, L. V. (2002). Environmental, policy, and cultural factors related to physical activity among rural, African American women. *Women and Health, 36*(2), 73-88.

Schachner, S. K. (2009). Clinical and cultural barriers to psychological help seeking in African American college students. *Dissertation Abstracts International: Section B: Sciences and Engineering, Vol. 69 (8-B)*, p. 5054.

Scheier, L. M., Botvin, G. J., Diaz, T., and Ifill-Williams, M. (1997). Ethnic identity as a moderator of psychosocial risk and adolescent alcohol and marijuana use: Concurrent and longitudinal analyses. *Journal of Child and Adolescent Substance Abuse, 6*, 21-47.

Schifter, D., and Ajzen, I. (1985). Intention, perceived control, and weight loss: An application of the theory of planned behavior. *Journal of Personality and Social Psychology, 49*(3), 843-851.

Seefeldt, V., Malina, R. M., and Clark, M. A. (2002). Factors affecting levels of physical activity in adults. *Sports Medicine, 32*(3), 143-168.

Sellers, R. M., Rowley, S. A. J., Chavous, T. M., Shelton, J. N., Smith, M. A. (1997). Multidimensional inventory of Black identity: A preliminary investigation of reliability and construct validity. *Journal of Personality and Social Psychology, 73*(4), 805-815.

Sellers, R., Rowley, S., Chavous, T., Shelton, N., and Smith, M. (1998). Multidimensional model of racial identity: A reconconceptualization of African American racial identity. *Personality and Social Psychology Review, 2*(1), 18-39.

Sellers, R. and Shelton, N. (2003). The role of racial identity in perceived discrimination. *Journal of Personality and Social Psychology, 84*(5), 1079-1092.

Siegel, J. M., Yancey, A. K., and McCarthy, W. J. (2000). Overweight and depressive symptoms among African American women. *Preventive Medicine, 31*, 232-240.

Smedley, B., Stith, A., and Nelson, A. (Eds.). (2003). *Unequal treatment: Confronting racial and ethnic disparities in healthcare*. Washington, DC: National Academies Press.

Smith, A. M., Phillips, C. M., and Brown, T. L. (2008). Ethnic identity, religiousness, and drinking among African Americans: What's the connection? *Journal of Ethnicity in Substance Abuse, 7*, 465-479.

Spector, R. (1996). *Cultural diversity in health and illness* (Fourth Edition). Stamford, CT: Appleton and Lange.

Steele-Moses, S. K., Russell, K. M., Kreuter, M., Monahan, P., Bourff, S., and Champion, V. L. (2009). Cultural constructs, stage of change, and adherence to mammography among low-income African American women. *Journal of Health Care for the Poor and Underserved, 20*, 257-273.

Stephens, D. P., and Few, A. L. (2007). Hip hop honey or video ho: African American preadolescents' understanding of female sexual scripts in hip hop culture. *Sexuality and Culture: An Interdisciplinary Quarterly, 11*, 48-69.

Stryker, S., and Serpe (1994). Identity salience and psychological centrality: Equivalent, overlapping, or complementary concepts? *Social Psychology Quarterly, 57*, 16-35.

Stryker, S., and Stratham, A. (1985). Symbolic interactionism and role theory, pp. 311-378. In G. Lindzey and E. Aronson (Eds.), *The handbook of social psychology*. New York: Random House.

Thompson, V. (1990). Factors affecting the level of African American identification. *Journal of Black Psychology, 17*, 14-23.

Thompson Sanders, V. L. (1991). Perceptions of race and race relations which affect African American identification. *Journal of Applied Social Psychology*, 21(18), 1502 1516.

Thompson Sanders, V. L. (1994). Socialization to race and race relations in African American families. *The Journal of Black Psychology, 20(2)*, 175-188.

Thompson, V. (1995). Sociocultural influences on African American racial identification. *Journal of Applied Social Psychology*, 25(16), 1411-1429.

Thompson, V. (1995a). The empirical characteristics of the multidimensional racial identification scale, rev. *Journal of Research in Personality, 29*, 208-222.

Thompson Sanders, V. L. (1999). Factors affecting African American racial identity salience and racial group identification. *The Journal of Social Psychology, 139*, 748-761.

Thompson, V. L. S., (2001). The complexity of African American racial identity. *Journal of Black Studies, 32*, 155-165.

Thompson, V. L. S., Kalesan, B., Wells, A., Williams, S-L., and Caito, N. (2010). Comparing the use of evidence and culture in targeted colorectal cancer communication for African Americans. *Patient Education and Counseling*. DOI. 10. 1016/j. pec. 2010. 07. 019.

Townes, D. L., Chavez-Korell, S., Cunningham, N. J. (2009). Reexamining the relationships between racial identity, cultural mistrust, help-seeking attitudes, and preference for a black counselor. Journal of Counseling Psychology, 56 (2), 330-336.

Townsend, T. G. (2002). The impact of self-components on attitudes toward sex among African American preadolescent girls: The moderating role of menarche. *Sex Roles, 47*, 11-20.

Townsend, T. G., and Belgrave, F. Z. (2000). The impact of personal identity on drug attitudes and use among African American children. *Journal of Black Psychology, 26*, 421-436.

Turner, J. C. (1982). Towards a cognitive redefinition of the social group, pp. 15-40. In H. Tajfel (Ed.), *Social identity and intergroup relations*. Cambridge, UK: Cambridge University Press.

U. S. Department of Health and Human Services (2009). *Health, United States, 2008*. Centers for Disease Control and Prevention, National Center for Health Statistics. http://www.cdc.gov/nchs/data/hus/hus08.pdf (Accessed February 4, 2011).

U. S. Department of Health and Human Services (2008). *Physical activity guidelines for Americans*. Office of Disease Prevention and Health Promotion. http://www. health.gov/paguidelines/pdf/paguide.pdf (Accessed February 4, 2011).

Vandiver, B. J., Cross, W. E., Worrell, F. C., and Fhagen-Smith, P. E. (2002). Validating the Cross Racial Identity Scale. Journal of Counseling Psychology, 49(1), 71-85

Wallace, J. M. (1999). The social ecology of addiction: Race, risk, and resilience. *Pediatrics, 103*, 1122-1127.

Weinstein, N., and Sandman, P. (1992). A model of the precaution adoption process: Evidence from home radon testing. *Health Psychology, 11*, 170-80.

Chapter Nine
Vascular Depression and African Americans: A Population at Risk

Amanda D. Persaud, Deepika Singh,
Susan Krauss Whitbourne, and Joel R. Sneed

Introduction

The vascular depression hypothesis states that a link exists between late-life depression and vascular disease, such that the accumulation of vascular disease leads to lesions in areas of the brain that regulate mood and executive dysfunction. Cardiovascular risk factors, such as obesity, smoking, hypertension, and diabetes, are exceedingly prevalent in the African American community. Not surprisingly, cardiovascular disease, stroke, and vascular dementia are highly prevalent in the African American community. Diagnosis and treatment of vascular depression in the African American community may be complicated by stigma and shame, religiosity, distrust, economic bias, and provider bias. However, vascular depression lies on the boundary between the medical and psychological, and therefore, represents a unique illness that can be alternatively understood as a consequence of vascular disease. As a result, it may be more amenable to treatment than other mental illnesses that are traditionally conceptualized as psychological. Reconceptualizing some late-life depression in this way may reduce stigma and increase help seeking behavior. We will provide an overview of the Heart and Soul Study at Harlem Hospital Center in New York City and detail the ways in which this academic-community partnership has attempted to spread awareness about vascular depression and increase African American participation in mental health research.

Literature Review

The prevalence of major depression in the geriatric community ranges from 1-4 percent (Blazer, 2003; Hybels and Blazer, 2002; Kramer et al., 2004), and commonly co-occurs with medical illness. Katon and Schulberg (1992) found that the prevalence of major depression increases in a linear manner as study samples move from consisting of community-dwelling adults to primary care patients to inpatient medical settings. One estimate of major depression in hospitalized older adults sixty and over ranged from 10 to 21 percent depending on the method of diagnosis (Koenig, George, Peterson, and Pieper, 1997). Depression is also associated with longer hospital stays and a greater number of primary care appointments (Luber et al., 2001; Luber et al., 2000) and, therefore, leads to greater health care costs (Simon, et al., 1995). Depression increased the risk of mortality by as much as 24 percent in the Cardiovascular Health Study (Schulz et al., 2000) and was found to increase the level of functional disability and the effectiveness of rehabilitation programs for older adults with stroke, Parkinson's disease, heart disease, and fractures (Katz, 1996). Finally, suicide rates are higher among the elderly than any other age group (McIntosh, 1992), and the association between depression and suicide has been clearly indicated (Conwell and Brent, 1995).

It is projected that by 2010, the world's elderly population will grow by 847,000 people each month, and that by the year 2050, 35 percent of the United States will be age sixty-five or older (Kinsella and Velkoff, 2001). Older adults are also getting older. In 1994, the older adult population between the ages of sixty-five to seventy-four was eight times larger than it was in 1990, the seventy-five to eighty-four year old age group was fourteen times larger, and the eighty-five and older group was twenty-eight times as larger (Cooley et al., 1998). Lebowitz et al. (1998) estimates that life expectancies for older adults around the world will increase by as much as thirty years in the twenty-first century. Furthermore, there is daunting evidence that future generations of older adults, which, as previously documented, are growing faster and getting older, will experience higher rates of depressive illness than earlier generations of older adults (Blazer, 1994; Kasen, Cohen, Chen, and Castille, 2003; Wittchen, Knauper, and Kessler, 1994).

DSM-IV (18) criteria for MDD are constant for all ages in adulthood, despite evidence that the presentation of MDD can change in late life and despite the psychological, social, and physical changes that occur across the lifespan. DSM-IV (American Psychiatric Association, 1994) criteria for unipolar depression are the same for younger adults as they are for older adults. These criteria do not make adjustments for the physical, psychological, and social role changes that are associated with aging and may influence the course and presentation of depression. For example, older adults are less inclined to report depressed mood and are more inclined to complain about somatic symptoms. Gallo and Rabins (1999) referred to this unique profile of depressive illness as depression without sadness. Several factors may affect the phenomenological presentation of depression over the life course. It could be that the illness itself changes over time. For example, the

cumulative impact of recurrent depressive episodes could alter depression in the same way osteoarthritis worsens with age. It could also be that the aging process itself, or the social and psychological challenges associated with it, impacts the disease altering its manifestation. For example, the loss of flexibility in the arteries with age and the continuing plaque deposits that accumulate over the life course make the heart function less effectively and efficiently in the later years, which may subtly affect brain functioning over the time (Whitbourne, 2000). Older adults must also negotiate a host of social role changes such as retirement and community relocation that require continued psychological and emotional adaptation (Brandstadter and Greve, 1994; Sneed and Whitbourne, 2003). This suggests that DSM-IV criteria for depression should be age-adjusted.

One of the most important advances in the treatment of depression was the recognition of subtypes within the mood disorder spectrum. Of course, there is the distinction between unipolar and bipolar illness, but within the unipolar spectrum, several phenomenologically distinct subtypes have been delimited, including melancholia, atypical, and psychotic depression. The recognition of this heterogeneity has had important implications for treatment, as different depressive subtypes respond preferentially to different medications (Roose and Sackeim, 2004). Mood stabilizers (e. g., lithium or valproate) are uniquely prescribed for the treatment of bipolar disorder. Within the unipolar spectrum, psychotic depressives have been found to respond less well to TCAs than non-psychotic depressives (Chan et al., 1987; Glassman and Roose, 1981); melancholic depression has been found to respond better to TCAs than to SSRIs (Roose, Glassman, Attia, and Woodring, 1994); and those with atypical depression have been found to respond better to MAOIs than to TCAs (Liebowitz et al., 1998). The DSM-IV assumes, however, that these subtypes also carry over unchanged into old age, despite the fact that some subtypes (e.g., melancholic depression) are more prevalent in older adults than they are in younger adults (Blazer, 2003). This raises an important question: Are there depressive subtypes distinct to old age?

One subtype that has been proposed, which may be unique to older adults, is vascular depression (Alexopoulos et al., 1997; K. R. Krishnan, Hays, and Blazer, 1997; K. R. Krishnan et al., 2004). Broadly defined, vascular depression refers to depression that occurs for the first time in late-life (after age fifty or sixty) in the context of vascular (e. g., hypertension, hypercholesterolemia, and diabetes) and/or cerebrovascular abnormalities (e. g., deep white matter hyperintensities) and/or executive dysfunction. A number of studies have documented associations between late-onset depression, vascular and/or cerebrovascular pathology, and executive dysfunction. For example, Baldwin and Tomenson (1995) found that a late-onset depression group had significantly more vascular risk factors such as hypertension, clinical evidence of arteriosclerosis, history of myocardial infarct, and previous stroke as compared to a early-onset depression group. O'Brien et al. (1996) found that 50 percent of late-onset depressed patients had severe deep white matter hyper-intensities. In a population-based study of 1,077 depressed older adults, de Groot et al. (2000) found that the likelihood of being diagnosed as having late-onset

depression was 3.4 times more likely with severe subcortical hyperintensities, as opposed to those with mild or no evidence of hyperintensities. Alexopoulos et al. (1997) found that those with late-onset depression and vascular disease showed greater executive dysfunction (e. g., impairment on word fluency and naming of line drawings) than those with early-onset depression without vascular disease. Hickie et al. (1995) examined thirty-nine hospital inpatients with severe depression (with 49 percent having either a history of hypertension or cerebrovascular disease and 51 percent having their first episode of depression after age fifty) and found that deep white matter hyperintensities significantly predicted poorer performance on decision time.

Different diagnostic criteria have been proposed to define vascular depression. For example, Hickie et al. (1995) hypothesized that underlying cerebrovascular pathology in older adults affects subcortical and basal ganglia structures causing late-onset depression and executive dysfunction. According to this definition, late age of onset, cerebrovascular disease, and executive dysfunction are essential features of vascular depression. Alexopoulos et al. (1997) regarded clinical and/or laboratory (i.e., magnetic resonance imaging) evidence of vascular disease or vascular risk factors and depression onset after age 65 as cardinal features of the disorder, and neuropsychological impairment (primarily executive dysfunction) was considered a secondary feature. Steffens and Krishnan (1998), however, regarded clinical and/or neuroimaging evidence of cerebrovascular disease or neuro-psychological impairment as the cardinal features of the subtype and depression onset after age fifty as an additional supporting feature of the diagnosis. Krishnan and his colleagues have further refined the notion of vascular depression disregarding evidence of neuropsychological impairment as a necessary feature and have, instead, emphasized the role of cerebrovascular pathology as evidenced by magnetic resonance imaging (Krishnan et al., 2004). Alexopoulos and his colleagues have also refined the notion of vascular depression and, while recognizing the role of cerebrovascular pathology in the etiology of the illness, have focused instead on the neuropsychological manifestation of executive dysfunction (Alexopoulos, 2001; Alexopolous, Kiosses, Klimstra, Kalayam, and Bruce, 2002). As a result, it is unclear (a) what the core features of vascular depression are, (b) how much, if any, unique variance each feature contributes to the diagnosis, (c) whether these features cluster together to define a distinct diagnostic group, and (d) which criteria most accurately defines the illness.

In order to establish the validity of a psychiatric illness, *both* the internal and external construct validity of a diagnostic construct must be evaluated. Establishing internal construct validity in the absence of external construct validity is incomplete because it would remain unclear whether the internally valid diagnostic entity was clinically meaningful. Similarly, establishing external construct validity in the absence of internal construct validity is incomplete because there is no way of knowing what the boundaries of the illness are, which features contribute unique information to the diagnoses, and whether it was representative of a distinct group

of patients. Below is a review of pertinent issues and empirical evidence pertaining to both of these critical aspects of diagnostic validity.

By internal construct validity, it is meant that the "specified clinical features must be jointly indicative of an underlying diagnostic classification" (Young et al, 1986, p. 257). Intrinsic to establishing internal construct validity is also determining diagnostic accuracy, which is reflected in indices such as sensitivity (i.e., the probability that an ill person will be diagnosed as ill) and specificity (i.e., the probability that a person who is not ill will not be diagnosed as ill) (Faraone and Tsuang, 1994). To address this problem, Sneed et al. (2008) used data from two, large clinical samples of late-life depressed patients and showed that the vascular group, defined by a high probability of having MRI hyperintensities (deep white matter and periventricular), executive dysfunction, and late age-at-onset, was most accurately identified by DWMH. Not only do these findings provide the first empirical evidence that vascular depression is a unique subtype in late-life, but also provide the first empirically-based diagnostic criteria for the illness.

Research that has focused on establishing vascular depression as a late-life nosological entity has concentrated exclusively on external construct validity (e. g., Alexopoulos, 2001; Krishnan et al., 2004; Steffens and Krishnan, 1998). By external construct validity, it is meant that the diagnostic entity is reliably associated with clinically meaningful external validators (Robins and Guze, 1970). According to the Robins and Guze criteria, it should be demonstrated that (a) the diagnostic entity has a distinct clinical profile, (b) the diagnosis is more prevalent in close family members, (c) response to treatment is similar in patients with the illness, and (d) it has a known clinical course.

Clinical Profile

Research suggests that late-life depression occurring in the context of vascular or cerebrovascular disease and executive dysfunction present with a distinct clinical profile that includes psychomotor retardation, anhedonia, limited depressive ideation, and lack of insight. For example, those with vascular disease as defined by a score of one or more on the Cumulative Illness Rating Scale - Geriatrics (CIRS-G) scored significantly higher than the non-vascular group on psychomotor retardation and lack of insight, and significantly lower than the non-vascular depressed group on depressive ideation (Alexopoulos et al., 1997). Krishnan et al. (2004) found that found that lassitude (I. e., difficulty getting started), which is related to but not synonymous with psychomotor retardation, predicted membership in a vascular depressed group defined by MRI lesion severity. Alexopoulos et al. (2002) found that depressed older adults with executive dysfunction displayed greater scores on psychomotor retardation, loss of interest in activities, and paranoia, and lower scores on vegetative symptoms. The extent to which this specific symptom profile has been replicated, however, is unclear. For example, Krishnan et al. (1997) did not find that loss of interest (anhedonia), psychomotor

retardation, or guilt feelings predicted membership in a vascular depression group defined by deep white matter hyperintensities on MRI. As a result, although researchers suggest that vascular depression has a specific symptom profile, it is unclear at this point what that profile is.

Family History

A potentially distinctive feature of vascular depression is that, as opposed to most psychiatric disorders, it may be marked by a conspicuous absence of mood disorder is close relatives. Hickie et al. (1995) examined thirty-nine hospital inpatients with severe depression (with approximately 50 percent having late-onset depression and a history of hypertension or cerebrovascular disease) and found that history of family affective disorder was significantly negatively associated (B = -.46) with deep white matter hyperintensities. In this same study, deep white matter hyperintensities were associated with impaired psychomotor speed. Krishnan et al. (2004) divided 139 depressed older adults into a vascular depression group (n=75) and a non-vascular depression group (n=64) based on MRI lesion severity and found that the likelihood of being categorized has having vascular depression decreased by .4 for every unit increase in family history of mental illness. However, support for this association is not unequivocal. For example, Krishnan and colleagues (1995) compared 113 late-onset and 113 early-onset depressed elderly adults age sixty and over and found in bivariate analyses that the late-onset group had fewer cases with a family history of alcohol/drug abuse or suicide. However, in adjusted logistic regression analyses, family history of family history of alcohol/drug abuse or suicide did not predict membership in the late-onset depression group.

Acute-treatment Outcome

Research suggests that late-life depression occurring in the context of vascular or cerebrovascular disease and executive dysfunction may be associated with poor treatment response. Hickie et al. (1995) found that treatment outcome was negatively associated with deep white matter hyperintensities in both patients treated with ECT alone (n=20) and pharmacotherapy alone (n=19). In another study, having 5 or more basal ganglia hyperintensities and any hyperintensities in the pontine reticular formation significantly predicted patient resistance to twelve weeks of antidepressant treatment (Simpson, Baldwin, Jackson, and Burns, 1998). Taylor et al. (2003) classified fifty-five initially depressed older adults as remitted and seventy-eight initially depressed older adults as having poor outcome over two years using a "real world" treatment algorithm and found that greater change in white matter hyperintensities increased the odds of being classified as a poor outcome case by almost seven times. Navarro et al. (2004) used functional neuroimaging to examine the correlates of remission status in a study of forty-seven

late-onset major depressed patients (thirty-four were classified as remitters and thirteen as non-remitters) and found that the odds of non-remission increased by approximately 2.5 for every unit increase in left-anterior frontal perfusion. Baldwin et al. (2004) studied a group of late-onset major depressed patients (twenty-nine were classified as treatment responders and twenty-one were not) and found that non-responders had significantly more impairment on neuropsychological tasks tapping executive dysfunction (verbal fluency and Stroop test) than responders to antidepressant monotherapy. Alexopoulos et al. (2000) examined major depression relapse (depression occurring within four to six months of remission) and recurrence (depression occurring four to six months after remission) in fifty-eight initially remitted patients on a maintenance dose of nortriptyline and found that only deficits in initiation and perseveration (tests of executive dysfunction) predicted relapse or recurrence. However, not all studies show this pattern of treatment response. For example, Krishnan et al. (1997) categorized fifty-seven patients on the basis of MRI abnormalities for six months receiving naturalistic treatment in a clinic setting and found that the recovery rate was approximately equal between the vascular and non-vascular groups. Similarily, Salloway et al. (2002) found no difference between patients (N=59) categorized as high or low on subcortical hyperintensities treated with sertraline. As a result, although findings suggest vascular depression may be associated with poor treatment response, it is not clear-cut. It is should be noted that none of these studies were designed a priori as a test of treatment response in vascular depression.

Course of Illness

Research suggests that late-life depression occurring in the context of vascular or cerebrovascular disease and executive dysfunction may be associated with cognitive decline. For example, Alexopoulos et al. (1993) found that irreversible dementia developed significantly more in a depressed group with reversible dementia than in a group who were depressed alone (43 percent versus 12 percent), suggesting that depression with cognitive impairment may be a prodrome to dementia in later life. Hickie et al. (1995) found that 27 percent of patients (ten out of thirty-seven) with late-onset depression and deep white matter hyperintensities went on to develop "probable" dementia syndromes of the vascular type. Although executive dysfunction that occurs in the context of late-onset depression tends to remit following treatment, it generally does not return to premorbid levels of functioning. Butters et al. (2000) examined changes in cognitive functioning following remission after twelve weeks of antidepressant treatment (nortriptyline or paroxetine) in forty-five (80 percent women) elderly patients and found that patients with cognitive impairment at baseline (n=10) improved more so than either controls or patient without cognitive impairment at baseline on tasks tapping conceptualization, and initiation and perseveration. However, the group of patients with cognitive impairment at baseline did not reach premorbid levels of functioning

suggesting that patients with executive dysfunction may be at risk for dementia. Similarly, Murphy and Alexopoulos (2004) found that older adults with impaired executive functioning (initiation and perseveration dysfunction) improved over time (receiving uncontrolled treatment as clinically indicated) but did not reach the level of executive functioning as those who were depressed at baseline without executive dysfunction or healthy, non-psychiatrically ill controls. Establishing vascular depression as a distinct late-life depressive illness has important implications.

Treatment

Identifying valid diagnostic subtypes is important because etiologically distinct subtypes respond differently to treatment. As previously discussed, vascular depression may be particularly treatment-resistant. Treatment of MDD often involves use of agents with potential cardio- and cerebro-vascular effects (e.g., TCAs). Conceivably, some of these effects, such as hypotension may aggravate the cerebrovascular process leading to vascular depression, and perhaps limit the efficacy or increase side effects of antidepressants. Thus, it is possible that some treatments that are effective in suppressing the expression of acute depressive illness in the short term may ultimately contribute to disease progression. As a result, not only do we know very little about the treatment of individuals with vascular depression, but it also unknown whether augmenting antidepressant treatment with, for example, antihypertensive and antiplatelet agents might have a beneficial effect on treatment outcome.

Prevention

Establishing diagnostic validity could prove to have important implications for its prevention by modifying and treating risk factors for cerebrovascular disease. However, without establishing the diagnostic criteria for vascular depression, we have no way of reliably identifying potential patients with the illness. Is laboratory evidence of cerebrovascular abnormalities (i.e., hyperintensities on MRI) necessary for a diagnosis? Or, is there a less expensive way of identifying a patient with vascular depression, such as through neuropsychological screening?

Prognosis

Establishing the validity of vascular depression may have important implications for prognosis. For example, it is unclear what the association is between vascular depression and dementia, and therefore, whether augmentation by reversible cholinesterase inhibitors may be indicated. Although evidence suggests that patients with vascular depression (defined by excessive encephalomalacia) have poorer long-term prognosis, prospective evaluation of the structural (MRI) and functional (executive dysfunction) deficits in relation to the course of vascular depression has

yet to be conducted. Given that older adults represent the fastest growing segment of the population, and that dementia dramatically increases with age, early detection and treatment may substantially improve and extend the quality of life of patients who may ultimately develop some form of irreversible cognitive impairment. As a result, it is critically important that we go about establishing the validity of vascular depression in a systematic and methodologically rigorous way because it will have important implications for our understanding of prevention and treatment.

Vascular Disease and African Americans

So far we have conceptualized vascular depression as a distinct subtype of late-life depressive disorder. Importantly, it may also disproportionately affect African Americans. The rates of cardiovascular disease (CVD) risk factors are significantly higher in African Americans compared to Whites. For instance, the rate of hypertension is significantly higher in African Americans (60 percent) than Whites (38 percent) (Kramer et al., 2004; Geronimus, Bound, Keene, and Hicken, 2007). African Americans are also more likely to have diabetes, with the risk of developing diabetes almost twice as high for African Americans than Whites (Brancati, Kao, Folsom, Watson, and Szklo, 2000). Obesity is also a significant health concern for African Americans; 77 percent of African American women and 63 percent of African American men over twenty are overweight or obese (Hedley et al., 2004). Rates of abdominal obesity are also higher in African American women over sixty-five compared to White women over sixty-five (Sundquist, J., Winkleby, M. A., and Pudaric, 2001). Smoking is yet another prevalent CVD risk factor for African Americans: nearly 25 percent of African Americans over age eighteen smoke (Mariolis et al., 2006). Not surprisingly, African Americans have higher rates of manifest CVD compared to Whites, with CVD being the leading cause of death in African Americans (American Heart Association, 2007). People with diabetes, hypertension, or individuals that smoke, are two to four times more likely to develop stroke than those without diabetes, hypertension or nonsmokers (Kawachi et al., 1993); stroke and stroke-related mortality rates are higher in African Americans compared to Whites across the lifespan (Harris et al., 2005; Kissela et al., 2004). Stroke increases risk for dementia, in particular, vascular dementia (Desmond, Moroney, Sano, and Stern, 2002). Indeed, the rate of vascular dementia is higher in African Americans relative to Whites (Kuller et al., 2005). Because of these high rates, African Americans may be at high risk for vascular depression.

Cardiovascular Disease Risk Factors (CVD)

Hypertension

Thirty-five percent of African Americans have hypertension, and they also have higher rates of high blood pressure in comparison to other races (Cooper, Rotimi, and Ward, 1999). Hypertension develops earlier in life for African Americans compared with Whites (Cooper, Rotimi, and Ward, 1999). In addition, about 20 percent of deaths among African Americans are from hypertension, twice the amount of deaths of Whites from hypertension (Cooper, Rotimi, and Ward, 1999).

Hypertension can result in stroke, heart disease, and kidney failure. African Americans with high blood pressure have an 80 percent higher chance of death from a stroke and a 20 percent higher chance of developing heart disease than other races (Cooper, Rotimi, and Ward, 1999). Finally, African Americans have a four-times greater risk of developing hypertension-related end-stage kidney disease than other races if they have high blood pressure (Cooper, Rotimi, and Ward, 1999).

The results of having hypertension can be devastating. What is more alarming is that it can often go undetected, clandestinely disturbing bodily organs. With routine blood pressure check-ups, this problematic health concern can be prevented or treated as soon as possible. However, if an individual lacks access to proper healthcare, his or her hypertension may be left untreated.

Obesity

Obesity is a serious and prevalent epidemic in the United States, especially in the African American community. Seventy-eight percent of African American women, and 60 percent of African American men are overweight. In addition, 28.8 percent of African American men and 50.8 percent of African American women meet the criteria for obesity, while African American children are 30 percent more likely to be obese than White children (Ogden et al., 2006). Obesity is a risk factor for diabetes, stroke, and heart disease. It also increases risk of breathing problems, arthritis, gallbladder disease, sleep apnea, and some cancers (Ogden et al., 2006).

Cultural factors, environment, and genetics all play a role in the food that we eat and how the body reacts to and processes certain foods. A diet high in fat has been associated with prostate, breast, and colon cancer (Ogden et al., 2006). Soul food, traditional meals in the African American community, may negatively affect the health of individuals. Soul food is mostly based on ingredients and preparation that rely heavily on fat, sugar, and sodium for their rich flavors. In all populations, including African Americans, salt sensitivity has been linked to obesity (Flack et al., 2002). Research has shown that many other cultural factors affect African American obesity, including the acceptance of larger body sizes, less guilt associated with overeating, and the fact that African Americans are less likely to engage in unhealthy and unsafe dieting behaviors, such as purging or over-

exercising (Ogden et al., 2006). Although having a positive acceptance of all body sizes is healthy, this can often lead to tolerating problematic weights that lead to serious obesity-related health concerns.

Smoking

The smoking behavior of African Americans has caused increased burden in the form of smoking-related diseases. White smokers consume 30-40 percent more cigarettes than African American smokers (Herbert, 2003). Surprisingly, African American men are more likely to develop lung cancer. The question arises, if African Americans smoke fewer cigarettes than White smokers, and begin smoking later in life, why is the highest prevalence of death due to smoking-related diseases within the African American community? Many theories are proposed, including factors such as poverty and population density accounting for increased incidences of cancer within the African American community. Factors such as disparities in healthcare access and treatment and prevention knowledge may affect the outcome of smoking behaviors. There has been evidence that psychological stress may be a factor in the continuation of smoking within the African American community (Feigelman and Gorman, 1989).

Research has suggested that African Americans that live in urban neighborhoods with a large African American population are at an especially high risk for smoking-related illnesses (Romano, Bloom, and Syme, 1991). The urban community itself may be targeted by the aggressive marketing ploys by tobacco companies (Davis, 1987). Newport, a mentholated cigarette brand, is heavily advertised in African American communities (Luke, Esmundo, and Bloom, 2000). Research has indicated that an ecological issue may be afoot as African Americans do, in fact, prefer menthol cigarettes (O'Connor, 2005).

Due to the prevalence of smoking within the African American community compared with other races, much attention has been focused on intervention and cessation efforts within this group. It has been found that the higher the education and income of an African American individual, the lower the smoking prevalence rate (King, Bendel, and Delaronde, 1998). Effective smoking cessation methods within the African American community are the combination of physician counseling and the distribution of print materials, as well as church-based cessation programs that offer counseling and culturally appropriate information materials (Lipkus, Lyna, and Rimer, 1999; Royce et al., 1995; Pederson, Ahluwalia, Harris, and McGrady, 2000; Schorling et al., 1997).

Diabetes

Diabetes has become one of the most serious and devastating epidemics within the African American community. African Americans have a higher risk of developing Type 2 diabetes due to genetic traits, obesity, and insulin resistance (Marshall, 2005). The prevalence of diabetes in the African American community is twice the

amount in Whites (Marshall, 2005). In addition, African Americans face morbidity and mortality burden associated with diabetes.

The link between diabetes and cardiovascular disease is obvious, as cardiovascular disease is the leading cause of death for those with diabetes. The mortality rate due to heart disease for those that have diabetes is also about two to four times higher than those without diabetes. In addition, African Americans are more likely to develop complications due to their diabetes such as diabetic retinopathy, kidney disease, and lower limb amputations compared with Whites (Harris, Klein, Cowie, Rowland, and Byrd-Holt, 1998; Resnick, Valsania, and Phillips, 1999).

Other Risk Factors

However, there are some risk factors for heart-related diseases that one cannot control. It has been found that as one ages, the progression of medical illness also increases. For example, those who are older are more susceptible to heart disease, affecting men who are forty-five and older, and women who are fifty-five years or older. Also, family history of heart disease is also an important factor. If an individual has a father or brother who had heart disease before the age of fifty-five, or a mother or sister with heart disease before the age of sixty-five, they may be more susceptible to heart disease.

As adults enter late-life, these risk factors have deleterious effects and manifest themselves as vascular illnesses that are prominent in African Americans. The most common of these illnesses are cardiovascular disease, stroke, vascular dementia, and as previously discussed, the proposed vascular depression. Not only are there higher rates of cardiovascular disease compared to whites, but it is also the leading cause of death in African Americans.

Stroke

Not only are African Americans twice as likely to experience stroke, but they are also twice as likely to die from stroke or stroke-related complications. Many hypotheses have been proposed to explain why there is a higher incidence of stroke mortality and risk for African Americans, including (a) increased cardiovascular risk factors within the African American community, (b) greater severity or sensitivity to these risk factors, and (c) a lack of access to appropriate and affordable healthcare (Gaines and Burke, 1995; Gorelick and Harris, 1993). One in three African Americans suffer from high blood pressure, the number one risk factor for stroke. Other risk factors include diabetes, sickle cell anemia, smoking, and obesity. The effects of stroke can leave devastating, and even fatal, consequences to those affected. The occurrence of stroke has also been found to increase risk for dementia, in particular, vascular dementia.

Vascular Dementia

Vascular dementia is considered the second most common type of dementia. It has been found that there are genetic risk factors that predispose individuals to certain types of dementia, with the rates of dementia differing according to race. The rate of vascular dementia is higher in African Americans compared with whites (Kuller et al., 2005). Vascular dementia has been deemed a "silent epidemic" among older adult African Americans (Alzheimer's Association, 2002). Early intervention is vital to treating African Americans with Alzheimer's disease, as it has been found that African Americans tend to be diagnosed at a later stage, limiting the available treatment options. Stroke increases risk of dementia, in particular, vascular dementia (Desmond, Moroney, Sano, and Stern, 2002). Prevention of vascular dementia includes the monitoring of blood pressure, weight, cholesterol and sugar levels, avoiding smoking, and engaging in heart-healthy behavior, like exercise.

African Americans and Mental Illness

There is much about the vascular depression hypothesis that is compelling. African American older adults are disproportionately affected by three broad classes of vascular illness: cardiovascular disease, stroke, and vascular dementia. In this regard, vascular depression may represent the fourth vascular illness that is over represented among this group. This is important because Africans Americans are a group that has historically been fearful and cautious about the diagnosis and treatment of mental illness. In trying to understand and treat vascular depression in the African American community, we must come to grips with the impact of stigma and shame, religiosity, distrust of researchers, economic bias, and provider bias as factors that may potentially influence the recognition and treatment of vascular depression.

Stigma towards mental illness is a pervasive problem in the African American community. As a result, African Americans are less likely to use mental health services than Whites (Neighbors et al., 2008) because of mental health stigma (Thompson, Neighbors, Munday, and Jackson, 1996). In fact, stigma has been identified as the most significant barrier to seeking mental health services among African Americans (Thompson-Sanders, Bazile, and Akbar, 2004). African Americans view mental illness as a personal weakness, and not a health-related problem. A survey examining the attitudes of African American women toward mental health revealed that they believed that an individual develops depression due to having a "weak mind, poor health, a troubled spirit, and lack of self-love" (Waite and Killian, 2008).

This belief may prevent African Americans from seeking appropriate professional help. Many African Americans do not enter the mental healthcare system, but utilize alternative sources of care, such as ministers, primary care physicians, and informal support networks (Neighbors, 1988). In addition, many

African Americans choose to ignore their mental illness and do not seek treatment at all (Neighbors and Jackson, 1984). Africans Americans are also afraid of being judged by others and bringing shame upon themselves and their family. As a result, both the mentally ill individual and the family attempt to hide the illness (Thompson-Sanders, Bazile, and Akbar, 2004).

Religiosity within the African American community may also negatively affect participation in mental health services and research. A prevailing belief among African Americans is that there is a religious or spiritual basis for mental illness, which consequently should not be handled through medical domains but through spiritual or religious channels. Religious African Americans may ascribe psychiatric symptoms to spiritual or moral failings, rather than as sadness or depression (Krishnan, Hays, and Blazer, 1997). Psychological illness is often thought to be a form of holy chastisement due to sin, resolved only through prayer and atonement. Not surprisingly, African Americans often to turn to the clergy as an alternate source of care for their mental health problems.

Research has indicated that African Americans exhibit a higher level of distrust towards researchers and a greater perceived chance of harm or injury by participating in research trials relative to Whites (Braunstein, Sherber, Schulman, Ding, and Powe, 2008). This greater distrust of medical research and researchers stems from a knowledge of controversial clinical trials conducted on minorities in the past, such as the Tuskegee study, coupled with historical and daily experiences of discrimination and racial biases. The morally and ethically corrupt Tuskegee Syphilis Experiment, which lasted from 1932-1972, destroyed the trust of African Americans towards public healthcare within the United States. The Tuskegee study stands as a testament of the exploitation of African Americans in medical research and has had long-lasting effects on their community. Therefore, it is understandable that African Americans are more distrustful of medical researchers, who are more often than not White, because they are aware of this history of racial discrimination in medical research (Corbie-Smith, Thomas, Williams, and Moody-Ayers, 1999).

Ethnically diverse communities are underserved in the U.S. mental healthcare system. It has been found that minorities are more likely to lack health insurance, receive lower quality of care, and to suffer from worse health outcomes compared to Whites. This socioeconomic disadvantage can be attributed to many overlapping factors, including poverty, racism, and access to healthcare facilities. Despite efforts to improve access to healthcare for ethnic minorities, those who do have insurance are less likely to have coverage for mental health services than coverage for other medical illnesses such as hypertension and diabetes. Only one out of three African Americans suffering from mental illness receive mental healthcare. In addition, transportation can also be a burden if the healthcare site is not located in an accessible, convenient setting.

In addition to stigma and shame, religiosity, distrust, and economic factors, many health professionals lack cultural awareness and sensitivity, leaving them unprepared to serve ethnic minority populations. Health professionals may be biased in terms of diagnosis due to unfamiliarity with idioms of distress among

African Americans. For example, African Americans have been perceived as paranoid, often leading to diagnoses of psychosis rather than depression (Fujikawa, Yamawaki, and Touhouda, 1993; Salloway, 1996). Paranoia may not represent true psychosis, but instead result from hypervigilance due to racism and cultural mistrust (Fujikawa, Yamawaki, and Touhouda, 1993; Salloway, 1996), psychological mechanisms to cope with depression (Lesser, Hill-Gutierrez, Miller, and Boone, 1993), or neurodegenerative processes from comorbid substance abuse (Fujikawa, Yamawaki, and Touhouda, 1993).

African Americans also must cope with the negative effects of institutionalized racism (structured differential access to services and opportunities), personally mediated racism (prejudice and discrimination), and internalized racism (acceptance of negative stereotypes by the stigmatized racial group) on their mental and physical health (Jones, 2000). In recent years, increased attention has been directed toward the relationship between experiences of racism and mental and physical health in African Americans (Pieterse and Carter, 2007; Williams, Neighbors, and Jackson, 2008; Jones, Cross, and DeFour, 2007). It has been found that perceptions of racial discrimination are positively associated to decreased levels of self-esteem in addition to depressive symptomology (Jones, Cross, and DeFour, 2007; Landrine and Konoff, 1996). Racism is also positively related to stress-related health conditions prominent in African Americans such as hypertension and cardio-vascular disease (Harrell, Merritt, and Kalu, 1998).

African American Identity Across the Life Span

We have argued for the existence of vascular depression as a distinct subtype of geriatric depression. We have also argued that it may represent the fourth vascular illness disproportionately affecting African American older adults. It was further pointed out that the diagnosis and treatment of vascular depression may be complicated by stigma and shame, religiosity, distrust, economic bias, and provider bias. These complicated ideas and beliefs about mental illness are not just whimsical beliefs, but are manifested in the African American identity and are central to how they perceive themselves. Although there a number models of African American identity (Cross, 1991; Phinney, 1990; Helms, 1995; Sue and Sue, 1990), these theories primarily concern themselves with the formation of a racial identity and do not address how beliefs about mental or medical illness are instantiated in identity. More importantly, they do not address how these beliefs, as aspects of our identity, might change across the lifespan. This is important because vascular depression can be thought of not as a "mental illness," but as an outcome of vascular disease (see Figure 9.1). Whitbourne's identity process theory, however, provides a useful framework for understanding how medical illness impacts one's sense of self, and importantly, can change across the lifespan.

As one ages, physical health, including medical illness such as vascular disease, becomes a more central and integral part of the self-concept (Bocknek and

Perna, 1994). According to identity process theory, adults resolve age-related changes (both physical and psychological) through the processes of identity assimilation, identity accommodation, and identity balance. Identity assimilation occurs when an individual chooses to interpret their identity salient experiences in terms of preexisting schemas regarding the self. Identity accommodation refers to the changing of identity in response to inconsistent self-representations. Identity accommodation only occurs after identity assimilation has first processed the new experiences. Both theoretical concepts of identity assimilation and identity accommodation merge together in a dynamic equilibrium to form identity balance. These three processes are used by all individuals to varying extents and interact during the evolution of one's identity. Findings suggest that when used together in a balanced way, assimilation and accommodation help those who are dealing with the transitory periods during adulthood. Using Erikson's theory of identity development and Piaget's cognitive-developmental model, several studies have utilized this conceptual framework to describe how identity can be altered by age-related changes in physical and cognitive functioning (Whitbourne, 1987; Whitbourne and Collins, 1998).

**Figure 9.1: A Schematic Diagram Depicting
the Vascular Depression Hypothesis**

Those who utilize identity assimilation may live under the façade of having a positive self-concept, high self-esteem, and may relish in their accomplishments. However, underneath this pretense lies insecurity and a lack of self-esteem. Aging adults who predominantly use identity assimilation have difficulty acknowledging weaknesses or deficiencies, which often leads to a lack of confrontation of these experiences (Whitbourne, 1986). They are unwilling to recognize and accept age-

related changes, which may allow for the preservation of a positive self-concept. A lack of acceptance for the aging process may lead to a fear of loss of control, divesting the individual of his or her faculties and achievements. People who use mostly identity assimilation may fail to acknowledge their age-related changes as they may be deterred from utilizing strategies that could aid in these changes (Baltes, 1997; Baltes and Baltes, 1990).

Adults who use identity accommodation are particularly sensitive to changes associated with the aging process, overreacting to small changes (e.g., memory slips). Those who utilize identity accommodation to an excessive degree may adopt negative stereotypes and attribute their age-related concerns to the aging process instead of environmental factors or circumstance (Rodin and Langer, 1980). Depression may ensue if one overreacts to age-related changes in the form of feeling hopeless and negative about the self, world, and future (Parmelee, Katz, and Lawton, 1991; Beck, Rush, Shaw, and Emery, 1979). This may lead to a failure to take proper care of oneself and a failure to maintain one's well-being and health. When negative ageist stereotypes (Sneed and Whitbourne, 2003) are confirmed, a downward spiral leading to utter despair, suicidal ideation, and hopelessness can result. Because providers are also affected by such stereotypes, they may chalk the patient's condition up to old age, which might lead to less effective treatment from health professionals who demand less from their patients (Rodin and Langer, 1980).

Older individuals who are high in identity balance, the most adaptive approach to aging, utilize both identity assimilation and accommodation. They are able to change when their identity is challenged, while still maintaining a stable self-concept. These adults are accepting of the aging process and integrate the changes into their sense of self, which ultimately means that the impact of these changes on their self-regard and how they see themselves is negligible.

This framework may be applied to the problem of vascular depression in the African American community in relation to recognition, interpretation, and integration of mental illness within one's self-concept. African Americans who excessively rely on identity assimilation possess fragile identities and will attempt to interpret their illness in the context of a preexisting identity. They find it painful to recognize identity-discrepant experiences and through identity assimilation, try to minimize, ignore, or deny the presence of vascular depression to defend their positive self-image. They may avoid confronting the illness and seeking treatment as well in order to prevent negative information from entering or invading their identity.

By contrast, individuals who use identity accommodation have unstable and incoherent identities that are highly responsive to external influences and new experiences. These individuals possess a sense of self fraught with low self-esteem. They may take on vascular depression as a new identity, signaling their ultimate decline or as evidence of lack of piety, leading to excessive guilt. They may seek out treatment not as an attempt to remedy the illness and return to premorbid functioning, but due to a need to take on the sick role. Unfortunately, they then become unable to take actions which would allow them to compensate for their

illness, hence making it difficult for them to live their life to the fullest extent possible.

If they are able to reconceptualize the notion of depression as a consequence of vascular disease burden, older individuals may be able to conceptualize the illness differently and approach it in a more balanced way. For example, those who rely predominantly on assimilation can be encouraged to use identity accommodation to a greater extent. They can integrate the concept of their illness into their identity because the illness will not represent as much a threat to their self-esteem (Sneed and Whitbourne, 2003). At that point, they may be ready to seek treatment. They can then not experience the illness as evidence of lack of piety or their ultimate decline, but they will start to conceptualize their treatment as a treatment of vascular disease rather than depression. These concepts provide hope for the treatment of vascular depression in African Americans.

The Heart and Soul Study at Harlem Hospital Center

The Heart and Soul Study aims to make significant contributions to understanding the phenomenology, treatment, and course of vascular depression in a population that we have argued is a high-risk, yet understudied group. The study consists of a one-year open treatment trial in which patients receive standardized antidepressant treatment with either a selective serotonin reuptake inhibitor (SSRI) and/or a serotonin-norepinephrine reuptake inhibitor (SNRI), a brain MRI to assess the degree of cerebrovascular disease, and baseline and follow-up neuropsychological assessments to understand cognitive performance and change throughout the year. To overcome barriers to African American participation in our research program, we developed a community-academic partnership by building a research infra-structure and fully integrating the project into the Department of Psychiatry at Harlem Hospital. Our goal was to combine the methodological expertise of the Life Span Lab (www.lifespan.org) with the clinical expertise at Harlem Hospital. Unlike most studies which recruit from the African American community, our study is conducted within the target community at Harlem Hospital Center, which eliminates transportation issues and fears of foreign neighborhoods. We also remain flexible to promote trust, diminish fear of exploitation, and encourage high study completion rates. Although the project is in its infancy, we look forward to its continued success.

Discussion

We have argued that vascular depression is a unique diagnostic entity of late life that may disproportionately affect African Americans. However, barriers such as stigma, shame, religiosity, distrust, economic bias, and provider bias must be overcome for successful diagnosis and treatment to occur. By reconceptualizing vascular depression as a consequence of vascular disease, African Americans will

be able to overcome stigma and shame associated with mental illness and seek out treatment. We believe that the initiatives of the Heart and Soul Study at Harlem Hospital in New York City will lead to better understanding of vascular depression in an understudied population.

References

Alexopoulos, G. S. (2001). The depression-executive dysfunction syndrome of late life: a specific target for D3 agonists? *American Journal of Geriatric Psychiatry, 9,* 22-29.

Alexopoulos, G. S., Kiosses, D. N., Klimstra, S., Kalayam, B., and Bruce, M. L. (2002). Clinical presentation of the "depression-executive dysfunction syndrome" of late life. *American Journal of Geriatric Psychiatry, 10,* 98-106.

Alexopoulos, G. S., Meyers, B. S., Young, R. C., Kakuma, T., Silbersweig, D., and Charlson, M. (1997). Clinically defined vascular depression. *American Journal of Psychiatry, 154(4),* 562-565.

Alexopoulos, G. S., Meyers, B. S., Young, R. C., Kalayam, B., Kakuma, T., Gabrielle, M., and Hull, J. (2000). Executive dysfunction and long-term outcomes of geriatric depression. *Archives of General Psychiatry, 57(3),* 285-290.

Alexopoulos, G. S., Meyers, B. S., Young, R. C., Mattis, S., and Kakuma, T. (1993). The course of geriatric depression with "reversible dementia": A controlled study. *American Journal of Psychiatry, 150(11),* 1693-1699.

American Heart Association. (2007). *Association AH: Heart Facts 2007: All Americans,* Dallas, TX.

American Psychiatric Association. (1994). *Diagnostic and statistical manual of mental disorders* (Fourth Edition). Washington, DC.

Alzheimer's Association. (2002). *African Americans and alzheimer's disease: The silent epidemic,* Chicago, IL.

Baldwin, R., Jeffries, S., Jackson, A., Sutcliffe, C., Thacker, N., Scott, M., and Burns, A. (2004). Treatment response in late-onset depression: Relationship to neuropsychological, neuroradiological and vascular risk factors. *Psychological Medicine, 34,* 125-136.

Baldwin, R. C., and Tomenson, B. (1995). Depression in later life: A comparison of symptoms and risk factors in early and late onset cases. *British Journal of Psychiatry, 167,* 649-652.

Baltes, P. B. (1997). On the incomplete architecture of human ontogeny: Selection, optimization, and compensation as foundation of developmental theory. *American Psychology, 52(3),* 66-80.

Baltes, P. B., and Baltes, M. M. (1990). Psychological perspectives on successful aging: The model of selective optimization with compensation, pp. 1-34. In P. B. Baltes and M. M. Baltes (Eds.), *Successful aging: Perspectives from the behavioral sciences.* New York: Cambridge University Press.

Beck, A. T., Rush, A. J., Shaw, B. E., and Emery, G. (1979). *Cognitive therapy of depression: A treatment manual*. New York: Guilford Press.

Blazer, D. G. (2003). Depression in late life: Review and commentary. *Journals of Gerontology Series A-Biological Sciences and Medical Sciences, 58(3)*, 249-265.

Blazer, D. G. (1994). Is depression more frequent in late life? An honest look at the evidence. *American Journal of Geriatric Psychiatry, 2*, 193-199.

Bocknek, G., and Perna, F. (1994). Studies in self-representation beyond childhood, pp. 29-58. In J. M. Masling and R. F. Bornstein (Eds.), *Empirical perspectives on object relations theory*. Washington, DC: American Psychological Association.

Brancati, F. L., Kao, W. H., Folsom, A. R., Watson, R. L., and Szklo, M. (2000). Incident Type 2 Diabetes Mellitus in African American and White Adults: The atherosclerosis risk in communities study. *Journal of the American Medical Association, 283*, 2253-2259.

Brandstadter, J., and Greve, W. (1994). The aging self: Stabilizing and protective processes. *Developmental Review, 14*, 52-80.

Braunstein, J. B., Sherber, N. S., Schulman, S. P., Ding, E. L., and Powe, N. R. (2008). Race, medical researcher distrust, perceived harm, and willingness to participate in cardiovascular prevention trials. *Medicine, 87*, 1-9.

Butters, M. A., Becker, J. T., Nebes, R. D., Zmuda, M. D., Mulsant, B. H., Pollock, B. G., and Reynolds, C. F., III. (2000). Changes in Cognitive Functioning Following Treatment of Late-Life Depression. *American Journal of Psychiatry, 157(12)*, 1949-1954.

Chan, C. H., Janicak, P. G., Davis, J. M., Altman, E., Andriukaitis, S., and Hedeker, D. (1987). Response of psychotic and nonpsychotic depressed patients to tricyclic antidepressants. *Journal of Clinical Psychiatry, 48(5)*, 197-200.

Conwell, Y., and Brent, D. (1995). Suicide and aging I: Patterns of psychiatric diagnosis. *International Psychogeriatrics, 7*, 149-164.

Cooley, S., Deitch, I. M., Harper, M. S., Hinrichsen, G., Lopez, M. A., and Molinari, V. A. (1998). What practitioners should know about working with older adults. *Professional Psychology: Research and Practice, 29*, 413-427.

Cooper, R. S., Rotimi, C. N., and Ward, R. (1999). The puzzle of hypertension in African Americans. *Scientific American, 280*, 56-62.

Corbie-Smith, G., Thomas, S. B., Williams, M. V., and Moody-Ayers, S. (1999). Attitudes and beliefs of African Americans toward participation in medical research. *General Internal Medicine, 14*(9), 537-546.

Cross, W. E., Jr. (1991). *Shades of Black: Diversity in African American identity*. Philadelphia: Temple University Press.

Davis, R. M. (1987). Current trends in cigarette advertising and marketing. *New England Journal of Medicine, 316*, 725-732.

de Groot, J. C., de Leeuw, F. E., Oudkerk, M., Hofman, A., Jolles, J., and Breteler, M. M. (2000). Cerebral white matter lesions and depressive symptoms in elderly adults. *Archives of General Psychiatry, 57(11)*, 1071-1076.

Desmond, D. W., Moroney, J. T., Sano, M., and Stern, Y. (2002). Incidence of dementia after ischemic stroke: Results of a longitudinal study. *Stroke, 33*, 2254-2262.

Faraone, S. V., and Tsuang, M. T. (1994). Measuring diagnostic accuracy in the absence of a gold standard. *American Journal of Psychiatry, 151*, 650-657.

Feigelman, W., and Gorman, B. (1989). Toward explaining the higher incidence of cigarette smoking among Black Americans. *Journal of Psychoactive Drugs, 21*, 299-305.

Flack, J. M., Grimm, R. H., Staffileno, B. A., Elmer, P., Yunis, C., Hedquist, L., and Dudley, A. (2002). New salt-sensitivity metrics: Variability-adjusted blood pressure change and the urinary sodium-to-creatinine ratio. *Ethnicity and Disease, 12(1)*, 10-19.

Fujikawa, T., Yamawaki, S., and Touhouda, Y. (1993). Incidence of silent cerebral infraction in patients with major depression. *Stroke, 24*, 1631-1634.

Gaines, K., and Burke, G. (1995). Ethnic differences in stroke: Black-white differences in the United States population. *Neuroepidemiology, 14*, 209-239.

Gallo, J. J., Rabins, P. V. (1999). Depression without sadness: Alternative presentations of depression in late life. *American Family Physician, 60*, 820-826.

Geronimus, A. T., Bound, J., Keene, D., and Hicken, M. (2007). Black-White differences in age trajectories of hypertension prevalence among adult women and men, 1999-2002. *Ethnicity and Disease, 17*, 40-48.

Glassman, A. H., and Roose, S. P. (1981). Delusional depression: A distinct clinical entity. *Archives of General Psychiatry., 38(4)*, 424-427.

Gorelick, P. B., and Harris, Y. (1993). Stroke: An excess burden on African Americans. *Chicago Medicine, 96(13)*, 28-30.

Harrell, J. P., Merritt, M. M., and Kalu, J. (1998). Racism, stress, and disease, pp. 247-280. In R. L. Jones (Eds.) *African American Mental Health*. Hampton, VA: Cobb and Henry.

Harris, C., Ayala, C., Dai, S., et al. (2005). Disparities in deaths from stroke among persons aged <75 Years - United States, 2002. *Morbidity and Mortality Weekly Report, 54*, 477-481.

Harris, M. I., Klein, R., Cowie, C. C., Rowland, M., and Byrd-Holt, D. D. (1998). Is the risk of diabetic retinopathy greater in non-Hispanic African Americans and Mexican-Americans than in non-Hispanic Caucasians with type 2 diabetes?: A U.S. population study. *Diabetes Care, 21*, 1230-1235.

Hedley, A. A., Ogden, C. L., Johnson, C. L., Carroll, M. D., Curtin, L. R., and Flegal, K. M. (2004). Prevalence of overweight and obesity among US children, adolescents, and adults, 1999-2002. *Journal of the American Medical Association, 291*, 2847-2850.

Helms, J. E. (1995). An update of Helms's White and People of Color racial identity models, pp. 181-198. In J. G. Ponterotto, J. M. Casas, L. A. Suzuki, and C. M. Alexander (Eds.), *Handbook of multicultural counseling*. Newbury Park, CA: Sage.

Herbert, J. R. (2003). Invited commentary: Menthol cigarettes and risk of lung cancer. *American Journal of Epidemiology, 158*(7), 617-620.

Hickie, I., Scott, E., Mitchell, P., Wilhelm, K., Austin, M. P., and Bennett, B. (1995). Subcortical hyperintensities on magnetic resonance imaging: Clinical correlates and prognostic significance in patients with severe depression. *Biological Psychiatry, 37*, 151-160.

Hybels, C. F., and Blazer, D. G. (2002). Epidemiology and Geriatric Psychiatry, pp. 603-628. In M. T. Tsuang and M. Tohen (Eds.), *Textbook in Psychiatric Epidemiology* (Second edition). New York: John Wiley and Sons, Inc.

Jones C. P. (2000). Levels of racism: A theoretical framework and a gardener's tale. *American Journal of Public Health, 90*(8), 1212-1215.

Jones, H. L., Cross, W. E., and DeFour, D. C. (2007). Race-related stress, racial identity attitudes, and mental health among black women. *Journal of Black Psychology, 33(2)*, 208-231.

Kasen, S., Cohen, P., Chen, H., and Castille, D. (2003). Depression in adult women: Age changes and cohort effects. *American Journal of Public Health, 93*, 2061-2066.

Katon, W., and Schulberg, H. (1992). Epidemiology of depression in primary care. *General Hospital Psychiatry, 14*, 237-247.

Katz, I. R. (1996). On the inseparability of mental and physical health in aged persons: Lessons from depression and medical comorbidity. *American Journal of Geriatric Psychiatry, 4*, 1-16.

Kawachi, I., Colditz, G. A., Stampfer, M. J., Willett, W. C., Manson, J. E., Rosner, B., Speizer, F. E., and Hennekens, C. H. (1993). Smoking cessation and decreased risk of stroke in women. *Journal of the American Medical Association, 269*(269), 232-236.

King, G., Bendel, R., and Delaronde, S. R. (1998) Social heterogeneity in smoking among African Americans. *American Journal of Public Health, 88(7)*, 1081-1085.

Kinsella, K., and Velkoff, V. A. (2001). *An aging world: 2001*. Washington, DC: U.S. Census Bureau.

Kissela, B., Schneider, A., Kleindorfer, D., Khoury, J., Miller, R., Alwell, K., and Broderick, J. (2004). Stroke in a biracial population: The excess burden of stroke among Blacks. *Stroke, 35*, 426-431.

Koenig, H. G., George, L. K., Peterson, B. L., and Pieper, C. F. (1997). Depression in medically hospitalized older adults: Prevalence, characteristics, and course of symptoms according to six diagnostic schemes. *American Journal of Psychiatry, 154*, 1376-1383.

Kramer, H., Han, C., Post, W., Goff, D., Diez-Roux, A., Cooper, R., Jinagouda, S., and Shea, S. (2004). Racial/Ethnic differences in hypertension and hyper-

tension treatment and control in the multi-ethnic study of atherosclerosis (MESA). *American Journal of Hypertension, 17*, 963-970.

Krishnan, K. R., Hays, J. C., and Blazer, D. G. (1997). MRI-defined vascular depression. *American Journal of Psychiatry, 154*, 497-501.

Krishnan, K. R., Hays, J. C., Tupler, L. A., George, L. K., and Blazer, D. G. (1995). Clinical and phenomenological comparisons of late-onset and early-onset depression. *American Journal of Psychiatry, 152*, 785-788.

Krishnan, K. R., Taylor, W. D., McQuoid, D. R., MacFall, J. R., Payne, M. E., Provenzale, J. M., and Steffens, D. C. (2004). Clinical characteristics of magnetic resonance imaging-defined subcortical ischemic depression. *Biological Psychiatry, 55(4)*, 390-397.

Kuller, L. H., Lopez, O. L., Jagust, W. J., Becker, J. T., DeKosky, S. T., Lyketsos, C., and Dulberg, C. (2005). Determinants of vascular dementia in the Cardiovascular Health Cognition Study. *Neurology, 64*, 1548-1552.

Landrine, H., and Klonoff, E. A. (1996). *African American acculturation: Deconstructing race and reviving culture.* Thousand Oaks, CA: Sage.

Lesser, I. M., Hill-Gutierrez, E., Miller, B. L., and Boone, K. B. (1993). Late-onset depression with white matter lesions. *Psychosomatics, 34*, 364-367.

Liebowitz, M. R., Quitkin, F. M., Stewart, J. W., McGrath, P. J., Harrison, W. M., Markowitz, J. S., Klein, D. F. (1998). Antidepressant specificity in atypical depression. *Archives of General Psychiatry, 45(2)*, 129-137.

Lipkus, I. M., Lyna, P. R., and Rimer, B. K. (1999). Using tailored interventions to enhance smoking cessation among African Americans at a community health center. *Nicotine and Tobacco Research, 1*(77-85).

Luber, M. P., Hollenberg, J. P., Williams-Russo, P., DiDomenico, T. N., Meyers, B. S., Alexopoulos, G. S., and Charlson, M. E. (2000). Diagnosis, treatment, comorbidity, and resource utilization in patients in a general medical practice. *International Journal of Psychiatry in Medicine, 30*, 1-13.

Luber, M. P., Meyers, B. S., Williams-Russo, P. G., Hollenberg, J. P., DiDomenico, T. N., Charlson, M. E., and Alexopoulos, G. S. (2001). Depression and service utilization in elderly primary care patients. *American Journal of Geriatric Psychiatry, 9*, 169-176.

Luke, D., Esmundo, E., and Bloom, Y. (2000). Smoke signs: patterns of tobacco billboard advertising in metropolitan region. *Tobacco Control, 9*(16-23).

Mariolis, P., Rock, V. J., Asman, K., et al. (2006). Tobacco use among adults - United States, 2005. *Morbidity and Mortality Weekly Report, 55*, 1145-1148.

Marshall, M. C. (2005). Diabetes in African Americans. *Postgraduate Medical Journal, 2005, 81*, 734-740.

McIntosh, J. L. (1992). Older adults: The next suicide epidemic? *Suicide and Life-Threatening Behavior, 22*, 322-332.

Murphy, C. F., and Alexopoulos, G. S. (2004). Longitudinal association of initiation/perseveration and severity of geriatric depression. *American Journal of Geriatric Psychiatry, 12*, 50-56.

Navarro, V., Gasto, C., Lomena, F., Torres, X., Mateos, J. J., Portella, M., and Marcos, T. (2004). Prognostic value of frontal functional neuroimaging in late-onset severe major depression. *British Journal of Psychiatry, 184(4)*, 306-311.

Neighbors, H. W. (1988). Needed research on the epidemiology of mental disorders in Black Americans, pp. 49-60. In A. O. Harrison, J. S. Jackson, C. Munday, and N. B. Bleiden (Eds.), *A search for understanding: The Michigan Research Conference on Mental Health Services for Black Americans.* Detroit, MI: Wayne State University Press.

Neighbors, H. W. and Jackson, J. S. (1984). The use of informal and formal help: Four patterns of illness behavior in the Black community. *American Journal of Community Psychology, 12*, 629-644.

Neighbors, H. W., Woodward, A. T., Bullard, K. M., Ford, B. C., Taylor, R. J., and Jackson, J. S. (2008). Mental health service use among older African Americans: The National Survey of American Life. *American Journal of Geriatric Psychiatry, 16(12)*, 948-956.

O'Brien, J., Desmond, P., Ames, D., Schweitzer, I., Harrigan, S., and Tress, B. (1996). A magnetic resonance imaging study of white matter lesions in depression and Alzheimer's disease. *British Journal of Psychiatry, 168*, 477-485.

O'Connor, R. J. (2005). What brands are U.S. smokers under 25 choosing? *Tobacco Control, 14*, 213-215.

Ogden, C. L., Carroll, M. D., Curtin, L. R., McDowell, M. A., Tabak, C. J., and Flegal, K. M. (2006). Prevalence of overweight and obesity in the United States, 1999-2004. *Journal of the American Medical Association, 295*(13), 1549-1555.

Parmelee, P. A., Katz, I. R., and Lawton, M. P. (1991). The relation of pain to depression among institutionalized aged. *Journal of Gerontology, 46(1)*, 15-21.

Pederson, L. L., Ahluwalia, J. S., Harris, K. J., and McGrady, G. A. (2000). Smoking cessation among African Americans: What we know and do not know about interventions and self-quitting. *Preventive Medicine, 31*, 23-38.

Phinney, J. S. (1990). Ethnic identity in adolescents and adults: Review of research. *Psychological Bulletin, 108*, 499-514.

Pieterse, A. L., and Carter, R. T. (2007). An examination of the relationship between general life stress, racism-related stress and psychological health among Black men. *Journal of Counseling Psychology, 54*, 102-109.

Resnick, H. E., Valsania, P., and Phillips, C. L. (1999). Diabetes mellitus and nontraumatic lower extremity amputation and nontraumatic lower extremity amputation in African American and Caucasian Americans: The National Health and Nutrition Examination Survey Epidemiologic Follow-up Study, 1971-1992. *Archives of Internal Medicine, 159*, 2470-2475.

Robins, E., and Guze, S. B. (1970). Establishment of diagnostic validity in psychiatric illness: Its application to schizophrenia. *American Journal of Psychiatry, 126*, 983-7.

Rodin, J., and Langer, E. (1980). Aging labels: The decline of control and the fall of self-esteem. *Journal of Social Issues, 36(2),* 12-29.

Romano, P. S., Bloom, J., and Syme, S. L. (1991). Smoking, social support, and hassles in an urban African American community. *American Journal of Public Health, 81*(11), 1415-1422.

Roose, S. P., Glassman, A. H., Attia, E., and Woodring, S. (1994). Comparative efficacy of selective serotonin reuptake inhibitors and tricyclics in the treatment of melancholia. *American Journal of Psychiatry, 151(12),* 1735-1739.

Roose, S. P., and Sackeim, H. A. (2004). Antidepressant medication for the treatment of late-life depression, pp. 192-202. In S. P. Roose and H. A. Sackeim (Eds.), *Late-life depression.* Oxford: Oxford University Press.

Royce, J. M., Ashford, A., Resnicow, K., Freeman, H. P., Caesar, A. A., and Orlandi, M. A. (1995). Physician- and nurse-assisted smoking cessation in Harlem. *Journal of the National Medical Association, 87*(4), 291-300.

Salloway, S., Correia, S., Boyle, P., Malloy, P., Schneider, L., Lavretsky, H., and Krishnan, K. R. (2002). MRI subcortical hyperintensities in old and very-old depressed outpatients: The important role of age in late-life depression. *Journal of Neurological Sciences, 203(4),* 227-233.

Salloway, S., Malloy, P., Kohn, R., Gillard, E., Duffy, J., Rogg, J., Tung, G., and Westlake, R. (1996). MRI and neuropsychological differences in early- and late-life-onset geriatric depression. *Neurology, 46,* 1567-1574.

Schorling, J. B., Roach, J., Siegel, M., Baturka, N., Hunt, D. E., Guterbock, T. M., and Stewart, H. L. (1997). A trial of church-based smoking cessation interventions for rural African Americans. *Preventive Medicine, 26(1),* 92-101.

Schulz, R., Beach, S. R., Ives, D. G., Martire, L. M., Ariyo, A. A., and Kop, W. J. (2000). Association between depression and mortality in older adults: The Cardiovascular Health Study. *Archive of Internal Medicine,* 60(12) 1761-1768.

Simon, G. E., VonKorff, M., and Barlow, W. (1995). Health care costs of primary care patients with recognized depression. *Archives of General Psychiatry, 52(10),* 850-856.

Simpson, S., Baldwin, R. C., Jackson, A., and Burns, A. S. (1998). Is subcortical disease associated with a poor response to antidepressants? Neurological, neuropsychological, and neuroradiological findings in late-life depression. *Psychological Medicine, 28,* 1015-1026.

Sneed, J. R., Rindskopf, D., Steffens, D. C., Krishnan, R. R., and Roose, S. P. (2008). The vascular depression subtype: Evidence of internal validity. *Biological Psychiatry, 64,* 491-497.

Sneed, J. R., and Whitbourne, S. K. (2003). Identity processes and self-consciousness in middle and later adulthood. *Journals of Gerontology, 58,* 313-319.

Steffens, D. C., and Krishnan K. R. (1998). Structural neuroimaging and mood disorders: Recent findings, implications for classification, and future directions. *Biological Psychiatry, 43,* 705-712.

Sue, D. W., and Sue, D. (1990). *Counseling the culturally different*. New York: Wiley.

Sundquist, J., Winkleby, M. A., and Pudaric, S. (2001). Cardiovascular disease risk factors among older Black, Mexican-American, and White women and men: An analysis of NHANES III, 1988-1994. *Journal of the American Geriatric Society, 49,* 106-116.

Taylor, W., Steffens, D., MacFall, J., McQuoid, D., Payne, M., Povenzale, J., and Krishnan, K. (2003). White matter hyperintensity progression and late-life depression outcomes. *Archives of General Psychiatry, 60,* 1090-1096.

Thompson, E. E., Neighbors, H. W., Munday, C., and Jackson, J. S. (1996). Recruitment and retention of African American patients for clinical research: An exploration of response rates in an urban psychiatric hospital. *Journal of Consulting and Clinical Psychology, 64(5),* 861-867.

Thompson-Sanders, V. L., Bazile, A., and Akbar, M. (2004). African Americans' perceptions of psychotherapy and psychotherapists. *Professional Psychology: Research and Practice., 35(1),* 19-26.

Waite, R., and Killian, P. (2008). Health beliefs about depression among African American women. *Perspectives in Psychiatric Care, 44(3),* 185-195.

Whitbourne, S. K. (2000). The normal aging process, pp. 27-60. In S. K. Whitbourne (Ed.), *Psychopathology in later adulthood.* New York: John Wiley and Sons, Inc.

Whitbourne, S. K. (1987). Personality development in adulthood and old age: Relationships among identity style, health, and well-being, pp. 189-216. In K. W. Schaie (Ed.), *Annual review of gerontology and geriatrics* (Vol. 7). New York: Springer.

Whitbourne, S. K. (1986). *The me I know: A study of adult identity.* New York: Springer-Verlag.

Whitbourne, S. K., and Collins, K. L. (1998). Identity processes and perceptions of physical functioning in adults: Theoretical and clinical implications. *Psychotherapy, 35,* 519-530.

Williams, D. R., Neighbors, H. W., and Jackson, J. S. (2008). Racial/ethnic discrimination and health: findings from community studies. *American Journal of Public Health, 98,* 29-37.

Wittchen, H., Knauper, B., and Kessler, R. C. (1994). Lifetime risk of depression. *British Journal of Psychiatry, 165,* 16-22.

Young, M. A., Scheftner, W. A., Klerman, G. L., Andreasen, N. C., and Hirschfeld, R. M. (1986). The endogenous sub-type of depression: A study of its internal construct validity. *British Journal of Psychiatry, 148,* 257-267.

Part Four

African American Racial Identity Development and Effects on Parents and Children

Chapter Ten
Black Like Me: The Race Socialization of African American Boys by Nonresident Fathers

Alvin Thomas, Cleopatra Howard Caldwell, and E. Hill De Loney

Introduction

With increased attention being paid to the role of fathers in the rearing of their children, the possible functions that African American fathers can assume and the efficacy of these functions has garnered increased interest. The literature on nonresident African American fathers has had, as its primary focus, the negative repercussions to the family and the child for not having the father as an available resource. African American fathers may serve as apt models for teaching their sons critical race messages that would prepare them to handle future experiences with discrimination and prejudice.

This chapter will add to the discourse on the role that African American nonresident fathers can play in the lives of their sons. We focus here on race socialization because of its possible contribution to building resilience in African American children and because of African American fathers' special advantage in communicating these types of messages. We explore the characteristics of these fathers while also investigating the congruency between the race socialization messages that fathers communicate, and those that the sons remember receiving from their fathers.

Key to understanding this paradigm is an appreciation for the factors that increase, appreciably, the likelihood of fathers engaging in different types of race

socialization communication practices with their sons. Essential characteristics of individual fathers, as well as their social experiences, may work to increase fathers' motivation. We report the results of a study of 345 African American nonresident fathers who participated in an evaluation study of a youth preventive intervention conducted in a Midwestern city. The Fathers' and Sons' Program (Caldwell et al., 2010) facilitates the involvement of nonresident African American fathers in the lives of their sons by engaging them in a parenting-skills intervention that is theoretically-based, culturally relevant and gender specific to the sample.

The current study investigates the connection between fathers' racial identity and their decisions to racially socialize their sons. It is expected that the father's racial and masculine identity, as well his exposure to stress, would serve to increase the likelihood that he would expose his son to race socialization messages that have to do with being proud of one's race and oneself by extension. Negative experiences and stressors may serve to heighten fathers' awareness of inequity in society and thus motivate him to communicate to his son messages aimed at preparing him to deal with such future incidences. We will close by proposing important applications and lessons learned from this discourse.

Socializing the African American Child

One of the main and most critical functions of primary caregivers in the lives of children is to acquaint and equip them with knowledge of their environment. This critical process introduces children to the roles, statuses, behaviors, mores and norms that exist in the general societal context. Tooled with this knowledge, it is expected that the child will grow into a functional and productive member of their society. At the core of attachment relationships is the referencing of the primary caregiver as a source of security to which the child returns to after having explored novel stimuli and environments (Bowlby, 1958).

For African American children the process of socialization must, of necessity, take on an additional responsibility. African American children are more likely than white children to be exposed to deficient and possibly hostile environments because of their race (Safyer, 1994), and it befalls the parents to prepare their children for these possibilities. This process is called race socialization. Race socialization has been described by some as the conveying of key messages and practices related to the nature of one's racial status as pertains to (1) personal and group identity, (2) intergroup and inter-individual relationships, and (3) position in the social hierarchy (Thorton, Chatters, Taylor, Allen, 1990). Others view it strictly along the lines of the historic Black versus White racial divide that permeates every facet of American life. From this view race socialization is conceptualized as efforts to (1) instill pride, (2) convey knowledge about African Americans, (3) protect against discrimination, and (4) provide strategies for succeeding in mainstream society (Hughes, Rodriguez, Smith, Johnson, Stevenson and Spicer, 2006).

In a review of research, Hughes and colleagues (2006) delineated the general thematic content that informs the race socialization messages that most African American parents communicate to their children. These include messages about cultural awareness, preparation for bias, promotion of mistrust, and egalitarian beliefs (2006). Stevenson (1994) identified the value of education, awareness of racism in society, appreciation for spirituality and religion, promotion of Black heritage and culture, appreciation of extended family involvement, and the importance of child rearing as additional thematic content. Race socialization messages have at their core preparation for inevitable negative racial incidents throughout the child's life because most African American parents believe that raising physically and emotionally healthy children who are Black, in a society in which being Black has negative connotations, requires this extra effort (Hughes et al., 2006; Peters, 1985; Stevenson, 1994).

The content of race socialization messages reflect an understanding by parents of two central issues (1) that their children's racial status distinguishes them from mainstream Americans (Peters, 1985), and (2) an expectation of hostility from the mainstream culture as a reaction to their child's blackness (Daniel, 1975; Harrison, 1985). Thus, the race socialization messages may be construed as a "suit of armor" forged in preparation for these hostilities (Thornton, Chatters, Taylor, and Allen, (1990). The perceived or real exposure to risks along with the presence of protective factors, are crucial to the development of resilience in the face of life obstacles (Rutter, 1993). Risk factors such as hostile attributes of one's social environment, as well as hostile interactions with one's environment, may be linked to the development of psychopathology (Grizenko and Pawliuk, 1994). Protective factors such as race socialization messages may shield African American children from the full negative impact of racism and racial bias (Peters and Massey, 1983; Stevenson, 1994). These messages serve both an adaptive and protective purpose (Miller and MacIntosh, 1999), allowing children to develop a positive social identity regarding race, which has been found to be critical to the psychological well-being of African American children (Marshall, 1995; Thornton et al., 1990).

Building an Armor

Current literature continues to support the buffering influence of race socialization against the deleterious effects of negative racial interactions on self-esteem and psychological well-being for African American children (Chavez and French, 2007; Harris-Britt et al., 2007; Neblett et al., 2008; Stevenson, 1994). Negotiation of two worlds (Black and White) requires that African Americans adapt and develop competencies necessary to survive in both worlds (Miller and MacIntosh, 1999). A healthy sense of self and connection to the community may serve to protect children as they maneuver around the demands of both worlds. The bicultural identity model (Clark, 1991) suggests that children are better placed to placate the effect of negative interactions and go on to thrive in such social conditions if they hold a

dual view of their environment. The child learns to aggregate those meaningful and helpful elements of their two worlds, marshalling these resources and employing them successfully across cultures (Miller and MacIntosh, 1999).

One of the few known studies exploring the effects of race socialization in middle childhood evidences less internalizing and externalizing problems in boys, and less behavior problems overall (Caughy et al., 2002). Other studies show equally impressive positive outcomes associated with race socialization, such as higher levels of anger control (Stevenson, 1997) and less fighting or initiation of fights (Stevenson et al., 2002). While studies have shown that race socialization has a protective effect, studies also exist suggesting possible maladaptive outcomes from an over-emphasis on racial discrimination, especially for African American boys. Selected focus on parental messages about discrimination against African Americans and coping with hostility motivated by racism (preparation for bias), for instance, have been found to inculcate attitudes of distrust of others and a heightened expectation of discrimination (Hughes et al., 2006).

Fathers Matter

Changing demographics for African American families indicate that by 2010, approximately 32 percent of African Americans were married (U.S. Bureau of the Census, 2010). African Americans' marriages had the lowest probability (50 percent) of lasting more than ten years, compared to 68 percent and 64 percent for Hispanics and Whites respectively (CDC, 2002). This translates into large numbers of African American children (about 70 percent in 2007) being born to single mothers (CDC, 2010). There is a need to reexamine the important role that fathers can play in child rearing.

Recently, the role of African American fathers in families has re-emerged as an important topic of discourse in current social science literature. Previous research focused more on the negative outcomes experienced by children because of the father's absence. More contemporary literature shows that African American fathers' absence in the home does not always equate to non-involvement with their children; in fact, African American fathers are more likely than any other ethnic group to remain single full-time fathers (McAdoo and Younge, 2009). These fathers, while not physically present in the home, maintain a noticeable presence in the lives of their children (McAdoo and Younge, 2009) and indicate that the most important mark of good fathering is spending time with their child (Hamer, 1997).

Few studies have examined the race socialization practices of African American nonresident fathers. Most studies have focused solely on the influence of the mothers' race socialization of her children, possibly because mothers are expected to be the primary socializing influence in children's lives, and mothers are easier to engage in research studies. Fathers may be especially well positioned to communicate race socialization messages regarding racial bias to their sons, given that African American males generally have more race-related discrimination

experiences than African American women (Stevenson et al., 2002). Thus, it is critical to gain a better understanding of how fathers are involved in the race socialization process of African American males in an effort to provide information that may be useful for intervention and clinical practice with African American families.

African American men continue to have less access to economic resources, lower levels of attained education, and higher levels of unemployment than their white counterparts, resulting in a limited ability to provide for their families (Hamer, 1997). This threat to the successful reflection of traditional view of masculinity is often proposed as one of the main reasons for the absence of African American men in families since often, economic status is a key indicator for marriage-readiness for both males and females (Popenoe and Whitehead, 2002). While these men may not be ostensibly present in the household, this does not translate to a lack of concern for children or the family. Residential fathers, however, have the advantage of their physical presence and thus are generally more involved than non-resident fathers (Furstenberg and Cherlin, 1991; Marsiglio, Amato, and Lamb, 2000; Stewart, 1999). While the past research does suggest that nonresident fathers are less involved with their children than resident fathers, most of these studies do not examine how nonresident African American fathers have engaged in the socialization processes of their children, especially once they reach late childhood and preadolescence.

Race Socialization Practices and Nonresident African American Fathers

One of the most essential responsibilities that African American fathers have to their children, especially their sons, is conveying messages that prepare them for the challenge of living in the sometimes noxious world of race relations in the United States. Any exploration of the messages that fathers pass on to their sons must by extension also investigate what kind of father is more likely to take up the responsibility of preparing his son for a seeming inevitable racially hostile social environment. Our sample consists of 345 African American nonresident fathers of eight- to twelve-year-old boys who participated in the Fathers and Sons Program (Caldwell et al., 2010). The intervention facilitates the involvement of non resident African American fathers in the lives of their sons by engaging them in exercises that strengthen and build parenting skills by using culturally relevant and gender-specific activities.

The fathers in our sample ranged in age from twenty-four to sixty-five, with a mean age of thirty-seven (S.D. = 7.57). Almost half of the fathers were in the age range of thirty-one to forty years old and about 20 percent being young fathers between twenty-two and thirty years old. Most of the fathers, 73 percent, had lived with their sons at some point of their life, with 37 percent having lived with the son during the first five years of life and 28 percent living with the child past the fifth

year of life. Almost 45 percent of the fathers sampled had never been married, and altogether about 28 percent of fathers reported being currently married or cohabiting. More than 70 percent of fathers had completed some college level education, a technical program, or had earned a high school diploma or GED.

We addressed the question of the types of race-related messages fathers gave to sons from the sons' perspectives. Essentially, we report on the messages that sons remember receiving from fathers about these issues. Specifically, sons were asked, "What was the most important thing your father has told you about being a black boy?" More than 75 percent of sons reported that their father had spoken to them about what it means to be a black boy, supporting the overwhelming amount of research that says that these conversations are in fact continuing to occur in African American families (Hughes et al., 2006).

Race Socialization and Psychosocial Characteristics of Fathers

Just as important as understanding the demographic characteristics of fathers who engage in race socialization is the need to understand who they are from a psychosocial perspective. What follows is a brief exploration of the fathers based on their masculine and racial identity attitudes, and experiences with life stressors. For life stressors, we report on the number of discriminatory experiences fathers reported having over the past year, how stressed they felt about their job, and how many times they had been stopped unfairly, questioned, searched or abused by the police. An understanding of these factors in the reality of the fathers' lives may provide a foundation for understanding the world these fathers may perceive awaits their sons, and thus allow us to better appreciate the motivation that may guide their race socialization behaviors.

Using three dimensions of masculinity (Hegemonic, Traditional, connectedness/community) derived from the masculinity scale by Powell-Hamond and Mattis (2005) we explored the fathers' masculine identity. Hegemonic masculinity is defined as endorsement of beliefs that the provider role is the main definer of masculine identity. This dimension is characterized by competition, aggression, power assertion, and objectification of women. It was measured with a five item scale (alpha = .75). Traditional masculinity is defined as holding norms such as being strong and being a provider as the main elements of one's masculine identity. It was measured with an 8-item scale (alpha = .83).

Connectedness/community reflects a view of masculinity that prizes relating to and working with others as central to masculine identity. It was measured on a 4-item scale (alpha = .65). Higher scores on each of these subscales mean more of the specific type of masculinity. In keeping with the research, fathers were found to endorse traditional as well as hegemonic definitions of masculinity; however,

more than 75 percent of the fathers reported that they moderately to highly endorsed connection to others and family as important elements of their masculinity.

Racial identity attitudes examined (Public and Private Regard) varied widely among fathers. The Multidimensional Measure of Racial Identity by Sellers et al. (1998) was used to measure racial identity. Specifically four items measured public regard, or fathers' beliefs about other groups favorable opinions of African Americans (alpha = .79) and private regard, what fathers thought about African Americans and about being a member of that group (four items; alpha = .71). High scores on these scales reflected more public or private regard. Many fathers, more than 70 percent, believed that others held less-than-favorable views of African Americans, while more than 90 percent reported feeling positive about African Americans in general and their own membership in that ethnic group.

As African American fathers remain aware of the hostility that exists towards their race in America in general, and as they continue to struggle with this hostility, our findings show that most remain proud to be African Americans. It is conceivable that the responsibility to help provide a "suit of armor" (Thornton et al., 1990) that their sons will need when facing a race conscious world may be more related to fathers' beliefs about how other groups view African Americans. This it is believed is what may be driving the provision of racial barrier messages. Their own sense of pride in being African American, on the other hand, should be associated with socialization messages related to cultural pride.

The impact of life stressors may also function as additional motivation or serve to attenuate fathers' desire to socialize their sons around racial issues. The 10-item Everyday Discrimination Scale by Williams et al. (1997) was used to measure the number of experiences with discrimination fathers reported for the previous year. Fifteen percent of fathers reported having experienced at least ten acts of discrimination, with more than 63 percent experiencing five to ten acts of discrimination in the past year. Some of these incidents of discrimination were at the hands of the police. Eighty-two percent of fathers said that they had suffered discrimination at the hands of the police—either being unfairly stopped, questioned, searched or in some other way abused by the police. Negotiation of the two worlds (Black and White) requires skills that fathers may have, but which sons do not currently possess at late childhood and preadolescence (Miller and MacIntosh, 1999). Added to this, a little more than half of the fathers also indicated moderate to high levels of stress on the job. Thus, the need to develop in their sons competencies for maneuvering between the two worlds (Black and White) may become acutely important to fathers even more so after such incidents. This background information is used to provide a social context for understanding the results of the multivariate analysis that presents a more comprehensive profile of nonresident African American fathers who were more likely to engage in race socialization practices with their sons.

Fathers as Armor Builders

Fathers responded to a race socialization measure (Martin, 2000; Thornton et al., 1990). This multidimensional measure has three subscales: Pride, Barriers, and Egalitarianism. Fathers who reported conveying messages of pride emphasized the need to celebrate African American holidays such as Martin Luther King Day and the need to learn about people from the African continent (alpha = .72). When fathers communicated race messages about barriers to their sons, they focused on the view that Whites believe that they are better, and fathers admonished their sons that some White people are prejudiced against African Americans or Blacks (alpha = .67). Fathers also communicated the balancing message that their sons should try to get along with all people, and that skin color is not what gives an individual worth in American society (alpha = .69).

More than half of the fathers reported having communicated some racial pride messages to their sons, while more than 75 percent agreed to having done it very regularly. Communication of race messages about barriers that African Americans face in society was also engaged in regularly as reported by more than 70 percent of the fathers. Egalitarian messages seemed to be communicated most often, as more than 50 percent of fathers reported conveying to their sons all the time that all people were equal in American society. This was the only class of messages that had such a high frequency (See Figure 10.1).

**Figure 10.1: Frequency of Race Socialization Messages
as Reported by Father**

This may be so because the egalitarian messages often serve as a balancing message for the possibly more jarring messages about hostility directed at one's race or because of the need to deliberately increase one's pride. Such messages could suggest hardship and challenges down the road. Key to conveying a message is feedback on whether the intended message was communicated. To investigate this, the question "What is the most important thing that your father has told you about being a Black boy?" was posed. Of the boys who provided responses to this question, eighteen reported that their fathers had not communicated anything to them about being a Black boy, or that they could not recall whether their fathers had talked with them about this issue. The responses from the remaining boys yielded the following themes: Pride in African American culture; Pride in self; Future achievements; Effects of racism and importance of getting along with others.

Messages that sons reported conveyed the idea that the son should always be proud to be African American and also featured discussions about African American cultural and historical accomplishments. These Pride in African American culture messages reflect the race socialization Pride messages that the fathers reported communicating to their sons, suggesting congruence in communication between fathers and sons. Qualitative data from this study indicated that one son said that his father informed him that:

"Black people are inventors too (such as the lawnmowers, etc.)"

The comment aims to build pride by providing the son with tangible and identifiable evidence of African American contributions to modern life. The inclusion of the word "too" in the statement suggests a kind of defensive posture against possible or perceived negation of the contributions of African Americans, and thus this statement and those like it may serve a dual purpose of engendering and encouraging pride, but also of sensitizing the son that there are challenges to be had. Another son indicated that his father had told him:

"I should be proud to be Black; people fought for Blacks to have a lot of rights."

Here, too, the aim is to encourage pride toward the race, and by extension to one's self. The intimation of a long struggle to secure the current conditions may suggest to the child a determined people, strong and proud, and thus excite him to want to be consciously affiliated to that group. Like the previous quotation, this one also reveals sub messages. That African Americans had to fight for rights that are today commonplace may be a difficult concept for a child to grasp, but there is hopefully an appreciation of a struggle and its outcome. Additionally, there is the unmistakable specter of an enemy, and the lingering question does the enemy still exist, and will we have to fight again?

Under the theme *Pride in self* sons reported that their fathers taught them to be proud of themselves. The messages under this theme did not indicate a defined accomplishment that the son was supposed to direct his pride towards. In these

messages, too, there were hints to additional ideas that fathers thought were just as important as the current message. One son reported that his father told him:

"Being a black boy is okay and skin color doesn't matter, only the way God made you is important."

This father clearly wants to impress upon his son concerns that many African American parents have: the child's adequacy, and his efficacy. The reference to a higher authority (God) solidifies that the child is adequate within himself and within his skin color. It also suggests that there may be contrary opinions about the child's adequacy based solely on his race, and thus this message may hope to supersede those opinions.

Sons disclosed that their fathers also advised them about their future, suggesting actions such as staying in school, believing in one's self and working hard. These messages about Future Achievement paralleled both the *Barriers* and *Pride* dimensions of Race socialization. This theme is well encapsulated in this quotation from one of the sons:

"Be proud of myself, stay in school, get good grades, grow up to be somebody."

Loaded with expectation, this quotation touches on a number of race socialization messages. It exhorts pride in oneself, and encourages the child to work hard for what he wants. It presents grades and by extension, educational achievements as the bench mark for success, and then links all of these to the overall message "grow up to be somebody." The suggestion could be made that for some reason the child and maybe those who look like him may not be valued in society; however, through his struggle and *Future achievements* in the mainstream culture, he can change the current evaluation of himself and by extension—his race.

Tied closely to *Effects of racism* is John Henryism, a construct that represents active coping among African Americans, especially men faced with stressful situations. The construct draws its name from the legend of a "steel driving" man who was pitted against the then- new steam-powered drill. He mustered all of his great strength to overpower the mechanical drill and win a closely fought contest, but died soon after from mental and physical exhaustion. So goes the story told by Williams, (1983). The hypothesis predicts that persons from low SES backgrounds who use high-effort coping, in general, had high levels of hypertension prevalence (James, 1994). In an earlier study examining the hypothesis, the team found hypertension prevalence in high SES African Americans at surprisingly high levels (James et al., 1992). The weight of expectation often levied upon African American children is aptly expressed in quotations from two sons about racial messages from their fathers:

Son 1: "Do best I can because it's hard to be a black man."
Son 2: "Must work harder for what you want."

Each father warns his son that it is not enough to just work hard, but that one must work even harder. The father of *Son 1* gives a more complete message by giving the source of this lofty expectation—racial interactions and disparities. In other words, as a Black boy it is not enough to just do well, you have to do twice as much, work twice as hard and succeed twice as much as your White counterparts to get just as much or less. It is a crash course in dealing with the seemingly insurmountable barriers that are instituted against African Americans.

Life for African Americans is lived in two worlds, and the ability to live comfortably in both is a skill that has to be nurtured early and learned quickly.

" . . . *get along with others even if they are White* . . . "

Messages like the one above are meant to communicate the *Importance of getting along with others*—an egalitarian ideal congruent with the messages that fathers reported conveying to their sons. If sons can be accepting of others, then maybe others may be more accepting or them. Additionally, sons need to be taught to live by the same egalitarian ideals that African Americans have sought throughout history—visibly present and equal. However, in the midst of this message fathers seem also to give hints to other deep set issues. The quotation from the son mentioned above, suggests some special expectation of Whites. It intimates that Whites may be difficult to get along with and thus hints at the negative history and current state of race interactions.

Current Study

The study explored the link between African American nonresident fathers' racial identity and their decisions to communicate specific race socialization messages to their sons. Additionally, we aimed to examine factors that best explained this link. The data comprised measurements of fathers' racial (*Private and Public*) and masculine identity (*Hegemonic, Traditional, Connectedness*). Accounting for key psychosocial variables like self-esteem, masculine identity, discrimination and job stress would allow for an exploration of how these factors may influence his race socialization of his son.

Racial Identity

The Racial identity literature continues to grow as scholars explore existing models and conceptualize new ones. The two more established approaches to the concept of racial identity are the stage and multidimensional models. The stage models as theorized by Cross (1971) and others hold that the individual's attitudes and beliefs about race and their level of identification with their racial group changes in discrete stages. The multidimensional models, on the other hand, posit an overarching concept of racial identity under which is subsumed multiple components or dimensions (Sellers, Smith, Shelton, Rowley, and Chavous, 1998).

Far from being a vague academic undertaking, racial identity has been shown to have important applications to understanding the lives of African Americans specifically. It has been linked with positive mental health among adolescents (Caldwell, Zimmerman, Bernat, Sellers, and Notaro, 2002) and young adults (Sellers et al., 2003). African American adolescents who are exposed to violence evidence a protective effect on their involvement in aggressive or violent behaviors if they also endorse various racial identity attitudes (Caldwell, Kohn-Wood, Schmeelk-Cone, Chavous, and Zimmerman, 2004). The researchers also suggest that strong racial identity and group affiliation "may offset the stigmatization and marginalization that being African American and male in this society often engenders" (p. 100). A strong internal sense of one's racial identity may serve as a buffer to negative environmental interactions such as discrimination and prejudice (Cross and Vandiver, 2001; Sellers et al., 2003), as they may serve to reorient the individual in the aftermath of this trauma.

Masculinity

The concept of masculinity is often colored by the traditional definitions of masculinity, which emphasize traits such as toughness, competitiveness, aggressiveness, athletic prowess, decisiveness, violence and power (Franklin, 1985; Cazenave, 1984). This hypermasculine identity is linked to negative mental health specifically to various types of psychological distress including higher levels of anxiety (Zamarripa et al., 2003; Courtenay, 2000), lower capacity for intimacy (Sharpe and Heppner, 1991); low self esteem and depression (Cournoyer and Mahalik, 1995). For African American men, the determination of gender identity places greater prominence on the provider or breadwinner role (Diemer, 2002).

A man's decision to be involved in his family may often hinge upon his ability to provide financially (Christiansen and Palkovitz, 2001), and this criteria is also seen by most men as a key element of being a good father (Hatter et al., 2002). Interestingly, research shows a negative relationship between fathers' income and their involvement (Petts, 2007); however, fathers' employment status has been positively linked to his involvement in his child's life (Cabrera, Fagan, and Farrie, 2008; Ryan, Kalil, and Ziol-Guest, 2008; Wildeman, 2008).

For African American fathers this may prove an especially difficult challenge. They have the dilemma of wanting to participate in the rearing of their children but lack the opportunity to meet what men deem the most critical criteria of fatherhood; provision (Hamer, 2001). The inability to live up to this bread winning role may affect fathers' self esteem (McAdoo and McAdoo, 2002) and further affect their willingness to participate in raising their child. Fathers who have lowered self esteem or poor self-concept may also be less able to communicate with their children, especially around issues of risk (Small, 1988). This is an especially critical concern as positive parental practices such as race socialization depend on communication between parent and child discrimination as interactions with Whites

increase. Additionally, the two variables were significantly correlated, thus Job Stress was included in the model.

Bivariate analyses were conducted on the data in preparation for determining mediation. Pearsons Correlations were calculated (see Table 10.1) to ascertain that the necessary associations among key predictor, mediator, and outcome variables were present as described by Baron and Kenny (1986). For ease of comparison of the different variables, z-scores were calculated for each and used in the multivariate analyses. We conducted two separate multiple regression analyses for each dependent variable (Racial pride and barriers) to test the main effects model.

In keeping with Sobel (1982), we ran subsequent separate regression analyses to confirm mediation relationships by allowing the key independent variable to predict the mediator variable. We then conducted a separate regression analysis with the independent variable and the mediator predicting the dependent variable. The regression coefficients were then used to calculate the Sobel test of significant for the mediation (Preacher and Leonardelli, 2001).

Race Socialization for Pride

The results of the correlations for Racial Pride (see Table 10.1) show that Public regard was related to Racial Pride at the $p = .001$ level. Multivariate results indicate that Masculinity (connectedness) was significantly associated with Racial Pride at the $p = .001$ level. Although Public regard was correlated with Racial Pride at the Bivariate level of analysis, it was no longer associated once other factors were controlled. Racial identity (Public regard) predicted the mediator (Masculinity, i.e., Connectedness) $b = .155$; $t = 2.332$; $p = .021$. Private regard was also a significant predictor at $b = .211$; $t = 3.108$; $p = .002$; however, only Public regard was included in further analyses. In keeping with the bi-cultural identity model (Miller and MacIntosh, 1999) that views the African American's existence as a Black and White world flowing one into the other, the concept of Public regard allows for the inclusion of the influence of the other half of this world was related to Racial Pride at the $p = .001$ level. Multivariate results indicate that Masculinity (connectedness) was significantly associated with Racial Pride at the $p = .001$ level. Although Public regard was correlated with Racial Pride at the Bivariate level of analysis, it was no longer associated once other factors were controlled. Racial identity (Public regard) predicted the mediator (Masculinity, i.e., Connectedness) $b = .155$; $t = 2.332$; $p = .021$. Private regard was also a significant predictor at $b = .211$; $t = 3.108$; $p = .002$; however, only Public regard was included in further analyses. In keeping with the bi-cultural identity model (Miller and MacIntosh, 1999) that views the African American's existence as a Black and White world flowing one into the other, the concept of Public regard allows for the inclusion of the influence of the other half of this world view. Private regard, on the other hand, with its focus primarily on the individual's evaluation of his place in his racial grouping, may not account for the influence of the mainstream culture as convincingly.

In the final regression predicting racial pride, fathers' masculinity *(connectedness)* appears to mediate the relationship between his racial identity and his likelihood to communicate race socialization messages of pride to his son. This model was significant ($b = .430$; $t = 5.681$; $p = .000$) and accounts for 25 percent of the variance in the dependent variable (see Table 10.2). We hypothesized that the relationship between *Public regard* and Racial Pride would be mediated by Masculinity *(connectedness)*. Therefore, we tested this hypothesis using the Sobel's test, which was significant $t = 2.169$; $p = .03$.

Race Socialization for Barriers

The second model included Racial Barriers as the dependent variable, with the same predictors as the first model. The results of the correlations for Racial Barriers in Table 10.1 show that Job stress is related to Racial Barriers at the p =.000 level. Multivariate results indicate that Private Regard was significantly associated with Racial Barriers at the $p = 001$ level. For this dependent variable, Racial Identity (Private regard) predicted the mediator (Job stress) $b = -.333$; $t = -3.288$; $p = .001$. Although Private Regard was associated with Racial Barriers, it was no longer associated once other factors were controlled. We hypothesized that the relationship between Private Regard and Racial Barriers would be mediated by Job Stress. Therefore, we tested this hypothesis using the Sobel's test, which was significant ($t = -2.522$; $p = .01$).

The results suggest that fathers' experiences of job stress mediated the relationship between Racial Barriers and his racial identity (*Private Regard*). This suggests that his likelihood to communicate race socialization messages with regard to barriers to his son may be best understood against the backdrop of the stress that the father experiences as a result of his job. This model accounted for 10 percent of the variance $b = .188$; $t = 3.913$; $p = .000$ in our dependent variable. Messages that oriented sons to the racial barriers that African Americans can expect to face in daily social interactions were linked to stress that the father felt with regard to his job and his own positive or negative feelings about African Americans as his African American identity (Private regard).

Discussion

Fathers may view their sons as extensions of themselves—male members of a highly stigmatized group in America. Having themselves experienced the trauma of racial prejudice and discrimination, they may be motivated to harden their sons against these inevitable interactions with a world they perceive as hostile to African Americans and particularly to African American men. Race socialization may be one of the more powerful tools available to nonresident African American fathers who wish to forge for their sons a "suit of armor" in preparation for negative racial experiences. The most common messages seem to be pride in one's self and one's

race, expecting and adapting to barriers, and a belief in the equality of all peoples, regardless of color.

Racial Pride messages encourage sons to be proud of the accomplishments of African Americas and learn more about the history of African Americans and the African continent. They expand that pride to include individuals' pride in themselves as members of the African American community. The Racial Barriers messages often take center stage in discussions of race socialization. These messages attempt to orient young African Americans to the existence of two different realities and prepare them to face the challenges of navigating between two worlds.

Egalitarian messages suggest an attempt to teach universal human values by proffering universal ideals of everyone getting along, everyone respecting each other and people being treated and judged by the content of their character and their efforts, rather than on phenotypic appearance. These ideals are held out to children as possibilities, goals that they should strive to reach, even though the reality is that the fathers themselves report having experienced very high levels of racial discrimination and prejudice. It may be that these appeals to egalitarianism are meant to soothe possible anxiety and feelings of helplessness or being overwhelmed that may be engendered by the barriers and pride messages. It may also be the case that these egalitarian messages are meant to ground the child in the larger context of personhood outside of the cramped race brackets. You are a person, and we are all people and all equal, these messages seem to say.

The results of our study suggest interesting explanations about possible models for understanding the race socialization decisions among nonresident African American fathers. Fathers' perceptions of how positively or negatively their race was viewed by others predicted how connected they felt to their community and their family and how much they valued this connection as part of their masculine identity. This definition of masculine identity appears to mediate the relationship between their public regard and whether or not they would communicate messages of racial pride to their sons, such that higher levels of public regard is associated with more communication of these messages.

For these fathers lower levels of private regard predicted higher levels of job stress. This may suggest that stress on job, which may be conceptualized as a routine and predictable occurrence, may wear away on fathers' senses of efficacy and self- esteem as most daily stressors do. However, without the buffer of a more positive personal perception of his racial identity, such a father would have fewer coping mechanisms and social resources to employ in dealing with aversive situations on the job. This fits the research that suggests that strong personal identification with one's race could be a buffer against negative environmental interactions such as discrimination and prejudice (Cross and Vandiver, 2001).

Table 10.1: Means, Standard Deviations and Correlations of Key Variables

	Mean	Std D	1	2	3	4	5
1) Race socialization: Pride	13.39	3.38	1				
2) Race socialization: Barriers	4.55	1.68	.384**	1			
3) Race socialization: Egalitarian	7.13	1.14	.359**	.128	1		
4) MIBI Racial ID-Centrality	3.00	0.62	0.079	-.014	-.005	1	
5) MIBI Racial ID-Private Regard	3.65	0.58	0.064	-.031	0.048	.454**	1
6) MIBI Racial ID-Public Regard	2.14	0.93	.188**	-.081	0.101	.274**	.170*
7) Masculinity-Hegemony	38.21	3.11	-.006	0.004	.142*	.140*	.250**
8) Masculinity-Traditional	17.47	4.27	.155**	0.072	-0.057	-.116*	-.131*
9) Masculinity-Connectedness	16.90	2.58	.368**	0.066	.147*	.165**	.205*
10) Father Age	37.11	7.57	.152**	0.069	0.082	-0.101	-0.001
11) Father self-esteem	35.30	4.66	0.124	-.070	.173*	.190**	.239**
12) Stress with job	2.71	1.37	0.068	.191**	0.061	-0.005	-.171*

*Correlation is significant at the 0.05 level (2-tailed).
**Correlation is significant at the 0.01 level (2-tailed).

Table 10.1: Means, Standard Deviations and Correlations of Key Variables (Continued)

	6	7	8	9	10	11	12
1)Race socialization: Pride							
2)Race socialization: Barriers							
3)Race socialization: Egalitarian							
4)MIBI Racial ID-Centrality							
5)MIBI Racial ID-Private Regard							
6)MIBI Racial ID-Public Regard	1						
7)Masculinity-Hegemony	0.048	1					
8)Masculinity-Traditional	.180**	0.1	1				
9)Masculinity-Connectedness	.223**	.548**	.230**	1			
10)Father Age	0.062	0.039	0.045	.147*	1		
11)Father self-esteem	0.025	.263**	-.125	.251*	-0.09	1	
12)Stress with job	-.152*	-.148*	-.152*	-0.114	-0.083	-.266	1

*Correlation is significant at the 0.05 level (2-tailed).
**Correlation is significant at the 0.01 level (2-tailed).

Table 10.2: Multivariate Results for Racial Pride and Racial Barriers

Variables Entered	RS-Pride				RS-Barriers			
	Model 1		Model 2		Model 1		Model 2	
	b	SE b	b	SE b	b	SE b	b	SE b
MIBI Racial ID-Private Regard	.211*		.024	.068	-.333**	.101	.021	.074
MIBI Racial ID-Public Regard	.155*		.074	.066	-.104	.101	-.108	.071
Hegemonic Masculinity	—	—	-.250**	.066	-.158	.101	-.041	.072
Connectedness Masculinity	—	—	.430**	.076	.025	.115	.041	.067
Ever Lived with Son	.227	—	.297*	.134	-.321	.203	.095	.145
Father Age	.019*		.018*	.008	-.007	.12	.013	.009
Stress with Job	—		—		—	—	0.188*	.048
	$r^2 = .17$		$r^2 = .25$		$r^2 = .13$		$r^2 = .10$	

The relationship between the father's private regard and his decision to convey messages about race barriers to his son was best understood through the stress he experienced related to his job. It suggests that fathers who personally identified with their race on lower levels also reported higher job stress. These fathers were more likely to seek to prepare their sons to face the race barriers that they expected were awaiting their sons in the real world. Fathers with greater levels of stress may be more primed to see and interpret stressful situations as threats. Having experienced high levels of stress, they would also be more highly motivated to try to protect their sons from these deleterious situations.

Implications

These findings have important potential applications both to intervention or clinical practice and the literature. Who exactly are these fathers who are engaging in the critical process of race socialization of their sons effectively enough so that sons remember any messages at all? The findings suggest an intricate interplay of identity variables, context and stressors in the race socialization decisions of African American fathers where their sons are concerned. Interventions that engage fathers in the lives of their children are very few. This study may serve as a catalyst by suggesting new angles from which issues of risk behaviors in African American children and adolescents may be explored. Engaging fathers in culturally appropriate interventions that allow them to explore their own racial identity by communicating more meaningfully with their sons on this issue may serve to benefit both members of the dyad.

References

American Psychology, ed. B. M. Tynes, H. A. Neville, and S. O. Utsey Thousand Oaks, CA: Sage.

Bennett, G. G., Merritt, M. M., Sollers III, J. J., Edwards, C. L., Whitfield, K. E., Brandon, D. T., and Tucker, R. D. (2004) Stress, coping, and health outcomes among African Americans: A review of the John Henryism hypothesis. *Psychology and Health, 19*(3), 369-383.

Branscombe, N. R., Schmitt, M. T., and Harvey, R. D. (1999). Perceiving pervasive discrimination among African Americans: Implications for group identification and well-being. *Journal of Personality and Social Psychology, 77*, 135-149.

Baron, R. M., and Kenny, D. A. (1986). The moderator-mediator variable distinction in social psychological research: Conceptual, strategic, and statistical considerations. *Journal of Personality and Social Psychology, 51*, 1173-1182.

Cabrera, N., Fagan, J., and Farrie, D. (2008). Explaining the long reach of fathers' pre-natal involvement on later paternal engagement. *Journal of Marriage and Family, 70*, 1094-1107.

Caldwell, C. H., Kohn-Wood, L. P., Schmeelk-Cone, K. H., Chavous, T. M., and Zimmerman, M. A. (2004). Racial discrimination and racial identity as risk or protective factors for violent behaviors in African American young adults. *American Journal of Community Psychology, 33*(1), 91-105.

Caldwell, C. H., Zimmerman, M. A., Bernat, D. H., Sellers, R. M., and Notaro, P. C. (2002). Racial identity, maternal support, and psychological distress among African American adolescents. *Child Development, 73*(4), 1322-1336.

Caldwell, C.H., Rafferty, J., Reischl. T.M., De Loney, E. H., and Brooks,C. L. (2010). Enhancing parenting skills among nonresident African American fathers as a strategy for preventing youth risky behaviors. *American Journal of Community Psychology, 45 (1-2)*,17-35.

Caughy, M. O., O'Campo, P. J., Randolph, S. M., and Nickerson, K. (2002). The influence of racial socialization practices on the cognitive and behavioral competence of African American preschoolers. *Child Development, 73*, 1611-1625.

Cazenave, N. A. (1984). Race, socioeconomic status, and age: The social context of American masculinity. *Sex Roles, 11*, 639-656.

CDC. (2002). Marriage and cohabitation in the United States: A statistical portrait based on Cycle 6 (2002) of the National Survey of Family Growth: Retrieved 24 March 2010 from http://www.cdc.gov/nchs/data/series/sr_23/sr23_028.pdf

Chavez, N.R., and French, S. E. (2007). Ethnicity-related stressors and mental health in Latino Americans: The moderating role of parental racial socialization. *Journal of Applied Social Psychology, 37(9)*, 1974-1998.

Christiansen, S. L., and Palkovitz, R. (2001). Why the "good provider" role still matters: Providing as a form of parental involvement. *Journal of Family Issues, 22,* 84-106

Clark, M. L. (1991). Social identity, peer relations, and academic competence of African American adolescents. *Education and Urban Society, 24*, 41-52.

Cooley, C. H. (1956). *Two major works: Social organization. Human nature and the social order.* Glencoe, IL: Free Press.

Cournoyer, R. J., and Mahalik, J. R. (1995). Cross-sectional study of gender role conflict examining college-aged and middle-aged men. *Journal of Counseling Psychology, 42*(1), 11-19.

Courtenay, W. H. (2000). Constructions of masculinity and their influence on men's well-being: A theory of gender and health. *Social Science and Medicine, 50*(10), 1385-1401.

Cross, W. E. (1971). The negro-to-black conversion experience. *Black World, 20*(9), 13-27.

Cross, W. E., Jr. and Vandiver, B. J. (2001). Nigrescence theory and measurement: Introducing the cross racial identity scale (CRIS). *Handbook of Multicultural Counseling, 2*, 371-393.

Daniel, J. (1975). A definition of fatherhood as expressed by black fathers. (Doctoral Dissertation, University of Pittsburgh, 1975). *Dissertation Abstracts International, 36*, 2090A.

Diemer, M. A. (2002). Constructions of provider role identity among African American men: An exploratory study. *Cultural Diversity and Ethnic Minority Psychology, 8*(1), 30-40.

Elligan, D., and Utsey, S. (1999). Utility of an African-centered support group for African American men confronting societal racism and oppression. *Cultural Diversity and Ethnic Minority Psychology, 5*, 156-165.

Franklin, C. W. (1985). The Black male urban barbershop as a sex-role socialization setting. *Sex Roles*, 12, 965-79.

Furstenberg, F. F., and Cherlin, A. J. (1991). Divided families: What happens to children when parents part. Cambridge, MA: Harvard University Press.

Grizenko, N., and Pawliuk, N. (1994). Risk and protective factors for disruptive behavior disorders in children. *American Journal of Orthopsychiatry, 64*, 534-544.

Hamer, J. (1997, November-December). The fathers of fatherless Black families: What they say they do as fathers. *Journal of Families and Society*, New York: Springer.

Hamer, J. (2001). *What it means to be daddy: Fatherhood for black men living away from their children*. New York, NY: Columbia University Press.

Hammond, W. P., and Mattis, J. S. (2005). Being a man about it: Manhood meaning among African American men. *Psychology of Men and Masculinity*, 6, 114-126.

Harris-Britt, A., Valrie, C. R., Kurtz-Costes, B., and Rowley, S. J. (2007). Perceived racial discrimination and self-esteem in African American youth: Racial socialization as a protective factor. *Journal of Research on Adolescence, 17*(4), 669-682.

Harrison, A. (1985). The black family's socializing environment, pp. 174-193. In H. McAdoo and J. McAdoo (Eds.), *Black children*. Beverly Hills, CA: Sage.

Hatter, W., Vinter, L., and Williams, R. (2002). Dads on dads needs and expectations at home and at work: Manchester: Equal Opportunities Commission.

Heckman, T. G., Kochman, A., Sikkema, K. J., Kalichman, S., Masten, J., and Goodkin, K. (2000) Late middle aged and older men living with HIV/AIDS: Race differences in coping, social support, and psychological distress. *Journal of the National Medical Association, 92*, 436-444.

Herek, G. M. (2000). The psychology of sexual prejudice. *Current Directions in Psychological Science, 9*, 19-22.

Hughes, D., Rodriguez, J., Smith, E. P., Johnson, D. J., Stevenson, H. C., and Spicer, P. (2006). Parent's ethnic-racial socialization practices: A review of research and directions for future study. *Developmental Psychology, 42*, 747-770.

James, K., Lovato, C., Khoo, G. (1994). Social identity correlates of minority workers' health. *Academy of Management Journal*, 37, 383-396. CDC (2010) Nonmarital childbearing, by detailed race and Hispanic origin of mother, and maternal age: United States, selected years 1970-2007. Retrieved March 25, 2011 from http://www.cdc.gov/nchs/data/hus/hus10.pdf#007.

James, S. A. (1994). John Henryism and the health of African-Americans. *Culture, Medicine, and Psychiatry*, 18, 163-182.

James, S. A., Keenan, N. L., Strogatz, D. S., Browning, S. R. and Garrett, J. M. (1992). Socioeconomic status, John Henryism, and blood pressure in Black adults: The Pitt County study. *American Journal of Epidemiology*, 135(1), 59-67.

Major, B., Quinton, W. J., and McCoy, S. K. (2002). Antecedents and consequences of attributions to discrimination: Theoretical and empirical advances, pp. 251-330. In M. P. Zanna (Ed.), *Advances in experimental social psychology* (Vol. 34). San Diego, CA: Academic Press.

Major, B., and Eccleston, C. P. (2005). Stigma and social exclusion. In D. Abrams, M. A. Hogg, and J. Marques (Eds.), *Social psychology of inclusion and exclusion*. New York: Psychology Press.

Marshall, S. (1995). Ethnic socialization of African American children: Implications for parenting, identity development, and academic achievement. *Journal of Youth and Adolescence, 24*, 377-396.

Marsiglio, W., Amato, P., Day, R. D., and Lamb, M. E. (2000). Scholarship on fatherhood in the 1990s and beyond. *Journal of Marriage and the Family, 62*, 1173-1191.

Martin, P. (2000). The African American church and African American parents: Examining relationships between racial socialization practices and racial identity attitudes (Unpublished dissertation). Michigan State University, MI.

McAdoo, H. P. and J. L. Mc Adoo. (2002). The Dynamics of African American Fathers' Family Roles. Pp. 3-11 in *Black children: Social, educational, and parental environments* (Second edition), edited by H. P. McAdoo. Thousand Oaks, CA: Sage.

McAdoo, H. and Younge, S. (2009). Black families. In *The handbook of African American psychology*, ed. Brendesha M. Tynes, Helen A. Neville, and Shawn O. Utsey. Thousand Oaks, CA: Sage.

Miller, D. B., and MacIntosh, R. (1999). Promoting resilience in urban African American adolescents: Racial socialization and identity as protective factors. *Social Work Research, 23*, 159-169.

Neblett, E.W. Jr., White, R. L., Ford, K. R., Philip, C. L., Hguyen, H. X., and Sellers, R. M. (2008). Patterns of racial socialization and psychological adjustment: Can parental communications about race reduce the impact of discrimination. *Journal of Research on Adolescence, 18*(3), 477-515.

Peters, M., and Massey, G. (1983). Chronic vs. mundane stress in family stress theories: The case of black families in white America. *Marriage and Family Review, 6*, 193-218.

Peters, M. F. (1985). Racial socialization of young black children, pp. 159-173. In H.P. McAdoo and McAdoo (Eds.), *Black children: Social, educational, and parental environments* (Second Edition). Newbury Park, CA: Sage Publications.

Petts, R. J. (2007). Religious participation, religious affiliation, and engagement with children among fathers experiencing the birth of a new child. *Journal of Family Issues*, 28 (9): 1139-1161.

Popenoe, D., and Whitehead, B. D. (2002). Should we live together? What young adults need to know about cohabitation before marriage (Second edition). National Marriage Project, Rutgers University. Retrieved November 16, 2003, from http://www.marriage.rutgers.edu/Publications/SWLT2 percent20TEXT.

Preacher, K. J. and Leonardelli, G. J. (2001). Calculation for the Sobel Test. An interactive calculation tool for mediation tests. /http://people.ku.edu/??preacher /sobel/sobel.htmS (retrieved December 8, 2008).

Pyszczynski, T., Greenberg, J., and Solomon, S. (1997). Why do we need what we need? A terror management perspective on the roots of human social motivation. *Psychological Inquiry, 8*, 1-20.

Rutter, M. (1993). Resilence: Some conceptual considerations. *Journal of Adolescent Health, 14*, 626-631.

Ryan, R. M., Kalil, A., and Ziol-Guest, K. M. (2008). Longitudinal patterns of nonresident fathers' involvement: The role of resources and relations. *Journal of Marriage and Family, 70*(4): 962-977.

Sellers, R. M., Smith, M. A., Shelton, J. N., Rowley, S. A. J., and Chavous, T. M. (1998). Multidimensional model of racial identity: A reconceptualization of African American racial identity. *Personality and Social Psychology Review, 2*(1), 18-39.

Sharpe, M. J., and Heppner, P. P. (1991). Gender role, gender role conflict, and psychological well-being in men. *Journal of Counseling Psychology*, 38, 323-330.

Small, S. A. (1988). Parental self-esteem and its relationship to childrearing practices, parent-adolescent interaction, and adolescent behavior. *Journal of Marriage and the Family, 50*, 1063-1072.

Sobel, M. E. (1982). Aysmptotic confidence intervals for indirect effects in structural equation models, pp. 290-312. In S. Leinhardt (Ed.), *Sociological Methodology*. San Francisco: Jossey-Boss.

Stevenson, H. C. (1994). Racial socialization in African-American families: The art of balancing intolerance and survival. *Family Journal: Counseling and Therapy for Couples and Families, 2*, 190-198.

Stevenson, H. C. (1994). Validation of the Scale of Racial Socialization for African American adolescents: Steps toward multidimensionality. *Journal of Black Psychology, 20*, 445-468.

Stevenson, H. C., Cameron, R., Herrero-Taylor, T., and Davis, G. Y. (2002). Development of the Teenager Experience of Racial Socialization Scale: Correlates of race-related socialization frequency from the perspective of Black youth. *Journal of Black Psychology, 28*, 84-106.

Stevenson, H. C., Reed, J., Bodison, P., and Bishop, A. (1997). Racism stress management: Racial socialization beliefs and the experience of depression and anger in African American youth. *Youth and Society, 29*, 197-222.

Stewart, Susan D. 1999. Nonresident mothers' and fathers' social contact with children. *Journal of Marriage and the Family, 61*, 894-907.

Thornton, M. C., Chatters, L. M., Taylor, R. J., and Allen, W. R (1990). Sociodemographic and environmental correlates of racial socialization by black parents. *Child Development, 61*, 401-409.

Twenge, J. M., and Crocker, J. (2002). Race and self-esteem: Meta-analyses comparing Whites, Blacks, Hispanics, Asians, and American Indians and Comment on Gray-Little and Hafdahl (2000). *Psychological Bulletin, 128*, 371-408.

U.S. Census Bureau (2010). Marital status of people 15 Years and over, by age, sex, personal earnings, for Black alone, not Hispanic, 2010: March, 2004: Retrieved March, 2010 (http://www.census.gov/population/www/socdemo/hhfam/cps2010.html.

U.S. Census Bureau, Current Population Survey, Annual Social and Economic Supplement (2003).

Whites, Blacks, Hispanics, Asians, and Native Americans, including a commentary on Gray-Little and Hafdahl (2000). *Psychological Bulletin, 128*, 371-408.

White, Joseph L., and James H. Cones, III. (1999). *Black man emerging: Facing the past and seizing a future in America.* New York: W. H. Freeman and Company.

Wildeman, C. (2008). Conservative Protestantism and paternal engagement in fragile families. *Sociological Forum, 23*(3): 556-574.

Williams, B. (1983). *John Henry: A Bio-bibliography.* Greenwood Press, Westport, CT.

Williams, D. R., Yu, Y., Jackson, J. S., and Anderson, N. B. (1997). Racial differences in physical and mental health. *Journal of Health Psychology, 2*, 335-351.

Zamarripa, M. X., Wampold, B. E., and Gregory, E. (2003). Male gender role conflict, depression, and anxiety: Clarification and generalizability to women. *Journal of Counseling, 50*(3), 333-338.

Chapter Eleven
Toward a Model of Racial Identity and Parenting in African Americans

Stephanie J. Rowley, Fatima Varner, Latisha L. Ross, Amber D. Williams, and Meeta Banerjee

Introduction

Research on racial identity has focused on adolescent and college-aged populations. Furthermore, research has linked adult racial identity to mental health outcomes (Banks and Kohn-Wood, 2007; Sellers, Caldwell, Schmeelk-Cone and Zimmerman, 2003), but has rarely taken up questions of how racial identity informs everyday decision-making and behavior in community samples. These facts, coupled with the centrality of race to the parenting agenda of parents of color (Garcia Coll, Crnic, Lamberty, Wasik, Jenkins, Garcia and McAdoo, 1996) motivated this chapter. In it, we examine the role of racial identity in the lives of African American parents. The chapter begins with the development of a conceptual framework for considering the ways in which racial identity informs parenting. We also use empirical data from two studies of achievement-related parenting that assessed similar constructs to illustrate connections between parent racial identity and (1) racial socialization, (2) parent school involvement, and (3) beliefs about the role of racial discrimination in their children's lives.

The first dataset, the Families and Schools (FAS) project, is from a three-year longitudinal study of seventy-six African American mothers of children beginning first grade (mean age= 34 years, SD= 6.67 years). This study was conducted from 2001-2005 in two ethnically and socioeconomically diverse cities located in the Midwest. Forty-four percent of the target children were male. Approximately half of the respondents reported being married, and half were single, never married,

divorced or widowed. Mothers tended to be from lower middle class families with the reported average monthly income being $3,369 (reported monthly incomes ranged from $235 to $10,000, with a $SD=$ $2,128.41). On average, the mothers had obtained an associate's degree, though their educational backgrounds ranged from high school diplomas to doctoral degrees.

The second sample is a cross-sectional study of seventy-one African American parents and their middle school children (The Middle School Experiences Study; MSES). About half (49 percent) of the children were female. The sample was from two middle schools in a small Midwestern city. Nearly all caregivers were mothers (84 percent). Parents in this sample also had an associate's degree on average with educational attainment ranging from less than high school to doctoral degrees. Family incomes ranged from under $10,000 to over $100,000 yearly with an average of $50,000 to $59,999. Just under half (44 percent) were married.

Racial Identity

Our discussion of racial identity in this chapter will primarily follow the tenets of The Multidimensional Model of Racial Identity (MMRI; Sellers, Rowley, Chavous, Shelton, and Smith, 1997). The MMRI was chosen because of its flexibility in describing racial identity and its dimensions (Rowley and Sellers, 1998). The model consists of four dimensions: racial salience, centrality, regard, and ideology.

Racial salience can be thought of as the extent to which race is at the forefront of an individual's consciousness in a particular context or situation. People may feel attuned to the fact that they are African American when in a space in which they are the only African American present, even if they typically do not identify strongly with their racial group (Sellers et al., 1998). Other social cues, such as experiences of racial discrimination, may make race salient as well. It is also possible for race to lose salience for individuals who are otherwise highly race-identified, for example, if another identity is made salient (e.g., gender), even a highly race-identified individual might view race as less salient in that specific situation.

Racial centrality can be defined as the extent to which a person feels that race is an important part of his or her self-concept. This dimension describes how important race is to the individual's sense of self regardless of situational race salience (Sellers et al., 1998).

Racial Regard consists of two subcomponents: private regard and public regard. Private regard is the extent to which an individual feels positively about the African American community and their sense of pride in being a member of that community. Public regard, on the other hand, is the extent to which an individual feels that out-group members feel positively about the African American community.

Racial ideology reflects individuals' beliefs about the ways in which African Americans should behave and the beliefs that they hold with respect to (1) political/economic development, (2) cultural/social activities, (3) intergroup

relations, and (4) perceptions of the dominant groups. The four ideologies outlined in the MMRI include (a) a Nationalist ideology that stresses the uniqueness of being Black; (b) an Oppressed Minority ideology that stresses the similarities in the experiences of African Americans and other oppressed minority groups; (c) an Assimilation ideology that stresses the need to create change for the African American community from within the majority system and which also promotes interaction with Whites; and (d) a Humanist ideology, which is similar to a "color-blind" ideology that views all people as simply human and does not view race, gender, or other characteristics used to separate people into social categories as important.

In the section that follows, we present a conceptual framework relating racial identity in African American parents to their parenting strategies and behaviors. We propose two mechanisms. First, racial identity serves as a lens that influences how events in the world are interpreted and responded to. For example, we examined whether racial identity might prompt parents to talk about race with their children more. Second, racial identity plays a social function by facilitating or undermining certain social interactions (Strauss and Cross, 2005). Parents' racial identities may influence the ways in which they connect with mainstream institutions like schools and the extent to which they encourage certain social interactions. In addition, we were also interested in whether racial identity might relate to parents' concerns that their children will be racially discriminated against at school.

Relating Racial Identity to Parenting

Racial identity is a reflection of an individual's beliefs about how the world "works" with regard to race. Identities are based on peoples' views about the relative positioning of relevant social groups in society, their beliefs about how social groups should interact, and their personal sense of connection to the social groups to which they belong. It is surprising then, that so little empirical attention has been paid to the importance of racial identity in crafting a socialization agenda in all families, especially in families of color for whom issues of race are particularly salient. The paucity of research in this area has led us to develop a framework from several different but related areas of inquiry.

Garcia Coll and colleagues (1996) were among the first to note the primacy of the issues of race to family functioning in families of color. In their seminal article that expanded traditional models of ecological development, they lamented the lack of attention to factors related to social stratification, such as prejudice, discrimination, and segregation. They noted that these race-related issues enter into socialization strategies at multiple points and can have a significant effect in shaping child development. We agree with their call to increase attention to these issues in research on families of color, but also suggest that race-related effects on socialization may take on other forms. That is, in addition to considering issues of social stratification in our conceptualization of group-specific processes, we might

think about how racial identity constructs such as connection to one's racial group, group pride, and ideological factors influence family processes.

A great deal of research demonstrates that parents' beliefs are powerful influences on their own behavior and on their children's development. For example, research on gender stereotypes shows that the extent to which parents believe that boys are better than girls in science and math relates to the number of science-related toys that they buy their children (Jacobs and Bleeker, 2004), their endorsement of adaptive attributions for their children's science and math performance (Rouland, Rowley, Kurtz-Costes, DeSousa and Wachtel, in review), and their beliefs about their children's abilities in this domain (Bleeker and Jacobs, 2004). That these relations hold over and above their children's actual performance has been interpreted as evidence that it is the parents' beliefs that drive their behavior. Social constructivist perspectives suggest that parents' beliefs about how the world operates are shaped largely against their own experiences and cultural context (Bugental and Grusec, 2006). Therefore, parenting reflects parents' interpretations of the social context. In the above example, it is argued that some parents have interpreted gendered cues in society to mean that boys are better than girls in more technical domains (despite research demonstrating that this is not true). Their parenting strategies with and expectations of their sons and daughters are influenced by these interpretations (Jacobs, 1991) and children's own self-views are strongly related to these parenting strategies and expectations (Herbert and Stipek, 2005).

Parents' race-related beliefs may operate in a similar way. All parents must interpret racial cues in their environment, and these interpretations influence parenting. Based on their experiences and observations, parents develop beliefs about equity among racial groups, personality characteristics of racial group members, the relative importance of group cohesion, the contributions of different racial groups to society, and the distribution of various abilities across groups. In short, parents' racial identities are influenced by their race-related experiences and their identities inform the choices that they make for their families. What we are attempting to do with this chapter is to build a framework for considering the ways in which parents' racial identities (as reflected in the previously stated race-related beliefs) may influence their parenting. We begin with a discussion of the connections between parents' racial identities and their racial socialization of their children.

Racial Identity and Racial Socialization

Perhaps the best reflection of the relationship between parent racial identity and socialization is found in the literature on racial socialization—parents' race-related communications to their children. Hughes and colleagues (2006) suggest that parent racial identity informs beliefs about what children need to understand about race. For example, parents with strong humanistic ideologies may feel that it is important

to downplay race in their conversations with their children and to emphasize tolerance of others regardless of race. We submit that parents' racial identity would also shape the extent to which race enters day-to-day conversation, the likelihood that parents will frame their children's experiences in terms of race, and the density of race-related artifacts in the home.

The few studies that explicitly examined the relationship between parent racial identity and racial socialization have shown that multi-dimensional conceptualizations of both constructs is important; that is, different dimensions of racial identity relate to different aspects of racial socialization. For example, a study examining racial identity in African American adults, found that identity internalization (i.e., the extent to which racial identity is both important and well-understood) positively predicted parents' use of pro-Black messages (Thomas and Speight, 1999), such that parents who had a more internalized racial/ethnic identity felt that it was important to provide their children with positive messages about being Black. Moreover, research on samples of African American caregivers found that reports on the Multidimensional Inventory of Black Identity, the survey used to measure stable aspects of the MMRI, were related to racial socialization. Specifically, racial private regard and centrality were positively related to cultural socialization, which includes an emphasis on racial pride and heritage, and preparation for bias, which is comprised of discussions about racial bias and awareness of racism (Scottham and Smalls, 2009; White-Johnson, Ford and Sellers, 2010). Private regard was also positively related to egalitarian socialization, which emphasizes equality among races.

Our own data echo similar trends. In the MSES, racial centrality, private regard, and nationalism were positively correlated with preparation for bias, whereas public regard and humanism were positively related to cultural socialization. These findings suggest that parents who are more "race central" and think highly of their racial in-group are more likely to share messages about pride in their ethnic heritage or preparing their children for racial bias or discrimination. Our research adds to the finding that racial ideologies also relate to socialization. When parents believe that African Americans have a unique history and should remain separate from others (nationalism), they talk to their children about discrimination more frequently. Interestingly, the study by Scottham and Smalls (2009), also suggests that greater positive feelings about parents' racial groups are associated with greater encouragement of their children to connect with children of other racial or ethnic groups. This underscores Strauss and Cross's (2005) contention that racial identity plays a bridging function, allowing individuals to connect with members of other groups. Conversely, de-emphasizing race as reflected in a humanistic ideology was negatively associated to preparation for bias, suggesting that when parents do not think that race is as important as other personal characteristics, they are less likely to provide their children race-related messages.

Though studies of the relationship between parent racial identity and racial socialization are sparse, they do seem to point to the same conclusion, that African American parents' beliefs about their racial group membership shape what they tell

their children about race. These studies are limited in a few ways. First, our understanding of racial socialization is largely limited by the collection of themes presented in popular pencil-and-paper measures of racial socialization. Overby (2005) found additional themes in a qualitative study of African American caregivers and children, including socialization of critical race consciousness (emphasizing political awareness and sense of community), education as a vehicle for group uplift, and spirituality as a key feature of African American survival. Most of this research focuses on explicit socialization in the form of verbal messages that parents share. Parent racial identity is also likely to show up in more implicit aspects of racial socialization that are not studied under that label, such as the racial composition of the schools where parents choose to send their children (Tatum, 1997), the social networks to which they expose their children (Tatum, 1987), parental encouragement of certain friendships (Banerjee, Harrell, and Johnson, 2011), exposure to cultural events, and cultural artifacts in the home (Caughy, O'Campo, Randolph and Nickerson, 2002). Within our Families and Schools (FAS) study which examined the transition to first grade, mothers were interviewed and asked if they saw race playing a role in their child's schooling. One of the common themes was that because of the diversity of the school, in both the student and teacher population, they did not foresee race playing a role in their child's education. Some of the mothers noted that they moved into a particular school district to diminish their child's exposure to discrimination.

Racial Identity and Parent Involvement

In addition to parent racial identity leading to race-specific parenting strategies, we argue that racial identity shapes African American parents' broader parenting agenda, including the ways in which they negotiate relationships with mainstream institutions such as schools. As far as we know, there are no studies examining connections between parents' racial identity and their school involvement. Still, we would imagine that racial identities might be important predictors of parents' school involvement. For example, McKay and colleagues (2003) found that African American parents who made their children more aware of racism, a dimension of racial socialization, were more likely to engage in achievement-related activities at home, but were less likely to engage at the school. As it is unlikely that parents' racial socialization *causes* these educational involvement outcomes, we suspect that these results reflect a third underlying variable—parent racial identity. McKay and colleagues propose that these results suggest that African American parents who are more aware of discrimination tend to try to help their children at home to protect them, but then are less involved at school because of discomfort with school personnel. This suggestion could be indicative of a parents' racial identity, which might include high racial centrality, but a low public regard. These two racial identity types in tandem might make parents feel uncomfortable with personnel (because the parent does not feel that teachers view African Americans positively

and thus anticipate discrimination), but may also motivate the parent to become more involved in the home (because the parent wants to protect and prepare the child against future discriminatory experiences). Future research that actually assesses relevant aspects of parents' racial identity and awareness of discrimination (as opposed to racial socialization beliefs) would help to clarify these points.

The ideological aspects of parents' racial identities may also influence school involvement. For example, parents who have more assimilationist views that reflect a strong belief in political and social integration of African Americans may be more involved in their children's schooling. Humanist parents may feel comfortable with teachers from a range of ethnic backgrounds. Nationalist parents may feel it necessary to supplement traditional American curricula with information about Black History or to place their child in a school that has a large population of other African American students. Finally, parents with minority ideologies may encourage their children to learn more about various cultures and might prefer that the child be placed in a more diverse school environment.

The relationship between parent racial identity and school involvement may not be direct. Although parents of all racial identity profiles may be equally involved at school, the reasons behind their involvement may be quite different. In the FAS study, we asked parents to report why they get involved in their children's school. Their responses were related to their racial identities. For example, mothers' nationalism scores were positively associated with their reporting that they get involved to make sure that their child is treated fairly by his or her teacher. On the other hand, mothers' assimilation scores were positively related to mothers getting involved to teach children the importance of education and negatively related to a desire to supplement what was happening in the classroom or to protect their children's rights in the classroom. Similarly, there was a positive connection between humanism scores and mothers' desires to monitor their children's progress and demonstrate the importance of education. These results likely reflect more nationalistic mothers' beliefs that mainstream schools are not to be trusted and humanist and assimilationist mothers' endorsement of mainstream institutions. Thus, results may extend to interactions with other mainstream institutions, such as medical institutions or workplaces.

Analyses that investigated the relationships between identity and variables such as school trust showed that assimilation ideologies and private regard were positively related to school trust. Interestingly, parents who value assimilation *and* parents who feel more positively about African Americans both trust school personnel more. Furthermore when asked about involvement, a positive relationship was found between parents' attitudes towards involvement and humanistic ideologies, suggesting that parents who believed in color-blind treatment of individuals were more likely to have positive attitudes about getting involved in school. Mothers with higher levels of humanistic ideologies also worried less about how their child would be treated in school.

These data are preliminary, but they suggest that the amount of time African American parents are spending at their children's schools does not vary signifi-

cantly by their racial identity, the reasons that they are getting involved are related to their racial identities. This might have important implications for the quality of parent-teacher interactions and the specific form that involvement takes on. Mothers who are getting involved to protect their children may be more wary of teachers and less supportive of teachers' efforts. On the other hand, mothers who are striving to teach their children the value of education may be more likely to partner with the teacher. Lareau and Horvat (1999) complicate this by considering the role of family socioeconomic status. They found that middle income African American families who were concerned that their children would be discriminated against at school tended to partner with teachers to improve child outcomes, but lower income parents were more likely to have negative interactions with the teachers or to withdraw from the school setting. More research investigating parents' reasons for school involvement is needed. These data suggest that parents' expectations regarding their children's treatment at school underlie their reasons for getting involved in their children's education. In the next section we consider more direct relationships between African American parents' racial identity and their beliefs about the role that race will play in their children's lives.

Racial Identity and Beliefs about the Role of Race in Education

Parents' racial identities may also influence their beliefs about how race will operate in their children's lives. Certain racial identity profiles may be associated with different views on the potential for their children to suffer from racial discrimination and negative stereotypes. We focus on parents' beliefs about the role that race will play in their children's schooling experiences as schools are typically the most salient mainstream institution in which parents and children engage.

While previous studies have not directly examined the relationship between racial identity and parents' concerns about racial discrimination, racial identity has been linked to perceptions of discrimination experiences. These studies have found that African Americans with high racial centrality and low public regard have greater perceptions of racial discrimination (Sellers, Caldwell, Schmeelk-Cone, and Zimmerman, 2003; Sellers and Shelton, 2003). Additionally, African Americans who endorse nationalist ideologies may perceive more discrimination (Sellers and Shelton, 2003; Smalls, White, Chavous, and Sellers, 2007), while those with humanist ideologies report fewer experiences of discrimination (Sellers and Shelton, 2003). Furthermore, concerns about racial discrimination have previously been linked to child gender (Boyd-Franklin and Franklin, 2000), parents' socioeconomic status, and parental age (Varner and Mandara, in review). The connection between racial identity and discrimination experiences, as well as the variation in parents' racial discrimination concerns based on, individual differences suggest that parents' expectations for discrimination can be influenced by parents' own experiences, contexts, and racial identity beliefs.

Using our middle school sample of parents and adolescents, we examined the connection between racial identity dimensions and parents' expectations that their children would be discriminated against in school. Parents' expectations for their children's school-based discrimination were positively associated with nationalist ideology scores but negatively associated with public regard and humanism. These findings suggest that when parents emphasize the uniqueness of African Americans (nationalism) and believe that others view African Americans more negatively (low public regard), they tend to expect their children to face more discrimination at school. Parents who have a more color-blind ideology (humanism) are less likely to expect their children to encounter negative race-related experiences at school.

Our FAS study included mothers' interviews about their own school experiences, their expectations for their children's school experiences, and their beliefs about the relative importance of education for African Americans. These interviews were coded for race-related content. In addition, we separated the interviews into two groups: those of mothers above the median score on the pencil-and-paper assessment of Racial Centrality, and those below the median score. We found that mothers in the high centrality group were much more likely to discuss race throughout their interviews. They were more likely than the mothers in the low centrality group to report that race had played a central role in their own educational experiences, often citing incidents of racial strife or discrimination; moreover, they were more likely to expect race to play an important role in their own children's lives and were more likely to report that getting a good education was imperative for African Americans because of America's history of racism against African Americans. One mother in the high centrality group noted that education is critical for African Americans because "we're such at a disadvantage that uh, and I, you know, there's no quick fix besides education." Another mother noted that African Americans need to be academically successful to counter the negative stereotypes of African Americans as single parent welfare recipients.

Mothers in the low race centrality group rarely framed their own educational experiences in terms of race. They also noted that they did not expect race to play much of a role in the lives of their own children. These mothers did not avoid acknowledgment of racial discrimination altogether, but rather downplayed its relevance for their children. They frequently noted that they had chosen schools where race would be less of a factor and that they would "watch what's going on" with teachers and other school personnel. Still, they seemed less concerned by potential race-related issues compared to their "race central" counterparts.

Social Context and Racial Identity

When examining the influence of racial identity on parenting practices and beliefs, it is important to consider the role of parents' social context on these processes. The MMRI takes the position that racial identity is neither good nor bad; its implications can only be understood in reference to the social context in which the beliefs exist

(Sellers et al., 1997). For example, a father's Nationalistic ideological beliefs may lead him to socialize his child in ways that lead to the child's social withdrawal in a predominantly White social context, especially if those views include the belief that African Americans should limit social contact with European Americans. Those same Nationalistic perspectives may lead to more positive social outcomes in a racially diverse or predominantly Black setting because the father might encourage the child to find social support in interactions with other Black youth. Research with adults shows that racial identity can have very different effects on behavior in social contexts that are more or less racially diverse (e.g., Sellers, Chavous, and Cooke, 1998).

In our interviews with mothers in the FAS study, we found interesting references to social context when the mothers were asked to describe the ways in which race was expected to affect their children in the future. Although mothers in the low centrality group were more likely to say that race would play little role in their children's educational experiences than mothers in the high centrality group, many of the mothers also noted that they had chosen racially diverse schools for their children to attend to minimize the effects of racial discrimination in their child's lives. One mother recounted experiences that her nephew had in a neighboring district that was less diverse, noting that she would not allow her daughter to attend that district. Another mother in the low centrality group noted that if race did become an issue for her son that she would step in on his behalf. Thus, even parents for whom race was not particularly important considered the social context as they parented their children.

Characteristics of the child may similarly influence relationships between parents' racial identities and socialization. That is, the same racial identity profile might result in different parenting action based on characteristics of the child. Again, there is little empirical work on parents' racial identity for us to draw from, but the literature on parents' racial socialization may shed some light on these processes to the extent that racial identity underlies racial socialization. For example, although we would not expect parents' racial identities to change markedly as their children get older, parents give more messages that promote mistrust or prepare for them for bias as children enter adolescence (Hughes and Chen, 1997). Parents may initiate more discussions around race with adolescents because they have greater ability to process information, are exploring issues of identity, and may be more aware of or have experienced racial discrimination (Hughes et al., 2006).

Similarly, we would not expect parents of girls to have different racial identities than those of boys, but we find that children's gender is also related to parents' racial socialization. For example, African American parents often express more concern about racial discrimination impacting boys than girls (Bowman and Howard, 1985; Boyd-Franklin and Franklin, 2000). Though some studies have found no gender differences in racial socialization (Caughy et al., 2002; Hughes and Chen, 1997; Stevenson, Reed, and Bodison, 1996), other studies found boys were

more likely to receive racial barrier messages, while girls received more racial pride messages (Bowman and Howard, 1985; Thomas and Speight, 1999).

As noted, we found that mothers in the high centrality group of the FAS study were more concerned about the role that race might play in the lives of their children than mothers in the low centrality group. As we more closely examined the narratives of those mothers, we also noted that these mothers were especially concerned about the experiences of their sons relative to daughters. One mother said, "He's a male. A Black male. I dread [him starting first grade]. I dread it very much. And there's no way to protect him." Another high centrality mother said that she thought that race was "gonna play a very big role" and that "race is a bigger issue for males as opposed to females." In this case, the mothers' racial centrality may have led them to be more aware of the potential for their children's negative racial experiences but this concern was exacerbated by their beliefs that Black boys experience more egregious racial discrimination than girls. Almost none of the low centrality mothers mentioned gender-specific concerns for their children.

Our review suggests that aspects of the social context moderate the relationship between parents' racial identity and their socialization beliefs and practices. Our ability to comment on these issues was limited by the lack of research on parents' racial identity. Still, our qualitative work and the research on racial socialization shed some light on these processes. Future research should examine how contextual factors influence the relationships between racial identity, racial socialization, and other parenting practices. Furthermore, research on how children's development might impact parents' racial identity would be an important area to explore.

Discussion

Our goal with this chapter was to suggest that despite the paucity of research linking African American parents' racial identity to their parenting, there is considerable evidence suggesting that racial identity shapes the ways in which parents negotiate race-related issues with their children, their interaction with the mainstream institutions in which their children are engaged, and their expectations for their children's race-related experiences. More general theory suggests that racial identity influences individuals' interpretations of the world around them, and it follows that these interpretations extend to their children. Furthermore, recent ecological theories of socialization and development acknowledge the prominence of race-related experiences in the crafting of socialization agendas for African American families (Garcia Coll et al., 1996). Somehow, though, these facts have led to increasing amounts of research on parent racial socialization and less examination of racial identity more specifically. This may stem from a lack of theoretical positioning around racial identity. We hope that this chapter begins to fill this void to some degree.

Overall, we found that the few studies that exist point to significant relation-ships between parent racial identity and socialization outcomes. Analysis of our

own data showed that all dimensions of racial identity, as conceptualized in the Multidimensional Model of Racial Identity (MMRI), are related to key parenting outcomes. In those data we found relationships between racial identity and racial socialization, reasons for school involvement, and expectations for children's discrimination experiences. We also described similar results from other empirical studies.

Our review pointed out areas where little or no research has been reported. In the section of racial identity and racial socialization, we noted that our understanding of racial socialization is somewhat limited by our reliance on pencil-and-paper measures that do not capture the full range of racial socialization dimensions. Future research might consider how parents' racial identity relates to their tendency to try to provide children with a color blind experience, their encouragement of children's critical political consciousness, or the endorsement of the notion that education is a key component of group uplift. Other instrumentation might also begin to address questions such as the degree to which choice of school or neighborhood reflects racial identity beliefs of the parent.

This review also raised questions about the subtle ways in which race enters the parenting agenda. For example, we found that although racial identity was unrelated to the frequency of school involvement, it was related to mothers' reports of why they get involved at their children's schools. It is likely then, that these differences in involvement motivation would relate to the effectiveness of involvement and children's achievement outcomes associated with that involvement. Current measures of involvement tend to focus more on the amount of involvement and less on the nature or quality of that involvement. Bugental and Grusec (2006) note that parenting cognitions are sometimes bigger predictors of outcomes than actual behaviors.

Finally, we demonstrated that parents' racial identities are related to their beliefs about the connection between race and the importance of education. Mothers with low levels of racial centrality were more likely to report that education was equally important for all people regardless of race, but mothers with high levels of centrality were more likely to report that education was especially important for African Americans who have been systematically excluded from many educational opportunities. These high centrality mothers also reported expecting race to play a critical role in their children's lives, whereas low centrality mothers tended to expect the fact that their children are Black to be of little consequence.

Overall we found that parents' racial identities serve as important filters of their social worlds. Racial identity relates to the messages that parents think are important to share, the ways that parents intervene on behalf of their children, and their expectations related to their children's futures. We suggest that ecological theories of socialization should include parent racial identity as a key predictor of socialization and child outcomes. More theoretical attention has been paid to the role of racial discrimination in parenting. Boykin and Toms (1985) note that although African Americans' experiences as oppressed minorities are critical influences on parenting agendas, their experiences and beliefs are larger than simple

reactions to racial discrimination and other forms of social stratification. While racial identity does reflect African Americans' views about how others view their group and about their beliefs about intergroup interactions, it also includes their sense of closeness to the group, pride in group membership, and their race-related political, economic, and cultural beliefs.

Limitations

Our review has several limitations. First, the data that we presented to support our theoretical framework were cross-sectional and the analyses were preliminary. We used the data as initial tests of our developing theory, but recognize their limitations. More systematic and rigorous research is needed to substantiate these findings. Second, we chose to focus on a small set of socialization processes and to include only African American parents. We made this choice to increase the clarity and specificity of the discussion. We chose these particular constructs as representative of broader issues and hope to extend the ideas in the future. We chose African Americans for convenience reasons, but also because the overwhelming majority of the research on racial identity conducted to date is with African Americans. We have no reason to believe that the conceptual relationships outlined here would not transfer to other groups. Third, our review is anchored in the MMRI's conceptualization of racial identity. Although studies utilizing other frameworks were included, this choice may have limited the range of relationships described. This was not meant to exclude other conceptions of racial identity, but to improve the clarity of the discussion.

Implications

In conclusion, the importance of racial identity to mental health, motivation, and social decision-making has been well established. It is somewhat surprising, then, that so little research has examined the influence of parental racial identity on their socialization practices. Just as interventions with youth are beginning to include racial identity as an important point for intervention, we might need to consider the practical implications of racial identity in parents. Our considerations of social context suggest that such programming should proceed with caution, though, as it is clear that the effects of parental identity may differ according to key aspects of the social context and characteristics of the child. Additional research is needed to more fully describe the role of racial identity in the crafting of African American parenting agendas. We believe that better understanding parents' racial identities will ultimately yield greater insight into the meaning and significance of socialization in African American families.

References

Banerjee, M., Harrell, Z. A. T., and Johnson, D. J. (2011). Ethnic socialization and parent involvement: Predictors of cognitive performance in African American children. *Journal of Youth and Adolescence, 40*, 595-605.

Banks, K. H., and Kohn-Wood, L. P. (2007). The influence of racial identity profiles on the relationship between racial discrimination and depressive symptoms. *Journal of Black Psychology, 33* (3), 331-354.

Bleeker, M. M., and Jacobs, J. E. (2004). Achievement in math and science: Do mothers' beliefs matter 12 years later? *Journal of Educational Psychology, 96*, 97-109.

Bowman, P. J., and Howard, C. (1985) Race-related socialization, motivation and academic achievement: A study of Black youths in three-generation families. *Journal of American Academy of Child Psychiatry, 24*, 134-141.

Boyd-Franklin, N., and Franklin, A. J. (2000). You must act as if it is impossible to fail: Challenges in raising African American teenage sons. In N. Boyd-Franklin and A. J. Franklin, *Boys into men: Raising our African American teenage sons* (pp. 1-15). New York, NY: Dutton.

Boykin, A. W., and Toms, F. D. (1985). Black child socialization: A conceptual framework, pp. 33-51. In H. P. McAdoo and J. L. McAdoo (Eds.), *Black children: Social, educational, and parental environments, Sage focus editions, Vol. 72.* Thousand Oaks, CA: Sage.

Bugental, D. B., and Grusec, J. E. (2006). Socialization processes, pp. 366-348. In W. Damon and R. M. Lerner (Eds.). *Handbook of child psychology: Social, emotional and personality development* (Sixth edition). Hoboken, NJ: John Wiley and Sons, Inc.

Caughy, M. O., Nettles, S. M., O'Campo, P. J., and Lohrfink, K. F. (2006). Neighborhood matters: Racial socialization of African American children. *Child Development,.77*, 1220-1236.

Caughy, M. O., O'Campo, P. J., Randolph, S. M., and Nickerson, K. (2002). The influence of racial socialization practices on the cognitive and behavioral competence of African American preschoolers. *Child Development, 73*, 1611-1625.

Cross, W. E. (1971). Toward a psychology of Black liberation: The Negro to Black conversion experience. *Black World, 3*, 13-27.

Demo, D. H., and Hughes, M. (1990). Socialization and racial identity among Black Americans. *Social Psychology Quarterly, 53*, 364-374.

Garcia, C., Lamberty, G., Jenkins, R., McAdoo, H. P., Crnic, K., Wasik, B. H., and Vazquez G. H. (1996). An integrative model for the study of developmental competencies in minority children. *Child Development, 67* (5), 1891-1914.

Gay, C. (2004). Putting race in context: Identifying the environmental determinants of black racial attitudes. *American Political Science Review, 98*, 547-562.

Herbert, J., and Stipek, D. (2005). The emergence of gender differences in children's perceptions of their competence. *Journal of Applied Developmental Psychology, 26*, 276-295.

Hughes, D., and Chen, L. (1997). When and what parents tell children about race: An examination of race-related socialization among African American families. *Applied Developmental Science, 1*, 200-214.

Hughes, D., Smith, E. P., Stevenson, H. C., Rodriguez, J., Johnson, D. J. and Spicer, P. (2006). Parents' ethnic-racial socialization practices: A review of research and directions for future study. *Child Development, 42,*747-770.

Jacobs, J. E. (1991). Influence of gender stereotypes on parent and child mathematics attitudes. *Journal of Educational Psychology, 83*, 518-527.

Jacobs, J. E., and Bleeker, M. M. (2004). Girls' and boys' developing interests in math and science: Do parents matter? *New Directions for Child and Adolescent Development,106*, 5-21.

Lareau, A., and Horvat, E. M. (1999). Moments of social inclusion and exclusion race, class and cultural capital in family-school relationships. *Sociology of Education 72*, 37-53.

McKay, M. M., Atkins, M. S., Hawkins, T., Brown, C., and Lynn, C. J. (2003). Inner-city African American parental involvement in children's schooling: Racial socialization and social support from the parent community. *American Journal of Community Psychology, 32*, 107-114.

Overby, M. H. (2005). Conversations about culture: Racial/ethnic socialization practices of African American families in a cultural museum. Unpublished Dissertation.

Rouland, K. K., Rowley, S. K., Kurtz-Costes, B., DeSousa, V. L., and Wachtel, S. (in review). Self-views of African American youth are related to the gender stereotypes and academic attributions of their parents.

Rowley, S. J. and Sellers, R. M. (1998). Nigrescence theory: Critical issues and recommendations for future revisions. In R. L. Jones (Ed.) *African American identity development: Theory, research and intervention.* Hampton, VA : Cobb and Henry.

Sellers, R. M., Caldwell, C. H., Schmeelk-Cone, K., and Zimmerman, M. A. (2003). The role of racial identity and racial discrimination in the mental health of African American young adults. *Journal of Health and Social Behavior, 44*, 302-317.

Sellers, R. M., Chavous, T. M., and Cooke, D. Y. (1998). Racial ideology and racial centrality as predictors of African American college students' academic performance. *Journal of Black Psychology, 24* (1), 8-27.

Sellers, R. M., Rowley, S. A. J., Chavous, T. M., Shelton, J. N., and Smith, M. A. (1997). Multidimensional inventory of Black identity: A preliminary investigation of reliability and construct validity. *Journal of Personality and Social Psychology, 73*, 805-815.

Sellers, R. M., and Shelton, J. N. (2003). The role of racial identity in perceived racial discrimination. *Journal of Personality and Social Psychology, 84*, 1079-1092.

Sellers, R. M., Smith, M. A., Shelton, N., Rowley, S. A. J., and Chavous, T. M. (1998). Multidimensional model of racial identity: A reconceptualization of African American racial identity. *Personality and Social Psychology Review, 2*, 18-29.

Scottham, K. M., and Smalls, C. P. (2009). Unpacking racial socialization: Considering female African American primary caregivers' racial identity. *Journal of Marriage and Family, 71*, 807-818.

Smalls, C., White, R., Chavous, T., and Sellers, R. (2007). Racial ideological beliefs and racial discrimination experiences as predictors of academic engagement among African American adolescents. *Journal of Black Psychology, 33, 299-330.*

Stevenson, H. C., Reed, J., and Bodison, P. (1996). Kinship social support and adolescent racial socialization beliefs: Extending the self to family. *Journal of Black Psychology, 22*, 498-508.

Strauss, L. C., and Cross, W. E., Jr. (2005). Transacting Black identity: A two-week daily diary study. pp. 67-95. In G. Downey, J. S. Eccles, and C. M. Chatman (Eds.), *Navigating the future: Social identity, coping and life tasks*. New York: Russell Sage Foundation.

Tatum, B. D. (1987). *Assimilation blues: Black families in a White community*. New York, NY: Greenwood Press.

Tatum, B.D. (1997). *Why are all the Black kids sitting together in the cafeteria?* New York, NY: Basic Books.

Thomas, A. J., and Speight, S. L. (1999). Racial identity and racial socialization attitudes of African American parents. *Journal of Black Psychology, 25,* 152-170.

Thomas, A. J., Speight, S. L., and Witherspoon K. M. (2010). Racial socialization, racial identity and race-related stress of African American parents. *The Family Journal, 18*, 407-412.

Thornton, M. C., Chatters, L. M., Traylor, R. J., and Allen, W. R. (1990). Sociodemographic and environmental correlates of racial socialization by Black parents. *Child Development, 61*, 401-409.

Varner, F., and Mandara, J. (in review). Discrimination concerns and expectations as explanations for gendered socialization in African American families.

White-Johnson, R. L., Ford, K. R., and Sellers, R. M. (2010). Parental racial socialization profiles: Association with demographic factors, racial discrimination, childhood socialization and racial identity. *Cultural Diversity and Ethnic Minority Psychology, 16*, 237-247.

Chapter Twelve
African American Children's Racial Identifications and Identity: Development of Racial Narratives

Stephen M. Quintana and Aaron V. Smith

Introduction

African American children's racial identifications have been the subject of psychological research for seven decades. Over that time, research has redressed some popular misconceptions and demonstrated the complexity in African American children's racial cognitions, identifications and identity. In the context of a hegemony and racism in U.S. society and without much direct acknowledgment of on-going racism, it is remarkable that African American children develop positive notions of self and of their racial group, as well as develop critical consciousness of messages and interactions reflective of racism. These notions and consciousnesses would be challenging to develop with adult faculties, but young African American children begin the development with limited cognitive skills and life experiences. Consequently, how these processes develop for African American children is remarkable and warrants careful examination. Moreover, this process is not only of intrinsic interest, but African American children's and adolescents' development has been used as a model for how other racial and ethnic minority children develop similar notions and ethnic or racial consciousness (Quintana, 1998).

Our chapter focuses on the development of different components and abilities that underlie the formation of mature racial identities in adulthood. Elucidating the ontological development of racial identity provides insights into the components that are intertwined in adult racial identity development. Examining the develop-

mental origins of mature forms of racial identity development provides insight into the different components that are inseparable in adult forms of racial identity.

We use two main frameworks for articulating the developmental sequelae of children's development, from acquiring racial labeling to the formation of adult forms of racial identity. The first framework is an alternative to the traditional basic unit of racial identity. That is, the traditional basic underlying components of racial identity are usually described as generalized intra- and inter-racial attitudes or the attitudes toward other African Americans, White Americans and other ethnic or racial minority groups (Helms, 1995). The attitudes are generalized orientations toward racial groups, same and different racial groups. For example, pre-encounter racial identity stage, status or themes is defined by a pro-White bias and anti-Black sentiments, fueled by miseducation or an absence of critical consciousness (Helms, 1995). The attitudes are defined in ways that are independent of specific contexts, and how these racial attitudes are applied in specific contexts is unclear. Moreover, these generalized attitudes fail to represent the complexity of feelings toward specific individuals. In short, how the generalized racial attitudes are translated for specific interpersonal relationships in particular contexts is difficult to discern. These building blocks of identity represent outdated models of normative identity development.

As an alternative to using generalized racial attitudes, our approach is based on more recent models of identity development, defining identity as complex individualized, autobiographical narratives about the self (Eakin, 2008; McAdams and Cox, 2010). Peter Brooks (1984) suggested:

> We live immersed in narrative, recounting and reassessing the meaning of our past actions, anticipating the outcomes of our future projects, situating ourselves at the intersections of several stories not yet completed.

We believe there are repetitive scripts that reflect patterns of interpersonal interactions among members between and within racial groups. These scripts define common roles enacted by persons, ascribing motivations and characteristics to those roles. The scripts articulate common interpersonal interactions associated with those roles, and identify main plots or trajectories of the interpersonal interactions. The narratives integrate past experiences into coherent stories that attach meaning and purpose to the past. The narratives also identify desired or future goals and implicate strategies for negotiating interpersonal situations.

Racial narratives involve repeated patterns of inter-racial and intra-racial interactions in which members of those interactions manifest familiar characteristics and in which the person may have had similar interactions before. Racial narratives represent intergroup perceptions and attitudes into interpersonal contexts. Constructing racial narratives from previous inter-racial and intra-racial experiences allows for new interactions to be anticipated and for efficient recognition of current interactions that reflect the basic features of a racial narrative. Preferred narratives may provide direction for how current interpersonal situations can be managed in

ways that lead to positive outcomes. Below, we use excerpts from interviews conducted with African American children and youth to illustrate themes of their racial narratives.

Racial narratives may be constructed through personal experiences but can also be constructed through stories told by others (family members, peers, respected elders) about their own personal experiences. The oral tradition of African cultures (Boykin, Jagers, Ellison, and Albury, 1997) may make the sharing and construction of narratives particularly important for African American children. Explicit advice given by parents about managing racialized experiences, which likely reflect the parents' own racial narratives, may be another source for children's construction of racial narratives. To illustrate, a coping-with-discrimination narrative would be instilled by parents imploring their children to challenge racial discrimination by standing up for themselves in ways that maintain their self-respect and dignity. Implicit within this narrative is motives, beliefs, stereotypes, values as well as behavioral actions and reactions as well as affective reactions that would be pieced together into a coherent framework. Given the sometimes subtle nature of micro-aggressions, advanced preparation would be critical to manage these racialized situations in an effective manner. Constructing racial narratives and being able to apply them efficiently to particular situations help persons to cope effectively to microaggressions. Hence, using racial narratives as fundamental building blocks of racial identity provides, we believe, a richer, contextually-embedded representation over using decontextualized and generalized racial attitudes as the basic units of racial identity.

The second main framework for this chapter is Quintana's (1998) model of racial cognitive development. Constructing these complex narratives and being able to apply them in these contexts requires considerable sophisticated skills, particularly social cognitive abilities. Young children's level of social cognitive development provides constraints on the possible narratives that they can construct. As children mature, more complex narratives become possible. Quintana's (1998) model of children's development of ethnic perspective-taking ability provides a framework for articulating the development of racial cognition that provides the opportunity for new and potentially more effective narratives available to children construe their racialized social experiences. This model has been applied to a wide variety of ethnic and racial groups and subgroups, including Latinos (Quintana, 1994), Native Hawaiians (Quintana, Chun, Gonsalves, Kaeo and Lung, 2004), transracially adopted Korean children (Lee and Quintana, 2005), international sojourners, as well as two different racial groups in Central America (Quintana, Ybarra, Gonzalez-Doupe and de Baessa, 2000). The present chapter represents the first explicit application of this model to African American children. We use the model to describe the developmental limitations for what narratives can be constructed and available to be applied to racialized contexts.

Quintana's (1998) model involves five levels of perspective-taking ability. Each level is defined by a perspective with which children use to understand their racial world and themselves. Children's perspective-taking ability represents the

logic or reasoning they use to construe what role race and racial differences play in their social life. Movement to the next developmental level involves the addition of social cognitive abilities that allows the children to add a new perspective on how they understand the implications of race in personal and social domains. The previous perspectives are not invalidated by a new perspective; instead, the new perspective can be integrated with the previous perspectives to allow multiple ways in which children understand race. That is, a level is defined as having access to a particular perspective, but all the previously developed perspectives remain available and can be used to construe their social and racial worlds. The levels of perspective-taking ability are cognitive rather than attitudinal in nature. Consequently, development of perspective-taking is defined more by the cognitive abilities that underlie how race is understood rather than the positive or negative valence of racial attitudes. The level may influence the manner in which the children explain or justify their attitudes.

Applying Quintana's (1998) framework allows us to identify kinds of racial narratives that are possible, given the child's level of development. Each new perspective of race allows children the ability to formulate new themes in their racial narratives. Conversely, early, immature levels of perspective-taking constrain the types of narratives that children can construct.

Level 0: Egocentric and Observable Perspective of Race

The earliest level of ability (PTA) represents development that occurs just before or during kindergarten or first grade, although children proceed at their own rates through the levels. This level of PTA is defined by the somewhat egocentric logic children use to racially classify themselves and others and may involve the children coining their own terms to refer to racial groups. Children have been known to refer to "Brown" people rather than Blacks in part because the color brown is more descriptive of the skin coloration for African Americans. Because children are using crude features to racially classify themselves and others, they may fail to use the same racial classifications as adults. An anecdote told to the first author: A parent was looking over her son's yearbook and noted, "You're the only Black child in your class," but the son disagreed and pointed to pictures of Latino, Middle Eastern and other dark complexioned children saying, "They're Black, too." As another illustration, a colleague overheard a first grade child explaining to her younger sister the origin of children's racial status: "Black means you have two Black parents, White means you have two White parents and Brown (referring to Mexican American child) means you have one Black and one White parent." These anecdotes reveal young children's limited understanding of racial categories used by adults. Children "explain" their nascent understanding of race by using egocentric or idiosyncratic logic, which reveals their level of cognitive development. These anecdotes also demonstrate that many young children rely on physical features in their verbal references concerning race.

Because young children's understanding of race is limited, their use of racial labels to themselves and their social world can be idiosyncratic. Indeed, some early research questioned that the accuracy of Black children's self-identifications. Clark and Clark's (1939) doll study and many other related studies compared Black and White children in rates of identifying with study stimuli that represented their own race; for example, dolls with black or white "skin" were used in the Clark and Clark study. In Clark and Clark's study and other related studies, Black children chose dolls that depicted their racial group at lower rates relative to White children. These findings were taken as evidence that Black children denigrate their own racial status (Banks, 1976). More contemporary research using different study methodologies across different cultural contexts (e.g., United States, Jamaica, Brazil) also reveals self-identifications are less strong among the darker- complexioned Black children (Averhart and Bigler, 1997; de França and Monteiro, 2002; Ferguson and Cramer, 2007). For example, young children in kindergarten were more likely to identify with lighter-complexioned stimuli, but older children tended to self-identify with greater accuracy with respect to their skin color. However, those children who evidence some distortion of their self-identifications by identifying with lighter complexioned stimuli evidenced racial bias against Blacks (Averhart and Bigler, 1997).

Before concluding that these patterns suggest young Black children denigrate their race, there are two important considerations. First, recent research has found that young children's racial identifications have a strong emotional or motivational component and reflect more than simple cognitive processes. That is, how young children feel about their race has implications for how strongly they identify with it. Hirschfeld (2008) suggested that nascent racial classifications are more strongly influenced by attitudes than cognition, and that racial classifications of peers and of self reflect children's affective reactions associated with race. Hirschfeld suggested that racial attitudes occur prior to young children's ability to classify using physical markers of race. These findings challenge the conventional assumption that children are first naïve with regard to race, then they learn to classify their social world into racial categories, and then develop racial attitudes once they have developed reliable racial categorizations. The research cited above on young Black children suggests that affective connotations about their race influence how strongly and accurately they identify with their skin coloration. Hence, Black children's tendency not to choose stimuli that represent their race may reflect the positive valuing of other racial groups, not necessarily their denigration of their own race. Interestingly, research conducted on adults shows that on implicit measures of racial attitudes, that is, when racial attitudes are measured in a disguised or subtle manner, there is a tendency to favor Whites over other racial groups (Smith-McLallen, Johnson, Dovidio and Pearson, 2006). Hence, Black children's responses to the use of subtle stimuli to reflect race is not unique to their developmental level or racial group.

Second, although the extant research has focused on the self-identifications for Black children, little attention has been given to the very strong trend for White

children identifying with their race. The strongest trend in this research is that White children show strong ethnocentrism in their self-identifications as well as positive attributions to stimuli representing Whites. In other contexts, White children reveal greater ethnocentric bias relative to children from other racial groups in their ratings of same-race peers and stimuli representing Whites (see Quintana and Chavez, in press). Research also supports the interpretation that White children manifest clear racial stigma that they use, probably unwittingly, to privilege themselves and their White peers and disadvantage their Black peers (for example, see Jackson et al., 2006). Looking closely at these trends suggest that White children appear to have a clear racial schema as evidenced by the overwhelming tendency to prefer or self-identify with study stimuli representing their racial group. This pattern of findings can be interpreted with Social Identity and Social Categorization Theories (Tajfel, 1978), which suggest that those who identify with a social group develop bias favoring in-group members and may develop derogation of out-group members. Based on these theories' principles, it seems apparent that young White children's strong and pervasive ethnocentrism reflects clear racial identifications. Conversely, Banks (1976) suggests that the results from the doll and other similar studies revealed that Black children's choices reflected no clear preference toward Whites or Blacks, given that the their choices were well within the distribution of chance responding. Analogous research suggests that Latino children do not evidence a bias toward their own or other groups, which is in stark contrast to the strong ethnocentrism that Anglo children manifested (see Quintana and Chavez, in press). Consequently, research suggests that many racial and ethnic minority children in early childhood do not evidence the racial/ethnic identification and ethnocentrism that their White peers develop.

It is important to differentiate racial identifications from racial identity in understanding young children's development. Young children can clearly identify their racial status, but do they have the social cognitive abilities for a racial identity? We believe that those who refer to racial identity in children should instead describe the children as having racial identifications, not racial identities. Racial identity has been connected to Eriksonian forms of personal identity (Cross and Cross, 2008; Phinney, 1989; Quintana, 1998), which forms during adolescence. For racial identity to occur, there must be a merging of adolescents' reference group with their personal identity (Cross and Cross, 2008). During childhood, racial identifications remain fixed on identifying the racial status that describes the child, similar to other personal descriptors (hair color, gender) that children use. Young children, recognizing that their skin color and other physical features makes them Black or African American, does not mean that they feel a social or psychological connection to others who share these phenotypical characteristics. Therefore, young African American children recognize that they share skin coloration and other physical characteristics with others, but they seem unaware of the social and ideological consequences of sharing these phenotypical characteristics. For these reasons, we use racial identifications, rather than racial identity, to describe young children's racial cognitions.

Interviews with young Black children demonstrate their focus on skin coloration and their sense that race is physical characteristics that is, in some cases, only skin deep:

Interviewer: What does it mean to be African American?
Child: It's just the color of your skin.
Child: [Could you become another race other than Black?]: Brown
Child: [What is different between African Americans and people who are White?] Mostly just their skin that's different about them.
Child: [Why do you like being Black?] Because I like the color.
Child: [What does it mean to be White?] Means to have, maybe, I don't know, what's color of their skin? They're just white, peach colored.

It is important to note that young children consider physical features of race as not just a characteristic or marker of racial status, but physical characteristics *are* race. In other words, physical features of race are equated with race, such that changes in physical features necessarily change racial status. Examples are illustrated from the following excerpts from interviews:

Interviewer: If you changed the color of your skin to this child's skin color [pointing to picture of White child], would you still be Black?
Child: No [Why not?] Because then you're a white girl.
Child: [Is there any way for a person to change her race?] There's really no way except for their skin color.

What are the implications of applying these social cognitive abilities to racial domain for what kinds of racial narratives can be constructed? The kinds of narratives that can be constructed at this level of development are clearly limited. A common narrative at this level suggests that there is some sense that being Black is a stigmatized status. Consistent with social identity theory is the principle that identifying with a low status or stigmatized group could be a threat to self-esteem and, when possible, those who can distance themselves from identifying with a stigmatized group may choose to do so. Very young children who conceive of racial status using idiosyncratic logic or magical thinking may believe that racial status can be changed or denied and thereby distance themselves from a stigmatizing characteristics. Those who are more negative in their orientation toward Blacks tended to misidentify with being African American (Averhart and Bigler, 1997). Consequently, a narrative to some children may be "Being Black is not good and other people besides me are Black." However, the main shift in narratives is the growing awareness that racial status is a permanent, fixed aspect of persons. Excerpts from interview responses illustrate this awareness:

Child: [Why might some people not like Blacks?] They don't like their color.

Child: [Do you like being African American?] There's nothing to like about it. There's nothing to like about being any color.

Other children also indicated "You can't change your color," which illustrates the fixed nature of racial status, but these responses also seem to introduce the possibility that some might wish either to change their racial status or that they had a different racial status. However, children come to realize that racial status is permanent, and they need to accept their racial status and the permanence thereof. The racial narrative at this age becomes, therefore, first there is realization of the permanence of racial status ("You can't change your race"), acceptance of racial status ("I like being Black") and asserting a neutral connotation with racial status ("There is nothing to like about being any color") or positively embracing racial status ("I like being Black because I like the color black"). More generally, the racial narratives available to young children are focused on physical, but not psychological, features of race.

Level 1: Literal Perspective of Race

At the next level of development, children are not limited to reasoning about the observable and physical features of their social and racial worlds. Children begin to consider that there are unseen or unobserved phenomena that underlie the observable features of their social and racial worlds. They begin to develop *theory of mind* capabilities in which children realize or theorize that others have mental events, which underlie observable and physical phenomena and then apply these abilities to their social world (see Samson and Apperly, 2010). They realize, therefore, that mental events such as wishes, desires, and intentions may motivate observable social behavior. These children realize that to understand social interactions, it is important to try to understand those mental events that motivate behavior. However, because these theory-of-mind abilities are nascent, children in early- to mid-childhood assume that behaviors and other observable social features (e.g., facial expressions) reflect the unseen mental events. That is, at this level, children use observable events to infer what others' mental or psychological states must be, and these interpretations of appearances are done in fairly literal manners. For example, when someone is observed as smiling, young children infer that that person must be happy (Selman, 1979). These social cognitive abilities have important implications for understanding racial cognition.

At this level of development, African American children realize that there are unobservable features to racial status. Importantly, these abilities allow children to understand that racial status is permanent, but because racial status is caused by the racial heritage of parents. Children at this level recognize that racial status persists despite some magical or unusual changes in physical appearance. The following illustrate African American children's responses reflecting Level 1 reasoning:

Child: [Would you be a different race if you could change the color of your skin?] No, because it's not just your skin color that makes you Black, it's your heritage.

Child: [How do you know you're Black?] I know I'm Black because I live in a Black family and on many charts and things, it says, like my birth certificate I am . . .

Like children from other ethnic or racial groups (see Lee and Quintana, 2005; Quintana, 1998), African Americans base their understanding of racial status on literal interpretations of the racial label. Mexican American children, for example, explain that they are Mexican American because they (or their parents/ancestors) are from Mexico. Similarly, African American children recognize that they have ancestry in Africa as well as America.

Child: [What does it mean to be African American or Black?] Well, Black is like, you're just Black, but African American means you're, like, you'd be African and American.

Child: [What does it mean to be African American?] That you're African American and that somewhere down the line your family was probably brought from Africa.

An important difference between African American children and children from ethnic groups with large immigrant subpopulations is that African Americans refer less often to cultural traditions as a fundamental part of their racial group membership. In contrast, Latino and Asian American children at this level refer to the different languages they may speak, the different religious or cultural traditions that they maintain, among other literal aspects of culture. Conversely, African American children only infrequently refer to cultural traditions that have been passed down from Africa or African countries. Instead, African American children identify the civil rights struggle, leaders, and heroes as their heritage.

Child: [What else does it mean to be Black or African American?] I can be proud about Martin Luther King or Harriet Tubman.

Child: [Do you like being Black?] Yes. [Why?] because of what Blacks did to get freedom.

Child: [What does it mean to be White?] That you didn't have to be sent from Africa, that you used to treat the Black people wrong and you're a different color.

The ability to infer that there is some unobservable, underlying feature of race opens the door to children's essentializing racial differences. That is, essentialistic thinking involves positing that there is some essence in, for example, racial status and that racial differences imply some differences in essential features of persons (Mahalingam, 2007). This essence attributed to racial status has important

implications for the social categories and the sense that there are these basic differences that, in most cases, cannot be changed or reconciled.

> Child: [Can a White child change her race?] No, it is in her blood also and she can't stop being White cause she can't change her blood whether she doesn't like being White or not, she can't change it, that's her and it's going to stay that way.

The above example reflects the sense that some essence underlies racial status and to this child, racial essence is phrased as "in her blood" and that this essence at a fundamental level makes racial status immutable and also suggests members of different races are different at some fundamental level.

More generally, like other children, African American children use their new social cognitive abilities to construct racial narratives across time. That is, the racial narratives that are possible at this level begin to focus on heritage components and to begin touching on aspects of the Diaspora of African peoples in the United States. The children also have the beginnings of a powerful racial narrative associated with redemption from slavery and, to some extent, Jim Crow laws. It is not apparent, however, that the children at this level personally identify with these redemptive narratives. Common to children across racial groups at this level of development is their sense that historical events have little contemporary relevance. To illustrate, children would indicate that now, unlike historically, African Americans can drink out of any drinking fountain, but following their logic, now that they have their rights (e.g., to use any drinking fountain), there is little awareness of the contemporary relevance to further struggle for other civil rights. That is, children, at this level of development did not identify the need for contemporary injustices that require redress. Moreover, the connection between their own heritage and the civil rights leaders seemed more academic and literal to the children rather than one with which they personally identified. The following excerpts illustrate these tendencies.

> Child: [Do you like being Black?] Yes, it's fun. [Why is it fun?] Cause I get more privileges now or something than I had, than people had before that, than Blacks had before that.
> Child: [Do you like being Black?] Yes. [Why?] Cause, I get to do things, and White people get to do things too. I get to go to school, I get to drink out of the same water fountain as others and I like it.

These excerpts suggest African American children's racial pride is based on historical events in which injustices were addressed. These responses suggest that racial pride is partly based on the removal of negative practices, the absence of negative conditions. These responses do not reflect the presence of positive reasons for racial pride. In contrast, those children whose ethnic group had a more recent immigrant history tended to identify cultural features, such as language as sources

of ethnic pride. Many of the children of these immigrant groups expressed pride in possessing the skills associated with speaking a second language and participating in cultural traditions. For example, when asked why they liked being their ethnicity or race, Latino children often suggested, "I can speak Spanish" and Korean American children indicated, "I can speak Korean and we celebrate Korean holidays." Given the history of African Americans in the United States to which African American children are exposed, there are relatively fewer positive associations with being African American. Many of the African American children cited reasons that reflected the absence of negative conditions (e.g., "There aren't slaves around"). When African American children cited positive reasons for why they enjoy being their race they tended to refer to family members (e.g., "I like having my Ma. She's Black and if I wasn't Black she wouldn't be my Ma.").

Nonetheless, the focus on the civil rights movement and leaders in African American children's understanding of their heritage allows for new racial narratives to be constructed. Black children are exposed to the notion of oppression and injustice that is perpetuated by Whites in U.S. society. This awareness is fostered at a time in which children's social cognitive development encourages the notion of egalitarianism (see Quintana, 1998). For African American children, they can especially appreciate the injustice that derives when a group of people is treated unfairly. The challenge for African American children at this developmental level, however, is to reconcile the awareness of historical injustices perpetuated by Whites with developmental tendency to respect and show deference to authority. There are several ways in which African American children resolve this dilemma by constructing racial narratives that suggest the injustice happened historically, and that the civil rights movement corrected those dated examples of racial injustice. Consequently, a second important racial narrative that develops at this level involves racism, but these narratives describing racism tend to involve only the more blatant forms of racism, such as those that expressed through racial epithets. The tendency toward literalness may lead children at this level of development to accept at face value those who, when caught acting in a racially discriminatory manner, defend or justify their actions as not being racially motivated. Cross's (1995) description of pre-encounter attitudes including miseducation are consistent with racial narratives that are constructed at this level of development. Importantly, at this level of development, children have not acquired the tendency to question appearances and develop a critical consciousness related to the history of inter-racial relationships.

Level 2: Social Perspective-Taking Ability

As students approach middle school, they reach an important milestone in their social cognitive development (e.g., Selman, 1980), in which they are able to take a social perspective on their interpersonal interactions. This development allows them to consider the social context and social motivations that underlie

interpersonal interactions. To illustrate, earlier in their development children would, somewhat literally, interpret smiling to reflect a person's internal state of happiness. However, by considering a social context, older children can appreciate that smiling might be performed, not because the person was happy, but because the person wanted others to think he or she was happy. Hence, at this level of development, children are consolidating the application of "theory of mind" abilities to their social worlds in which they are better able to infer the intentions and motivations underlying social behavior. This social cognitive development has important implications for African American children's understanding of inter-racial and intra-racial interactions.

By assuming a social perspective, African American children can better appreciate the contemporary relevance of the role of race in their lives by being able to reflect on the social consequences of race and racial group membership. At this developmental level, they are able to look beyond appearances and hypothesize or intuit others' intentions, attitudes, and feelings in inter-racial interactions. This important milestone allows African American children to infer prejudicial attitudes that may underlie social facades or posturing. At this level, children appreciate that race is not only about one's heritage or history, but racial status influences mundane social behavior, such as manner of speaking and behaving as well as worldviews, among other aspects of social interactions, as illustrated by the following interview excerpts.

> Child: [How are Whites and Blacks different?]" Sometimes White people talk different from Blacks, I could hear the difference.
> Child: [Would you like to have friends who are Black?] Yes. [Why?] Because sometimes Black friends are easier to stick with, cause sometimes White people don't want to be your friend and they just run off with other Whites and don't want to be your friend.
> Child: [Can you change your race?]: Can't stop to change your skin color, but you can stop like and act White or something.
> Child: [Have there been times when you wished you weren't Black?] Yes, because when I get in trouble, I wish I'd be White because they say that White people's parents are always nice, so when I get in trouble, I want to be White but if I'm not in trouble I like being Black.

These interview responses illustrate children's application of a social perspective to the racial domain. Whereas at previous levels, the implications of race were limited to children's heritage and a few exceptional occasions in which cultural traditions were practiced, at this level of functioning, children recognize significant implications of race for their everyday interactions. There is a growing awareness of how race influences social norms, patterns, and interactions. As illustrated above, there are ways of acting White and, presumably ways of acting Black as well. Friendships and relationships are influenced by racial differences, as the above example reveals children's growing awareness of challenges in inter-

racial friendships. The last example above implies that social norms in disciplinary practices vary across race.

Perhaps the most important milestone associated with a social perspective is African American children's ability to infer racial prejudice and bias. At this level, the racial bias in interpersonal interactions need not be literally or directly expressed in order for the child to infer racial prejudice. This advance in racial perspective-taking ability opens the door for more complex racial narratives, which involve being able to infer racial prejudice that underlies inter-racial conflict. At this level of development, during pre- and early-adolescence, many African Americans have constructed racial narratives that involve racial discrimination, and, importantly, how to contest and/or cope with it.

Recent developmental research and theory describes the complex processes required in order for children to infer that an action was racially biased. Brown and Bigler (2004) identify the situational factors and cognitive processes required for children to infer discrimination. If a child receives hostile treatment, the child must infer if (a) the treatment was legitimate or not, (b) the treatment was based on racial differences, (c) the perpetrator harbors racial bias, and (d) the perpetrator is discriminatory in the treatment of same race versus different race children. To determine if the response they received was legitimate or reflect racial bias, the child needs to compare the current treatment to previous responses they have received. Because racism is more likely to occur when the perpetrator perceives the target's behavior as being consistent with racial stereotypes, in order for a child to detect racial bias, he/she may need to view his or her behavior from the perspective of a member of a different racial group and be familiar with that racial group's racial stereotypes. Moreover, to detect discrimination, the child must infer mental events of the perpetrator, such as racial hostility. To differentiate between hostile treatment and racialized hostile treatment, the child may need to compare how the perpetrator treats children from other racial groups with how the perpetrator acts toward other children from the child's racial group. The ability to detect discrimination is further challenged by the general tendency to underestimate the prevalence of discrimination. As noted in research across stigmatized groups, because humans like to feel as if they are in control, perceiving racism can be a threat to this sense of control, and there is a tendency to underestimate unwarranted racial bias (see Major, Kaiser, O'Brien and McCoy, 2007). Although it's unclear if children will evidence this tendency to under-report bias, there are likely negative costs associated with perceiving bias for children. In short, there are many cognitive, situational, and personal factors that have to be overcome in order for a child to detect a simple act of discrimination.

Given the complexity of detecting racism, it seems apparent that children and adolescents will need to have advanced preparation in order to detect it efficiently. We suggest that the social perspective on race allows children and adolescents to construct discrimination narratives that can be applied to inter-racial contexts. By having previously constructed racial narratives that involve discrimination, children and adolescents can apply this basic narrative in situations in which they perceive

they are being targeted. In this manner, they need not to undergo the complex process of constructing a racial narrative involving discrimination on the spot, but rather can transfer features of the current situation into a more generalized racial narrative and track the predicted unfolding of the racial narrative. An important source of the construction of a discrimination narrative is previous experience in which children were targeted. Being exposed to discrimination without sufficient preparation for bias may be traumatizing to the child in part because they may not have a racial narrative with which to construe the current events. In the first exposure to undeniable racial bias, children require some support to be able to sort through the different components of detecting discrimination, as described above. In this context, parents and extended kin and peers may potentially assist a child in constructing this kind of narrative. Although about half of all African American children by eleven years of age report being target of racial bias, nearly all of them have been vicariously exposed to discrimination, either through observing it or by being told about such experiences (see Brown, 2008). Racial socialization from parents and peers, to the extent to which the socialization involves preparation for bias (Hughes et al., 2008), could be conceptualized as co-constructing racial narratives involving the child. Frank discussions with parents and other authorities can help children construct discrimination narratives they can use when they find themselves the target of discrimination.

This level of perspective-taking ability is consistent with some aspects of the encounter phase of development in Cross's (1995) model. Cross suggested that racial identity development is triggered by "encounters" with experiences of discrimination. The discriminations that trigger this development can be particularly egregious, in which the role of race and racism can no longer be ignored. The encounter experiences that trigger racial identity development, however, need not be particularly unusual or profound, but could result from the cumulative effect of multiple microaggressions that build up to the point that an encounter experience is triggered. The encounter experience seems similar to our description of the construction of racial narratives that provide meaning to previous experiences with discrimination and help anticipate future encounters with discrimination.

Experiences of discrimination are particularly influential in the development of racial identity. In cross sectional research, there are strong empirical connections between racial identity development and centrality and reported experiences of discrimination (e.g., Seaton, 2009). Correlational relationships may mean that with a strong or developed racial identity, persons are more apt to perceive discrimination than those with weaker or more peripheral forms of racial identity. This longitudinal research clarifies that experience with discrimination trigger racial identity development, and advanced racial identity development sensitizes persons to racial discrimination, but the effect is particularly strong in the direction of discrimination leading to racial identity development (Pahl and Way, 2006; Sellers and Shelton, 2003). In sum, the social perspective of race provides for critical perspective in the development of racial identity for African Americans.

Level 3: Racial Group Consciousness Perspective

The next level of perspective-taking ability usually occurring during the middle or high school years, involves the ability to generalize beyond individuals and beyond isolated incidents to infer characteristics of groups and general patterns. The early development of Level 3 abilities allows youth to posit personality traits about others (Selman, 1979). Their formulation of personality types grows from being able to assemble discrete characteristics into more generalized traits. At first, because this social cognitive ability is in the process of being developed, there is often an over-generalization of these perceived tendencies, as well as an oversimplification of the complexity of persons and their personalities. The early use of this ability may promote exaggerated generalizations of these inferences, such that youth's notions become caricatures of others. When these abilities are applied to the racial domain, there may be a tendency for adolescents to exaggerate the extent to which racial interests motivate interpersonal interaction, as well as stereotype members of other racial groups (Quintana, 1998). That is, adolescents may typecast others and to some extent themselves, which reflects the overgeneralization of Level 3 cognitive abilities.

Moreover, the early application of these social cognitive abilities may lead to the tendency to attempt to build cohesion within peer groups by suppressing dissention from group norms and by suppressing individual differences within the group. The tendency to suppress individual differentiation is consistent with the formation of cliques in adolescence in which conformity to group norms is demanded in order to maintain membership in the clique (Ennett and Bauman, 1994). Cliques or peer groups that consist of individuals with this nascent group consciousness may also be relatively intolerant of diversity within the group, and may be most concerned with ensuring conformity and allegiance to the group.

Level 3 abilities applied to the racial domain is consistent with Cross's (1995) description of the immersion phase of racial identity development in which the person, awakened by encounters with discrimination, immerses him or herself into his or her racial group. The immersion may be intense enough to suppress individual identities in order to strengthen the connection between the individual and the group to which the individual identifies closely and intensely. For cliques based on racial group membership, there may be derogation of individual members who do not rigidly conform to group norms. For African Americans, these individuals may be considered "oreos" in the sense that they may be phenotypically Black, but their psychological and social identifications may be more consistent with Whites. Additionally, these abilities applied to the racial domain may underlie the competition within a group or clique over who is most closely aligned with the group and its identity. On the positive side, there may be significant social and personal rewards by closely affiliating and identifying with a social group (e.g., Oyserman, Brickman, Bybee, and Celious, 2006; Phinney, 1994). There may be an *espirit de corps* in a peer group, in which a "one for all and all for one" mentality

may be experienced. This strong affiliation to the group helps build and strengthen an identity with that group. Nonetheless, youth demonstrate awareness of the pressure to conform to group norms, as suggested in the following quote.

> Youth: [If you hung around a group of Whites, what would happen?] The Black people would probably think I don't like Black people, I want to be White.

Whereas the social perspective allowed children during pre- and early adolescence to understand social dynamics in inter-racial interactions, the tendency for these children was to view bias as happening in isolated events, and that individuals were acting on their own individual interests. With racial group consciousness (Quintana, 1998), the adolescent is beginning to appreciate the role of collective racial interests in inter-racial interactions. That is, the adolescent is able to infer generalized attributes about peer groups, which can include the perception that there may be group interests associated with racial group membership. Inter-racial interactions, therefore, become not just interactions between two individuals, but as interactions between two racial groups, which have a history of intergroup relations. Individual interactions between strangers, therefore, are understood as occurring in the context of a long history of relationships between racial groups. Previous experiences and stereotypes, among other sequelae of the legacy of inter-racial relationships, are brought to life in the inter-racial interaction between two individuals. Different interpretations of the role of individual responsibility for the legacy of slavery and bias stem, in part, from different levels of perspective-taking. The ability to hold Whites responsible for the prior actions of their racial group requires Level 3 racial perspective-taking ability, but many Whites have not obtained this level, and consequently, do not understand their connection to the past and refuse to be held responsible for past actions or even contemporary actions of other members of their racial group.

Another important advance associated with Level 3 perspective-taking ability is the appreciation that the actions of an individual can influence how others perceive the larger racial group. To explain, African American adolescents can appreciate that the actions and portrayals of another African American, for example, in the media, will influence how members of other racial groups will view their racial group and also, by extension, how the adolescents themselves are viewed by other racial groups. In short, they are better able to understand how isolated events or actions can be generalized by others into racial stereotypes and how those stereotypes are maintained. The follow quotes are illustrative.

> Youth: [Why are some people racist?] Because if a Black person did something to them, they'll say all of the other Black people will do the same thing.
> Youth: [Why do some Whites not like Blacks?] Because in school somebody was messing with you that's a Black person and that White

person might not like the rest of the Black or the Blacks might not like the rest of the Whites because they messed with each other and Black people never like each other, it's always Black on Black fight.

Importantly, this ability to generalize across discrete events helps adolescents better anticipate and identify those who may discriminate against them or their racial group. As described above, the ability to more efficiently infer who may harbor racial prejudice will allow for the application of racial narratives associated with discrimination to current situations and interactions.

Together, applying these social cognitive abilities to the racial domain provides for more complex racial narratives. For example, the discrimination narrative described above for the social perspective may reflect that children may be aware that some Whites are prejudiced and act in biased ways, but these events were seen as somewhat isolated and unpredictable. However, with the social cognitive abilities associated with racial group consciousness, the adolescent is better able to anticipate who may be more prone to bias.

Another important consequence of the ability to generalize across discrete elements is that for the racial group consciousness level, there is a merging of individual narratives and prevalent racial group narratives. Now that adolescents may closely identify with their racial group, they can adopt the narratives of the racial group as their own narratives. Identifying commonalities and merging identities with a racial group allows adolescents to draw inspiration and connection to historical racial narratives, such as the civil rights struggle and identify with racial group heroes that may include civil rights leaders. Identifying with the civil rights struggle and their leaders allows Africa American youth to apply those powerful narratives of struggle for justice to their own lives. At this level, adolescents can perceive the connection between their own experiences and the experiences of other members of the racial group, including historical figures. The following quotes reflect a merging of personal sense of self with racial group membership, with the latter two quotes suggesting individual actions that mirrored the actions of civil rights movement.

Youth: [What does it mean to be Black] It means to be proud about who you are, and what you are.
Youth [What does it mean to be Black?] It means stand up for your rights, don't let nobody judge who you are, just believe in yourself.
Youth: [What does it mean to be Black?] It means that you should respect who you are and what you do and don't let anybody put you down because of your skin color, and Black is a wonderful color to be cause I'm proud to be Black.

Moreover, racial *espirit de corps* and strong racial group consciousness allows the adolescent to act as if the experiences of other members of their racial group had happened to the individual: injury to one is injury to the entire racial group.

This merging of experiences allows for the further development of racial narratives associated with a variety of common inter-racial and intra-racial dynamics. Below an African American youth suggests a narrative that translates how peer segregation can lead to racism.

> Youth: [How do people become racist?] They might have White friends and not, they [the friends] could be racist or something and they'll make her go against her [Black] friends and then she won't have any friends except for them.

Level 3 racial perspective-taking abilities also allow the youth to reflect on their own racial group and, at times, be critical of some tendencies, as illustrated below.

> Youth: [How are Blacks and Whites different?] Only the Black people mess with their own race.
> Youth: [Why would someone not like being Black?] Because they think every time something comes up all the Whites get something better than us and if we need something they'll get it and we don't.

At Level 3 of perspective-taking ability, several responses suggested some essentialistic thinking about race and racial group differences. These responses emerged in response to youth's responses to a hypothetical situation in which a Black child was adopted by a White family, but did not discover her race until later. The question was designed to assess for children's understanding of the role of a racial identification, in this case, knowing your racial status, relative to parental socialization. The follow responses suggest that the children believe there is some racial essence to African Americans, and that this essence is associated with racial self- consciousness.

> Interviewer: Pretend that a Black child was adopted by a White family but did not know what her racial status was until one day she discovered she was Black. How would she be different because she now knows she's African American?
> Youth: She would just feel like a whole different person, she wouldn't be herself, she would start acting all strange and stuff, just wouldn't be herself.
> Youth #2: Yes, because she thought she was probably Mexican or mixed or something all that time, and she's just now finding out she's Black or whatever color she is, she'd just be a whole new person, she would just change her ways and thinking.

Racial consciousness of these two Black youth is seen as a critical essence of what it means to be African American. This racial self-awareness seems consistent

with the models of racial identity. In early childhood, the essence of being Black was associated with physical or biological status, but later in adolescence, the essence underlying race is racial identity or racial self-consciousness. The basis of this essentialistiic thinking is consistent with the tendency to derogate those African Americans who are perceived as selling out their racial group by labeling them as "oreos." These "sell outs" lack a critical essence of what it means to be African American: strong self-identification with their racial group and strict adherence to racial group norms.

Level 4: Pluralistic and In-depth Perspective

The highest level perspective-taking ability is less well-defined than the lower levels because interviews assessing the model are based on high school or younger populations, and this level may not appear fully until late adolescence or early adulthood. To some extent, the highest level of development for other racial identity models also seems less well-defined than the earlier levels of development (e.g., Helms, 1995).

In the current model, the other levels of racial perspective-taking ability were formulated based on normative development of social perspective-taking ability that was applied to the racial domain. For Level 4, the social perspective-taking ability is described as pluralistic and in-depth perspective (Selman, 1980). The main features of Level 4 social cognition are an appreciation for pluralistic group formation and dynamics. Whereas for Level 3, dissension from group norms was viewed as a threat to group cohesion, diversity within and across groups is valued and appreciated. Differences within groups are viewed as potential strengths of the group; in-group diversity can lead to higher functioning groups and facilitate the group's adjustment to new situations and contexts. Conversely, group homogeneity is viewed as leading to stagnation and suppression of individuality of group members. Applying these principles of a pluralistic perspective of group formation and dynamics to the racial domain would lead to the young adult being able to view him or herself and inter-racial and intra-racial relationships from a more pluralistic or multicultural perspective. A pluralistic perspective allows the young adult insight into the strengths and challenges of his or her racial group, as well as that of others. The young adult can appreciate the multiplicity of ethnic and racial influences, such that contact with other racial groups can lead to the cultivation of biculturalism or multiculturalism in terms of lifestyle, worldviews, and sense of self. Consequently at this level of development, the ways the individual differs from his or her racial group is no longer viewed as a source of embarrassment as it might have been at Level 3, but is better integrated into a racial identity. Being able to draw from a diverse array of socialization sources, the young adult at this level of development may express his or her racial identity in more fluid ways with more tailoring of racial self expression to diverse settings, situations, and contexts. Inter-racial

relationships will be viewed with greater nuances than at Level 3, such that other racial groups will be viewed as being less monolithic.

This more nuanced experience of other racial groups may lead to some evolution in the orientation toward other groups, particularly those groups for which a person's racial group has experienced conflict. That is, there may be some reconciliation and forgiveness in the relationships and orientation toward racial groups. At this level, similar to the level of reconciliation described by Kelman (2006, p. 23) between ethnic groups in conflict:

> The primary feature of that change in identity is removal of the negation of the other as a central component of each party's own identity. Such a change implies a degree of acceptance of the other's identity, at least in the sense of acknowledging the legitimacy of the other's narrative without necessarily agreeing with it.

At earlier levels of development, there is often in-group bias and/or out-group derogation such that collective self esteem is bolstered by the negative or dismissing orientations toward other group(s). In contrast, a more pluralistic perspective is assumed in which the sense of racial identity is based not on a rejection of the legitimacy of another racial group, but on some *rapprochement* or reconciliation with other racial groups. The African concept of *Ubuntu* is consistent with this level of racial identity development:

A person with Ubuntu is open and available to others, affirming of others, does not feel threatened that others are able and good, for he or she has a proper self-assurance that comes from knowing that he or she belongs in a greater whole and is diminished when others are humiliated or diminished, when others are tortured or oppressed. (Tutu, 1999)

At Level 4, therefore, there is a sense of belonging to a larger society than merely a racial in-group and that the dehumanization of another, even if from a racial out-group, diminishes the humanity of the self, even if the out-group had dehumanized the person's in-group. Paolo Freire argues:

> Because it is a distortion of being more fully human, sooner or later being less human leads the oppressed to struggle against those who made them so. In order for this struggle to have meaning, the oppressed must not, in seeking to regain their humanity (which is a way to create it), become in turn oppressors of the oppressors, but rather restorers of the humanity of both. (Freire, 1993, p. 44)

The higher level of racial identity restores some fundamental psychological and social aspects of functioning that were threatened through racial stigmatization. Specifically, racism, discrimination, stereotyping, and stigmatization function to dehumanize members of a target group. Racial identity development involves the process for responding to, by coping with and healing from, this dehumanization.

Consequently, the higher levels of perspective-taking involve reclaiming one's humanity in a more complete way than was possible at previous levels.

Chandler and Quintana (2009) suggest movement to a higher level of racial identity development can involve some racial forgiveness for previous transgressions. They emphasize that such forgiveness is not forgetting about the racial transgressions, absolving others for transgressions or even relinquishing the right to seek justice for previous transgressions and working to prevent further transgressions or injustices. Instead, the racial forgiveness is intended to help the target's healing and moving beyond the intense emotional reactions provoked through racial transgressions. Chandler and Quintana draw on powerful examples of racial and ethnic forgiveness in South Africa (Truth and Reconciliation Commission) and Rwanda. Racial forgiveness establishes or re-establishes a sense of *ubuntu* to the person and to the person's social relationships. Clearly, living consistent with *ubuntu* does more than simply restore what was threatened through racial stigmatization. The higher levels of development involve themes of redemption in racial identity. Racial identity not only restores the sense of humanity that was threatened by racial transgressions, but that by experiencing the challenges from racial stigmatization, the person is more able to appreciate and draw out his or her own humanity as well as that of others. That is, a deeper consciousness of a sense of humanity is achieved from the struggle and challenge to reclaim one's own humanity in the context of a biased society. Moreover, this developmental trajectory does not end with restoring a sense of one's own humanity, but by treating others and other groups with this same respect and dignity in a way that promotes more collective growth in the community. Additionally, by forgiving others for their transgressions, the person can free him or herself from the resentment that holds him or her back from achieving higher levels of personal effectiveness and functioning.

The other side of the growth manifest in Level 4 is an in-depth appreciation of the diversity within oneself. As opposed to Level 3 in which persons attempted to conform to some racial ideal or norms, the person functioning at Level 4 is able to appreciate the pluralistic nature of the self. With a Level 4 perspective, the person is able to integrate areas of privilege with those social identities which are stigmatized. There is a greater awareness of the intersections of social identities. With this greater appreciation for one's own complexity in terms of cultural experiences, the person functions with fluidity among social identities while being committed to understanding the experiences of others with different social identities. Connection among and between social identities, along with respect for critical differences between social identities, is appreciated and celebrated. At this level, some of the essentializing that was pronounced at previous levels is less relevant in the person's sense of self.

These somewhat ideal and aspirational notions of racial perspective-taking ability make possible new racial identity narratives. These narratives are lived and constructed by the leaders and peace-makers who were able to approach inter-racial conflict in new ways and bring about some reconciliation in areas where many

others had failed. These are those leaders who were able to engage in dialogues, listening carefully to the experiences of others around them in a way such that they were able be changed by what they heard. These new narratives can be transformational, being able to cut new paths for inter-racial relations. More research is needed to understand this level of racial identity development.

References

Averhart, C. J., and Bigler, R. S. (1997). Shades of meaning: Skin tone, racial attitudes, and constructive memory in African American children. *Journal of Experimental Child Psychology, 67(3)*, 363-388. doi:10.1006/jecp.1997.2413.

Banks, W. (1976). White preference in Blacks: A paradigm in search of a phenomenon. *Psychological Bulletin, 83(6)*, 1179-1186. doi:10.1037/0033-2909.83.6.1179.

Boykin, A., Jagers, R. J., Ellison, C. M., and Albury, A. (1997). Communalism: Conceptualization and measurement of an Afrocultural social orientation. *Journal of Black Studies, 27*(3), 409-418. doi:10.1177/002193479702700308

Brooks, Peter (1984). *Reading for the plot: Design and intention in Narrative*. New York: Random House.

Brown, C. (2008). Children's perceptions of racial and ethnic discrimination: Differences across children and contexts, pp. 133-153. In S. M. Quintana and C. McKown (Eds.) *Handbook of race, racism, and the developing child*. Hoboken, NJ: John Wiley.

Brown, C., and Bigler, R. S. (2005). Children's perceptions of discrimination: A developmental model. *Child Development, 76(3)*, 533-553. doi:10.1111/j.1467-8624.2005.00862.

Chandler, D. Quintana, S. M., and Owen, A. D. (2006). Racial Identity, transgressions, and forgiveness for HBCU students. Symposium Presentation at the Annual Convention of the American Psychological Association, August, 2006, New Orleans.

Clark, K. B., and Clark, M. P. (1939). Segregation as a factor in the racial identification of Negro preschool children. *Journal of Experimental Education, 8*, 161-163.

Cross, W. E., Jr. (1995). The psychology of nigrescence: Revising the Cross model, pp. 93-122. In J. G. Ponterotto, J. M. Casas, L. A. Suzuki, and C. M. Alexander (Eds.), Handbook of multicultural counseling. Thousand Oaks, CA: Sage.

Cross, W. E., Jr. and Cross, T. B. (2008). Theory, research, and models. In S. M. Quintana and C. McKown (Eds). *Race, racism and developing child*. (pp. 154-181). New York: John Wiley.

de França, D., and Monteiro, M. (2002). Identidade Racial e Preferência em Crianças Brasileiras de Cinco a Dez Anos. Psicologia: *Revista da Associação Portuguesa Psicologia, 16(2)*, 293-323.

Eakin, P. J. (2008). Living autobiographically: How we create identity in narrative. Ithaca: Cornell University Press.

Ennett, S. T., and Bauman, K. E. (1994). The contribution of influence and selection to adolescent peer group homogeneity: The case of adolescent cigarette smoking. *Journal of Personality and Social Psychology, 67(4)*, 653-663. doi:10.1037/0022-3514.67.4.653.

Ferguson, G., and Cramer, P. (2007). Self-esteem among Jamaican children: Exploring the impact of skin color and rural/urban residence. *Journal of Applied Developmental Psychology, 28(4)*, 345-359. doi:10.1016/j.appdev. 2007.04.005.

Freier, P. (1993). *Pedagogy of the oppressed*. New York: Continuum.

Helms, J. E. (1995). An update of Helms' White and people of color racial identity models, 181-198. In J. G. Ponterotto, J. M. Casas, L. A. Suzuki, and C. M. Alexander (Eds.), *Handbook of multicultural counseling*. Thousand Oaks, CA: Sage.

Hirschfeld, L. (2008). Children's developing conceptions of race, 37-54. In S. M. Quintana and C. McKown (Eds.) *Handbook of race, racism, and the developing child*. Hoboken, NJ: John Wiley and Sons Inc.

Hughes, D., Rivas, D., Foust, M., Hagelskamp, C., Gersick, S., and Way, N. (2008). How to catch a moonbeam: A mixed-methods approach to understanding ethnic socialization processes in ethnically diverse families, pp. 226-277. In S. M. Quintana and C. McKown (Eds.) *Handbook of race, racism, and the developing child*. Hoboken, NJ: John Wiley and Sons, Inc.

Jackson, M., Barth, J. M., Powell, N., and Lochman, J. E. (2006). Classroom contextual effects of race on children's peer nominations. *Child Development, 77(5)*, 1325-1337. doi:10.1111/j.1467-8624.2006.00937.x.

Kelman, H. C. (2006). Interests, relationships, identities: Three central issues for individuals and groups in negotiating their social environment. *Annual Review of Psychology, 57*, 1-26.

Lee, D. C. and Quintana, S. M. (2005). Benefits of cultural exposure and development of Korean perspective-taking ability for transracially adopted Korean children. *Cultural Diversity and Ethnic Minority Psychology, 11*, 130-143.

Mahalingam, R. (2007). Essentialism, power, and the representation of social categories: A folk sociology perspective. *Human Development, 50(6)*, 300-319. doi:10.1159/000109832.

Major, B., Kaiser, C. R., O'Brien, L. T., and McCoy, S. K. (2007). Perceived discrimination as worldview threat or worldview confirmation: Implications for self-esteem. *Journal of Personality and Social Psychology, 92(6)*, 1068-1086. doi:10.1037/0022-3514.92.6.1068.

McAdams, D. P., and Cox, K. S. (2010). Self and identity across the life span, pp. 158-207. In M. E. Lamb, A. M. Freund, R. M. Lerner, M. E. Lamb, A. M.,

Freund, and R. M. Lerner (Eds.), *The handbook of life-span development, Vol 2: Social and emotional development.* Hoboken, NJ: John Wiley and Sons Inc.

Pahl, K., and Way, N. (2006). Longitudinal trajectories of ethnic identity among urban Black and Latino adolescents. *Child Development, 77(5)*, 1403-1415.

Quintana, S. M. (1994). A model of ethnic perspective taking ability applied to Mexican-American children and youth. *International Journal of Intercultural Relations, 18*, 419-448.

Quintana, S. M. (1998). Development of children's understanding of ethnicity and race. *Applied & Preventive Psychology: Current Scientific Perspectives, 7*, 27-45.

Quintana, S. M., Ybarra, V. C., Gonzalez-Doupe, P., and de Baessa, Y. (2000). Cross-cultural evaluation of ethnic perspective-taking ability in two samples: US Latino and Guatemalan Ladino children. *Cultural Diversity and Ethnic Minority Psychology, 6*, 334-351.

Quintana, S. M., Chun, E., Gonsalves, S., Kaeo, W., and Lung, L. (2004). Development of Native Hawaiian children's understanding of race and culture. *Hulili: Multidisciplinary Research on Hawaiian Well-Being, 1*, 173-196.

Quintana, S. M. and Chavez, T. (in press). Ethnic Identity and Socialization in Mexican American Families. In Y. Caldera and E. Trejos (Eds.) *Understanding Mexican-American Families & Children: Multi-Disciplinary Perspectives.* Thousand Oaks, CA: Sage.

Oyserman, D., Brickman, D., Bybee, D., and Celious, A. (2006). Fitting in matters: Markers of in-group belonging and academic outcomes. *Psychological Science, 17(10)*, 854-861. doi:10.1111/j.1467-9280.2006.01794.x.

Phinney, J. (1989). Stages of ethnic identity development in minority group adolescents. *Journal of Early Adolescence, 9(1)*, 34-49.

Phinney, J. (1992). The multigroup ethnic identity measure: A new scale for use with diverse groups. *Journal of Adolescent Research, 7(2)*, 156-176.

Phinney, J. (1996). When we talk about American ethnic groups, what do we mean? *American Psychologist, 51*, 918-927.

Samson, D., and Apperly, I. A. (2010). There is more to mind reading than having theory of mind concepts: New directions in theory of mind research. *Infant and Child Development, 19(5)*, 443-454.

Seaton, E. K. (2009). Perceived racial discrimination and racial identity profiles among African American adolescents. *Cultural Diversity and Ethnic Minority Psychology, 15(2)*, 137-144. doi:10.1037/a0015506.

Selman, R. L. (1979). Assessing interpersonal understanding: An interview and scoring manual. Cambridge, MA: Harvard-Judge Baker Social Reasoning Project.

Selman, R. L. (1980). The growth of interpersonal understanding: Developmental and clinical analyses. San Diego, CA: Academic Press.

Smith-McLallen, A., Johnson, B. T., Dovidio, J. F., and Pearson, A. R. (2006). Black and white: The role of color bias in implicit race bias. *Social Cognition, 24(1)*, 46-73. doi:10.1521/soco.2006.24.1.46.

Tajfel, H. (1978). Social categorization, social identity, and social comparison, pp. 61-76. In H. Tajfel (Ed.), Differentiation between social groups: Studies in the social psychology of intergroup relations. London: Academic Press.

Tutu, D. (1999). No future without forgiveness. Ann Arbor, MI: Doubleday.

Part Five

African American Racial Identity and Influence on Educational Behavior

Chapter Thirteen
Racial Identity as a Buffer to Discrimination among Low Income African American Adolescents: An Examination of Academic Performance

Debra D. Roberts and Ronald D. Taylor

Introduction

The disparity in academic performance among various ethnic groups in the United States continues to be one of the major concerns in the study of adolescent achievement (Ogbu, 2003; Redd, Brooks and McGarvey, 2002; Steinberg, Dornbusch and Brown, 1992). Of particular concern is the pattern of comparatively poor performance of African American youth. Although educational achievement among African Americans has steadily increased over the past few decades, narrowing the gap between White and Black academic success (Child Trends, 2003), this achievement gap still persists.

The underachievement of African American adolescents has historically been attributed to genetic and social/environmental factors (Jensen, 1969; Herrnstein and Murray, 1994). However, exploring academic performance within the context of social/environmental factors (e.g., living in a culturally hegemonic society) affords us the opportunity to develop successful intervention strategies, which can help to ensure that the academic performance of these youth parallels that of other ethnic groups. Expanding on Bronfenbrenner's (1989) seminal work on the ecology of human development, several researchers have stressed the importance of using such an ecological framework in the study of child development. This approach seems critical when attempting to examine the development of the minority child living

in a culturally hegemonic society, in which they are often exposed to psychosocially toxic environments (PTEs) including poverty, discrimination, violence and less -than- adequate living conditions.

Consistent with demographers' projections that over 50 percent of American youth will belong to minority groups by the mid twenty-first century, recent census data reflect a major shift in the ethnic and cultural make-up of youth in this society (U.S. Census Bureau, 2010). Therefore, it is reasonable to conclude that the economic future of this country will depend heavily on the quality of young people produced in the minority community, as projected many decades ago (Neisser, 1986). Recent reports of the dismal academic performance of American youth, compared to other industrialized nations, highlight the potential impact of this trend. However, many barriers to academic success exist for African American youth in a society that is often intolerant of differences (Spencer, Cunningham and Swanson, 1995; Spencer and Dornbusch, 1990). Some of these barriers include poverty and discrimination (Byrd and Chavous, 2009; Jackson et al., 1997; Thomas, Caldwell, Faison and Jackson, 2009).

Given the view of some researchers (Ogbu 1978, 1986; Spencer, Cole, DuPree, Glymph, and Pierre, 1993; Spencer and Dornbusch, 1990; Taylor et al., 1994) that the persistent underachievement of African American youth is an adaptive response to limited social and economic opportunity, one can reasonably assume that these barriers to academic achievement must be addressed at the societal and/or individual levels to ensure that academic success is an attainable goal for all groups within society. However, addressing barriers to academic success at the individual level within the African American community demands an understanding of the impact that discrimination can have on psychosocial functioning. Few studies have considered intragroup variability among African Americans as a means of gaining insight into the effects of discrimination on academic performance. Clearly, some African American youth succeed academically in spite of discrimination, whereas other adolescents are academically unsuccessful in the midst of PTEs. Research demonstrates that successful adolescents may be insulated against the debilitating effects of discrimination (Clark, 1991; Seaton, Caldwell, Sellers, and Jackson, 2010). Hence, one strategy for removing barriers to academic success is to discover factors that buffer the youth against these negative effects (Spencer et al., 1993; Spencer et al., 1995; Cady et al., 2009). Some researchers have suggested that a positive sense of group identity can indeed insulate African Americans against the negative effects of discrimination (Howard et al., 2004; Jordan, 1981; Spencer et al., 1995; Thomas et al., 2009).

In an effort to further explore the buffering effects of racial identity, this paper examines the linkages between discrimination, racial identity, and academic performance. Throughout the paper, the term *discrimination* is used to denote the unfavorable treatment which African Americans endure within the larger society based solely on race or ethnicity, and the terms *racial identity* and *ethnic identity* are used interchangeably in reference to that component of the self which has a sense

of belonging to a group based on common ancestry (Phinney and Rotheram, 1987). It is hoped that the current research will contribute to our understanding of the complex relationships between racial/ethnic identity and psychosocial adjustment among African Americans within the context of a culturally hegemonic society where they are disproportionately exposed to psychosocially toxic environments. Guiding Theoretical Framework

Historically, some researchers have examined the ethnic gap in academic achievement from a deficit perspective (Herrnstein and Murray, 1994; Rosenberg and Simmons, 1972). Over the past few decades, a handful of researchers have made significant contributions to the field by proposing conceptual models of development that consider the proximal and distal ecologies affecting children of color (Garcia Coll et al., 1996; Spencer, Dupree and Hartman, 1997). These contextual models incorporate some useful tenets of important works, such as "ecological theory" (Bronfenbrenner, 1977; 1989); however, they place special emphasis on "constructs salient only to populations of color (e.g., racism) that contribute unique variance to their developmental processes" (Garcia Coll et al., 1996, pg. 1895). Margaret Spencer and her colleagues (1993) presented a "phenomenological approach to an ecological systems theory of human development" that has been used to generate empirical studies explaining the achievement and health outcomes of urban African American youth. In 1996, Garcia Coll et al. presented a conceptual model for the study of developmental competencies in minority children. Cautioning researchers against falling back into the trap of using traditional models to explain the normative development of minority children, Garcia Coll and her colleagues (1996) revisited some of the central themes in earlier works. Most notably, emphasis was placed on considering the effects of both proximal and distal factors on child development. The authors also stressed the importance of considering process rather than outcomes in our study of these children, and they emphasized that we pay more attention to intragroup variability. In addition, the model provides some guidelines for examining the intersection of class, culture, ethnicity, and race for use in the study of children of color. The emphasis on a process-person-context relationship is important in the study of minority youth, as it considers how these adolescents come to understand society, how they interpret the experience of being a minority in a culturally hegemonic society, and how this interpretation influences the individual's development. Using these models as a guideline, the conceptual model displaying the predicted relationships among the variables of interest in our study is presented in Figure 13.1.

In 1972, Rosenberg and Simmons noted that Black children, as a group, tend to perform worse than White children, whether assessed by standardized tests or other measures. Over a decade later, Boykin (1985) expressed concern for the educational plight of African American children. He stated that the "academic performance of minority children remains a persistent, troubling, and seemingly intractable national problem" (p. 57). More recently, this concern was echoed by

Mickelson (1990) who reported that African American students "generally earn lower grades, drop out more often, and attain less education than do whites" (p. 44). These sentiments are echoed in the findings of other empirical studies, which indicate that achievement differences between African American and White youngsters begin in elementary school, persisting throughout all grade levels (Humphreys, 1988; Norman, 1988); and the disparity is quite substantial by the teenage years (Armor, 1992; National Center for Education Statistics, 2003).

Figure 13.1: Conceptual Model of Racial/Ethnic Identity as a Buffer to Discrimination

Sadly, many of these observations still ring true in the twenty-first century. For example, recent reports of high school graduation rates have been reported as low as 50 percent for Black students; only 13 percent of Blacks in the fourth grade are reading at grade level compared to 41 percent of their White peers; and 17 percent of Black students were retained for at least one grade in grades K-12, compared to only 9 percent among White students (Children's Defense Fund, 2004). Whereas ethnic differences in academic competence are found at every socioeconomic level, economically disadvantaged African American youth seem to suffer the greatest consequences (Connell, Spencer and Aber, 1994; Crocker and Major, 1989; National Center for Education Statistics, 2003; Spencer et al., 1993), consistent

with the finding that poor children are three times as likely to drop out of high school as are non poor children (Children's Defense Fund, 2004).

Many writers posit that discrimination impacts academic success in a number of ways (Fordham and Ogbu, 1986; Ogbu, 2003). Based on several national studies, researchers consistently report that large numbers of Blacks (compared to members of other ethnic groups) continue to report that they have been treated badly because of their race (Gee et al., 2006; Jackson et al., 1997; Sigelman and Welch, 1991; Williams and Chung, 1997). However, as indicated by the Committee on National Statistics' initiative in convening a panel of scholars to consider the definition of racial discrimination (National Academy of Sciences, 2003), the term "discrimination" is not clearly defined in the extant literature. This lack of clarity becomes problematic when addressing the broad scope and negative impact of discrimination at the institutional and personal levels. Whereas systematic and personal experiences of racism are different, both forms are potentially harmful to the individual and thus considered for the purposes of this study. According to Simpson and Yinger (1965), systematic discrimination is the devaluation of minority groups to maintain the system of cultural hegemony or domination. Discrimination contributes to the pervasiveness of poverty within racially and economically segregated African American communities (Simpson and Yinger, 1965).

Since the historic decision to mandate school desegregation as a result of the landmark case of *Brown vs. the Board of Education* (1954), studies have sought to examine the link between discrimination and academic underachievement. Some have found that racial and economic segregation has a detrimental effect on academic competence among African American students (Yancey and Saporito, 1994). Others found that discrimination itself is an "environmental stressor," which adversely affects students' academic performance by reducing their willingness to persist at academic tasks, and that it interferes with the cognitive processes involved in learning (Boykin, 1985; Gougis, 1985; Massey and Denton, 1993; Ogbu, 1986; Ogbu, 2003). Whereas some findings suggest a direct link between systematic discrimination and academic success, others indicate that perhaps discrimination also affects academic performance indirectly by contributing to the student's negative self-concept, which in turn can lead to poor academic performance. Either way, it is clear that discrimination is indeed a barrier that African American youngsters must overcome in order to succeed academically, as well as within the larger society.

Self-Concept

Self-concept is an overall view of self that consists of self-awareness or self-knowledge that is derived from a history of interactions with others and the evaluation of one's coping ability (Powell, 1989). According to Cross (1987), global self-concept consists of two sets of components: (1) personal identity, which

includes self-esteem, self-worth, and ego identity; and (2) reference group orientation, which includes racial identity, ethnic identity, and group identity.

Beginning with the seminal works of Kenneth and Mamie Clark (1940, 1947), for years researchers have examined the theory that discrimination may have a negative impact on self-concept and/or self-esteem among African Americans (see Cross, 1991 for a review of empirical research). The impetus for much of this research was sociologists' emphasis on the importance of "reflected appraisals" or the "looking-glass self" in the development of the self-concept (Cooley, 1956; Mead, 1934; Shrauger and Schoeneman, 1979). Cooley (1956), for example, argued that the self-concept consists of "the imagination of our appearance to the other person; the imagination of his judgment of that appearance, and some sort of self-feeling, such as pride or mortification" (p. 184). According to this perspective, members of stigmatized and oppressed groups may develop negative self-concepts, either because specific individuals with whom they interact (e.g., peers, teachers) hold negative attitudes toward them, or because members of their group are generally devalued in the wider culture, as expressed in books, television shows, and in one's entire sociocultural environment (Crocker and Major, 1994).

Several empirical studies have focused on the relationship between positive self-concept and academic achievement among African American students. Self-concept is thought to play a significant role in initiating and guiding behavior (Powell, 1989). For years, psychologists have linked self-concept with psychosocial outcome variables, including academic achievement (Areepattamannil and Freeman, 2007). Some examine the relationship between global self-concept and academic achievement (Bledsoe, 1967; Campbell, 1967; Kenny and McEachern, 2009; Pershey, 2010; Rosenberg and Simmons, 1972), and others look at the relationship between the various components of self-concept and academic achievement (Chung and Sedlacek, 1999; Gurin and Epps, 1975; Jordan, 1981; Lay and Wakstein, 1985; Mboya, 1986; Sedlacek and Brooks, 1976; Tracey and Sedlacek, 1984). Based on the aforementioned studies, there is ample support to suggest that academic self-concept is indeed linked to academic performance.

Racial/Ethnic Identity, Self-Concept and Academic Performance

The terms ethnicity and race are somewhat interchangeable in that the definition of ethnicity includes race as well as customs, language, and ancestry of a group of people. Ethnic identity refers to one's sense of belonging to a group based on common ancestry (Rotheram and Phinney, 1987). It is comprised of several components including ethnic awareness, ethnic self-identification, ethnic attitudes and ethnic behaviors. Individuals who feel a strong sense of belonging to their ethnic or racial group of origin are considered to possess a strong racial and/or ethnic identity, whereas those who do not feel strongly attached to their ethnic or racial community are considered to possess a weak identity (Rotheram and Phinney, 1987).

Whereas ethnic identity is an important component of self-concept that can be linked to a number of psychosocial variables, ethnic identity is particularly salient to the study of African American adolescents (Aries and Moorehead, 1989; Harris et al., 1995; Osyerman, et al., 1995; Spencer, Swanson, and Cunningham, 1991). Adolescence is described as a potentially difficult period for any youth; a period when a normative "identity crisis" is experienced and involves the exploration of many new roles in preparation for adulthood (Erikson, 1968). For African American youth, the challenges of this developmental period are exacerbated due to discrimination and other barriers to personal growth (Aries and Moorehead, 1989; Garcia Coll et al., 1996; McLoyd and Steinberg, 1998; Spencer, 1995; Spencer and Dornbusch, 1990).

Some scholars have noted that having a strong sense of racial and/or ethnic identity inoculates African American children and youth against racial and economic oppression (Howard et al., 2004; McAdoo, 1985; Peters, 1985; Spencer, 1983). There is some consensus that the more successful African American parents are at socializing their children toward developing a sense of racial and ethnic identity, the more likely these children will grow up to be well-adjusted members of society (Hughes and Chen, 1997; Hughes and Johnson, 2001). Since ethnic identity fosters feelings of pride and self-respect concerning the features and accomplishments of one's racial group, ethnic identity may be positively related to African American adolescents' self-concept, and hence, may positively influence their school performance (Taylor et al., 1994).

Some studies examining the relationship between racial identity and academic performance have typically focused on the tendency for high achieving African American youth to identify with mainstream culture rather than their culture of origin (Fordham and Ogbu 1986). Although oppositional or "reactive" identity may serve as a form of resilience in terms of social development (Clark, 1991), the "oppositional identity" theory is limited in terms of explaining academic under-achievement among African American youth. For example, studies indicate that African American adolescents, like their White and Asian counterparts, recognize the importance of getting a good education (Mickelson, 1990; Steinberg et al., 1992), and that ethnic identity is, in fact, positively associated with adolescents' academic achievement (Taylor et al., 1994). Hence, in order to gain a better understanding of academic performance among African American youth, it is important to examine the context within which these relationships are played out.

Racial/Ethnic Identity as a Buffer to Discrimination

Many researchers theorize about the positive effects a strong sense of racial identity is likely to have on all aspects of African American life (Nobles, 1980; Seaton, Yip and Sellers, 2009; Yip, Sellers, and Seaton, 2006). Paster (1994) suggests that racial identity is one resource that Black youth can draw on in the struggle against the stressors within a culturally hegemonic society. Given the presence of discrimin-

ation and other PTEs that can contribute to the underachievement of African American youth, some researchers argue that racial identity may play a role in reversing the negative outcome of being socialized in such a hostile environment (Barbarin, 1983; Caldwell et al., 2004; Clark, 1991; Lee and Winfield, 1991; Ramseur, 1991; Seaton et al., 2009; Spencer et al., 1993; Spencer et al., 1995; White and Johnson, 1991; Wong, Eccles, and Sameroff, 2003).

As students of human development, it is imperative that we understand the buffering activities or protective factors within the African American community that foster the psychosocial well-being of African American children and adolescents (Bowman and Howard, 1985; McAdoo, 1985; Peters, 1985; Phinney and Rotheram, 1987; Spencer, 1983, 1991; White and Johnson, 1991). Spencer (1991) suggests that, due to the unique role it plays in the development of minority adolescents, ethnic identity is such a coping device. The development of racial/ethnic identity is a process involving awareness of one's connection to a group based on similar ancestry that leads to ethnic pride, which in turn bolsters self-respect (positive self-concept) that inures the individual against the debilitating forces within society. Thus, racial/ethnic identity can promote a sense of awareness about one's self-worth as related to behaviors, customs, appearance, speech patterns, ancestry, etc., that are shared by the group with which one identifies. This sense of meaning and belonging can help offset the impact of any negative views (racism) and resulting behaviors (discrimination) of the "outgroup."

Summary

Discrimination has been discussed as an impediment to academic performance, and hence, social mobility among African American adolescents. The potential buffering role of racial/ethnic identity on the effects of discrimination was also discussed. The literature suggests that among African American youth, group identity may serve to buffer the negative effects of discrimination by enhancing self concept, making academic achievement an attainable goal. In this study, the "buffering" role of ethnic identity on academic competence among economically disadvantaged African American youth was examined. The underlying hypotheses are that: (a) academic self-concept is directly related to academic performance; (b) discrimination impedes academic performance among African American adolescents; and (c) a strong sense of ethnic identity can serve as a buffer to the detrimental effects of discrimination on academic self-concept and academic performance. Finally, it was predicted that results will vary for males and females, as it has been suggested that societal influences may affect the process and outcome of psychosocial development differently for African American males and females due to a number of contextual factors (Swanson, Cunningham, and Spencer, 2003; Stevenson, 1994; Wilson and Banks, 1994).

Methodology

Sample

The subjects for this study consist of 183 African American middle and high school students (92 females, 91 males) from a large northeastern metropolitan city. Students were randomly selected from a large number of classrooms within the target schools that were purposefully selected for the study, as they were concentrated in an area with the highest 20 percent of delinquency and poverty in the city, and populated with approximately 98 percent African Americans. Thirty-seven percent (66) of the subjects came from two-parent households, and 63 percent (112) came from single-parent households. Sixty five percent (108) of the students reported that their parent(s) had a high school education or less, and more than 50 percent of the adolescents come from families that qualify for government assistance (AFDC), placing them under the poverty level.

Measures

Students were asked to report their age, sex, ethnicity, and parental level of education. Other variables of interest in this study were perceived discrimination, ethnic identity, academic self-concept, and academic performance. *Perceptions of discrimination* was assessed using a series of questions developed by McCord and Taylor (1992) to assess the degree to which individuals perceive discrimination within this society. The measure consists of fourteen true/false statements concerning society's attitudes toward, and barriers encountered by the ethnic groups of interest. The subjects in this sample indicated whether they felt the statement was true or false for both Whites and Blacks. Examples of the statements are: *Black people can get almost any job they want; Black people can eat in almost any restaurant; Black people often get hassled by the police; Black people can date almost anyone they want; Black people can get a college education if they want.* Subjects responded true or false to each question twice. The word "White" was substituted for "Black" the second time. Cronbach's alpha yielded a reliability of sixty for this sample.

The ethnic identity subscale (nine questions) of the Phinney Ethnic Identity Measure (PEIM) was used to assess *racial/ethnic identity* among students. The PEIM is a 32-item Likert questionnaire, which examines aspects of identity, including (1) the strength of identification with one's own racial/ethnic group; (2) ethnic identity search and commitment; and (3) orientation toward other groups. Subjects are asked how strongly they agree with each statement and respond using a 6-point Likert scale, ranging from strongly agree to strongly disagree. The PEIM was used in this study because it is widely used reliably with African American samples in various empirical studies. Specifically, the ethnic identity development subscale was used because it assesses the level of interest in gaining knowledge and

understanding of one's ethnicity and implications for one's own life, as well as the extent to which one has a clear sense about the meaning of one's racial/ethnic group membership for oneself (Phinney, 1992). Cronbach's alpha was .66 for this sample.

Academic self-concept was assessed using the academic self-concept subscale of the Hare General and Area Specific Self-Esteem Measure (Shoemaker, 1980). The instrument measures both global and area specific (i.e., home, school, self, and peer) self-esteem. The measure was chosen because it has been used extensively with African American adolescents and has good psychometric properties (Shoemaker, 1980). The correlation between the Hare scale and Rosenberg's (1965) general self-esteem measure has been reported as .83 in the extant literature. The reported test-retest reliability for the academic subscale and the general self-esteem measure are .61 and .74 (Shoemaker, 1980), respectively, and Cronbach's alpha = .66 for the current sample.

Academic performance was assessed using students' reports of their performance in each of the core subject areas (math, English, social studies, and science) on a four-point Likert scale from very good to very bad. Using Cronbach's alpha, a reliability of .69 was obtained.

Procedures

Data were collected during class with the teacher and two research assistants present. The research assistants, who were all African American, were trained to administer the questionnaire prior to data collection. Students were given a self-report questionnaire to complete within the sixty-minute period. One research assistant read each question and the respective choices aloud to the entire class. The students were instructed to mark their answers on the questionnaire in response to each question asked. All students were given complete instructions regarding the procedure for questionnaire completion before they began. These instructions were also read aloud by the research assistant. The second research assistant monitored the students and was available to answer student's individual questions and help students who were having trouble keeping up with the group.

Results

Preliminary Analyses

The correlations among major variables are reported for males and females in Table 13.1, and descriptive statistics for variables of interest are shown in Table 13.2. The effects of demographic variables (sex, parent education, and school) on independent and dependent variables were assessed using a 2x2x2 multivariate analysis of variance (MANOVA), followed by pairwise comparisons for significant MANOVA effects using the Tukey procedure. A dummy variable was created for parent education where the numbers 1 and 2 were assigned for subjects whose parents had

a high school education or less, and more than a high school education, respectively. Similarly, students were assigned a value of 1 for middle school and a value of 2 for high school. Males were assigned a value of 1, and females were assigned a value of 2.

Analyses revealed that sex had a significant effect on academic self-concept, F=7.34, p<.01, and academic performance F=10.49, p<.01, confirming the suspicion that females would surpass males on scores of both variables. Parental education had a significant effect on academic self-concept, F=7.97, p<.01, ethnic identity development F=13.42, p<.001 and academic performance F=6.33, p<.05, revealing that students of parents with more than a high school education scored higher on each of the variables than students of parents with a high school education or less. No school effect was found.

Table 13.1: Correlations among Major Variables for Males and Females

Variable	(1)	(2)	(3)	(4)
Males				
Females				
(1) Racial/Ethnic identity	X			
(2) Perceived Discrimination	-.02	X		
	.14			
(3) Academic Self-Concept	.29**	-.12	X	
	.13	*.09*		
(4) Academic Performance	.23**	.06	.40***	X
	.16	*.03*	*.48*****	

p<.01 *p<.001 ****p<.0001

Testing the Main Effects

Path models examining the hypothesized relationships between the independent and dependent variables were assessed using least squares regression analyses, controlling for the effects of sex, parent education and school. First, partial regression analyses were conducted for two separate paths, each depicting the relationship between one predictor variable, academic self-concept and academic performance. Then all predictors were entered into the analyses simultaneously to see if this process altered the nature of the relationships among variables. Analyses were repeated for males and females, separately. The results depicting the relationships among the variables of interest are shown in Figure 13.2.

Predictions that academic self-concept would be positively related to academic performance were supported. Adolescents' self-concept was significantly associated with academic performance (β =.48, p<.0001). Separate analyses revealed that the above relationship was significant for males (beta=.41, p<.0001) as well as for females (β =.58, p<.0001). It was predicted that adolescents' perceptions of dis-

crimination would negatively affect academic self-concept and academic perform-ance. There was no support for this hypothesis. Perceptions of discrimination was not significantly related to academic self-concept (β =.06, \underline{p}=.47) nor to academic performance (β =.11, \underline{p}=.15). It was also hypothesized that racial/ethnic identity would be positively related to academic self-concept and academic performance. Again, there was little support for this hypothesis. Racial identity was not significantly related to academic self-concept (β =.13, \underline{p}=.13). However, racial identity was positively related to academic performance (β =.21, \underline{p}=.01). Further analysis revealed that this relationship was significant for males (β =.26, \underline{p}=.02) but not for females (β =.15, \underline{p}=.23). See Table 13.3.

Table 13.2: Descriptive Statistics for Major Variables

Variable	M	SD	Range
Racial/Ethnic Identity	3.78	.82	1.0-5.75
Males	3.66	.83	1.0- 5.4
Females	3.90	.80	2.1- 5.8
Perceptions of Discrimination	15.40	2.83	7.0-24.0
Males	15.45	2.60	8.0-20.0
Females	15.36	3.06	7.0-24.0
Academic self-concept	2.91	.46	1.7-4.0
Males	2.83	.46	1.7- 3.7
Females	2.99	.46	1.9- 4.0
Academic performance	2.45	.80	0.0-4.0
Males	2.29	.73	0.0- 4.0
Females	2.61	.83	0.0- 4.0

Interaction Effects

Partial support for the predicted relationships among the interaction between ethnic identity and discrimination, academic self-concept and academic performance was found.

The path diagram depicted in Figure 13.1 above was used as a prototype to test the moderating effect of racial/ethnic identity on the association between dis-crimination and the outcome variables (academic self-concept and academic performance).

Figure 13.2: Results Depicting Relationships Among Variables of Interest

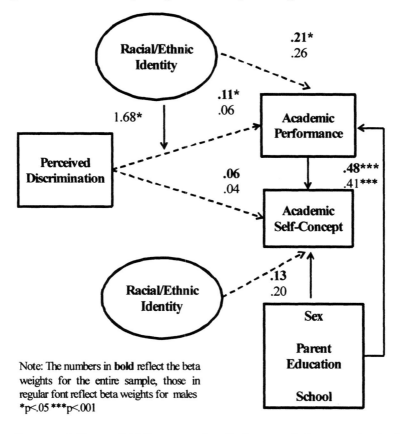

Note: The numbers in **bold** reflect the beta weights for the entire sample, those in regular font reflect beta weights for males
*p<.05 ***p<.001

Baron and Kenny (1986) suggest that "a framework for capturing both the correlation and the experimental views of a moderator variable is possible by using a path diagram as both a descriptive and an analytic procedure." Within this framework, moderation implies that a causal relation between two variables changes as a function of the moderator variable. According to Aiken and West (1991) regression analyses can be used to effectively test the effects of a moderator variable and independent variable upon a dependent variable. Moderation would be indicated by a statistically significant effect of the interaction between the moderator and independent variables on the criterion or dependent variable. The interaction term would be created by multiplying the moderator and the independent variable.

Table 13.3: Regression of Academic Performance
on Ethnic Identity Development

Independent Variable	B	β	T
Entire Sample			
Ethnic Identity Development	.19	.21*	2.56
Sex	.35	.23**	2.83
SES	.09	.17	2.07
School	.09	.06	.80
$R^2 = .12$			
$F(4, 143) = 6.10$****			
Males			
Ethnic Identity Development	.23	.26*	3.40
SES	.12	.23*	2.07*
School	.06	.04	.37
$R^2 = .11$			
$F(3, 74) = 4.32$**			
Females			
Ethnic Identity Development	.14	.15	1.22
SES	.06	.11	.89
School	.14	.09	.75
$R^2 = .01$			
$F(3, 66) = 1.28$			

*$p<.05$ **$p<.01$ ****$p<.0001$

Given the above explanation, least squares regression was used to test the hypothesis where the independent variable was discrimination, the moderator variable was racial/ethnic identity, and the criterion was either academic self-concept or academic performance. Using perceived discrimination in the regression analysis, there was no significant relationship between the interaction term and academic self-concept. However, separate analyses revealed a significant inter-action effect on academic performance for males ($\beta =1.67$, $p< .05$) but not for females ($\beta =-.39$, $p=.68$), confirming the prediction that the buffering effects of ethnic identity are more visible for males than for females (see Figure 13.2 above). The results indicated the slopes of perceived discrimination at different levels of ethnic identity are significantly different from one another. Results of regression analyses for the interaction effect are shown in Table 13.4.

Table 13.4: Regression Model Showing Effects of Interaction on Academic Performance for Males

Independent Variable	B	β	T
Ethnic identity development	-1.11	-1.25	-1.93
Perceptions of discrimination	-.28	-1.01*	-2.07
Interaction	.08	1.68*	2.26
(Ethnic ID X Discrimination)			
Academic self-concept	.69	.43	3.97
SES .08		.14	1.37
School	.07	.05	.50

$R^2 = .33$
$F(6, 76) = 5.83$****
*p<.05 ****p<.0001

In order to further investigate the interaction effect for males, academic performance was regressed on ethnic identity development at three different levels of perceived discrimination: (1) one standard deviation above the mean (Z_H); (2) the mean (Z_M); and one standard deviation below the mean (Z_L). Cohen and Cohen (1983) suggest that the above three conditional values of the third variable (perceived discrimination in this case) be used when no scientific rationale exists to guide the choice of these values.

For each level of perceived discrimination, a new variable (Z_{cv}) was created by subtracting the conditional value of perceived discrimination from the variable "perceived discrimination." This new variable was then reentered into the original regression equation replacing the variable "perceived discrimination." The analyses indicated the slopes of the regression lines for ethnic identity at $Z_H(\underline{b}=.35, \underline{p}<.01)$ and $Z_M(\underline{b}=.21, \underline{p}<.05)$ were significantly different from "0" and that the slope of the regression line for ethnic identity at $Z_L(\underline{b}=.07, \underline{p}>.05)$ was not significantly different from "0." These analyses suggest that ethnic identity development had more of an effect on academic performance at high levels of discrimination than at lower levels of discrimination. These results are depicted in Figure 13.3.

Discussion

Given recent demographic shifts and the changing distribution of the African American population in the United States, it is clear that America's future depends, in part, on our ability to produce African American youth who are competent citizens within our society and even globally. This challenge is somewhat daunting, given the many barriers to academic success for African American youth. These

barriers include socioeconomic disadvantage and discrimination. The current study examined the hypothesis that racial/ethnic identity can buffer the negative effects of discrimination on academic self concept and academic performance among African American adolescents.

Figure 13.3: Effect of Ethnic Identity (axis X) on Academic Performance (axis Y) at Various Levels of Discrimination (slope) for males

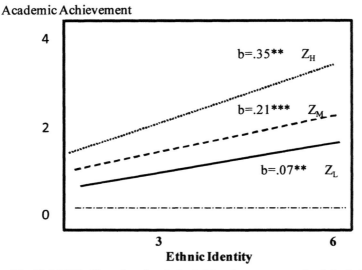

Academic Achievement

Note: ZL, ZM, ZH indicate levels of ethnic identity at one standard deviation below the mean, at the mean, and one standard deviation above the mean, respectively. **p <.01 ***p<.001

Consistent with the extant literature, females scored higher than males on both academic self-concept and academic performance. Academic self-concept was positively related to academic performance, and racial/ethnic identity was positively related to academic performance for all subjects. Also, the interaction between racial/ethnic identity and perceived discrimination was associated with academic performance for males. That is, the positive relationship between identity development and academic performance was stronger as levels of perceived discrimination increased.

The Buffering Effect of Racial/ethnic Identity

The discrepancy between males and females on scores of self-concept and academic performance supports the theory of some scholars that African American

males are more at risk for negative psychosocial development due to many obstacles present in society. In the absence of much empirical research that examines the processes underlying the differences in psychosocial development of African American males and females, explanations for the discrepancy in scores are only speculative. Perhaps society has marginalized the African American male, as suggested by Miller (1994), to the point where their psychosocial development consistently lags behind that of the African American female. Clearly, more empirical research is needed to further investigate the causes for the gap between African American males and females on scores of academic self-concept and performance. Consistent with the findings of Stevenson (1995) and Spencer (1995), African American males may use different methods of coping with the harsh reality of living in a culturally hegemonic society. Although ethnic identity was positively related to academic performance for the entire sample, separate analyses revealed that this relationship was strongest among males. Furthermore, racial/ethnic identity seems to significantly buffer the negative effects of discrimination on academic performance for males but not for females. It is plausible that, for males, academic success demands that one develop a positive sense of self as an African American to a greater extent than females in a society that devalues African Americans, and that particularly devalues African American males.

The hypothesis that racial/ethnic identity acts as a buffer is based on the assumption that discrimination has a negative impact on the academic performance of African American youth.

Our finding that perceived discrimination does indeed have such an effect may imply that, for African American adolescents, abstract attitudes about discrimination are indeed a reflection of their own personal experiences with discrimination within the larger society. For example, a person of any race or ethnic background may score high on the perceived discrimination scale if they acknowledge the fact that discrimination against African Americans exists within society. However, the salience of this acknowledgment for an African American adolescent lies in the potential of this realization to affect the student's behavior. Given the findings of Taylor et al. (1994) that perceptions of discrimination are negatively related to school engagement for African American, but not for White adolescents, it is clear that more empirical research is needed to determine whether students' actual reported experiences with discrimination is indeed a better predictor of academic performance than perceived discrimination.

Although our study suggests that identity can indeed serve as a protective factor among African American youth who are exposed to PTEs, our universal measures of identity should capture both reactive and proactive forms of identity. This, however, is not an easy task. The complex history of African Americans in this country demands that cultural factors (i.e., spirituality, ancestry, rituals, etc.) other than race and ethnicity be examined as potential buffers to PTEs. In the previous section we discussed the fact that available measures of ethnic identity are limited in their ability to identify the components of ethnic identity that may be crucial in our effort to produce resilient youth. Research on racial socialization

suggests that there are many ways in which African American families socialize their children to survive in a racist society. Paster (1994) alludes to the fact that simply asking an individual to share his attitude toward his own racial group and an out-group does not tell us much about that individual's dependence on the strengths within his own culture to buffer the negative forces within society. We must develop measures that tap into the relevance of all aspects of culture as opposed to those that focus on the physical differences between Blacks and Whites.

Finally, the significant effect of the interaction term on academic performance can be interpreted in two ways: (1) as levels of perceived discrimination increase, the magnitude of the positive relationship between ethnic identity and academic performance increases; or (2) as levels of ethnic identity increase, the relationship between discrimination and academic performance changes. The results seem to favor the first interpretation. Although there was no support for the second interpretation of the interaction effect, one could speculate about the implications of such a finding. Cohen and Cohen (1983) remind us that it is important to consider both interpretations as each may reflect the social relevance of the questions asked.

For example, if the relationship between discrimination and academic performance became more negative as levels of ethnic identity increased, then this would be consistent with the hypothesis that ethnic identity buffers the effects of discrimination. If, however, the relationship between discrimination and academic performance became more positive as levels of ethnic identity increased, then one must consider not only the possible buffering effects of ethnic identity but also the possibility that a positive ethnic identity can heighten one's awareness of discrimination. Hence, more empirical research is needed that examines the true buffering effects of ethnic identity.

Limitations of the Study

Findings of our study have implications for developing strategies to buffer the effects of discrimination among low income African American youth. However, given the limitations of the current study, caution must be exercised in interpreting the findings. First, the self-report method of data collection can only tell part of the story. The use of only self-report measures for student academic performance brings validity of this construct into question, as one could argue that the measures are not a true assessment of the student's academic ability. Although a relatively high correlation is reported in the literature between actual and self-reported measures in some cases (for grades), future research should consider the use of actual measures of the constructs, or the method of triangulation (using parent and/or teacher assessment) to increase the validity of the study. In light of these limitations, however, it is important to consider the fact that self-report measures provide an important window on the process associated with achieving the grades.

Given the variety of contexts to which these adolescents are exposed, the sole use of self-report data made it difficult to gain a thorough understanding of the processes that contribute to the negative and positive influences on academic self-concept and performance. The measure of discrimination used required that students be aware of society's discriminatory views toward African Americans and Whites in general. The extent to which these adolescents are insulated and isolated by living in a culturally and economically homogenous environment may influence their reports of discrimination, making it difficult to assess the true impact of discrimination on academic performance. Future research should include subjects in racially heterogeneous environments as a comparison group, or include the use of qualitative methods of analysis (i.e., focus groups) in homogenous environment.

Also, students' comments during the debriefing session provided some insights that could be helpful in interpreting the findings with the goal of designing a study that would incorporate some of their comments. Too often in empirical research with low income, African American populations, preconceived notions of the group's attitude and behavior drive the questions asked and the approaches to our investigation. The adolescents' comments revealed that they struggled with issues of group identity and its role in their lives; however, post hoc analyses of the debriefing session revealed how some felt about sharing their views on the subject of discrimination. One adolescent commented that he was "happy to see someone finally talking about Black issues." Another youth wrote, "I think the study will be helpful to Blacks."

Furthermore, although this paper examines racial/ethnic identity specifically, there has been a long-standing dialogue within the field about the interchangeable use of the terms race, ethnicity, and culture. However, it should be noted that there are some important differences. Whereas race has been defined as both a sociobiological marker (Rushton, 1992; Yee et al., 1993), as well as a social and/or historical construct (Erikson, 1968) in psychological research, ethnicity is defined in terms of ancestry, which can be traced through nationality or tribal membership (Diop, 1991; Betancourt and Lopez, 1993; James, 2003; Mbiti, 1990). As noted at an earlier point in the paper, it refers to group patterns that can reflect ancestry, race, religion, customs, and language; hence, one may think of ethnicity as being subsumed by race (James, 2003). Both race and ethnicity are included as components of culture, which is defined as a medium through which all things function, or a dynamic process that gives people a general design for living, and patterns for interpreting their reality (Nobles, 1985). Given the relative complex nature of "culture" and the elaborate historical and social contexts of Diasporic Africans, more studies are needed to enhance our understanding of African Americans as more than their race (i.e., Black) or ethnicity (i.e., African American) if we are to truly understand the processes that facilitate or impede healthy psychosocial development.

Conclusion and Directions for Future Research

In spite of the noted limitations, it is encouraging that some support for our hypotheses was found, particularly because of statistical limitations on finding interaction effects in social science research, when in fact they may be present (Jose, in press). The findings suggest that, indeed, racial/ethnic identity is an important tool in promoting resilience among African American adolescents. Clearly, more process-oriented studies are needed to examine the interplay among proximal and distal factors on the development of these youth. Considering the small amount of variance explained by the models presented, especially for females, we cannot ignore the fact that many other variables may indeed impact academic performance among low-income youth. The literature must continue to address such factors if we are to truly understand antecedents of the seemingly persistent academic achievement gap, particularly in light of the disproportionate number of African American youth exposed to PTEs in our society.

As students of human development, we are often consumed with understanding the effects of various predictor variables on psychosocial well-being with the goal of fostering healthy adjustment. Often, when we examine the development and adjustment patterns of African American youth, we ignore the particular social and environmental contexts within which development occurs. We must consider that sociocultural (discrimination or oppression) and psychocultural (chronic stress due to internalized racism) variables interact in complex ways to influence the development of minority adolescents (Spencer et al., 1993; Spencer and Dornbusch, 1990). Notwithstanding, it is hoped that this paper will contribute to our understanding of the complex relationships between racial/ethnic identity and healthy psychological and social development among minority youth.

References

Aiken, L. S., and West, S. G. (1991). Multiple regression: Testing and interpreting interactions. Newbury Park: Sage.

Areepattamannil, S., and Freeman, J. G. (2007). Academic achievement, academic, self-concept, and academic motivation of immigrant adolescents in the Greater Toronto Area secondary schools. *Journal of Advanced Academics, 19*(4), 700-743.

Aries, E., and Moorehead, K. (1989). The importance of ethnicity in the development of identity of black adolescents. *Psychological Reports, 65*, 75-82.

Armor, D. J. (1992). Why is black educational achievement rising? *Public Interest, 108*, 65-80.

Barbarin, O. A. (1983). Coping with ecological transitions by Black families: A psychosocial model. *Journal of Community Psychology, 11*, 308-322.

Baron, R. M., and Kenny, D. A. (1986). The moderator-mediator variable distinction in social psychological research: Conceptual, strategic, and statistical considerations. *Journal of Personality and Social Psychology, 51* (6), 1173-1182.

Betancourt, H., and Lopez, S. R. (1993). The study of culture, ethnicity, and race in American psychology. *American Psychologist, 48,* 629-637.

Bledsoe, J. (1967). Self-concept of children and their intelligence, achievement, interests, and anxiety. *Childhood Education, 43,* 436-438.

Borislow, B. (1962). Self-evaluation and academic achievement. *Journal of Counseling Psychology, 9,* 246-254.

Bowman, P. J., and Howard, C. (1985). Race related socialization, motivation, and academic achievement: A study of black youth in three-generational families. *Journal of American Academy of Child Psychiatry, 24,* 134-141.

Boykin, W. (1985). The triple quandary and the schooling of Afro-American children, pp. 57-91. In U. Neisser (Ed.), *The school achievement of minority children.* Hillsdale: Lawrence Earlbaum.

Bronfenbrenner, U. (1977). Toward an experimental ecology of human development. *American Psychologist, 32,* 513-531.

Bronfenbrenner, U. (1979). *The ecology of human development.* Cambridge, MA: Harvard University Press.

Bronfenbrenner, U. (1989). *The ecology of human development: Experiments by nature and design.* Cambridge, MA: Harvard University Press.

Byrd, C. M., and Chavous, T. M. (2009). Racial identity and academic achievement in the neighborhood context: A multilevel analysis. *Journal of Youth and Adolescence, 38*(4), 544-559.

Cady, B., Murry, V., Hurt, T., Chen, Y., Brody, G, Simons, R., Cutrona, C. and Gibbons, F. (2009). It takes a village: Protecting rural African American youth in the context of racism. *Journal of Youth and Adolescence, 38*(2), 175-188.

Caldwell, C., Kohn-Wood, L. P., Schmeelk-Cone, K. H., Chavous, T. M. and Zimmerman, M. A. (2004). Racial discrimination and racial identity as risk or protective factors for violent behaviors in African American young adults. *American Journal of Community Psychology, 33*(1), 91-107.

Campbell, P. B. (1967). School and self-concept. *Educational Leadership, 24,* 510-515.

Child Trends. (2003). *High school dropout rates: The gap narrows between Blacks and Whites.* Washington: D.C.

Children's Defense Fund. (2004). *The road to dropping out: Minority students and academic factors correlated with failure to complete high school.* Washington, D.C.

Chung, Y. B. and Sedlacek, W. E. (1999). Ethnic differences in career, academic, and social self-appraisals among incoming college freshmen. *Journal of College Counseling, 2*(1), 14-25.

Clark, K., and Clark, M. (1940). Skin color as a factor in racial identification of Negro pre-school children. *Journal of Social Psychology, 11,* 159-169.

Clark, K., and Clark, M. (1947). Racial identification and preference in Negro children, pp. 169-178. In T. M. Newcomb and E. L. Hartley (Eds.), *Readings in social psychology*. New York: Holt.

Clark, M. (1991). Social identity, peer relations, and academic competence of African American adolescents. *Education and Urban Society, 24*(1), 41-52.

Cohen, J., and Cohen, P. (1983). *Applied multiple regression/correlation analyses for the behavioral sciences* (Second Edition). Hillsdale, NJ: Lawrence Erlbaum.

Connell, J., Spencer, M. B., and Aber, J. (1994). Educational risk and redilience in African American youth: Context, self, action, and outcomes in school. *Child Development, 65*(2), 493-506.

Cooley, C. H. (1956). *Human nature and the social order*. New York: Free Press.

Crocker, J., and Major, B. (1989). Social stigma and self-esteem: The self-protective properties of stigma. *Psychological Review, 96*(4), 608-630.

Crocker, J., and Major, B. (1994). Reactions to stigma: The moderating role of justifications, pp. 28-314. In M. P. Zanna and J. M. Olson (Eds.), *The psychology of prejudice: The Ontario symposium* (Vol. 7). Hillsdale, NJ: Lawrence Erlbaum Associates, Inc.

Cross, W. E. (1987). A two factor theory of Black identity: Implications for the study of identity development in minority children, pp. 177-133. In J. Phinney and M. J. Rotheram (Eds.) *Children's ethnic socialization: Pluralism and development*. Newbury Park: Sage Publications.

Cross, W. E. (1991). Shades of Black. Philadelphia: Temple University Press.

Cross, W. E., Parham, T., and Helms, J. (1991). The stages of black identity development: Nigrescence models. In R. Jones (Ed), *Black psychology* (pp. 319-338). Berkeley: Cobb and Henry.

Diop, C. A. (1991). *Civilization or Barbarism: An authentic anthropology*. Chicago: Lawrence Hill Books.

Erikson, E. (1968). *Identity, youth and crisis*. New York: W. W. Norton.

Fink, M. (1962). Self-concept as it relates to academic underachievement. *California Journal of Educational Research, 13*, 57-62.

Fordham, S., and Ogbu, J. (1986). Black students' school success: Coping with the burden of acting white. *The Urban Review. 18*(3), 176-206.

Garcia Coll, C., et al. (1996). An integrative model for the study of developmental competencies in minority children. *Child Development, 67*, 1891-1914.

Gee, G. C., Ryan, A., Laflamme, D. J., and Holt, J. (2006). Self reported discrimination and mental health status among African descendants, Mexican Americans, and other Latinos in the New Hampshire REACH 2010 Initiative: The added dimension of immigration. *American Journal of Public Health, 96*(10), 1821–1828.

Gougis, R. (1985). The effects of prejudice and stress on the academic performance of Black-Americans, pp. 145-158. In U. Neisser (Ed.), The school achievement of minority children. Hillsdale: Lawrence Earlbaum.

Gurin, P., and Epps, E. (1975). *Black consciousness, identity, and achievement.* New York: John Wiley and Sons, Inc.

Harris, H. W., Blue, H. C., & Griffith, E. H. (1995). Racial and ethnic identity: Psychological development and creative expression. New York: Routledge.

Helms, J. E. (Ed.). (1990*). Black and white racial identity.* New York: Greenwood Press.

Helms, J. E. (1990). Introduction: Review of racial identity terminology, pp. 3-8. In J. Helms (Ed.) *Black and white racial identity.* New York: Greenwood Press.

Herrnstein, R. J., and Murray, C. (1994). *The bell curve: Intelligence and class structure in American life.* New York: Free Press.

Howard, C., Kohn-Wood, L., Schmeelk-Cone, K., Chavous, T., and Zimmerman, M. (2004). Racial discrimination and racial identity as risk or protective factors for violent behaviors in African American young adults. *American Journal of Community Psychology 33*(1), 91-107.

Hughes, D., and Johnson, D. (2001). Correlates in children's experiences of Parents Racial Socialization behaviors. Journal *of Marriage and the Family, 63* (4), 981-996.

Hughes, D., and Chen, L. (1997). When and what parents tell children about race: An examination of race-related socialization among African American families. *Applied Developmental Science, 4,* 200-214.

Humphreys, L. G. (1988). Trends in levels of academic achievement of Blacks and other minorities. *Intelligence, 12,* 231-260.

Jackson, J. S., Williams, D. R., and Torres, M. (1997). Perceptions of discrimination: The stress process and physical and psychological health. Washington, DC: National Institute for Mental Health

James, C. E. (2003). *Seeing ourselves: Exploring race, ethnicity and culture* (Third edition). Toronto: Thompson Educational Publishing.

Jensen, A. R. (1969). How much can we boost I.Q.? *Harvard Educational Review, 3* (1), 1-123.

Jones, J. M. (1991). Racism: A cultural analysis of the problem, pp. 609-636. In R. Jones (Ed.), *Black psychology.* Berkeley: Cobb and Henry.

Jordan, T. J. (1981). Self-concepts, motivation, and academic achievement of black adolescents. *Journal of Educational Psychology, 73*(4), 509-517.

Jose, P. E. (in press). *How to do statistical mediation and moderation.* New York, NY: Guilford Press.

Kenny, M. C., and McEachern, A. (2009). Children's self-concept: A multicultural comparison. *Professional School Counseling, 12*(3), 207-212.

Lay, R., and Wakstein, J. (1985). Race, academic achievement, and self-concept of ability. *Research in Higher Education, 22*(1), 43-64.

Lee, V., and Winfield, L. (1991). Academic behaviors among high-achieving African American. *Education and Urban Society, 24*(1), 65-87.

Massey, D., and Denton, N. (1993). *American apartheid: Segregation and the making of the underclass.* Cambridge: Harvard University Press.

Mbiti, J. S. (1990). *African religions and philosophy* (Second edition). Johannesburg: Heinemann Press.

Mboya, M. M. (1986). Black adolescents: A descriptive study of their self-concepts and academic achievement. *Adolescence, 21*(83), 689-696.

McAdoo, H. P. (1985). *Black children: Social, educational, and parental environments.* Beverly Hills: Sage.

McCord, J., and Taylor, R. D. (1992). Unpublished measure of discrimination.

McLoyd, V. C., and Steinberg, L. (1998). *Studying minority adolescents: Conceptual, methodological and theoretical issues.* Mahwah, NJ: Lawrence Erlbaum Associates.

Mead, G. H. (1934). Mind, self, and society. Chicago: University of Chicago Press

Mickelson, R. (1990). The attitude-achievement paradox among Black adolescents. *Sociology of Education, 63*, 44-61.

Miller, E. (1994). *Marginalization of the black male: Insights for the development of the teaching profession.* Barbados, WI: Canow Press.

Mitchell, J. (1959). Goal-setting behavior as a function of self-acceptance, over and underachievement, and related personality variables. *Journal of Educational Psychology, 50*, 93-104.

National Academy of Sciences (2003). *Measuring racial discrimination.* Washington, DC.

National Center for Education Statistics. (2003). Digest of Educational Statistics, 2003. Retrieved May 20. 2005. from http://nces.ed.gov//programs/digest/d03/

Neisser, U. (1986). *The school achievement of minority children.* Hillsdale: Lawrence Earlbaum.

Nobles, W. (1980). African philosophy: Foundations for Black psychology, pp. 23-26. In R. Jones (Ed.), Black psychology. Berkeley: Cobb and Henry.

Nobles, W., and Goddard, L. (1984). *Understanding the black family: A guide for scholarship and research.* Oakland: The Institute for the Advanced Study of Black Life and Family Culture.

Nobles, W. (1985). Africanity and the Black family: The development of a theoretical model. Oakland: Black Family Institute Publications.

Norman, C. (1988). Math education: A mixed picture. *Science, 241*, 408-409.

Ogbu, J. (1978). *Minority education and caste: The American system in cross-cultural perspective.* New York: Academic Press.

Ogbu, J. (1986). The consequences of the American caste system, pp. 19-56. In U. Neisser (Ed.) *The school achievement of minority children.* Hillsdale: Lawrence Erlbaum.

Ogbu, J. (2003). *Black American students in an affluent suburb: A study of academic disengagement.* Mahwah, NJ: Lawrence Erlbaum Associates.

Oyserman, D., Grant, L., and Ager, J. (1995). A socially contextualized model of African American identity: Possible selves and school persistence. *Journal of Personality and Social Psychology,69*(6), 1216-1232.

Paster, V. (1994). The psychosocial development and coping of black male adolescents: Clinical implications, pp. 215-230. In R. G. Majors and J. U. Gordon (Eds.) *The American black male*. Chicago: Nelson-Hall Publishers.

Pershey, M. G. (2010). A Comparison of African American students' self-perceptions of school competence with their performance on state-mandated achievement tests and normed tests of oral and written language and reading. *Preventing School Failure, 55*(1), 53-62.

Phinney, J. S. (1992). The multigroup ethnic identity measure: A new scale for use with diverse groups. *Journal of Adolescent Research, 7*(2), (156-176).

Phinney, J. and Rotheram, M. J. (Eds.). (1987). *Children's ethnic socialization: Pluralism and development*. Newbury Park: Sage.

Powell, G. (1989). Defining self-concept as a dimension of academic achievement for inner-city youth, pp. 69-82. In G. Berry and J. Asamen (Eds.) *Black students: Psychosocial issues and academic achievement*. Newbury Park: SAGE.

Ramseur, H. P. (1991). Psychological healthy black adults, pp. 353-378. In R. Jones (Ed.), *Black psychology*. Berkeley: Cobb and Henry.

Redd, Z., Brooks, J., and McGarvey, A. (2002, August). *Educating America's youth: What makes a difference*. Research Brief. Washington, DC: Child Trends.

Rosenberg, M. (1965). Society and the adolescent self-image. Princeton, NJ: Princeton University Press.

Rosenberg, M. and Simmons, R. (1972). *Black and white self-esteem: The urban school child*. Monograph series. Washington, DC: American Sociological Association.

Rotheram, M. J., and Phinney, J. (1987). Ethnic behavior patterns as an aspect of identity, pp. 201-218. In J. Phinney and M. J. Rotheram (Eds.), *Children's ethnic socialization: Pluralism and development*. Newbury Park: Sage Publications.

Rushton, J. P. (1992). Contributions to the history of psychology: XC. Evolutionary biology and heritable traits (with reference to Oriental-White-Black differences): The 1989 AAAS paper. *Psychological Reports, 71*, 811-821.

Seaton, E., Caldwell, C., Sellers, R., and Jackson, J. (2010). An intersectional approach for understanding perceived discrimination and psychological well-being among African American and Caribbean Black Youth. Developmental Psychology, *46*(5), 1372-1379.

Seaton, E. K., Yip, T., and Sellers, R. M. (2009). A longitudinal examination of racial identity and racial discrimination among African American adolescents. *Child Development, 80*(2), 406-417.

Sedlacek, W. and Brooks, G. (1976). Racism in American education: A model for change. Chicago: Nelson-Hall.

Shoemaker, A. L. (1980). Construct validity of area specific self-esteem: The Hare self-esteem scale. *Educational and Psychological Measurement, 40*, 495-501.

Shrauger, J. S., and Schoeneman, T. J. (1979). Symbolic interactionist view of self-concept: through the looking glass darkly. *Psychological Bulletin, 86,* 549-573.

Sigelman, L. and Welch, S. (1991). *Black Americans' views of racial inequality: The dream deferred.* Cambridge, MA: Harvard University Press.

Simpson, G. and Yinger, M. (1965*). Racial and cultural minorities: An analysis of prejudice and discrimination* (Third Edition). New York: Harper and Row.

Spencer, M. B. (1983). Children's cultural values and parental child rearing strategies. *Developmental Review, 3,* 351-370

Spencer, M. B. (1987). Black children's ethnic identity formation: Risk and resilience of caste-like minorities, pp. 103-116. In J. Phinney and M. J. Rotheram (Eds.), *Children's ethnic socialization: Pluralism and development.* Newbury Park: Sage Publications.

Spencer, M. B. (1990). Identity processes among racial and ethnic minority children in America. *Child Development, 61*(2), 290-310.

Spencer, M. B. (1991). Development of minority children: An introduction. *Child Development, 61*(2), 267-269.

Spencer, M. B., Cole, S. P., DuPree, D., Glymph, A., and Pierre, P. (1993). Self-efficacy among urban-African American early adolescents: Exploring issues of risk, vulnerability, and resilience. *Development and Psychopathology, 5,* 719-739.

Spencer, M. B., Cunningham, M., and Swanson, D. P. (1995). Identity as coping: Adolescent African American males' adaptive responses to high-risk environments, pp. 31-52. In H. Harris, H. Blue and E. Griffith (Eds.), *Racial and ethnic identity: Psychological development and creative expression.* New York: Routledge.

Spencer, M. B., and Dornbusch, S. (1990). Challenges in studying minority youth, pp. 123-146. In Elliot and Feldman (Eds.), *At the threshold: The developing adolescent.* Cambridge, MA: Harvard University Press.

Spencer, M. B., Dupree, D., and Hartmann, T. (1997). A phenomenological variant of ecological systems theory (PVEST): A self-organization perspective in context. *Development and Psychopathology, 9,* 817-833.

Spencer, M. B., Swanson, D. P., and Cunningham, M. (1991). Ethnicity, ethnic identity, and competence formation: Adolescent transition and cultural transformation. *Journal of Negro Education, 60*(3), 366-387.

Steinberg, L., Dornbusch, S., and Brown, B. (1992). Ethnic differences in adolescent achievement. *American Psychologist, 47*(2), 723-729.

Stevenson, H. (1994). Validation of the scale of racial socialization for African American Adolescents: Steps toward multidimensionality. *Journal of Black Psychology, 20*(1) (445-468.

Swanson, D., Cunningham, M., and Spencer, M. B. (2003). Black males' structural conditions, achievement patterns, normative needs, and opportunities. *Urban Education, 38*(5), 608-633.

Taylor. R. D., Casten, R., Flickenger, S., Roberts, D., and Fulmore, C. (1994). Explaining the school performance of African American adolescents. *Journal of Research on Adolescents, 4*(1), 21-44.

Thomas, O., Caldwell, C., Faison, N., and Jackson, J. (2009). Promoting academic achievement: The role of racial identity in buffering perceptions of teacher discrimination on academic achievement among African American and Caribbean Black adolescents. *Journal of Educational Psychology, 101*(2), 420-431.

Tracey, T., and Sedlacek, W. (1984). Noncognitive variables in predicting academic success by race. *Measurement and Evaluation in Guidance, 16*, 171-178.

U.S. Census Bureau (2010).

White, J. L, and Johnson, J. (1991). Awareness, pride and identity: A positive educational strategy for black youth, pp. 141-166. In R. Jones (Ed.), *Black psychology*. Berkeley: Cobb and Henry.

Williams, D. R. and Chung, A. (1997). Racism and health. In R. Gibson and J. S. Jackson (Eds.) *Health in Black America*. Thousand Oaks, CA: Sage Publications

Williams, J. H. (1973). The relationship of self-concept and reading achievement in first-grade children. *Journal of Educational Research, 66*, 378-381.

Williams, D. R., Spencer, M.S., and Jackson, J. S. (1999). Race, stress, and physical health: The role of group identity, pp. 71-100. In R. J. Contrada and R. D. Ashmore (Eds.), *Self social identity, and physical health: Inter-disciplinary explorations* (Rutgers Series on Self and Social Identity, Vol. 2). New York: Oxford University Press.

Wilson, T. and Banks, B. (1994). A perspective on the education of African American males. *Journal of Instructional Psychology, 21*(1), 97-100.

Wong, C. A., Eccles, J. S., and Sameroff, A. (2003). The influence of ethnic discrimination and ethnic identification on African American adolescents' school and socioemotional adjustment. *Journal of Personality, 71*(6) 1197-1232.

Yancey, W., and Saporito, S. (1994). *Racial and economic segregation and educational outcomes: One tale-two cities*. Philadelphia: The National Center on Education in the Inner Cities.

Yee, A. H., Fairchild, H. H., Weizmann, F., and Wyatt, G. E. (1993). Addressing psychology's problems with race. *American Psychologist, 48*(11), 1132-1140

Yip, T., Sellers, R. M., and Seaton, E. K. (2006). African American racial identity across the lifespan: Identity status, identity content, and depressive symptoms. *Child Development, 77* (5), 1504-1517.

Chapter Fourteen
The Congruence between African American Students' Racial Identity Beliefs and Their Academic Climates: Implications for Academic Motivation and Achievement

Christy M. Byrd and Tabbye M. Chavous

Introduction

Does having a strong connection to their racial identity promote African American students' academic achievement, or does it place them at risk for academic disengagement and underachievement? Is an emphasis on African American identity compatible with the beliefs and orientations that characterize a positive academic identity? Or, does strong African American identification relate to academic dis-identification, e.g., disconnecting one's personal identity from the academic domain, or viewing pro-achievement orientations as "acting white"?

Over the past several decades, social science scholars have been concerned with the above types of questions, leading to explorations of whether particular racial identities lead to adaptive or maladaptive academic outcomes among African American youth. However, in conceptual and empirical treatments of these questions, seldom is the role of context considered explicitly, for instance, the norms and values around race that youth experience in their day-to-day school environments. In this chapter we describe the importance of considering the congruence between African American youths' academic settings and their racial identity

beliefs in studying motivational processes and outcomes among this group. The racial identity-context congruence perspective we present draws on person-environment fit perspectives, organizational theory (e.g., Chrobot-Mason and Thomas, 2002) and self-determination theory (Deci et al., 1991) to highlight processes through which particular racial identity beliefs can impact academic motivation, specifically through individuals' connections to and engagement with their proximal school contexts. We posit that the relationship between racial identity and motivation in school varies based on the experienced racial norms (that is, racial climate) in the school setting. We present two empirical examples, one with a high school sample and one with a college sample, to illustrate our congruence perspective. In taking a congruence perspective, we seek to answer not *whether* racial identity beliefs are adaptive or *which* racial identity beliefs are more adaptive, but *when* and *under what circumstances* they are more or less adaptive.

Literature Review

Racial Identity and Academic Motivation

The congruence perspective we present is an alternative to two prevalent frameworks for explaining the relationships of African American racial identity with academic motivation and achievement: the "racial-identity-as-promotive" perspective and the "racial-identity-as-risk" perspective. These frameworks most often emphasize aspects of racial identity related to the significance and meanings that individuals place on their racial group membership, including affective beliefs. We will discuss these three aspects of racial identity using constructs outlined in the Multidimensional Model of Racial Identity (MMRI) developed by Sellers and colleagues (1998). These constructs include the extent that the group membership as a central part of individuals' self-concept (centrality), individuals' personal evaluation of or positive affect related their group membership (private regard), and individuals' affective evaluation of the broader society's value and regard for their group (public regard).

First, the racial-identity-as-promotive perspective (Smalls, White, Chavous, and Sellers, 2007) acknowledges the historical value placed on education as a means to overcoming racial barriers in the African American community. According to this perspective, having a strong racial identity (e.g., high centrality and high private regard) will result in identification with these values and a strong academic orientation, which results in higher motivation and achievement. Previous research studies with middle and late adolescents show positive associations of high centrality and high private regard with personal valuing of education and academic aspirations (e.g., Chavous, Bernat, Schmeelk-Cone, Caldwell, and Kohn-Wood, 2003; Chavous, Rivas, Smalls, Griffin, and Cogburn, 2008; O'Connor, 1999; Oyserman, Harrison, and Bybee, 2001; Spencer, Noll, Stoltzfus, and Harpalani, 2001). Additionally, research with emerging adult samples (e.g., college students)

has found positive relationships between students' reported racial centrality and their intrinsic motivation to achieve (Cokley, 2001, 2003). These studies suggest that, across adolescence and young adulthood, a strong connection to being African American and positive feelings about being African American can promote higher achievement motivation and, ultimately, educational success.

A second perspective, however, emphasizes the potential risks of stronger identification. Social identity theory describes how identifying more with a stigmatized group (high centrality) and having higher awareness or consciousness about the group's stigmatized status (conceptually related to low public regard) poses a risk to the self-esteem in domains in which that group has been traditionally stigmatized, such as the domain of education (Crocker and Major, 1989; Steele, 1997). In order to protect the self-esteem from the effects of stigmatization, the individual must choose to disidentify with the group or with the domain. This perspective acknowledges that, in the academic domain, African American youth are likely to receive negative treatment and low expectations and predicts that many will choose to dis-identify with academics, rather than the group (Crocker and Major, 1989; Steele, 1997). With less identification with academics, youth no longer value the behaviors and outcomes associated with that domain, and achievement suffers subsequently. Most empirical research examining connections between racial identity beliefs and achievement motivation does not support the racial-identity-as-risk perspective. A few studies, however, have found negative associations between a strong, positive racial identity and grade achievement (Harper and Tuckman, 2006; Worrell, 2007). Furthermore, studies with college students have linked higher stigma consciousness (conceptually similar to lower public regard) with negative achievement outcomes (e.g., Brown, 2005). Thus, there is some support for the racial-identity-as-risk perspective.

While the promotive and risk perspectives may seem at odds with one another, we do not view them as such. Each perspective is informative about different ways that youth might process and manage racial barriers and stigma and the implications for motivation. Both frameworks provide insights into particular motivational processes, specifically those related to how youth develop values around the importance/utility of education, as well as their self-concepts around the academic domain. Each perspective emphasizes the role of the broader societal context of race where many African Americans encounter racial barriers, discrimination, and stereotyped treatment; although each perspective proposes differing responses to perceiving barriers or stigma. The promotive perspective posits that a strong and positive group identification relates to adaptive responses to racial barriers and stigma that enhance or maintain motivational beliefs about the value of schooling and academic self-concept, while the risk perspective views stronger identification and stigma awareness as exacerbating negative effects of experienced racial barriers and stigma on those motivational outcomes. Taken together, the scholarship representing and supporting both perspectives raise the possibility of variation in ways that racial identity influences African American youths' academic achievement.

The Racial Identity-Context Congruence Perspective Defined

One factor in the seeming contradictions between the racial identity-as-promotive and racial identity-as-risk perspectives is that neither perspective explicitly considers motivational processes related to students' proximal environments, for instance, how students connect their personal identities and self-concepts to their day-to-day school settings. As such, we present a racial-identity context congruence perspective (Byrd and Chavous, 2011), which adds to and complements the aforementioned literatures on African American achievement motivation by describing mechanisms linking youths' racial identity to their motivation through their connections with the school context. Instead of a focus on motivational beliefs such as educational values or academic self-concept, our congruence approach emphasizes youths' motivational beliefs and orientations related to their everyday school contexts and draws from theoretical perspectives emphasizing the role of person-environment fit in successful adaptation.

With regard to the relationship between racial identity and motivation, we make explicit the idea that no one set of racial identity beliefs is in itself positive or negative with regard to academic outcomes (Cross, 1991; Sellers et al., 1998). Instead, how racial identity functions to influence youths' adjustment outcomes differs according to the extent that contextual norms and values support youths' own values and affective beliefs. In other words, from a congruence perspective, the effect of a strong and positive sense of racial identity on motivation for school would vary as a function of the specific academic contexts youth experience. In a school setting with norms and values that are congruent with individuals' strong and positive racial identity beliefs, individuals would feel greater connection to the setting and valued outcomes within that setting. However, when individuals' racial identity beliefs and their perception of norms within their environment are incongruent, individuals are less likely to feel less connected to the environment and, subsequently, are less likely to develop motivational orientations where they connect their personal values and self-concepts to the environment.

A contribution of the congruence perspective is that it accounts for variation in ways students might experience race at school. In some cases, African American youth may find themselves in school contexts where they experience many racial barriers, racially stigmatizing experiences, and low expectations, while in other settings they may experience relatively fewer racial barriers, and members of their group may be held to similarly high expectations as other students. As such, students with similar beliefs around the significance and meaning of their racial group membership may fare differently when experiencing academic contexts that vary in the degree that they support or counter those beliefs.

School Racial Climate as Context

In our consideration of academic context, we focus on students' perceptions of their school racial climate, defined in this chapter as perceived norms and values around race and interracial interactions (Chavous, 2005), or "how race works" in a particular school. Because of the heightened salience of race for many ethnic minority groups in the United States, the racial climate of school settings is a particularly important construct to consider in psychological examinations of African American students' achievement processes (Booker, 2006; Mattison and Aber, 2007). Conceptualizations of racial climate in psychological literatures focus on individuals' perceptions of interpersonal, social, and institutional norms related to race, most often emphasizing norms related to intergroup relations (Green et al., 1988). In the current chapter, we highlight dimensions of school racial climate based in intergroup contact theory (Allport, 1954), a theory describing the conditions necessary for successful racial integration in a setting. For instance, a commonly studied dimension of school racial climate drawing from intergroup contact theory is the frequency of interactions between people of different races within the school. Other dimensions tap into the qualitative nature of those intergroup interactions, for instance, whether intergroup interactions are based in equal status, or the degree to which students of different races in the setting hold similar social status and are treated equitably. This dimension also relates to the beliefs and attitudes individuals in the schools hold about particular racial groups, for instance, negative stereotypes. Another indicator of the quality of intergroup contact involves interdependence, for instance, the extent that racial groups function harmoniously toward common goals, rather than in adversarial ways that would increase intergroup tensions. A fourth dimension considers institutional level supports (e.g., from teachers, administrators) for positive intergroup relationships. This dimension also might involve whether a setting values and celebrates racial differences as a beneficial aspect of the school community (Plaut, 2010), that is, a multicultural ideology, rather than a color-blind or assimilation ideology that de-emphasize or devalues race or cultural difference (Bell, 2002).

The literature on school racial climate suggests that experiencing a positive racial climate can be beneficial for youth of all races (e.g., Green et al., 1988). However, studies indicate that African American students (at secondary and post secondary levels) consistently report more negative perceptions of their school racial climate (e.g., more intergroup tension, unequal treatment relative to other groups, racially biased treatment) than do students from other groups (e.g., Chavous, 2005). That said, in contexts where African American youth experience fewer racial barriers, fairer treatment, and positive norms around race and intergroup relations in their day-to-day experiences, they show more positive motivation attitudes (e.g., Brand, Felner, Shim, Seitsinger, and Dumas, 2003; Ryan and Patrick, 2001) and achievement (e.g., Green et al., 1988). However, school climate research generally has not addressed within-racial group differences in

African American students' perceptions of and responses to their perceived school racial climate. Furthermore, fewer studies consider how students' own race-related beliefs relate to their perceptions of and responses to their schools' racial climates. Thus, our congruence approach contributes to the school climate literature by presenting racial identity as an individual difference factor that can help explain variation in effects of racial climate on achievement outcomes among African American students. In fact, we suggest that experiencing a positive racial climate can be particularly beneficial for African American youth with a strong and positive sense of their racial identity.

Motivational Processes Related to Identity-Context Congruence

The congruence perspective proposes that the match between individuals' personal identity beliefs and the perceived norms and values in their contexts is essential for promoting autonomous motivation, that is, motivation in which an activity is inherently valuable and is experienced as self-determined (Deci and Ryan, 2008). The most autonomous form of motivation is intrinsic motivation, in which an activity is inherently enjoyable. Although school achievement is contingent on a number of individual activities and student attributes, intrinsic motivation for school in general can be seen as an overall experience of positive affect connected to the school, and also includes interest and curiosity around tasks and activities at school, all of which have been linked to academic achievement and attainment outcomes (Deci et al., 1991).

We focus on two domains around which racial climate may be congruent or incongruent with racial identity beliefs in ways that influence motivation: significance and affect. Congruence in significance would be represented, for instance, if individuals feel that their race is a defining characteristic (high centrality) and perceive that those in their school also see racial group membership as an important personal characteristic (e.g., a racial climate that promotes multiculturalism, acknowledging and celebrating difference rather than minimizing difference or encouraging a "color-blind" views of students). It is important to note that racial identity attitudes about the importance of race are different from attitudes about the meaning of racial group membership (i.e., ideologies; Sellers et al., 1998). A "multicultural" or "color-blind" ideology can indicate to youth how important or worthy of attention racial group membership is, which is different from conveying values about the meaning of one's racial group. Youth can also perceive congruence on the meaning of racial group membership.

In the affective domain, students' private regard or public regard also might be congruent or incongruent with perceived school norms. An example of congruence in affect would be individuals having high private regard and high public regard and perceiving a school racial climate in which positive intergroup interactions are normative and where teachers and students like and have positive feelings toward their racial group. In contrast, experiencing a school racial climate in which African

Americans are lower in status or disrespected, receive unequal treatment relative to others, or are segregated in undesirable ways can send the message that being African American is a negative trait in that context (and would be incongruent with high private regard) and signal that out-group members feel negatively about their group (incongruent with high public regard).

A primary mechanism through which congruence between racial identity beliefs and school racial climate impacts intrinsic motivation for school is through youths' connectedness, or sense of belonging with their school contexts. Belonging is a basic human need for acceptance and support from others in an environment (Goodenow, 1993). Achievement motivation theories, e.g., self-determination theory, highlight the role of belonging in promoting autonomous motivation in a setting (Deci et al., 1991), and researchers have found links between students' reported sense of belonging at school and various academic motivation outcomes (e.g., Booker, 2006). Experiencing congruence between students' racial identity attitudes and their school racial climate can increase sense of belonging in several ways: youth may feel that their teachers and fellow students accept them for who they are; youth may also perceive that they are similar to those around them and thus feel included in the school community; and both factors can facilitate social bonds and supportive interpersonal relationships (Booker, 2006; Goodenow, 1993). Our congruence perspective also draws from organizational theory in highlighting the importance of congruence between individual values and contexts for connection to the setting. For example, Chrobot-Mason and Thomas (2002) suggest that individuals who value their racial group membership would be more comfortable in settings with a multicultural orientation, and that this comfort has implications for satisfaction and perseverance. This scholarship suggests the importance of students' affective connections with their school environments as critical to enhancing and sustaining motivation within the school environment.

Predictions

Our congruence perspective predicts that the effect of strong and positive racial identity on academic motivation at school will vary by the racial climate of the school. In the literature, researchers most often conceptualize a strong and positive racial identity as characterized by high centrality and high private regard. We expect that youth with higher centrality would report higher autonomous motivation when race is made salient in positive ways—that is school racial climates where youth perceive school norms as emphasizing the importance of race and appreciation for group differences. For private regard, congruence will relate to aspects of the school racial climate that relate to positive or negative affect. For instance, youth with high private regard in settings characterized by positive experiences around their racial group membership (such as positive intergroup contact, equal status, and positive attitudes/respect) would experience higher intrinsic motivation for school. However, youth with high private regard and perceiving more negative

climates would experience lower intrinsic motivation because these settings do not affirm youths' positive feelings toward their group.

Fewer studies of connections between African American students' racial identity and achievement focus on public regard. A few studies suggest positive associations between public regard and achievement motivation beliefs. Chavous et al. (2003), for instance, found that youth with profiles of racial identity beliefs indicating high centrality, high private regard, and high public regard were more attached to school than youth with high private regard, high centrality, and relatively lower public regard. Furthermore, while lower public regard has been related to perceiving more racial stigma (e.g., discrimination), research suggests lower public regard also can buffer the negative psychological impact of stigma (Sellers, Copeland-Linder, Martin, and Lewis, 2006). Specifically, youth whose perceptions of societal regard for their group include the possibility of bias may experience fewer negative consequences on well-being or motivation when faced with evidence of group bias.

The congruence perspective can extend this work by considering the motivational implications of whether students' daily school settings are consistent or inconsistent with their broader beliefs systems around society's views of their racial group. Based on our congruence perspective, we would expect that youth with higher public regard would report higher intrinsic motivation than those with lower public regard when their school racial climate experiences are consistent with their expectation that others view their group positively. On the other hand, while perceiving negative racial climates generally would relate to decreased intrinsic motivation and positive affect around school, youth with lower private regard likely would report higher intrinsic motivation than those with high public regard when perceiving negative racial climates. We posit that youth with lower public regard would be more buffered from the negative impacts of negative racial climate than those holding higher private regard beliefs.

Summary

The first part of this paper has outlined the congruence perspective, which takes a person-environment fit approach in conceptualizing the role of racial identity in achievement motivation processes. A main premise was that considering the nature of youths' academic contexts and how racial identity relates to students' connections with their contexts could help reconcile seemingly mixed findings in the literature linking racial identity to achievement motivation and contribute to understanding of mechanisms linking racial identity to achievement outcomes.

Empirical Examples

In this second section we present two empirical examples supporting our congruence perspective. The first example is from a study of high school youth first

reported in Byrd and Chavous (2011). The second example is from a new multi-university study of college students. Both examples examine the interaction of private regard, public regard, and centrality with racial climate to predict motivational outcomes. These examples illustrate how congruence between students' racial identity and perceived racial climate relate to the ways that they connect to their daily academic settings and the implications of this connection for important motivational and achievement outcomes. Finally, we use these examples to point to important next steps in work examining racial identity-context congruence.

Example 1: High School Study

The first example provides evidence of the importance of congruence between affective components of racial identity (private regard) and school racial climate. In assessing school racial climate, we focused on perceptions of the extent that positive intergroup interactions and respect for all races were normative at school. We considered whether congruence between private regard and climate was related to intrinsic motivation, measured by students' reported interest in and enjoyment of school. Additionally, we tested whether students' sense of belonging at school was a mechanism linking congruence and intrinsic motivation by examining whether a sense of belonging mediated the relationship between congruence and motivation.

Participants

Participants were 263 African American eleventh grade public school students (53 percent male) drawn from the Maryland Adolescent Development in Context Study (MADICS). Participants lived in neighborhoods varying in urbanicity and socio-economic status (see http://www.rcgd.isr.umich.edu/pgc/home.htm for the detailed study and sample information). In face-to-face and self-administered interviews, participants completed measures of racial identity, racial climate, discrimination, belonging, and intrinsic motivation, along with reports of demographic characteristics.

Measures and Variables

Racial identity was measured using a shortened version of the Multidimensional Inventory of Black Identity (Sellers, Rowley, Chavous, Shelton, and Smith, 1997) with a response scale ranging from 1 (strongly disagree) to 5 (strongly agree). The *centrality* subscale consisted of three items measuring the importance of race to the self-concept (e.g., "Being Black is an important reflection of who I am"; $\alpha = .73$). The *private regard* subscale consisted of six items measuring youths' affective (positive or negative) feelings about their racial group membership (e.g., "I am happy that I am Black"; $\alpha = .77$). Finally, two items measured *public regard*,

indicating the youths' perceptions of how positively or negatively society felt about their group (e.g., "Others think that Black people are unworthy"; $r = .41$).

School racial climate was measured using two scales developed by the MADICS researchers. Peer racial climate was assessed with four items tapping into norms around the frequency of intergroup associations at school, as well as the quality of those interactions. Youth reported the amount of interracial contact between students and the degree of respect shown between students of different races at school (e.g., "How often do students of different races sit together in the cafeteria?"; $\alpha = .73$). These items were on a scale of 1 (never) to 5 (very often) or 1 (none) to 5 (all). Teacher/staff racial climate tapped into equal status and institutional supportive norms and was assessed with two items that asked youth how many teachers showed equal respect for students of different races on a scale of 1 (none) to 5 (all), and degree of racial tension between staff and students on a scale of 1 (almost never) to 5 (almost always; $r = .37$).

Our motivational outcome of interest, *school intrinsic motivation*, was measured by three items. Participants indicated how much enjoying their classes, liking what they were learning, and feeling smart were important reasons they went to school on a scale of 1 (not an important reason) to 7 (a very important reason; $\alpha = .84$).

We conceptualized youths' individual, interpersonal experiences with racial discrimination at school as separate from their perceptions of the normative school racial climate. To account for the effects of personally experienced discrimination when examining identity-climate congruence effects, we included racial discrimination in tested study models. School-based racial discrimination was measured with two scales with possible responses ranging from 1 (never) to 5 (almost every day). Peer discrimination consisted of three items on how often youth were excluded or got into conflicts at school because of their race ($\alpha = .87$), and teacher discrimination consisted of five items on how often teachers treated youth unfairly because of their race ($\alpha = .89$). Other control variables included in tested models were eleventh grade GPA, gender, and a composite measure of family socioeconomic status representing family income and highest education attained in the home (reported by parents when youth were in eighth grade).

Sense of belongingness at school was measured by two scales indicating youth reports of support and acceptance from teachers and peers at school. Two items assessed peer support, or how often youth depended on other students for help with problems at school and schoolwork on a scale of 1 (almost never) to 5 (almost always; $r = .43$). Three items were included for teacher support, or how happy youth were with their relationships with their teachers, and whether they experienced acceptance or conflict on the same response scale ($\alpha = .59$).

Table 14.1: Hierarchical Regression of Racial Identity and School Racial Climate Predicting Intrinsic Motivation (High School Sample)

	Step 1		Step 2		Step 3	
Model F df regression,	3.87 (11,346)***		3.67 (17,340)***		4.83 (19,338)***	
df R2 change	0.10*		.05**		.05***	
	B	**Std. Err.**	**B**	**Std. Err.**	**B**	**Std. Err.**
Intercept	35.04*	14.47	38.47**	14.30	42.54**	13.88
Year of Birth	-0.40	0.18	-0.45*	0.18	-0.52**	0.18
Gender	0.05	0.16	0.03	0.16	0.01	0.16
SES	-0.07	0l09	-0.05	0.09	-0.11	0.09
GPA	0.38***	0.11	0.39***	0.11	0.25*	0.11
Teacher Discrim.	0.05+	0.15	-0.01	0.15	0.08	0.14
Peer Discrim.	0.16	0.17	0.07	0.17	0.09	0.17
Private Regard	0.31	0.17	0.29+	0.17	0.22	0.17
Public Regard	0.09	0.09	0.05	0.09	0.02	0.09
Centrality	-0.01	0.11	0.03	0.11	0.07	0.11
Peer Racial Climate	0.07	0.11	0.11	0.11	0.12	0.11
Teach. Rac. Climate	0.41**	0.14	0.34*	0.14	0.23	0.14
Priv Reg x Peer Clim			0.57**	0.21	0.43*	0.21
Priv Reg x Teach Clim			0.43*	0.21	0.32	0.20
Pub Reg x Peer Clim			0.08	0.12	0.08	0.12
Pub Reg x Teach Clim			-0.11	0.10	-0.14	0.10
Cent x Peer Climate			-0.04	0.14	0.03	0.14
Cent x Teacher Climate			-0.18	0.15	-0.21	0.14
Teacher Acceptance/ Support					0.55***	0.12

Results

The results are briefly summarized here—see Byrd and Chavous (2011) for full reports on analysis techniques, descriptives, and bivariate correlations. A hierarchical ordinary least squares regression was conducted with racial identity and racial climate as predictors of intrinsic motivation (see Table 14.1).

Figure 14.1: Interaction of Private Regard and Peer Racial Climate (High School Sample).

Intrinsic Motivation

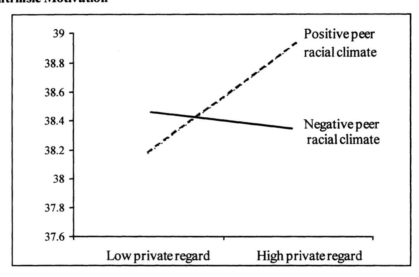

Interactions between racial identity and racial climate were found for private regard and both racial climate scales. The interactions were plotted according to procedures outlined by Aiken and colleagues (Aiken, West, and Reno, 1991). Figure 14.1 illustrates the interaction between private regard and peer racial climate ($B = 0.57$, $p < .01$). As predicted by the congruence perspective, youth with high private regard in settings with more frequent and positive interactions between students of different races reported higher intrinsic motivation than youth with high private regard in more negative settings. Figure 14.2 shows a similar pattern for private regard and teacher/staff racial climate ($B = 0.43$, $p < .05$). We found no relationship between centrality or public regard and racial climate; neither did we find interactions between centrality or public regard and climate.

Figure 14.2: Interaction of Private Regard and Teacher/Staff Racial Climate (High School Sample)

Intrinsic Motivation

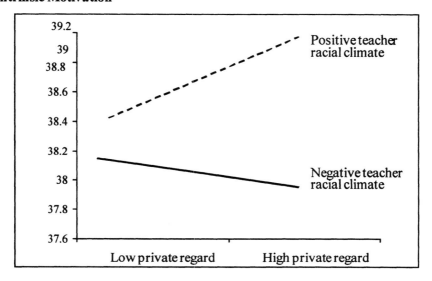

In this dataset we were able to test whether belongingness acted as a mediator of the effect of congruence on intrinsic motivation. We examined several conditions within a mediated moderation framework (Muller, Judd, and Yzerbyt, 2005). Peer support did not act as a mediator, but teacher support did mediate the interaction of private regard and teacher/staff climate (B_{step1} = .34, p < .05; B_{step2} = .23, ns). Furthermore, this mediation was moderated by private regard (B = .18, p < .10), such that youth with higher private regard reported a stronger relationship between teacher/staff racial climate and teacher support. The results suggest that not only are youth with higher private regard experiencing more support and acceptance in positive climates, and that this accounts for their higher enjoyment of school, those with high private regard also perceive more support from teachers in positive climates, compared to those with low private regard. In other words, high private regard youth are experiencing multiple benefits from the congruence between their beliefs and their perceptions of the school setting.

Discussion

The analyses in the high school sample provided strong support for our identity-context congruence perspective. Specifically, students with positive affective feelings about their racial group (high private regard) showed higher intrinsic

school motivation when their perceived racial climate was consistent with their positive racial identity beliefs. Also consistent with our expectations, the relationship between private regard-racial climate congruence and intrinsic school motivation was mediated through school belongingness. However, our inquiry raised several questions. First, as we did not find evidence of congruence effects for centrality and public regard, we speculated that one factor is the particular dimensions of school racial climate we assessed. For instance, our peer climate scale tapped into students' views of the normative amount of contact, as well as the quality of the contact, while the teacher/staff climate scale included items addressing both equal status and institutional norms. Would distinguishing aspects of racial climate that assess the frequency of intergroup context from the quality of that contact help illuminate congruence processes and provide more explanatory power? Alternatively, we posited that racial identity-racial climate congruence may function in different ways for different dimensions of racial identity. For instance, does congruence between perceived racial climate and particular aspects of racial identity (e.g., private regard) "matter" more than congruence with other dimensions of identity with regard to impact on affective connections to and motivation within the school setting? Another question is related to the types of contexts we assessed. For instance, would the consequences of racial identity- racial climate congruence or incongruence look similar in secondary and post secondary contexts? Our second example below provides some insight into these questions using data from a study of first year college students.

Example 2: College Student Study

Participants

Participants included 164 second-semester freshmen (24 percent male) drawn from the Racial Identity Longitudinal Study (RILS, R. Sellers, P.I.) of African American college transition. Three universities were included in the study, including a predominantly White university in the Midwest (n = 56), a predominantly White university in the Southeast (n = 96), and a historically Black university in the Southeast (n = 54). Male and female students were evenly distributed across campuses ($\chi^2(2) = 2.13$, ns). The participants ranged in age from 18 to 22 ($M = 18.45$, $SD = 0.59$). They completed self-report measures of racial identity, college racial climate, satisfaction with their campus experience, and demographic information.

Measures

Racial identity was measured similarly to the high school sample, though using the full Multidimensional Inventory of Black Identity (Sellers et al., 1997) with a

response scale ranging from 1 (strongly disagree) to 7 (strongly agree). The *centrality* subscale consisted of eight items (α = .75), the *private regard* subscale consisted of six items (α = .79), and the *public regard* subscale consisted of five items (α = .84).

Students' perceptions of their *college racial climate* were assessed on four dimensions using Chavous' (2005) modification of the Green et al. (1988) scale of school interracial climate for secondary students. Perceptions of *intergroup association* were measured by six items about norms around intergroup contact (e.g., "Students at [university] think it's good to get to know other students of different races"; α =.84). Perceived *equal status* between races was measured by six items (e.g., "All students at [university] are treated equally"; α =.80). Perceptions of *interdependence*, or the degree to which different racial groups worked toward common goals and benefitted from one another on campus, was measured with six items (e.g., "Black and White students at [university] need each other"; α =.74). Finally, *institutional supportive norms* (administrator and faculty support for intergroup contact) were assessed with four items (e.g., "The university administration at [university] encourages students to make friends with students of different races"; α =.81).

Like the high school study, we were interested in examining students' affective connection to the college context. In this study, we assessed *academic satisfaction* as our main dependent variable, which was measured with one item asking how satisfied students were with their academic life on a scale of 1 (very unsatisfied) to 7 (very satisfied).

As in the high school sample, personal racial discrimination was included as a variable in study models to account for the effects of personal experiences on satisfaction when examining racial identity-racial climate congruence effects. Racial discrimination was measured using the Daily Life Experiences scale (Harrell, 1994). Participants rated how frequently 18 discriminatory events occurred in the past year on a scale from 0 (never) to 5 (once a week or more). Other control variables entered in study models included gender, age, university, and a composite measure of family socioeconomic status representing family income and parents' education.

Results

Means and standard deviations are presented in Table 14.2. To examine associations of racial identity and racial climate with academic satisfaction, we conducted hierarchical ordinary least squares regression. All predictor variables were centered around the grand mean, and interaction terms were computed between each of the three racial identity variables and the four racial climate variables. Control variables were entered in step 1, followed by racial climate and

racial identity variables in step 2, with racial identity by racial climate interaction terms entered in step 3. Any significant interactions were plotted using the procedure recommended by Aiken and colleagues (Aiken et al., 1991).

Table 14.2: Means and Standard Deviations for Study Variables (College Sample)

	Mean	SD
Age	18.45	0.59
SES	5.58	1.74
Personal racial discrimination	1.54	0.75
Centrality	5.18	1.07
Private regard	6.49	0.65
Public regard	3.58	1.06
Intergroup association	4.28	1.21
Equal status	3.99	1.19
Interdependence	5.29	0.99
Institutional supportive norms	4.67	1.17
Academic satisfaction	6.02	1.48

The findings are presented in Table 14.3. The final model explained 28 percent of the variance in academic satisfaction. A marginal main effect was found for public regard, such that those who reported higher public regard reported being less satisfied with their academic life ($B = -0.24$, $p < .10$). There was also a main effect of perceived equal status, such that perceptions of higher equal status were associated with more satisfaction ($B = 0.36$, $p < .01$). This was qualified by two interactions. There were no other main effects of racial identity or racial climate but several interactions, three with private regard and two with centrality.

The first interaction was between private regard and equal status ($B = 0.42$, $p < .05$). The main effect of equal status on satisfaction can be seen in Figure 14.3. What is also evident is that individuals who reported higher private regard reported higher satisfaction when they perceived their school as fair relative to those who perceived less equal status.

Table 14.3: Hierarchical Regression of Racial Identity and School Racial Climate Predicting Academic Satisfaction (College Sample)

Model F df regression, df R2 change	Step 1		Step 2		Step 3	
	0.42 (6,156)		1.08 (13,149)		2.112** (25,137)	
	0.02		.07		.19**	
	B	**Std. Err.**	**B**	**Std. Err.**	**B**	**Std. Err.**
Intercept	2.23	3.89	0.99	3.91	0.39	3.72
Gender	-0.05	0.28	0.07	0.29	-0.02	0.28
SES	-0.08	0.07	-0.08	0.07	-0,11+	0.07
Southeast PWI	0.25	0.34	0.60	0.37	0.72*	0.36
Midwest PWI	0.34	0.37	0.72+	0.41	0.83*	0.40
Age	-0.01	0.21	0.03	0.21	0.07	0.20
Discrimination	0.14	0.16	0.23	0.18	0.21	0.17
Private Regard			-0.35+	0.20	-0.20	0.23
Public Regard			-0.19	0.13	-0.24+	0.13
Centrality			-0.06	0.13	-0.04	0.12
Association			-0.04	0.12	-0.11	0.12
Equal Status			0.24+	0.13	0.36**	0.13
Supportive Norms			-0.08	0.14	-0.01	0.15
Interdependence			-0.09	0.15	-0.10	0.15
Priv Reg x Association					0.27	0.23
Priv Reg x Equal Status					0.42*	0.21
Priv Reg x Supportive					-	0.30
Priv Reg x Interdepend.					1.21***	0.23
Pub Reg x Association					0.47*	0.11
Pub Reg x Equal Status					-0.13	0.12
Pub Reg x Supportive					-0.11	0.15
Pub Reg x Interdepend.					0.21	0.16
Cent x Association					0.04	0.11
Cent x Equal Status					-0.11	0.13
Cent x Supportive					-0.39**	0.16
Cent x Interdependence					0.41	0.14
					0.13	

*p<.05 **p<.01 ****p<.0001

Figure 14.3: Interaction Between Private Regard and Equal Status (College Sample)

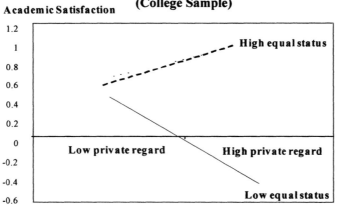

The second interaction, between private regard and interdependence ($B = 0.48$, $p < .05$), is pictured in Figure 14.4. Similar to the first interaction, there was a stronger, positive relationship between private regard and satisfaction among students perceiving higher interdependence on campus, that is, perceiving racial groups as working together, having positive interactions and valuing the contributions of the other group.

Figure 14.4: Interaction of Private Regard and Interdependence (College Sample)

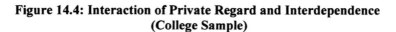

Figure 14.5 shows the third interaction, between private regard and supportive norms ($B = -1.21$, $p < .001$). Here, incongruence is associated with higher satisfaction in that there was a significant, negative relationship between private

regard and academic satisfaction among students perceiving institutional norms as being more supportive of intergroup contact relative to those with more negative supportive norms perceptions.

Figure 14.5: Interaction of Private Regard and Supportive Norms (College Sample)

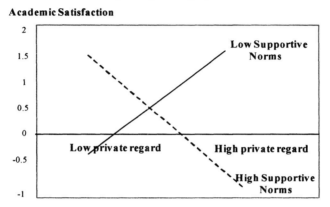

Two interactions were found for centrality. Figure 14.6 shows that equal status was not a factor in academic satisfaction for students higher in centrality, although the lower centrality individuals did differ ($B = -0.39$, $p< .01$). In Figure 14.7, we see that higher perceived university support for intergroup contact is associated with higher satisfaction for high centrality individuals, compared to lower perceived support ($B = 0.41$, p < .05).

Figure 14.6: Interaction of Centrality and Equal Status (College Sample)

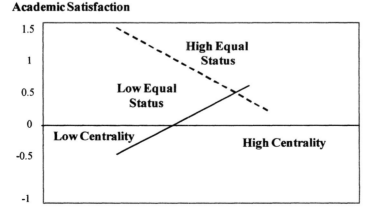

**Figure 14.7: Interaction of Centrality and Supportive Norms
(College Sample)**

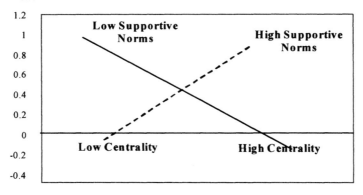

Discussion

The college sample results provided some support for our congruence perspective, while other findings were counter to our predictions. The significant interactions between private regard and equal status, private regard and interdependence, and centrality and supportive norms are consistent with our expected relationships, indicating that racial identity-context congruence and academic outcomes relate to affective connections to the college context (academic satisfaction) necessary for autonomous motivation in the setting (Deci and Ryan, 2008).

Two other interaction effects were unexpected, however. Private regard was positively related to academic satisfaction for those perceiving fewer supportive institutional norms, and negatively related to satisfaction for those reporting more supportive norms. One reason for this finding could be that information obtained from the racial climate is differentially related to students' beliefs about the significance of race (centrality) relative to their affective feelings about their race (private regard). Administrative support for intergroup contact may give African American students the message that racial difference is valued and that group membership is an important characteristic to consider in one's interactions. For students higher in centrality, this will be congruent with their beliefs, and the interaction between centrality and supportive norms supports this (Figure 14.7). On the other hand, more institutional efforts to support positive intergroup contact may reflect the administration's efforts to improve a college context where racial problems and tensions are present. For instance, African American students may see the administration's support as reactive rather than an institutional value and as efforts that may force them into interactions that likely will be negative. For individuals higher in racial pride (private regard) then, perceiving more institutional efforts to support intergroup relations may relate to a more negative experience of

their college academic life (lower satisfaction) than those perceiving fewer institutional efforts (as suggested by Figure 14.5). These results suggest that different dimensions of racial climate may interact in ways not fully captured in this study.

The resulting interaction between centrality and equal status, at first glance, appeared to be counter to what would be expected based on our congruence perspective. In this case, higher centrality related to higher satisfaction among students reporting lower equal status across racial groups, while centrality related positively to satisfaction among students perceiving lower equal status. However, a closer consideration of the equal status climate dimension could help illuminate the seemingly unexpected finding. Perceiving equal status within an academic setting could signal a color-blind ideology, which could mean that group differences are downplayed, which would be incongruent with high centrality beliefs. Thus, students higher in centrality might feel less satisfied in their academic settings when perceiving these norms. An alternative explanation is that among higher race central students perceiving lower racial equality may relate to higher academic satisfaction, because negative academic experiences may be more likely to be attributed to factors related to inequality rather than to the self. The findings raise important questions about what constitutes congruence or incongruence in relation to the significance dimension of racial identity beliefs (centrality) relative to affective beliefs (private regard).

As in the high school sample, we found no interaction effects for public regard, although there was a main effect. Public regard may function uniquely from other assessed dimensions of racial identity, perhaps because public regard does not concern individuals' own perceptions of their group but, rather, their beliefs about others' perceptions. Public regard may have a greater impact on other forms of motivation (e.g., educational values, utility beliefs, or expectations). Unlike the high school sample, we found interactions for centrality in the college sample, which may speak to the need to distinguish between aspects of climate that give youth messages about the significance of race, rather than how much their group is liked and respected.

The college sample was able to shed insight into how different aspects of climate can be congruent with youths' racial identity beliefs. In fact, significant interactions resulted with three of the four measured dimensions of racial climate. In contrast, there were no significant interactions with intergroup association. This variable may not have informed congruence effects in this study because the intergroup association scale was primarily concerned with the frequency of intergroup contact rather than the positivity or negativity of the interactions. The other racial climate variables tap into the quality of intergroup interactions and thus may be more informative for examining how racial identity-context congruence relates to affective connections with students' academic contexts. We also saw evidence of congruence effects related to both the significance and affective domains of racial identity. However, findings suggest different processes related to congruence for significance and affective beliefs around racial identity. Finally, the

two examples suggest similar and different congruence effects in secondary and post secondary contexts.

Future Directions and Conclusions

This chapter has extended the description of the congruence perspective offered in Byrd and Chavous (2011) by describing specific conditions of racial identity-context congruence and showing how congruence can occur on multiple dimensions of racial climate and across levels of education. This research calls on scholars interested in the effects of racial identity on motivation and achievement to also consider the norms and values in the settings where youth are situated.

The data in this chapter point to several areas of future exploration. One direction is to measure the match in racial attitudes even more closely. Instead of assuming that positive intergroup interactions mean African Americans are liked, participants could report on how positively African Americans are perceived in their schools. Similarly, participants could report on how much they see racial group membership emphasized or celebrated in their school settings. Other racial attitudes can contribute to congruence as well, such as individuals' ideological beliefs around the meaning of race (Sellers et al., 1998). For instance, the degree to which participants themselves have a multicultural orientation could be differentially associated with their feelings of belonging in schools with different perceived ideological value systems (e.g., schools with multicultural approach or color-blind/assimilation approach), as suggested by Chrobot-Mason and Thomas (2002).

Another direction of exploration is to consider how dimensions of racial climate interact in determining congruence with racial identity beliefs. For example, to what extent would high racial centrality be congruent or incongruent with a perceived school racial climate characterized by high equal status, but also a color-blind ideology? Similarly, it is important to explore whether congruence between different aspects of racial climate and racial identity beliefs has an additive effect on motivation, or whether congruence on some dimensions of racial climate can compensate for incongruence in other areas. Finally, while our analyses focused on comparing students with higher or lower racial identity beliefs relative to the sample, future research also could consider youth with varying levels of endorsement of particular identity beliefs (i.e., differences in the nature and effects of racial identity-context congruence for individuals with very strong beliefs versus those with moderate beliefs, or with youth who vary in their patterns across a particular set of identity beliefs). Finally, while we focused on motivational outcomes related to individuals' connections with their proximal academic contexts, future work might consider the implications of congruence or incongruence for other motivational outcomes, such as educational values or future aspirations.

In sum, our goal in this chapter and empirical examples was to complicate the discussion of the linkages between African American racial identity and achieve-

ment motivation by offering a framework explicitly considering the role of school context. Results suggest the utility of considering variation among African American students, both in their racial identity beliefs and in ways they experience race in their daily academic settings. Our conceptual framework and examples highlight how similar racial identity beliefs can have different consequences depending on students' experience of their school/institutional racial climate. Our work has important implications and potential for informing literatures on ethnic minority achievement motivational processes. One implication is that a strong and positive sense of African American identity is not incompatible with positive academic identities and motivation beliefs, and contexts that affirm students' positive views of their group identity can lead to their developing even more positive connections between their personal identities and schooling. Thus, interventions aimed at changing African American youths' educational values or identity beliefs may be less effective relative to efforts to create more inclusive academic contexts.

References

Aiken, L.S., West, S.G., and Reno, R.R. (1991). *Multiple regression: Testing and interpreting interactions.* London: Sage Publications.

Allport, G. W. (1954). *The nature of prejudice.* Boston: Addison-Wesley Pub. Co.

Bell, L. A. (2002). Sincere fictions: The pedagogical challenges of preparing White teachers for multicultural classrooms. *Equity and Excellence in Education, 35,* 236-244.

Booker, K. C. (2006). School belonging and the African American adolescent: What do we know and where should we go? *The High School Journal, 89,* 1-7.

Brand, S., Felner, R., Shim, M., Seitsinger, A., and Dumas, T. (2003). Middle school improvement and reform: Development and validation of a school-level assessment of climate, cultural pluralism, and school safety. *Journal of Educational Psychology, 95,* 570-588.

Brown, R. (2005). Stigma consciousness and the race gap in college academic achievement. *Self and Identity, 4(2),* 149-157.

Byrd, C. M., and Chavous, T. M. (2011). Racial identity and intrinsic motivation among African American youth: The importance of person-context congruence. *Journal of Research on Adolescence, 21*: no. doi: 10.1111/j.1532-7795.2011.00743.x.

Chavous, T. M. (2005).An intergroup contact-theory framework for evaluating racial climate on predominantly White college campuses. *American Journal of Community Psychology, 36,* 239-257.

Chavous, T. M., Bernat, D. H., Schmeelk-Cone, K., Caldwell, C. H., Kohn-Wood, L., and Zimmerman, M. A. (2003). Racial identity and academic attainment among African American adolescents. *Child Development, 74,* 1076-1090.

Chavous, T. M., Rivas, D., Smalls, C., Griffin, T., and Cogburn, C. (2008). Gender matters, too: The influences of school racial discrimination and racial identity on academic engagement outcomes among African American adolescents. *Developmental Psychology, 44*, 637-654.

Chrobot-Mason, D., and Thomas, K.M. (2002). Minority employees in majority organizations: The intersection of individual and organizational racial identity in the workplace. *Human Resource Development Review, 1*, 323-344.

Cokley, K. O. (2001). Gender differences among African American students in the impact of racial identity on academic psychosocial development. *Journal of College Student Development, 42*, 480-487.

Cokley, K. O. (2003). What do we know about the motivation of African American students? Challenging the "anti-intellectual" myth. *Harvard Educational Review, 73*, 524-558.

Crocker, J., and Major, B. (1989). Social stigma and self-esteem: The self-protective properties of stigma. *Psychological Review, 96*, 608-630.

Cross, W. E. (1991). *Shades of black: Diversity in African American identity.* Philadelphia: Temple University Press.

Deci, E. L., and Ryan, R. M. (2008). Facilitating optimal motivation and psychological well-being across life's domains. *Canadian Psychology, 49*, 14-23.

Deci, E. L., Vallerand, R. J., Pelletier, L. G., and Ryan, R. M. (1991). Motivation and education: The self-determination perspective. *Educational Psychologist, 26*, 325-346.

Goodenow, C. (1993). The psychological sense of school membership among adolescents: Scale development and educational correlates. *Psychology in the Schools, 30*, 79–90.

Green, C. W., Adams, A. M., and Turner, C. W. (1988). Development and validation of the school interracial climate scale. *American Journal of Community Psychology, 16*, 241-259.

Harper, B. E., and Tuckman, B. W. (2006). Racial identity beliefs and academic achievement: Does being Black hold students back? *Sociology of Education, 9*, 381-403.

Harrell, S. P. (1994). The racism and life experience scales. Unpublished manuscript.

Mattison, E., and Aber, M. (2007). Closing the achievement gap: The association of racial climate with achievement and behavioral outcomes. *American Journal of Community Psychology, 40*(1), 1–12.

Muller, D., Judd, C.M., and Yzerbyt, V. Y. (2005). When moderation in mediated and mediation is moderated. *Journal of Personality and Social Psychology, 89*, 852-863.

O'Connor, C. (1999). Race, class, and gender in America: Narratives of opportunity among low-income African American youth. *Sociology of Education, 72*, 137-157.

Oyserman, D., Harrison, K., and Bybee, D. (2001). Can racial identity be promotive of academic efficacy? *International Journal of Behavioral Development, 25,* 379-385.

Plaut, V.C. (2010). Diversity science: Why and how difference makes a difference. *Psychological Inquiry: An International Journal for the Advancement of Psychological Theory, 21*(2), 77-99

Ryan, A. M., and Patrick, H. (2001). The classroom social environment and changes in adolescents' motivation and engagement during middle school. *American Educational Research Journal, 38,* 437-460.

Sellers, R. M., Copeland-Linder, N., Martin, P. P., and Lewis, R. L. (2006). Racial identity matters: The relationship between racial discrimination and psychological functioning in African American adolescents. *Journal of Research on Adolescence, 16,* 187-216.

Sellers, R. M., Rowley, S. A. J., Chavous, T. M., Shelton, J. N., and Smith, M. A. (1997). Multidimensional inventory of Black identity: A preliminary investigation of reliability and construct validity. *Journal of Personality and Social Psychology, 73,* 805-815.

Sellers, R. M., Smith, M. A., Shelton, J. N., Rowley, S. A. J., and Chavous, T. M. (1998). Multidimensional model of racial identity: A reconceptualization of African American racial identity. *Personality and Social Psychology Review, 2,* 18-39.

Smalls, C., White, R., Chavous, T., and Sellers, R. (2007). Racial ideological beliefs and racial discrimination experiences as predictors of academic engagement among African American adolescents. *Journal of Black Psychology, 33,* 299-330.

Spencer, M. B., Noll, E., Stoltzfus, J., and Harpalani, V. (2001). Identity and school adjustment: Revisiting the "acting white" assumption. *Educational Psychologist, 36,* 21-30.

Steele, C. M. (1997). A threat in the air: How stereotypes shape intellectual identity and performance. *American Psychologist, 52,* 613-629.

Worrell, F. C. (2007). Ethnic identity, academic achievement, and global self-concept in four groups of academically talented adolescents. *Gifted Child Quarterly, 51,* 23–38.

Chapter Fifteen
The Influence of African American Racial Identity on Standardized Test Performance

Keena Arbuthnot

Introduction

In recent years the prevalence of standardized testing within our schools has drastically increased. The No Child Left Behind Act (2002) has changed the nature and stakes related to testing. This legislation has called for testing students once a year in third through eighth grade and at least once in high school. With the increased use of standardized tests, researchers need to focus their attention on the standardized testing situation. Ideally, tests are used as a way to analyze and evaluate how well students understand and comprehend learned material. Although, this is the intent of many testing initiatives, we must ask ourselves, how much information can we garner from standardized tests? The state of affairs now begs the question: Are all students experiencing the testing environment in similar ways, or are there social and psychological processes that could potentially undermine or hamper certain students' performances on tests? More importantly, why are certain groups of students outperforming other groups of students on standardized tests?

Literature Review

Achievement Gap

The achievement gap between Black and White students has been well documented. Studies and test score data show that Black students consistently underperform White students on most standardized tests. For example, on the NAEP Blacks

scores significantly worse the White students. On the SAT Black students are scoring consistently lower than their white counterparts. Blacks, on average, score approximately 100 points less (one standard deviation) than White students. This same pattern exists on tests used to gain admission into graduate/professional programs. The documented differences on these tests are even more exacerbated. Researchers have studied the sources and/or explanations for these differences to provide a better understanding of why Black students show such marked differences in test performance. The research to date has identified factors related to school (i.e., teacher expectations, resources), home environment (i.e., number of books in the home, television watching), parental background (i.e., socioeconomic status, educational background) and student-centered factors (i.e., motivation, worry, self-efficacy, racial identity) that help to explain why there are such large differences on standardized tests. In addition, some research has been focused on examining how different groups experience the testing environment. This research has shown that Black and White test takers experience the testing environment in vastly different ways.

The student- centered factors are a pivotal aspect in understanding the Black White achievement gap. Although other explanations mentioned above are important, the factors directly related to the student personally have great potential in helping to unlock why we see such large gaps in performance.

Test Anxiety, Self-efficacy, and Motivation

Many researchers have examined how differences in test anxiety, self-efficacy and motivation affect test performance and possibly have an effect the test performance differences of Black and White test takers (Ryan, Ryan, Arbuthnot, and Samuels, 2007). Research has shown that there is a relationship between test anxiety and test performance: As anxiety increases, performance decreases (Hembree, 1988). Although several studies have examined the differences in anxiety levels of Blacks and Whites, the findings are inconsistent. Some found that Blacks had higher levels of test anxiety, while others found that Whites had higher levels of anxiety (Hembree, 1988; Payne, Smith, and Payne, 1983). Nonetheless, it has been raised that differences in test anxiety could explain some of the differences in performance of Black and White test takers. Next, another explanation that has been raised in reference to Black and White test performance differences is test takers' motivation. This includes both why students are motivated to do well on the test, as well as an individual's level of motivation to exert effort and perform on a test (Ryan, Ryan, Arbuthnot, and Samuel, 2007; Ryan, 2001). Lastly, differences in self-efficacy, or the belief that an individual has the ability to be successful on the task at hand, may be able to explain differences in test performance. Although there is not agreement on this topic, some research has found evidence that Black students may have lower self-efficacy in regards to how successful they feel they will be on tests (Graham, 1994).

Cognitive Disorganization

Some researchers have examined how cognitive disorganization differs for groups of individuals in reference to their test-taking experiences. Students exhibit cognitive disorganization when they have difficulty with the time constraints of the test or feel confused when solving test items. These situations seem to provide additional obstacles for students to successfully finish standardized tests. For example, statements such as "I was worried about the time left on the test," or "I felt like I had to rush on this problem because time was running out," are instances of cognitive disorganization in relation to time or pace of the test. Statements such as "I felt very confused working on this problem," or "I didn't understand what the question was asking me" relate to when students experience cognitive disorganization in reference to confusion or difficulty solving test items. Arbuthnot (2009) found that Black students who were in a high-stakes in comparison to a low-stakes standardized testing situation experienced more cognitive disorganization in reference to their ability to deal with time constraints.

Racial Identity

Theories of Racial Identity

Racial identity is an ambiguous and socially constructed concept. It implies a "consciousness of self within a particular group" (Spencer and Markstrom-Adams, 1990). It's the "meanings a person attributes to the self as an object in a social situation or social role" (Burke, 1980), and it relates to a "sense of people-hood, which provides a sense of belonging" (Smith, 1989). The "level of uncertainty about the nature of racial identity" (Herring et al., 1999) and the "indicative confusion about the topic" (Phinney, 1990) is illustrated by the lack of a standard definition. Nevertheless, according to symbolic interactionism, "racial identity is treated as one of the many identities contained within self" (White and Burke, 1987), and it is given fundamental and overriding importance in the United States. For example, Winant (1995) explains "racial identity outweighs all other identities. We are compelled to think racially, to use the racial categories and the meaning systems into which we have been socialized. It is not possible to be 'color blind,' for race is a basic element of our identity. For better or worse, without a clear racial identity, an American is in danger of having no identity" (pp. 31-32).

Racial identity formation is produced by the everyday "interactions and challenges" (Davis and Gandy, 1999) that an individual encounters. It is affected by socioeconomic status and situational context (Cornell and Hartman, 1998). It is "dynamic and changing over time, as people explore and make decisions about the role of race in their lives" (Phinney, 1990). In other words, racial identity is "achieved through an active process of decision making and self-evaluation" (Phinney, 1990). Cross (1971) and Banks (1981) have proposed the idea that racial

identity development is a "progressional process which occurs in a hierarchical sequence from racial unconsciousness to racial pride and commitment" (Gay, 1985, p. 49). For example, Cross (1978) said the five stages to identity development include the following: pre-encounter, encounter, immersion-emersion, internalization, and internalization and commitment. In essence, these stages represent a process by which people come to a "deeper understanding and appreciation of their race" (Phinney, 1990). Even so, a deeper understanding may not translate into a greater acceptance of their racial identity; nevertheless, it has an effect on behavior.

The importance of this is that "positive racial identification for most racial minorities does not happen automatically; nor does it for all individuals. When it does happen, it is learned" (Gay, 1985). This suggests that racial identity sentiments and attitudes are heterogeneous even among people of the same race, because individual's experiences and encounters differ.

Theories of Black Identity

Black identity is "emerging, changing, and complex" (Hecht and Ribeau, 1991). Banks (1981) has suggested that "there is no one identity among blacks that we can delineate, as social scientists have sometimes suggested, but many complex and changing identities among them" (pp. 129-139). Due to its multifaceted nature, scholars have conceptualized Black identity in a variety of different ways; consequently, several different psychometric scales have been used to tap the different dimensions of Black identity. Black identity has been often conceptualized as "racial categorization" (Jaret and Reitzes, 1999), "common fate or linked fate" (Gurin et al., 1989; Dawson,1996), "racial salience" (Herring et al., 1999), "closeness" (Allen et al., 1989; Broman et al., 1988; Conover, 1984), "black separatism or racial solidarity" (Allen and Hatchett, 1986; Allen et al., 1989), "racial self-esteem" (Porter and Washington, 1979), "Africentrism" (Grills and Longshore, 1996), and "racial awareness and consciousness" (Jackson, 1987). Others suggest that Black identity has "multiple dimensions" (Seller et al., 1998) and formation occurs over time through various "stages" (Cross, 1978).

Psychometric scales that are used to assess Black identity range from one question to sometimes over sixty questions, depending on how Black identity is operationalized. Furthermore, scholars use different measures to tap the same aspect of Black identity. Recognizing the various dimensions of Black identity and the different measures that tap it, scholars have forged ahead with the understanding that no one conceptualization of racial identity or psychometric scale is better than the other.

Regardless of complex nature of Black identity, scholars have focused their attention on exploring the factors shaping Black identity and the effect Black identity has on human behavior. Let's begin with the factors shaping Black identity. Black identity is affected by socioeconomic status and situational context. Studies

have suggested that social and demographic factors (Broman et al. 1988; Allen et al., 1989), childhood socialization (Gecas, 1979), interracial interaction (McGuire et al., 1978), social class (Gecas, 1979), age (Broman et al., 1988; Porter and Washington, 1979), family and friends (Gecas and Mortimer, 1987; Hughes and Demo, 1989), and socioeconomic status (Allen et al., 1989; Broman et al., 1988) are important factors influencing Black identity. Broman et al. (1988) found people who were older, Southern, and less educated scored higher on an index measuring closeness to other Blacks.

Demo and Hughes (1990) examined the social structural process and arrangements related to racial group identification. They found that group identity is shaped by the content of parental socialization. In particular, "feelings of closeness and black group evaluation are enhanced by positive interpersonal relations with family and friends" (p. 372). Interracial contact has also been found to shape Black identity. Harris (1995) explored the impact of childhood interracial contact on adult Black identity. The findings suggest that "interracial contact in childhood weakens adult feelings of closeness to other blacks" (p. 243). Similar findings were also found in Demo and Hughes's (1990) study, in which they discovered that the impact of interracial interaction depends on timing. Specifically, "contact during childhood and adolescence has a negative impact on the Black group identity; however, interracial relationships during adulthood promote positive black group evaluations" (p. 372). Social movements have also been shown to affect racial identity. Condi and Christiansen (1977) found that there has been "significant shift in identity structure of blacks and that the Black Power movement was an important causal factor in effecting change" (p. 53)

Residential racial composition, competition, and conflict have been shown to affect Black identity. Conflict theorists argue group identity and cohesiveness increase as a result of conflict with an adversary (Coser, 1965), and competition theorists argue competition among racial-ethnic groups in work and community settings will also increase the likelihood people will attach more importance to their racial-ethnic identity (Olzak and Nagel, 1986). Jaret and Reitzes (1999) explored Black identity changes in different social settings. The findings indicate Black identity changes across various settings; specifically, Black identity is more important for Blacks at work and least important at home. In addition, changes in Black identity are affected by racial composition of the local area. They find that Blacks "living in areas that are 'intermediate' in percentage Black say that their racial-ethnic identity is more important to them than do Blacks living in areas with 'low' amounts of Black residents or with 'high' amounts of Black residents" (p. 725).

Contrary to the findings of Jaret and Reitzes (1999), Bledsoe et al. (1995) found those who live in neighborhoods with more Blacks score significantly higher on racial solidarity scale; mixed-neighborhoods show less solidarity than those who live in more heavily Black neighborhoods (p. 449). The major reason is because "those who live in mixed-race neighborhoods have more frequent and intimate contact with whites; surrounded by white friends, acquaintances, neighbors,

merchants, and service providers, these Blacks may simply perceive less reason to engage in collective action on behalf of blacks" (p. 450).

Racial Identity and Achievement

As stated in the literature presented above, one's racial identity has an impact on many aspects of one's life. Educational researchers have examined the role in which racial identity affects student achievement. Grantham and Ford (2003) suggest that when high achieving or gifted Black students develop healthy racial identities, they are less likely to succumb to negative peer pressure and are given the freedom to achieve at higher levels. Harper and Tuckman (2006) examined the role of Black identity and achievement of high school students. In this study they used the MMRI to assess Black identity. They developed several different profiles of students. Most notably, they had the "idealized" group, which included those students who exhibited high levels of racial centrality, public regard and private regard. On the contrary, there were the alienated students who had very low levels of racial centrality, public regard and private regard. Surprisingly to the authors, the "alienated" students had higher levels of academic achievement in comparison to the "idealized" group. This finding was contrary to the finding of Chavous et al. (2003). Other studies have found that racial identity has an effect on academic efficacy as well (Oyserman, Harrison and Bybee, 2001). These studies show that for Black students, one's racial identity can have an impact on his or her achievement. However, no research to date has examined how one's racial identity affects the way in which Black students experience the test taking environment.

This study aims to investigate how racial identity influences the standardized test-taking experience for Black college students. Specifically, the study examines how one's racial regard, one's evaluative attitude toward one's race, impacts standardized test-taking. Specifically, the study answers the following research questions: (a) Does racial regard impact the level of test anxiety students feel in a standardized testing situation? and (b) Does racial regard affect the level of cognitive disorganization (i.e., confusion, difficulty keeping track of time) that a Black test taker experiences while taking a standardized test?

The participants in the study were asked to take a timed standardized mathematics examination under normal testing conditions. Upon completion the students took a battery of survey items that assessed the extent to which they were worried or felt some form of cognitive disorganization. Additionally, the participants were administered the racial regard scales of the MMRI to assess the different dimensions of their racial identity. Based on the previous literature, it was hypothesized that a Black student's public regard would have an impact on his or her worry and cognitive disorganization while taking the standardized test. Specifically, there would be a negative relationship between public regard and the worry and cognitive disorganization constructs. Consequently, the higher a

student's public regard, the lower their worry and cognitive disorganization while taking standardized tests.

Methods

Sample/Participants

Ninety high-achieving African American college students participated in the study. These students attend colleges and universities across the country and are from Kansas City, Missouri; Washington, DC; St. Louis, Missouri; and Florida. They ranged in age from eighteen to twenty-two. Some of the students in the study are participants of a college program in their respective cities.

Measures

The Sellers et al. (1998) multidimensional model of racial identity (MMRI) scale was used to assess Black racial identity. The regard dimension was used for this study. This dimension consisted of two subscales, *private regard* and *public regard*. The three item private regard subscale (α= .69) measures a person's evaluative judgment about his or her race (i.e.,"I feel good about Black people"). The higher the mean on this subscale, the more the person felt good or positive about being Black. The four-item public regard scale (α= .79) measured how an individual perceives that others view his or her group (i.e., in general, others respect Black people). Consequently, the higher the mean on the public regard subscale, the more that the individual believes that Blacks are regarded in a positive way in society. On each of the subscales, participants were asked to identify the extent to which they agreed or disagreed with each item based on a seven- point likert scale.

Test Anxiety

An adaptation of the Morris et al. (1981) scale was used to assess how much students worried while taking the examination. The worry scale is designed to measure the extent to which one is worried about test failure. The worry (5-items) scale had a reliability estimate of a =.86. The scale consisted of five survey items in which participants were asked to mark the extent to which they agreed or disagreed with each test item based on a five-point likert scale.

Cognitive Disorganization

The cognitive disorganization measure consisted of two subscales, time constraints and confusion. The *time constraints* scale was used to measure the extent to which participants paid attention to or were bothered by the time constraints they had for solving the mathematics test items (i.e., "I felt rushed while working on the problems"). The second subscale *confusion* measured the extent to which

participants had difficulties starting questions and had concerns about what ways to approach the items (i.e., I didn't know what to do or where to begin on this item). Pilot study data done with eighth grade students showed the cognitive disorganization scale a reliability of a =.80. The mean for each of the scales was calculated for each participant. The higher the time constraint score, the more the participant experienced problems organizing his or her time. Similarly, the higher the confusion score, the more the participant had difficulties or problems approaching the test items. Both scales consisted of five survey items in which participants were asked to mark the extent to which they agreed or disagreed with each test item based on a five-point likert scale.

Procedures

Each participant consented to participating in the project. Participants in each city were assembled as a group in a university auditorium or classroom. At each site, there was one Black administrator and an assistant. First, participants were asked to fill out their personal information (i.e., name, sex, racial/ethnic background) located on the first page of the survey booklet. Next, students were asked to carefully read the test directions on the first page of their test booklet. The directions stated, "A group of researchers from Harvard University and historically Black colleges have been studying math achievement. To participate in the project you will be asked to complete a standardized test consisting of math items taken directly from the ACT. Your score on this test will be compared to your classmates and with college students across the nation. At the end of this session, you and your professor will be given your results from this standardized test."

These directions were intended to be similar to directions that would typically be presented in a typical standardized testing situation. After giving participants sufficient time to read the directions, they were informed that they would have 30 minutes to complete the thirty-item standardized mathematics test. After completing the mathematics test, participants were asked to answer survey questions regarding their test anxiety, cognitive disorganization and lastly, their racial identity. Participants were informed that their participation was voluntary and they could stop at anytime.

Results

Descriptives and Correlations

Table 15.1 presents the means and standard deviations for participants on each of the variables in the study. The results show that on average students had a very high private regard (M=6.50). The findings show that on average, students had very positive feelings about being Black. However, on the public regard measure students on average were much more moderate (M=3.22) in how they perceived

that other people viewed Black people. In reference to their test-taking patterns, participants on average were not extremely worried about taking the test (M=2.87) and the time constraints (M=3.06) for the standardized test. However, on average the participants were not very confused while taking the standardized test (M=2.28).

Table 15.1: Means, Standard Deviations for Each Study Variable

	N	M	SD
Private Regard	84	6.50	0.61
Public Regard	84	3.22	1.25
Worry	90	2.87	1.13
Time Management	90	3.07	1.28
Confusion	90	2.28	0.95

Correlation coefficients were calculated for each of the variables of interest. Table 15.2 shows the results of the correlational analyses. For the purposes of this study it was important to identify which test taking variables had significant correlations with the public and private regard scales. The findings show that there were no significant correlations with the private regard scale. This finding shows that the extent to which the students had positive feelings about being Black did not relate to how worried or confused the students would feel, or the difficulty with which they had to deal with time constraints while taking the standardized test. On the other hand, the public regard scale had significant negative correlation with the worry, time constraints and confusion scales. Hence, participants who had a lower public regard, or felt as though the public viewed Black people in a negative manner, had higher levels of worry, confusion and difficulty with time constraints. Overall, these findings suggest that the way in which a student perceives the public view of Black people could have a potential effect on the way in which Black students experience the standardized test environment.

Table 15.2: Intercorrelations for Primary Study Variables

	A.	B.	C.	D.	E.
Private Regard	—				
Public Regard	.030	—			
Worry	-.050	-.301*	—		
Time Constraints	.051	-.288*	.436*	—	
Confusion	-.006	-.350*	.605*	.313*	—

Note. *correlation is significant at the .01 level

Analysis of Variance

Separate one way analysis of variance (ANOVA) were conducted to determine the relationship between public regard and private regard to the test taking constructs (worry, confusion, and time constraints). A median split criterion was used on both the public (Median=3.00) and private (Median=6.67) regard scales to divide participants into low- and high- public and private regard groups. As shown in Table 15.3, the results revealed there were no significant differences on the worry, confusion or time constraints scales for the low-private regard group in comparison to the high-private regard group. As shown in Table 15.4, in reference to public regard, the ANOVA for worry revealed a significant difference between those participants who had low- and high-public regard, $F(1, 81) = 7.75, p< .01, d = .62$. Next, the results showed that for time constraints there was a significant difference between those participants in the low- and high-public regard group, $F(1, 81) = 11.99, p< .01, d = .77$. Lastly, the findings revealed that there was a significant difference on the confusion measure between the low- and high-public regard groups, $F(1, 81) = 10.20, p< .01, d = .71$.

Table 15.3: Means, Standard Deviations, and Effect Sizes for Test-Taking Variables as a Function of Private Regard

	Low Private Regard			High Private Regard			
	N	M	SD	N	M	SD	d
Worry	49	2.82	1.04	35	2.93	1.32	-0.09
Time Management	49	2.98	1.08	35	3.36	1.45	-0.30
Confusion	49	2.14	0.78	35	2.37	1.10	-0.26

Table 15.4: Means, Standard Deviations, and Effect Sizes for Test-Taking Variables as a Function of Public Regard

	Low Public Regard			High Public Regard			
	N	M	SD	N	M	SD	d
Worry	42	3.21	1.12	41	2.53	1.11	0.62
Time Management	42	3.59	1.18	41	2.69	1.19	0.77
Confusion	42	3.55	0.99	41	1.93	0.76	0.71

Discussion

The purpose of this study was to examine the relationship between Black students' Racial Regard and their test-taking experiences. As stated, the achievement gap between Black and White test takers has been one of the most important educational issues of our time. Being able to understand and conceptualize possible

reasons and explanations for these differences is important. One area that has been explored extensively is how Black and White students' experiences with standardized testing differ. Understanding these differences is most important. It can potentially be the key to unlocking a central part of the reason we see large differences in standardized testing. Previous research has examined how one's racial identity affects achievement in Black students; however, no research to date has investigated how racial identity is related to one's standardized test-taking experiences. The present study shows that there is a significant relationship between the way in which an individual views the public's interpretation of Black people and the way in which that same participant experiences standardized tests. Specifically, it shows that the more a Black student perceives that others do not think positively of Black people, the more likely that student will experience more worry, confusion and have issues managing their time while taking a standardized test. Having to contend with more worry, confusion and difficulty managing time on a standardized test has been shown to potentially have a negative effect on standardized test performance.

Test Anxiety

The present study showed that the worry component of test anxiety is related to a Black student's interpretation of public regard, or the way in which the public or society perceives Black people as a whole. Previous research has been inconsistent in understanding how test anxiety differs for Black and White test takers. Some research shows that Blacks have higher test anxiety, and other research shows that White experience higher test anxiety (Hembree, 1988; Payne, Smith, and Payne, 1983).The present findings show that Black students are not necessarily a homogenous group of test takers. Certain aspects of students' Black identity are related to the extent to which Black students worry while taking standardized tests. This suggests that those Black students who feel that Blacks are perceived positively in our society may not experience as much worry on standardized tests. Consequently, the extent to which a student exhibits worry or some form of test anxiety can have an adverse effect on his or her overall test performance. These findings can provide useful information in helping to understand and conceptualize the diversity of Black test takers and in understanding how Black test takers experience the test taking environment. It shows that the interpretation of negative perceptions about one's group in society can affect test taking styles and performance. Future research should focus on providing more details in the way in which Public Regard affects achievement inside and outside the testing environment. This research can provide a more refined understanding of test taking experiences.

Cognitive Disorganization

The present study also showed that the public regard component of racial identity was related to the extent of cognitive disorganization that a Black student experienced in the test taking environment. Specifically, the research showed that the more a Black student felt that Blacks were perceived positively in society, the less confusion and difficulty with time constraints they had on a standardized test. Previous research examined the extent to which the type of testing situation (low- or high-stakes) affected the level of cognitive disorganization a Black student felt in a testing environment. The findings showed that Black students experienced significantly more problems with dealing with time constraints in the high-stakes testing environment; however, the type of testing environment did not affect the extent to which they were confused (Arbuthnot, 2009). The present study builds upon this research to show that testing environment alone does not impact cognitive disorganization. It suggests that cognitive disorganization is also impacted by students' perceptions of society and the way in which society perceives their particular racial group. Future studies should further examine the role that racial regard has on the experiences of test takers.

Implications

This research shows that perceptions of the outside world can and do impact standardized test performance. Although we want to believe that all test takers experience the standardized test situation the same, it is not the case. There are several factors that can contribute to the way in which Black students take standardized tests. Many policymakers are interested and invested in closing the achievement gap between White and Black students. The present study shows that Black students' racial identity could have an impact on their standardized test performance. These findings could have an impact on educational theory and practice. First, it is worthwhile to understand the within-group differences of Black test takers. These differences can be instrumental in helping to disentangle the reasons and explanations for the achievement gap. Further research in this area should examine how and why students differ in the way in which they interpret how society views Black people. Are there certain groups of students that feel that Blacks are viewed more positively or negatively in our society? Second, this type of research can be useful to practitioners as well. Although there may be no way to change a student's opinion about the way in which society views Blacks, it is still helpful for teachers to understand the reasons why certain students may exhibit more worry, confusion and issues with time constraints on standardized tests.

References

Allen, R., and Hatchett, S. (1986). The media and social reality effects: Self and system orientations of blacks. *Communication Research, 13*, 97-123.

Allen, R., Dawson, M., and Brown, R. (1989). A schema-based approach to modeling an African American racial belief system. *American Political Science Review, 83,* 421-41.

Arbuthnot, K. (2009). The effects of stereotype threat on standardized mathematics test performance and cognitive processing. *Harvard Educational Review, 79*(3), 448-472.

Banks, J. (1981). Stages of ethnicity : Implications for curriculum reform. Pp. 129-139 in *Multiethnic education: Theory and practice*, edited by James A. Banks. Boston: Allyn and Bacon.

Bledsoe, T., Welch, S., Sigelman, L., and Combs, M. (1995). Residential context and racial solidarity among African Americans. *American Journal of Political Science, 39*, 434-458.

Broman, C., Neighbors, H., and Jackson, J. (1988). Racial group identifications among black adults. *Social Forces, 67,*146-58.

Burke, P. J. (1980). The self: Measurement requirements from an interactionist perspective. *Social Psychology Quarterly, 43*, 18-29.

Chavous, T., Bernat, D., Schmeelk-Cone, K., Caldwell, C., Kohn-Wood, L., and Zimmerman, M. (2003). Racial identity and academic attainment among African American adolescents. *Child Development, 74*, 1076-1090.

Condi, J., and Christiansen, J. (1977). An indirect technique for the measurement of changes in black identity. *Phylon, 38*, 46-54.

Conover, P. (1984). The influence of group identification on political perception and evaluation. *Journal of Politics, 46*, 760-85.

Cornell, S., and Hartman, D. (1998). *Ethnicity and race: Making identities in a changing world.* Thousand Oaks, CA: Pine Forge Press.

Coser, L. (1965). *The functions of social conflict.* Glencoe, IL: Free Press.

Cross, W. (1971). Discovering the black referent: The psychology of black liberation. Pp. 95-110 in *Beyond black and white: An alternative America*, edited by Vernon J. Dixon and Badi G. Foster. Boston: Little, Brown and Company.

Cross, W. (1978). The Thomas and Cross models of psychological nigrescense: A review. *Journal of Black Psychology, 5*, 13-31.

Dawson, M. (1996). Black power and demonization of African Americans. *PS: Political Science and Politics 24*: 456-61.

Davis, J., and Gandy, O. (1999). Racial identity and media orientations: Exploring the nature of constraint. *Journal of Black Studies, 29*, 367-397.

Demo, D., and Hughes, M. (1990). Socialization and racial identity among black Americans. *Social Psychology Quarterly, 53*, 364-374.

Gay, G. (1985). Implications of selected models of ethnic identity development for educators. *Journal of Negro Education, 54,* 43-55

Gecas, V. (1979). The influence of social class on socialization. Pp. 365-404 in *Contemporary theories about the family,* edited by Wesley Burr, Reuben Hill, Ivan Nye, and Ira Reiss. New York: Free Press.

Gecas, V., and Mortimer, J. (1987). Stability and change in the self-concept from adolescence to adulthood. Pp. 265-86 in *Self and identity: Individual change and development,* edited by T. M. Hones, and K. M. Yardley. New York: Routledge and Kegan Paul.

Graham, S. (1994). Motivation in African Americans. *Review of Educational Research, 64,* 55-117.

Grantham, T. C., and Ford, D. Y. (2003). Beyond self-concept and self-esteem: Racial identity and gifted African American students. Chapel Hill, NC: The University of North Carolina Press.

Grills, C., and Longshore, D. (1996). Africentrism: Psychometric analysis of a self-report measure. *Journal of Black Psychology, 22,* 86-106.

Gurin, P., Hatchett, S., and Jackson, J. (1989). *Hope and independence: Blacks' response to electoral party politics.* New York: Russell Sage Foundation.

Harper, B. E., and Tuckman, B. W. (2006). Racial identity beliefs and academic achievement: Does being black hold students back? *Social Psychology of Education, 9,* 381-403.

Harris, David. 1995. Exploring the Determinants of Adult Black Identity: Context and Process. *Social Forces 74*: 225-239.

Hecht, M., and Ribeau, S. (1991). Socio structural roots of ethnic identity: A look at America. *Journal of Black Studies, 21,* 501-513.

Hembree, R. (1988). Correlates, causes, effects and treatment of test anxiety. *Review of Educational Research, 58,* 47-77.

Herring, M., Jankowski, T., and Brown, R. (1999). Pro-Black doesn't mean anti-white: The structure of African American group identity. *Journal of Politics, 61,* 363-386.

Hughes, M., and Demo, D. (1989). Self-perceptions of Black Americans: Self-esteem and personal efficacy. *American Journal of Sociology, 95,* 132-159.

Jackson, B. (1987). The Effects of racial group consciousness on political mobilization in American Cities. *Western Political Quarterly, 40,* 631-646.

Jaret, C., and Reitzes, D. (1999). The importance of racial-ethnic identity and social setting for blacks, whites, and multiracials. *Sociological Perspectives, 42,* 711-737.

Morris, L., Davis, M., and Hutchings, C. (1981). Cognitive and emotional components of anxiety: Literature review and a revised Worry-Emotionality Scale. *Journal of Educational Psychology, 73,* 541–555.

No Child Left Behind Act of 2001. (2002). Pub. L. No. 107th Congress., 110 Cong. Rec. 1425. 115 Stat.

Olzak, S., and Nagel, J. (1986). *Competitive Ethnic Relation.* Orlando, FL: Academic Press.

Oyserman, D., Harrison, K., and Bybee, D. (2001). Can racial identity be promotive of academic efficacy? *International Journal of Behavioral Development, 25(44)*, 379-385.

Payne, B. D., Smith, J. E., and Payne, D. A. (1983). Sex and ethnic differences in relationships of test anxiety to performance in science examinations by fourth and eighth grade students: Implications for valid interpretations of achievement test scores. *Educational and Psychological Measurement, 43*, 267-270.

Phinney, J. S. (1990). Ethnic identity in adolescents and adults: Review of research. *Psychological Bulletin, 108,* 500.

Porter, J., and Washington, R. (1979). Black identity and self-esteem. *Annual Review of Sociology, 5,* 53-74.

Ryan, A. M. (2001). Explaining the Black-White test score gap: The role of test perception. *Human Performance, 14*(1), 45-75.

Ryan, K. E., Ryan, A. M., Arbuthnot, K., and Samuels, M. (2007). Student's motivation for standardized math exams. *Educational Researcher, 36*, 5-13.

Sellers, R., Shelton, J., Smith, M., Shelton, J., Rowley, S., and Chavous, T. (1998). Multidimensional model of racial identity: A reconceptualization of African American racial identity. *Personality and Social Psychology, 2*, 18-39.

Sellers, R., Caldwell, C., Schmeelk-Cone, K., and Zimmerman, M. (2003). Racial identity, racial discrimination, perceived stress, and psychological distress among African American Young adults. *Journal of Health and Social Behavior, 44,* 302-317.

Smith, E. M., (1989). Black racial identity development: Issues and concerns. *The Counseling Psychologist, 17,* 277-288.

Spencer, M. B., and Markstrom-Adams, C. (1990). Identity process among racial and ethnic minority children in America. *Child Development, 61*, 290-310.

Thomas, C. (1971). *Boys no more: A black psychologist's view of community*. Beverly Hills: Glencoe Press.

White, C., and Burke, P. (1987). Ethnic role identity among Black and White college students: An interactionist approach. *Sociological Perspectives, 30*, 310-331.

Winant, H. (1995). Dictatorship, democracy, and difference: The historical construction of racial identity. P. 31-49 in *The Bubbling Cauldron*, edited by M. P. Smith and J. R. Feagin. Minneapolis: University of Minnesota Press.

Yip, T., Sellers, R. M., and Seaton, E. K. (2006). African American racial identity across the lifespan: Identity status, identity content, and depressive symptoms. *Child Development, 77*(5), 1504-1517.

Chapter Sixteen
An Exploration of Racial Identity among Black Doctoral Students Involved in Cross-Race Advising Relationships

Marco J. Barker

Introduction

Only 1 percent of those eighteen years and older in the United States hold doctoral degrees (U.S. Census, 2000). In 2000, the U.S. Census reported that Blacks (used synonymously with African American) with doctoral degrees comprised only 0.3 percent of those eighteen years and older and only 3.5 percent of those with doctoral degrees (U.S. Census, 2000). Later in 2004, the *Journal of Blacks in Higher Education* or *JBHE* reported that, in 2003, a record number of Blacks earned doctorate degrees, comprising approximately 6.5 percent of U.S. doctoral degree holders. Black doctoral students experienced the most change between the academic years of 1994 to 1995 and 2004 to 2005 (see Figure 16.1). The number of Blacks attaining doctoral degrees doubled over the ten years (Cook and Cordova, 2006). From 1994 to 1995, 1,363 Black students received doctoral degrees, representing 4.4 percent of U.S. citizens awarded doctoral degrees. From 2004 to 2005, the number of Blacks who received doctoral degrees was 2,873, representing 8.1 percent of U.S. citizens awarded doctoral degrees. Although Blacks and domestic ethnic minorities as a whole experienced a 68.6 percent increase in obtaining doctoral degrees from 1994 to 2005, Whites still accounted for 79 percent of those doctoral degree recipients from 2004 to 2005. In 2008, Blacks comprised only 6.6 percent of U.S. citizens who held doctoral degrees compared to 75 percent of Whites who held doctoral degrees (National Science Foundation, 2010).

Although there has been an increase in the number of Blacks enrolling in doctoral programs (Cook and Cordova, 2006), Nettles and Millett (2006) found that Blacks and Latin Americans have higher attrition rates compared to Asian American, international, and White doctoral students.

**Figure 16.1: Doctoral Degree Attainment
Ten-year Trend for Ethnic Minorities**

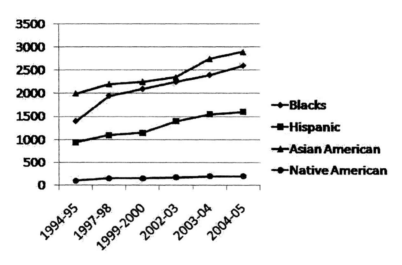

Similarly, national organizations (e.g., Carnegie Foundation, Lumina Foundation, Southern Regional Education Board, and Woodrow Wilson National Fellowship Foundation) have brought greater attention to the need to examine diversity and the Ph.D. In their report, the Woodrow Wilson National Fellowship Foundation (2005) called for a thorough examination of programs designed to increase the diversity of students pursuing doctoral degrees.

Whereas Blacks have the highest level of enrollment, compared to other under-represented ethnic minorities (Cook and Cordova, 2006), yet a higher rate of attrition (Nettles and Millett, 2006), a greater examination of Black doctoral student experiences is warranted. Compounding this occurrence, White faculty still comprise more than 80 percent of full-time faculty (Cook and Cordova, 2006), leading to a greater likelihood of cross-race advising relationships. Although there have been some studies that examine Black doctoral students experiences within predominantly White contexts (Gasman, Gerstl-Pepin, Anderson-Thompkins, Rasheed, and Hathaway, 2004; Milner, 2004; Milner, Husband, and Jackson, 2002; Patterson-Stewart, Ritchie, and Sanders, 1997) and studies that examine the racial identity of undergraduate students (Chavous, 2000; Pillay, 2005; Wilson and Constantine, 1999), there remains a dearth in the literature on studies examining the

ways in which these Black doctoral students negotiate racial identity within these contexts in general, and across race (i.e., having a White advisor), in particular.

In this chapter, I present findings from an in-depth study where I examined the role of race in cross-race advising relationships between White faculty advisors and their Black doctoral student protégés. Exploring racial identity scores and the experiences and perspectives of the Black doctoral student protégés, I present instances where racial identity indicators manifest through the narratives of these students and correlations between the reported racial identity and the student's noted experiences. Through such an examination, I intend to travel across methodological borders in an effort to explore how racial identity may be measured through both quantitative and qualitative discovery. For my initial study, I posed the research question: How does race impact the cross-race advising relationship between Black doctoral student protégés and their White faculty advisors?

Literature Review

Black Doctoral Student Experience

There is a growing body of literature that supports the notion that Black students in higher education have unique experiences that differ from other students of color and White students (Allen, Epps, and Haniff, 1991; Davidson and Foster-Johnson, 2001; Fleming, 1984; Fries-Britt and Turner, 2002; Jones, 2001). Although some of the experiences are consistent for undergraduate, master, and doctoral students, there are experiences that are specific to graduate students in general (Austin, 2002; Gardner, 2008b; Gardner and Barnes, 2007; Golde, 2005; Golde and Dore, 2001; Lovitts, 2001; Nettles and Millett, 2006; Tinto, 1993) and doctoral students in particular (Anderson-Thompkins, Gasman, Gerstl-Pepin, Hathaway, and Rasheed, 2004; Gasman et al., 2004; Holland, 1993; Jones, 2000; Mabokela and Green, 2000; Milner, 2004; Nettles, 1990; Rogers and Molina, 2006; Willie, Grady, and Hope, 1991; Woodrow Wilson National Fellowship Foundation, 2005).

Racial Climate for Black Graduate Students

The racial climate for Black graduate or doctoral students may be a reflection of the student's interaction with the institution (Clark and Garza, 1994), department (Davidson and Foster-Johnson, 2001), and individuals (i.e., faculty and students) (Milner, 2004). According to Nettles (1990), Black doctoral students report a greater sense of racial discrimination than Latino/a and White doctoral students. Institutional or campus racism experienced by Black graduate and doctoral students may include Black students perceiving a lack of friendliness on the greater campus and lack of overall campus diversity (Willie et al., 1991). On a more departmental level, Davidson and Foster (2001) forwarded that graduate schools tend to focus more on assimilation than cultural pluralism. Cultural pluralism is the idea of

recognizing each person's background and cultural contribution (Davidson and Foster-Johnson, 2001). The issue of cultural identity is consistent with Robinson's (1999) findings that doctoral students in predominantly White settings sometimes feel a sense of "social estrangement and sociocultural alienation" (p. 124).

Black doctoral students have also reported feeling invisible, isolated, and undervalued. A sense of invisibility emerged in Patterson-Stewart, Ritchie, and Sanders' (1997) study on Blacks in doctoral programs at predominantly White institutions. Black doctoral students indicated the history of marginalization of Blacks compounded with the racist behaviors (primarily being ignored) of White faculty and students both added to the their sense of invisibility. Related to the sense of invisibility, is the sense of isolation. In a personal narrative, Sligh-Dewalt (2004) recounted her doctoral program experiences where she often did not receive the same information as peers and the experience of being isolated for knowing more than her professor on a particular topic. Consistent with graduate program assessment, Rogers and Molina (2006) found isolation to be an issue for retaining students of color, noting multicultural affairs centers as an important aspect of the graduate school experience in connecting students.

Feeling undervalued is often linked in the literature with feeling pressured to over perform. Milner (2004) reported that Black doctoral students faced issues of feeling valued and respected. According to Milner, Black students experienced not feeling valued and respected through not having a voice in the classroom and not having the Black student experience valued by others. The sense of feeling undervalued is exacerbated by Black students' perception of peers and faculty having negative stereotypes of Black student performance. These instances lead to Black students feeling as if they must over perform (Bonilla, Pickron, and Tatum, 1994; Milner, 2004) or feeling that their [Black doctoral students] work quality is less than the work quality of Whites (Bonilla et al., 1994), creating a sense of vulnerability.

Access to Faculty

Faculty interaction during the doctoral process is critical to the successful completion of the doctorate (Lovitts, 2001). Overall, Black graduate students have reported less access to faculty compared to their White peers (Robinson, 1999). In his study on racial differences between White, Black, and Latino/a doctoral students, Nettles (1990) found that holding teaching and research assistantships correlated to greater student-faculty interactions, and that Blacks were more likely to finance their education through loans and fellowships, being at a disadvantage in forming greater student-faculty relationships. Willie, Grady, and Hope (1991) also found that graduate students of color described a lack of opportunities to collaborate with faculty through teaching and research assistantships. Participants in Willie, Grady, and Hope's (1991) study discussed little involvement with faculty of color due to the lack of racial diversity amongst the faculty ranks. Having access

to faculty is important as faculty mentoring and advising is found to be another important method in retaining graduate students of color (Rogers and Molina, 2006).

Faculty Mentoring and Advising

Mentoring graduate students of color has a number of benefits to both departments and students of color. Unfortunately, traditional mentoring programs may not consider the role of culture in enhancing "student performance and satisfaction" (Davidson and Foster-Johnson, 2001, p. 557). Furthermore, because there is a lack of formal mechanisms to socialize minority students, mentoring may serve as an opportunity to orient and support minority students, in addition to recruiting future minority students (Robinson, 1999; Woodrow Wilson National Fellowship Foundation, 2005). Mentoring has also been found to aid in student retention. Ninety-seven percent of Black Ph.D.s in Dixon-Reeves's (2003) study and Black doctoral students in Patterson-Stewart, Ritchie, and Sanders' (1997) qualitative study reported having a mentor. These mentors provided professional and academic development through helping students become more involved in academic activities like associations and publishing (Dixon-Reeves, 2003) and other career socialization like networking (Thomas, Willis, and Davis, 2007). The composition and type of mentoring relationships between faculty and doctoral students can vary.

Nationally, Black full-time instructional faculty comprise less than 6 percent of total full-time instructional faculty in the United States, with the majority of instructional faculty comprising White and Asian faculty at 80.3 percent and 9.1 percent, respectively (NCES, 2007). The growing diversity of doctoral programs (Woodrow Wilson National Fellowship Foundation, 2005), coupled with the under-representation of Black faculty in academia, highlights the occurrence of cross-race advising relationships and the saliency of race in doctoral education. Davidson and Foster-Johnson (2001) further support the claim that way in which race is framed can impact the effectiveness and satisfaction with the cross-race relationship and the overall experiences of Black doctoral students.

Black Student Experiences and Racial Identity

There have been several scholars who have explored the correlations between racial identity and college student outcomes. Early studies included the correlations between Black college students' racial identity and preferences for Black and White counselors (Parham and Helms, 1981). Using Cross's (1971) model of Nigresence, Parham and Helms developed the Black Racial Identity Attitude Scale or BRIAS and found correlations between racial identity attitudes and racial preferences of counselors. Wilson and Constantine (1999) explored the correlations between Black college students' racial identity, concept of themselves and internal sense of values and beliefs, and perceived family cohesion. Studying 164 Black college students,

Chavous (2000) studied the relationships between racial identity, perceived ethnic fit or perception of how one's racial group is viewed, and organizational involvement. Chavous introduces the term racial centrality as the level of importance a person places on race and how this racial centrality is illustrative of Black identity. Studies connecting racial identity and mental health among college students have also emerged in the literature. Pillay (2005) researched the predictive qualities of racial identity and Blacks' psychological health, while Johnson and Arbona (2006) examined both ethnic and racial identity in relation to race-related stress among Black college students. Mizock and Harkins (2009) examined the predictive nature and correlations of racial identity, cultural mistrust, and students' interest in research. Although there has been a growing body of literature addressing the racial identity predictors of Black college students' outcomes, there has been little attention given to the measure of racial identity and racial identity manifestations among graduate or doctoral students.

Theoretical Framework

As a theoretical framework, I use Cross's (1971, 1995) psychology of Nigrescence. Cross's approach to identifying attitudes and perspectives of Black racial identity is one of the seminal works in racial identity and has later been incorporated as points of measure in Parham and Helms' (1981) development of the Black Racial Identity Attitude Scale (B-RIAS), which is used as the measure of racial identity for the study in this chapter. Cross identified five stages that provided a psychological lens to better understand the ways in which Blacks perceived and internalized Blackness. These stages included the (a) Pre-Encounter stage, (b) Encounter stage, (c) Immersion—Emersion stage, (d) Internalization stage, and (e) Internalization-Commitment stage. Since its original formation in 1971, Cross (1995) readdressed areas (i.e., pre-encounter and integration stages) of the Nigrescence model to better fill theoretical gaps that have emerged from other research and literature reviews on the theory.

The Pre-Encounter stage is the stage in which there is a "pre-existing identity" or "identity to be changed" (Cross, 1995, p. 97). Cross describes this stage as the state in which "persons place value in things other than their Blackness, such as their religion, their lifestyle, their social status, or their profession" (p. 98). While the Pre-Encounter stage was previously seen as the stage where individuals held only notions of anti-Blackness, this stage has been reconceptualized and further interrogated as the stage where individuals may exhibit low saliency or neutrality toward race, may view race as carrying a "stigma" (p. 98), and have an anti-Black attitude.

Cross (1995) notes the Encounter stage of Nigresence as "pinpoint[ing] circumstances and events that are likely to induce identity metamorphoses" (p. 104). This metamorphoses represents the transition from Pre-Encounter attitudes to where the individual begins to process, contextualize, and rethink their Black

identity. An encounter may either be negative (e.g., racist action) or positive (e.g., strong Black role models) and may result in a range of emotions from shock to depression (Cross, 1995). Whatever the emotion, the individual begins to recognize her or his Black identity.

The next two stages, Immersion and Emersion, are typically combined to represent one complete stage: Immersion-Emersion (Cross, 1995; Parham and Helms, 1981). Noted as one of the most prevalent and important stages (Cross, 1995), Immersion-Emersion entails the point where the individuals begins to reconcile the Encounter experiences and formulate who they will become. The beginning attitudes of the person immersing tend to be highly romanticized Blackness; she or he begins to simply identify Black images to help define their identity (Cross 1995). According to Cross, individuals operating within this stage may display feelings of anxiousness as they attempt to become "the right kind of Black person" (p. 106). Individuals may also chose more direct and blunt communication strategies when dealing with other people, regardless of their racial background (Cross, 1995). Emersion within this stage represents the individual's greater understanding of what it means to be Black beyond the surface-level imagery. The person begins to comprehend that one's Black identity is "continued growth" (p. 111). While the Immersion-Emersion stage illustrates a Black identity awareness process, it is important to note that this stage may lead the individual to regress when faced with trying to develop a new identity (Cross, 1995).

The last stage, Internalization, is described as the "point of dissonance resolution, and the reconstitution of the person's steady-state personality and cognitive style" (Cross, 1995, p. 113). Individuals at this stage have begun to internalize their Black identity, exhibiting a higher saliency of Blackness, which becomes shaped by the context and other "ideological considerations" (p. 113). Cross identified three major functions of internalized Blackness:

- to defend and protect a person from psychological insults that stem from having to live in a racist society;
- to provide a sense of belonging and social anchorage; and
- to provide a foundation or point for departure for carrying out transactions with people, cultures and human situations beyond the world of Blackness (p. 113).

Internalization may also represent the point where a person begins to interweave their Blackness into their other identities, deciding the saliency of their Black identity based on their surrounding environment or situation. Jackson (2001) described Internalization as the stage where Blacks may have to "nurture this sense of self" (p. 25). In other words, the Black individual may recognize that racism and racial disparity still exist, and so it is important for her or him to identify positive ways or outlets to further ground their her or his identity.

Methodology

The purpose of this mixed-method study was to explore the manifestation of racial identity among Black doctoral students through both quantitative and qualitative approaches. The phenomenon identified in this study is the unique relationship of Black doctoral students who have White faculty advisors. Van Manen (1990) described phenomenology as the way in which a human "orients to lived experience" (p. 4). The cross-race advising relationship represented the "lived" experience between the student and faculty member. In addition to having to navigate predominantly White contexts, these participants must also operate across racial differences in working with their faculty advisor.

Quantitative Study

The sample for the quantitative portion of this study included nine Black doctoral students (See Table 16.1). The sampling approaches for this study were convenience, criterion, and snowball sampling. These students were doctoral level students pursuing degrees in the social sciences and humanities at one research extensive (McCormick, 2001) predominantly White institution or PWI in the South. Student participants must had completed at least two years of course work, identify as Black or African American, have a White faculty advisor, and attend the institution. Because disciplines represent their own "cultural phenomena" comprised of "codes of conduct, sets of values, and distinctive intellectual tasks" (Becher, 1981, p. 109) and disciplinary practices impact the ways in which students and faculty members interact (Golde, 2005; Lovitts, 2001), I attempted to remain within one disciplinary area or taxonomy to avoid potential discipline differences. I solicited participants through a broadcast announcement to all Black doctoral students at the institution.

Table 16.1: Study Participants

Student	Race	Gender	Age	Years in Program
Daphne	B	F	30-35	More than 3.5
James	B	M	25-30	Less than 3.5
Jordan	B	F	30-35	More than 3.5
Lionel	B	M	35-40	Less than 3.5
Marion	B	F	30-35	Less than 3.5
Terrie	B	F	30-35	More than 3.5
Walter	B	M	35-40	More than 3.5
Michael*	B	M	35-40	More than 3.5
Angela *	B	F	35-40	More than 3.5

*Participants were not included in qualitative analysis

Data were collected using the Black Racial Identity Attitude Scale (B-RIAS) (Parham and Helms, 1981). Permission was granted from the Boston College's Institute for the Study and Promotion of Race and Culture. The B-RIAS consists of sixty statements that are scored on a five-point Likert scale ranging from "Strongly Disagree" to "Strongly Agree." Statements fall within one of five categories: Pre-Encounter of Conformity (seventeen items), Post-Encounter of Dissonance (eight items), Immersion (fourteen items), Emersion (eight items), or Internalization (thirteen items). In their use of the BRIAS, Mizock and Harkins (2009) found "high to moderate" internal consistency among the sub-categories: Pre-Encounter (.76), Post-Encounter (.51), Immersion-Emersion (.69), and Internalization (.80), with the overall reliability for the instrument measuring Cronbach's alpha coefficient of .93.

Participants completed the inventory prior to their interview. This ensured that I captured their initial feelings prior to engaging in a conversation on race. Because the sample size was less than ten, I performed data analysis using basic descriptive statistics. I computed averages, medians, and modes for each subcategory in order to compare the responses of individuals to the group.

Qualitative Study

Because one interview was inaudible and one student's advisor was unavailable, seven students from the quantitative sample were included in this portion of the study. To collect data, I utilized a standardized open-ended interview protocol. This type of questioning allowed me to follow an interview protocol and ask all participants the same questions in the same order; however, the questions were open-ended and enabled me to further investigate in-depth information regarding their "thoughts, beliefs, knowledge, reasoning, motivations, and feelings about" race (Johnson and Christensen, 2004, p. 183).

The original qualitative study included both students and faculty, for which I performed a specific constant comparative method for dual pairs and pheno-menological reduction (Boeije, 2002). For this specific study, I revisited themes using the racial identity framework. I analyzed themes using the racial identity stages to allow for correlations between the quantitative and qualitative data sets.

Results

Racial Identity Measures

Pre-Encounter

Statements within in this category included, "I believe that Whites look and express themselves better than Blacks" and "I feel uncomfortable when I am around Black people." The Pre-Encounter sub-score was the second lowest average score among

doctoral students when compared to other sub-scores. The Dissonance average score was 1.47. Angela, a Black female age 35-40, reported the lowest score (1.29); while Terrie, a Black female age 30-35, reported the highest score (2.18). The median score among participants was 1.82. The relatively low Pre-Encounter score suggests that the Black doctoral students, to some degree, recognized their Black identity as important as opposed to a greater adoption of Eurocentric views. According to Cross (1995), this stage of identity is a "person's first identity," involving a socialization process of "years of experiences with one's family, extended family, neighborhood and community, and schools, covering the periods of childhood, adolescence, and early adulthood" (p. 104).

Table 16.2: Participant's BRIAS Results

Category	Conformity	Dissonance	Immersion	Emersion	Internalization
Michael	1.47	1.00	4.57	5.00	3.62
Terrie	2.18	1.50	2.57	3.75	4.62
Marion	1.88	1.75	2.93	4.13	4.00
Lionel	2.12	2.13	2.93	4.50	4.31
Walter	1.35	1.25	2.64	4.25	4.38
James	1.47	1.75	2.00	4.00	4.54
Angela	1.29	1.00	1.57	4.25	4.23
Jordan	1.82	1.63	2.86	4.13	4.08
Daphne	2.00	1.63	2.07	3.25	4.00
Average	1.73	1.51	2.68	4.14	4.20
Median	1.82	1.63	2.64	4.13	4.23
Mode	1.47	1.00	2.93	4.13	4.00

Post-Encounter

This category was the lowest average score among participants compared to the other sub-scores. Doctoral students averaged 1.51 out of the 5-point scale. An example of statements reflecting the Post-Encounter stage included, "I'm not sure how I feel about myself racially" and "I can't feel comfortable with either Black people or White people." The lowest score (1.00) reported was by two participants, Michael and Angela, and the highest score (2.13) reported by one participant,

Lionel. Those participants ages 35-40 reported the three lowest scores among doctoral students. The median score among participants was 1.63, slightly above the average. The low score among the doctoral students indicates that the students were not heavily faced with issues of negotiating their Black identity. This finding supports the low Pre-Encounter rating; Black doctoral student participants were not likely to grapple with their Black identity.

Immersion

The Immersion sub-score was the middle and median score compared to the other sub-scores. Examples of Immersion attitudes on the survey included, "I believe that Whites should feel guilty about the way they have treated Blacks in the past" and "I am changing my style of life to fit my beliefs about Black people." The average Immersion score for participants was 2.68, slightly below the RIAS's midpoint (3.0). The lowest score (1.57) reported was Angela, and the highest score (4.57) reported was Michael. Michael's score was 70 percent above the group's average. The median score among participants was 2.64, which suggests that the students had a moderately low level of perspective which led them to be pro-Black. One student, Michael, demonstrated an extremely high level within the immersion category. Michael held a strong sense of his Black identity that included a negative view of White culture. These findings suggest that Black doctoral students held a higher level of Black identity that led them to embrace their race in comparison to their levels of conformity and dissonance.

Emersion

This sub-score was the second highest rated compared to other sub-scores. Examples of statements within this stage included, "My identity revolves around being a Black person in the United States" and "I feel that I belong to the Black racial group." The average Emersion score was 4.14. The lowest score (3.25) reported was by Daphne, while the highest score (5.00) reported was Michael. The median score among participants was 4.13. The moderately high rating suggest that the Black doctoral students had a moderately high level of Black identity that was not based on an anti-White ideology but allowed them to embrace their Blackness and see ways to emotionally and psychologically manage being Black. They indicated an above- average level of transition to a greater acknowledgment of racial saliency or race as prevalent and important.

Internalization

An example of statements within this category included, "People, regardless of their race, have strengths and limitations" and "A person's race may be a positive aspect of who he or she is." Doctoral students, on average, rated 4.20 within this sub-

score, the highest average among other sub-scores. The highest score (4.54) reported was James, and the lowest score (3.62) reported was Michael, who also scored the highest within the Immersion and Emersion sub-categories and the lowest within the Post-Encounter category. These findings suggest that Black doctoral students in this study had a moderately high sense of their Black identity in addition to their other identities. Overall, Black doctoral students had a healthy, balanced sense of their Black identity. However, there are exceptions and spectrums of the racial salience that an individual may exhibit (Cross, 1995).

The higher levels of Emersion and Internalization among the Black doctoral students indicate that Black doctoral students who are involved in cross-race advising relationships with White faculty advisors have a high sense of their Black identity, see the saliency of race, and are not undergoing major identity issues that challenge their Black identity. However, this is not withstanding that Black doctoral students are not faced with experiences and feelings that impact their own Black identity. There may be instances and interactions that lead Black doctoral students to question the role of their race in doctoral programs, in institutions, or in society. In order to best capture the depth in which doctoral students manage and negotiate their Black identity and race in doctoral programs, and specifically in predominantly White contexts and across racial lines, a qualitative approach is essential.

Black Doctoral Student Experiences and Perspectives

The B-RIAS has been used to measure an individual's attitudes towards their racial identity. While this approach allows the researcher to quantify Black identity, the essence of a person's identity is still grounded in context, situations, and experiences (Gardner, 2010; Milner, 2004; Patterson-Stewart et al., 1997; Willie et al., 1991). Using Cross's (1971, 1995) theory of Nigresence as a framework, I explored the perceptions of Black doctoral students who were navigating their doctoral studies in a predominantly White context and were under the advisement of a White faculty member. The qualitative approach allowed me to explore how students internalized their racial identity, exercised their Blackness, and as a Black doctoral student, navigated through White and Black spaces on their campus and in their doctoral program.

Black doctoral students shared their experiences of racial socialization and racism, within both geographic and institutional contexts, and also in ways in which they expressed or explored their Black identity through cross-race interactions (i.e., racial discussions) and through same-race connections. Examining these themes through a Black identity lens provides greater depth into the ways in which Black identity "practices" get applied and reapplied by individuals who already have a sense of their Black identity with high measures of emersion and internalization. These perspectives indicate the true fluid nature of identity and the continuous racial negotiation, compromise, and confrontation that Black doctoral students must

face while attempting to complete their doctoral program in PWIs and, often times, with White faculty advisors.

Racial Socialization

Four of the doctoral students described their experiences in being socialized to navigate their own Black identity in predominantly White spaces and in one instance, predominantly White male spaces. This form of socialization, or the process in which students learn the cultural nuances of a discipline so that they are inspired and able to operate within the discipline (Merton, Kendall, and Reader, 1957), was aimed at providing these students with insight into how ethnic majority (White) spaces may oppress, silence, or disadvantage ethnic minorities. The socialization came from family, peers, mentors, faculty, or any combination of the previous. Jordan received insight from her family and undergraduate mentor on working in predominantly White contexts, particularly in the South. When asked about why she creates space between her and White faculty she said,

> Yeah, well, my father is from the South and Dr. Weathers [a mentor] is from the South. I think as a child my parents have instilled in me and some of the conversations I had with Dr. Weathers, you know, they tell you about racism. I think me. I've learned from a very early age to put up this wall, this wall that you're [reference to an earlier question] talking about. I just think my parents and just, you know, people who care about me like Dr. Weathers in preparing me to go forward. They let me know what I would be up against so it didn't come up as a surprise.

Similarly, Marion's mother had shared with her the same concept of understanding the historical significance of race. Additionally, her mother passed down historical racial knowledge in an effort to teach Marion about racial discrimination and power dynamics and equip Marion with racial guards or techniques to safe guard against discrimination. She commented:

> It's kind of like once you hear the wisdom of my mom, it was just always because she came from such a small town and she was born in the '50s and she went through that whole like racist-era thing. It's always been like, "Never ever forget that you're Black," and that's kind of been and like she said this the other night, like, "You'll never forget that you're Black and well you know White people can get away with some things Black people can't." And so that's been kind of my thing as well.

However, Marion struggled in maintaining social distance while not creating a socially constructed racial divide between her and fellow students and faculty. Marion later shared, "It's like I don't always want to be stand offish just because I'm Black kind of thing. It's kind of working that balance of not crossing the line."

Both Jordon and Marion speak to how they came to develop their Black identity in the context of Whiteness. However, Marion described cognitive behaviors referenced in Cross's (1995) Immersion-Emersion. Through her own family's socialization, Marion came to place her race at the center of her experiences; however, she struggled balancing her Black identity in a way that allowed some form of integration or relationship building with Whites in her department. With the exception of Michael (4.57), Marion (2.93) reported the second highest score among Black doctoral students. Of the doctoral students, she discussed in greater lengths her issues with working across racial lines while protecting her Black identity.

Racism Within Geographical Contexts

Several doctoral students in the study shared how race was connected to geography or being in the South. Students commented that persons from the South carried a higher level of racism than those persons from the North. Jordan, in particular, articulated how she saw racism exaggerated in the South:

> At [my previous institution in the North], like I said, people . . . you know . . . people don't really like Black people or they have problem with racism, but they really just kept to themselves . . . kept their comments to themselves. You know, very covert racism. But here, it's more overt. People don't mind expressing their opinion, you know, just by the way people treat you. They're just more out with it.

James, who was from the South, discussed how context was not a major issue. He stated, "I was use to [being in this state]. So I was used to being the minority in the class and I was in [my major]. So I was the only dark-skinned person in the class." A second student from the South, Walter, expressed his concern with Whites in the South and their acceptance with Blacks. During the interview, he relived one racist experience being in the South and being deeply disturbed by this experience. He told me:

> I had a raggedy car one year and the car would start and stop and start and stop. So, I was waiting for it to actually kick in [and] this [White] kid drove by me and flipped me off. Well, as soon as he drove by, it started to kick in. So, I followed him to his journey and I said, "What was that for?" [The kid responded], "NIGGER!" I said, "Dude, don't you worry about it." So I drove off. [The kid responded] "You fucking Nigger!" I pulled back and I said, "Why did you say that?" You do not know me, man." So we went through the process and I tell him, "I teach here [at the university]. I teach here. Why would you say that?" And try to engage him into a teaching moment and he's not remorseful at all. Now you have folks here [in the university's town] who still believe Blacks should still be in chains out there working in the cane field somewhere.

Jordan, James, and Walter speak to the notion of how race becomes assigned to geographic context and how this has impacted their own identity. Walter and James reported two of the top three highest Internalization attitude scores, and Jordan and James reported two of the top three highest Dissonance scores. The experiences of these students indicate a heightened awareness of their Blackness in relation to geography and experiences. James's experience showcases how doctoral students' Black identity is continuously developing. He speaks to having an understanding of context and having to adapt to the specific context over time, which may be categorized as Emersion and Internalization behaviors. Although doctoral students may be more mature than undergraduate students, there may still be experiences or encounters that are still alarming, as in the case with Walter.

Racism within Institutional Contexts

Students shared experiences with acts of racism, marginality, and salient object status within their departments and the institution. The students described their feelings of being underestimated and taken advantaged, serving as the evidence of diversity, and having to prove themselves. Students had these experiences in and out of the classroom.

Racial-marginalization occurs when students feel objectified based on their race (Suarez-Balcazar, Orellana-Damacela, Portillo, Rowan, and Andrews-Guillen, 2003). Marginalization manifested in various ways and forms for the students in the study. Two doctoral students experienced forms of marginalization through departmental events. One student, Daphne, shared instances where she was often invited to departmental and institutional events, social functions, or recognition ceremonies. However, she had reservations about attending those events because it began to feel that she was only invited to represent the "diversity" of the department. Daphne is describing difficulty in fully immersing herself in depart-mental events. She sees her Black identity being used as property, where race is assigned value (Harris, 1995) and the representation of people of color, like Daphne, become part of an institutional economy and market. Within these feelings of property status, Daphne may be faced with difficulty of reaching high levels internalization. She was among the three lowest scores within the Internalization category, which shows a correlation between her rated level and her shared experience.

Lionel shared his feelings of marginalization through his advisor assignment process. He commented that he had feelings that he was chosen because he was a Black male, and there was a sense that his advisor thought he was operating at a deficit:

> You know what, if I had to guess, I guess [my advisor's] initial interest in me was
> that he/she would . . . 'cause it's all Black [students] sitting there and she/he had
> probably thought these Black [students] are going need more help and support
> then what he/she was expecting and he/she was probably really impressed. I think

that [was] his/her initial [feeling] . . . being impressed. Okay, these Black [students] are more capable than what I expected. And I hope that he/she decided that I'm not just capable for an African American but I'm capable as a student, period.

Students discussed how their racial socialization assisted them in dealing with being salient objects or hyper-surveillance associated with being the only person of color in a predominantly White space (Jones and Shorter-Gooden, 2003). Jordan and Terrie described their salient objectivity in the context of having to outperform. Jordan commented:

I think what comes to mind is a talk that I went to and the title of the talk was "[Yes, You Do Have to Outperform.]" I think race matters. I think as African American doctoral students, we have to be better. We cannot just come in and be as good. We have to better because if we're not better, we're not going to seem good! And, I think that like I said before . . . some of the things that White students can get away with such as saying, "I'm having a baby, I need to graduate, or you know my family needs money. I need to get a job and do this part-time." I don't think that we would be able to do that and, if we did, it we wouldn't have that support that they [White students] still have. They are able to do it and maintain the support from their advisor. I think if we made those choices, we would just be kind of out there.

Whereas, Terrie remarked:

Because for me, it's more like . . . honestly, I feel like I have so much more to prove than a student from a majority race. I feel like there's more eyes on me to see how long it take me to finish, and what my grades were like in school, and what my dissertation [is] going to be like because of stereotypes and things like that.

In many instances, the status of salient object is heightened for Black women (Jones and Shorter-Gooden, 2003). For some of the students, being a salient object was a bit unsettling. Lionel, Jordan, and Terrie described how they felt their Blackness carried a stereotype and how part of their identity included actions to prove this "deficit" stereotype as wrong. These behaviors are most connected with Cross's description of the Immersion and Emersion stage where individuals begin to see the heightened saliency of their Black identity, which may lead to greater Black action or activism or a pro-Black stance. Within the Immersion construct, both Jordan and Lionel scored above the group's average, while Terrie scored slightly below the group's average. Within the Emersion construct, Lionel was the only doctoral student among the three to score above the group's average. The experiences of these students indicate that Black doctoral students formulate perceptions on their Blackness that lead them to act in ways to bring greater value to Blackness. This idea of deconstructing racial stereotypes is not one fully discussed by Cross, but it

appears to be an aspect of the ways in which Blacks may proceed in further developing their Black identity.

Racist experiences with faculty were more referenced than experiences with students. Walter and Marion experienced faculty who underestimated them. Walter shared completing an essay and having faculty members shocked by how well he articulated his arguments. After seeing that he was an exceptional, academically astute student, Walter felt that the faculty members then came to show him greater respect, wanting Walter to work with them. Marion had an experience where she was mistaken for a master's-level student at one instance and later received a B grade in the faculty member's class and wondered if race was at the center of both experiences:

> I always kind of think about [race]. It's always kind of there. Did I really just get this B or did you just grade me even harder . . . you know, I have gotten that from one member of the faculty. It was kind of like, when I first met her, she was like, "Oh you're a master's student." I was like, "No I'm a doctoral student." Every time I see her, it's kind of like [her] nose up in the air, kind of thing. Like, "You didn't see me coming down the hall when we were the only two people?" So, from that, I've got to prove myself because I am the only [Black student] and so, I'm always working harder and stuff. So anytime something like that comes up, it always crosses your mind like, "You grade me harder because you feel I'm not supposed to be here," that kind of thing.

James, who noted that he would often dress down during the day, encountered a faculty member who he felt judged him for his appearance. One day James was asked to retrieve the professor on behalf of another professor. He was dressed casually and described his experience of how the professor responded: "She looked at me and turns around and kept walking. So I told them, 'Look, she did not want to talk to me, so I'm going to move on.'" Walter, Marion, and James had experiences that were negative racial encounters. For Walter and Marion, the experiences led to a form of cognitive dissonance or a reexamination of whether their Blackness was at the root of their experiences. These type of experiences may be illustrative of Post-Encounter occurrences, albeit the individual has overall low measures of Post-Encounter or Dissonance identity. Although Walter was below the group's average of Post-Encounter attitudes, Marion and James were above the group's average and were among the top three highest Post-Encounter scores. While these doctoral students had higher levels of Emersion and Internalization attitude scores, it was evident that they still had racialized experiences that prompted a "hypersensitivity to racism" and a defense move to protect their Black identity (Cross, 1995, p. 117). Because these doctoral students demonstrated a more Internationalization attitude level, their "defensive function becomes much more sophisticated and flexible" (p. 117).

Racial Discussions across Racial Differences

The students described three areas of topics for racial discussions: academic context which included topics related to research or courses; current events and society, which included contemporary topics that gained national attention, topics in the media, or broader social issues; and racial incidences, which included the student's actual experiences or feelings related to a negative racial experience.

Academic Contexts

In terms of interactions with faculty on racial issues, academic contexts (i.e., class topic, research project, dissertation topic, etc.) served as the major avenue for discussing race. Five of the seven doctoral students mentioned that they gained insight into their advisor's perceptions and understandings of race through discussing research. All of the doctoral students in the study either had conducted or were conducting research related to race or culture, while four of the seven faculty advisors were studying a topic related to race or culture. One student shared his experience working with his faculty member and the racial understanding that occurred during and after the experience. During one particular project, he described the experience saying,

> Looking at differences . . . 'cause with the family, we ask them a question about race—if they believed race influenced their current living conditions. Stemming from [this question], [we] talk about the differences and the stuff that we've noticed in different families, mainly between Whites and Blacks, because that's pretty much the dynamic in the city. There was another thing. We talked about, last week, the economic mobility and stuff. Like, how a lot of Black families have less mobility than White women and how the economic philosophies in social work are off . . . that kind of thing. And, [we discussed] different perceptions and how research has put stuff out there versus the actual reality and stuff. [For example], how African Americans are not as successful but that might not be the case. So, it kind of stems from research, but we've gone into a lot of different topics and stuff about that.

In some cases, the dissertation topic of the doctoral student differed from the research of the faculty advisor. There were students in the study who shared how their faculty advisor would ask questions about their topic or a specific concept. Lionel gave an example of how his professor engaged in learning more: "She's asked me about it and I've explained it to her and she's talked to other professors about it and she thinks it's very interesting."

Current Events and Society

Students did not limit their discussions of race with their advisors to academic-related topics. Students and faculty also engaged in racial discussion regarding current events or greater societal issues. Particularly for the three doctoral students in my study, the focus of Black life and politics in the media served as an opportunity to discuss race. Terrie shared, "We talked the presidential election. She was more than willing to talk to me about that. I think she's more open to bringing up race stuff than I am as far as racial issues." Similarly, Jordan commented,

> I talked about being Black at RSU, being Black in our department and he . . . I think she [is] just one of those White people who felt a lot of guilt and just was really shocked by some of the things I said. [She was like], "I never really thought about that, that type of thing."

Race-Related Incidences

While the doctoral students appreciated that their faculty members wanted to know more and discuss racial topics, they had mixed feelings sharing negative experiences with their faculty advisors. Among four of the students, responses were mixed in discussing occurrences of racial discomfort, concern, or discrimination. Two doctoral students mentioned that they would take a racial issue to their professor. While some of the students had discussions related to their academic work and current events, only one doctoral student in the study had actually taken an issue to his professor that he thought was racially motivated. Two doctoral students stated that they would not or did not discuss moments of racial discomfort. One doctoral student, Daphne, was concerned that it would become an issue of a professor being seen as a bully. When asked if she would take a negative racial issue to her advisor, she commented,

> Never! Never, ever! Never! I don't care how I was feeling. I never brought it up to him! I didn't want him . . . I didn't want to say, "Oh, I think [a professor] is picking on me because I'm Black." Because, you know, this is how [the professor] could have been with all students. I don't know what the interactions were with other doctoral students. So I just didn't [tell him].

While there was dialogue on race taking place between faculty and students, there were few discussions of the students' personal discomfort. This was articulated by Lionel's hesitancy to study race. He noted his concern with eventually becoming the "The Black professor" who studies race, saying,

> The very first thing I told her when we got together is I don't want to do a topic for my dissertation [that] has anything to do with race. That's kind of where my head was when I first came in here. I said, "I don't want to be known as 'the Black professor.'" When people see me as a Black professor I don't want them being

able to say, "Oh, he's probably into race studies." And she was very supportive of that.

These experiences captured the varying ways that students interacted with their White advisors. Academic matters (e.g., dissertation and research) and current events discussions provided opportunities for doctoral students to interweave race into their conversations. Making race at the center of conversations in this form is illustrative of Emersion and Internalization behaviors where students are provided a forum to make race salient. In contrast were students Daphne and Lionel, who were not comfortable bring race at the center of their experiences. Both Daphne and Lionel had the two of the top three scores within the Pre- and Post-Encounter attitude categories, which may suggest their struggle with managing their Black identity in larger White contexts. In other words, doctoral students may be faced with the conundrum of when and how to bring attention to issues related their Black identity or Blackness.

Same-Race Connections

While students engaging in these cross-race relationships found their faculty advisors to be culturally responsive, they also felt the importance of having connections to same-race colleagues, faculty, administrators, and others who could provide insight or guidance or validate their feelings of being a Black doctoral student. The doctoral students in the study described the role or importance of same-race (Black) colleagues, faculty, and administrators in their pursuit and persistence of the doctorate. Through a series of questions, Daphne shared her thoughts about her support group of Black women. She commented,

> Well, first of all, they were African American and they were female. And I did not have that kind of that in my department at all. It was good to go and be around people who were like me and who understood what I was going through. Who understood I'm in a class with all these White men and old White male teachers that I'm speaking for the race and the gender you know still it was just they understood what I was going through at the time. They had experienced it you know. It was just a good support. And I did do social things with them I went to one of their houses. One time we had dinner. Another time I went to one of the girls' houses and we had like wine and dinner and just talking and stuff like that.

Later, when I asked what made her experience different from her stance on being strictly professional, and not engaging with students, she responded,

> It was completely different because I was able to let my guard down because I felt they understood what I was going through, you know; it was just completely different. They were out of my department. They were in another department, so I just felt like I was able to let my guard down. They were like mothers. They

were older than me. I felt I wasn't being challenged or intimidated. They were very accepting and they were really trying to genuinely help me and not hurt me in any kind of way.

Another student, Jordan, shared her feelings about having a confidant in her department. She said,

My colleagues in my department, one in particular, I mean, everything that has happened to me, she knows. Everything that has happened to her I know about. We just talk about everything. That feels good to have someone to vent to, but somebody who's in the same experience so she can identify and give me advice or whatever support.

Terrie also felt it was important to have support from other Black doctoral students on campus. When asked about the importance of having same-race peer support, she shared,

To me, [having same-race support is] important [in] that I [align] myself with people who understand what I'm going through and they can relate to the feelings that I have. I'm feeling anxious about, you know, certain things. Like, I know there are people in my life who love me and support me, but they just can't quite understand what I'm going through. I know [my same-race peers] fully support me and try to be understanding, but there are other people that I can talk to because they've been there and they're going through the same thing right now. They can call me when they having a problem or trying to look for an article or need something reviewed or send me their PowerPoint presentation. I know I can send them, mine, and they look over it and give me constructive criticism 'cause they have my best interest in mind

As a follow-up, I asked Terrie about the unique nature of having other Black PhD students supporting her. She explained,

It's basically at a predominately White institution. It's a totally different experience than if we were a PhD student at an HBCU getting a PhD. So, you know, I think that they can relate. They've been there. They understand the dynamic of the university as well and, you know, so we're going through our journeys together so it's been very similarly done.

Students also referenced the same-race peer support gained through participation in the Black graduate association and cultural offices on campus. James commented,

I'm always in [the cultural office]. So, I love going talk to them. If I have [time], I'll run over there go and sit and talk with them Also, the Black graduate association . . . I gained a lot of friends through that. Oh, and the McNair program. I'm always over there.

Students credited the organization with serving as a network of and connection to other graduate students of color. However, they also noted smaller, task-oriented groups of same-race students tended to be more productive, as evident in Daphne's above quotations.

These same-race connections may represent the students' full emersion into their Black identity. While these students faced issues during their doctoral experience, they were able to manage and process these experiences by having same-race support, being able to connect with others who would allow them to express their Blackness and make sense of racial incidences. Cross (1995) described Internalization as the stage where the individual's identity is self-perceived as more multidimensional and other types of identity (e.g., religion and gender) become as intricate to self as her or his Black identity. For Daphne and Terrie, they found connecting with other Black women as important to their success because of the shared racial and gender experiences. The doctoral students' experiences over their lifespan may explain their higher Emersion and Internalization scores. Through racial socialization, racial experiences, and same-race connections over the doctoral students' lifespan, the students have been provided with opportunities to deal with their Black identity.

Discussion

Doctoral education is an extremely difficult process for students to enter, navigate, and complete. Less than 1 percent of U.S. citizens hold doctoral degrees. However, Blacks have begun to enter doctoral programs at significant levels in the past ten years. While this is promising news for the status of Blacks in higher education, there are still major issues that remain: Blacks remain highly under-represented among the faculty ranks, Black doctoral students report higher levels of attrition compared to their White peers, and Black doctoral students still experience racism and wrestle with their Black identity within doctoral programs and within their disciplines. While there has been a growing body of research examining the Black racial identity of Black collegians, the majority of this research targets undergraduate students. Similarly, advising research has historically focused on advising and student-faculty relationships at the undergraduate level. There has been little research focused on the racial identity of students at the graduate level.

Based on the findings in this study, racial identity development remains a factor in the doctoral process for Black doctoral students, particularly for those students who are studying at PWIs and who have White advisors. Furthermore, there exist some correlations between Black doctoral students' reported racial identity attitudes and their shared experiences. On average, Black doctoral students have a moderate to high sense of their Black identity. One explanation for this is that Black doctoral students are older and more mature and have had opportunities to deal with and process their own racial identity. Many of the students went through both undergraduate and graduate programs where they may have been

under represented; therefore, they had racialized experiences prior to beginning their doctoral programs.

Although these students had an internalized sense of their Black identity, there were still racial identity development practices that these students exercised and reconsidered when matriculating through their doctoral programs. Students described how they were prepared or socialized to deal with racism, discussed specifics acts of racism that forced them to contextualize their Blackness and make decisions on how to respond to such acts, and shared their experiences with working across racial differences with a White advisor in addition to the importance of their same-race relationships. Through these narratives, students spoke of their struggles of having a dual identity, being Black and a doctoral student. The majority of the students had instances where their identity was an "either or" negotiation. Either they had to bring race to the center of the conversation, or they had to decide not to bring race to the center for the purpose of not being racially alienated.

Doctoral programs should consider the ways in which racial identity manifests. Doctoral programs comprise students, faculty, and departmental and disciplinary cultures (Gardner, 2008a; Golde, 2005). Students who enter these programs must operate within and between these multiple cultures. Because Black doctoral students are highly under-represented, it is essential that doctoral programs reevaluate how racial identities are silenced or made salient within these complex cultural structures. Therefore, I propose that departments and institutions create opportunities for dialogue and participate in other cultural awareness activities that unpack the role of race in these programs.

Lastly, these findings suggest that additional scholarship is needed where racial identity constructs are studied in the context of doctoral education. The juxtaposition of doctoral education and race presents a unique dynamic where identity formation and development happens from both an individual level and a professional level and how advisors, institutions, and professional associations have a specific role in this development. While this study attempts to begin this conversation, there are limitations. This study was based at one institution in the South and consisted of only seven students in the social sciences and humanities. Future research should expand the number of students, occur at institutions in other geographical areas to delve deeper into the power of context, and examine other disciplinary nuances that may impact the doctoral experience.

References

Allen, W. R. and N. Z. Haniff (1991). Race, gender, and academic performance in U.S. higher education, pp. 95-109. In W. R. Allen, E. G. Epps and N. Z. Haniff (Eds.), *College in Black and White: African American students in predominantly white institutions and historically Black public universities*. New York: State University of New York.

Anderson-Thompkins, S., Gasman, M., Gerstl-Pepin, C., Hathaway, K. L., and Rasheed, L. (2004). "Casualties of war": Suggestions for helping African American graduate students succeed in the academy, pp. 228-240. In D. Cleveland (Ed.) *A long way to go: Conversations about race by African American faculty and graduate students*. New York: Peter Lang Publishing.

Austin, A. E. (2002). Preparing the next generation of faculty: Graduate school as socialization to the academic career. *The Journal of Higher Education, 73*(1), 94.

Becher, T. (1981). Towards a definition of disciplinary cultures. *Studies in Higher Education, 6*(2), 109-121.

Boeije, H. (2002). A purposeful approach to the constant comparative method in the analysis of qualitative interviews. *Quality and Quantity, 36*(4), 391–409.

Bonilla, J., Pickron, C., and Tatum, T. (1994). Peer mentoring among graduate students of color: Expanding the mentoring relationship. *New Directions for Teaching and Learning* (57), 101.

Chavous, T. M. (2000). The relationships among racial identity, perceived ethnic fit, and organizational involvement for African American students at a predominantly White university. *Journal of Black Psychology, 26*(1), 79-100.

Clark, M., and Garza, H. (1994). Minorities in graduate education: A need to regain lost momentum, pp. 297-313. In M. J. Justiz, R. Wilson and L. G. Björk (Eds.), *Minorities in higher education*. Phoenix: American Council on Education and Oryx Press.

Cook, B. J., and Cordova, D. I. (2006). *Minorities in higher education: Twenty-second annual status report*. Washington, DC: American Council on Education.

Cross, W. E. (1971). The negro-to-Black conversion experience. *Black World, 20*(9), 13-27.

Cross, W. E. (1995). The psychology of nigrescence. In J. G. Ponterotto, J. M. Casas, L. A. Suzuki and C. M. Alexander (Eds.), *Handbook of multicultural counseling* (pp. 93-122). Thousand Oaks, CA: Sage.

Davidson, M. N., and Foster-Johnson, L. (2001). Mentoring in the preparation of graduate researchers of color. *Review of Educational Research, 71*(4), 549-574.

Dixon-Reeves, R. (2003). Mentoring as a precursor to incorporation: An assessment of the mentoring experience of recently minted Ph.Ds. *Journal of Black Studies, 34*(1), 12-27.

Fleming, J. (1984). Blacks in College. San Francisco, CA: Jossey-Bass Publishers.

Gardner, S. K. (2008a). Fitting the mold of graduate school: A qualitative study of socialization in doctoral education. *Innovative Higher Education, 33*, 125-138.

Gardner, S. K. (2008b). "What's too much and what's too little?": The process of becoming an independent researcher in doctoral education. *Journal of Higher Education, 79*(3), 326-350.

Gardner, S. K. (2010). Doctoral student development, pp. 203-222. In S. K. Gardner and P. Mendoza (Eds.), On becoming a scholar: Socialization and development in doctoral education. Sterling, VA: Stylus Publishing.

Gardner, S. K., and Barnes, B. J. (2007). Graduate student involvement: Socialization for the professional role. *Journal of College Student Development, 48*(4), 369-387.

Gasman, M., Gerstl-Pepin, C., Anderson-Thompkins, S., Rasheed, L., and Hathaway, K. (2004). Negotiating power, developing trust: Transgressing race and status in the academy. *Teachers College Record, 106*(4), 689.

Golde, C. M. (2005). The role of the department and discipline in doctoral student attrition: Lessons from four departments. *The Journal of Higher Education, 76*(6), 669.

Golde, C. M., and Dore, T. M. (2001). *At cross purposes: What the experiences of today's doctoral students reveal about doctoral education.* Philadelphia, PA: Pew Charitable Trusts.

Harris, C. L. (1995). Whiteness as property, pp. 276-291. In K. Crenshaw, N. Gotanda, G. Peller and K. Thomas (Eds.), *Critical race theory: They key writings.* New York: New York Press.

Holland, J. W. (1993). *Relationships between African American doctoral students and their major advisors.* Paper presented at the American Education Research Association, Atlanta, GA.

Jackson III, B. W. (2001). Black identity development: Further analysis and elaboration, pp. 8-31. In C. L. Wijeyesinghe and B. W. Jackson III (Eds.), *New perspectives on racial identity development: A theoretical and practical anthology.* New York: New York University Press.

Johnson, S. C., and Arbona, C. (2006). The relation of ethnic identity, racial identity, and race-related stress among African American college students. *Journal of College Student Development, 47*(5), 495-507.

Johnson, B., and Christensen, L. (2004). Educational research: Quantitative, qualitative, and mixed approaches (Second Edition). Boston: Pearson Education, Inc.

Jones, C., and Shorter-Gooden, K. (2003). *Shifting: The double lives of Black women in America.* New York: HarperCollins Publishers.

Jones, L. (2000). *Brothers of the academy : Up and coming black scholars earning our way in higher education.* Sterling, VA: Stylus Publishing.

Jones, L. (2001). Creating an affirming culture to retain African-American students during the post affirmative action era in higher education, pp. 3-20. In L. Jones (Ed.), Retaining African Americans in higher education: challenging paradigms for retaining students, faculty, and administrators. Sterling, VA: Stylus Publishing.

Lovitts, B. E. (2001). *Leaving the ivory tower: The causes and consequences of departure from doctoral study.* Lanham, MD: Rowman and Littlefield Publishers.

Mabokela, R. O., and Green, A. L. (2000). *Sisters of the academy: Emerging black women scholars in higher education.* Sterling, VA: Stylus Publishing.

McCormick, A. C. (2001). *The Carnegie classification of institutions of higher education*. Menlo Park, CA: The Carnegie Foundation for the Advancement of Teaching.

Merton, R. K., Kendall, P. L., and Reader, G. G. (1957). *The student-physician: Introductory studies in the sociology of medical education*. Cambridge, MA: Harvard University Press.

Milner, H. R. (2004). African American graduate students' experiences of African American students in higher education, pp. 19-31. In D. Cleveland (Ed.), *A long way to go: Conversations about race by African American faculty and graduate students*. New York: Peter Lang Publishing, Inc.

Milner, H. R., Husband, T., and Jackson, M. P. (2002). Voices of persistence and self-efficacy: African American graduate students and professors who affirm them. *Journal of Critical Inquiry into Curriculum and Instructions, 4*(1), 33-39.

Mizock, L., and Harkins, D. (2009). Relationships of research attitudes, racial identity, and cultural mistrust. *American Journal of Psychological Research, 5*(1), 31-51.

National Science Foundation, Division of Science Resources Statistics. 2010.Doctorate Recipients from U.S. Universities: 2009. Special Report NSF 11-306. Arlington, VA. http://www.nsf.gov/statistics/nsf11306/.

NCES (2007). *Digest of education statistics*. U.S. Department of Education. National Center for Education Statistics.

Nettles, M. T. (1990). Success in doctoral programs: Experiences of minority and White students. *American Journal of Education, 98*(4), 494.

Nettles, M. T., and Millett, C. M. (2006). *Three magic letters: Getting to the Ph.D.* Baltimore, MD: Johns Hopkins University Press.

Parham, T. A., and Helms, J. E. (1981). The influence of Black students' racial identity attitudes on preferences for counselor's race. *Journal of Counseling Psychology, 28*(3), 250-257.

Patterson-Stewart, K. E., Ritchie, M. H., and Sanders, E. T. W. (1997). Interpersonal dynamics of African American persistence in doctoral programs at predominantly White universities. *Journal of College Student Development, 38*(5), 489-498.

Pillay, Y. (2005). Racial identity as a predictor of the psychological health of African American students at a predominantly White university. *Journal of Black Psychology, 31*(1), 46-66.

Robinson, C. (1999). Developing a mentoring program: A graduate student's reflection of change. *Peabody Journal of Education, 74*(2), 119-134.

Rogers, M. R., and Molina, L. E. (2006). Exemplary efforts in psychology to recruit and retain graduate students of color. *American Psychologist, 61*(2), 143.

Sligh-DeWalt, C. (2004). In the midst of a maze: A need for mentoring, pp. 41-46. In D. Cleveland (Ed.), *A long way to go: Conversations about race by African American faculty and graduate students*. New York: Peter Lang Publishing.

Suarez-Balcazar, Y., Orellana-Damacela, L., Portillo, N., Rowan, J. M., and Andrews-Guillen, C. (2003). Experiences of differential treatment. *Journal of Higher Education*, 428-444.

Thomas, K. M., Willis, L. A., and Davis, J. (2007). Mentoring minority graduate students: Issues and strategies for institutions, faculty, and students. *Equal Opportunities International, 26*(3), 178-192.

Tinto, V. (1993). *Leaving college: Rethinking the causes and cures of student attrition* (Second edition). Chicago: University of Chicago Press.

Van Manen, M. (1990). *Researching lived experience: Human science for an action sensitive pedagogy*. New York: State University of New York Press.

Willie, C. V., Grady, M. K., and Hope, R. O. (1991). *African Americans and the doctoral experience: Implications for policy*. New York: Teachers College Press.

Wilson, J. W., and Constantine, M. G. (1999). Racial identity attitudes, self-concept, and perceived family cohesion in Black college students. *Journal of Black Studies, 29*(3), 354-366.

Woodrow Wilson National Fellowship Foundation (2005). *Diversity and the Ph.D.: A review of efforts to broaden race and ethnicity in us doctoral education*. Princeton, NJ: Woodrow Wilson National Fellowship Foundation.

Chapter Seventeen
The Relationship between African American Males' Collegiate Peer Support Groups and Their Racial Identity Development

Jonathan L. Johnson and Michael J. Cuyjet

Introduction

Collegiate co-curricular involvement has been shown to produce specific educational and psychosocial outcomes for all students. Prior literature indicates that student interactions among peer groups enhance their cognitive and intellectual development (Astin, 1977). Other studies affirm that the influence of peer groups may be equal to or greater than traditional classroom experiences (Astin, 1993; Terenzini, Springer, Pascarella, and Nora, 1995), influence student learning (Baxter Magolda, 1992; Terenzini, Pascarella, and Blimling, 1996), as well as positively foster persistence and educational attainment (Astin, 1993; Tinto, 1975, 1993, 1998).

Racial/ethnic-specific student organizations gained momentum after the Black Power and Civil Rights Movements of the 1960s and 1970s at American colleges and universities, as Black Student Unions, African Student Associations, and Black gospel music organizations formed on many campuses. The presence of African American men in gender-specific student organizations has existed for decades in historically Black fraternities and college athletics. Over recent years, the presence of organizations that are both racial/ethnic-specific and gender-specific, such as Student African American Brotherhood (S.A.A.B.), Collegiate 100, and other related organizations, has contributed to retention efforts. Such groups also service

the needs of this population of collegiate men to acquire social capital, encourage cultural awareness, and promote academic success (Cuyjet, 2006).

This chapter will examine the connection between African American college men's engagement in ethnic-specific clubs and organizations and their racial and ethnic identity consciousness. By exploring the research literature on the topics of African American men's engagement within gender-specific or male-oriented clubs and organizations, such as fraternities, peer support groups, cultural heritage groups, and campus (co-curricular) leadership groups, and examining the factors that enhance African American male racial identity development, we hope to identify elements common across those two themes.

Beverly Tatum (1997) suggests that ethnic and gender-specific group orientation is a contributing factor towards the positive psychosocial growth of students of color. For African American college men, ethnic and gender-specific clubs and organizations not only serve as a traditional resource for transitioning students into the diverse experiences of college, these groups also serve as a resource to further bridge the gap between the cultural majority at predominantly White institutions (PWIs) and their family's cultural values and beliefs, along with their specific characteristics of masculine and ethnic identity.

Advocates for increasing the presence of students of color in college have shifted their rationale from access and equity for the enrollment of under represented groups toward advocating diversity in higher education as an educational component in developing both the holistic education of individual students and, consequently, democratic citizenship among all students (Inkelas, 2004). However, opponents argue that increasing the numeric composition of racial/ethnic groups in American colleges and universities and focusing specifically on their individual development only results in the increase of racial segregation. In other words, while it may be expected that some students who may feel marginalized are likely to self-segregate around some common characteristic intellectually, socially, and in co-curricular activities, such as only participating within clubs and organization that are culturally or ethnically specific. Opponents argue that such compartmentalization devalues the potential outcomes of interacting with diverse peers and hinders developing democratic citizenship. In a longitudinal study of Asian Pacific American undergraduates, Inkelas (2004) found gains in ethnic awareness of Asian Pacific American community issues and intercultural understanding of participants involved with ethnic-specific student organizations.

Astin (1996), Kuh, Schuh, Whitt, and Associates (1991), and Pascarella, Nora, Terenzini, Whitt, Edison, and Hagedorn (1996) have all contributed literature supporting the *involvement*, *engagement*, and subsequent positive *impact* of providing learning opportunities for all college students outside of the classroom. The use of such learning opportunities has been shown to positively influence the academic, intellectual, social and personal development and experiences of students. These principles can also be applied to culturally specific groups and the benefits derived from them.

In addition to the benefits for African American males specific to the collegiate environment, we intend to explore how psychosocial development on the campus coincidentally enhances positive identity development and consciousness as depicted in several racial and ethnic identity models (Cross, 1971; Jackson, 2001).

Theoretical Framework for Involvement

Astin (1970a, 1970b, 1977, 1984) established a widely used model for student involvement, whereby inputs-environments-outcomes (I-E-O) assess the impact of college on students. Astin's simple, yet effective theoretical framework has been used and peer reviewed for over forty years to assess the impact of a college environment on students. The framework's use of *inputs*—prior background and characteristics students bring to college; *environments*—educational and co-curricular encounters students experience during college; and *outcomes/outputs*—the outcomes or gained characteristics of students after experiencing college, complement this chapter's inquiry of the relationship between the cultural awareness and co-curricular involvement of collegiate African American men.

The most significant characteristics of Astin's (1984) model are the "I" or inputs of African American male students' background. The inclusion of African American men's family histories, current social status, values and beliefs serve as guiding principles as to how each student, given his distinct background, will interact with the "E" or the environment upon entering and while matriculating through the college environment. For example, Astin's (1977, 1984, 1985) involvement theory suggests that students who are not involved are more likely to drop out of school than those who are involved in student organizations, live in residence halls, or participate in some type of intercollegiate sport. He also found that students who attend religiously affiliated institutions are more likely to persist if their faith is aligned with the schools' religious doctrine, and African American students who attend Historically Black Colleges and Universities (HBCUs) are more likely to graduate than African American students who have attend PWIs. In other words, student involvement and retention is impacted by the psychological investment and social experiences in the college environment.

In a diverse college environment, African American college students certainly join organizations that are not culturally or gender-specific; however, it is questionable whether or not majority White student groups adequately enhance the degree of involvement or quality of student effort needed for African American men to take full advantage of institutional resources. An advantage of racial/ethnic and gender-specific organizations is that they generally account for the cultural predispositions, as well as enhance the ethnic identity development of African American collegiate men, thus, fostering an environment conducive for leadership and intellectual development.

Black Affinity Student Organizations

African Americans' early pursuit of higher education was limited until after 1954, the year "separate but equal" laws were found unconstitutional. For many African American students attending PWIs, they were not often welcomed on college and university campuses across the nation. As a critical mass of African American students began to integrate into university campuses, they formed their own groups for social support and to affirm the civil rights movement (Wolf-Wendel, Twombly, Tuttle, Ward, and Gaston-Gayles, 2004). SNCC, the Student Non-Violent Coordinating Committee, was a group of students who voluntarily supported civil rights efforts during the 1960s with peaceful campus and community protests for racial equality. African American students, with the allied support of other student populations, wanted to take action. A quotation at the National Civil Rights Museum attributed to a member of SNCC made students sentiments from that era clear, "Truth comes from being involved and not from observation and speculation" (Wolf-Wendel et al., 2004, p. vii). With the support of a national out-cry for social justice and change in government policy, other Black student-led groups began to organize with a heavier stream of African American students being recruited onto predominantly White college and university campuses than ever before. Students not only brought their educational ambitions, they brought a rediscovered and redefined sense of cultural consciousness (Cross, 1971; Jackson, 2001).

An immediate challenge faced by African American students was that they had been admitted to institutions that had historically served almost exclusively White students. Resources and opportunities for social engagement were limited, at best. Many institutions of higher education were not adequately prepared for the racial harassment and cultural isolation experienced by its new population of students. As a result, African American students began to form organizations that were culturally affirming, which also served as a refuge from the social challenges on campus. For this reason, as more African American students enrolled, Black student related organizations became the primary source of African American students' collegiate experience at predominantly White institutions (Wolf-Wendel et al., 2004). Today, African American students continue to seek the familiarity of peers with similar racial and ethnic backgrounds (Tatum, 1997).

While there are studies that support the need for gender and racial/ethnic-specific student organizations, opponents to racial/ethnic-specific student organizations suggest that these affinity groups contribute to campus segregation. Empirical studies offer further insight about students who participate in racial/ethnic student organizations (Treviño, 1992; Mitchell and Dell, 1992). These studies illustrate that students are involved with these organizations because they enhance their sense of identity, particularly at predominantly White institutions. Furthermore, these studies have shown that participation in racial/ethnic student organizations influence students' capacity to seek cultural and cross-cultural involvement, as well as found to be more likely to attend cultural and racial workshops (Treviño, 1992). Hurtado, Milem, Clayton-

Pederson, and Allen (1998), who reviewed a study by Gilliard (1996) that examined factors impacting the racial climate at predominantly White institutions between African American and White students, noted that African American students who were involved with the cultural affinity organizations, such as the Black Student Union, had greater social involvement, took advantage of student support services, and interacted with faculty.

Student support services like Black Cultural and Multicultural Centers, and the faculty and staff who advise them or who are aware of cultural specific concerns of African American collegiate men also aid in their overall satisfaction and persistence on campus. As a matter of institutional policy and practice, Hurtado, Milem, Clayton-Pederson, and Allen (1998) underscore the significance of such cultural specific services and affinity groups with research findings noting the important role of ethnic student organizations and other student support services for students of color on predominantly White campuses. Hence, campuses must insure that these services and organizations have enough staff, funding, and resources to serve students successfully (p. 292).

The collective support of university services, along with cultural and gender-specific student organizations, offer a combined effort to ease the often challenging transition of African American men as they enter college and to facilitate their matriculation. Moreover, the combination of established racial/ethnic-specific and gender-specific student organizations can deliver peer-to-peer support that has a lasting and significant effect on students because they provide a roadmap that socializes African American men to the unique characteristics of the institution's campus culture and environment.

Benefits of Black Male Peer Support Groups

While involvement in college and engagement in the campus community of any sort—academic or co-curricular—tends to benefit Black male students as it does students of any demographic group, there are clear advantages for some Black male students to engage in groups that consist exclusively of Black males. One basic benefit is that their visibility on campus is enhanced. Cuyjet (2006, 2009) addresses the problem occurring on numerous campuses at which the percentage of Black males is quite low compared to Black females, such that the Black male students become "invisible" as their issues are defined by the concerns of the entire the community of Black students, which is dominated by females as the numerical majority. Thus, if, for example, females attain higher GPAs and have better academic behaviors, Black men's issues in these areas can be lost or overlooked by administrators who even try to monitor them.

Another very important benefit to those who participate in Black male peer groups is the enhanced sense of community that can evolve from such involvement. This appears to be a rather critical need for almost all African American students, particularly those on PWI campuses, as a component of identity development that

must now include the role of student and scholar with the other aspects of manhood formation occurring with the transition to the campus environment. The outcome of the transitional identity development process as described by Johnson and Cuyjet (2009) is for African American men to adopt a new identity and self-image that is redefined, renamed, reaffirmed, and reclaimed, whereby . . . employing this newfound (or newly refined) positive sense of identity, an African American male college student may, thus, try to develop a sense of community . . . a sense of identity-enhancing "belongingness" on the campus. (p. 68).

The relative "safety" of a group of other African American males can offer a place to feel grounded and comfortable in the campus environment. This is likely what Tatum (1997) was referring to when she described "a place to be rejuvenated and to feel anchored in one's cultural community" (p. 80). Bonner (2001) found that participants in his study of high-achieving African American male students acknowledged increased levels of confidence in their own abilities in the academic and social support they received from peers. Within this safe environment of race-specific student organizations, African American males find a positive venue to expand their understanding of their own Black identity and to express that identity to peers experiencing the same development (Harper and Quaye, 2007). This, in turn, offers a fertile environment for these students to form a sense of "studentness" as a critical component of the total sense of self (Palmer and Strayhorn, 2008).

Black male peer groups can also serve an important function as sources of collegial support and reinforcement for their members' academic and social achievements. In his conversations with high achieving African American college men, Harper (2011) found that "they spoke at length about the value of having a close-knit group of African American male peers for whom achievement was important" (p. 447) and that "many intentionally chose to surround themselves with guys who were 'going somewhere,' doing positive things on campus and staying clear of trouble" (p. 448).

One significant benefit to Black male peer groups is the support these men give to each other for success in their academic endeavors. As Harper (2011) states, "There is an erroneous assumption that Black male college achievers are socially disconnected from their same-race peers and thus accused of acting White" (p. 878). Another of Harper's studies seems to have documented that we have turned a corner of the earlier issues of successful African American males student having to, as Ogbu stated, conduct a "social cost-benefit analysis" on his academic success and act accordingly. Black male peer groups in which academic prowess is prized and reinforced allow these individuals a community of peers where they can get support for academic success instead of the derision for "acting white' that characterized earlier studies of this phenomenon (Fordham and Ogbu, 1986).While this phenomenon of discouraging academic success may still occur in individual cases, most Black male peer support groups actually encourage academic achievement and provide group reinforcement for such successes. An example is the "props" that members of the Student African American Brotherhood (SAAB)

chapters give to each other to encourage and promote scholarship and academic achievement in each other.

Two final benefits of Black male peer group membership merit mention here. One is the opportunity to remove the distinction of race in one's interpersonal interactions and thus to explore the heterogeneity of the Black male population. Harper and Nichols (2008) remind us of the demographic variances that can occur in the Black male population on many campuses. When Black men are brought together, particularly on campuses where they are spread thin and may not even see each other for days at a time, these interactions among peers who have a common Black identity, but also many other characteristics of distinction and diversity, provides useful opportunities to learn about and from each other.

A second benefit of Black male peer group membership is the opportunity to acquire leadership experience and to hone those skills related to leadership roles. A substantial number of those Black males who serve in campus leadership roles profess to first serving as positional leaders in their fraternities or other race/ethnic-related student organizations. These organizations provide the opportunities to "acquire social capital on the campus"(Johnson and Cuyjet, 2009, p.70) and to test one's leadership abilities before venturing into more interactive roles in organizations and activities in the larger campus community.

Recommendations

It is important to create and support opportunities for African American college men that bridge the transition from home to college and both maintain and further develop their cultural identity through that process. University campuses must continue to provide quality experiences that value the individual culture and identity of all students, specifically when developing environments conducive for learning for African American college men at predominantly White institutions. Involvement in collegiate Black male peer support organizations is a critical component in ensuring positive growth of African American men's social, psychological, intellectual, and identity development. The positive impact of gender and racial/ ethnic-specific organizations, as well as student support services, must be included in all college and university strategic initiatives to enhance the diversity of experiences that may benefit the entire campus community (Hurtado, Milem, Clayton-Pederson, and Allen, 1998). Therefore, proper funding, staffing, and resources must be made available and assessed to adequately identify the developing needs essential for student success.

Lastly, African American men joining a peer support groups are only the beginning and merely opens an opportunity to ensure their success. Their continuing degree of involvement in such a group creates a dynamic, on-going opportunity to develop a salient understanding of peer support, leadership and academic success, while diminishing feelings of isolation and marginality.

References

Astin, A. W. (1970a). The methodology of research on college impact (I). *Sociology of Education, 43*, 223-254.

Astin, A. W. (1970b). The methodology of research on college impact (II). *Sociology of Education, 43*, 437-450.

Astin, A. W. (1977). *Four critical years: Effects of college on beliefs, attitudes, and knowledge.* San Francisco: Jossey-Bass.

Astin, A. W. (1984). Student involvement: A developmental theory for higher education. *Journal of College Student Personnel, 25*, 297-308.

Astin, A. W. (1985). *Achieving educational excellence: A critical assessment of priorities and practices in higher education.* San Francisco: Jossey-Bass.

Astin. A. W. (1993). *What* matters in college? *Four critical years revisited.* San Francisco: Jossey-Bass.

Astin, A.W. (1996). Involvement in learning revisited: Lessons we have learned. *Journal of College Student Development, 37*, 123-133.

Baxter Magolda, M. (1992). *Knowing and reasoning in college: Gender-related patterns in students' intellectual development.* San Francisco: Jossey-Bass.

Bonner II, F. A. (2001). *Gifted African American male college students: SA phenomenological study.* Storrs, CT: National Research Center on the Gifted and Talented.

Cross, W. E., Jr. (1971). The Negro to Black conversion experience: Toward a psychology of Black liberation. *Black World, 20*(9), 13-27.

Cuyjet, M. J. (2006). *African American men in college.* (Ed.) San Francisco: Jossey-Bass.

Cuyjet, M. J. (2009). Invisible men—almost: The diminution of African American males in higher education, pp. 1-11. In H. T. Frierson, W. Pearson, Jr., and J. H. Wyche (Eds.) *Black American males in higher education: Diminishing proportions.* United Kingdom: Emerald Books.

Fordham, S., and Ogbu, J. U. (1986). Black students' school success: Coping with the burden of acting White. *Urban Review, 18*(3), 176-206.

Harper, S. R. (2010). Peer support for African American male college achievement: Beyond internalized racism and the burden of "acting White," pp. 434-456. In S. R. Harper and F. Harris III (Eds.) *College men and masculinities: Theory, research, and implications for practice.* San Francisco: Jossey-Bass.

Harper, S. R. (2011). Niggers no more: A critical race counter narrative on Black male student achievement at predominantly White colleges and universities, pp. 875-887. In S. R. Harper and S. Hurtado (Eds.) *Racial and ethnic diversity in higher education, ASHE reader series* (Third edition). Boston: Pearson Learning Solutions.

Harper, S. R., and Nichols, A. H. (2008). Are they not all the same? Racial heterogeneity among Black male undergraduates. *Journal of College Student Development, 49*(3), 199-214.

Harper, S. R., and Quaye, S. J. (2007).Student organizations as venues for Black identity expression and development among African American male student leaders. *Journal of College Student Development, 48*(2), 133-159.

Hurtado, S., Milem, J. F., Clayton-Pederson, A. R., and Allen, W. R. (1998). Enhancing Campus Climates for Racial/Ethnic Diversity: Educational Policy and Practice. *The Review of Higher Education, 21*(2), 279-302.

Inkelas, K. K. (2004). Does participation in ethnic cocurricular activities facilitate a sense of ethnic awareness and understanding? A study of Asian Pacific American undergraduates. *Journal of College Student Development, 45*, 285-302.

Jackson, B. W. (2001). Black identity development: Further analysis and evaluation, pp. 8-31. In C. L. Wijeyesinghe and B. W. Jackson (Eds.) *New perspectives on racial identity development: A theoretical and practical anthology.* New York: New York University Press.

Johnson, J. L., and Cuyjet, M. J. (2009). Enhancing identity development and sense of community among African American males in higher education, pp. 57-78. In H. T. Frierson, J. H. Wyche, and W. Pearson, Jr. (Eds.) *Black American males in higher education: Research, programs and academe.* United Kingdom: Emerald Books.

Kuh, G. D., Schuh, J. H., Whitt, E. J., and Associates (1991). *Involving colleges: Successful approaches in fostering student learning and development outside the classroom.* San Francisco. Jossey-Bass.

Mitchell, S. L., and Dell, D. M. (1992). The relationship between Black students' racial identity attitude and participation in campus organizations. *Journal of College Student Development, 33,* 39-43.

Palmer, R. T., and Strayhorn, T. L. (2008). Mastering one's own fate: Non-cognitive factors associate with the success of African American males at an HBCU. *NASPA Journal, 11*(1), 126-143.

Pascarella, E. T., Nora, A., and Terenzini, P. T., Whitt, E. J., Edison, M. I., and Hagedorn, L S. (1996).What have we learned from the first year of the National Study on Student Learning? *Journal of College Student Development, 37,* 182-192.

Tatum, B. D. (1997). *Why are all the Black kids sitting together in the cafeteria?: And other conversations about race.* New York: Basic Books.

Terenzini, P., Pascarella, E., and Blimling, G. (1996). Students' out-of-class experiences and their influences on learning and cognitive development: A literature review. *Journal of College Student Development, 37,* 149-162.

Terenzini, P., Pascarella, E., and Nora, A. (1995). The multiple influences on students' critical thinking skills. *Research in Higher Education, 36,* 23-29.

Tinto, V. (1975). Dropout from higher education: A theoretical synthesis of recent research. *Review of Educational Research, 45,* 89-125.

Tinto, V. (1993). *Leaving college: Rethinking the causes and cures of student attrition.* Chicago: University of Chicago Press.

Tinto, V. (1998). Colleges and communities: Exploring the educational character of student persistence. *Review of Higher Education, 21*, 167-177.

Treviño, J. G. (1992). *Participating in ethnic/racial student organizations.* Unpublished doctoral dissertation, University of California, Los Angeles.

Wolf-Wendel, L. E., Twombly, S. B., Tuttle, K. N,, Ward, K., and Gaston-Gayles, J. L. (2004). *Reflecting back, looking forward: Civil rights and student affairs.* Washington, DC: NASPA.

Index

425

About the Editors

Jas M. Sullivan, PhD, is an assistant professor of political science and African and African American studies at Louisiana State University. His primary research interest is centered on race, identity, and political behavior. Dr. Sullivan received his MA in African American and African Diaspora studies and his PhD in political science from Indiana University-Bloomington.

Ashraf M. Esmail, PhD, is an assistant professor in social sciences at Southern University at New Orleans. His research interests include urban, multicultural, and peace education, family, cultural diversity, political sociology, criminology, social problems, and deviance. He is senior editor of the *Journal of Education and Social Justice*. He served as president of the National Association for Peace Education from 2010 to 2011. He serves as the proposal lead for the National Association for Multicultural Education.

About the Contributors

Keena Arbuthnot, PhD, is an assistant professor at Louisiana State University in the Department of Educational Theory, Policy and Practice. She received her PhD in educational psychology from the University of Illinois at Urbana-Champaign, specializing in psychometrics/educational measurement, applied statistics, and program evaluation. Prior to working at Louisiana State University, Dr. Arbuthnot held a dual appointment as a postdoctoral fellow and lecturer on education at Harvard University. She conducts research that addresses issues related to the Black-White achievement gap, differential item functioning, psychological factors related to standardized test performance, stereotype threat, test fairness, and mathematical achievement.

Meeta Banerjee is a doctoral candidate in the ecological-community psychology program at Michigan State University. Her research focuses on parenting processes in African American families such as racial/ethnic socialization in different ecological contexts such as families, schools, and communities.

Marco J. Barker, PhD, serves as the assistant to the vice provost and director of educational equity for Equity, Diversity and Community Outreach at Louisiana State University. His area of research includes diversity, doctoral education, cross-cultural developmental relationships, mentoring, service-learning, and leadership in higher education. Dr. Barker received his PhD in educational leadership and research with an emphasis in higher education from Louisiana State University.

Cathryn D. Blue is a doctoral candidate in the area of experimental social psychology at Saint Louis University (SLU). She received her master's of science (research) from SLU. Blue's research interests include racial identity and time orientation.

Christy M. Byrd is a doctoral candidate in the combined program in education and psychology at the University of Michigan. Her research interests focus on

the impact of school racial climate on adolescent academic achievement and development. She is also interested in how racial identity and racial attitudes are implicated in the impact of climate on youth outcomes.

Cleopatra Howard Caldwell, PhD, is an associate professor of health behavior and health education at the School of Public Health and the director of the Center for Research on Ethnicity, Culture and Health at the University of Michigan. Her research and publications focus on psychosocial and family factors as influences on the mental health and health risk behaviors of African American and Caribbean Black adolescents, intergenerational family relationships and early childbearing, discrimination, racial identity, and adolescent well-being, research with Black churches, and intervention research using community-based participatory research approaches.

Tabbye M. Chavous, PhD, is an associate professor in the School of Education and the Department of Psychology at the University of Michigan. Her primary research interests and activities involve ethnic minority adolescent development, with an emphasis on social identity processes related to academic and psychological adjustment outcomes among adolescents and emerging adults. Additionally, her work focuses on the influence of educational contexts (teacher-student classroom interactions, organizational climate, and peer interactions) on the academic and social development of youth in secondary and post-secondary settings.

Eddie M. Clark, PhD, is a professor of psychology at Saint Louis University. His research examines health attitudes and persuasion, especially culturally appropriate health communication, and the relationship between religiosity and health. His research also examines close relationships including infidelity, relationship maintenance, and ex-partner relationships. He received his bachelor's degree in psychology from Northwestern University and his master's and doctorate in social psychology from Ohio State University. He completed a postdoctoral fellowship in behavioral medicine at the University of Memphis, where he was also a faculty member. He has been at SLU since 1991.

William E. Cross, Jr., PhD, is professor and coordinator of graduate studies in the Department of Counselor Education, School of Education, at the University of Nevada at Las Vegas. He has been a major contributor to the discourse on African American identity across a thirty-five year career in the academy.

Michael Cunningham, PhD, is an associate professor with a joint appointment in psychology and African and African Diaspora studies at Tulane University, as well as the founding executive director of the Center for Engaged Learning and Teaching, which is a division of Academic Affairs. His research focuses on ado-

lescent development with a particular focus on gender-specific patterns. He received his doctorate from Emory University after completing undergraduate studies at Morehouse College. He also completed a postdoctoral fellowship at the University of Pennsylvania.

Michael J. Cuyjet, PhD, is a professor in the Department of Educational and Counseling Psychology at the University of Louisville, teaching and serving as program coordinator in the College Student Personnel Program. Among his recent publications, he edited and coauthored the 2006 book *African American Men in College,* and was both editor and an author of the 2011 book *Multiculturalism on Campus: Theories, Models, and Practices for Understanding Diversity and Creating Inclusion.* Dr. Cuyjet received a bachelor's degree in speech communications from Bradley University and a master's degree in counseling and a doctorate in counselor education from Northern Illinois University. In 2006, he was named a Diamond Honoree by the ACPA Educational Leadership Foundation. In 2009, he was named one of ACPA's Senior Scholars and in 2011 he was named a Pillar of the Profession by NASPA.

E. Hill De Loney, MA, is the director of the Flint Odyssey House in Flint, Michigan. De Loney, a psychologist, was the community co-principal investigator of the Flint Fathers and Sons Project. She has extensive experience as a community-based participatory researcher, community organizer, and program developer, especially for youth programming. De Loney is an expert in cultural competence in working with African American communities and families. She conducts cultural awareness trainings and workshops throughout the nation.

Corinn A. Elmore is a doctoral candidate at Loyola University Chicago in the clinical psychology department where she is in the child/family subspecialty. She also holds a degree in marital and family therapy from Northwestern University. Her research is broadly focused on positive minority youth development and has included such topics as parenting, racial socialization, culturally-relevant coping processes, and racial identity.

Alexandra Z. Ghara is a graduate student in political science at Louisiana State University. She specializes in racial and ethnic politics with a concentration in political psychology. Her research interests include racial and ethnic identity, group conflict, political communication, and implicit cognition.

Bruce Ormond Grant, PhD, is an independent scholar who currently resides in New York City. Dr. Grant holds a PhD in African studies and research from Howard University. His research interests are African and African American development over the life span.

Lauren Gray is a special education teacher in Irving, Texas. She is a graduate of the University of Michigan. While at the University of Michigan, she majored in psychology and collaborated with several research teams, including the Gender, Ethnicity, and Depression team, The Detroit Initiative, and the Center for the Study of Black Youth in Context.

Richard D. Harvey, PhD, is an associate professor of psychology in both the social psychology and industrial/organizational psychology programs at Saint Louis University. He currently holds a double appointment and his areas of interest include collective identity, prejudice/racism, organizational development, program evaluation, and teaching scholarship. Harvey is a fellow of the Center for the Application of Behavioral Sciences (CABS). He received his PhD from the University of Kansas.

Kyle Huckeis a doctoral student in Tulane University's psychological sciences doctoral program. With a focus on developmental psychology, his research interests are associated with gender-specific patterns associated positive youth development. Kyle completed his BS and MS degrees in psychology at Tulane University.

Charles Jaret, PhD, is professor of sociology in the Department of Sociology at Georgia State University. Besides racial/ethnic identity, his current research deals with racial/ethnic socioeconomic inequality and effects of immigrants becoming naturalized U.S. citizens.

Jonathan L. Johnson is a doctoral candidate in the counseling and college student personnel program at the University of Louisville. He currently serves as the associate director of facilities and operations for Housing and Residence Life at the University of Louisville. He consults and collaborates with colleges and universities on issues related to men and masculinities, identity development of college students, and critical race theory. The intersection of ethnicity and masculinity of African American collegiate men's identity are among recent scholarly research and publications.

Jelani Mandara, PhD, is an associate professor at Northwestern University in the human development and social policy department. He is a family and developmental psychologist and his research examines the nature and effects of socialization, father's involvement, and how they interact with gender, race, and socioeconomic status to impact youth development. He also examines how differences in parenting and other family factors account for ethnic and gender disparities in achievement and the likelihood of engaging in risky behavior.

Rosa Maria Mulser is a doctoral candidate at Tulane University. Her research interests include risk and protective factors impacting the mental health of African American adolescents such as racial identity, race-related stress, religiosity, and perceived parental support. She completed her doctoral dissertation in the Spring of 2011 and will graduate Tulane University in May 2012 after completing her pre-doctoral internship in Cleveland, OH.

Amanda D. Persaud is the post-baccalaureate research coordinator of the Heart and Soul Study at Harlem Hospital. She graduated magna cum laude from the University of Massachusetts-Amherst, where she received her BA in psychology. She completed an honors thesis under the direction of Dr. Paula Pietromonaco and Dr. Sally Powers, studying the effects of physical and sexual trauma on cortisol levels in the body. Her research interests include trauma, substance abuse, and depression.

Jason Purnell, PhD/MPH, is an assistant professor at Washington University in St. Louis, George Warren Brown School of Social Work, Institute for Public Health. Dr. Purnell is interested in how sociocultural and socioeconomic factors influence cancer prevention and control behaviors and how information and communication technologies (e.g., cell phones, Internet, etc.) can be employed to reduce health disparities in low-income and racial and ethnic minority populations. He is trained in both applied psychology and public health. He completed undergraduate studies at Harvard University, received his doctoral degree in counseling psychology from the Ohio State University, and received his master of public health degree from the University of Rochester School of Medicine and Dentistry. Dr. Purnell completed an NCI-funded fellowship in cancer prevention and is a licensed psychologist in the states of New York and Missouri.

Stephen M. Quintana, PhD, is a professor in the Department of Counseling Psychology at the University of Wisconsin-Madison. Dr. Quintana's current research is in developing and evaluating a model of children's understanding of social status, which includes ethnicity, race, gender, religion, and social class. His other multicultural research has focused on racial and ethnic identity, students' adjustment to higher education, children's understanding of ethnic prejudice, and multicultural training in professional organizations. He was associate editor of *Child Development* and lead editor for a special issue of *Child Development* on *Race, Ethnicity, and Culture in Child Development*. Currently, he is associate editor of *Journal of Counseling Psychology* and lead editor for the book *Race, Racism and the Developing Child*. He received his PhD from the University of Notre Dame. He taught at the University of Texas-Austin for seven years before joining the faculty at UW-Madison. He received a Ford Foundation Postdoctoral Fellowship for research investigating Mexican-American children's

understanding of ethnicity. He received a Gimbel Child and Family Scholar Award for promoting Racial, Ethnic, and Religious Understanding in America.

Donald C. Reitzes, PhD, is professor and chair of the Department of Sociology at Georgia State University. His ongoing research interest is the investigation of identity processes and outcomes including the influence of worker, grandparent, and retirement identities on well-being. He has collaborated with Charles Jaret on earlier studies of racial/ethnic identities and on the impact of reflected appraisals on self-esteem.

Debra D. Roberts, PhD, is an associate professor in the psychology department at Howard University. As a developmental psychologist, Dr. Roberts' primary area of research involves examining various aspects of culture and ethnicity as they impact the relationship between psychosocially toxic environments (e.g., poverty, violence, discrimination, trauma, etc.) and psychosocial well-being among children and adolescents. She has served as research coordinator for a longitudinal study on violence prevention that examined the influence of community violence on Head Start families, and helped to develop a community-based violence intervention program. She holds a BS in neuroscience/psychology from the University of Toronto, a MS in community psychology from Florida A&M University, and a PhD in developmental psychology from Temple University.

Latisha Ross is a doctoral student at the University of Michigan in the combined program in education and psychology. Her research centers on understanding the ways in which adolescents are academically socialized. Her research also examines the effects of gendered academic socialization on the academic outcomes of adolescents.

Stephanie J. Rowley, PhD, is a professor at the University of Michigan in the psychology department and School of Education. She is also a co-director of the Center for the Study of Black Youth in Context at Michigan. Her research focuses on the role of parents in young adolescents' developing self-concepts. She also considers the ways in which issues of race and gender intersect to influence motivational processes.

Deepika Singh, MD, serves as chief of outpatient service and an attending psychiatrist at Harlem Hospital Center. She is also an assistant clinical professor of psychiatry at the Columbia University College of Physicians and Surgeons. Dr. Singh is co-principal investigator along with Dr. Joel Sneed of the Heart and Soul Study at Harlem Hospital.

Aaron V. Smith is a doctoral student in the counseling psychology program at the University of Wisconsin-Madison. He is a clinician at Wisconsin Psychiatric Institute and clinics teaching assistant in the Department of Counseling Psychology. His research and clinical interests are working to empower underrepresented populations. He received his bachelor's and master's degrees from Michigan State University.

Joel R. Sneed, PhD, is an assistant professor of psychology at Queens College of the City University of New York, an adjunct assistant professor of medical psychology at Columbia University and the New York State Psychiatric Institute in the Departments of Geriatric Psychiatry and Psychiatric Epidemiology. Dr. Sneed is the director of the Lifespan Lab and is currently funded by a Career Development Award from the National Institute of Mental Health. He is co-principal investigator along with Dr. Deepika Singh of the Heart and Soul Study at Harlem Hospital.

Ronald D. Taylor, PhD, is an associate professor in the Department of Psychology at Temple University. Dr. Taylor's work has been focused on factors associated with the social and emotional adjustment of ethnic minority adolescents. In addition, his work has focused on family relations, including parent styles and parenting practices and the links to African American adolescents' psychological well-being. Dr. Taylor graduated with a BA in developmental psychology from University of California, Santa Barbara, and he received his PhD from the University of Michigan in developmental psychology.

Rachel E. Tennial is a graduate student in experimental social psychology at Saint Louis University. She received her master of science (research) from SLU. Rachel is currently conducting research in the areas of stereotyping, stigma, prejudice, and racial/ethnic identity and identification.

Alvin Thomas, MS, is a doctoral candidate in the Department of Psychology at the University of Michigan. His research and publications examine gender and racial identity in African Americans, masculine identity construction in Caribbean Blacks, and vocational discernment in Tibetan Buddhist monks. Additionally, he has focused on piloting a brief intervention program with a clinical sample in a state run boys' group home in the Caribbean. The program explores the risk and protective factors for aggression and techniques for building resilience in that sample.

Vetta Sanders Thompson, PhD, is an associate professor at Washington University in St. Louis, George Warren Brown School of Social Work, Institute for Public Health and Urban Studies. Her research has focus on racial identity, psy-

chosocial implications of race and culture for mental health, health communication and promotion, health services utilization, and determinates of health and mental health disparities. Dr. Thompson is PI of the NCI-funded African American Multi-Construct Survey of Cultural Constructs, which is developing measures of health related cultural variables among African Americans, and completed NCI-funded research on HPV attitudes and vaccination in the African American community. Dr. Thompson received her bachelor's degree in psychology and social relations from Harvard University and her master's and doctorate in psychology from Duke University, where she also completed the clinical training program. Dr. Thompson is a licensed psychologist and health service provider in the state of Missouri.

Angelique Trask-Tate, PhD, is a psychology intern with the Houston Independent School District. She received her PhD in school psychology from Tulane University. Her research interests include factors contributing to the academic and psychological resilience of African American youth, such as parents' racial socialization techniques, parent support, and racial identity.

Fatima Varner, PhD, is a postdoctoral research fellow with the Center for the Study of Black Youth in Context at the University of Michigan. Her research focuses on the influence of parenting and family processes on African American adolescents' academic achievement and mental health. She also studies the influence of contextual factors on parenting.

Ana Ventuneac, PhD, is a research scientist at the Center for HIV Educational Studies and Training at Hunter College of the City University of New York (CUNY). Dr. Ventuneac's primary research focuses on HIV prevention for gay and other men who have sex with men, especially for young men of color. Her research interests include applying innovative Internet and mobile-based technologies as tools in social science research, particularly for online HIV prevention programs, as well as examining the acceptability of new biomedical strategies in the prevention of HIV among men who have sex with men. Dr. Ventuneac received her PhD in social and personality psychology from Graduate Center at CUNY.

Susan Krauss Whitbourne, PhD, is a professor of psychology at the University of Massachusetts Amherst. The author of over 130 refereed articles and book chapters and 15 books (many in multiple editions and translations), her most recent work is *The Search for Fulfillment* (January 2010, Ballantine Books). Dr. Whitbourne is the recipient of a 2011 Presidential Citation from the American Psychological Association. The lead author of a forty-year longitudinal study, she focuses on lifespan personality development and cognition in later life.

Amber Williams is a doctoral student at the University of Michigan in the developmental psychology department. Her research focuses on the development of racial identity in children and adolescents. She is interested in how family racial socialization and the racial demographic of one's school and community affect the development of racial identity over time. She completed her undergraduate studies at Rice University.

CPSIA information can be obtained at www.ICGtesting.com
Printed in the USA
BVOW040247170412

287693BV00001B/4/P